Juan de Herrera

Architect to Philip II of Spain

Juan de Herrera

Architect to Philip II of Spain

Catherine Wilkinson-Zerner

Yale University Press
New Haven and London 1993

For Henri, Rachel, and Charles Theodore

Designed by John Trevitt
Set in Linotron Sabon by Best-set Typesetter Ltd., Hong Kong
Printed in Hong Kong through World Print Ltd.

LC 93-60701
ISBN 0-300-04991-9

Contents

Note

Unless otherwise noted, measurements are given in Castilian feet.
The Castilian foot was ⅓ of a Roman *vara* and equivalent to 28 cm.

Photographic acknowledgments

The author is grateful for permissions granted to photograph Herrera's buildings and to the Archivo Histórico Nacional in Madrid, the Archive and Museum of the Cathedral and Museo Municipal in Valladolid, and the Archive of the Tavera Hospital in Toledo for permissions to photograph documents in their collections. Other photographs were kindly supplied by the owners of the works or by the Patrimonio Nacional in Madrid (Pls 20, 38, 46–9, 58, 60, 62, 67, 91, 100, 101, 104, 105, 106, 114, 118, 160) or by Bibliothèque Nationale, Paris (Pls 110, 115). Plates 13, 16, 71, 81 are reproduced from *Arte y decoración en España*; pls 63, 159 from Lhermitte, *Le Passetemps*; pls 72, 136, 140 from Ruiz de Arcaute; pl. 132 from F. Chueca Goitia, *La Catedral nueva de Salamanca*; pl. 168 from F. Arribas Arranz, *El Incendio de Valladolid en 1561*; pls 141, 142, 143 by Mário Novais from G. Kubler, *Portuguese Plain Architecture*.

Foreword

THIS BOOK was prompted by a desire to know how Spain fitted into a larger picture of Renaissance architecture. As a student of Spanish sixteenth-century architecture I found it particularly rich and various and I was impatient with the notion that these buildings were simply derivative of Italian style. But the opposite view, that they belonged to an indigenous and wholly Spanish development which had been only slightly adulterated by Italianism, was not satisfying either. It seemed likely that such original buildings as the cathedral of Granada, the convent of San Esteban in Salamanca, and the merchants' exchange in Seville were the product of a more dynamic process of exchange and adaptation.

Research into the mechanisms of this process led naturally, one might say inevitably, to Philip II and his royal monastery of St Lawrence at the Escorial outside Madrid. Here, at this ultimate monument of the Spanish Renaissance – the most Italianate and the most Spanish of all Spanish buildings – and in the vast documentation and scholarly writing that surrounds it, I thought I would find answers to some of my questions. I had begun with a strictly architectural problem, but the more I studied the Escorial, the larger loomed its royal patron and his architect, Juan de Herrera, and I decided to focus on Herrera himself.

Herrera is the most famous Spanish architect before the Catalán Antonio Gaudí but the only monograph, Agustín Ruiz de Arcaute's *Juan de Herrera, arquitecto de Felipe II* of 1936, was more than fifty years old and its assertions had been aggressively challenged by Amancio Portables Pichel in two books, published in 1945 and 1952, that set out to demolish Herrera's reputation as a great architect.[1] More had been written since – some in support of Herrera's reputation, some designed to deflate it. Meanwhile, expanding interest in Spanish architecture and two centenary celebrations of the Escorial (one in 1963 for the foundation, the other in 1984 for the termination of construction) stimulated a wealth of excellent specialized studies, but these did not address the issues I wished to explore and they were not concerned with Herrera's relationship to architectural developments outside Spain.

The more I studied the published and unpublished evidence, the more unusual Herrera seemed. Even his status as an architect was unclear. Judged by the Renaissance idea of the architect as the unique creator of a building, it would be difficult to maintain that any of Herrera's buildings were fully his. Every one of his major projects involved either predecessors, collaborators, executants or followers. Herrera may be only an extreme example of the usual state of affairs – how many architects in the sixteenth century designed a building to the last detail and saw it accordingly completed? Certainly not Bramante or Michelangelo – but Herrera's career raises more pointedly the issue of authorship in architecture and the related problem of counter-pressures: what the contributions of non-architects might be. How important, for example, are the words of the client, his/her choice of a certain style or building type, to the final conception? Is the little sketch, the evocative squiggle the true invention of a building? The embryo from which the design naturally grows? Alberti, whose role as an architect has much in common with Herrera's, may have thought so but he does not describe the process or the kind of layered collaboration that Herrera faced, although he encountered it himself.

This matter requires careful thought because Herrera's whole career was interwoven with the life of his patron, Philip II. Many Renaissance designers were lucky enough to work for rich clients who loved building, but no other architect enjoyed so complete and sustained a relationship with his patron. Philip was no ordinary amateur: even in an age noted for its ambitious builders, his involvement in building was extraordinary. An avid consumer of architectural publications as well as a prodigious builder, he sought architectural ideas from all over Europe. Everything from printed books and city views to designs and actual construction quickened his interest and his desires. At the end of his reign, Herrera, who by then had become famous as his architect, would reveal the treasures of Philip's collections to a few privileged initiates, like the Jesuit architect, Villalpando, who was staggered to see 'trunks, and even whole rooms, stuffed full' of designs for churches and for all kinds of buildings by the most skillful architects in the world.[2] Philip evaluated these designs himself and was not beyond making a sketch or two of his own. Clearly, no assessment of the buildings he commissioned from Herrera could be made without considering his aims and architectural tastes.

Finally there was the problem of style. Herrera's reputation as an architect rests upon a style – the famous *estilo desornamentado* – that is idiosyncratic precisely in its impersonality. In the Renaissance, when buildings came to be viewed as works of art as personal as any poem or painting, Herrera's abstract manner is most remarkable for its effacement of individuality.

There is something paradoxical about a great architect who may not have designed any buildings, just as there is something odd about a sixteenth-century architect who dissociated himself from

Foreword

the artistic values of the Renaissance. Herrera enjoys a heroic reputation as Spain's first great classicist – the Spanish equivalent of Michelangelo and Palladio or, perhaps more accurately, of François Mansart and Inigo Jones – but he does not fit our model of a Renaissance architect. I began to wonder if the model, rather than Herrera, may not be the problem.

Herrera's architecture, although in many ways derived from and connected to Italian thinking, was shaped by different values. There is no reason to believe that he was unique in this, but defining the ideas that lay behind his work and that of architects who shared his views was more difficult than I had anticipated. As the book took shape, slowly, it organized around a series of topics, each a facet of Herrera's architectural personality, and not as a chronological account of an individual's development. In the end Herrera emerges as one of the first architects to have consciously drawn upon a European architectural culture to realize a new ambition, synthesizing the confrontations between apparent contradictions, between northern and southern, modern and ancient buildings, into a universal style.

Publication on Spanish architecture has flourished in the past ten years and I have profited enormously from a body of research that is changing almost daily as new documentation is discovered and new interpretations proposed. I have tried to acknowledge as many of these writings as possible in the notes to the text, but wish to mention here Gregorio de Andrés, Antonio Bonet Correa, Agustín Bustamante, John Bury, Luis Cervera Vera, Fernando Checa Cremades, Fernando Chueca Goitia, Francisco Iñiguez Almech, George Kubler, Vicente Lleó Cañal, Juan José Martín González, Pedro Navascúes Palacio, Fernando Marías, and Alfonso Rodríguez G. de Ceballos whose writings and, in some cases, personal assistance have been invaluable.

I am fortunate to have had the generous support of many institutions. The ideas on drawings and building practice and an interpretation of the *capilla mayor* of the basilica at the Escorial were worked out while I was a Visiting Member of the School of Historical Studies at the Institute for Advanced Study in Princeton where I was supported by a fellowship from the National Endowment for the Humanities in 1977–78. A sabbatical leave from Brown University and a grant from the American Council of Learned Societies in 1982–83 enabled me to continue my research in Europe and to study the unpublished treatise on architecture that was written for Philip. I am grateful to Kurt Forster for inviting me to spend a year as a Getty Scholar in the stimulating atmosphere of the Center for the History of Art and the Humanities in Santa Monica where I began to write in 1985–86. I continued in Europe during a sabbatical leave from Brown in 1987–88.

The staffs of the archive of the Escorial and the Archivo General de Simancas and, in Madrid, at the Patrimonio Nacional, Archivo Historico Nacional, Archivo Historico de Protocolos, Biblioteca y Museo del Ayuntamiento, and Biblioteca Nacional and Biblioteca del Palacio Real were unfailingly helpful and patient. To Fr S. Jonas de Castro Toledo in Valladolid my special thanks for providing access Herrera's drawings. The staffs of the Bibliothèque Nationale, Bibliothèque Mazarine, and archive of the Ministère des Affaires Etrangères in Paris kindly helped locate material.

Some of the material included here was tried out first in lectures at various institutions and conferences, and at the annual meetings of the College Art Association of America and the Society of Architectural Historians. My discussion of building technique was published in the *Art Bulletin* and an assessment of the anonymous treatise appeared in the *Journal of the Society of Architectural Historians* in 1985. Over the years, the colloquia led by the late André Chastel and Jean Guillaume at the Centre d'Etudes Supérieures de la Renaissance in Tours have provided an environment for an examination of Renaissance architecture in a European context, and many of the issues I first raised there have found their way into this book. Preliminary versions of material included in chapters 2, 3, and 4 were presented in my papers there between 1979 and 1990, and appeared in the volumes devoted to these colloquia. I wish to thank Richard Kagan for inviting me to present my ideas on Madrid at a symposium in honor of John Elliott sponsored by the Department of History at the Johns Hopkins University in the Spring of 1990 and Sylvie Deswarte and Catherine Goguel for their invitation to discuss the iconography of the Panadería in Madrid at their seminar sponsored by the CNRS in Paris in the Spring of 1991. I have learned much from the discussions stimulated on these occasions.

My friends and family have encouraged this project and I owe more than I can acknowledge here to them. George Kubler guided the beginnings of my work on Spanish art and has generously shared his knowledge with me. Jonathan Brown, John Elliott, Christine Flon Granveaud, Irving Lavin, Marjorie Grene, Dr James McLennan Charles Rosen, Una Wilkinson, and Rachel Zerner, have all read drafts at various times and their criticisms helped to clarify the text. Most of all, my deepest thanks to Henn Zerner for the inspiration, criticism and encouragement that made it possible to write this book. To my publisher, John Nicoll, and to John Trevitt, who copyedited and designed the book, for the time, effort and kindness they gave to me, my thanks.

Comparative material has been illustrated as much as possible from drawings or prints that Herrera could have known.

I
The making of a royal architect

THE KING AND THE COURT were the focus of Herrera's existance. Philip II introduced him into the royal works, kept him in personal attendance, and sponsored nearly all his designs. Herrera's entire life as an architect was lived at court. It is even as the king's servant that he emerges as a person. In later life he became a famous intellectual, an image which he must have cultivated. An allegorical engraving made for him shows him beset by Venus, Bacchus and Poverty, struggling on the path to virtue under the protection of Athena (pl. 1).[1] The accompanying poem alludes to a rowdy life followed by sober maturity and virtue: a stock portrait perhaps, at any rate not very informative. There is little else. Herrera did not write much about himself and contemporaries did not write extensively about him either. This might seem surprising, since he was a famous man, but there was no genre of artist's biography in Spain, as there was in Italy, although some writers included brief lives of scientists or artists in other contexts. Even measured against this modest standard, however, contemporaries wrote little about Herrera. José de Sigüenza, a monk and historian of the Escorial, a brilliant writer whose impressions we would like to have, knew Herrera well. Unfortunately, Herrera was not one of his heroes and he chose to mention him only briefly. Most biographies – Sigüenza's portrait of Fray Antonio de Villacastín or Ambrosio de Morales' sketches of the geographer, Pedro Esquivel or of the engineer, Juanelo Turriano – were prompted by friendship and admiration. Perhaps Herrera was not close enough to any literary people for that; perhaps, living and working hard at the center of a complex bureaucracy, he had few friends.

Herrera's career is inseparable from Philip's peculiar style of artistic patronage and the circumstances that this created in Spain; but Herrera actively contributed to shaping this patronage and his own role. We can think of Philip II and Herrera as actors in a play for which they together wrote the script and assembled and trained the cast, although their production, as in any theatre, was subject to circumstances beyond their direct control.

Herrera does not fit our assumptions about artistic creativity, one of which is that artists' lives reveal an inborn genius for their chosen art which naturally seeks expression, sometimes in spite of the culture in which they live. If we focus instead on Herrera's mundane involvements, however, it becomes easier to understand how these conditioned his activities and, ultimately, his architecture. Herrera redefined his profession; of course, he did not accomplish this singlehandedly, but he played a major role by taking advantage of his circumstances in a highly original way.

THE ASCENSION OF AN HIDALGO: FAMILY, HONOR AND WEALTH

Juan de Herrera was born about 1530 in Mobellán in the small community of Roiz in the valley of Valdáliga near Santander in the north of Spain.[2] He belonged to the gentry: his grandfather, Ruy Gutiérrez de Maliaño, was Señor of Maliaño and the *mayorazco* de Herrera with substantial lands in the region. Herrera's father, Pedro Gutiérrez de Maliaño, was the child of Ruy Gutiérrez's second marriage, however, and the family titles and estates went to an older son from a previous marriage. Pedro Gutiérrez had, as far as

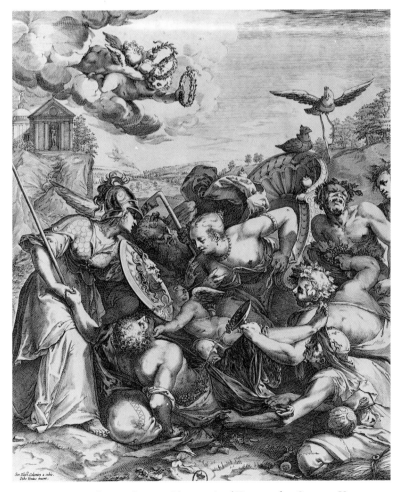

1 Pedro Perret, *Allegorical scene* with portrait of Herrera after Otto van Veen. (Paris, Bibliothèque Nationale)

is known, only two children, Juan and Maria, who lived to be adults; his estate including that of his wife, Maria Gutiérrez de la Vega, was very modest – Herrera was later to buy it back for less than four hundred ducats. The cultural life of the region was severely limited: in 1579, Herrera willed the bulk of his estate to found a school for instruction in Christian doctrine there because, as he said, for lack of teachers the inhabitants were living 'muy brutal y ignorantemente'.[3] Herrera had no future in such a place and, like many other poor *hidalgos* in the sixteenth century, was obliged to seek his fortune elsewhere.

The magnet was the court, and the traditional paths to advancement the church or the army. It is clear that Herrera's family used some connections to give their son a chance in life because Herrera entered the service of Prince Philip in 1547 at Valladolid. In 1548, he was among the young courtiers who left on the voyage to Italy and on to Brussels where Philip was introduced to his subjects. Philip was twenty years old, Herrera a little younger. Presence at court did not guarantee a living and, returning to Spain with Philip in 1551, Herrera chose the army. He enlisted in 1553 in the company of Capitán Medinilla and left for the Italian campaigns. In 1554, he was an *arcabucero de acaballo* in the guard of Ferrante Gonzaga, with whom he went to Flanders. When Gonzaga returned to Italy, Herrera remained with the emperor's guard in Brussels. In 1556 Charles V abdicated all his kingdoms except the Holy Roman Empire in favor of his son Philip, then ruling in Spain. Herrera was present at the famous ceremony and accompanied Charles V on his return to Spain, and (it is usually supposed) to the Hieronymite monastery at Yuste. Herrera's name does not appear among the members of Charles's small household at Yuste, however, and it seems likely that he was one of the many soldiers and courtiers who were dismissed when the emperor retired to the monastery.[4]

Herrera's activities over the next several years are unknown. Even if he did remain at Yuste, he must have left at the emperor's death in 1558. He does not appear again in documents until 1562. Most of the information about Herrera's early life comes from his wills and from a memorandum that he wrote to Philip II in 1584.[5] Herrera did not report in detail on his life during these years but merely wrote that he had been in the service of the emperor and Philip between 1553 and 1563. Perhaps he went to Valladolid to serve in the guard of the infante, Don Carlos. The evidence, thin as it is, shows Herrera as a young soldier, a member of the 'German guard,' as he was later identified by an observer at court. Looking back, Herrera claimed to have been attracted to military life (although the Italian campaigns seem to have cured him of soldiering), but it is difficult to see what other career he could have chosen. His parents could not have afforded a university education or preparation for the priesthood.

Life in Mobellán may have been backward but the thread of Herrera's attachment to it runs throughout his life. During the 1560s and early 1570s Herrera lived in Madrid. He did not marry but maintained a relationship with a woman, Juana Martínez, who, he later implied, was a servant. Herrera raised their child, Luisa, as his own 'natural daughter,' allowing her to use his name. In 1575, he provided a considerable dowry of two thousand ducats for her marriage to Pedro de Baños. Nothing is known of this man's

origins. He was certainly respectable and probably poor, since Herrera designated five hundred ducats of the dowry to be paid in clothes, furniture, and a house in which the couple could live.[6] Herrera thus set up a household in Madrid for his son-in-law and daughter and probably also arranged for a court appointment as *alguacil* for Pedro de Baños.[7]

What enabled Herrera to provide so handsomely for his illegitimate daughter was his own marriage in 1571[8] to the wealthy María de Alvaro, heiress to the estate of her father, Pedro de Alvaro, and widow of Juan de Landa, both of whom had been businessmen in Madrid.[9] The marriage permitted Herrera to recover his family property in Maliaño. When Herrera's parents died, their property had been mortgaged to Juan Linares de la Mata and perhaps to others who had confiscated it as payment of the family's debts.[10] Herrera sued to repossess the estate, and a settlement was reached in 1573 when Herrera agreed to pay 21,000 maravedis, or slightly more than 56 ducats, for part of the property and the family house. A final settlement with the heirs of Juan Linares de la Mata was concluded in 1575 when Herrera paid them 300 ducats.[11] Herrera's sister was still living in Maliaño and he gave her a lifetime tenancy in the property, but concern for his sister cannot have been Herrera's only motivation. The family house, a few parcels of farm land, a mill, and an orchard were valued at less than 400 ducats. It seems hardly worth the effort that Herrera expended to recover them but, as we shall see, there were other reasons.

Herrera's ties to the region were further strengthened in later years. María de Alvaro died in 1576, leaving her estate, apart from numerous pious bequests, to her husband.[12] The value of the estate was considerable and there were no children. In 1579 Herrera made a will leaving all his property, apart from religious bequests relating to María de Alvaro and her connections and a small legacy of 200 ducats to his sister María, to found a school for religious instruction in Maliaño.[13] He seems to have considered his obligations to his daughter, Luisa, discharged since he specifically excluded her from the inheritance.[14]

In the 1580s, however, a new opportunity arose for Herrera to establish himself in Maliaño. The elder branch of the family, which had inherited the seigneurial estate, had now descended to Marcos de Herrera who had a single daughter, Iñes, fifteen years old. Herrera had been in contact with the other branch of the family: in 1579, he had named Marcos as one of the executors of his estate and, in 1581, Marcos was in Madrid acting as Herrera's agent managing some of his property while Herrera was in Lisbon; other affairs were managed by Herrera's nephew, Pedro del Yermo. The family was moving to Madrid, clustering around its most successful member, and Herrera was able later to arrange for modest court appointments for his relatives. The family relations culminated, some time in 1582, in Herrera's marriage to Iñes. A papal dispensation was procured from Rome and the two branches of the family were united. When Marcos de Herrera died in 1586, Iñes inherited his estate.

Herrera had been thinking of the succession and Iñes de Herrera bore him six children in eight years: a daughter, Lorencia, was born in 1584, followed by Ursula (1587), Luisa (1590), Petronilla (?), Catalina (1592), and a son, Juan (1594), heir to the title. Iñes died

at the birth of their son. The little boy lived only over a year, leaving the title to his father. Of the other children, only Lorencia seems to have survived infancy. When Herrera died on 17 January 1597 there was no child to succeed to the inheritance that he had so carefully reassembled.

Herrera's estates did not represent wealth: they never earned a ducat for him and when they were liquidated in the early seventeenth century, the entire holdings of his father and paternal grandfather were worth less than 1000 ducats.[15] At the time of his death, Herrera was worth approximately 37,000 ducats.[16] He owned a golden chain (probably a gift from the king) which alone was valued at more than his father's lands and house.[17] But Maliaño represented dignity. These unprofitable lands in a remote province were a point of reference in a society full of people of the same class. Maliaño was the sign of Herrera's respectability, distinguishing him from a mass of rootless individuals who were trying to survive, many in the army. Herrera kept the proof of his nobility, which was presented to the Royal Chancellory at Valladolid, with his most important papers.[18]

Spanish concern for family honor and dignity were proverbial in the sixteenth century but money was important too, and Herrera died a wealthy man. A large part of his income came from the estate of his first wife, María de Alvaro, which was invested in rental properties in Madrid and in censos — short and long term loans — to individuals; but Herrera did not become rich simply by marrying well. He was able to marry money because, as a gentleman well-placed in the court bureaucracy, he had a promising future. And he was no longer so poor. In 1571, Herrera was earning, by his own account, 400 ducats a year in salary from his appointments as ayuda de la furriera and as the king's designer. In 1577, Philip doubled his salary and, as Herrera had requested, relieved him of the appointment as ayuda de la furriera. Herrera's salaries were charged to the works at the Escorial and Madrid. In 1579, however, the king appointed him Aposentador Mayor de Palacio (roughly, court chamberlain) with an income of 250 ducats a year. Thus, in 1579, Herrera's annual income from royal appointments was 1050 ducats per year, a very good salary. Together with the 2000 ducats that he listed as annual income from his wife's property, Herrera was, if not really rich, at least very comfortable.

Philip used to say that he wished he could live like an ordinary gentleman on a few hundred ducats a year. Herrera had reached that goal, but he was not living a simple gentleman's life. In his memorandum of 1584, which described his financial situation, Herrera complained that he had exhausted his resources in the service of the king, neglecting his estates (which were once worth 6000 ducats) and depleting the inheritance from his wife. There is no doubt that life at court was expensive and Herrera was probably often out of pocket for the costs of his job. He complained, for example, that the trip to Portugal in 1580–82, where he went to arrange for Philip's arrival and lodgings, cost him 6000 ducats. In a letter to Philip's secretary, he pointed out that, as his correspondent well knew, to serve princes one had to keep up appearances and that, all in all, he had spent 20,000 ducats of his own money in Philip's service.[19] There is no reason to doubt Herrera's word, except perhaps as to the value of his family property, but his

request followed a conventional form. In 1584, Herrera was in his fifties and had been ill; he was, or thought he was, nearing the end of his career in Philip's service. A request for a pension in acknowledgement of a lifetime of service was expected. Herrera may have feared (the memorandum and letters have a touch of hysterical urgency) that Philip would discard him once the Escorial was finished.[20] He need not have worried. In addition to the gift of a fine building lot in Madrid which had been given to him earlier as a marriage present, Philip provided Herrera with a juro worth 14,000 ducats on salt mines at Cuenca and there probably were other gifts of money or goods (a golden chain, for example) which cannot now be traced.

It is always difficult to disentangle money and status, particularly in the sixteenth century when it is almost impossible either to reconstruct the values placed upon privileges and perquisites or to assess the costs of things. Herrera probably needed the pension he felt was owed to him, but he also wanted the honor it would bring:

So that after my days the reward for my services can serve as testimony to [the fact] that with them and with virtue, one can acquire some renown.[21]

He asked for a perpetual appointment as mayor of the town of the Escorial which could be passed down in his family. Philip withheld this but it is possible that he was planning at the end of Herrera's life to make him a knight of the order of Santiago.[22]

Honor and money mingle in Herrera's court appointments. As ayuda de la furriera (the department concerned with lodgings), Herrera had a position in the king's household. As Aposentador Mayor de Palacio in charge of the king's lodgings and furnishings, he had unrestricted access to the king, hence an honorable position in the court bureaucracy. In documents from outside the court, Herrera was always identified by his official title, Aposentador de Su Magestad. This was one way for Philip to distinguish Herrera, increase his salary, and keep him in attendance at the same time; it is typical of a man who knew how to get the most out of his servants, carefully balancing financial rewards with honorific titles. Herrera was expected to work at the job.

Herrera lived very well as a result of his royal service. A man is not spartan who owns fifty shirts, many pairs of shoes and boots, other fine clothes, good furniture, gold and silver plate, and jewels. His household was full of tables, chests, desks and buffets; there were linens, blankets, and rugs to spare.

Herrera also lived well within the norms for a courtier: he was a faithful Catholic and owned a number of religious objects. The number and value of Herrera's religious artifacts and bequests to the Church in his will of 1584 may seem excessive — endowments of masses in a number of locations, gifts to hospitals, funds to provide dowries for poor gentlewomen, etc. — when he had a wife and baby daughter living; but the style of sixteenth-century Spanish piety is alien to modern sensibility. Historians have expressed shock at the thousands of masses Philip ordered sung for his soul, for example, forgetting that these represented support for the clergy, a duty discharged by one branch of society to another. Herrera's bequests were not significantly different from those of his wife, María de Alvaro, or from other people of similar economic standing.

In these ways Herrera fits a pattern in sixteenth-century life.

The making of a royal architect

Many of Philip II's servants were drawn from the ranks of poor *hidalgos* and it is not surprising that Herrera should have escaped from Mobellán to seek his fortune at court, entered the army, and then returned to insinuate himself into the royal bureaucracy to become a trusted servant. To succeed required special gifts and intelligence as well as prodigious good luck, and Herrera must have been an exceptional person, but there were other clever, ambitious men who followed a similar path. It would not have been surprising if Herrera had become a royal secretary, or perhaps the captain of a squadron of the king's guards, like some of his friends.

What would be utterly unforseeable is that he should become an architect. Nothing in Herrera's social background or circumstances predicts such a career: Spanish gentlemen did not turn to the design of buildings in the sixteenth century or enter the ranks of the building industry; and if they had they would not have been called architects. The role itself was new. When Herrera went to court in 1549 there were no 'architects' there. What drew him to architecture is something of a mystery. In order to understand his introduction into architectural practice, we must take a long detour into the world of building practitioners in Spain in the sixteenth century and examine Philip's relations with it.

THE SPANISH BUILDING PROFESSION

In the years from 1559 through 1567, Philip imposed a new model of architectural practice in his commissions. None of the persons involved – the king, Herrera's predecessor Juan Bautista de Toledo, or the Spanish masters who worked on the buildings – found this easy, and the problems that arose and the adjustments that had to be made set the stage for the role Herrera was to play.

Spanish building practice was descended from a late-medieval system of organization (many great cathedral programs were still under way). The building industry was a hierarchical organization: at the top were the masters of the works [*maestro mayores*], who were responsible for designs, for planning, and for selecting their representatives who would supervise construction at the building site [*aparejadores*]. Design and building were in principle parts of a continuous process. Thus a master of the works might supervise construction himself, or through his assistant [*aparejador*], arrange for the contracts for carpentry or masonry, choose the men himself, and put up money to purchase materials or a bond against such purchase. His product was the building. When a commission was finished, whether a whole building or a contracted part, it was often paid for by the system of *tasación*: the completed work was appraised and value assigned to it by a committee of masters appointed by both master and client. This system was widely used for painting and sculpture as well as for buildings and has often been criticized by historians. It meant that payment for work was hostage to the client (who might appoint as appraisers masters favorable to the client's side). In the case of painting, as El Greco unhappily discovered some years later when he sought payment of debts owed him by the Cathedral of Toledo and the Hospital de la Caridad in Illescas, the value placed on a work was often less than an artist might want.

When one is dealing with a piece of a cathedral rather than a painting, however, the situation is somewhat different. The masters of the works constituted the available pool of designers and the construction of one master was evaluated by other masters. Since the Middle Ages, the title 'master of the works' had referred in principle to a particular program. One became a master of the works by being appointed to head a specific program. For example, the masters of the cathedrals of Granada and Seville appraised the work of the master of the cathedral of Toledo, and the master, although responsible to the overseers who represented the client and to the administration of paymasters and clerks for daily financial dealings, was – in matters of design and construction – answerable only to his colleagues. The result was that the man responsible for designing a building was a member of a largely self-regulating profession; his standards were determined by himself and his peers. He also had economic power: hiring workmen, offering lucrative contracts, sending orders to certain quarries and industries, etc.; he could depend upon loyal masons, builders, and carpenters who often worked with the same construction teams.

It is often thought that men who wanted to become designers worked their way up the ladder from laborer to master, but this was probably rare, at least in the sixteenth century. Most men who became masters of the works were the sons of other masters or of master stone-cutters who trained their sons or apprentices and married their daughters to talented assistants or to the sons of other building families. These men served their apprenticeship to the master in a privileged position. Many masters in Castile in the sixteenth century came from such professional families and, while the system did not absolutely prevent outsiders from rising, it encouraged a closely knit professional organization that could close ranks if necessary. Spanish masters were rightly proud of their standing and competence; in their own domain, they were unchallenged.

This differed from what we think of as a Renaissance model of architecture in two fundamental ways: it associated design and building in a continuum and it assigned responsibility for design entirely to a professional who would remain in contact with the building. These related assumptions – that design and building are one and that design is the concern of the builder – underlay the debates at the Cathedral of Milan in the fourteenth century and still supported Spanish building practice in the middle of the sixteenth century. But by this time – although it may have happened much earlier in some areas – the profession had begun to recognize independent designers. Men still bore the title of master of the works but were frequently called in as design consultants, providing plans for buildings which they supervised very loosely or not at all. Rodrigo Gil de Hontañón is a good example of such a figure. Operating from a base as master of the works at the Cathedral of Segovia, he criss-crossed Spain as an advisor, collaborator, designer, and master of the works at other building sites.[23] The tie between design and building was loosening. Rodrigo Gil could not hope to supervise all his design projects himself, or even to place his own men at the heads of them. Of necessity, the construction teams and skilled labor would have to be found locally.

The system was changing in other ways. Traditionally, problems between a client and designer were settled by masters called to-

gether from other building programs. A client might summon such a meeting, but decisions were reached by the practitioners themselves. This evolved from the assumption that design was related to construction and required the expertise of a builder. The client was not part of the design process since, by definition, he was not an expert in building. In the 1540s, this was beginning to change under the impact of ideas from Italy, where the patron had become a crucial component of the practice of architecture. One need only think of great patrons like Lorenzo de' Medici, Ludovico Sforza, and Julius II, and of dynasties like the Gonzaga, the Medici, and the Farnese whose relationships with their architects were close and personal.

Ultimately this style of patronage derived from Leon Battista Alberti's view of architecture as he described it in *De re aedificatoria*. In Alberti's system, the most important aspect of building was design, which was an intellectual undertaking shared between client and architect. Design required practice and skills which only the architect would be expected to possess but was founded on an intellectual base which he shared with the client. Architecture was an intellectual discipline grounded in mathematics, knowledge of antiquity, and a high level of culture. The elements of buildings became highly expressive not only of accepted standards of beauty but also of ideas. Alberti's architecture was a literate discipline and its expression in design could be understood by educated people; in fact, it could be understood only by educated people. Alberti warned the architect:

Do not offer your services to everyone who tells you that he is going to build, as do superficial people, those who are consumed with a greed for fame. . . . I would take care, wherever possible, to deal only with principal citizens who are generous patrons and enthusiasts of such matters: a work will be devalued by a client who does not have an honorable situation. How much, do you think, will the reputations of those outstanding men, to whom you would prefer to offer your services, contribute to your fame?[24]

Ideally Alberti's architect and client were united by a bond of understanding and solidarity in their common venture that would bring glory to both. The execution of a building belonged on a lower intellectual level – it was the concern of the capable craftsmen and workmen, who could not be expected to share in the lofty conception of architecture. By the late fifteenth century, Alberti's paradigm had attracted powerful people who were eager to play the role of the intellectual and to employ artists and architects to do their share.

By the sixteenth century the Italian conception of architecture was beginning to affect building in Spain, which was in close and constant contact with Italy. Two of the great early sixteenth-century Spanish sculptors, Alonso de Berruguete and Diego de Siloe, turned to architecture on their return, and Siloe had a particularly distinguished career as *maestro mayor* of the new Cathedral of Granada and the designer of buildings in Andalucia. In Toledo in 1526, the cleric Diego de Sagredo published his *Medidas del Romano*, one of the most successful Renaissance treatises on classical style.[25] Sagredo's text is addressed to practitioners of the new style and was one of many agents of change from Gothic to Renaissance manner in Spanish buildings, but, although Sagredo used the term

architect in its Renaissance sense and Siloe operated as a designer in classical style, neither of them tried to establish an Italian mode of practice.

There is no evidence of serious disruption of the late medieval system of organization in Spain until slightly later in the sixteenth century, when educated men, who had lived in Italy, began bringing back a different notion of the client's relation to building. In 1542, for example, the secretary and amateur architect (later Jesuit) Bartolomé de Bustamante, who had lived in Italy, was appointed administrator at Cardinal Juan Tavera's new foundation of the Hospital of St John the Baptist in Toledo. Bustamante began immediately to concern himself with the design of the building, which was in the hands of a Spanish professional, Alonso de Covarrubias, master of the works at the Cathedral of Toledo, Cardinal Tavera's designer, and the leading practitioner in the city. Covarrubias was furious. From his point of view Bustamante was an unqualified meddler, and the two quarreled over style and construction, but beneath their arguments was a deeper, unstated conflict. Bustamante was threatening the most cherished prerogative of a master of the works, his right to design the building; he was radically altering the rules of the game.[26]

Not that Covarrubias was a humble mason – one of his sons became a famous scholar – but he was a designer-builder: his father-in-law, Enrique Egas, had been *maestro mayor* at the Cathedral of Toledo and first designer of the Cathedral of Granada; Covarrubias was his protegé and successor in a prestigious position, a product of the Spanish late medieval building industry.[27] It is often said that medieval designers were not theoretical, but this is only a way of saying that they were not Renaissance architects. Medieval practitioners and their descendents like Covarrubias possessed an extensive building lore, some of which had been written down by the sixteenth century. This body of thought, in so far as it is recoverable, consisted of rules and habits of practice: a body of professional experience which involved everything from mathematical design formulas to ideas about materials and about symbolism, but it was a specialists' domain. In opening the discipline of architecture to literary culture, Alberti, and the artists and clients who followed him, had relegated this body of thinking to the level of inarticulate craftsmanship, to the status of recipes without intellectual structure.

In Italian terms Covarrubias was not a theoretical architect; he was a skillful practitioner. As Spanish professionals became aware of the implications of Italian ideas, their reactions varied. Covarrubias's response was outrage followed by grudging accommodation. Rodrigo Gil de Hontañón began to write a book, attempting to adapt his professional knowledge to the format of an architectural treatise and thus legitimize its intellectual content.[28] Other, younger men were able to shift more completely to an Italian model. In 1552, Francisco de Villalpando, an associate of Covarrubias in Toledo and of Gaspar de Vega in Madrid, published a translation of the Italian Sebastiano Serlio's most popular books on architecture and proclaimed himself an architect on the title-page. The dedication and preface to his translation are entirely in the mode of an Italian architect, stressing the dignity, intellectual stature, and theoretical importance of architecture. Villalpando's

text inscribes architecture within the classics and relates it to the ancients, to science, to mathematics – in short to the recognized disciplines of the liberal arts, but not to the techniques of building. Reading his words, one would never know that he was a bronze caster turned designer or that he was then working for Covarrubias at the Alcázar in Toledo.[29]

PHILIP II AND THE BUILDING PROFESSION

Spanish architectural practice was changing in the late 1540s and 1550s, and Philip was at the center of change in Castile. By the time he was ready for his great projects in the late 1550s, the young king was a seasoned client. His interest in building can be documented during the regency when, in the 1540s, he began to take an active interest in the royal building programs that had been started under his father.

When he became regent, Philip inherited building programs at Madrid, Toledo, and Granada, and soon undertook new ones of his own. During the 1550s, his concern for these projects intensified; documents show him asking for plans, studying designs, suggesting revisions. Historians have rightly seen in this activity the signs of the great builder he was to become and it can be assumed that Philip was familiar with contemporary Italian architecture, if only in a general way. He had grown up when the prestige of Italian culture was at its height. He saw Italian buildings on his way to Brussels in 1548 when he stopped in Genoa, Mantua, and Milan. Above all, his father was a model of a great Renaissance patron, although a patron more of painting than of architecture.

Very little is known of Philip's personal views on architecture, but recently a manuscript copy of a treatise on architecture written for him has come to light.[30] This reveals that during his regency Philip was introduced to a specifically Albertian model of architecture. The treatise is anonymous and undated, although it must have been written by someone at court before 1556, most probably about 1550. It is in the style of a report – what good architecture is and why it is important – of the kind that Philip often requested on various subjects later in his reign. The author makes it clear that the prince had personally asked for the treatise and all signs are that the manuscript was written for his private use. The author based his discussion on Alberti (large sections are copied directly from *De re aedificatoria*) but was highly selective. He envisaged an architecture supported by the authority of antiquity and by the writings of Vitruvius and Alberti, a classical style which he believed was not then practiced in Spain. Unlike Alberti, however, he was almost exclusively concerned with the moral aspect of building and concentrated upon useful buildings, justifying the moral worth of each before considering its design.

Compared to Alberti, the author's attitude was extremely rigid, one might say puritanical, strongly flavored with the Counter-Reformation. He began from a notion of the relation between society and architecture that allowed him to argue that buildings both expressed and influenced human values. He had discovered this idea in Alberti, but his tone was quite different. He made the notion explicit at the beginning of his work when he explained that greed, the greatest social evil, led to waste in fanciful buildings. The

imperfections and impropriety of this architecture and its excessive cost were signs of moral corruption. His conclusion that a new, classical style – economical, correct, and restrained – was morally good is evident throughout the second part of the treatise where building types were discussed. There is a constant parallelism between ideological aims and architectural implementation so that, within the treatise, the forms of buildings appear as the consequence of moral demands. Thus the author offered an argument for classicism based on its utility to the state.

The author recognized that two things would have to change before his version of a pure classical style could be implemented in Spain. In the first place, there would have to be architects on the Albertian model; architects must be separated from craftsmen.

Many Spaniards, he wrote, live thinking that no one can be a good architect who has not been a builder [*official*] when the truth is, on the contrary, that it would be a great marvel if a man who had been a builder could manage to become a good architect, because to achieve this he would have to learn many arts which those who must spend their time learning and practicing their job would have great difficulty knowing of, for there is no mechanical art which does not in itself require much occupation.[31]

He was well aware that this view might meet resistance in Spain where

if a man professes to be an architect not being a builder [*official*] who has his hands hardened and calloused with working with tools for many years, then will he bring up against himself the whole profession [*la universad he los officiales*] and even many who are not [professionals].[32]

The author wished to make the distinction between an architect and a craftsman absolutely clear. Great architects, in his view, were those who had time for study, men like the emperors Hadrian and Justinian who no one would ever claim had been practitioners [*officiales*]. The experience that Vitruvius demanded of the architect need not come from the practice of building but should arise from 'bringing together the rules of good architecture with the work and from learning from being present at the site and discussing the work with the builders.' This was how the architect 'should acquire experience and not by having been a craftsman because not one of the great architects we referred to ever was.' The Spanish professional is downgraded to a craftsman with calloused hands, to be replaced by the intellectual architect in a supervising role.

The second requirement for classicism was a proper client. The author appealed to his prince to create the new style, reform Spanish practice, and establish architects who would build the structures that would symbolize good government. He praised what had already been done in the royal programs:

If some practitioners have had and at the present time have the name of architects in these kingdoms, they are those who have followed the order and invention of the above named lords in the buildings ordered by the Emperor, our lord, your father, that you have commissioned. And as long as they do not try to exceed the limits of their ability, we cannot deny that there are many good craftsmen who would be the better – as Leon Battista [Alberti] says following Plato – were they in the hands of an architect.[33]

A start has been made, the author is saying; let it continue under the prince's patronage into real reform. The author praised the

prince's knowledge of building, his taste and judgment as greater than his own.

The treatise was carefully tailored to appeal to the young Philip and was probably written from mixed motives, especially when we consider that, all false modesty aside, the author presented himself as an architect of the kind he had described: an intellectual, learned in theory, with a considerable experience as an observer of building practice in Spain, Italy, and Germany. The treatise may have been an oblique application for the job as Philip's architect. Without knowing who wrote the treatise, however, it is impossible to judge if these ideas had an impact on Philip's thinking, since the author may well have been telling the prince what he wanted to hear or articulating views that were already latent at court. But this is not the main issue. The treatise is the only evidence of architectural thinking in Philip's immediate entourage and shows that, already during the regency, architectural reform was discussed, and that an Italian – specifically Alberti's – conception of architecture had entered directly into the prince's thinking about building. The writer of the treatise offered Philip a complete program for the reform of Spanish architecture on an Albertian model. Under an enlightened patron, perhaps a princely architect like Hadrian or Justinian (as the author implied), educated designers would direct Spanish practitioners and craftsmen to build in a new style that embodied the virtues of the Spanish state.

Knowledge of Philip's interest in architecture must have spread quickly. When Villalpando dedicated his translation of Serlio to Philip in 1552, he stressed the prince's knowledge of architecture and his hope that he would turn to the construction of great things. Yet Philip did not immediately take up suggestions for reform, nor is there any sign of a well-traveled, amateur architect at court. He was very little in Spain during these years, and, from posts on his travels continued to employ the same Spanish masters who had served his father.

PHILIP II AND JUAN BAUTISTA DE TOLEDO

In 1559, as he was preparing to return to Spain after four years of absence, Philip suddenly altered his style of patronage. He appointed as 'nuestro arquitecto' Juan Bautista de Toledo, an Italian-trained Spaniard who was then in Naples working for the viceroy, and called him to Madrid. The document by which Philip renewed this appointment in Madrid in 1561 clarifies his conception of Juan Bautista's role:

It is our wish that from this time forward, for all your life, you should be our architect, and as such that you are to serve and to serve us in making the designs and models that we command, and in all our works, buildings and other dependencies of the office of architect, and to reside at our court, or where it is commanded and ordered by us; and as architect, you are to enjoy all the privileges attached to and concerning that office, without there being in any way or aspect of your office, any difficulty or impediment whatsoever.[34]

This appointment was unprecedented in Spain, where no such 'office' had existed and where no royal architects had ever been appointed. Following traditional practice, Charles V had appointed Luis de Vega and Alonso de Covarrubias as masters of the works

at the royal fortresses of Madrid and Toledo where they were responsible for both designs and supervision of construction. By contrast, Juan Bautista was not attached to any specific project. His responsibility was to the king, to go where he was ordered, to design what was required. Design – the drawing of plans and making of models – was Juan Bautista's charge. Philip clearly envisioned an architect in personal attendance who would work closely with him. It was an appointment modeled on Alberti's definition of the architect.

Juan Bautista de Toledo was apparently a good choice for the role. He was an educated man, a mathematician, and an architect in the classical style. He had been Michelangelo's chief assistant at St Peter's in Rome for a few years until he left for Naples, where he had supervised a number of building projects for the Spanish viceroy. He had both the theoretical background and the practical experience of building in Italy, some of it with the greatest architect of the day at the most famous building program in Europe.[35] Philip began to employ Juan Bautista in the ways we would expect: planning new buildings, consulting with him regarding existing as well as new projects, preparing designs and models with the help of a small staff that he seems to have brought with him from Italy. Documents show Juan Bautista in almost constant attendance on the king. Philip and his architect were working together in the Renaissance manner.

Part of Alberti's program, however, was that an architect should see that his designs were carried out. The builders were ideally willing tools in the hands of the architect. Some organizational structure was needed to implement designs, but Alberti said little about this, perhaps expecting that the role of the architect could be grafted relatively painlessly upon the existing building industry, as indeed happened in central Italy. We do not know Philip's thoughts on this issue: there was no word in Juan Bautista's appointment about supervising construction, although he was granted so much power that his freedom to organize building practice must be considered as implied in the document. As far as one can tell, Juan Bautista was expected to work with the Spanish professionals who were already in place at the royal works. It helped that he was a Spaniard, and that, in spite of being an intellectual architect, he was a fully qualified *maestro mayor*, having served his time as the Italian equivalent of *aparejador* under Michelangelo.

It is clear from the documents that Juan Bautista also brought his own working habits to his relationship with the king. He preferred to supervise construction closely, and expected to be able to make decisions at the site and to count on a loyal work force that understood his ideas and could carry them out. In itself, this was not an easy task. Although Spanish by birth, Juan Bautista was in some way alien. He had no established ties to the Spanish building industry and, furthermore, displaced the men who had been working for Philip during the regency. His role as royal architect cut off the *maestro mayores* from design yet forced him and them to work together. Philip's appointment of Juan Bautista had turned the Spanish masters into the architect's executants – just as the writer of the treatise had predicted. Indeed, something of the kind was inevitable, since it was obviously impossible to reconstitute an entirely separate building industry for the royal works. Moreover,

the existing profession was organized to build large buildings – it had come into being to build cathedrals – and it would have been unthinkable not to use it. The obvious solution was to appoint Juan Bautista *maestro mayor* at the major building programs. In 1561, indeed, he was named *maestro mayor de las obras de el Escorial* in addition to his position as *Arquitecto de Su Magestad*. The same year Philip appointed him 'master of the works of the Alcázar and stables of this city of Madrid and in the royal buildings of El Pardo and ponds and of the other works and things around this city of Madrid that we shall command.' Such a string of responsibilities had never been attached to the traditional title (any one of these projects was enough for a normal *maestro mayor*) and this shows that Philip was trying to establish Juan Bautista's authority on terms acceptable to the Spanish profession and, perhaps, to Juan Bautista himself.

Juan Bautista's double role raised problems of a different nature: he now had two appointments: *Arquitecto de Su Magestad* and *maestro mayor* of the Escorial and of the other royal works. Both were necessary if the buildings were to be built. The Italian image of the architect had been combined with the Spanish professional in one individual. Philip had found someone who combined the qualities of both traditions and could function in both. It cannot have been that easy – there were no such men in Spain and no distinguished Spanish architects in Italy. The real difficulty was the workload. Juan Bautista was a mature man in his fifties when he returned to Spain in 1559 and he suffered the loss of his family and most of his books and papers on their separate voyage to Spain. But although these circumstances may have disheartened and weakened him, it was the job that killed him.

Philip expected constant consultation at court; the staff at the building sites – each one from the Escorial to Aranjuez and Madrid – expected his presence and supervision. The administrators – overseers, book-keepers, and the like – expected their share of attention, too. When they could not get direct consultation, all these parties, especially the king, expected memoranda which Juan Bautista found extremely frustrating to write. Juan Bautista soon found it impossible to meet all these obligations, as well he might: he missed appointments with the king, was late with drawings, enraged the prior at the Escorial, insisted on remaining at the Escorial when the king said he needed him in Madrid, and so on. The prior complained that he was never at the site supervising construction. Money was short, suppliers had to be organized, requests were held up in the bureaucracy. Everyone became nervous and dissatisfied. Juan Bautista, obviously exhausted, fell ill and died in 1567.

Looking over the documents, it is amazing that he survived seven years. The king's plans were grandiose: Juan Bautista worked on more than ten major building projects at once, each of them enough to keep an architect and a staff of assistants occupied full-time. The Escorial was only one building; there were also the palaces at Aranjuez, El Pardo, Aceca, and the Casa del Campo, the royal fortresses at Toledo and Madrid. There were fountains and gardens to be laid out, bricks and wood to be ordered, building teams to be assembled, work to be supervised. Above all, there were designs to

be conceived and drawn up, discussed and revised with the king. Not all the building programs were new like the Escorial and the palace at Aranjuez, but Juan Bautista rehandled all existing designs and in most cases made new plans. He had a small staff of personal assistants on whom he could rely for drawings and models.

The greatest pressure came from the expectations that Philip and Juan Bautista set for themselves. Philip wanted to be involved in every stage of the design process, in each decision. Once he had approved designs he did not want any changes made in them. His passion for detail meant that literally no changes should be made. Juan Bautista was used to having the freedom to make decisions on the building site while supervising construction. He seems not to have been able to work in any other way. His habits of practice had been influenced by the example of Michelangelo at St Peter's where no complete set of designs had been drawn up preliminary to construction. All evidence shows that design and construction in Italy were still something of a give and take. Michelangelo, for example, was concerned that he was too old to supervise the building of St Peter's himself and the history of his designs show that he worked in stages from a general idea, modifying it as he went along. Given the speed at which Juan Bautista was working, it was impossible to prepare every design to the last detail before construction. Supervision was essential. This was probably more typical of sixteenth-century building practice in Italy than is generally thought. It is likely that Philip (rather than Michelangelo or Juan Bautista) was the anomaly and had not realized that Alberti's system, though perfectly consistent in theory, might be difficult to implement.

Philip was a good bureaucrat who stood by his staff. He never failed to support Juan Bautista to outsiders, but his confidence wavered, and he fell back on the system he knew. He began to invite criticisms of Juan Bautista's plans from other people and to solicit design advice from Spanish masters. In 1564, Philip allowed the prior of the Escorial to call a meeting of outside masters, among them Rodrigo Gil de Hontañón and Hernán Gonzalez de Lara from Toledo, to give an opinion of Juan Bautista's designs. The king had earlier solicited a critique of his architect's plans for the basilica from Francesco Paciotto, an Italian architect and engineer, who was passing through. Juan Bautista, outraged, demanded that his plans be sent to Italy for evaluation. Sensing the uncertainty in Madrid, Juan Bautista's assistants at the Escorial became restive and insubordinate. His classicism was new to them and on one occasion they made an 'improvement' of a conservatively Spanish kind and proceeded to execute it without his permission.

Yet in spite of such troubles, Juan Bautista left a pleasant memory in Spain. Contemporaries found him difficult but liked and admired him. José de Sigüenza praised his learning with genuine enthusiasm, and it is clear that Juan Bautista successfully embodied the new image of the architect.[36] There is no sign that Philip was disappointed in his architect, but, at the same time, there is no doubt that the king had failed fully to integrate his conception of architecture with existing institutions.

HERRERA'S TRAINING WITH JUAN BAUTISTA

With this situation in mind, we can at last turn to the events that introduced Juan de Herrera into the royal works. Juan Bautista de Toledo had arrived in Spain in 1560; from 1561 until 1563, he managed with very few assistants, principally Jerónimo Gilli, an Italian later named *maestro mayor* at the Alcázar in Toledo, who was in charge of models. As planning for Philip's new foundation at the Escorial got underway, however, it must have become clear that Juan Bautista needed more assistants to help him prepare designs. On 1 January 1563, Philip authorized an addition of 200 ducats to Juan Bautista's salary in order that he maintain two disciples to assist him.[37] A month later (18 February 1563) Philip appointed Herrera and Juan de Valencia to these jobs.[38] Both Herrera and Juan de Valencia had been working for the royal tutor, Honorato Juan, who may have recommended them to Philip since he was at this time being pensioned off from his job to the bishopric of Osma. Philip cited the ability of both men in architecture. Juan de Valencia, as the document explains, was the stepson of Luis de Vega, who had been *maestro mayor* of the Alcázar in Madrid, and had been trained by him. He was moving from the old office of the royal works to a new position under Juan Bautista.

Both appointments were hybrid positions. Top men at a building operation – a master of the works and his *aparejador* – were traditionally allowed to have apprentices (*discípulos*). This was how young designers, future masters, were trained at the site. Juan Bautista, however, was given apprentices, not in his capacity as *maestro mayor* (although he had been appointed to this position at Madrid and the Escorial), but as a royal architect. Philip seems to have envisioned that Herrera and Juan de Valencia would work mainly at on the design side, preparing drawings and models, and this was how Juan Bautista used them.

It is not clear what Herrera's qualifications were; the document describes him simply as a 'servant of the King's' [*criado de Su Magestad*]. Scholars have speculated widely on Herrera's early knowledge of architecture: everything has been suggested from a complete education in architecture before 1563 to a wide but casual experience and study in his travels. Very few documents give us a glimpse of the private person which might explain his vocation and, as we have seen, little is known of his early life. His wills and the inventories of his possessions reflect his interests, his friendships, and his intellectual life at a later time, but we know very little about how these were formed. Although in later life Herrera became a famous intellectual, he never claimed to be highly educated. On the contrary, he referred to himself as self-taught, and other sources confirm this. His library was splendid but he preferred to read classics like Cicero in Italian or Spanish translations rather than in the original. Attempts by scholars to place Herrera at the University of Valladolid in 1551–53 have not been supported by documents. We can be sure of only two things: by 1562, Herrera was a skilled scientific draftsman and had manifested a special interest in machines.

There is some evidence that these interests developed during Herrera's years in the army, which left a permanent impression in other ways as well. In 1579, he owned a small arsenal which included weapons from pikes and muskets, probably collected during his army days, to pistols and fine swords. The inventory, which is in his own hand, describes these items with care. Herrera also made enduring friendships in the army. His will of 1579 made bequests to two members of the king's 'guarda española,' one of whom, Juan de Carrión, was also named an executor. Apart from a legacy to a Gregorio de Flores Calvo from Carabaña, these were his only gifts to individuals outside his family and household. Juan de Carrión, now risen to head the king's Spanish guard, was again named as a beneficiary and as one of the executors of Herrera's third will in 1584.[39]

Herrera could have learned to draw in the army, where map-making and fortifications (two of his later concerns) were regularly practiced. His position could also have put him in contact with the engineers and architects working for Gonzaga. He could have known the gifted amateur, Vespasiano Gonzaga, who later built Sabbioneta, from his early years at court. In Brussels, Herrera had friends among the emperor's retinue and in later life he was close to Juanelo Turriano, the emperor's clockmaker and engineer, a man of exceptional technical abilities who was with Charles V in Brussels and accompanied him to Yuste. As we shall see, many of Herrera's later interests parallelled Turriano's.

The documentary silence of the early years is broken in 1562 when Herrera completed a set of scientific illustrations for a copy of a medieval astronomical treatise, *Libro de las Armellas*. The text was copied by Juan de Valencia. The book was ordered for the infante, Don Carlos, by his tutor Honorato Juan, who had also been a tutor to Philip in the 1540s, when Herrera could have known him.[40] By this date, Herrera was an accomplished draftsman, at least in the field of scientific illustration and, lacking other evidence, we may assume that because of this book Philip saw a new use for Herrera.

If Herrera was not already an architect (and this is doubtful), he certainly became one between 1563 and 1567. As a draftsman in Juan Bautista's office he participated in what was emerging as the most important aspect of architecture. He was in daily contact with an intellectual designer whose experience of Italian building, specifically of Roman architecture in the circles of Sangallo and Michelangelo, was profound. It is unlikely that Herrera had ever been in the company of so sophisticated a designer as Juan Bautista or had the opportunity of seeing the Renaissance ideal in practice. He did not have responsibilities at the building sites, nor indeed could he have had since he did not possess the qualifications of an *aparejador*. Besides, Spanish professionals already filled these positions. Yet, even if Herrera could not supervise construction, he was well placed to learn the theory and techniques of Renaissance classicism and he had access to the king. He lost no time in putting himself forward. A few months after his appointment, in September 1563, he was proposing (in competition with Juan Bautista) his own design for a crane to be used at the Escorial.[41] By November, when there was trouble between Juan Bautista and one of his *aparejadores* at the Escorial, the king noted that perhaps more use could be made of Herrera.[42] By 1566, Herrera was bringing

drawings to the king for discussion and taking orders directly from him.[43] Juan de Valencia, who held the same appointment as an apprentice of Juan Bautista, does not appear in these roles. He seems to have become and remained a competent, unambitious draftsman, well liked by everyone; indeed, he later became Herrera's assistant. Herrera, on the other hand, was moving up. On the first of January 1567, a few months before Juan Bautista's death, when he was already ill, the king raised Herrera's salary from 150 to 250 ducats to be paid 'for his service and work in things touching architecture.' In the margin was written 'Herrera arquitecto.'[44]

BECOMING ROYAL ARCHITECT

Five months later Juan Bautista was dead; but if Herrera had hoped to replace him quickly, he was wrong. He officially remained a draftsman [*trazador de su Magestad*], but his influence increased rapidly. In 1568 he proposed his own design for the roofs of the Escorial to replace those designed by Gaspar de Vega. They were accepted. Herrera was proud of this design and years later reminded the king of the 'extraordinary'[45] service he had performed which had 'made the building more beautiful and saved 200,000 ducats.' The design of the roofs may have been a turning point in Herrera's career, since from then on he often appears in the documents as designer – for a wrought-iron grille in 1569, for two courtyard fountains in 1570 – as well as the chief draftsman in charge of preparing drawings for the building. By 1570, Herrera was functioning as the royal architect for the Escorial, in charge of design, and began to direct construction through his agents. From 1571, he had a house given to him by Philip at the Escorial 'in which to keep the drawings and other papers bearing on the works'.[46]

Why then did Philip not appoint Herrera to the position vacated by Juan Bautista de Toledo at this time? This question has puzzled many scholars. The answer lies partly in Philip's character: his caution verging on indecision, his unwillingness to allow too much independence to individuals in his government. As we have seen, Juan Bautista de Toledo had not worked entirely in the ways that Philip had wanted and the king was no doubt pondering this experience. As long as Herrera functioned as his architect, there was no pressing need for Philip to grant him the title. One reason that Herrera and Philip worked together so well over thirty years may have been that, during the period when their relationship was established in the late 1560s and 1570s, Herrera was entirely dependent on the king, with no personal authority whatsoever. He performed exactly as Philip wished.

There was also a difficulty inherent in the situation that Philip and Herrera inherited. Juan Bautista's double appointments as *arquitecto de su Magestad* (his Renaissance role) and as *maestro mayor de las obras reales* (his traditional title) were a temporary solution which could not survive him. The two different views of building remained distinct. At Juan Bautista's death in 1567, the king lost an architect, but the two *aparejadores* of stone work, Lucas de Escalante and Pedro de Tolosa, became de facto heads of the building program at the Escorial. Men in this position at

other building sites assumed direction of the works automatically. According to accepted Spanish practice, the *aparejadores* were the master's assistants and would function as designers until they were themselves promoted or a new *maestro mayor* was brought in over them. Many building programs in Spain ran for years with only an *aparejador* as the resident designer as well as the supervisor of construction. Since Philip wished to separate design from construction, it was necessary to insure that the *aparejadores* did not take over as designers at the Escorial and at other projects.

The king's first decision was, characteristically, a non-decision: he failed to appoint a new *maestro mayor* of the royal works or at any of the specific sites. Then in 1569 he issued an order reforming certain articles in the official building regulations. In 1572, he issued a completely revised and expanded set of procedures which defined the building program at the Escorial, and at other sites, from then on. Both documents took months to prepare and had the same general aims: to reduce costs, to bring the building bureaucracy under royal authority, and to curtail the powers of the *aparejadores* of stone work who might threaten the authority of an outside designer.[47]

The order of 1569 affected the *aparejadores* in six major and specific points: (1) they were not to change anything in the approved designs. In a sharply worded directive, Philip told them not to pretend ignorance of this. From now on 'they are in no way to continue or put under construction anything which it seems to them ought to be done, even if they say they have spoken with the king.' (2) Everything was to be done by contract. In principle there was to be no more day-labor – skilled men simply hired by the day to work on the job until it was completed. This was intended to reduce costs, prevent padding, and speed up building. It also meant that once designs were prepared for bidding and the price fixed, changes would be difficult to make. In 1564, the *aparejadores*, at the prior's insistence, had altered the profile of a molding at the base of the Escorial without Juan Bautista's knowledge. The new regulations prevented this kind of insubordination. (3) The *aparejadores* were to have their drawings ready on time for the contractors. These drawings were prepared from master drawings which had been approved by the king. (4) They were not to meddle with each other or interfere in any way with the contractors once construction was underway. (5) They were not to hire or fire anyone without orders from the Congregation, the governing body of the monastery. (6) They were not to have their apprentices on the building payroll. This last was an especially wounding withdrawal of a traditional privilege that had been explicitly guaranteed in the original regulations of 1563, it was later modified to allow them one apprentice each.

The instructions of 1572, an enormous document covering every aspect of building practice and organization, reduced the power of the *aparejadores* still further. The orders of 1569 were confirmed and the Prior was appointed 'superior and head' of the works at the Escorial with authority over 'everything touching it.' The prior, however, was not a designer and did not pretend to be one. He was to issue orders 'according to the general plans and detailed plans which have been made and which we will order to be made from

now on.' The prior had the right to fire the *aparejadores* – a fact not published but which soon became known and resented.

The idea behind the instructions was clear: Philip abolished the office of *maestro mayor* (although he never said so plainly). In doing so he had chopped the head from the Spanish building industry and severed design from construction. From now on, *aparejadores* were not on the final rung of the ladder to becoming masters of the royal works, at least at the Escorial; even if they were given the rank of master, as happened at sites outside the area of Madrid, the responsibilities of the title had changed. Masters and *aparejadores* would never be royal designers; they were construction supervisors. At the Escorial, the *aparejadores* were responsible for supervision and for the preparation of working drawings and copies of drawings for the contractors. They were to keep regular hours at the site, the hours of ordinary workmen.

The procedures of 1572 are often attributed to Juan de Herrera, but this is doubtful, although he was consulted and may have had a hand in them. They form a work of bureaucratic genius that is probably due to several people, Philip first among them. It is certain, however, that these procedures made it possible for Herrera to function as an architect. Herrera, who did not have Juan Bautista de Toledo's qualifications to supervise construction, would not have been accepted by the work-force even if Philip had wished to appoint him as *maestro mayor*, and Philip was far too good an administrator to make a difficult situation worse by such action. He left the hierarchy of the building industry intact in his programs, simply amputating the function of design, which now depended exclusively on royal authority.

A new chain of command, replacing the old powers of the *maestro mayor*, led directly from the king to his architect to the prior and thence to the *aparejadores* and craftsmen. Herrera prepared the designs, which were discussed by the Council on Architecture and approved by Philip. A secretary then forwarded them to the prior of the Escorial, who gave them to the *aparejadores* who made sets of copies. The original was returned to the royal administration. The instructions spell this out. From 1572 onwards every decision about design was made this way and every design was officially approved before it was executed.

Backed by the king's authority, Herrera could function as an architect, and Philip began to use him as he had used Juan Bautista. Herrera took on other royal projects: reworking plans at the Alcázares in Toledo, Madrid and at the royal palaces in Granada and Aranjuez among many others. Herrera was becoming indispensable as Philip's architect, but he still did not enjoy Juan Bautista's title. There are signs that Herrera was dissatisfied with this arrangement. Early in 1572, for example, he was working on plans for the remodelling of the fortress at Simancas, which was being converted into a royal archive. Designs were prepared in consultation with the supervisor at the site, Juan de Salamanca, who in this case held the title of master of the works. The project's administrator, Diego de Ayala, had a career to make, however, and plagued Herrera with questions for years. Finally exasperated in 1576, Herrera wrote to Ayala that he had done enough, far more than was his responsibility. Herrera knew perfectly well this would

reach the king and must have counted on its doing so, since his complaint was justified. Herrera was not the royal architect; his appointment was as the king's draftsman at the Escorial and the works at Madrid, and it was not part of his official responsibility to work endlessly on designs for the king's other projects, although he had been doing so for years.[48]

Philip compromised. At Herrera's request he relieved him of the appointment as *ayuda de la furriera* and in exchange gave him a salary of 800 ducats a year: 400 to be paid by the Escorial and 400 charged to the works at the Alcázar in Madrid. Herrera was obliged to live 'where the king commands and to take care of and go out to the works as is necessary' and was 'to serve in all things touching the works and architecture; and whatever else is attached to and dependent upon his profession.' He would now find it difficult to refuse requests from Simancas and elsewhere. This appointment confirmed that Herrera was Philip's architect but it did not quite make it so: Herrera was called 'Our servant [*nuestro criado*].'[49]

But Herrera did not have to wait much longer. Some time in the next year Philip decided that Herrera could be safely allowed the official position he wanted. In 1578, Jacopo da Trezzo designed and cast a portrait medal of Herrera with the legend: IOAN. HERRERA. PHIL. II. REG. HISP. ARCHITEC (pl. 2). Two examples in gold (one

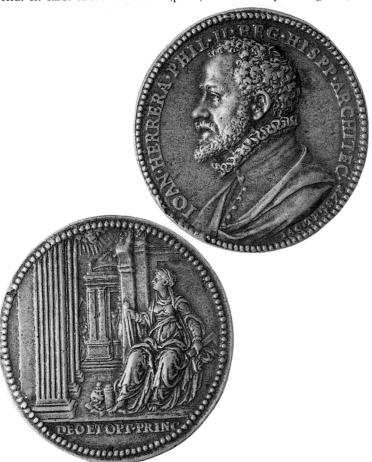

2 Jacopo da Trezzo, portrait medal of Juan de Herrera with reverse commemorating the basilica of the Escorial and the birth of Philip III, 1578. (Madrid, Museo Arqueológico)

for the king?) and a number in bronze were cast. Jacopo da Trezzo was a friend of Herrera and Philip's goldsmith and, even though the medal had no official status, it is inconceivable that it would have been made without the king's permission.[50] At the very least, Philip must have held out the promise of the title. In 1579, he granted it at last: Herrera was appointed *Nuestro Architecto* and *Aposentador de Palacio*.[51]

When the appointment finally came, it was rather in the nature of a reward for services than a new job. Herrera's responsibilities as an architect did not change – he had after all been designing the king's buildings for more than ten years – but his public position was greatly enhanced. Herrera was now routinely referred to as 'Arquitecto de Su Magestad' and 'nuestro arquitecto' and could issue orders with his full title: 'criado de Su Magestad y aposentador mayor de su palacio y arquitecto general de todas sus obras.'[52] Like Juan Bautista before him, he took two young apprentices: his nephew, Pedro del Yermo, who never amounted to anything as an architect but was studying mathematics, and Francisco de Mora, Herrera's eventual successor.[53] As we might expect from Philip, the appointment had a practical aspect. The king was preparing to leave for Portugal. Herrera was to go with him but he might need to return to the works during the king's absence. The title bolstered his authority, giving him the right to make decisions on his own when it was not practical to refer to the king himself.

The 1580s were the peak of Herrera's career, the years when he enjoyed official recognition as the leading architect in Spain. His achievement was remarkable considering that he had been a poor guardsman at court with no status in the building profession. Herrera owed it all to Philip II yet it brought him little security. On the contrary, Herrera was uncomfortably aware that no royal servant was indispensable. The greatest of Philip's projects, the building of the Escorial, which had shaped Herrera's career, was drawing to a close. Amazingly, considering the magnitude of the undertaking, the Escorial would be finished. What would become of him when it was done? Perhaps Herrera had been too busy before to confront the reality of his situation but in 1584 it stared him in the face. The last stone of the major construction of the Escorial had been ceremoniously laid in place by the monk Antonio de Villacastín, *obrero mayor*, who had skipped the foundation ceremonies twenty years before, saying he would save himself for the great moment of completion. In fact, the Escorial was not quite finished in 1584 but the major work of building was done. Building the Escorial had consumed Philip II's emotional energies: there were other royal projects but there would be no other single building of this magnitude, nothing that required the total absorption in design that the Escorial had exacted from both Herrera and the king.

Herrera took stock of his situation. The endless toil, the extra duties, the money he had invested in making his career came back to him as he realized that it might be about to end. In 1584, he wrote a memorandum outlining 43 years of service: his salaries, expenses, and extraordinary services beyond those of his profession of architecture. He thought of his inventions, which had saved the king so much money, his advice, his expertise. He balanced the money he had saved Philip against what had been paid him and what he had spent of his own funds and made his request for a

pension, so that 'after my death I might leave the reward of my works as testimony that with them and with virtue I acquired some renown; and something to leave to my children, should God grant me any, and not for myself especially since in my life everything is to serve his majesty.'[54] It was probably true. Philip had made Herrera's career, had placed him with Juan Bautista to train as an architect and had made it possible for Herrera to design some of the most important buildings of the sixteenth century; but Herrera had also made the king, in the sense that he made it possible for him to be a great Renaissance patron of architecture.

Without his architect Philip could not have played his role with traditional Spanish building professionals, enjoyed an intimate involvement with the design process, and participated in the decisions – all of which brought him personal satisfaction. A contemporary reported that in 1597 (when Herrera died) Philip, who had by then lost four wives and many small children, said he felt the loss of his architect most keenly of all. It is not improbable: Herrera and Philip had in a sense grown up together as architect and patron.

After so long a discussion, it may seem flat-footed to conclude that Herrera was made, not born, an architect. Herrera needed to make good as an *hidalgo*: Philip needed an architect: the result was a new professional model and a great architect. Accepting this interpretation, however, alters our view of the situation. An otherwise puzzling and seemingly random series of events and decisions assumes coherence: Herrera and Philip tailored themselves to the prescriptions of Alberti's *De re aedificatoria*, consciously so if the anonymous treatise written for Philip may be taken as evidence. About 1550, the writer described, almost to the letter, the architect that Herrera became twenty years later. Yet the result was not exactly what the author had imagined. Life did not follow the text, although it tried its best to do so. Alberti (and his Spanish emulator), compelling as they were in the circumstances, only provided a point of departure, the incentive for reorganization that rapidly assumed its own momentum in the hands of Philip and Herrera.

Philip imposed an Albertian model of architecture on the royal projects but the result was somewhat different from anything elsewhere in Europe at the time. He established an exceptionally harmonious relationship with his architect – not one recorded quarrel disturbed the peace of their association over thirty years – but in order to do so he made architecture into one of the branches of his government. Philip brought the same concern for detail to the business of architecture as he did to provisioning his army. Procedures were bureaucratized. There was a pool of advisors, an established chain of communication and command under the authority of the king. Architecture under Philip begins to look like another department of state, except that it ran more smoothly and successfully than the various wars and economic programs that Philip promoted (this must have been one of its sources of satisfaction). For his part, Herrera was an exemplary bureaucrat – careful of procedures, watchful of authority, and imaginative in finding solutions within the system. Thus, a new branch of government modeled partly on Alberti and partly on existing governmental structures came into being. The ideal of a humanist patron of

architecture had been integrated into the institutions of the state, a process which was not to occur elsewhere until the seventeenth century. Philip II and Herrera already played their roles in a style much closer to that of Louis XIV and Jules Hardouin Mansart than to the earlier pattern of Renaissance patronage.

When Herrera retired, his legacy was divided between his two apprentices. Pedro del Yermo, Herrera's nephew, took over as *Aposentador de Palacio* in what was more the king's parting gift to Herrera and his family than a recognition of artistic ability, and Francisco de Mora took up the role of royal architect which he continued in the reign of Philip III, serving as royal chamberlain, royal draftsman (*Aposentador de Palacio* and *Trazador de Su Magestad*), and finally as Philip III's *Maestro Mayor de Obras*. But the highest title – *Arquitecto de Su Magestad* – seems to have eluded him. This may have been because his training, in spite of his discipleship under Herrera, was indistinguishable from that of Spanish professionals. He had served as a building foreman and master under Herrera and, later, as master of the works. He was well qualified to direct construction.[55]

When Francisco de Mora, in his turn, took an apprentice, he chose his young cousin, Juan Gomez de Mora, from Cuenca.[56] The self-perpetuating family dynasty, which was characteristic of Spanish practice and which Herrera had tried to introduce with his nephew Pedro, was thus re-established in the royal works.

Juan Gómez de Mora turned out to be an architect of talent and enormous productivity, but he was never able to play Herrera's role. He became master of the royal works and the king's draftsman, succeeding his uncle, but was never made architect to the king under Philip IV. Gómez de Mora was a professional in the traditional sense, and had a further disadvantage: he was the cousin of Francisco de Mora, architect to the powerful Duke of Lerma for whom he had built the town of Lerma, palaces, and public buildings. He belonged to a regime which the Count Duke Olivares had overthrown and was anxious to expunge from public memory. Olivares may have doubted that he could ever trust a man who had been so close to his rival. When the time seemed ripe, Gómez de

Mora was disgraced, accused of various crimes, and sent to work on engineering projects in faraway Murcia. With Gómez de Mora out of the way, the field was clear for the noble, rich, and talented Giovanni Battista Crescenzi, a painter and amateur architect, and the king's new favorite, the painter Diego Velázquez.

Herrera's true inheritance passed almost intact to Velázquez, who became *Pintor de Camara*, *Aposentador de Palacio*, and artistic director at the court of Philip IV. Herrera, a genuine if minor nobleman, confidant of his king, and possibly candidate for the Order of Santiago, paved the way for Velázquez's uncertain nobility, courtly role, and knighthood.[57]

Herrera and Velázquez, alike in their devotion to their princes and in their fulfillment of a Renaissance image of the courtly, intellectual artist, are alike, too, in being exceptional figures in the history of Spanish art. Their eccentric positions may indeed reflect their genius, for both were more ambitious and gifted than those around them. But it also attests to the absence of institutions to support their particular models of artistic practice. Very little of their glory reflected on others, if only because there was little common ground with other Spanish architects and painters. An academy of mathematics, founded by Philip in 1584, was supposed to raise the intellectual level of practitioners and might, like the French academies, have served as a center, nurturing artists in the ambience of the court. But Herrera had given the academy a scientific program that included architecture but neither painting nor sculpture. The academy never had much of an audience among artists and never became an artists' institution. By Velázquez's time, its original momentum was gone and probably he did not care to resuscitate it. Velázquez moved artistic power and prestige deliberately from architecture to painting. As a result, Herrera's efforts to generalize his model of architectural practice lapsed. Spanish architects and artists remained without an academy until the eighteenth century, when the Real Academia de Bellas Artes de San Fernando was founded, modeled partly on the French academies.

2
Architecture: between science and art

HERRERA'S SCIENTIFIC ACTIVITIES

IN THE PREFACE to his treatise on fortifications of 1613, Christóbal de Rojas, an engineer who knew and admired Herrera, called him the Spanish Vitruvius and Archimedes.[1] To call an architect the new Vitruvius sounds very much like conventional flattery, but the name of Archimedes is surprising here. In fact, it was a fitting compliment since Herrera was something of a mathematician, with a special interest in mechanics.

Herrera's ties to science and technology were close. His first known graphic works are the illustrations to the copy of a medieval astronomical text which he prepared for Honorato Juan in Alcalá in 1562; he was later given the maps and papers of the royal geographer, Pedro Esquivel, for the purpose of his continuing or finding someone to continue the king's ambitious project for an exact survey of the Iberian peninsula.[2] This came to nothing, but over the years he advanced a number of scientific projects on his own account, most of which related to building operations.[3] In 1563, he proposed to the king a design for a hoist and, in 1567 and in 1568, designs for a big crane with double wheels, many of which were built for use at the Escorial (pl. 3). These machines worked and increased efficiency in building to the point that Herrera could boast he had saved the king a fortune in construction costs. (pl. 4). Over the years he continued to produce machines and to work on engineering projects.[4] Often, as at the Escorial, he collaborated with specialist engineers and hydraulic experts.[5]

Much of Herrera's technical activity left no record because it was what we would now call consulting. He referred to this in his memorandum of 1584 when he boasted that he had protected the king from investing in worthless machines and had trained a number of people in mechanics.[6] On the other hand, Cabrera de Córdoba, an unsympathetic observer, declared that Herrera 'protected charlatans and phony alchemists who wasted a lot of money on experiments.'[7] The results of Herrera's interventions were probably neither so disastrous nor so wholly triumphant. He functioned as Philip's advisor in scientific matters, screening projects, making criticisms and corrections, and sending on promising schemes. He must have been a magnet for any inventor seeking a royal subsidy, and inevitably he backed experiments that came to nothing just as on other occasions he identified capable people.[8]

Herrera's scientific role at court was polymorphous. Consulted on every scientific subject from fortifications to botanical illustra-tions, he made direct contributions to technical matters and kept an eye on the work of others.[9] Although he had no official position as a scientist, his activity was extensive and, characteristically, embedded in the routine of court bureaucracy.

HERRERA'S LIBRARY AND THE ACADEMY OF MATHEMATICS IN MADRID

Herrera's interests were reflected in his extraordinary collection of books, which covered all the branches of Renaissance science from mathematics to alchemy and hermetic philosophy. He had at hand the mathematical tradition from Archimedes and Pappus to Tartaglia and Commandino, scientific writing from antique texts to the contemporary works of Copernicus, Agrippa, and Bruno, and books by every important Renaissance writer on mechanics. With the exception of a handful of religious and historical books, and a special collection of the writings of Raymond Lull, Herrera's was a scientific library where books on optics, perspective, astronomy, geometry, arithmetic, mechanics, music, magic and astrology were set beside those on architecture.[10] Not surprisingly, he also owned many editions of Vitruvius, important Renaissance treatises like those of Alberti, Serlio, and Philibert de L'Orme, and volumes of architectural plates and drawings, but this part of his library only came second, after science and technology. He also accumulated an impressive collection of scientific instruments: compasses, astrolabes, globes, numerous maps, charts, and mathematical papers.[11]

The crowning of these scientific activities was the foundation of the academy of mathematics in Madrid, which the king established in 1584 on the model of a similar institution in Lisbon.[12] Herrera had urged Philip II to create the academy and seems to have been its mentor during the 1580s and 1590s, although he was not its official director. On 25 December 1582 the Portuguese cosmographer, Juan Bautista de Lavaña, was appointed, together with the mathematician, Pedro Ambrosio de Onderiz, and the royal cartographer, Luis Georgio to teach classes on mathematics, architecture and 'related subjects'.[13]

The aims of the academy were to demonstrate the mathematical foundation of various branches of technology, to combine theory with practice, and so raise the level of contemporary practice by bringing intellectuals and practitioners together. Ginés de Rocamora mentions 'the many other gentlemen' who attended the lectures but it is not clear whether practitioners were welcome or

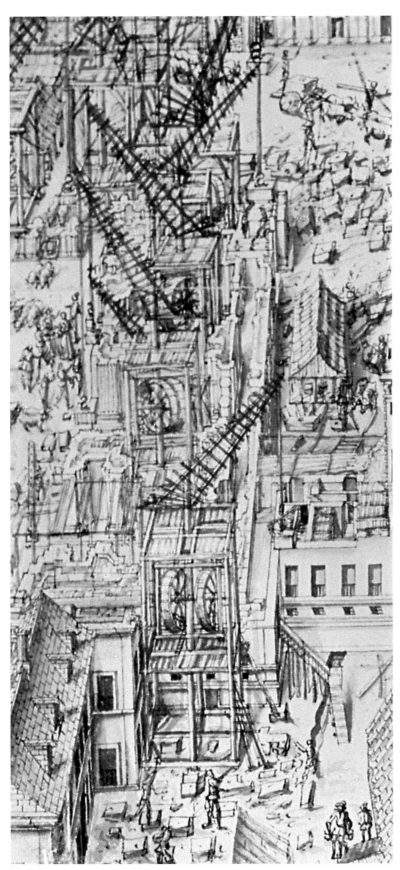

3 Drawing of the Escorial under construction after 1576, detail of pl. 4

whether there were regular classes. The academy functioned until 1625 when its library was given to the Jesuit Colegio Imperial.[14]

In spite of its courtly setting and clientele, the academy was not supposed to be an intellectuals' institution. It was the model for public schools that Philip and Herrera wished to establish throughout the country.[15] Philip's and Herrera's enthusiasm for technology was characteristic of late-sixteenth-century culture, but their decision to implement a national educational program based on it was a novel move. Philip II's mathematical schools would have been the first of their kind in Europe.[16] Clearly Herrera was fully abreast of contemporary scientific culture and capable of taking an active part in its activities, even if he was not perhaps an original mathematician or engineer. This implies a considerable investment of time and energy. The question arises whether this was simply a devouring hobby, or whether Herrera considered it an integral part of his domain as an architect.

VITRUVIUS AS THE MODEL FOR ARCHITECTURE

The answer may appear to be simple. Vitruvius's *Ten Books on Architecture* was a major point of reference for Renaissance architects and, if we look at his treatise, we find that of ten books only seven are directly concerned with building. The eighth is addressed to hydraulic engineering, the ninth to astronomy and the design of clocks and sundials, and the last to various kinds of machines with an emphasis on military technology. There is no doubt that Vitruvius considered these part of his subject: 'There are three departments of architecture: the art of building, the making of timepieces, and the construction of machinery.'[17] This program corresponds precisely to the interests and involvements of Herrera, and what should be more natural for a Renaissance architect than to follow Vitruvius? But the art historian is not entirely comfortable with this answer because other architects did not concern themselves with such matters.

Vitruvius played a peculiar role in the architectural thinking of the Renaissance. *De Architectura libri decem* enjoyed immense prestige because it was the only treatise on any of the fine arts to survive from antiquity and the only sustained theoretical writing on architecture from before the Renaissance. Vitruvius's text – edited, translated, commented upon, and illustrated many times in the Renaissance – became the most available book on architecture.[18] What is more, Vitruvius was the model behind modern architectural writing. Alberti's *De re aedificatoria* (1450) was in one sense a modern Vitruvius, a description of the art of building as Alberti thought Vitruvius should have written it; Diego de Sagredo based his *Medidas del Romano* (Toledo, 1526), the first modern illustrated treatise on classical style, on Vitruvius's authority. By the middle of the sixteenth century, any architect who was serious about building in a classical style could claim, like Palladio, that he had taken 'VITRUVIUS for my master and guide' and had interpreted the remains of ancient buildings 'in the manner that VITRUVIUS shews us they were made.'[19]

But Renaissance architects were not as Vitruvian as we would tend to expect, and it was precisely with reference to Vitruvius that Herrera's views parted company with the mainstream of

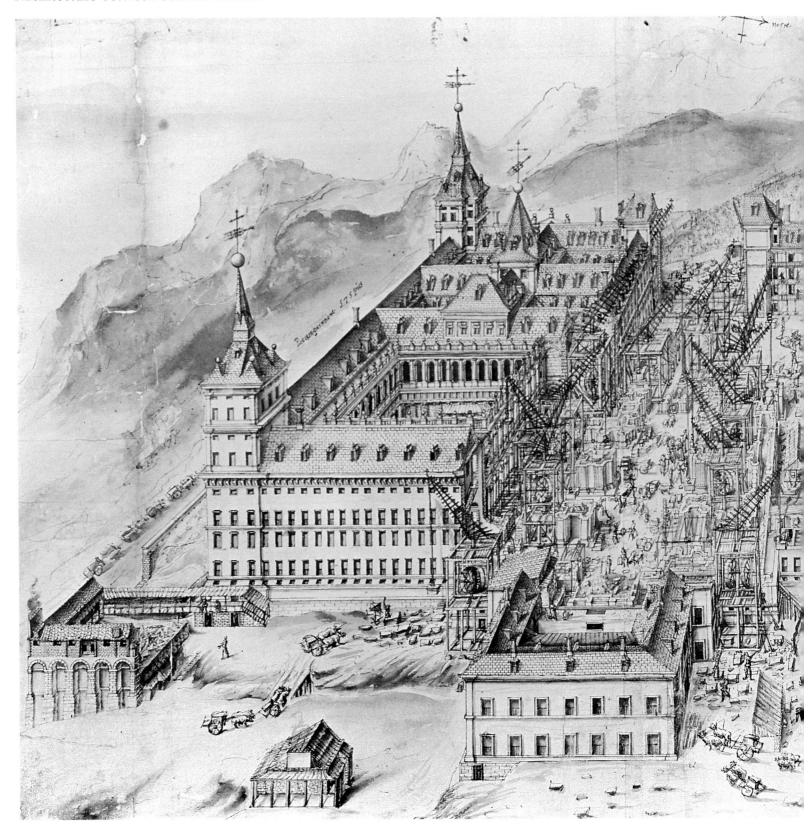

4 Fabricio Castello(?), the Escorial during construction c. 1576. (Hatfield House,
Courtesy of Lord Salisbury)

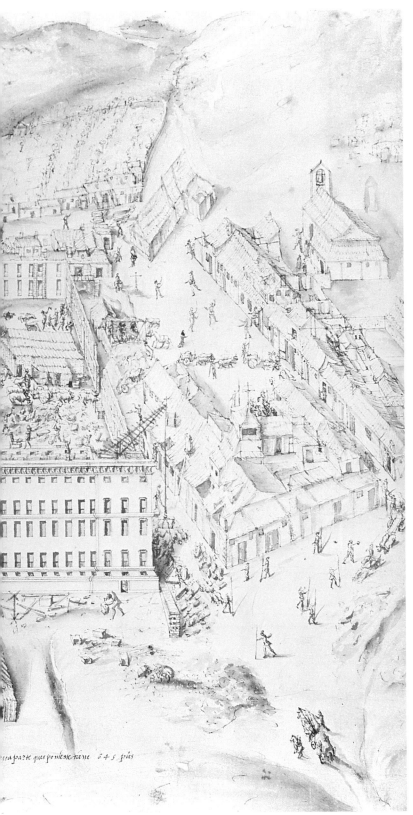

Renaissance architectural thinking. Palladio claimed to have followed Vitruvius in becoming an architect but a glance at his treatise shows that they had very different conceptions of their profession. Palladio was prepared, as he said, to 'treat briefly of . . . aqueducts; and lastly of the manner of fortifying cities and seaports.' He included designs for some of his own bridges in Book Three, because he considered them architecture, but he stopped short of clocks and catapults.[20] He was not particularly attracted to military architecture and, like Serlio before him, separated architecture from fortification. This selective use of Vitruvius was characteristic of Renaissance architects. Alberti already made it clear that clocks were not the architect's concern. He distanced architecture from technology and insisted instead on its privileged relation with painting and sculpture.[21]

Herrera himself was more than casually interested in Vitruvius. He owned twelve printed copies of the *Ten Books* – four in Latin and nine in Italian and Spanish – a manuscript in Spanish, as well as separate printed editions of Book IV in Italian, Book IX in Latin, and a vocabulary of Vitruvian terms. Altogether he owned more of Vitruvius than of any other writer on architecture.[22] While he might have collected these books the way some men collect horses as an emblem of prestige, it is more probable that he used them in his profession. His mathematical and technological interests suggest that he may have understood Vitruvius differently than his Italian colleagues.

THE CENTRAL ITALIAN MODEL OF THE ARTS

An alternative to Vitruvius's view of architecture flourished in central Italy, where the desire to set painting, sculpture, and architecture on a common theoretical foundation appeared in Alberti's *Della Pittura*.[23] A close association between the arts had existed since the time of Giotto and Arnolfo di Cambio in the fourteenth century. Arnolfo was a sculptor turned architect; Giotto was invited to design the bell tower of the Cathedral of Florence and no one seems to have had serious qualms about his lack of experience as a builder. At the time this attitude, which seems typical of the Renaissance, was unique to central Italy. One cannot imagine a northern – Milanese or Venetian – painter of Giotto's time being asked to design a monumental building. Medieval practice was generally organized around the materials and skills for building and survived in the distinctions between specialized guilds. Specialists in one art did not encroach on the territory of another. In some places, sculptors were obliged to hire painters to paint their statues; elsewhere painters were forbidden to carve the frames for their own altarpieces.

What made a unified approach to the arts possible in central Italy was the idea of drawing. The Florentine notion of *disegno*, which included both the skill and the concept of design, transcended the traditional distinctions among the various arts. Drawing was an intellectual skill and, like writing, was a way to express thought. It was separate from the materials – wood, stone, or pigments – that would be crafted into a particular work of art. The Divine Maker, wielding a compass and creating the world, an image familiar in medieval art, is the supreme craftsman. The Renaissance rep-

resented creation in thought: maker became designer. Francisco de Holanda's God creating the universe is the force of pure geometry and Dosso Dossi's Jupiter is a god painting butterflies.[24] Through the abstraction of drawing, the making of works of art became an intellectual activity.

Design did not denigrate skill; on the contrary, it was from the world of practice that it had come. Alberti praised artists for their discoveries, putting theory in the service of practice and Leonardo spoke confidently of practice as the mother of theory, but both he and Alberti were speaking of practice grounded in *disegno*.

A sense of wonder at the originality of this idea and pride in its Florentine origin was still strong in the sixteenth century. Vasari's legend of the young shepherd Giotto discovered while drawing a perfect sheep on a stone (a type of story not repeated for later artists) must be understood as a myth of origin for what was still felt as a miraculous achievement.[25] Artistic traditions, which had no equivalent concept, discovered that it was difficult to promote the arts as intellectual disciplines, and outside Italy, or areas under its influence, the artist-architect was correspondingly rare. Various arts tended to remain specialized and practitioners to stay confined within the commercial and workshop structures that had evolved earlier.

In the early fifteenth-century the sculptor Brunelleschi's invention of mathematical perspective technique, useful to all artists, had drawn painting and architecture even closer together, but no one did more than Alberti to give authority to the central Italian inheritance of artistic practice. In his various writings on the arts, he explained how an artist's work was an intellectual achievement, describing techniques like drawing, composition, and perspective as objects of thought and showing their connections to recognized forms of intellectual life, like literature.[26] In discussing the arts as related through their common dependence on drawing, for example, he made it understandable that a painter could be an architect and justifiable that the design of buildings should be an intellectual pursuit.

Alberti was tireless in his promotion of the arts of design as intellectual undertakings. The judgment, intelligence, study, and deliberation that Alberti requires of the architect are matters of thought. From design emerges the building, as abstract thought becomes stone and mortar. As Alberti realized, Vitruvius was no longer, if indeed he had ever been, a satisfactory model.[27] Architecture was an art of design, not an applied science, and Vitruvius's science – exemplified by his clocks and machines – was difficult to integrate into an artistic view of building. The aesthetic value of machinery as such seemed doubtful. Machines had nothing to do with the illusion of natural appearance created by painting or sculpture, nor with the imaginative appeal of poetry. Conscious of the difficulty, Alberti and his followers were nevertheless reluctant to give up so prestigious a text. Later commentators on Vitruvius felt obliged to justify why these things appeared in the book at all, but when architects turned to writing their own treatises, they glossed over or simply discarded this troublesome aspect of their model.

In the Renaissance discourse on architecture as an art, Vitruvius's usefulness was limited to his discussion of building types and of the orders. In this latter respect, however, his importance was unsurpassed. He was the only ancient writer to explain the classical orders and his opinions, which he claimed to derive from Greek as well as Roman practice, were an invitation to the study of ancient buildings. Vitruvius became the foil for Renaissance discussion of the forms, proportions, and decorum appropriate to classicism. Sagredo's *Medidas de romano* was a compendium of Vitruvius in the very limited sense of being concerned with the orders.[28] The Vitruvianism of other writers from Serlio to Palladio was concerned with the orders and building types. The Vitruvius of the great Renaissance architects was stripped of technology and science to become the authority on classical usage.

Herrera was concerned with many of the same issues that interested Palladio: harmonic proportions, the orders, ancient building techniques.[29] Although there is no evidence that his antiquarian investigations delved as deeply as those of Alberti or Palladio, we may assume that he thoughtfully compared his own designs with ancient practice, but he was even closer to Vitruvius through his deep interest in engineering and other forms of technology. If this were simply antiquarianism, a pedantic Vitruvianism, it would not be very significant except as an idiosyncratic obsession, but Herrera's radical Vitruvianism reflects an understanding of architecture significantly different from that of Palladio and the mainstream of the Renaissance in Italy. Herrera looked on architecture as a science, whereas Palladio saw it as an art. This point of view was not an individual peculiarity: it belonged to a tradition different from that of the great Italian architects, one that went back to antiquity, had survived alongside the Albertian paradigm, and was, in fact, enjoying a new lease on life when opportunity made Herrera an architect.

That Herrera should have adapted a scientific model to his practice is surprising, and it is possible to see it as a deliberate attempt to change contemporary beliefs about architecture. Herrera appears so much out of step in the artistic development that one has to wonder how he came to such an abnormal position. One might be tempted to believe that he had found inspiration among the building practitioners of Spain, a largely dynastic trade where the mechanical and technological view of building survived, but he had nothing to do with this closed and defensive world, which had showed itself incapable of effectively challenging the Renaissance artistic paradigm. As we have seen in the previous chapter, he was certainly much more attracted by Alberti, whose *De re aedificatoria* had a profound impact on him, and this makes his divergence from the artistic tradition all the more perplexing. It was not the garbled text of Vitruvius alone that could have catalyzed his thought.

ARCHITECTURE AMONG THE SCIENCES, AN ALTERNATIVE MODEL

The idea that building belonged with technology was based on the belief that all these subjects derived from mathematics, specifically from geometry and the geometrical laws of mechanics. According to this view, building was one branch of the science of mechanics. This idea was current in antiquity and is reflected in Vitruvius, but so garbled as to be nearly unintelligible. Vitruvius never explained

why buildings and machines belonged together or what principles they held in common.[30] Had he been able to express it clearly, his view might have been similar to that of some ancient writers on science. At least from the time of Heron of Alexandria in the first century there were those who believed that technology and architecture went together because they derived from mechanics. Heron's works on this subject are lost, but reference to his kind of thinking was made in the sixth century by the distinguished mathematician, Pappus of Alexandria, who divided the science of mechanics into a theoretical part consisting of geometry, arithmetic, astronomy, and physics, and a practical part with building, carpentry, metalwork, and painting.[31]

Pappus grouped building and the making of machines and instruments under the science of mechanics because of their common dependence upon geometry, Archimedes proofs of mechanics being geometrical.[32] Byzantine designers and builders were known as, and presumably were, 'practitioners of the science of mechanics.' Anthemius of Tralles, one of the designers of Hagia Sophia in Constantinople for Justinian, was a mathematician.

Pappus was not available in western Europe before the Renaissance; nor did the idea of a science of mechanics survive in the form he gave it. Over the centuries, the notion of a unified science encompassing technology and building faded from writing on the arts and sciences. Mechanics lost touch with geometry and ceased to be understood as a form of mathematical knowledge, and the mechanical arts became identified with the crafts.

Western thinkers in the Middle Ages chose to view building as the product of a lower form of the intellect, making the antique notion of the superiority of abstract thought over manual skill into the cornerstone of the division of knowledge into the liberal arts of pure speculation and the servile, mechanical arts of practice and experience. The opposition between the seven liberal arts – the trivium and quadrivium – and the seven mechanical arts was given its popular form by Hugh of St Victor in the *Didascalicon* around the middle of the twelfth century.[33]

Hugh's mechanical arts captured the popular imagination, and the social effects of his scholastic taxonomy were deeply felt in European culture well into the seventeenth century, but the schema that placed bulding, painting, and sculpture in the same realm of knowledge as shoemaking and cooking – arts for the body rather than the mind – also necessarily placed a premium on ingenuity and practical skill, on reworking nature for human ends. When Spanish and Italian translators began to make Islamic science available in Latin in the mid twelfth century, the calculations necessary for the construction of machines, optical devices, and building were linked to experience and skill. A practical branch of mathematics – as it were, an intellectual form of non-speculative thought – was reunited with technology though not with the word mechanics.[34]

The first writer to make this connection explicit was the Spaniard Gundisalvo, who, working from the ninth-century text of Alfarabi, produced a classification of the sciences that comes close to that of Pappus.[35] Gundisalvo's *scientia de ingeniis* and *scientia de ponderibus* are virtually equivalent to the science of mechanics as Pappus described it. In the later twelfth century building was grouped with other branches of technology, and this association

persisted in the concept of the *scientia de ingeniis* and the *scientia de ponderibus* which coexisted with Hugh's mechanical arts.[36]

The Renaissance inherited the medieval divorce between the science of mechanics and the mechanical arts as devised by Hugh of St Victor. At the same time, it recovered the classical texts with which to restore the name and substance to the ancient science of mechanics. This situation had important consequences for the status of building. As the science of mechanics was revitalized in the sixteenth century in response to the rediscovery of ancient mathematical texts by Archimedes and Pappus of Alexandria, it became possible to justify the intellectual stature of technology and other branches of practical knowledge.[37] Architecture, however, was not reintegrated into the rediscovered science of mechanics; it had already separated from technology and allied itself exclusively with the fine arts of painting and sculpture.

That art and technology went separate ways was partly the result of tensions which were felt in the tradition. We should not underestimate the stigma attached to the 'machanical' as a term for labor as opposed to thought. Throughout the Renaissance, artists were intensely concerned with their social standing and for years their concern fueled academic debates like the *paragone* – the discussion of whether painting or sculpture, or sometimes poetry, was the more noble art – and inspired Leonardo's seemingly trivial assertion that painting was superior because the painter could wear nice clothes while he worked whereas the sweaty and dusty sculptor was more of a laborer. From Brunelleschi to Velázquez, artists insisted on the intellectual stature of their work as a way of achieving social recognition. It was partly to escape being a mechanical art that architecture was redefined in the fifteenth century. Alberti's art of architecture sidestepped the lowly mechanical arts and came forth as a new discipline, making the highest claims for its intellectual status. From the moment when Alberti's ideas began to be diffused in Italy, as happened quickly in the later fifteenth century, the old, popular view of building associated with utilitarian crafts and tied to medieval practice was doomed.[38]

Building, however, continued to belong to both realms. The Renaissance mathematicians and engineers who embraced the newly revitalized science of mechanics rediscovered building as one of the technological sciences. Francesco Maurolico, a sixteenth-century Sicilian mathematician, described the sciences that mediated between the abstract truth of mathematics and the natural world as 'music, astronomy, perspective, the science of wieghts, stereometry, cosomography, geography, architecture, painting, sculpture, and all those based on Mechanics.'[39] A little earlier, Niccolo Tartaglia outlined a similar list of mathematical sciences in the preface to his translation of Euclid (1543). In 1537, he had portrayed the mathematical sciences in the frontispiece of his *Nova Scientia*. In an enclosure guarded by Euclid, a group of personifications stands behind the author and observes a ballistics experiment. In the distance, Plato and Aristotle stand at the entrance to the precinct where Philosophy is enthroned. The group of sciences includes Architecture, Astronomy, Optics, Astrology, the Science of Weights, Music, Perspective, Physics: their presence attests that the study of Euclid is the basis of practical as well as theoretical subjects and leads on to the highest truths of philosophy (pl. 5).[40]

5 Nicolo Tartaglia, frontispiece of *Nova Scientia*, 1536

Tartaglia represented the contemporary scientific classification of these subjects, one in which the medieval tradition of mechanics has been reunited with its classical sources. Renaissance mathematicians were highly conscious of their return to Euclid, Archimedes, Heron, and Pappus of Alexandria, but their recovery of antiquity was also vastly enriched by investigations of current subjects. Tartaglia's frontispiece comes from a book on ballistics – the 'new science' of the title and the first on this subject. In the illustration itself, Perspective, another new science, stands proudly next to ancient Optics. Tartaglia's idea that a practical technology, like artillery, was a branch of mathematics was self-consciously modern as well as classicizing.

Mathematicians, more classicizing in this respect than artists, used 'mechanics' in its ancient sense, although they fought a losing battle to change the popular meaning of the term. Filippo Pigafetta, an engineer and scientist, wrote despairingly that 'in many parts of Italy a man is called a mechanic in scorn and degradation, and in some places, people are offended even to be called engineer.'[41]

Most scientific writers were eager to relate theory to technology and to practice if not to manual labor. One of the greatest mathematicians of his age, Simon Stevin, summed up the views of his contemporaries in a witty preface to his treatise on fortification (1594):

Your Honour [he is writing to a fellow mathematician] called those who only study Euclidian principles, without proceeding to practice, 'sham fighters'... Now although I have always been of the opinion that the theories of the Theoreticians can serve to further the practical work of the Practicians ... and because I do not wish you to reckon me among the simple 'sham fighters' I have sent you this actual example, which though still they are only (as is said) castles in the air, or, even more properly expressed, bastions of paper, yet come nearer to the matter than theoretical ideas of magnitudes separated from matter. For since drawings and descriptions have to precede the practical work, it seems that it might be to some extent called a part of the practical work.[42]

If scientists, in their enthusiasm for antiquity, returned to an integration of science and technology that embraced all kinds of applications including architecture, this was, however, a matter of classification and they did not propose to challenge the artistic architects and attempt to replace them; but certain kinds of buildings were less important in the new art of architecture and the scientists were quick to take advantage of the situation.

Alberti envisaged an architecture that embraced all building from a sewer to a church, but he left no doubt that the creation of beauty was the highest and most difficult challenge and arranged buildings in a hierarchy from the purely functional to the most expressive. Roads and drains belong on the first level of *necessitas* and are discussed in terms of practicality and solidity. Alberti considers them noble works and beautiful in their way, but the issue of their ornamentation does not arise. Renaissance architects and theorists generally accepted Alberti's hierarchical classification. Hydraulic works, like canals, dams, and drains, and utilitarian structures such as warehouses, streets, and city walls were considered part of the art of building, but their practical functions placed them at the periphery of architecture considered as a fine art.

What canals, bridges, dams, and fortifications might lack as architecture, however, they were free to assert as technology. They were necessarily concerned with problems of materials, statics, and stress, and frequently associated with machinery that made them work; they fitted neatly into the science of mechanics. Sixteenth-century writers were proud to say so but, with rare exceptions, they gave up trying to pretend that hydraulic engineering or fortification belonged to architecture. Armed with the science of mechanics, they wrote to give theoretical stature to kinds of building that were not art, defending them instead as science.

THE EXAMPLE OF MILITARY ARCHITECTURE

Writing on military architecture reflects this situation. Alberti included city walls in his treatise, although he omitted war machines. Within a few years, however, as the deployment of artillery changed military architecture, fortresses all over Europe had to

be rebuilt to deal with cannon and writing on military subjects flourished in response to contemporary practice. Writers on fortification tended to classify their subject as a mechanical art – not in the sense of craft but as a branch of the science of mechanics:

The art of fortification of palaces and towns and of defending them which may be called military architecture is a mechanical profession, for with bastions and barricades and other defenses a man with a few soldiers essays to repel many be means of machines and instruments and to maintain his advantage.[43]

From this perspective, a fortress is a kind of machine – a stationary construction animated by soldiers working to overcome force with

force. The design principles of Renaissance fortifications were geometrical: ideally a fortress should enclose the greatest area with the least construction and its projecting elements should be aligned according to the fire from its guns (pl. 6).[44]

Fortification remained a branch of the science of mechanics, while architecture became an independent discipline. Writing on fortification became increasingly independent of writing on architecture until it finally became the province of professional soldiers and engineers. Architectural writers, with the exception of commentators on Vitruvius, were no longer deeply interested in it and, like Serlio, Palladio, and Philibert, omitted it from their discussions of buildings.[45]

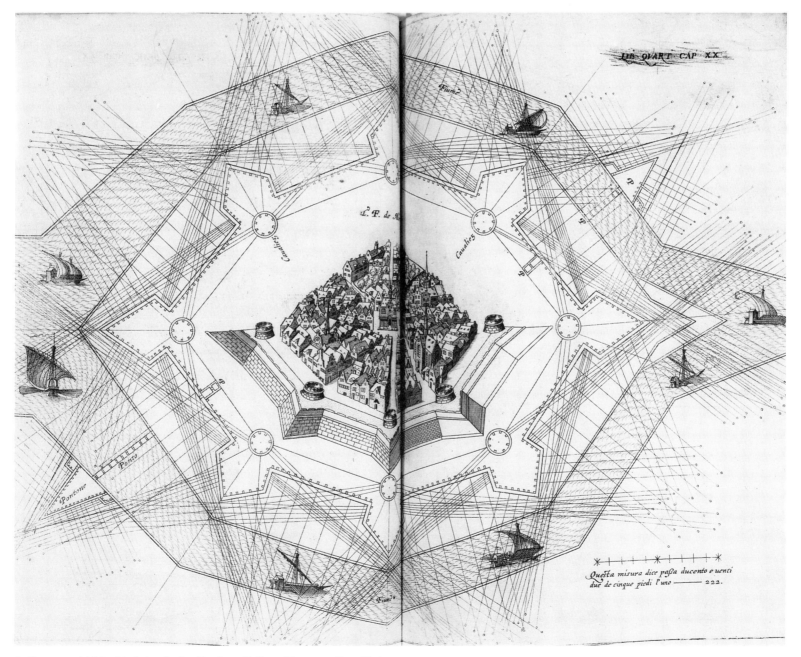

6 Francesco de' Marchi, design for fortifications, *Della architectura miltare libri tre*, 1599

SOME RELATIONS BETWEEN THEORY AND PRACTICE

How important were these theoretical models for working architects and engineers? Theory and practice are not homologous and the relation between them is neither straightforward nor always the same. Vitruvius was a practitioner, but it is difficult if not impossible to reconstruct the relations between his book and the writings on building which he used that are now lost. It is possible, although it cannot be proved, that his work was shaped as much by a tradition of theoretical writing as by his experience as an army engineer and architect. The situation is different but equally obscure for the Middle Ages. The apparently heterogeneous subjects – machines, building, design formulas, geometrical constructions, figure drawing – that make up the twelfth century sketchbook by Villard de Honnecourt and others, for example, belong together as examples of the *scientia de ingeniis*, and Villard's assertion that his book is about what the art of geometry teaches is consistent with Gundisalvo's view of these subjects. But the fact that Villard's manuscript has a theoretical armature makes one wonder how close to practice he really was. Since there is no way of knowing if Villard was a designer or builder – the current view is that probably he was neither – his interests need not reflect practitioners' views.[46]

There are some corollaries to Gundisalvo's views in the realm of medieval practice, albeit concerning general issues only. Statements from the practical sphere are virtually unanimous in asserting that design and building techniques derive from geometry;[47] practitioners thought that their geometrical formulae were relevant to problems of statics and measurement. The designers summoned to confer on designs for the Cathedral of Milan in the fourteenth century, for example, were chiefly concerned with whether the cathedral would stand and, in spite of underlying differences in aesthetics, they used geometrical figures to symbolize structural forces.[48] Masons did not claim to be mathematicians but practitioners of an equivalent of Gundisalvo's *scientia de ingeniis*.

There is no evidence that philosophers, mathematicians, and designers were in frequent contact or that builders were directly influenced by scholastic thought. The terminology of practitioners did not derive from university culture, or even from practical handbooks produced by the educated elite, a fact that confirms its independence.[49] Nor can we speak of these practices as informed by theory in Alberti's sense. The mechanical tradition seems to have survived rather in design and workshop practices where the range of practical activities, which Pappus had grouped together in antiquity and which Gundisalvo described in his sciences of weights and mathematical devices, remained closely associated in a cluster of activities that included various geometrical design techniques and the design of fortifications, hydraulics, machines, and automata.

In the fifteenth century, this old association of building, design, and machines was still in evidence, even in central Italy. Brunelleschi, for example, sculptor and Renaissance architect, the inventor of linear perspective and designer of palaces and churches, worked on fortifications and designed machines for use in building the Duomo in Florence.[50] The same could be said of some later artist-architects like Francesco di Giorgio, whose writings are filled with designs for fortresses, dams, and machines as well as for cities and individual buildings, and who seems close, in some ways, to an engineer like Taccola, known to his friends as the Archimedes of Siena.[51] The multifaceted designer who worked on machines and engineering projects as well as buildings can be traced through the fifteenth century in central Italy and survived even longer elsewhere.

At the end of the fifteenth century, Leonardo still thought of architecture as part of mechanics, 'the paradise of the sciences,' and his various architectural investigations, extraordinary as they were, fitted comfortably into the old *scientia de ingeniis*. By this time, however, something had changed: Leonardo seems to stand outside the mainstream of Renaissance architecture as Brunelleschi does not.[52] This is not simply because he was such an exceptional character. Leonardo is a central figure in the history of Renaissance painting, but he was too involved in statics, structures, materials, and mechanical contraptions generally and not sufficiently interested in antiquity to embody what seem to us the major concerns of Renaissance architecture. A large share of his surviving drawings is devoted to mechanical inventions and to studies of statics in buildings: a range of interests that is not radically different from Villard de Honnecourt's. The painter-architect Bramante, studying antiquities and inventing the new style in Rome, seems to belong to the future; Leonardo, the ageing wizard, making mechanical dragons in the Vatican, is a marginal figure. The focus of building has shifted from mechanics to art.

During the following century, the exemplary careers of great Italian artists like Bramante, Raphael, and Michelangelo helped to promote the idea of the unity of the three arts of design and the concept of the artist-architect. In central Italy, where architects were normally trained as painters or sculptors and often continued to practice in all the arts – where Michelangelo's mastery of sculpture, painting, and architecture was the ultimate model of artistic practice – a scientific view, already irrelevant to the practice of painting and sculpture, was becoming marginal to architecture. The artist and architect Giorgio Vasari, writing at mid-century, described painting, sculpture, and architecture as offshoots of one art of design. Writing about Michelangelo's achievements, he did not even mention mathematics. Perspective, the major link between mathematics and all the arts, had become a practical tool; its theoretical study was the domain of mathematicians, and Vasari was not deeply concerned with it. He certainly did not think of architecture, let alone painting, as a science. The heroes of his narrative did not make clocks. He was careful to avoid the image of a technician tinkering with machinery. Even an architect like Palladio, who began as a mason in the building trades, accommodated himself to this image and made himself an artist. By the later sixteenth century the close relation between building and technology, which was apparent in Alberti's writing or Brunelleschi's practice, was perceived as incompatible with a strictly artistic view.

In practice, however, military architecture was often in the hands of these men. Architects, not mathematicians, invented the bastion, and, throughout the sixteenth century, leading architects, with Michelangelo at the top of the list, continued to design fortifications.[53] The overlap of architecture, engineering, and technology survived longer in building practice than in theoretical writing

probably because it had been deeply ingrained. Michelangelo considered himself an expert on fortifications as a matter of course, although he made it clear that he did not consider it the highest of his accomplishments.[54]

Francesco Paciotto, who was summoned to Spain to work on fortifications in 1561, moved easily between planning a palace for the Farnese in Piacenza, criticizing Juan Bautista's designs for the basilica of the Escorial, and designing the citadel at Antwerp.[55] There were many architects of this stamp in the sixteenth century and they were particularly welcome at the court of Philip II. Francesco de' Marchi's beautiful book of military designs was prepared for the king in the 1550s.[56] These engineer-architects were by no means all military specialists. Giovanni Battista Antonelli and his brother left Italy to work on civil as well as military projects in Spain; Giovanni Sitoni came from Milan to work on canals, dams, and dikes.[57] The documents of Philip's building projects are filled with the names of foreign technicians, some of whom probably considered themselves architects.

On the other hand, engineers were also emerging as specialists. The engineer-architect was the successor of the medieval builder, inheriting his geometrical design techniques, an attachment to mechanics and technology, and practicing a profession which was largely closed to outsiders. Engineers were a highly regarded group. In the late 1570s, for example, the Italian hydraulic specialist Sitoni was earning 80 gold scudi a month working for Philip II and was furious when the king proposed to reduce his salary to 600 ducats a year.[58]

Sitoni is a good example of the divergence between the architect and engineer in the later sixteenth century. Very little is known about his life but nothing in his career suggests an artist. In 1579 he prepared a report on plans for various hydraulic systems in Castile, Aragon, and Catalonia which shows that he had carefully reviewed the legal arrangements with the towns, designated the personnel necessary to operate the facilities, specified their salaries and perquisites, and estimated the profit that would accrue to the king once construction and operation were paid for.[59] Antonelli wrote similar reports that integrated design, technical information and economic considerations. Strictly artistic matters do not figure in these reports. The drawings the engineers prepared for fortifications, dams, sluices, and dikes are ambitious buildings that make few references to the artistic side of architecture.

HERRERA'S VIEWS ON ARCHITECTURE

Herrera showed a much greater propensity to science and technology than to the fine arts, and this affected his views on building.[60] His attitude toward practical skills, for example, was close to the mathematician, Simon Stevin's:

We of the Spanish nation think as no other nation does, so that it seems to us that craftsmen and workers are men outside our species. And as soon as someone knows anything, the person who doesn't understand that subject cannot trust him; they do not realize that a man and a shoemaker is worth more than a man alone, and that the appropriate qualities much adorn a man, not as a man but rather as quality.[61]

Herrera's praise of practical know-how was not mere rhetorical posturing. He had none of the prejudice of his class against useful work; the young hidalgo soldier, who has discovered science and learned to draw, later saw himself poised between the different realms of intellectual and manual work. These two extremes, popularly thought to be incompatible, appeared to him linked, as they did so often to scientists and engineers who were also battling the widespread prejudice against the dignity of useful skills.

Describing the design of a crane, he explained it as an illustration of the science of mechanics:

I say then that from this circle proceeds the capability of scales . . . and that all the machines in the world and so the crane, which Your Majesty ordered to be brought to this town of the Escorial, and all the rest of the machines which can be made or are made in the world are founded on the Roman balance.[62]

Herrera's crane was not his invention. Similar machines were used in Flanders, where he must have seen them, but it is characteristic that he should cast his description of a useful machine in theoretical terms, in order to stress that 'in this manner, the wheel [of the crane] has become a roman balance'.[63] This desire to link theory and practice in the creation of a modern technology animated the program of the academy of mathematics in Madrid.[64]

Mathematicians and engineers did not privilege the classical tradition in the same manner as artists. Their revival of the science of mechanics was inspired by antique texts, but those who developed the machines and instruments that claimed descent from ancient sources were proud of the novelty and superiority of their modern inventions like the bastion, which had been unknown to the ancient world. In the world of technology, a classicizing point of view was not necessarily tied to the forms of ancient culture.

This in turn made it easier to appreciate buildings that were not inspired by antiquity. In areas where medieval design techniques were still flourishing – as in Spain or in France, for example – the new science of mechanics encountered a similar, if not identical, view in traditional building practice.[65] Herrera was not as disdainful of late medieval practice as we might expect of a follower of Vitruvius and Alberti. He was open to un-classical forms, particularly if they appeared to be technologically or mathematically sophisticated.

Herrera shared this with his French contemporary, Philibert de L'Orme, another aggressively modern architect in Alberti's sense of the word, although an utterly different character. Philibert emerged from the world of practice in Lyon, but visited Italy in the 1530s and returned to forge a brilliant career for himself. He was deeply involved in building technology. His Premier Tome de l'architecture (1567), which is both amtitious and original, includes a detailed discussion of stereotomy – the geometrical design techniques for cut-stone vaulting – and his designs for appareled vaults, squinches, and staircases are virtuoso performances (pl. 7). Yet this art had no classical pedigree. It had developed in France and Spain in the fifteenth century in the bosom of Flamboyant style. Philibert proudly put forward an analysis of one of the 'secrets of architecture that should be known and taught' to masons. One day, as he said, he hoped to reconcile the theory of Euclid 'with the practice of

7 Philibert de l'Orme, design for a cut-stone vault, *Premier Tome de l'Architecture*, 1567

our [French] architecture, together with Vitruvius.'[66] Stereotomy was well rooted in Spanish practice, too, and in the later sixteenth century architects like Alonso de Vandelvira turned to writing treatises on the subject (pl. 8). The fact that Herrera integrated this non-classical feature into his architecture suggests that he shared Philibert's appreciation (pl. 9, 10). Stereotomy transcended the distinction between medieval and classical architecture by showing how geometry and extraordinary workmanship could make a building beautiful without reference to the antique.

Herrera's architecture was more closely tied to mathematics than most Renaissance architects. Even Philibert felt obliged to defend stereotomy; he never published the treatise that would have reconciled it with classical architecture and we feel an unresolved tension. Herrera seems to have had no such scruples. Mathematics legitimized classicism and stereotomy alike; beauty was a matter of mathematical relations. Daniele Barbaro had insisted that 'geometry was the mother of design' but this was not really true of Renaissance artistic practice. In spite of Palladio's extensive use of harmonic proportions, his architecture is not defined by them. His classicism is too rich in its references to antique culture and in pictorial and sculptural values to be contained by mathematics; and the same can be said of Philibert. Herrera's architecture, however, was mathematicized in ways that the designs of Palladio and Philibert were not. Mathematical relationships contribute to the visual, as well as underlying and doctrinal, order of his buildings. This is, finally, the justification for this long discussion of Herrera's scientific activities and views. He was probably not an original scientific thinker and none of his inventions has stood the test of time, but his 'scientific' ideas had a profound impact on his approach to design and governed his peculiar brand of classicism.

This does not sound like a Renaissance painter's view of architecture and, indeed, it was not. By Herrera's time, painting and sculpture were far from this realm of mathematical technology and symbolism. Should we have any doubt as to just how different Herrera's outlook was from the established artistic view of building, however, there is evidence in an extraordinary contemporary document which addresses precisely this issue.

8 Alonso Vandelvira, design for a cut-stone vault, *Tratado*, c. 1599. (Madrid, Biblioteca Nacional)

ART VERSUS SCIENCE — EL GRECO'S VIEWS ON ARCHITECTURE:

In 1578, the painter El Greco came to Spain from Italy, bristling with theoretical ideas, one of which was to see the art of painting as sufficient training for architecture. In his notes in his copy of Barbaro's annotated edition of Vitruvius, El Greco flatly states that what is really important in architecture is art and the artist's perceptions.[67] He angrily asserts that mathematics and especially machines and technology (although he did not use this word) have nothing to do with the subject. Following in Vasari's footsteps, El Greco argued that architecture was based upon *disegno*, considered

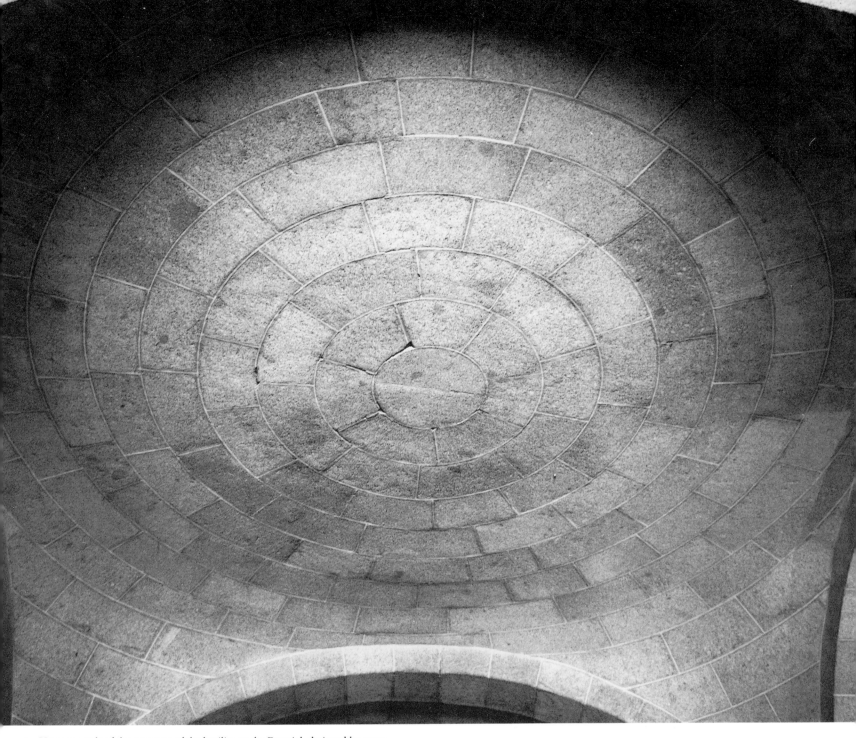

9 Herrera, vault of the sotocoro of the basilica at the Escorial, designed by 1575

as the fundamental freedom of the artist to invent new forms, and he perceived its tie to mathematics as a threatening constriction of this freedom. He saw architecture as a kind of painting, an art whose mastery lay in perception and in imagination, not in rules and formulas and, legitimately or not, he cited Michelangelo's authority for his ideas. El Greco's views were radical and extreme – few contemporary architects would have agreed that building had *nothing* to do with mathematics – but they were a logical extension of a prevailing view among central Italian artists.

El Greco was angry not only with Vitruvius and his commentator; he fumed against practice in Spain. Considering that El Greco wrote these notes in the 1590s in Toledo at a time when

Herrera's influence was at its height, his impassioned attack on 'charlatans' who claimed that architecture was based on mathematics strongly suggests he was thinking specifically of Herrera, who was the most visible target around. He might even have feared that the mathematical view of building might reach out to the criticism of painting with disastrous results for his own practice, for it is hard to imagine any painting less compatible with a scientific view than El Greco's intensely subjective manipulation of space and color.[68]

It is easy to sympathize with El Greco's opinions, especially since they were expressed with engaging directness and passion: 'Draw, draw, and draw more,' he wrote, and 'it is the same with archi-

10 Herrera, entryway of the merchants' exchange in Seville, designed c. 1582

El Greco did not make much of a dent in Spanish attitudes toward the architect. Herrera gave shape and authority to a scientific view of building which lasted for two generations in his successors and followers. Both Francisco de Mora and Juan Gómez de Mora were engineers as much as architects and kept the intellectual status of architecture pegged to mathematics. At the end of the sixteenth century, the Jesuit Juan Bautista Villalpando, who was Herrera's pupil, buttressed his reconstruction of the Temple of Solomon by extensive commentary on Vitruvius, mathematics and mechanics.[69] His attitude survived in architectural writing into the late seventeenth century when Caramuel's *Arquitectura Recta y Obliqua*, a remarkable synthesis of novel ideas, geometrical design problems, and piety, claimed descent from Villalpando and the Escorial.[70]

The memory of Herrera and of what he had stood for lingered in Spain but his technological model was forced to yield. Gómez de Mora lost his place to Giovanni Battista Crescenzi, a cultivated artist turned architect, who was followed by the painter Velázquez in the role, if not the title, of artist-architect at court. Velázquez, without any previous experience as an architect, turned as effortlessly as El Greco to the design of interiors and decoration – not perhaps without a backward glance at the old science of mechanics, as we can see from his collection of scientific and mathematical books – but without any real conviction. It was not science but *disegno* that legitimized Velázquez and it was his status as an artist that made it possible for him to be an architect. Thus challenged by the greatest painter of the age, and lacking a figure of Herrera's stature to defend the scientific view, Herrera's idea of architecture returned to the world of practice whence it had come. In the 1660s, Juan de Torija made himself a spokesman for it when he wrote on vaults and building regulations for the city of Madrid, but by then he was writing for practitioners like himself.[71]

Spain, along with England, was one of the last countries in western Europe to adopt the Renaissance paradigm and bring architecture entirely into the realm of the fine arts. It was a powerful view that still lies behind our idea of architecture, but it is neither as straightforward, nor its victory as complete, as it often seems. The division between architecture and engineering remains largely theoretical and architects, in giving engineering over to the engineers, who must collaborate with them, have truncated Alberti's vision of the discipline and deliberately estranged themselves from its principles. Nor have engineers universally accepted the artistic view of engineering as a purely utilitarian, scientifically determined, branch of building. The Eiffel tower and the Pont de Garabit are evidence to the contrary, and Pier Luigi Nervi's demand to be considered as an engineer – when his buildings powerfully assert the presence of the designer and the aims of monumental, socially conscious architecture – stands as a polemical challenge to the aestheticism of architects as well as to the conventions of engineers.

tecture.' But a strictly artistic conception of architecture, as El Greco discovered, was not to be taken for granted outside Italy. In Spain, where painters were still popularly considered to be craftsmen and where Herrera's view of building reigned supreme, the idea of the artist-architect was no more than a curiosity.

3
Measure and design

HERRERA was an architect not an engineer but his passion for mathematics comes out in his buildings with such clarity that it has always been perceived as an essential component of his style. The relations between mathematics and other aspects of classicism in his work, however, have been subject to different interpretations that depend finally on what the author believes constitutes classicism in architecture.

HERRERA, CLASSICISM, AND THE *ESTILO DESORNAMENTADO*

José de Sigüenza, whose contemporary history of the Escorial has been the foundation of modern interpretations, based his assessment of its style on paired notions of modernity and perfection (pl. 11).[1] The Escorial not only rivalled the ancients; it surpassed them. Looking at the Escorial, Sigüenza said, made one forget the famous buildings of the past bacause:

here one finds almost all the splendors that have been celebrated through the discourse of centuries, only taking away all that is superfluous and that which in them served to promote ambition and display.

The architecture of the Escorial achieved perfection; it was true classicism. Sigüenza could say, 'as Galen says in his book on the uses of the human body that . . . there is much of divine wisdom in such celestial harmony and correspondence.'[2]

According to Sigüenza, Herrera's role in this nearly divine achievement was relatively straightforward: Herrera continued the path laid out by Juan Bautista:

Juan Bautista de Toledo, a Spanish master, as a man of excellent judgement in architecture, worthy to be equalled with Bramante and with any other great [architect], made a small model out of wood for the entire plan and elevation . . . his disciple, Juan de Herrera, altered this in many parts, as we shall see in another discourse, although without damaging it and, even perfecting the work according to the opinion of many.[3]

Such was the prevailing view in the sixteenth century, expressed succinctly also by Juan de Arfe early on: 'In the building of the royal temple of St Lawrence which is now being built near the town of the Escorial by order of our lord, the powerful and Catholic king Philip II, the art of architecture has been brought to perfection.' The architect of this plan was 'Juan Bautista, native of Toledo, who was the first master of that famous design.' He was succeeded by 'Juan de Herrera . . . in whom there was a prompt and original genius to continue and raise this whole building.'[4]

Sigüenza's work is a sustained eulogy of Philip II: the king's piety, wisdom, order, and authority dominate the narrative and are embodied in the architecture. The divine plan that guides the king is mirrored in the proportions, rules, and sobriety of his building. Sigüenza's equation of classicism with royal authority passed into later interpretations of the style. The prologue to the *Noticias de los Arquitectos y Arquitectura de España desde su Restauración*, written by Eugenio Llaguno y Amirola in 1798 and completed by Juan Agustín Ceán Bermúdez, was unambiguous: good architecture needed the backing of the state; classicism and authority were interdependent. As the author explained, principles were abandoned in the middle of the seventeenth century when the arts and sciences declined and the excesses of the Baroque reigned until the beginning of the tenth epoch (the writer's own), when at last the situation changed:

A strong arm and a wise master were required to banish the former plague from Spain. . . . By good luck Divine Providence destined the dynasty of the Bourbons and the best professors then in Italy and France for this great undertaking.[5]

Under Bourbon patronage, classicism was reinstated and a royal academy of fine arts established. 'Philip V, of whom an eloquent orator has said that "when he passed the Pyrenees, his desire to restore the arts and sciences in Spain blazed forth," conceived a great project to build a magnificent palace in Madrid . . . and with equal zeal and generosity our dear sovereign Sr D. Fernando VII follows in protecting architecture and . . . men who "uphold the rules, the character, the simplicity and taste that Spanish architecture had in the reign of Philip II."'[6] The old tie between Philip's political power and the power of a pure and authoritative classicism was brought back to buttress a new regime. Herrera, cast as the agent of this power, became the totem of the newly founded Royal Academy.

By the end of the eighteenth century, the classicism of the Escorial had acquired the status of a national style with deep roots in the self-image of Spain, but the style of the Escorial was not considered fundamentally distinct from classicism elsewhere. In the passage quoted above, the restorers of Spanish architecture in the eighteenth century were French and Italian architects hired by the Bourbons, although their successors were Spaniards, namely Juan de Villanueva and Ventura Rodriguez.

The *Noticias* expanded what had been for Sigüenza a unique achievement of perfect classicism at the Escorial into a comprehensive reform of Spanish architecture. This book – the first of its

Measure and design

kind in Spain – attempted to demonstrate, through the publication of documents that the classicism of the Escorial was the culmination of an earlier Spanish tradition and determined the later course of Spanish architecture. The painstaking archival labor had been undertaken in order that architects could 'prosper in the future and recover the reputation and renown they possessed in the reign of Philip II.'[7]

The same style was detected in other buildings and Herrera's role enlarged. The prologue to the *Noticias* defined the sixteenth century as a period of striving culminating in Herrera's achievement:

in spite of the great progress that was made then in Spain, Greco-Roman architecture did not arrive at its perfection until 1563, the year in which the great Juan Bautista de Toledo designed the sumptuous monastery of S. Lorenzo del Escorial, and, to put it more correctly, not until his disciple Juan de Herrera had augmented and completed it. Then Spanish architecture reached the peak of its perfection and splendor, as the result of the order that the wise king Philip II sent out that no public building in the kingdom should be constructed without Herrera having examined and approved the plans beforehand in the royal presence at a meeting or conference concerning public buildings that Herrera himself held twice a week with the king.

Herrera was directly responsible for the propagation of classicism throughout Spain:

Such a wise measure could not but have good effects; and within a short time the pure and excellent taste for ancient Roman architecture extended itself through all the provinces.[8]

The notion of an ideal classicism, spread by Herrera, became well entrenched, but its appreciation was aggressively attacked by Carl Justi in his famous article on Philip II as a patron of the arts. Justi, who in 1879 christened the *estilo desornamentado*, or 'stripped style,' focussed on the Escorial. Here, according to Justi, was an architecture of 'pedants who could hear only the stiff Latin of their Vitruvius and Vignola,' a building 'executed in a style which its contemporaries termed noble simplicity and its admirers majesty, while the taste of today finds it only repulsive dryness.'[9] The *estilo desornamentado* was nothing but the bare bones of a doctrine, an architecture stripped of personal expression and imagination.

Justi put the blame squarely on Philip for 'the way in which the royal builder prescribed the most minute detail; his restless and omnipresent superintendence; his often niggling criticism; his sober habit of docking the designs submitted to him of all that seemed

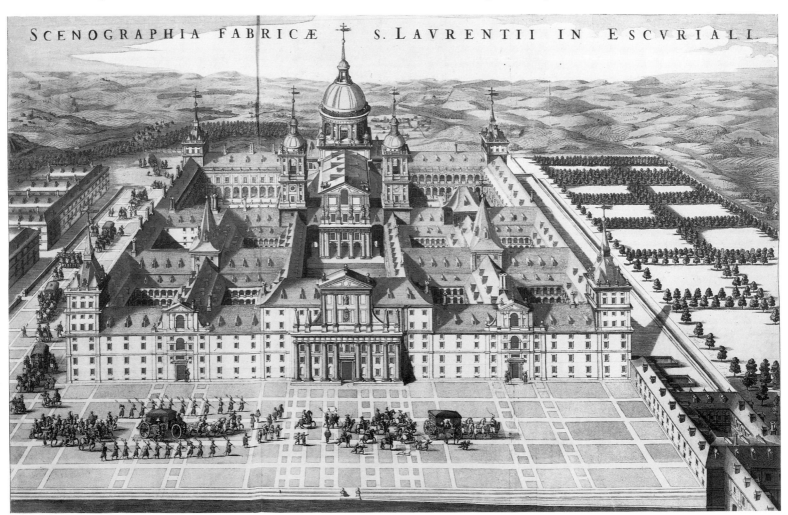

11 Joan Blaeu, perspective view of the Escorial, based on Herrera's perspective in the *Estampas*, published in *Atlas Maior sive Cosmographiae Blaviana*, 1662

over-rich or too ostentatious – these and other similar causes could not but paralyze the joy of creative energy...Without freedom neither beauty nor truth is possible.'[10] Herrera's style was the product of repression and a reflection of the personality of Philip: a negative classicism, a classicism of absence.[11]

For those who dislike the Escorial and are unsympathetic to Philip II, the analogy between Philip's personality and the *estilo desornamentado* seems to explain a great deal. What should we expect of a reactionary, authoritarian monarch if not a rigid, pedantic style? Who but Philip, who avoided ostentation in all things, would have commissioned such denuded architecture? Justi's idea that rigid classicism reflected a lack of personal freedom was a judgment of Philip's politics transposed to architecture, the transmutation of Schiller's *Don Carlos* to the style of the Escorial.

Before we dismiss Justi's overtly ideological interpretation, however, we do well to ask if a non-political or at least non-ideological interpretation of the Escorial is even possible. Ideology has been the persistent feature of discussions of the Escorial. More interesting is that Justi put discussions of Escorial and of Spanish classicism on a new footing, but not simply by condemning the building. What radically altered the course of future interpretations was his idea that the Escorial lacked *personal* style.

The classicism that Sigüenza and Juan de Arfe perceived in the Escorial was whole and seamless, transcending the personal style of its architects. There could be no significant difference between Herrera and his master in such a context. Castigating the Escorial for authoritarian, rule-bound, derivative, unimaginative classicism, Justi seized on the rules that Sigüenza had eloquently called up in its praise. In Justi's view, the Escorial was no one's style, a non-style, an antistyle. Its fault was that no artist had been allowed to think, to feel, to express, and so to bring the architecture to life. The purity and perfection of the Escorial was a hideous flaw. It was only a matter of time before this judgment settled on Juan de Herrera. No one could remain forever mesmerized by Justi's sleight of hand in blaming the king; some architect had to be responsible and the choice naturally fell upon Herrera, who was already identified with the style. The *estilo desornamentado*, for good or for ill, became synonymous with Herrera.

Justi created an interpretative structure that has dominated discussion of Herrera ever since, because it dovetailed with earlier components. The classicism of the Escorial, as Sigüenza understood it, did not represent individual style, even when it was, as he argued, the intellectual achievement of its several architects. When the *estilo desornamentado* was adopted to describe Herrera's architecture, it brought this definition of classicism and its train of ideological associations to bear on the problem of individual artistic expression.

This created a tension between classicism and individuality. In terms adapted from Sigüenza, classicism came to be defined as a set of rules derived from Vitruvius and codified in the sixteenth century by Italians like Serlio and Vignola. Herrera mastered this doctrine and so became a classicist, which is to say a follower of Vitruvius and Vignola, but the more pure and correct Herrera's architecture seemed to be, the less room there could be for individual expression. If this may have been a virtue according to Sigüenza, writers since Romanticism find it difficult to reconcile this notion with the originality expected of a great architect. Herrera's style was, and still is, considered pure but impersonal, even by its admirers. More problematic still, the *estilo desornamentado* seems to announce the arrival of a mature and accomplished classicism, which, on closer inspection, turns out to be nothing more than the ideas of Serlio or Vignola transposed to Spain.

In all these arguments the facts are loaded and every position is ideological, as it has always been and will be. Modern writers have not achieved detachment from an interpretative structure which is by now so well entrenched as to seem intrinsic to its subject, but the old arguments can always be invested with new significance. Justi's eloquent denunciation bit deep into the notion of a 'national' style. Preserving the ideology and maintaining the integrity of a national style was the aim of Amancio Portables Pichel who, in 1945 and 1952, published two books of documents arranged in a polemical argument.

Portables tried to save the style by getting rid of Herrera. He set out to prove that the *estilo desornamentado* was falsely called Herreran when it was really a collective accomplishment, the product of all the supervising architects, stonemasons, and workmen who built the Escorial. This thesis allowed him to reinstate the originality and authenticity of Spanish classicism defined as the product of Spanish practitioners and, at the same time, to jettison the negative associations that the style had acquired since Justi. These he dumped on Herrera: the style of the Escorial was not foreign, derivative, or authoritarian, but Herrera was.

For Portables, curiously enough, Philip was not authoritarian. Neatly reversing Justi, he asserted that 'those who today talk of democracy ought to recognize that Philip was a great democrat at the Escorial.'[12] He invented workman's compensation long before it was a state law. Quoting Vicente Lámperez, he asserted that 'Philip was a victim of Herrera, who was to blame for the rigidity and repression that are associated with the reign, at least as far as architecture was concerned.'[13] Although Portables insisted repeatedly that Herrera was not an architect, he needed him for the role that Justi had sketched out for Philip:

Herrera, as a draftsman, never separated himself from the norms that channeled him in the office of Juan Bautista de Toledo who followed Bramante, Vitruvius, Michelangelo, etc.; but as Herrera lacked not only the talent but the science and experience of his master, he did not create anything. And although he did not design the many things which are attributed to him, it is natural that in his last years, when the monastery [of the El Escorial] was finished, he should have come to be the king's drafsman and thus to influence all the masters of the period, who in a certain way depended upon him, and repressed themselves; they imprisoned line in an Italianism that only began to move freely after his death, appearing then in the Baroque, that is: Spanish architecture.

Herrera 'imprisoned the thought of the Spanish artists of those times in molds, rigidly suppressing all flight of the imagination.'[14]

Portables' demonic image of the non-architect who stifled architecture still haunts modern scholarship, if only as a ghost who must be ritually laid each time Herrera's role as Philip's architect is discussed. But Portables's target was not really Herrera. He saved the old ideology for another purpose: to strike at the elitist academy

of 'intellectual' architects through attacking its symbol, Herrera, and to restore dignity and authority to professional Spanish builders by setting their ancestors up as the inventors of national architecture. Using the methods and format of the *Noticias*, he assembled documents with which he tried to overturn the central premise of the earlier book.

Few writers on Herrera have had a political agenda so explicit, but no one is able completely to avoid the ideological associations of the style. George Kubler attempted to bridge the gap between Herrera and the *estilo desornamentado* by assigning individuality to the former and collective invention to the latter: 'Plain Style' originated in Portugal where it was practiced by a number of architects in the reign of John III and migrated to Spain where Philip II adopted it for his own.[15] This has the advantage of placing Herrera's personal manner in an identifiable tradition. Others have tried to neutralize the issue by falling back on Justi's idea of Vitruvian or Vignolan style, trying to see it in more positive terms, but the premise itself – that Herrera's architecture imitates Vignola's – makes this problematic since ostensibly a copy is not original.

The concept of a purified classicism obviously has its own history, which has been shaping the understanding of Herrera since the sixteenth century. Without it, he would probably have been forgotten. Documents, as years of fruitful archival research have shown, will not resurrect a 'real' Herrera whom we could simply put in the place of the Herrera that has developed over time. Contemporary documents do not speak for themselves; they are of necessity interpreted, but they carry a powerful charge of authenticity which can unconsciously mask interpretation as historical fact. Every author from Sigüenza onward has offered documents in support of an interpretation which purports to be true. And each one has described the ideological tradition in which interpretation takes place only to contrast his own posture of detachment – the truth of his arguments – from the bias perceived in others.

The ideological view of classicism as pure and perfect order, inherited from Sigüenza, was not framed to accommodate personal expression, and, if we wish to examine Herrera's style as an individual accomplishment, we are better off without the notion of an ideal style. We should be aware, however, that this can in no way represent Herrera's own views of his art. Every thing we know about him suggests that he believed in fixed standards of good architecture. He would not have liked to be told that he was practicing a variant classicism, or that an ideal of true classicism was dying as he worked. Even less would he have appreciated being placed at the beginnings of a classicism he would not live to see. He was proudest of having brought the Escorial to completion and made no effort to record his role in other buildings. He would have been affronted by Justi's remarks about Philip but he might well have been pleased to know he was considered a follower of Vitruvius and Vignola.

Regardless of what Herrera himself may have thought, however, there is no doubt that his style was idiosyncratic. He was no docile pupil of Vignola's *Regola*, but neither was he a partisan of untrammeled invention. What lends Herrera's personal manner its

larger interest is the fact that he sought to establish a new and purer classicism and, in the process, seriously undermined accepted notions of classical style.

HERRERA'S TRANSFORMATION OF THE CLASSICAL ORDERS

Nowhere is Herrera's personal style so visible as in his treatment of ornament, traditionally the most artistic side of building. John Summerson has aptly remarked that 'we must accept the fact that classical architecture is only recognizable when it contains some allusion, however slight, however vestigal, to the antique "orders"'[16] Herrera was a classicist in the sense that he embraced the Renaissance system of the ancient orders, but he reduced these to their simplest form and, in a few buildings, almost dispensed with them entirely.

We tend to assume that the classical orders were a fixed system of forms with rules for their use (Renaissance architects seem always to be claiming this) although we know that the orders were an unstable system that was constantly changing. Herrera was no exception. His style was a radical departure from earlier Spanish practice which, in a first wave of enthusiasm in the 1520s and 1530s, adapted columns, pilasters, and balusters as substitutes for Flamboyant ornament in Late Gothic compositions of great freedom and ingenuity (pl. 12). Rodrigo Gil de Hontañón employed

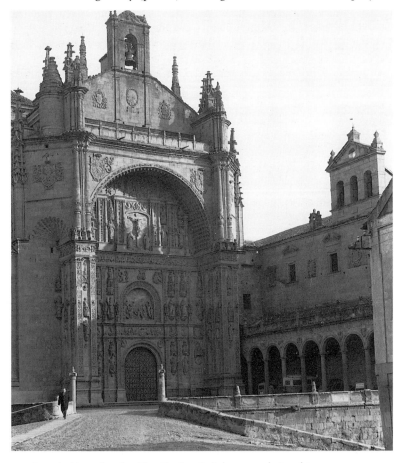

12 Juan de Alava, façade of San Esteban in Salamanca, designed in 1524

Cathedral of Granada were sensitive to the full syntax of classical usage but insisted on the tectonic integrity of the orders as structural supports (pl. 16).

The view of the orders as a system of architectural expression developed in Italy in response to the desire to integrate ornament with the overall design of a building. Proportions of four orders of columns – Tuscan, Doric, Ionic, and Corinthian – could be extracted from Vitruvius. Alberti gave authority to the Vitruvian orders by describing Tuscan, Doric, Ionic, and Corinthian styles as variants of a columnar system and by discussing the proportions of the various elements in terms of the diameter of the base of the column as Vitruvius had done, but the orders were not codified as 'orders' until the sixteenth century.[17] Before 1550, many different versions of the orders coexisted. Serlio, who added the Composite order that Alberti had merely mentioned in passing to the Vitruvian canon, was the first to popularize a system of five related orders of columns in his *Regole generali di architectura* published in 1537 (pl. 17). He arranged them according to the proportion of the diameter of the column of its height, from the thickest Tuscan (6 diameters) to the slender Composite (10 diameters).[18]

Serlio's five orders were accepted, but his proportions were not. In 1544 the French Humanist Guillaume Philandrier, who had been

13 Rodrigo Gil de Hontañón, corner tower of the Palacio Monterey in Salamanca designed in 1539

pilasters to frame vertically aligned windows creating the *travées* that were also typical of French architecture in the 1520s (pl. 13). Alonso de Covarrubias and Diego de Siloe used the orders in isolated compositions set against a plain wall (pl. 14). But the orders were seldom used to articulate the divisions of a plan or to organize exteriors in Spain, where a rigorous consistency between plan and elevation was a rarity. Of all Spanish architects only Diego de Siloe, who was an accomplished sculptor, developed orders that were both respectful of the antique and original. His baluster columns in the courtyard of the Colegio Fonseca in Salamanca are set against piers (pl. 15). His Portal of Pardon and interior of the

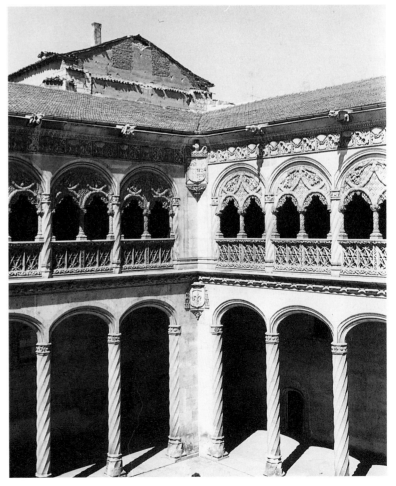

14 Juan Guas, courtyard of the College of San Gregorio in Valladolid, 1487–96

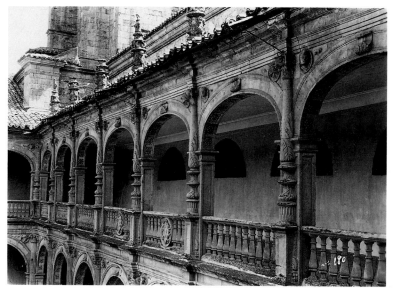

15 Diego de Siloe, courtyard of the Fonseca College in Salamanca, designed in 1529

briefly Serlio's pupil in Venice, modified Serlio's canon by making each order successively more slender by adding one diameter to its height. As a result, his orders range from 7 diameters for Tuscan to 11.5 for Composite.[19]

Vignola, who must have encountered Philandrier at the Vitruvian Academy in Rome, provided another set of proportions in his *Regola* published in 1562. Vignola's orders are like Philandrier's in being slenderer than Serlio's, except for Composite which is identical, but Vignola made the proportions of the different orders closer to each other. Only 3 diameters (instead of 4 in Serlio or 4.5 in Philandrier) separate Tuscan from Composite and the proportions between pedestal, column, and entablature are the same for all the orders.[20]

The ongoing quest for a coherent system of rules went hand in hand with recognition of the need for flexibility in their application.

17 Sebastiano Serlio, the five orders of columns, from Francisco Villalpando's Spanish translation, 1552

16 Diego de Siloe, Portal of Pardon, cathedral of Granada, 1531

18 Vignola, the Doric order, from Pedro Caxesi's *Regla de las cinco ordenes de architectvra de Iacome de Vignola*, 1593

19 Pedro Perret after a drawing by Herrera or his assistants, retable of the main altar of the basilica at the Escorial, Eighth Design of Herrera's *Estampas*, published in 1589

Architects needed classical orders that they could use. Serlio, who stressed the separate indentity of each order was not entirely satisfactory in this respect. The sculptural independence of his columns made it difficult to apply the orders to walls. A canon of similar proportions like Vignola's made it easier to combine them in mural compositions.[21] Vignola also introduced a system of modular notation that assigned a certain number of modules (a module being equal to $\frac{1}{2}$ the diameter of the column at its base) to the total height of each order and to each of its parts. An architect could design his orders by dividing the height he needed by the number of modules. In these ways, Vignola made the orders subject to the overall design (pl. 18).[22]

In Rome in the later 1540s Juan Bautista de Toledo was heir to the eccentric inventions of Michelangelo and to a body of thinking about the orders that descended unbroken from Bramante, Raphael, and Peruzzi to Antonio da Sangallo the Younger and Vignola. Herrera seems particularly close to this Roman development.[23] The orders of the main retable of the Escorial reflect Juan Bautista's thinking even if the designs were revised by Herrera, to whom the

33

20 Herrera, undated cross section through the basilica of the Escorial. (Madrid, Biblioteca del Palacio Real)

21 Herrera, Doric pilasters in the basilica of the Escorial, completed by 1584

22 Anonymous, drawing for a portal, late sixteenth century. (New York City, The Cooper Hewitt Museum, The Smithsonian Institution's National Museum of Design)

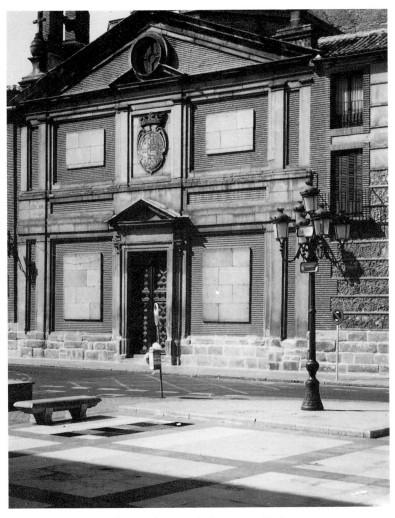

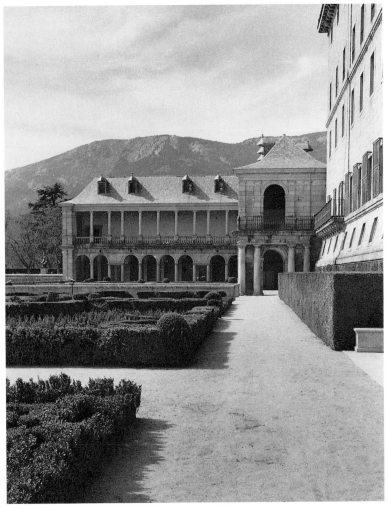

23 Façade of the Descalzas Reales in Madrid, completed before 1567

24 Detail of the Sun Corridors at the Escorial, lower story by Juan Bautista de Toledo before 1567, upper parts by Herrera after 1571

design is usually attributed (pl. 19).[24] It is a composition of five superposed orders; the proportions of the columns are Vitruvian, except for the Composite order at the top, which seems too squat.[25]

It was not always easy to reconcile the proportions of the orders with the rest of the design, however, and Francesco Paciotto found nearly everything in Juan Bautista's designs for the basilica of the Escorial 'lacking the reason and measure of noble, good, and beautiful architecture.'[26] He criticized the 2:3 ratio between the width of the secondary arches and their height (30 and 45 feet respectively) because the architect had failed to take the thickness of the arch (1 foot) into account, which resulted in a 'most imperfect ratio, and truly of mean and bad effect (30′ by 43′ [sic]).'

A good deal of flexibility in the proportions of the orders was necessary if an interdependence between the overall design of the building and its decoration was to be maintained. Juan Bautista's plans, which are lost, must have shown pilasters that would reach his vaults, and he was prepared to skimp $\frac{1}{2}$ a foot on the width of the pilasters of the secondary arches in order to achieve this. For his part Paciotto was willing to stretch the main Doric pilasters to nine

diameters, 'the greatest height that which can be assigned in this position,' and to add extra height where he thought optical correction necessary. Both Juan Bautista and Paciotto represented current Italian ideas that linked ornament to the plan and elevation of the building in the most exacting ways. Any changes to the overall design were inevitably reflected in the proportions of the orders and vice versa.

Herrera was not yet working for Juan Bautista in 1562, but he cannot have escaped the consequences of Paciotto's critique of the basilica, which initiated a process of revision of its design that occupied him for the next twelve years and we may take it for granted that he was well schooled in the issues involved. His columns are often close to the proportions recommended by Philandrier or Vignola, but the Doric pilasters in the basilica are 65 feet high with diameters of 6.5 feet (as tall as allowed for Corinthian or Composite), a height that was dictated by the overall proportion of 1:2 in the design (pl. 20).[27]

Herrera began from the Italian idea of using the orders to express the design of the building, which was why he was always more

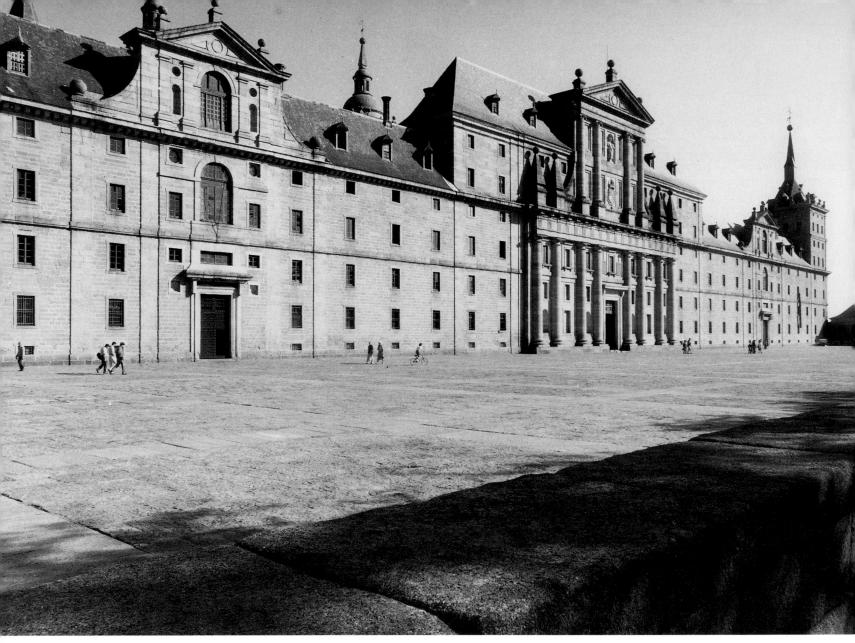

25 Herrera, the main façade of the Escorial

interested in pilasters than in free-standing columns (pl. 21), but compared to his Italian contemporaries or even to his master, he vastly increased the visual explicitness of geometric form and mathematical proportion in the orders by emphasizing the joints in modular stone work and by combining columns and pilasters with purely abstract decoration. His radical simplification of elements makes this geometry all the more visible. The resemblance between square panels, strips of molding, and plain pilaster capitals is much stronger than the separate identity of the order. This abstraction is at the root of the 'noble simplicity' that Sigüenza saw as well as of the 'repulsive dryness' that Carl Justi felt in the Escorial, and it separates Herrera from most Renaissance practitioners.

Herrera's use of the orders probably also owes something to Paciotto's simplified decoration, like that of the courtyard of the Farnese palace in Parma, and it is tempting to think that an anonymous drawing for a 'Villa Paciotta', might also be his. The aesthetic effect, such as it is, derives from the geometric pattern of

joints in the stonework (pl. 22). The stark geometry of the façade of the Descalzas Reales in Madrid, a church in whose design Paciotto was involved, is the closest precedent in Spain for Herrera's later manner (pl. 23).[28]

Herrera went farther toward simplification than the Italians, however, and judged by the standards of Italian artistic practice his reduction of ornamentation was extreme. He used the rich vocabulary of the orders very sparingly, preferring Doric for exteriors and using Corinthian only occasionally, as for the interior of the Cathedral of Valladolid or the staircase at the Alcázar in Toledo. Herrera also chose the plainest possible versions of the ornamental elements. He eliminated decorative sculpture and stripped the orders themselves of all unnecessary ornament. As a result, his orders are not merely plain, they are monotonous and repetitious. He seems to have based his orders on canonical examples, and the capitals, moldings, and bases are remarkably uniform throughout his architecture. Once he chose a type that

suited him, he seems to have had no interest in variation. The Doric of the Escorial could serve as well in Toledo or Seville; as well in a courtyard as on a facade.

Herrera preferred the flat pilaster to the column and would sink the column in the wall, merging its structure with its masonry. This preference is apparent in the Sun Corridors at the Escorial, where there is an obvious contrast between the sculptural Doric on the first level, by Juan Bautista de Toledo, and the flattened Ionic by Herrera in the upper story. This order is not merely simplified; it is drained of vitality (pl. 24). As a result Herrera's orders no longer played their customary roles, or did so only in a caricatured fashion. His large compositions rarely acknowledged the sculptural integrity of the orders except in an awkward manner. His temple front on the façade of the Escorial, for example, is a paste-up image of a church façade, thin and unconvincing (pl. 25). Everything that Renaissance architects tried to avoid when using the orders is plainly visible here: the columns carry no weight, define no space, assert no mass. One need only compare this to Michelangelo's vigorous designs for the façade of San Lorenzo in Florence to see Herrera's deficiencies. Herrera's composition has no organic coherence. It is as if the core of the system had been destroyed, leaving only its shell. The devices of Italian Renaissance composition, in this case derived from Serlio, have been severed from their original intention.

This is nowhere more obvious than in the capitals. Herrera's drawing for the Corinthian order of the nave of the Cathedral of Valladolid (pl. 26) is based on the Pantheon in Rome, a favorite in architectural writing and practice, where it was notably used by Bramante and Michelangelo at St Peter's. However, one of Philibert de l'Orme's illustrations (pl. 27) is so close to Herrera's drawing that it seems likely to have been his source.[29] Herrera chose a didactic illustration in Philibert's treatise and simplified Philibert's diagram even further, removing its strong central axis and flattening the first row of acanthus leaves, turning them from a slight diagonal to the frontal plane. The springy vitality that still comes through Philibert's schematic drawing is completely extinguished. Herrera's cool indifference to the naturalism of classical forms, his ruthless pruning of this symbolically charged image of nature and living things may seem surprising or even shocking, but it is consistent with his approach to ornament.

Herrera's rejection of naturalism separates him from contemporary European practice. At the core of the Italian Renaissance system of the orders was an organic metaphor derived from antiquity: the orders embodied living nature. The conception of the column and capital as a kind of body and of the various parts of an order as the organic relation of individual members followed from this idea. The structural metaphor of the column, which appears actively to hold something up, is organic. Its proportions, which are appropriate to living things, are those of the human body. Natural order is manifested in the carved forms of the orders, and in the ease with which they accommodate representational sculpture. This fundamental naturalism underlies whole compositions based upon the orders, which, in Italian architecture, strive to retain the unity of the metaphorical body. More abstractly, there is an underlying

organicity to the differentiation between the orders – the virile Doric, the matronly Ionic, the graceful, virginal Corinthian (as described by Vitruvius) – and to the rich variation in their details, which grow up like so many individuals of a common species.

Herrera deliberately suppressed these qualities as organic metaphors were overpowered by geometry. It is true that geometry was by no means a new feature and mathematical relations had existed beside the notion of organicity since antiquity – the orders were always an expression of 'order.' Proportion and geometry were thought to underlie nature, uniting its different aspects. Italian Renaissance architects, like Alberti, believed that these mathematical proportions could be seen, or at least sensed, like the intervals in music even though they were not directly represented in the elements.[30] By the later Renaissance, mathematics had become more explicit. Giulio Romano had experimented with rigorously abstract ordering and Vignola's modular system made the mathematical component of the orders not only more coherent abstractly, but also much more visible.[31] But Italian Renaissance practice, even Vignola's, limited the orders to what columns and pilasters could reasonably control without loss of identity. As a result, it was problematic to apply the orders on a very large scale: the dangers inherent in multiplying the number of columns over long façades, or superimposing them on very large buildings were evident in Antonio da Sangallo's projects for St Peter's. The colossal order, as Michelangelo used it on the Capitoline, was only a stop-gap solution to the problem. In the famous twin palaces the scale of the orders and the building are identical. Italian architects usually preferred to compose the orders in episodic fashion, concentrating effects (pl. 28).

Herrera rejected the Renaissance idea of organic structure and put abstract composition in its place. His orders, no longer constrained by organic identity and schematized to a degree never envisioned by Vignola, were stretched to perform new functions. Columns and pilasters define horizontal and vertical divisions of the wall, set out intervals, establish proportions. Working together with geometrical panels and strips, they control the elevation and answer the harmonies of the plan. One could say that with Herrera the classical orders came fully into their own as the ordering principle of the building. The side elevation of the Cathedral of Valladolid is a good example (pl. 29). Five panels each 16′ wide are framed by six Doric pilasters, each 6.5′ wide; at the corners are additional pilasters 4.5′ wide and two pilaster strips, each one foot wide, creating two units of 13′ wide which frame a series of pilasters half that width. This series is set against the rhythm of the panels. The height of the pilasters (60′) is a dimension controlled by the horizontal division of the facade into two units of 30′. The result is a composition organized around its orders, but the orders themselves have lost much of their internal coherence. Herrera sacrificed the sculptural qualities of his order, integrating decoration with the wall, flattening pilasters and simplifying them so they are reduced to strips (pl. 30). On the interior, Hererra drew a pair of pilasters on the piers by carving a shallow vertical groove between capital and base. The logic behind such reductive ornament is partly revealed by the geometrical order of the plan.

26 Herrera, drawing for the Corinthian capital for the nave pilasters of the Cathedral of Valladolid, c. 1580. (Valladolid, Cathedral archive)

27 Philibert de L'Orme, Corinthian capital from *Premier Tome de l'Architecture*, 1567

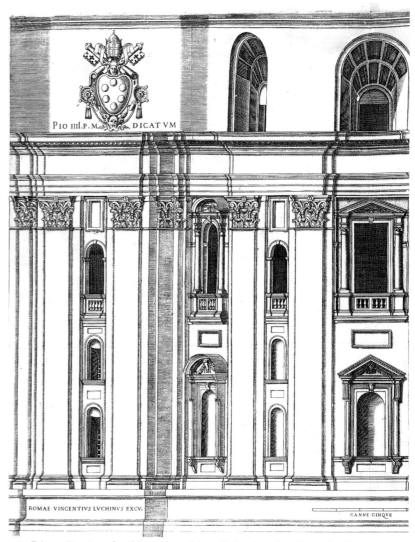

28 Etienne Dupérac, detail from the etching of Michelangelo's design for the apse of St Peter's in Rome, published in 1568. (Santa Monica, California, The J. P. Getty Center for the History of Art and the Humanities)

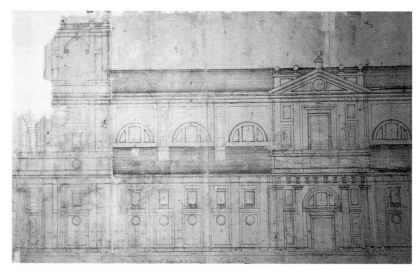

29 Herrera, detail of a drawing for the side elevation of the present Cathedral of Valladolid, c. 1580. (Valladolid, Cathedral archive)

The geometry of the overall plan was frequently Herrera's point of departure for further mathematical relations. The earliest surviving plan of his merchants' exchange indicates that the eastern and western façades were supposed to be 198 Castilian feet (the northern and southern ones were 196') and each façade is eleven bays on a side, which yields a grid of 18' bays (18' × 11 = 198).[32] But this grid is also used to create three squares set inside each other. The outer square encloses an inner square (134' on a side) which defines the halls behind the façades and the interior wall around the courtyard, and the third square (80' on a side) is that of the courtyard (pl. 32).

The exterior elevation articulates the units of this plan. The eleven bays are arranged in a three-part division: the two bays at the corners of each façade are balanced by a group of five bays in the middle. Separating these on each side of the central section is a wider bay formed by grouping of a pilaster and half pilaster in shallow relief so that the façade is composed in visual units of 32, 27, 80, 27, 32'. The central group of bays (80') corresponds to the width of the inner courtyard as well as to the length of the vestibules while the two adjacent bays delimit the inside square of 134'.

For all its symmetry and order, this organization is different from that of most Renaissance buildings. Italian architects, even those who applied mathematics to their designs, respected organic rather

30 Detail of the southern façade of the Cathedral of Valladolid

HERRERA'S ABSTRACTION OF THE PLAN

The Cathedral of Valladolid is a double square (pl. 31). The merchants' exchange in Seville is square with a square courtyard, and the geometry of these plans is reflected in their elevations. The heights of the first, second, and third stories of the Cathedral of Valladolid (60', 21', 41'), as shown in his drawings, for example, echo the widths of the nave to the center of its piers, aisles, and depth of the side chapels (63', 42', 21.5'). Such correspondences were carefully contrived. Hererra drew the side elevation and longitudinal section of Valladolid on the recto and verso of the same sheet so that, holding the drawing to the light, one can see the relations between exterior and interior. These relationships are reflected in ornament, so that the entire building seems derived from a consistent process of ordering.

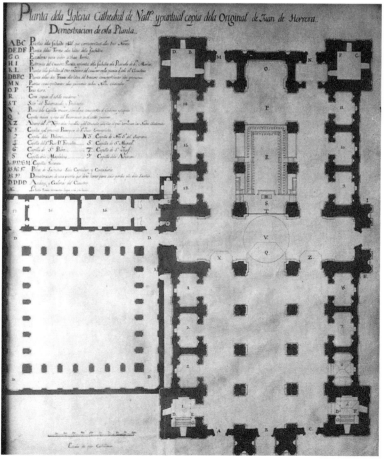

31 Copy of Herrera's plan for the Cathedral of Valladolid, c. 1580. (Valladolid, Cathedral archive)

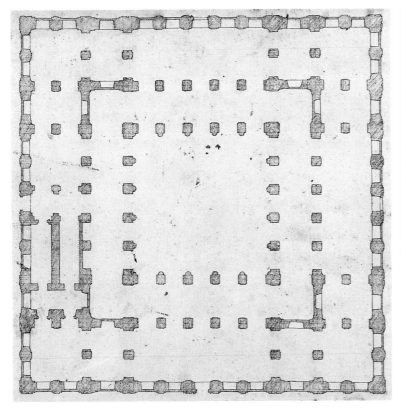

32 Early-seventeenth-century copy after Herrera's plan for the merchants'
exchange in Seville. (Madrid, Biblioteca Nacional)

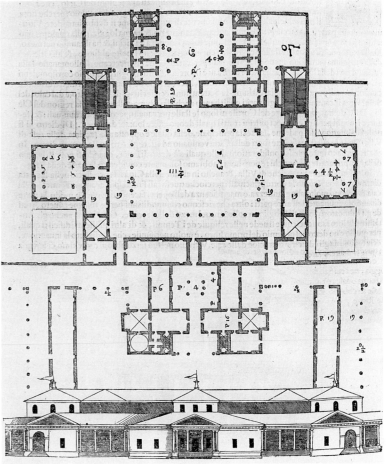

33 Andrea Palladio, plan of a villa reconstructed according to Vitruvius from
Quattro Libri, 1570

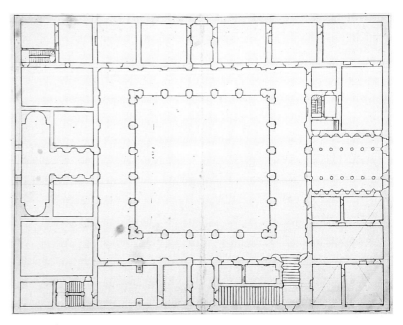

34 Antonio da Sangallo the younger's plan of the Palazzo Farnese, drawn by
Giacomo della Porta from the collection of Giovanni Vincenzo Casale c. 1560.
(Madrid, Biblioteca Nacional)

than abstract order. Palladio's designs, for example, are bilaterally
symmetrical about their frontal axis with single elements placed
along a spine, as in a human body, and these parts are grouped
according to a hierarchy that culminates in the core of building
(pl. 33). Not all Renaissance architects were as concerned with
morphology, nor did they necessarily make the mathematical
relations among the parts exact and explicit. James Ackerman has
explained that even though the notion of a mathematically ordered
hierarchical design was Alberti's ideal in the fifteenth century,
organic composition was fully achieved only in the later sixteenth
century.[33] But it was seldom entirely absent. Compared to Palladio,
the Farnese Palace in Rome is a simple box with a central court-
yard, but its plan is nevertheless symmetrical and its major spaces
are hierarchically organized along the axis from the monumental
vestibule through the courtyard (pl. 34). Its façade is a kind of face,
with windows for 'eyes' and a central portal for a 'mouth.'[34]

Herrera's merchants' exchange has none of these qualities. Its
plan is not built up from major and minor parts; there are no real
parts in Alberti's or Palladio's sense, only divisions, and there is no
hierarchical structure to hold them together. Instead, the building is
contained in a uniform envelope. There is not even a central portal,
and, were it not for the slight variations in the grouping of the
pilasters, which create an intriguing rhythm that contrasts with the
regularly spaced windows, each façade would consist of identical
bays.

This design refers to abstract mathematical relationships rather
than to a metaphorical body. This is a consistent feature of Herrera's

architecture. His Cathedral of Valladolid has no hierarchical structure. Its double-square plan produces a giant, symmetrical box which appears subdivided into nave, aisles, and chapels. The crossing is slightly larger than the bays of the nave and privileged by its central position in the overall geometry, but this is not accentuated in the elevation. The dome is a shallow saucer and its piers are nearly identical to those of the nave. Palladio's notion of constructing a whole from a series of individualized spaces, as in his plan for Il Redentore in Venice, designed a few years before Valladolid, is completely alien to Herrera's geometrically ordered totality.

Herrera's mural architecture belongs entirely to the Renaissance tradition, but unlike most Renaissance buildings, his plans produce spaces that are relatively static in feeling. The chapels of the Cathedral of Valladolid read as separate from the nave. Walls do not appear to shape the space that they enclose, but are both massive and flat.

On the other hand, Herrera's walls become visual fields for a play among geometrical relations that one does not find in Italian building. The façades of the merchants' exchange in Seville appear as rhythmic compositions in two dimensions (in fact they are in very low relief) and their purely visual unity is a primary value, overpowering other considerations. At the Cathedral of Valladolid, the impressive series of pilasters alternating with rectangular panels creates a regular division of the side façades which is underscored by a roundel set on the surface of each panel. It is natural to interpret these pilasters as corresponding to the piers of the nave, and the panels as filling walls between them. But the panels, rather than the pilasters, are aligned with the piers of the nave and alternately with the walls between the chapels and with the niche in the rear wall of each chapel. From an Albertian or Palladian point of view, such articulation is defective, not because the pilasters do not support the wall (in fact they may well reinforce it) but because they do not express a 'natural' coherence among the parts of the building. Herrera saw no compelling need to unify interior and exterior architecture in a physical way.

This is clear from his treatment of an important detail. As mentioned, each panel of the side façade contains a circle surrounded by a wide, flat molding which just touches the top edge of the panel. Apart from the pilasters, these roundels are the principal decoration of the lower story. A closer look at them, however, reveals that some of them are also windows. Blind circles alternate with open ones which light the chapels behind them. Rather than appearing as the closed or open 'eyes' of the building, Herrera's windows are identified with an abstract geometric shape which is integrated into the visual rhythm of the side façade. Any visual association between actual structure (windows) and the architectural order (roundels) is obliterated.[35]

Such details reveal Herrera working with a dematerialized aesthetic. The relationships among plan and elevation are essentially optical, not sculptural; and the plainer these elements are, the more fully they reveal the underlying order. Sculptural ornament, whose naturalism can never be completely dematerialized, might have rendered these correspondances illegible.

THE PROBLEM OF PROPORTIONS

The prominence of geometrical shapes in both plan and elevation necessarily raises the question of whether Herrera generated dimensions according to a system. It is logical to suppose that he did, since systems of proportion, which were at the center of Renaissance discussions of universal order as well as an established topic in architectural culture, were the obvious form for mathematics to assume in relation to building. Furthermore, proportional systems were theoretical issues in all the arts from the fifteenth century. As Cesariano noted in his commentary to Vitruvius in 1521, Pythagorean musical proportions were simply another form of the laws of geometry that applied also to measure and to weight in the science of mechanics.[36] When Herrera described himself, obscurely, as 'the proportional mean between an artificer and a non-artificer,' it would seem to indicate that, whatever this may have meant exactly, his concern, with proportion was significant at least metaphorically.[37]

What proportional systems and mathematics generally may have meant to him as a designer, however, is by no means clear. All agree that he used proportions; but there is no agreement as to what the proportions actually are. Many proportional diagrams can be imposed on Herrera's plans and elevations; all match more or less; none matches exactly.

Herrera unified his designs in various ways, the simplest of which was to repeat the same dimension for different elements. At Valladolid the width of the large panels in the lower story is 12', the same as the height of the windows above them. The distance on center between the pair of pilasters in the second story of the frontispiece, the height of their pedestals, the width of the central window in the frontispiece, and the height of the arch in the tower are all 15'. These equivalencies were reinforced by the decoration. The plain three-foot horizontal band that separates the large panels from the windows between the large pilasters in the lower story is visually linked to the equally plain pilaster in the frontispiece, a technique that Herrera used earlier in the façade of the basilica at the Escorial.[38] The repetition of dimensions occurs in all buildings, but Herrera gave it aesthetic value, simplifying his elements so that these relationships become visually significant. For example, the height of the window with the band below it is precisely one-fourth the height of the pilaster order that encloses them; the bottom of the band also divides the lower story into two identical units.

Some of Herrera's dimensions reveal the harmonic (musical) ratios that Alberti recommended and that Palladio used in his buildings.[39] The width of the opening of the windows between the pilasters on the lower story of the side façade of the Cathedral of Valladolid, the total width of window with its moldings, and its height are in a harmonic proportion of 6 : 8 : 12', but other occurrences are less coherent. Herrera noted the distance between the buttresses as 45' on center, for example, a dimension that occurs three times elsewhere in a true harmonic ratio but not with reference to three contiguous elements. The width of the niche in the frontispiece, the width of the buttresses, and the distance between the buttresses are in a harmonic relation of 5 : 9 : 45'. The nave piers are 13' (a dimension Herrera also often used for the thickness of

the walls) and the relation between the nave pier (13′), the width of the side chapels (20.5′), and the width of the space of the nave (50′) is close enough to argue that Herrera intended to relate them; but unless such ratios occurred accidentally, Herrera created harmonies among widely separated elements.

Not all Herrera's ratios are harmonic. Arithmetic and geometric ratios – the other types of means that Alberti recommended to architects – also occur in his drawings and it is tempting to seek an architectural justification for these too. The geometrical proportion 5:15:45, for example, refers to the width of the niches in the frontispiece of the side façade, the distance on center between the pilasters framing these niches, and the distance between the buttresses on center, a relation that is readily visible.[40]

The most numerous mathematical ratios in Herrera's drawings, however, are those that ought not to appear at all. These are false 'harmonic' ratios calculated by following Alberti's procedure for finding the mean between six and twelve by subtracting six from twelve, dividing the result by three, and adding the product to six, producing 6:8:12. This procedure does not invariably produce a harmonic ratio, although it does in this example.[41] The proportions in Herrera's design for the façade of the basilica of the Escorial are predominantly of this type. We might suppose that such ratios would appear simply as a matter of probability had Herrera been using whole numbers. But many of Herrera's numbers are fractions. All but one of the dimensions in Herrera's drawings for the façade of the basilica of the Escorial and for the church in Valladolid appear at least once, and many appear repeatedly, as one term in such a relation. These ratios are often architecturally coherent: the ratio 6.75:13:21.5′ in the façade of the basilica at the Escorial is a striking example because 13 refers to the span of the arch between a small pier (6.75′) and a larger pier (21.5′), making the 'harmonic' mean the space between them.

There is virtually no end to such correspondences, and one might suppose they are simply the result of finding relationships that are bound to occur in numbers were it not that Herrera's ornament encourages the viewer to seek them out. A panel appears to be framed by a pilaster which turns out to be a frame; a pilaster functions as a vertical band until we discover its simplified capital; a seemingly neutral wall is cut away so we have to reconsider its relation to surrounding motifs. The web of mathematical relationships seems to correspond to a densely woven but shallow geometrical grid locked in the surface of the stone.

Even if we cannot determine precisely what system or systems of proportions Herrera was using, some general conclusions may still be drawn. There are enough examples of harmonic or nearly harmonic ratios in his annotated drawings to argue that he deliberately sought such correspondances. But these ratios do not appear to be organized systematically in extended sequences. Herrera applied harmonic ratios to three-dimensional space – the ratio of the width, height to the top of the thermal window, and length of his chapels at Valladolid (20.5′, 27.25′, 40.5′) is as close to being harmonic as it was possible to make it – but the chapels are not visually related to the space of the aisles or nave (pl. 35). Herrera's architecture expresses order more through subdivisions of a total height or length than through 'spatial' harmonies like Palladio's.

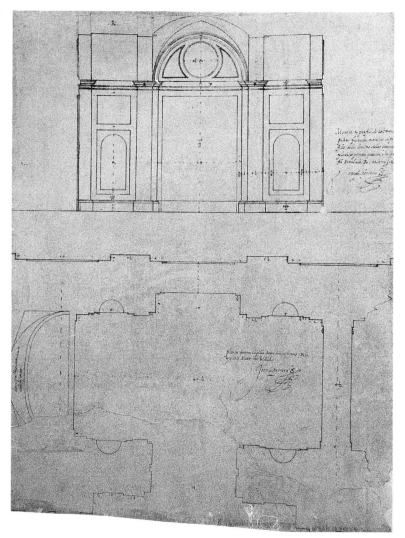

35 Herrera, plan and elevation of a chapel for the Cathedral of Valladolid, c. 1580. (Valladolid, Cathedral archive)

The total height of the chapels at Valladolid is 30.5′, for example, almost exactly half the height of the first story (60′) and roughly half the width of the nave to the center of the nave piers (63′). The divisions of the double square in plan and elevation, as Fernando Chueca Goitia has explained them, conform to the sexquialtera proportions (2:3) which had long been favored for churches in Spain.[42]

HERRERA'S LULLISM AND DIVINE PROPORTION

Herrera believed that, in his own words, 'the whole harmony of the universe consists in the principle of proportion and the principle of comparison, for lacking these, there can be no relations between the creator and his creatures nor [internal relations] in the creatures themselves nor [relations] among different creatures.'[43] The general framework of such thinking, which was widespread if not universal in the Renaissance, was supported by the conviction that mathematical relations underlie the whole of nature and come from God.

As Rudolf Wittkower demonstrated, any serious concern with harmonic proportions, in architecture or music, rests on this assumption.[44] Herrera does not appear to have expressed harmony in a direct, unambiguous fashion, but there are different ways to envisage divine harmony, just as there are different ways to apply mathematics and proportions to architecture, and it is logical to wonder if Herrera's dematerialized and inorganic designs reflect a view of the world that was substantially different from that of humanist architects like Alberti and Palladio.

If we look closely at the personifications in Tartaglia's frontispiece (pl. 5 in chapter 2), we can see Astrology, Alchemy, even Sorcery, standing companionably with Astronomy and Optics. Herrera's ideas belonged in this framework – not to the new mechanics of the seventeenth century but to an intellectual edifice that was built on Neoplatonism and included sixteenth-century hermetic philosophy as well as the science of mechanics.[45]

This view of the world touched all European culture of the later Renaissance, but it was not perforce a Christian view. Tartaglia's goal is an enthroned personification of Philosophy, not Religion, and many thinkers in this tradition – like Paracelsus, Agrippa, and Bruno – incorporated so much non-Christian thinking that they appeared to be heretics. Some practices, especially those of alchemy, were treated with skepticism and criticized as simply fraudulent but, in the eyes of some, secret or highly technical investigations of whatever kind were suspect because they were effective. It was well known that the Devil often granted his followers secret powers, especially powers over nature, in exchange for servitude.[46] For those who were serious about their science and their religion, as Herrera was, complete congruence between science and doctrine was safer.

Herrera found his own synthesis of science and religion in a special branch of the Neo-Platonic tradition: the philosophy of Raymond Lull, a late-thirteenth-century Catalan philosopher, who was something of a troubadour and scholastic combined, and wrote on every conceivable subject, from geometry to love and medicine.[47] Lull's thinking on the arts and sciences dovetailed with the views of Renaissance scientists; his scholastic classification of knowledge was much like theirs and derived from some of the same sources.[48] His Art, a system of analogies for decoding the universe, explained the nature of everything in heaven and on earth and defined its role in a divine order which was most fully revealed in the doctrine of the Trinity.

Herrera acquired every work of Lull's that he could get his hands on. He must have been a believer by 1579, when he made a will leaving his money to found a Lullist school in his home town.[49] He had Lullist friends: the writer Pedro de Guevara and the librarian Pedro Dimas. At some unknown date, at the latter's request, he even wrote a short primer of Lull's philosophy which has since gone under the title, *Tratado de la figura cúbica*.[50] Herrera's treatise is the only direct evidence of his personal views on Lull. In it, he set out to explain the Art in terms of Euclid by representing it in grid form on the six faces of a cube.

Lull's theories provided the intellectual support for some strange beliefs in the sixteenth century: for judicial astrology, alchemy, and mystical attempts to make contact with angels. His orthodoxy was sometimes questioned, although not in Spain. Herrera's treatise is silent on such issues. Taken by itself, it is 'no-nonsense' Lullism, an attempt to present Lull's ideas in terms which make the doctrine appear both true and rational. To judge only from the treatise, it is likely that Herrera thought of the Art as a kind of natural philosophy, a system of analogies for interpreting nature. And, while it is not possible to guess where his Lullism may have led him – how far towards astrology and alchemy, how deeply into hermetic philosophy – it seems certain that is sustained his scientific endeavors by providing a system in which these were legitimate aspects of Catholic doctrine.[51] There was nothing necessarily occult in such a view of Lull. In the preface to the summary of Lull's doctrine which he addressed to Philip II, Pedro de Guevara stressed its relevance to the newly established academy of mathematics.[52] However, Herrera's Lullism – whatever it meant to him exactly – should remind us that there is no precise modern equivalent for his kind of thinking. Mathematics and the science of mechanics linked architecture to the sciences, whose principles were universal. The divine machine was designed on mathematical principles, and architecture, like science, employed the universal code. The science of mechanics gave coherence and intellectual stature to this approach. Herrera found the justification for his convictions in Vitruvius. He integrated Alberti's image of the intellectual designer into the contemporary view of science, and he further folded science into the all-encompassing structure of Lull's philosophy. It was a fragile intellectual construction, but, in contrast to Alberti's only nominally Christian philosophy, it was both classicizing and Catholic.

Herrera's involvement in Lullism and the science of mechanics does not imply that he designed buildings to look like machines or that he based his plans on the semi-magical diagrams that can be found in Lull or in his own *Treatise on the Cube*. On the other hand, Lullism and the science of mechanics had in common their desire to break away from the Aristotelean substantiality of things in order to find the abstract principles that govern the universe. Lull's view was that these laws were to be found in the operation of opposing forces (active/passive, internal/external, fire/water, etc.) which interacted in complex ways in order to produce each created thing. Harmony was 'plenitude': fullness of being defined as an equilibrium in relation to the action of these forces upon each other. Any natural or created thing is the totality that contains the relationships of 'being' and 'working' that make up its composition rather than an entity of a particular shape with clearly defined anatomical parts. This notion has something in common with Herrera's view of the science of mechanics as the operation of opposing forces governed by geometry. Herrera's view of proportions was Lullist to this extent. Describing Lull's doctrine, he wrote that 'So also in all external harmony, active and passive are insufficient without the connective, connectives being the means from the extremes or the proportions that link active to passive. These proportions proceed from the same active and passive because proportion, or nexus, is the mean between the participating extremes.'[53]

What would a Lullist architecture look like, if these ideas were to be applied to building? Obviously, as many Lullist kinds of buildings as interpretations of Lull are possible, but two elements of this view seem relevant to Herrera's thinking. First, a building

36 Herrera, main staircase at the Escorial, c. 1576

achieves harmony not by imitating the outward forms or organization of natural things, but by representing the opposing forces which make up its nature. Second, what is important is that proportional means work themselves out in the building (in Lull, this is a working out of basic qualities according to the system of his Art). Mathematical means are abstract; Lullist harmony need not correspond to a musical chord, a length of string, or any physical object.

But how do we know such relations? And how would a building embody them? For Lull, this is above all a visual experience. Speaking of circles, he said 'It is nevertheless said that no whole thing represents forms and differences of substances like figures, from which it follows that the power of vision is of more importance [in presenting] a figure to the imagination than any other sense.' Therefore 'he who begins to know a thing by the power of sight rather than through another sense, that person knows it better than another person for that is how form and area are represented [to the imagination].'[54] Applied to architecture, this means that the essential nature of a building is known through vision; one does not 'feel one's way' through its spaces or 'hear' its visual harmonies, or sense its physical presence otherwise than through sight. The physical is dematerialized in order to reveal its true nature, but its truth is visible, which may explain why Herrera chose to insist so strongly on geometry in the appearance as well as in the abstract order of his buildings.

Herrera dispensed with the visual richness of classicism without renouncing its ideal of comprehensive harmony. In the main staircase at the Escorial (pl. 36 and 37) he produced a system of ornament which records the logic of the composition but whose effect of classical order depends more on its geometrical clarity than on the presence of the orders or other forms derived from antiquity. His drawing for one of the Casas de Oficios at the Escorial shows how much he invested in purely abstract relationships. The height of the building (68′) is exactly half the width of the main plaza that separates it and its plaza from the Escorial (136′); the width of the plaza in front of it (50′) is in an arithmetic proportion with the height of the building without the roof (55′) and the distance from the adjacent building (60′) (pl. 38). The heights of the stories, the dimensions of doors, windows and moldings are all bound together

37 Herrera, detail of the main staircase at the Escorial, c. 1576

in proportional relationships.[55] Every interval in this building – and between the building and its surroundings – has been carefully calculated, as can be seen in the drawing, but classical ornament is no more than a vestigial reference. Not even a pilaster remains to mark the intervals that Herrera so carefully calculated.

38 Herrera, undated elevation and section of the Casas de Oficios at the Escorial. (Madrid, Biblioteca del Palacio Real)

4
Drawings

EVERY RENAISSANCE ARCHITECT was above all a designer and
hence a draftsman. The Renaissance idea that a building is a work
of art, which is shaped by its author into an aesthetic whole,
naturally placed a premium on drawings. In the fifteenth century,
painting led the way in defining graphic techniques for all the arts,
and in the sixteenth century most Italian architects still trained as
painters. Herrera's relationship to this tradition is eccentric: on
the one hand, he learned the theory and practice of architecture
through drawing, but unlike Palladio, who began as a mason,
Michelangelo, who thought of himself primarily as a sculptor, or
Vignola, who was first a painter, Herrera was trained to rely on
drawing almost exclusively. He was not a painter, however, and he
employed graphic techniques that had been, if not devised then
certainly perfected, specifically for representing buildings (pl. 39).
This kind of specialization seems to have more in common with
that of a modern professional architect than with that of any
Renaissance practitioner, but, as we shall see, it evolved from
Renaissance practices.

RENAISSANCE ARCHITECTURAL DRAWINGS

Alberti imagined the architect as designing every part of his
building, but his allusions to drawings and models that were com-
plete in every detail was considerably ahead of practice in his own
day.[1] In central Italian culture, drawing of any kind was closely tied
to the suggestion of three-dimensional volume, but the techniques
that made it possible to represent a building fully in drawings
developed only gradually in Italy in the fifteenth century in response
to new conceptions of space. Wolfgang Lotz traced the evolution of
architectural drawings from painterly perspective constructions to
perspective techniques, developed first by Bramante and then by
Raphael, which allowed the architect to control the entire design, to
visualize its space more completely, and to represent its decoration
in relation to volume.[2] Representation of a building in strict
orthogonal projection – an abstract slice of a building projected on
the plane of the sheet – which was first described by Raphael in a
famous letter to Leo X in 1519, was a response to the limitations
of perspective constructions.[3] Orthogonal projections are not
illusionistic renderings of appearance like a perspective view; each
drawing is an abstract fragment of the whole, and it takes at least
three separate drawings – a plan, elevation, and section – to rep-
resent an entire building, but they do not distort the represented
elements as perspective necessarily does. Orthogonal projection

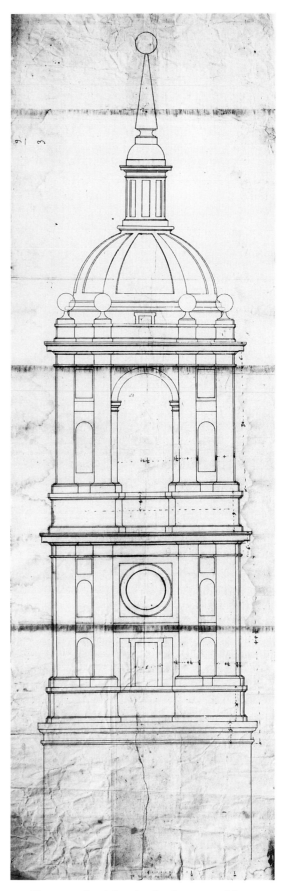

39 Herrera, undated elevation for the towers of the
Escorial. (Madrid, Biblioteca del Palacio Real)

46

made measured elevations possible (measured plans had long been in use), and, once this was accomplished, drawings could be used to build.

Thus a new technical tool was added to the design and building process and rapidly became the more 'professional' form of representation, separating architects from painters, but it also made design more accessible to those outside the profession. Construction requires a builder's knowledge and experience, but, to the extent that it is based on a technical drawing, amateur and professional share the information that is in the drawing for it. This is one reason why architectural treatises which were illustrated with technical drawings could be read and used by patrons, and why architecture, which was very much an expert's (builder's) domain before the Renaissance, could become increasingly open to non-practitioners.

MODELS

Architectural models are often seen in opposition to drawing but they may also be seen as complementary. While it is true that architectural drawings gradually displaced models in practice over the course of the sixteenth century, and it is historically correct to treat drawings as the more 'progressive' form of representation, models and drawings coexisted for an extended period, and it is equally valid to see them synchronically as different elements that supplemented each other in a total system of representation.

Small models played an important role in early Renaissance practice as early as the fourteenth century – Arnolfo di Cambio, for example, left a model of the Cathedral of Florence as a record for patrons and workmen to follow, and, later, Brunelleschi regularly used models to illustrate his designs to clients and workmen, even though he experimented with measured drawings. Preferring a model to scale drawings seems a curious choice, especially for the inventor of linear perspective: what possible advantage could a small model have over a measured drawing? The drawing would have been the more accurate, especially when we learn that the models were rough affairs. If Manetti is to be believed, on one occasion Brunelleschi demonstrated a piece of construction to his men by carving his model from a turnip! Brunelleschi's finished wooden models, like that of the lantern for the dome of the cathedral, do not show details of the architecture very well (pl. 40).

The single advantage of a model over a drawing is to show how the pieces of a building fit together, which is why Alberti stressed the importance of visualizing projected buildings and urged the architect to make simple models.[4] In a construction like the dome of the Cathedral of Florence, which had to be built without centering, each element of the building was particularly dependent on the whole. A nearly tactile understanding of the entire structure was essential both for Brunelleschi and for his workmen and, from this point of view, a cupola-shaped turnip may have been better than any drawing.

Models were not perfect tools, however. Construction models, usually made of wood (personal models were often of clay), were time-consuming to produce and the architect rarely made them himself. Brunelleschi employed a model-maker, as did Michelangelo,

and both men complained of the errors that crept into their designs as a result. There is also a strict limit on the degree of fidelity that can expected in any model. The scale and material of the model limit precision; even if the details are there it is virtually impossible to take precise measurements from them.

The fact that a model is superior to a drawing for the representation of volume helps to explain the coexistence of both types of representation well into the sixteenth century, although the fact that many Renaissance architects were trained as sculptors in a tradition of modelling as well as carving probably also has something to do with it. From Brunelleschi onward, architects continued to make models for their own use, for presentation to patrons, and for the workmen. Antonio da Sangallo the Younger's and Michelangelo's models for St Peter's are good examples.

Herrera, as far as is known, never used models to work out his ideas nor, with the possible exception of a model of the basilica of the Escorial, to have prepared them for his workmen. The evidence suggests that he relied on his drawings.

Working for Juan Bautista, Herrera was better placed than most Spaniards to learn advanced techniques of draftsmanship, as one can see from Juan Bautista's surviving drawings.[5] Apart from a few rough sketches, these are finished technical drawings (See pl. 114). Like most drawings by Italian Renaissance architects, however, they are pictorial images, modelled in light and shade to suggest volume. Even the orthogonal projections that illustrate Palladio's *Quatro Libri* of 1570 remain senstive to pictorial composition and manage to suggest both volume and mass (pl. 41). Herrera's drawings are far less pictorial. They are closer to scientific illustration, to line diagrams, to the conventions of architectural drawings in the Gothic style, and to drawings for stereotomy. Only in his engraved prints of the Escorial did Herrera allow himself a judicious use of modelling to bring out the volume of the building.

Personal sketches, studies after antique and modern buildings,

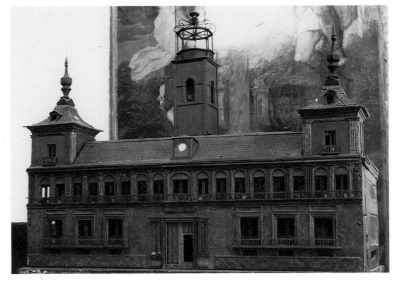

40 Wooden model of project for the city hall of Valladolid, seventeenth century. (Valladolid, Museo Municipal)

Drawings

41 Andrea Palladio, elevation of the courtyard façade of the palace of Iseppo da Porta in Vicenza, from *Quattro Libri*, 1570

of drawing because there is nothing else. These nevertheless have a distinctive aesthetic: their very lack of sensuality gives the impression of transparency to the conceived building, as if it were pure design rather than stone. Individual elements are rendered with simple lines and the complete lack of modeling – not even column capitals are shaded – reduces all the elements to one plane, forcing us to read the drawings in terms of their relationships without regard to their situation in space. There is little feeling for what the building will look like, but there is a compelling sense of the internal order of its elements (see pl. 29).

HERRERA'S *ESTAMPAS*

In 1589, Herrera celebrated the completion of Philip II's Escorial and his own role in the enterprise by publishing a set of twelve prints of measured plans, elevations and sections of the building, engraved by the Flemish engraver Pedro Perret. Begun in 1583, the project underwent some revision before it appeared together with *El Sumario de las Estampas de San Lorencio de El Escorial*, a brief explanatory booklet written by Herrera.[6] In the context of Renaissance architectural illustration, these engravings emerge as exceptional works culminating nearly fifty years of experimentation. Adopting the conventions of Italian orthogonal views that had been popularized by Labacco's engravings of Sangallo's model of St Peter's and continued in Dupérac's prints of Michelangelo's designs (pl. 42, 43), Herrera's elevations and sections are carefully shaded to bring the building into relief.[7] The *Estampas* commemorate the Italian Renaissance ideal of an architectural design as virtually a surrogate building, complete and thought out, lacking only the mass of the real thing, (pl. 44).

With minor exceptions, the prints correspond to the executed building, but they do not reproduce drawings used in the building process. Herrera's design drawings for the Escorial never employ the modelling techniques used in the engravings. In any case, it is improbable that a complete set of drawings for the Escorial existed either prior to construction in 1563 or at any time until 1584, since written documents show unequivocally that designs were reworked at many points.[8]

The *Estampas* were engraved from drawings that Herrera and his assistants prepared specifically for the prints, but they followed the style and format that had hitherto been used to publicize projects rather than finished buildings. They were intended to compete with other architectural engravings of famous designs like those of Antonio da Sangallo and Michelangelo for St Peter's and with the prints of famous ancient buildings published in Rome by Salamanca and Lafrery, but Herrera included as the seventh print in the series a magnificent cavalier perspective view of the Escorial that rivals the perspective views of Dupérac and the buildings illustrated in Jacques Androuet Du Cerceau's *Les Plus Excellents Bastiments de France*.[9] Du Cerceau challenged the authority of Italy and antiquity with his images of French chateaux and Herrera's perspective seems meant to show that the Spanish Escorial was superior to anything the French had to offer.

Herrera insisted on architectural values to a far greater degree in his *Estampas* than may be found in earlier prints. All extraneous

and perspective drawings – the kinds of drawings that make up a substantial percentage of Italian architects' drawings of the period – do not survive from Herrera hand. He may have learned to draw in the broader sense: to sketch, to shape, to imagine in drawing, while he was working for Juan Bautista, but no drawing by him corresponds to the creative studies of Renaissance architects like Michelangelo or Palladio, and this makes his surviving drawings difficult to appreciate. Technical drawings are not artistic sketches; they may even get in the way of an artistic appreciation. They have no sculptural vitality and record the results rather than the processes of thought. What they lack is made up in another way: a technical drawing is closer to the building which is to be built. In studying Herrera, we are forced to concern ourselves with this type

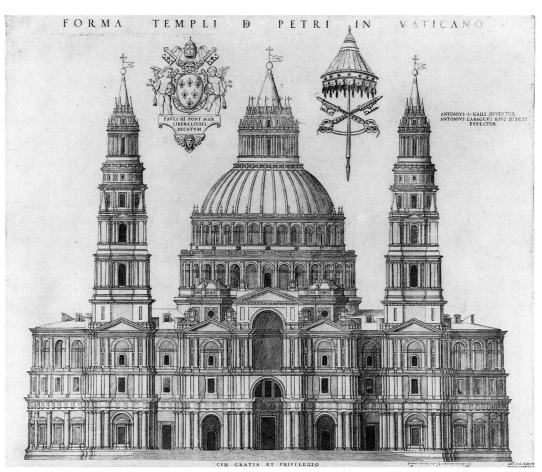

42 Elevation of Antonio da Sangallo the Younger's project for St Peter's in Rome, engraving published by Lafrery in 1548. (Santa Monica, California, The J. P. Getty Center for the History of Art and the Humanities)

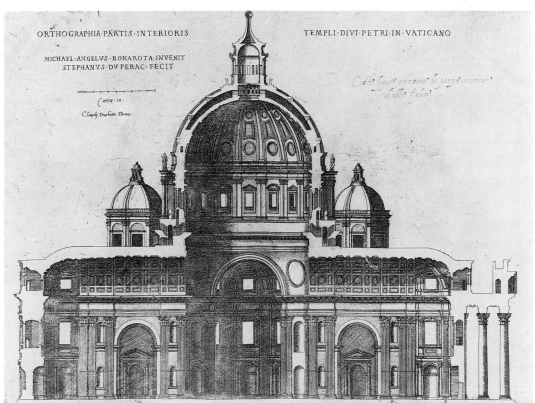

43 Etienne Dupérac, longitudinal section of Michelangelo's project for St Peter's, etching published by Lafrery in 1569. (Santa Monica, California, The J. P. Getty Center for the History of Art and the Humanities)

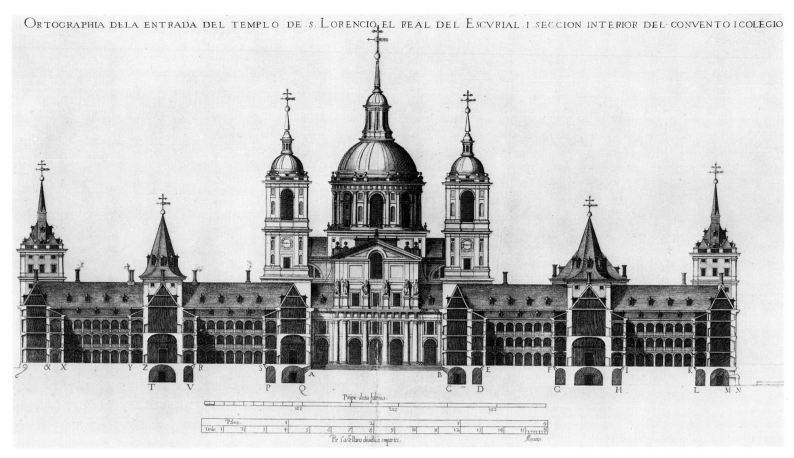

ORTOGRAPHIA DELA ENTRADA DEL TEMPLO DE .S. LORENCIO EL REAL DEL ESCVRIAL .I.SECCION INTERIOR DEL·CONVENTO.ICOLEGIO

44 Pedro Perret, elevation of the entrance to the basilica and section through the convent and college of the Escorial, engraved after a drawing by Herrera or assistants and published as the Third Design in Herrera's *Las Estampas de la Fábrica de San Lorenzo el Real de El Escorial*, 1589

text or imagery – inscriptions, coats of arms, allegorical figures – that might interfere with the image of the building is eliminated. Each print is titled only with a technical description of the type of view (plan, elevation, section or perspective) and an indication of the part of the Escorial that is represented. Finally, apart from the seventh print, the *Estampas* show the Escorial drawn to a consistent scale with the *pitipie* and an actual Castilian foot represented together underneath the image. In these respects, the graphic conventions of the *Estampas* parallel those of cartography in the later sixteenth century. The *Estampas* and *Sumario* engaged a set of references from the world of publication. In their own genre this set of prints is as ambitious an undertaking as the Escorial, the most complete and technically perfect publication of a single building in the sixteenth century. Using the latest graphic techniques, adding measurements, and explaining functions, Herrera gave the Escorial an authority which was independent of the actual building. When a plate from the *Estampas* was laid beside an engraving of the Pantheon, the Coliseum, or the projects for St Peter's, there was no doubt which image was the more formidable. The Escorial could be seen as a Christian counterpart to, and replacement for, ancient pagan monuments and as the rival of the greatest contemporary works.

VILLALPANDO'S TREATISE AS A REFLECTION OF HERRERA'S VIEWS ON DRAWING

The *Estampas* were based on techniques that were originally developed by Italian artist-architects but there is some indirect evidence that Herrera considered this kind of representation to be fundamentally different from drawings by painters and other artists.

The evidence comes from the work of two Jesuits, Jerónimo Pardo and Juan Bautista Villalpando, who, in 1580, conceived a project to demonstrate 'that the entire foundation and design of Roman and Greek architecture, or of any other of the most noble and ancient architectures, was taken from the design of the Temple of Solomon.'[10] By his own account, Villalpando was a 'disciple' of Herrera with whom he studied architecture.[11] His set of fifteen magnificent copperplate engravings of measured plans, elevations, sections, and perspectives of the Temple, which were the centerpiece of the lavish folio publication in the second volume, are usually cited as evidence that the architecture of the Escorial was a reconstruction of the Temple and inspired the project (pl. 45).[12]

It is not the Escorial but Herrera's images of it in the *Estampas* which so strikingly resemble Villalpando's Temple. The format and style of the engravings and the presentation of the architecture are the same as in the *Estampas*. Villalpando used orthogonal projection and perspective for his reconstruction; his prints included a

scale (in Biblical cubits) at the bottom, and his discussion of his reconstruction was arranged, as in Herrera's *Sumario*, as a commentary on each plate.

Herrera was apparently not involved with the mystical aspect of Villalpando's project, which identified the ancient Temple with the body of Christ and the Christian church, nor well informed about the Temple itself, although he was entirely in sympathy with the search for divinely ordered architecture. According to Villalpando, when Herrera saw the reconstruction drawings of the Temple, 'he was able to appreciate everything with exactitude' and 'to scent something of divine wisdom in the proportions of the architecture, in such a way that, although he had only seen the graphic descriptions and heard nothing from anyone nor read what was in the sacred texts, he was easily able to judge that this building had been imagined by no human intellect but designed by God himself with infinite wisdom.'[13]

Drawings are the only way such harmonies can be represented clearly, and Villalpando devoted an extensive discussion to graphic techniques.[14] 'Drawings,' writes Villalpando, 'are necessary so that the inventions of the mind can be seen with the eyes and contemplated by the mind, not once but many times.'[15] The angel drew the Temple that Ezekiel describes, just as David and Solomon drew the Temple from God's instructions; and drawings are the basis of the human architect's art and its communication. Even perspective views 'which would seem to be of little use to architects . . . and for the workmen none at all' are essential for representing the whole building as it is conceived in the mind; he does not mention three-dimensional models.

Villalpando's views on design echo Alberti, but where Alberti saw similarities between the drawings of painter, sculptor and architect, Villalpando sees differences. The mere idea that the arts share graphic techniques is irksome, and the notion that a painter might use his skill in drawing to play the architect is repellent.[16] 'The business of the painter and the sculptor consists in the imitation of nature, while that of the architect is not so.' 'Applied to building, the fictions [of the painter or sculptor] seem feeble, inept, at least similar to monsters . . . and such buildings will not stand long.'[17] Painting, if it brings anything to building, can add only elegance, not substance, to the geometrical truth that underlies real architecture.[18]

Villalpando's ideas, which Rudolf Wittkower aptly described as the 'speculations of a counter-reformatory theologian in which the spirit of the Middle Ages was peculiarly revived,' were probably not identical with Herrera's in every respect, but his notion of a divinely ordered draftsmanship coincides with Herrera's aim to link his architecture to universal principles.[19] In any case, it is difficult to imagine from whom, other than Herrera, or where, other than from the *Estampas*, Villalpando could have so thoroughly instructed himself in the character and use of the graphic techniques he adopted for his reconstruction. It would appear that the techniques of orthogonal projection and perspective had acquired an ideological significance based on a perceived separation between architecture and the artistic arts of imitation, on the one hand, and an alliance with other types of 'true' representation like measured maps, diagrams, and mathematical demonstrations on the other.

THE ADMINISTRATIVE ROLE OF DRAWINGS AT THE ESCORIAL

Drawings had more prosaic functions. Philip II wanted to use drawings to build the Escorial from the beginning, because he realized that only in this way would he be able to participate in its design and control its expenses. His confirmation in 1561 of Juan Bautista's appointment as royal architect mentioned that one of his duties was to prepare drawings.[20] In 1563, when Philip appointed Juan de Valencia and Juan de Herrera to be Juan Bautista's assistants, their principal duty was to prepare drawings.[21]

Measured drawings were part of Juan Bautista's design and building procedure but they were not sufficient: drawings required the architect's presence and interpretation. There is ample evidence that he could not work with a system which required that every detail of the building be known in advance, which suggests that Juan Bautista was not entirely responsible for the role that drawings later assumed at the Escorial.

Implementing Alberti's ideal proved more difficult than the king had first imagined. A building administration that relied on drawings was not perfected until the 1570s, when Herrera willingly adapted himself to its requirements. In 1569, and again in 1572, building administration had to be reorganized to make drawings the official basis for all decisions from design to final product.[22] The new system assumed that the drawings would represent the building fully and accurately and, from 1572 onwards, the Escorial was built from drawings. Without them, the entire operation would have stopped in its tracks: work could not have continued for one day without drawings, not because the workmen did not know how to dig foundations or the masons how to square blocks without them, but because they would not have been allowed to continue.

The directive of 1569 ordered the *aparejadores* at the site to work from drawings that had been approved by the king. They were ordered not to change anything in the plans. Philip ordered them not to 'pretend to be ignorant of this' or to act as if the monks were supposed to tell them what to do.[23] In addition, all construction (with a few exceptions) was to be determined by bidding for contracts based upon measured drawings and written specifications. Once approved and contracted, nothing could be changed.

The reorganization of 1572 confirmed and strengthened this procedure. The prior became the official head of the building program, but his function was simply to pass along the drawings that Herrera made and the king approved. The prior was to give orders 'according to the general plans and detailed plans which have been made and which we will order to be made from now on.'[24]

The *aparejadores* were responsible for making copies from the master set.[25] They had to make three sets of copies from every approved drawing that they received: one for the prior to keep on file, one to keep for themselves to write specifications, and one to give to the contractors for building. The specifications for contracts and the contracts themselves were written from the drawings and always refer to the 'plantas, montaes, y perfiles' which are to be followed exactly.[26]

The contractor bid on these specifications, received the drawings, and was given final payment when his work was checked against

Drawings

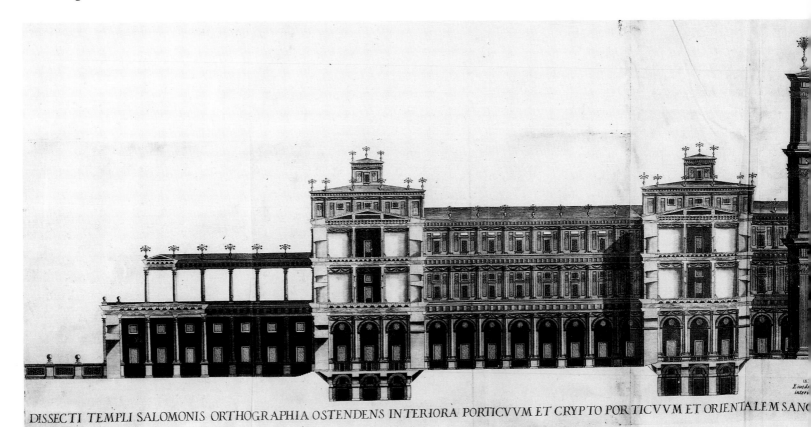

DISSECTI TEMPLI SALOMONIS ORTHOGRAPHIA OSTENDENS INTERIORA PORTICVVM ET CRYPTO PORTICVVM ET ORIENTALEM SANC

45 Juan Bautista Villalpando, cross-section of his reconstruction of the Temple in Jerusalem according to the vision of the prophet Ezekiel, pl. xv of the second volume of *De Postrema Ezechielis prophetae*, 1604

the drawings and specifications. This system was spelled out and almost any contract for work at the Escorial shows that it was followed faithfully. The aim of the whole procedure was to insure that the construction conformed to drawings as exactly as possible. Fidelity to drawings was expected, so drawings had to be to scale and measurements provided. These must have been technical drawings of the Italian type: measured plans, elevations and sections and geometrical projections for the stereotomy.

Drawings were the basis of the building organization: the only thing which linked all parties to the building enterprise in a continuous chain. A design – a drawing – went from architect to king, from king to prior, from prior to *aparejador* and thence to builder and craftsman. Along its route it was copied, filed, and checked; but it was never altered. The drawing was the fixed point of reference from design to final construction. Workmen used drawings to build; but the bureaucracy used drawings to administer the building process.

The use of measured drawings meant that labor costs, construction time, and materials could all be estimated and verified against the same drawings that were being used on the site. This was not necessarily more efficient than other ways of building, although it aimed to be, but it established a system of monitoring which, in itself, guaranteed that the architect's designs would faithfully reproduced.

Using drawings this way affected ingrained habits of Renaissance practice. Even Herrera could not alter a design without author-

ization; but he did not need to be as close a supervisor, head contractor, or building coordinator, and was none of these things. The old 'hands on' role of the Spanish master of the works which survived in Renaissance practice even in Italy was superseded by the organization; the intimate relationship between designing and all aspects of construction, which had been the cornerstone of architectural practice and was still to some extent Juan Bautista's preference, was replaced by a bureaucratic system whose aim was ultimately to remove the design process from the hazards of building, to make architecture as completely as possible a matter of design in the hands of the architect and his client, and thus to implement Alberti's ideal of the architect and his patron working together to create a building. At the Escorial, execution was finally just craftsmanship.

SETS OF DRAWINGS

None of the surviving drawings for the Escorial can be associated with a specific contract or related directly to the building process. Existing drawings all seem to belong to the designing phase, because they either do not match extant construction or do not have the detailed measurements described in the documents.

The drawing for the façade of the basilica is a good example (pl. 46).[27] It is drawn to scale and measurements are given; but it cannot be a working drawing since there are not enough measurements to build from.[28] Specifications prepared for contracts for

52

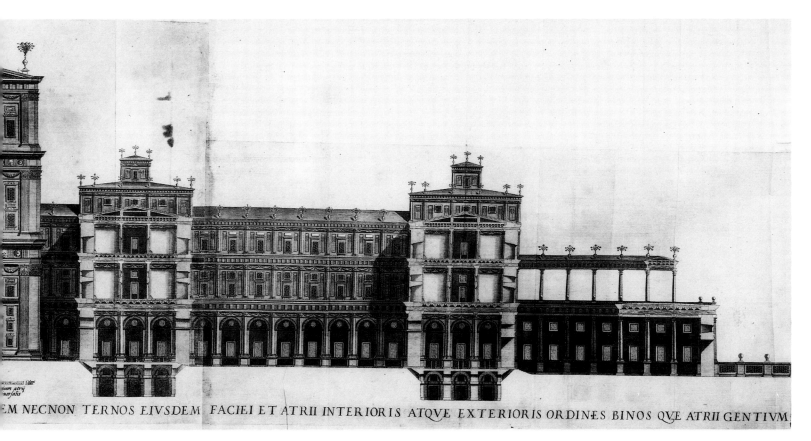

EM NECNON TERNOS EIVSDEM FACIEI ET ATRII INTERIORIS ATQVE EXTERIORIS ORDINES BINOS QVE ATRII GENTIVM

other parts of the Escorial reveal that contractors were supplied with complete sets of drawings which had extensive written measurements to be followed 'al pie de la letra.'[29] Such drawings must have provided more information than this one.

Drawings for the second Casa de Oficios at the Escorial give a better idea of working drawings. The plans and elevations show the *pitipie* and have essential dimensions. Such drawings were probably keyed to a master set of drawings for the whole structure. For example, one plan is more complete and each section is keyed with letters (pl. 47).[30] The letters connect the drawing to a description of each space written above the plan. This system was useful for writing specifications and contracts in which some elements had to be described in words, and the letters also made it possible to relate drawings to each other. LM: 'pieças para los cozineros de sus altezas' on the master plan could be used to identify detailed designs of this section on other sheets. A drawing for the royal palace at the Escorial is a simple example of this system (pl. 48). The pier at the lower left corner is labeled 'A.' To the right is a more detailed plan of that pier with the notation 'Este pilar es el señalado A.'[31]

In this way, individual drawings made for the Escorial were not isolated architectural ideas (pl. 49). Detailed drawings belonged to a larger unit, which, as the documents indicate, represented a major part of the building. The final designs of a particular section – the basilica is a good example – seem to have been prepared by Herrera only when construction was ready to begin on a specific part of the building. In 1575 Diego de Alcántara was busy preparing the working drawings for the contractors of the basilica.

THE PROBLEM OF WORKING DRAWINGS

The supervising architects at the Escorial were expected to make working drawings, but how detailed were these? Specifications and contracts usually refer to the drawings for measurements, but design drawings show that Herrera usually worked with a scale that divided the Castilian foot into sixteen parts, a unit called a *dedo*, although he occasionally gave measurements in thirty-seconds of a Castilian foot, which suggests that working drawings were sufficiently precise and large in scale to represent such dimensions. Important as drawings were, however, they were not completely sufficient for building. Design drawings rely almost entirely on unshaded lines and written measurements. The decorative elements were represented in these drawings too, but it is doubtful that the decoration was carved from them. The contracts describe full-scale templates from which to carve details.[32] Documents also describe a model for the height of the courses. Masons must also have been given geometrical patterns for the stereotomy, which required drawings similar to those used in France and described by Philibert de L'Orme.[33] Specifications refer to *baybeles* which were formwork for vaults but may also have been drawings.[34]

Not one working drawing has survived. Possibly they were not saved, as blueprints are not always saved now. Craftsmen were not always allowed to keep drawings, which were considered to be royal property. In 1587, Herrera demanded the return of the designs for the choir stalls of the Escorial which had been included in the estate of a sculptor.[35]

46 Herrera, undated drawing for the façade of the basilica of the Escorial. (Madrid, Biblioteca del Palacio Real)

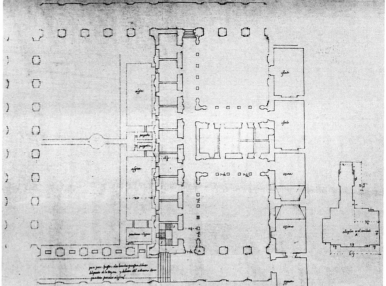

48 Herrera or assistant, undated plan for part of the royal palace at the Escorial. (Madrid, Biblioteca del Palacio Real)

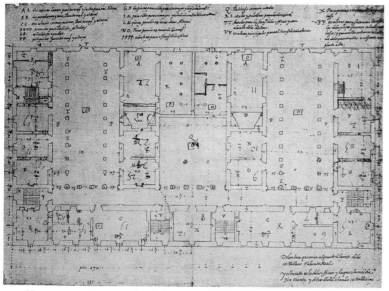

47 Herrera or assistant, undated plan for the second Casa de Oficios at the Escorial. (Madrid, Biblioteca del Palacio Real)

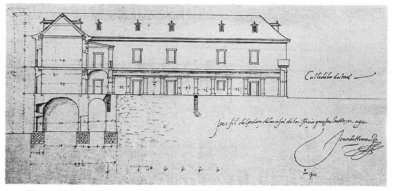

49 Herrera, undated section of the second Casa de Oficios. (Madrid, Biblioteca del Palacio Real)

BUILDING FROM DRAWINGS AT THE ESCORIAL

Herrera's style demanded a high standard of workmanship. He may not have expected distinctions as small as one sixteenth of a foot to register in the finished basilica at the Escorial but such precision was part of his aesthetic (pl. 50, 51). This is particularly visible at the Escorial, where the hard, coarse-grained granite was worked with great attention to uniformity and homogeneity of surface. One striking effect of the architecture comes from the contrast between the roughness of the stone and the finesse with which it was worked. There is an emphasis on the material itself (pl. 52). Impressively large stones were often chosen, as in the shell of niches carved from a single stone (pl. 53). The jambs of the main door on the west façade were each carved from monoliths over three meters high, and at one point, architraves of single stones were ordered, so

large that it proved impossible to transport them to the building site.[36] The door jambs alone required a team of eighty oxen to haul each one of them. Many teams of workmen were employed on the building, yet it is impossible to distinguish any differences in handling. The almost perfect uniformity of the technical execution of the Escorial is an amazing accomplishment.

It was partly made possible thanks to a new method of working stone that Herrera himself introduced in 1576. The method required three distinct stages. The stone was first cut at the quarry, where each block was measured, squared, and finished on five faces, leaving the front face rough. At the building site, the stone was examined for faults, corrected if necessary, and laid up in regular courses. Drawings were necessary to both these stages. Finally, after an important section of the building had been completed – the interior of the basilica or its façade, for example – the entire surface of the section was polished, shaved down 'by the width of a cord'.[37] This method of working encountered strong opposition from the builders. The master-masons, upheld by the supervising architects, at first refused to work stone at the quarries, and it was not until these supervisors were banished to other building sites

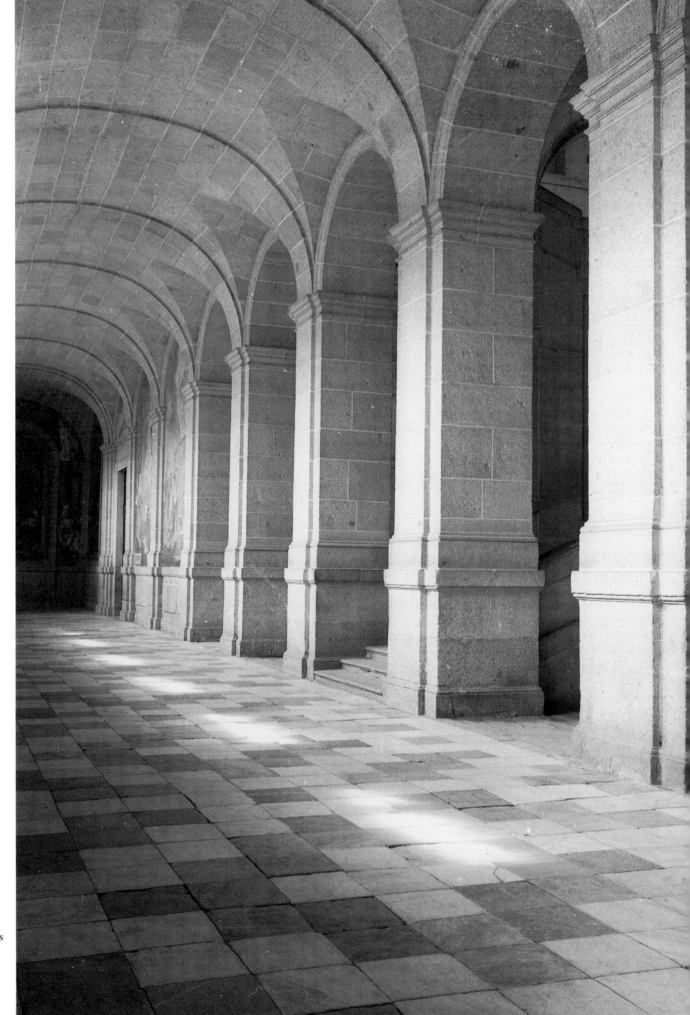

50 Cloister walk surrounding
the Courtyard of the Evangelists
at the Escorial, completed by
1584

51 Detail of the engaged Doric columns on the main façade of the Escorial, completed by 1584

and the masons were guaranteed a twenty percent raise in their monthly advances that Herrera's system was put in place.

Herrera's procedure was partly designed to save money and time. Cutting the stone at the quarry reduced waste and the opportunity for fraud. Since the quarries belonged to the king, there was always the possibility that masters would redirect stone to their own purposes. Under the new system, only good stone was sent to the site, which reduced the cost of transport. Herrera's method was thus, in principle at least, more economical. Speed was also a factor. In 1576, after fourteen years of building, only a third of the Escorial had been completed. Philip intended to see his monument

53 Niche at base of main staircase of the Escorial, designed c. 1574

built and decorated in his lifetime. Working stone at the quarry meant less work at the Escorial itself and a better organized system of delivery. On a crowded building site, where portions of the building were to rise simultaneously, the use of pre-dressed stone was a great advantage.

The technique seems to have been extraordinarily effective. The basilica was built quickly by ten teams of workmen, each working under a pair of masters, simultaneously building a portion from the foundation up. Two teams were responsible for the façade and four teams came together when construction arrived at the dome.[38]

Herrera's system made homogeneity easier to achieve because the components of the building were standardized to an extraordinary degree: the courses of masonry are almost identical in height and the stones are of several modular sizes. This regularity of the stonework is apparent throughout the immense building – in the orders and decoration as well as in wall surfaces. Yet, to speak only of the basilica, ten teams of workmen, each quarrying its own stone and building its own section, could not be expected to choose the same sizes of stones or lay them in matching courses. Even if masons were ordered to do so, their performance could not be strictly

52 Detail of the Courtyard of the Kings at the Escorial, completed by 1584

supervised by the single architect who was responsible for over-seeing stonework. Modular stones were finished at the quarry, making it easier to identify discrepancies and to discourage masters from altering plans. Unlikely as it might seem, deliberate and unauthorized alterations of the architect's designs had happened before at the Escorial. The building teams were working in an unfamiliar style and the danger that they might introduce changes or not respect the dimensions that Herrera gave them was real, especially given the hectic schedule of construction. The new procedures provided much greater control over the building process.

Contracts mention the size of the stones and the height of the courses of masonry, as well as the thickness of the walls, etc. – all of which 'we see in the said plans, and elevations.'[39] The same contract also reveals how precisely the workmen were expected to follow their specifications. The thickness of the mortar joints is described as 'un real de a ocho' for the vertical joints (i.e., 41 mm), and as 'un real de a quarto' for the horizontal joints between courses. The dimensions of other sections are often specified, with the phrase 'poco mas o menos.' We should perhaps interpret this to mean 'as exactly as possible,' since contracts also include the statement that drawings and measurements are to be followed strictly or rigorously.

Herrera's three-step procedure was another step towards the mechanization of the building process that was implied already in the use of measured drawings. The architect could design every detail of his building and expect to see his design realized. Skillful execution became essentially reproductive. Before 1576, the *aparejadores* and their contractors retained a small degree of freedom in interpreting the drawings provided to them – they might vary the size of a stone here or there and some variation is visible in the earlier sections – but the ideal of a completely uniform workmanship preexisted Herrera's technique. Early contracts actually speak of a surface that ought to look 'as if it had been polished.'[40] After 1576, the size and shape of every stone and its future position was known so that the building could rise, quite literally, stone by stone from verbal and visual specifications. The surface texture of the Escorial was designed by the architect rather than left to the choice of the builders. Standardized workmanship was designed into it.

The implications of this were not lost on the builders at the Escorial. Twenty years before, when the Escorial was just beginning, some of these men had thought of themselves as designers as much as builders. Philip and Herrera had gradually removed design from their hands and now Herrera's procedure stripped away such remnants of their old profession as they had managed to retain. Even their craftsmanship was ruthlessly standardized. Assembly-line workers in a pre-industrial age, the builders of the Escorial were obliged to work to specifications as detailed as a sixteenth of a foot without being able to design the smallest part of the machine they were building.

The architecture of the Escorial seems cold and impersonal to many observers – it is certainly abstract – so it is perhaps necessary to insist that this is a contrived effect, conceived by the architect and deliberately asserted as a constituent feature of the style. Nothing so clearly illustrates this as the third step in Herrera's

building technique: the final polishing. Dressing stone at the quarry may well have been more economical; standardization certainly speeded up construction, and money and time were of intense concern to Philip II, who felt himself short of both. But grinding down the surfaces of this enormous building to a pristine smoothness was expensive and time-consuming. It was unprecedented to handle granite this way. Its rationale was not practical but aesthetic: Herrera's final gloss on the surface of the Escorial revealed the exactitude of its execution, the regularity of its stone work, the perfection and elegance of the geometrical patterns in its masonry. It unified the structure so that, rather than seeming an assembled thing, it appeared almost miraculously, as José de Sigüenza put it, 'like a building that had been carved from a mountain.'[41]

DESIGN AT A DISTANCE

The Escorial was built in a way which we can recognize as modern. Drawings made possible the independence of the architect from building and an efficient, largely mechanical, execution of the architecture. Ultimately, they also made possible design-at-a-distance through the sets of measured drawings which could be shipped anywhere to be built.[42]

Bernini, in the seventeenth century, stands at the crossroads of this international development. In 1665, it was still thought necessary, for political as well as artistic reasons, to bring the great Italian to France in order that he design a palace for Louis XIV and produce the drawings for the new Louvre on the spot. By the end of the century, however, French royal architects like Robert de Cotte were backed by the royal administration and able to export their designs to sites they had never seen, never would see. Buildings in the latest fashion were produced in sets of technical drawings which issued from their architectural offices.

Herrera glimpsed these possibilities himself. In 1575, when he designed the city hall in Toledo, he did not plan to supervise its construction. His instructions gave brief indications for foundations, quality of materials, specified some iron chains, but concluded 'that for all the rest, one should follow the design [*la traza*] of the work, keeping to what it shows, because if this is done, there can be no fault in anything.'[43] His presence was limited to attendance at an early meeting of civic officials in Toledo. Neither did Herrera plan to live in Seville to watch over the building of the merchants' exchange there. He merely sent down his drawings from Madrid in 1583.[44] The city officials would have to find their own skilled labor and materials in Seville, although Juan de Minjares, Herrera's assistant from the Escorial, was sent to act as master of the works.

These were important buildings. Herrera's detachment does not mean he cared little about them, but his confidence in his drawings appears complete. This is surprising when we realize how few drawings were involved. Herrera's drawings for the city hall in Toledo are lost, but his covering memorandum survives and lists them:

– a plan [*planta*] of the whole work and its parts ... which plan is marked with the letter M.

- another detail of this said plan done at large scale where are particularly the form of the members which the pilasters have to have, those which are under the audience hall; which is marked with the letter M.
- another general plan of the audience hall and passage marked with the letter R.
- the main elevation [*montea*] of the whole façade of this building, marked with the letters A. B. C. D. E.
- another elevation from inside the audience hall with all its niches and steps marked with the letter F.
- a section [*perfil*] of the whole work, marked with the letter G.
- a detail section of the vault which is underneath the same audience hall with its exits and steps, marked with the letter H.
- a large sheet of paper showing a base of the columns of the first order at full scale, and on the back of the sheet are two other moldings, the upper and lower, of the banister, marked with the letter J. The said moldings are to be used also for the pedestals of the first order.
- another sheet of paper where the molding of the impost of the arches and the molding of the architrave of the said arches is drawn, marked with the letter L.
- three and a half sheets of large paper pasted together. On which there is the capital, architrave, frieze, and cornice of the Doric order of the first floor at full scale [*al tamaño que a de ser*], marked with the letter T.
- another large paper where there is a detail of the main elevation with all the measurements and heights of the windows and the other members [of the architecture] and the form the stonework [*los despieços*] is to have.[45]

Herrera also mentioned a section marked S (apparently a longitudinal section), making twelve drawings in all: a measured plan, elevation, section for the whole building, detailed drawings for the vault and the moldings, columns, and capitals of the decoration, each one signed. Herrera's drawings supplied accurate measurements; sculptural elements (capitals and molding profiles) were shown full-scale; the pattern of the stonework was specified in a detail of the elevation. Nevertheless this is a small number of drawings.

Herrera followed a similar procedure in redesigning the *colegiata*, later Cathedral, of Valladolid, from 1580 onwards, when he was less taken up with royal projects.[47] This building was, in its way, as great a challenge as the Escorial, an enormous church for which Herrera provided a new design. Yet, as far as we know, he only went twice to Valladolid: once in 1578, on matters concerned with Simancas probably before he had made the designs, and again in 1585, when he must have looked over the cathedral site. The years between 1585 (when the Escorial was more or less finished) and his death in 1597 Herrera spent mostly in Madrid. His concern for his great project to the north, which was then under construction, seems to have been limited to consultation and exchanges of drawings with his executant-architect in Valladolid.

Herrera's drawings for Valladolid were probably also prepared as a set. A part survives, including a plan, side elevations of the interior and exterior (pl. 54), a cross section, a detailed plan and elevation for a chapel, and drawings of the ornament: nine drawings in all. This is not a large number, but it is unlikely that a great many have been lost.

Herrera was not indifferent to this building either, and we can only suppose that he believed, as he said, that his drawings were

enough. It is extraordinary to what extent this appears to have been the case – few doubt that, apart from later modifications, the city hall in Toledo, the merchants' exchange in Seville, and the vast fragment of the Cathedral of Valladolid are Herrera's work, but this cannot be because Herrera's drawings were really complete in a modern sense. His drawings and the contemporary copies after them are very far from modern blueprints. Furthermore, we have just seen that rigid quality control was necessary to build the Escorial in conformity with the drawings. This was just as necessary for the other buildings. Backed up by the royal bureaucracy and hedged about with orders at every turn, Herrera's drawings still depended for execution on sympathetic assistants who were fully conversant with his style. Valladolid, for example, required an architect who knew that he would want modular stonework (although this was represented in the Toledo drawings), that he would wish the surface to be as abstract and homogeneous as possible, that he cared about the precision of even small dimensions. Juan de Minjares had worked for years with Herrera, first at Aranjuez and then at the Escorial, and thus was qualified to interpret his designs at Seville and at the palace of Charles V in Granada. Diego de Alcántara was Herrera's representative in Toledo. Diego de Praves, Herrera's executant in Valladolid, had never worked directly with him but was no doubt helped by men who had worked at the Escorial. Drawings by themselves were not enough; they never are, which is why to this day building programs that can afford it still require the architect's presence.

Few of Herrera's drawings survive, although this was not for lack of trying to save them. As many have pointed out, Philip's government was the first to run on paper and was conscious of its archival responsibilities. Drawings were scrupulously collected and filed in royal archives as well as at the building sites. Later generations honored this inheritance, but Herrera's drawings have nearly all disappeared: burnt in the fire that destroyed the Alcázar in the eighteenth century, rummaged and dispersed from the Escorial during the French occupation, lost or stolen from provincial archives in periods of neglect.[48]

We do not need the drawings themselves to see that Herrera founded his career on his draftsmanship. A few archival documents will tell the story. In the early years at the Escorial, drawings laid the foundations of his relationship with the king:

Madrid, May 1567: Philip II: Get Herrera to come there to eat on Thursday and bring the drawings...and the elevations of the staircases that I saw the other day.[49]

That the drawings in question may not have been Herrera's own designs is not the issue here. More important is the fact that he increasingly assumed the role of spokesperson, bringing drawings and memoranda for consultation and explaining various proposals, and that this consolidated his role in the building enterprise:

El Escorial, May 1570 from the prior to the king's secretary: Get Herrera to send the drawing of the cloister fountains that has been made because we cannot finish until his majesty decides on the form they are to have.[50]

A decade later, drawings were the instrument of Herrera's official control:

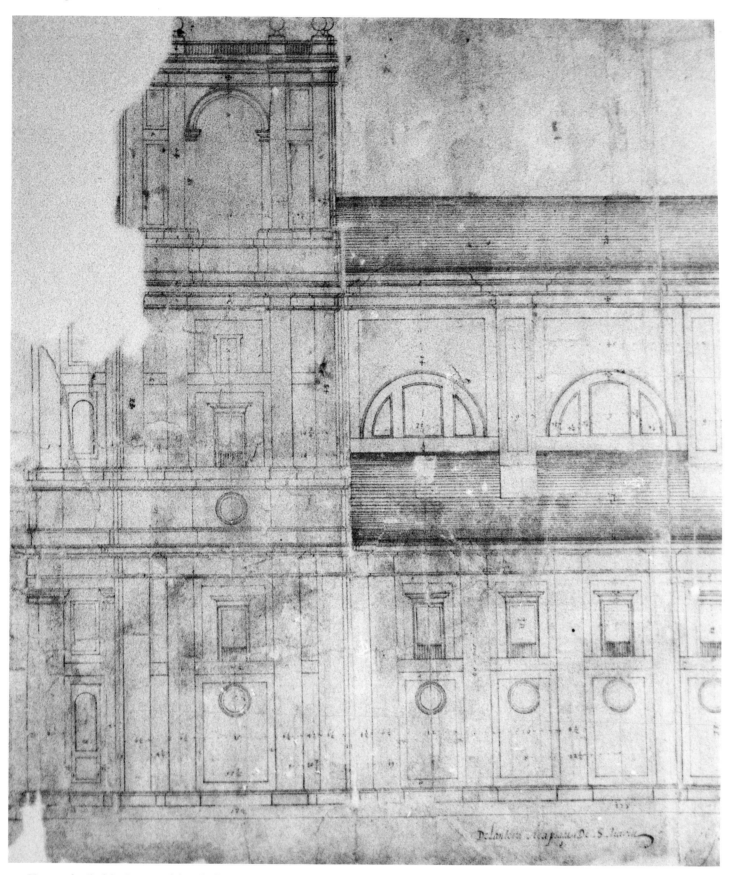

54 Herrera, detail of the drawing of the side elevation of the Cathedral of Valladolid, c. 1580. (Valladolid, Cathedral archive)

Badajoz, June 1580: Item. That the roof be built and continued according to the order and design that one finds in the little paper drawing made and shown to his majesty. And it is signed by Juan de Herrera, his [majesty's] chief architect.

[appended to the report:] The drawings which Juan de Orea, master of the works of the Alhambra at Granada, brought to Badajoz. And his majesty saw them and resolved on the matters contained above [in this report]. They are six [drawings] and all six are signed with my name: Juan de Herrera.[51]

Twenty-five years after Herrera's death, his drawings were still being followed:

Granada, April 1622: his opinion is that it be roofed later, beginning with the main room . . . to be completed in all its perfection in the form which his majesty Lord Philip II approved in the city of Badajoz . . . that we continue the work according to the old plan which is signed.[52]

Even in eighteenth-century Valladolid, Herrera's drawings, by then nearly two hundred years old, were being copied:

Copy of the drawing by Juan de Herrera, Aposentador of his Majesty, for the Holy Cathedral Church of the City of Valladolid, in which is shown the state of the building and that which remains to be done to its complete conclusion.[53]

The insistence on Herrera's signature in three of the passages above was not casual or insignificant. His signature implied not only his authorship but the authority of Philip II: signed orders were official orders and, in so far as buildings were a royal concern, Herrera's drawings were part of the fabric of Philip II's administration.

Herrera went beyond earlier practice in implementing the Renaissance ideal of the designer-architect. By making drawings the essential feature of his practice, he gave substance to Alberti's ideal of the designer and created the means for architect and patron to work together. The drawings that secured the king's favor were also the foundation of the architect's professional identity and independence.

They were above all the foundation of his art. The truth of this becomes clear if we compare Herrera's original drawings with later copies that we may assume were intended to reproduce them faithfully. Herrera's elevation of the southern side of the Cathedral of Valladolid conveys the dematerialized aesthetic that was respected in the early stages of construction. Later architects found this difficult to interpret, however, and a later copy of Herrera's drawing not only tried to make the elements more uniform (the roundels are all shown as windows) but to give them a sculptural relief and substance that Herrera's original does not possess (pl. 55). An even later version of the church (pl. 56) insisted on an even greater physical mass so that columns and moldings acquire the ponderous presence that they also have in the later portions of the executed building.

Alberti had not spoken of fees and the price of design services was still not established in Herrera's time. Architects were paid a salary as masters of building programs, and they might also be paid on retainer by a patron, as Herrera was. But neither system openly acknowledged design as the service being purchased. In theory, the

55 Copy of Herrera's drawing of the side elevation of the Cathedral of Valladolid, detail. (Valladolid, Cathedral archive)

56 Revised side-elevation drawing of the Cathedral of Valladolid based on Herrera's design, seventeenth century. (Valladolid, Cathedral archive)

master's salary was paid for the supervision of construction and the courtier-architect was expected to be in attendance on his patron, and was often rewarded with gifts beyond his salary, even if both were in effect operating primarily as designers. The closest parallel

to a designer's fee in Spain was the traditional consultant's fee that was paid to masters who were called in to evaluate and often to revise designs for a building.

The use of consultants was a long-standing practice and the king occasionally found it useful. Philip paid travel expenses and per diem to Hernán González de Lara and Rodrigo Gil de Hontañón in order to bring them to the Escorial in 1564 to look over Juan Bautista's designs, but there is no record that Francesco Paciotto, who did not belong to the Spanish profession, was paid for his similar services.[54] In any case, although Hernán González de Lara was paid the considerable sum of 32 ducats for five days of work at the Escorial, no architect could make his living from consulting.

Herrera did not often design for anyone but the king but, when he did, he demanded and received enormous sums for his drawings.

He charged 1000 ducats for the drawings for the water system in Valladolid and for his set of drawings for the merchants' exchange in Seville. These prices were unprecedented in Spain, where 1000 ducats was roughly three times the annual salary of a full-time supervising architect at a major building program and more than Herrera's annual salary as royal architect. This fee was for design – drawings and their accompanying memoranda. Herrera described it as payment for 'the time I spent making plans, designs, other reports and paintings of the said merchants' exchange, one of which, by command of his Majesty, is being used for constructing the said merchants' exchange.'[55] Design was the most important part of architecture, and Herrera did not hesitate to treat his expertise as a marketable product.

5
Creating a royal style for Philip II's palaces and public buildings

IN 1552, Francisco Villalpando in his translation of Serlio dedicated to Prince Philip reminded the reader that a prince needs his architects for it is they who 'build the impregnable fortresses in time of war and, in time of peace, the delightful buildings and apartments with all sorts of gardens and amusements.' More important still, architects perpetuate the prince's fame with splendid buildings, for, 'if in reading a history or chronicle of a prince, it seems that we hear his deeds, in architecture we see them' because every stone represents 'the person, majesty, power, and authority of the founder.'[1]

What the portrait-palace of a king might look like was still undecided when Villalpando wrote these lines. Vitruvius had not described Roman imperial palaces, not having lived to see them. While Alberti spoke of the 'intrinsic difference in character' that there should be between a princely palace and a private house, he recommended only a few architectural features that should be specific to a princely residence: a great number of rooms, noble decoration, an open character, and clearly separated quarters for the prince and his consort. Between the palace of a legitimate ruler and that of a strong-man he drew a sharper difference:

A royal palace should be sited in the city center, should be of easy access, and should be gracefully decorated, elegant and refined, rather than ostentatious. But that of a tyrant, being a fortress rather than a house, should be positioned where it is neither inside nor outside the city. Further, whereas a royal dwelling might be sited next to a showground, a temple, or the houses of noblemen, that of, a tyrant should be set well back on all sides from any buildings.[2]

Alberti did not conceal his humanist preference for a legitimate ruler, as *primus inter pares*, whose residence resembles those of his fellow citizens, and the echo of his attitude is found in later writers.

Filarete was writing for the Sforzas in the years after their conquest or Milan, but the palace that he described and illustrated in his *Trattato* conforms to Alberti's description of the city residence of a ruler who does not fear his subjects.[3] An open ground-floor arcade is raised upon a platform and forms a base for a colossal order of pilasters on the main façade. In the sixteenth century, the Farnese chose to build their villa at Caprarola on the plan of a pentagonal fortress, but their urban residence in Piacenza, like their earlier palace in Rome, avoided military imagery.

Alberti saw no fundamental difference between a city palace and a country villa, although he revived the ancient notion of the villa as a retreat to nature and an escape from the responsibilities of urban life. Of all the princely buildings built in Italy in the fifteenth century only the palazzo-villa of Poggioreale in Naples, built for Alfonso of Aragon by Guiliano da Maiano in 1487/8, seems to have been widely viewed as distinctively royal (pl. 57).[4]

If in Italy the architecture of power turned to classicism to define an image of the cultivated, intellectual ruler, a different standard for palace architecture in northern Europe and Spain had been set by seigneurial castles, which in the fourteenth century developed an extravagant and beautiful courtly architecture. By the last quarter of the fifteenth century, feudal castles were being transformed into residential chateaux converting defensive towers and walls into symbols of prestige. In Spain in the early sixteenth century the basic form of a noble residence was still a castle, although it was being transformed there as well. Manzanares El Real, built for Diego Hurtado de Mendoza, has a decorated Gothic courtyard built after 1467 which integrated the amenities of urban living into a fortified building.[5] In 1508–12, La Calahorra was built for Rodrigo Vivar de Mendoza as a fortified castle with a luxurious Renaissance courtyard.[6] In France, a humanist ideal of culture combined with chivalric imagery in Francis I's chateau of Chambord (first projected in 1519, revised design c. 1524) and fused in a new classicizing style at Fontainebleau in the 1540s.

European architects shared the problem of creating an architecture to distinguish the status of the occupant, while the occupants themselves were no less concerned. A royal palace belonged to an 'extended family' of European princely buildings whose owners had been keeping track of each other's projects for generations, if not for centuries. No ruler was more alert to – or better informed about – the palaces of his fellow rulers than Philip and he had first-hand experience of princely buildings in Flanders, England, and Italy. Should a royal palace be palazzo, villa, chateau, or fortress? The answer in the sixteenth century was not obvious to European princes and their architects. In France, Sebastiano Serlio addressed himself to this problem in his Libro VI on 'residences for men of all social levels.'[7] The house of the prince should be the most dignified and splendid of all, but Serlio hesitated between designs based on an Italian palazzo with multiple courtyards like a French chateau and variations of a cross-in-square *donjon* derived from Chambord.

57 Sebastiano Serlio, plan of Poggio Reale in Naples, from Francisco Villalpando's Spanish translation, 1552

His desire to combine humanist and seigneurial is evident, but no clear image of a royal building emerges from his projects.

PHILIP'S RESIDENCES

Charles V had not established a personal palace style. His only new commission, for a royal palace in the gardens of the Alhambra in Granada (projected 1528, begun 1533), embodied the humanist ideal of a villa/palace, but when he ordered the remodelling of the old royal fortresses in Madrid and Toledo, which were the traditional royal seats in Castile in 1537, he did not attempt to transform their feudal character.[8] Prince Philip took over a heterogeneous collection of royal buildings that included the Moorish Alcázar in

58 View of El Pardo in the early seventeenth century. (Escorial, palacio)

Seville, medieval alcázares in Madrid and Segovia and the Italianate palace rising in Granada. The additions made to these buildings in the 1550s were in a simplified Italianate style that did not fundamentally alter their character.[9] In 1559, however, Philip began to impose a new image on his residences.[10] His frame of reference became decidedly European, and unlike his father he wanted northern as well as Italian features.[11]

Philip's European taste was revealed first in his hunting lodges at Valsaín and El Pardo (pl. 58 and 59). Views of these buildings in the sixteenth century look to us like Flemish palaces, as they already did to a contemporary called Jehan Lhermitte.[12] In 1559, the king ordered the elaborate slate roofs for El Pardo and for

59 Plan of El Pardo annotated by Philip II, c. 1560. (Simancas, Archivo General)

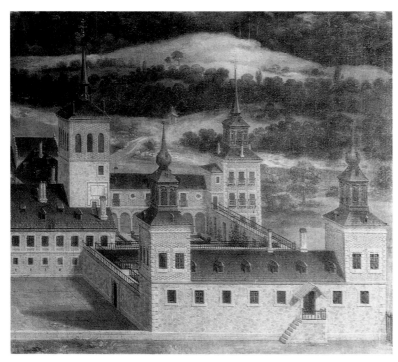

60 View of Valsaín in the late sixteenth or early seventeenth century. (Escorial, palacio)

pleted a ring of residences within a forty-mile radius: at least two major country palaces (Valsaín and Aranjuez), the retreat at La Fresneda, and several hunting lodges, including El Pardo, in addition to the palace in the Escorial and a system of modest overnight stops to connect them (pl. 62). This undertaking had much in common with Francis I's program of palace building around Paris initiated in 1528, when the king abandoned his chateaux at Blois and Chambord in the Loire Valley for buildings within easy reach of his capital. Philip's buildings made a set of royal residences where he could remove himself to enjoy kingly pleasures like hunting, while remaining in contact with his government. They affirmed the seigneurial past in a new image of settled, centralized authority, and their distinctive style distinguished them from the castles of the Spanish nobility.

Valsaín in deliberate imitation of the architecture of Flemish buildings. He also freely rearranged interior apartments and circulation. Some time before 1562, for example, he called for changes to El Pardo which involved moving the chapel and disturbing the regularity of the old four-towered fortress plan. The king wanted a long southern gallery, opening on the gardens, and a tower for his personal apartments added on the southern facade. He said he didn't care if this 'added a certain ugliness to the building.'[13] The chapel was moved but, in the end, his architects prevailed and he gave up the tower. The incident reveals his taste for open galleries and views to the countryside, even for a certain irregularity which he knew to be unclassical (pl. 60).

Not that Philip was uninterested in classicism. He was entirely committed to the Italian Renaissance idea of the educated designer-architect and patron; his own education in contemporary Renaissance style, backed up by such writers as Serlio and Alberti and a collection of contemporary prints and drawings, was oriented towards Renaissance ideas. The ornament of Valsaín was Italianate (pl. 61). Fernando Checa Cremades has suggested that the design of the country retreat at La Fresneda near the Escorial in the 1560s was based on the Renaissance idea of a Roman villa.[14] This is not at all unlikely, but La Fresneda is an instructive example: it may well be a reconstruction based on Vitruvius, but it deliberately recalls a Flemish house with its slate roofs and gables.

Philip was developing country estates where gardens were integrated with the architecture. Both Italian villas and northern chateaux provided precedents for this, but the associations of the northern buildings may have tipped the balance in their favor. Philip had decided to change the traditionally itinerant life of his predecessors and settle his government at Madrid, and he com-

61 Detail of the ruins of Valsaín

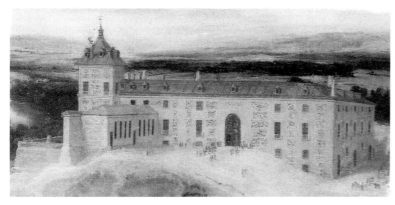

62 View of Aceca in the late sixteenth or early seventeenth century. (Escorial, palacio)

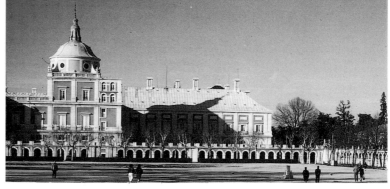

64 View of Aranjuez

PALACE PROJECTS BY JUAN BAUTISTA DE TOLEDO AT MADRID AND ARANJUEZ

If Juan Bautista de Toledo expected a patron in the style of the Farnese or Gonzaga, he must have been surprised to find a prince who wanted towers, Flemish cupolas, and French roofs. Not much in Juan Bautista's experience prepared him for the assignment.

At the Alcázar in Madrid, Juan Bautista added a new tower to the south-west corner of the main façade, the *Torre Nueva*, four stories tall with a high slate roof (pl. 63).[15] The style of this tower was not fundamentally different from the simplified classicism of Gaspar de Vega, which was already established in the royal works: its rusticated windows and quoins recall the combination of Flemish and Italian motifs in the contemporary architecture of Valsaín. Juan Bautista also designed a gallery and royal stables

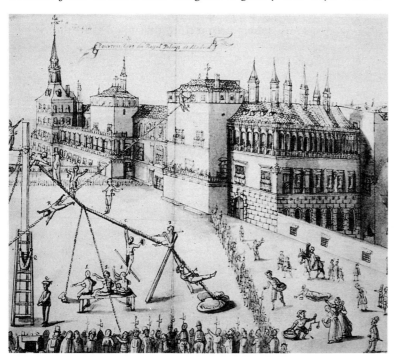

63 Jehan Lhermitte, acrobats performing in front of the Alcázar in Madrid, 1596. From his *Passetemps* (Brussels, Bibliothèque royale)

framing the square in front of the palace in the same style. He succeeded in integrating his classicizing vocabulary with the northern spires that the king wanted, but, purposely or not, the medieval character of the old Alcázar was never disguised, although it was eventually masked on the south by a new main façade, designed and built by Juan Gómez de Mora between 1608 and 1630.[16] At Madrid, Philip chose to affirm an old symbol of feudal authority rather than build anew.

The palace at Aranjuez was a different kind of program altogether (pl. 64). It stands on a large estate south of Madrid that had been royal property since the reign of the Catholic Kings.[17] An old building was allowed to remain while Juan Bautista de Toledo designed and executed the new residence. In 1561 he was preparing designs for the chapel.[18] After 1567, Geronimo Gilli and Herrera completed the chapel, making a few changes to its elevation.[19] Only on 16 April 1574 did Herrera order work to begin on the western wing that was attached to it.[20] Aranjuez was still unfinished at the end of the century when construction lapsed, and when work was taken up again in the seventeenth and eighteenth centuries the western façade was rebuilt, the chapel interior was redone, and new wings were built in 1771, so that the overall appearance is now that of an eighteenth-century building.

Juan Bautista's original designs are lost, but a set of plans of the palace prepared by Juan Gómez de Mora in 1636 claims to copy the 'old designs' [*las trazas antiguas*].[21] We do not know whose sixteenth-century drawings he was using, but it is likely that Juan Bautista roughed out plans for the whole palace. The layout of the main block with a central courtyard is similar to his plan of the royal palace at the Escorial, although Aranjuez was intended to be a more open building with arcades on the western façade and open galleries overlooking the enclosed private gardens of the king and queen on the south and north (pl. 65).

It has been pointed out that the loggias and the square pavilions at Aranjuez recall Alfonso of Aragon's villa of Poggioreale in Naples mentioned earlier, a building that Juan Bautista must have known. But this reference was probably one of many resemblances among princely buildings. Francis I, whose architects may have been influenced by Poggioreale when designing Chambord, may himself have been influenced by the Casa de Campo in Madrid

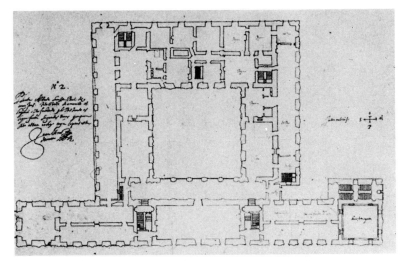

65 Juan Gómez de Mora, copy of an old plan for Aranjuez, prepared in 1626. (Vatican City, Biblioteca Vaticana)

when he comissioned the new chateau of Madrid outside Paris (pl. 66).[22] The corner pavilions of Aranjuez – the one containing the chapel is very high with a visible cupola – suggest the pavilions of Francis I's Madrid more than the Poggioreale represented in Serlio, and the separated volumes and placement of the chapel in a corner tower French ideas.[23]

Beneath these references is the common theme of a loggia façade. The first designs of Chambord, the chateau of Madrid, the Casa de Campo, and Aranjuez all allude to it. Serlio, who admired Poggioreale, was preoccupied with the idea in his projects for Book VI. The fortunes of the open ground-floor arcade may be followed down to Bernini's first project for the Louvre in the later seventeenth century. The most obvious connection among these permutations on a theme is through rulers, who probably wished to emulate each other's buildings, but the original motivation may have been the symbolic. An open façade conveyed accessibility, suggesting that the king's house is the house of his subjects.[24] Alberti spoke of the public character of a princely palace (in contrast to a tyrant's fortress) where people would be expected to 'go everywhere,' and Serlio identified the splendor of Poggioreale with peace.

Philip's idea of a palace set in a large wooded park with ponds and canals, however, was northern – Flemish like the palace of the Dukes of Brabant in Brussels, or French, like Fontainebleau, even though the brick walls with white stone ornamentation reflect traditional Spanish building, as at the Casa de Campo. It is as if he wanted an updated version of a country palace that combined the best of contemporary French chateaux and Italian villas. But Philip may not have known exactly what kind of palace he wanted. Aranjuez could have set a style for his palaces had its architect lived to complete it, but the king did not designate enough money for the building.[25] He clearly preferred to invest in the park and gardens (See below chapter 8). Only in interiors did Juan Bautista's Italian taste triumph without resistance. Royal apartments, even in buildings that were otherwise strongly marked by Flemish or Spanish features, were filled with mythological scenes and colorful grot-

teschi in stucco and fresco. This Renaissance decor seems to have been executed almost industrially by teams of Italian artists in Madrid and El Pardo.[26]

HERRERA'S MODIFICATIONS TO ARANJUEZ

Philip's palace program was sketched out by 1567, and, except for the royal palace in Lisbon, the next thirty years of the reign saw no new projects. Juan Bautista de Toledo had not set a clear stylistic direction, however, and not enough evidence remains for us to speculate what he would have accomplished had he lived longer; he seems to have been experimenting right up to his death. It was Herrera who united the disparate traditions of the king's buildings by unifying their eclectic motifs in a new, distinctive style.

Herrera respected Juan Bautista's overall plan for Aranjuez, but he radically altered its main façade. A painting that is thought to represent Herrera's project shows these changes (pl. 67). Juan Bautista's open arcade was replaced by a closed, flattened façade whose high avant corps served as the backdrop for a schematic temple front with the king's coat of arms.[27] Two corner pavilions, three stories high with lead covered domes and lanterns, are separated from the central section by two-story wings. On both levels white stone pilasters between large windows with white stone frames and rectangular stone panels set above them stand out against brick walls. There is a balustrade with bolas in front of a steep roof and dormers (pl. 68, 69, 70).

Herrera synthesized and unified disparate references to foreign architecture. The avant-corps, visible roofs, and high pavilions ultimately derive from northern building and the severity of the project recalls Du Cerceau's illustrations of the southern façade of Lescot's Louvre and Valery.[28] Juan Bautista's open façade was replaced by a more stately architecture that alluded to the corner towers of the Alcázar in Toledo and to the Escorial whose avant corps and basilica façade provided its basic ideas. These became references that signaled a royal building. Philip had adopted a classicized image of a chateau in his royal residences.[29]

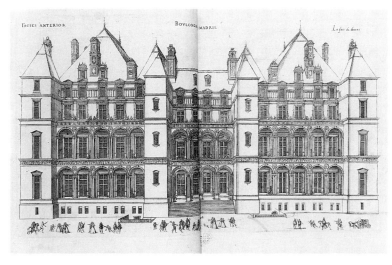

66 Jacques Androuet Du Cerceau, Francis I's chateau of Madrid outside Paris, from *Les Plvs Excellents Bastiments de France*, 1576

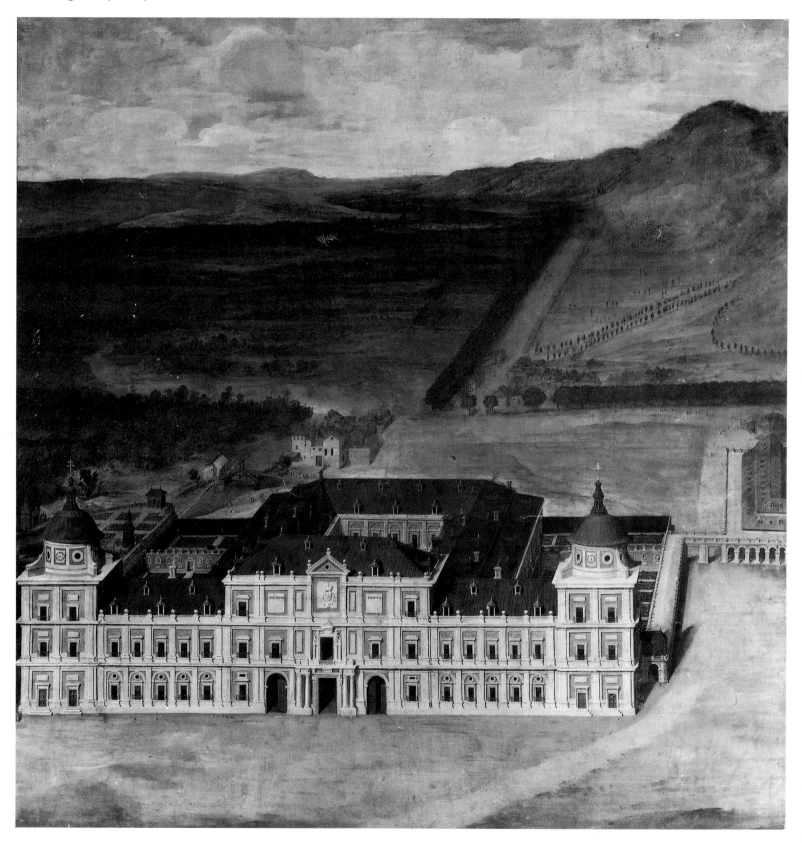

67 Undated painting of Herrera's project for Aranjuez. (Escorial, palacio)

68 Side view of the chapel and walkway at Aranjuez

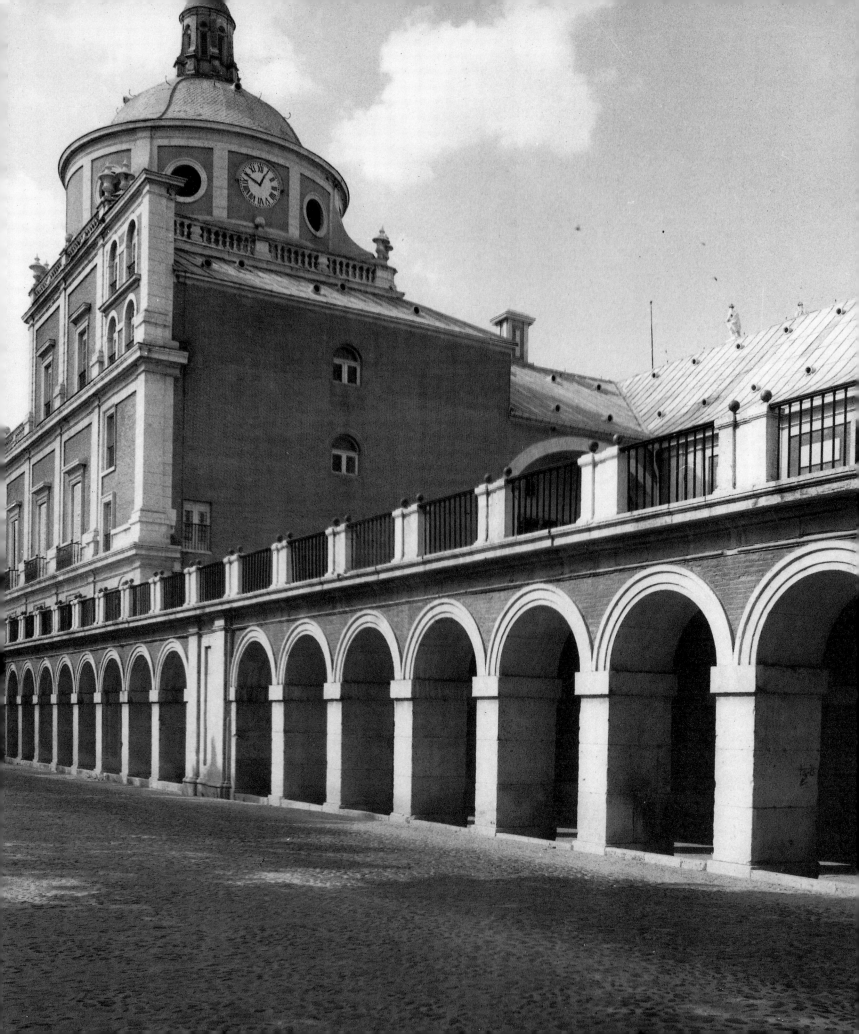

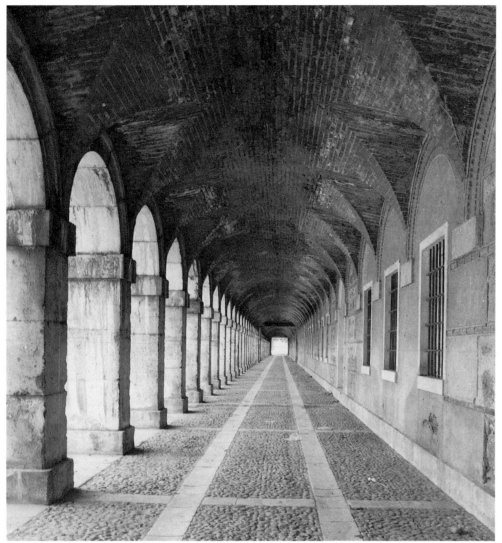

69　Interior of the walkway at Aranjuez

70　The Casa de Oficios at Aranjuez

THE ALCÁZAR IN TOLEDO

The Alcázar in Toledo was a real fortress, the residence of Spanish kings since the Reconquest and the seat of royal authority in the capital of New Castile. It was the symbol of Toledo's status as a capital and, later, an imperial city. Charles V had ordered its rebuilding by Alonso de Covarrubias and Luis de Vega in 1537, at the same time that he commissioned the rebuilding of the Alcázar in Madrid. Covarrubias seems always to have been the principal architect in Toledo and the old rectangular building with its four corner towers was transformed under his direction. Between 1543 and 1570, a new façade between the towers on the north and a large and elegant courtyard were built in Renaissance style (pl. 71).[30] The monumental staircase was planned and a southern façade may have been projected. Lacking funds, however, construction proceeded slowly and a number of revisions to the designs were made. Covarrubias employed Francisco de Villalpando, the translator of Serlio, to build the courtyard in a more classical style, and other changes were prompted from outside by Philip or his overseers. When Herrera became involved in the early 1570s, the southern façade and main staircase were the major elements still to be completed.

In 1570, Herrera and Jerónimo Gilli, who was the official overseer from Madrid, inspected the works. At this time, their attention was concentrated on the southern wing of the palace. Covarrubias had designed a monumental open-well staircase facing the courtyard, but there was little space remaining between the stairwell and the extant masonry of the old southern façade. The problem was not immediately solved. Gilli took charge in 1571 while Diego de Alcántara, who later became a loyal executant of Herrera's designs, was made executant architect. Collaboration between Gilli and Alcántara turned out to be impossible, although the basis of their disagreements may have been simply personal rather than stylistic, for Gilli was an irascible character who disliked working in the king's bureaucratic system. Little was accomplished during the next several years. In 1574, after Gilli resigned and went back to Madrid, Herrera requested plans of the building and took charge of its design.

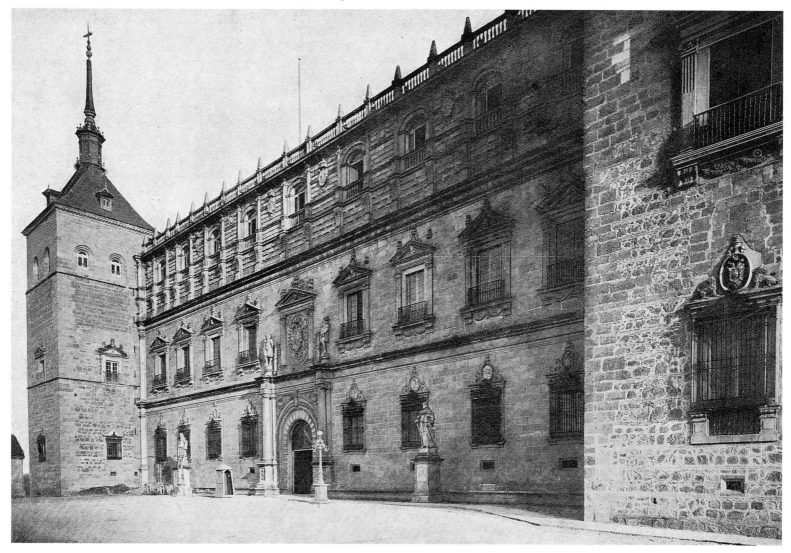

71 Alonso de Covarrubias, northern façade of the Alcázar in Toledo, commissioned in 1537

Creating a royal style

Herrera chose to continue the southern façade in the simplified classicism which first appeared in Philip's projects of the 1550s and had attained a measure of authority with Juan Bautista's additions to the Alcázar in Madrid (pl. 72). One of the few drawings for the Alcázar in Madrid by Juan Bautista to survive shows a three-story façade topped by a balustrade rising over a base of rusticated arches.[31] The bays of the upper stories are framed by pilasters with single large windows set between them. Juan Bautista's entire composition is a strikingly simple Doric in which paired pilasters are almost treated as a single notched pilaster on a common pedestal and the fourth-story pilasters have no capitals at all (pl. 73). Juan Bautista's and Herrera's compositions recall Guilio Romano's architecture or the brick and stone façades of Vignola's Villa Farnese at Caprarola.

Simple as it is, Juan Bautista's façade nevertheless has a clear tectonic structure: the composition is a symmetrical five bays; the rustication of the base is bold and supportive of the two main stories; and the classical membering is clearly distinguished from the walls. Herrera's façade is ten bays long and lacks even an imaginary center axis. The distinction between base and super-structure is blurred by rusticating the pilasters in the upper story and flattening the stonework on the ground floor. As a result, Herrera's façade looks like a vast, textured screen stretched between the towers, an effect that is alien to the spirit of Juan Bautista's composition (pl. 74).

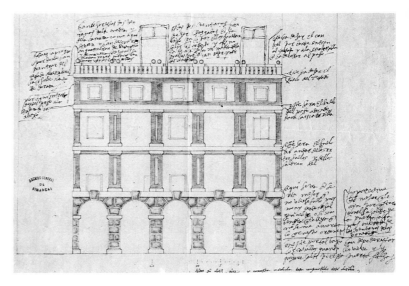

73 Juan Bautista de Toledo, drawing for corridor at the Alcázar in Madrid, 1562. (Simancas, Archivo General)

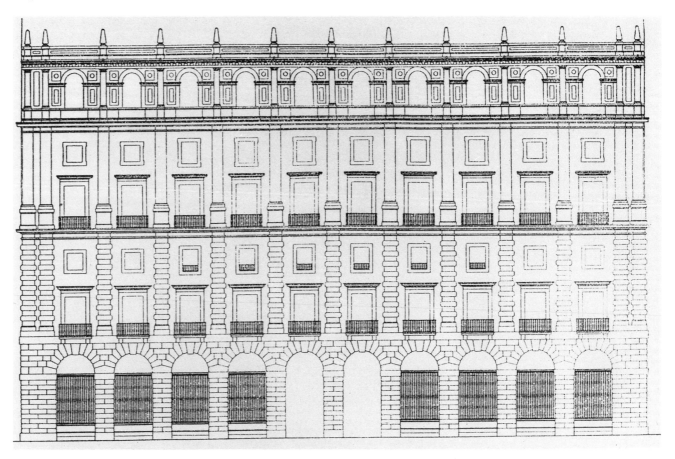

72 Herrera, southern façade of the Alcázar in Toledo, designed c. 1574 (after Ruiz de Arcaute)

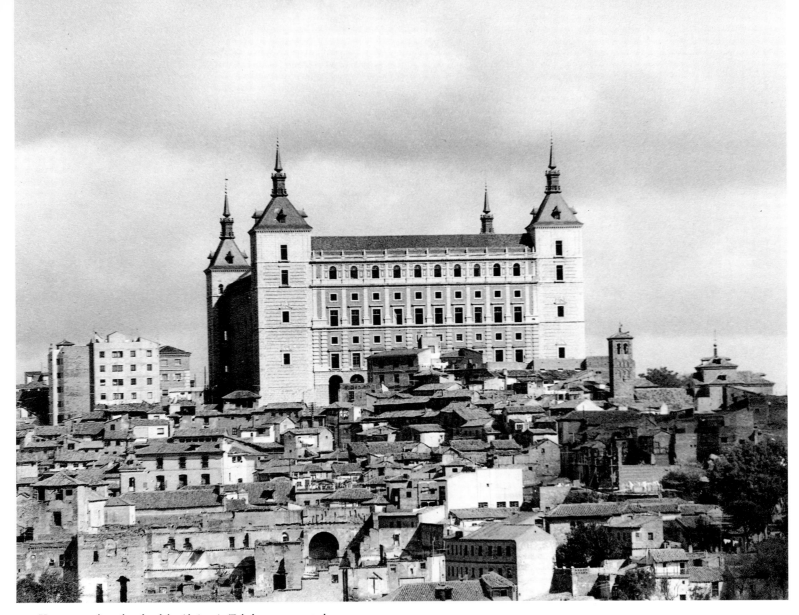

74 Herrera, southern façade of the Alcázar in Toledo, reconstructed

Herrera's bays are tall and narrow and embrace two superposed windows in the two main floors. The window frames and geometric pattern of the rustication create a surface animation that is accentuated in the fourth story, where round-arched windows, moldings and attached panels of white stone create an agitated pattern of diminutive serlianas between the small pilasters. This composition is related to Covarrubias's earlier northern façade where stories of roughly equal height are treated as an animated surface of decorated stone. In Covarrubias's upper story, rustication, sculpture, and classical ornament are overlaid. Herrera's ornamentation is simpler, but the two façades go well together in spite of their differences as Herrera must have intended.

Herrera took up another traditional feature of Spanish architecture in his designs for the ceremonial staircase that led to the main hall on the south and served the upper level of the courtyard. Covarrubias, who was responsible for a whole series of symmetrical staircase designs based on the traditional Spanish open-well staircase in the 1540s and 1550s, had planned a symmetrical staircase, facing the courtyard (pl. 75). La Calahorra classicized staircase design at the beginning of the sixteenth century and Covarrubias

and others continued to use the type until the 1540s (pl. 76, 77, 78). At the Alcázar he placed two open-well staircases of three flights symmetrically side by side and combined their first flight. This produced a grand staircase that rose to a landing and then branched off left and right in two straight flights turning at landings to straight flights that reached the upper gallery of the courtyard. This design was revised once by Francisco de Villalpando in 1553 and again by Herrera in 1574.[33]

Covarrubias' staircase was designed like an open E and this arrangement was preserved in the final design (pl. 79, 80). The first floor of the Alcázar is, however, extremely high. If, as is believed, the depth of the stairwell was the same as the present one, Covarrubias's first staircase would have been extremely steep. This was perhaps a reason for widening the central flight and also for extending the length of the staircase by yet two more bays, since this made it possible to have longer lateral flights and a more gradual ascent. Covarrubias was not adverse to flights of different lengths, although, in his original five-bay design, they were apparently identical. He did not, however, use radically different widths. The relation among the flights is important because they,

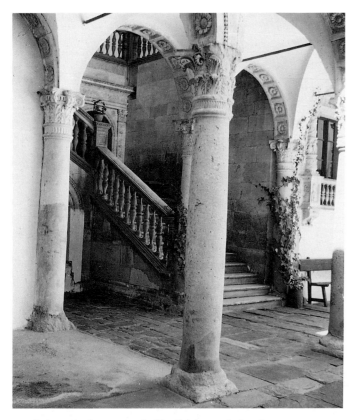

75 Staircase in the courtyard of La Calahorra, designed 1509

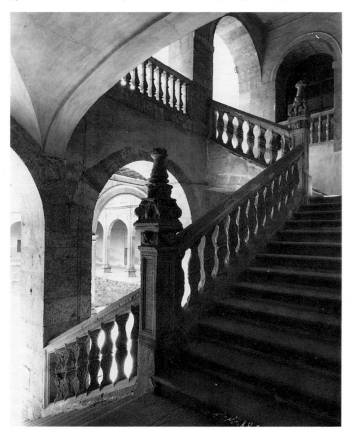

76 Diego de Siloe, staircase in the Fonseca College in Salamanca, designed in 1529

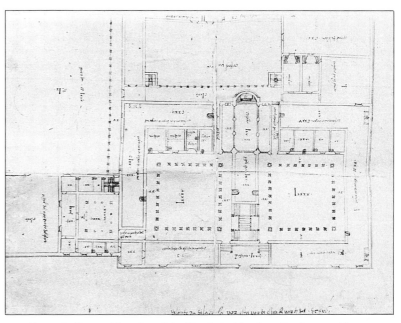

77 Alonso de Covarrubias, plan of the Hospital of San Juan Bautista outside Toledo, 1541. (Toledo, Archive of Hospital Tavera)

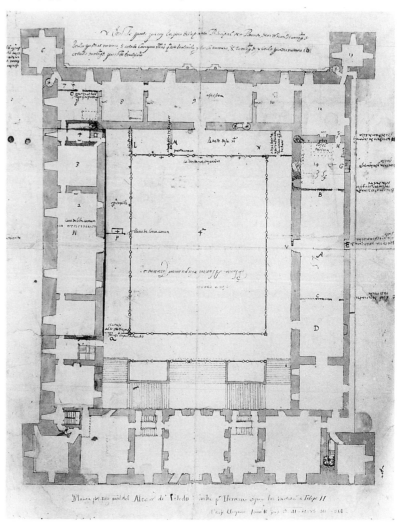

78 Plan of the Alcázar in Toledo with notes by Herrera, 1581–5. (Madrid, Biblioteca Nacional)

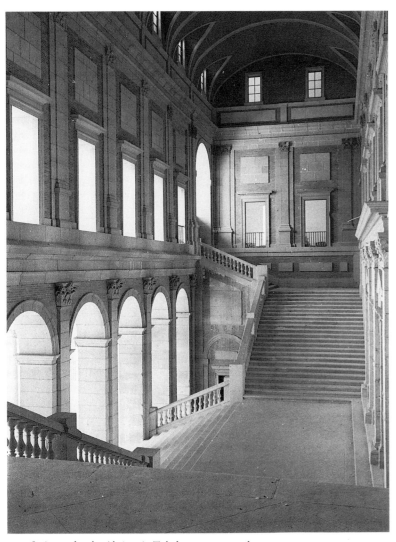

79 Staircase for the Alcázar in Toledo, reconstructed

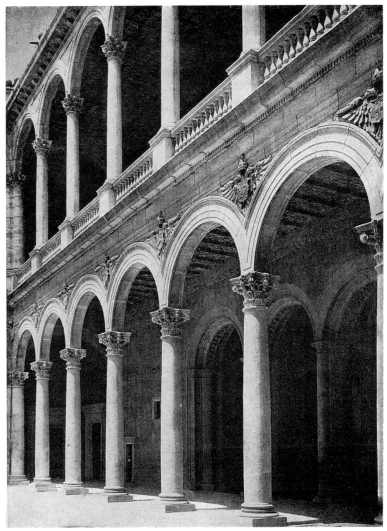

80 Francisco de Villalpando, courtyard of the Alcázar in Toledo, designed c. 1550

rather than the stairwell, were the principal element in his composition. Covarrubias's staircases had decorated balusters and rich ornamentation on the supporting walls of the flights, and the stairwell, except for its ceiling or vault, was always left conspicuously plain. Covarrubias's original design for the Alcázar, in which the flights were still close together, would have been similar.

The revised design of the staircase created a unified space of imposing scale. The stairwell was nearly twice that of the original layout, and flights spread far apart. Nothing in Covarrubias's or Villalpando's experience, as far as we know it, prepared them to deal with a space that so dwarfed the stairs.[34] Construction stopped until a solution was found. Herrera made the stairwell rather than the flights a major element in the design. Using piers facing the courtyard, rather than the columns favored by Covarrubias, he enclosed the upper story, separating the staircase from the courtyard. The walls of the stairwell were designed like an exterior façade wrapping the interior.[35]

Herrera's additions to the Alcázar in Toledo established the public image of Philip's palaces as one of aloof authority. The

southern façade, which has no main entrance, is most effective seen from a distance. The giant arches of its base are forbidding, a sign of power rather than an invitation to enter. Northern and Spanish features (roofs, towers, fortress imagery) are combined with Italian classicism (rustication, pilasters, pedimented windows) in a composition that resembled other royal buildings. This exterior provided Herrera with the elements for his royal palace in Lisbon and Juan Gómez de Mora with the model for the new façade of the Alcázar in Madrid.

ALTERATIONS TO THE PALACE OF CHARLES V IN GRANADA

The incompatibility between Renaissance principles, as these were understood in Italy, and the idiosyncratic classicism that Herrera devised for the king's palaces is clearest in his modifications to the royal palace in Granada, which was a showpiece of Renaissance classicism and is still the most purely Italian building in Spain (pl. 81). The designs were apparently drawn up by the Italian

trained painter and sculptor, Pedro Machuca, who became the first master of the works in 1528, and the square palazzo with round central courtyard (pl. 82) derived from Italian projects. Construction began in 1533 and continued until 1550 when Pedro died. He was succeeded by his son, Luis, who continued the work until 1571.

Herrera became involved in 1572 when he looked over the application for the position of master of the works by the Andalucian architect, Juan de Orea, who sent him drawings and a report on the current state of the building. From this time, the designs were carefully scrutinized in Madrid: in 1574, Orea was in Madrid consulting directly with Herrera. In 1580, at the same time that he was planning the new royal palace in Lisbon, Herrera reviewed the plans again.[36] The designs that were approved at Badajoz in 1580 governed the project henceforth. In 1584, Juan de Minjares was sent over from Seville to be master of the works. For the next thirty years, while architects came and went, Herrera's designs remained the model for the architects at the palace, and they were still cited in 1644.

Herrera's transformations were in conflict with the spirit of Machuca's original project. Herrera may have looked at Machuca's version of Bramante's Palazzo Caprini façade when he designed the façades of Philip's palaces in Toledo and Lisbon, but when he came to modify Machuca's designs he showed no more respect for them than for any other alien style. He planned to raise the height of the

81 Pedro Machuca, detail of the main façade of the palace of Charles V in Granada, designed 1533
82 Pedro Machuca, courtyard of the Palace of Charles V in Granada designed 1533, continued on Herrera's revisions by Juan de Minjares after 1582

chapel above the roof line, to add a steep roof and dormers to the entire palace, and to simplfy and flatten Machuca's ornament. The 'Burlington elevation', dated by Earl Rosenthal between 1574 and 1580, shows what are probably Herrera's addition of a balustrade at the top and a simplification of the central portal.[37] Herrera's style is visible in the western vestibule where all the elements are unified with the surface. The angles of doorways are cut through the wall and emphasize the relation between the circular wall and its undecorated annular vault.[38] Fortunately, not all Herrera's modifications were executed. The visible roofs would have destroyed Machuca's scale and can be explained only by Herrera's or the king's desire to give a common appearance to all his palaces.[39] Herrera's modifications turned out to be relatively minor because Philip was not much interested in this building and simply wanted to finish it. Even so, the palace was never completed.

THE PAÇO DE RIBERA IN LISBON

The rebuilding of the palace in Lisbon was Philip's last palace project and Herrera's most ambitious design for a royal residence. The occasion for it was provided by the Spanish conquest and annexation of Portugal undertaken in 1580 (pl. 83). While Philip was awaiting the outcome of his invasion in Badajoz, plans of existing Portuguese palaces were drawn up by the Italian, Felipe Terzi, architect of the previous regime in Lisbon, and submitted to the king.[40] Herrera was with the king and revised designs for other royal buildings at this time, so that even though his role is not documented it is virtually certain that he was involved in the design for the additions to the Paço de Ribera.

Construction was supervised between 1580 and 1598 by Terzi and the Italian engineer, Juan Bautista Antonelli.[41] These buildings were destroyed in the Lisbon earthquake of 1755, but some sense of the exterior architecture can be had from later views which show an enormous tower overlooking the waterfront. This structure, called the *Torreão*, rose on a fortified base, one hundred feet square, in four stories to a huge domical roof and lantern. The façades were treated as two principal stories of five bays with colossal paired pilasters at the corners and single pilasters between monumental pedimented windows. Pedimented *lucarnes* were set into the roof. The exterior architecture was executed in white stone, whose perfect pattern of joinings was remarked on by contemporaries.

The interior arrangements at Lisbon are not known in detail, but descriptions make it clear that the great tower contained the king's guard and armory in its basement. Above were lodgings for important members of the court. On the second floor were the library and reception rooms, while the top floor was occupied by the richly decorated Hall of the Ambassadors and the king's private apartments. The Hall of the Ambassadors was reached from a monumental staircase in the new wing at the base of the tower which connected to an immensely long gallery on the floor below (pl. 84). The exterior architecture of this gallery was a simpler version of the tower and thus probably conceived at the same time. It is worth stressing that the sequence of a long gallery, reception hall, and private apartments, which is not Italian, recalls Charles V's additions to the royal palace at Brussels, which both Philip and Herrera knew well, while the promenades at the top of the tower recall the roof terrace at Chambord.

The Lisbon addition departs from the alcázares of Madrid and Toledo. There were no Portuguese precedents for such a design either and, as George Kubler pointed out, its antecedents were partly French. Herrera could have found the high wooden domical roof on a square base in Philibert de L'Orme's *Nouvelles Inventions pour bien bastir* (pl. 85) or in Jacques Androuet Du Cerceau's illustration of Verneuil in *Les Plus Excellents Bastiments de France*.[42] The raising of a stylar façade on a rusticated base harked back to Roman Renaissance palaces, but Herrera accentuated the image of a *donjon* in the base with battered walls, and he transformed the idea of a palazzo by the addition of the dome with French dormers. This is as close as Philip II came to evoking the fortress-palace of a tyrant, described by Alberti long before. The white stone façades contrasted with Philip's usual preference for simplicity and may have been a concession to local tastes.[43] Juan Gómez de Mora called the palace a combination of a fort and a palace in 1626, but most observers stressed its splendor and the beauty of the public square in front of it.[44]

Herrera's tower in Lisbon was different from most palaces of its time, and even the most tolerant view of Italianism will not stretch to include its eccentricity. Too big and broad to be a tower in the usual sense, it was much too high to be anything like a conventional *palazzo*. It was always known as 'the tower.' Part medieval *donjon* and part palace, it dominated the harbor like a lighthouse, which its position and overall shape recalled. It loomed like a fortress in the cityscape, guarding the king and Portugal with the cannon in its base. Yet the white stone façades with their large windows and open balustrade proclaimed a princely residence. Above the rusticated base with its small plain windows – the station of the garrison – the royal apartment looked down generously upon its subjects in the open city square, and, from its upper belvedere, the king could scan the sea. For all its associations in the past, this was a fully modern building whose gleaming façades and huge dome recalled the most ambitious contemporary European palaces. It was as classicizing as the Farnese palace at Piacenza and more imposing than the riverfront façades of the Louvre.

The Lisbon tower is unimaginable as anything but the abode of a ruler. A later observer, noting its kingly presence, remarked that it 'displayed the majesty and design' of Philip himself.[45] It is perhaps no accident that it predicts Bernini's final project for the east façade of the Louvre in 1669, since both designs sprang from similar roots and developed parallel solutions.[46] Herrera and Bernini both gave up the sense of ordered space and human scale that the Italian palazzo façade had managed to achieve – a process that was difficult for Bernini – in order to assert isolation, detachment, and colossal scale. Their designs depended chiefly on large volumes over which their ornamentation could be applied indefinitely. This proved to be especially suitable for the long façades of later royal palaces like Versailles, and conveyed precisely the tone considered appropriate for the architecture of seventeenth-century monarchy.

The symbolism of Renaissance classicism was based upon complex structures of associations. As forms and usages changed, so did

83 View of the Lisbon waterfront showing Philip II's palace, designed 1580. (Paris, Bibliothèque Nationale)

meaning. Unlike Pierre Lescot, Philibert de l'Orme, and most Italian architects, Herrera thoroughly modernized and schematized architectural forms, deliberately removing many of the associations of antiquity and the rich figural iconography based on the orders that characterized Renaissance classicism in France and Italy. Compared to other princely buildings, Herrera's simplicity, plainness, and repetition may look like a recipe for monotonous architecture, but this restricted vocabulary, drawn from models that had been approved in theory and recognized in practice, made possible a new kind of architectural unity and symbolic content.

Philip's palaces, which by choice had few if any inscriptions and no exterior sculpture to explain their purpose, relied on architecture to assert their meaning. The explicit similarities between the façades of Madrid, Toledo, and Lisbon – the repetition of individual elements, like the balustrades, as well as the similar composition of pilasters and windows – were like the visible roofs and towers on the king's other palaces. They created a resemblance among his buildings that signified the presence of royalty and, through repe-

tition, affirmed the extent of royal power. Antiquity was not banished from these buildings – Herrera's pilasters and rustication could not be mistaken for anything but classicism – but his ornamentation does not celebrate ancient culture. It is at once classicizing and modern, much like Philibert's wooden domes which he asserted were inspired by antiquity but surpassed anything done by the Romans. Based upon canonical motifs and purged of individuality, Herrera's palaces conveyed the order and authority that were associated with classicism, recasting it in an unmistakably modern guise. These palaces did not resemble anything in earlier Spanish architecture, but they were probably not supposed to, any more than Charles V's palace in Granada had: royal architecture sought to be both distinctive and unmatched, like the king it represented.

Philip's distinctive classicism was exclusively his own and he did not encourage its imitation by the Spanish nobility. In a few instances, however, he did impose it in a public context where the identification of the king in the architecture, while not necessarily

84 View of Philip's palace in Lisbon. (Paris, Bibliothèque Nationale)

85 Philibert de l'Orme, project using wooden vaulting in *Nouvelles Inventions pour bien bastir et à petits fraiz*, 1561

to be expected, was inescapable and therefore inevitably significant. Philip's program of public works will be examined in the last chapter, but two building programs which illustrate the transference of style from the royal residences to public buildings may be briefly considered here.

THE CITY HALL IN TOLEDO

The city hall in Toledo employs a rusticated lower story, arcades, balustrade, and Doric columns. Had Herrera's plans, which were prepared in 1574, been followed faithfully, the building would have looked more like Serlio than it does (pl. 86).[47] What is most remarkable, however, is that Herrera reproduced the ornamental vocabulary of the Escorial with great fidelity. The rusticated base recalls the retaining walls on the southern side of the Escorial, while the engaged Doric columns, pilasters, and empty niches are those of

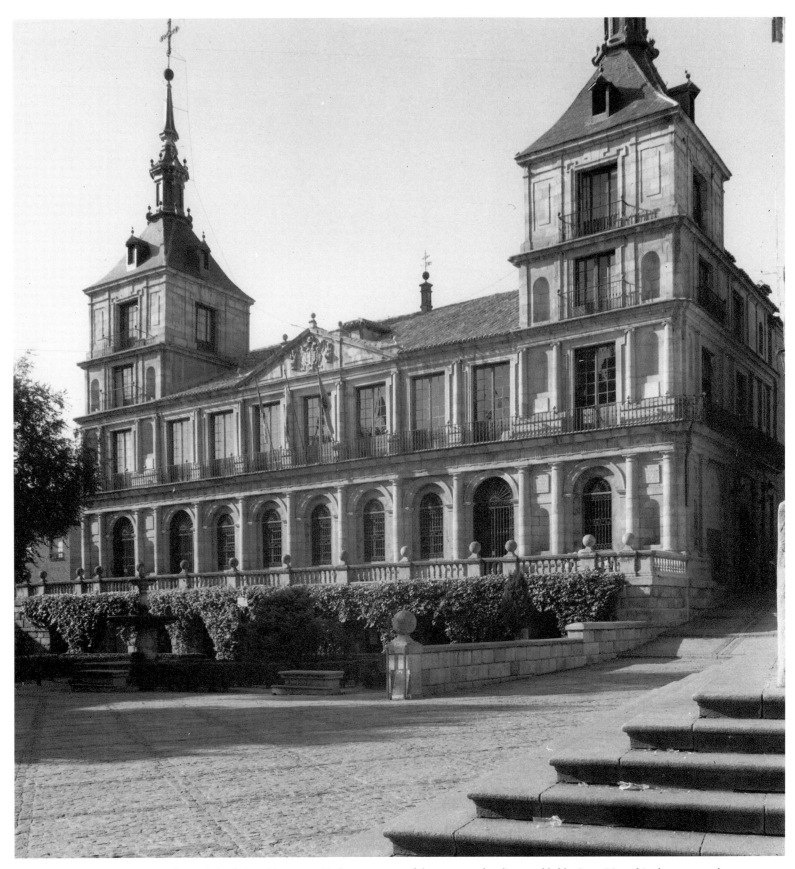

86 Herrera, façade of the City Hall in Toledo, designed in 1574, with the upper parts of the towers and pediment added by Jorge Manuel in the seventeenth century

the façade of the basilica designed at about the same time. Using the orders to organize the façade of any building other than a church was rare in Spain, and there was nothing like this in Toledo – not even Herrera's southern façade of the Alcázar is as close to the Escorial as the city hall, which duplicates not only motifs but also the material and workmanship of the monastery.

THE MERCHANTS' EXCHANGE IN SEVILLE

Philip's desire to be identified with a building program that was not in the strictest sense his, and Herrera's use of northern motifs to seal this identification, emerge from the constructional history of Herrera's most famous, and perplexing, building – the merchants' exchange in Seville. It was built at a time when Herrera was royal architect at the height of his powers, but it was also very much the king's work, architecturally as well as institutionally (pl. 87).[48] The creation of permanent quarters for Seville's merchants was discussed with him in May 1572. By August, a site adjacent to the cathedral and near the royal Alcázar had been selected and negotiations begun for the expropriation of land and structures. Herrera was involved from the beginning. On 13 November 1583, he stated that he had been working on 'plans, designs and other memoranda and depictions' of the exchange since 1572, but apparently he had made a new design or revised an old one that had just been approved.[49] Philip issued official approval of the design on 11 July 1582 from Lisbon; only then could construction proceed. Juan de Minjares was appointed *maestro mayor* of the works on the exchange in Seville and at the palace of Charles V in Granada.[50] When a plaque was put up over the entrance in the middle of the northern façade facing the cathedral to commemorate the completion of the ground floor in 1598, it identified the exchange as the king's undertaking, even though the merchants had paid for it.[51]

The exchange is Herrera's most important civic building, larger and more ambitious than the city hall in Toledo, begun a decade earlier. It sits on a huge square platform isolated on all sides in its own plaza, surrounded by stone posts and an iron chain. The whole building was slightly elevated by several steps in order to regularize

87 Herrera, merchants' exchange in Seville, designed 1582, built by Juan de Minjares and Alonso de Vandelvira 1584–99, completed in the early seventeenth century

the site, in a manner that reminds us of a classical reconstruction after Vitruvius while the central courtyard is austerely classical in the manner of the Escorial (pl. 88).[52] To the critical eye of José Gestoso y Pérez in the nineteenth century, this was the kind of architecture that satisfied the most exacting of classical tastes 'for whom the simplicity and severity of its lines, the perfection of its proportions, the austere and cold correction applied to its large masses were the distinctive qualities... [of] the most finished and accomplished expression of artistic perfection.' Gestoso considered the exchange to be a building of the intellect, a monument of reason as opposed to feeling.[53]

Even today, the sense of the architecture is considered to be most fully revealed in its geometrical plan, which Fernando Chueca has called 'one of the most perfect in Spanish classicism.'[54] Perfect the exchange was intended to be, but its abstraction is not what we generally associate with the beauty of Renaissance architecture. Compared to Jacopo Sansovino's library in Venice, for example, Herrera's exchange is closed and lifeless. Its pilasters allude to classicism without conveying vigor or physical beauty. As a result, Herrera's composition looks stiffly dignified rather than dynamic. A late French engraving, which is inaccurate in other respects, captures this quality as well as Herrera's careful siting of the building in relation to the cathedral.

As it stands today Herrera's exchange looks italianate and is always understood as one of the most complete examples of Italian classicism in Spain. There is, however, one detail which jars in this classical context, the four obelisks at the corners that have always seemed ugly and out of scale. It is generally assumed that this obvious solecism is to be blamed on Herrera's executant architect, Juan de Minjares, who either designed them himself or misinterpreted Herrera's drawings.

Although this seems at first like a reasonable explanation, we know Juan de Minjares to have been a faithful executant. In fact, he owed his career as a trusted assistant to his ability to follow Herrera's drawings exactly. It is therefore unlikely that he would have introduced his own decoration, especially such a prominent motif. As for his misunderstanding Herrera's intention, that is even more improbable. Herrera's elevation drawings, like those he made for the cathedral of Valladolid and for the city hall in Toledo, would have been difficult to misinterpret for they would have been complete and have shown the obelisks drawn to scale.

The obelisks are not ugly in themselves; their style is purely Herreran (pl. 89). They are carefully disposed and their tapering at the bottom is an original invention that gives them the independence of a statue. In fact, examined separately, these obelisks are quite remarkable and they make a disastrous impression only because of their architectural setting.[55] A later print reduced their size drastically in order to make the building appear more classical. (pl. 90)

If we look once again at Herrera's exchange, it does seem to refer to Italian models, but unlike those, or, for that matter, Spanish precedents, it is not a covered hall. It is conceived as an remarkably fluid interior space defined by piers and opened on to central courtyard. This conception comes much closer to northern public buildings like the exchange in Antwerp or the later exchanges in

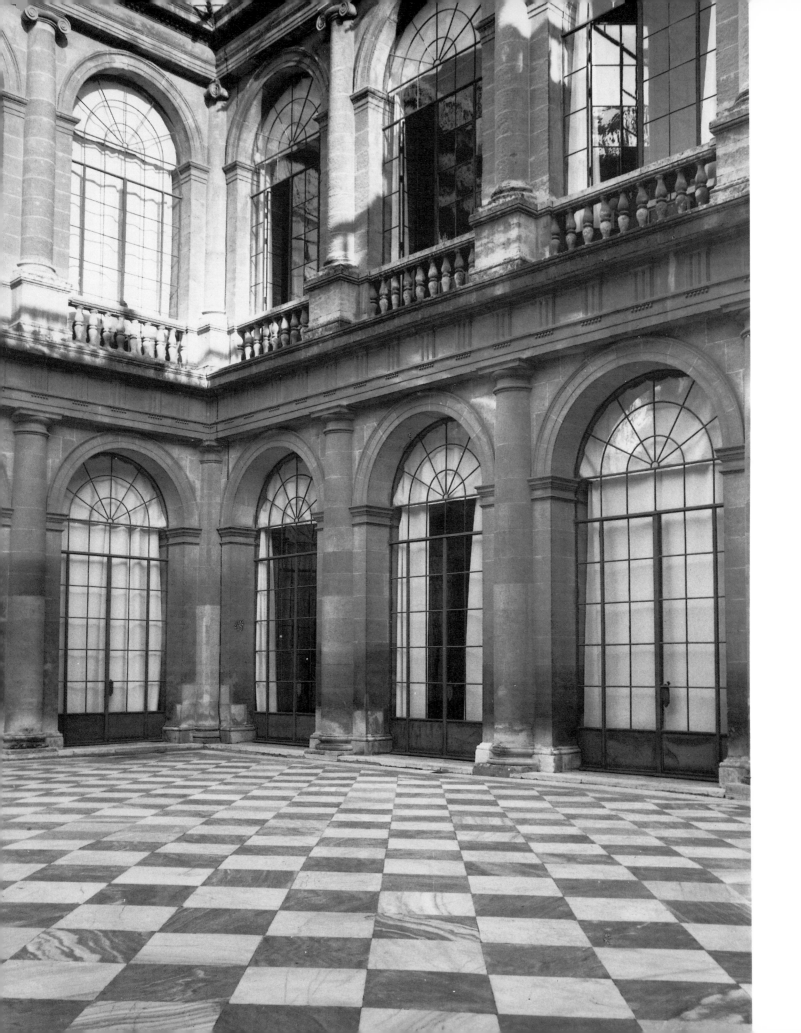

89 Herrera, detail of the exterior of the merchants' exchange in Seville

90 Herrera, the merchants' exchange in Seville. (Paris, Bibliothèque Nationale)

Amsterdam and London. Of course the northern examples look totally different, and one fundamental difference is their large picturesque roofing.

The exchange is the only building executed by Herrera's assistants which does not have a prominent roof. Furthermore, the final design was approved at a time when Herrera was involved in the enormous wooden roof for the palace in Lisbon and had just projected the addition of a steep lead-covered roof for the royal palace in Granada, which hardly called for one. A few years later, the bakery in Madrid, which is in many ways similar to the exchange, was given just such a roof and dormers.

In fact Herrera did design a roof for the exchange as is evident from written documents. In the late 1590s, after the courtyard had been completed, the administrators began a hectic search for pine trees. At least seven hundred trees had been paid for in 1601 and many had been cut to the required lengths for the timber roof when, in September 1609, the administrators on the advice of their architect, Juan Bautista Zumárraga, gave orders to substitute stone vaults for the wooden superstructure.[56]

If the roof was planned, why was it not executed? Seville was a city with her own independent classical tradition where Philip's Flemish taste did not have much meaning, and, later in the seventeenth century, when the problem of roofing became a major issue, the cost of such a huge structure may have seemed extravagant. It was easy enough to abandon the roof and substitute a series of exposed stone cupolas, but this altered the character of the building considerably, leaving only the four obelisks as a strange testimony to Herrera's original intention. It was the king who initially wanted the high slate- or lead-covered timber roofs that Herrera made into the signature motif of the royal buildings, and it would seem that Philip wanted his monument in Seville to have one, too.

88 Herrera, courtyard of the merchants' exchange in Seville, designed 1582

6
The appropriation of the Escorial

THE PROBLEM OF AUTHORSHIP

THE ESCORIAL (pl. 91) has always been associated with Herrera, even by those trying to isolate the contributions of other architects. In the early accounts he played a major role as the man who completed the building and implemented the king's will.[1] Fray Juan de San Jerónimo, who was a monk at the Escorial from 1562, treated the Escorial as the king's deed and only secondarily as the work of architects, but he acknowledged the role of both Juan Bautista de Toledo and Herrera as designers of the building.[2] Only Fray Antonio de Villacastín, the lay brother in charge of supervising construction on behalf of the monastic community, did not mention Herrera in his *Memoirs* but, in fact, he tells us virtually nothing about the work of architects or builders, not even about his own share in the enterprise.[3]

Some modern historians have attempted to find documentation that could establish the single authorship of the Escorial once and for all, but in vain. No such simple solution can be reached. Building accounts, contracts, and memoranda reveal much about the building process, but they fail to designated Herrera or anyone else as the one and true designer. Nor is there any reason to think that some as-yet-undiscovered document will do this. Herrera has retained his place as the major architect of the Escorial but, disconcertingly enough, the precise extent of his responsibility has become more obscure than it was thought to be.

Others have insisted that the design of the Escorial is a collective accomplishment that cannot and should not be disentangled. Only how did many individuals come to produce a building that impresses everyone as exceptionally homogeneous? Some stylistic disparity was rather the rule than the exception in the sixteenth century, simply because buildings took so long to build, and it is usually possible to distinguish the successive contributions of different architects. At St Peter's the nave is obviously added to the centralized building; dome and façade are clearly by different architects. The Escorial ought to be a composite, considering the number of architects involved in its designs, their differing backgrounds, their personal and artistic antagonisms. If it really juxtaposed the personal styles of Juan Bautista de Toledo, Paciotto, Gaspar de Vega, Rodrigo Gil de Hontañón, and Herrera – to name only the most prominent architects whose participation can be documented – it should be a gallery of mid-sixteenth-century fashions from Rome to Castile. Even those who dislike the building, however, have never found it disparate or incoherent. The Escorial conceals individual contributions. Although written evidence will not support an unequivocal claim that one architect designed the Escorial, it is equally difficult to account for its unity without assuming a single, or at least a powerful, author.

How then can we isolate Herrera's share? The question could, perhaps, be profitably displaced: why, if he was not the only architect, did the building come to be seen as his? The idea that the Escorial is essentially Herrera's building is not the product of our modern obsession with authorship. The early accounts of the Escorial, it is true, describe Herrera simply revising the designs of Juan Bautista de Toledo and one might infer from this that Herrera's role at the Escorial was not architecturally decisive, but already by 1594, when a Doctor from Murcia named Almela wrote a description of the building, Herrera appeared as 'His Majesty's genial architect,' the only architect named and, by implication, the designer.[4]

As a matter of fact, Herrera himself was the first to promulgate the idea that he was the legitimate architect of the Escorial, and he quite deliberately and systematically made it his own. This is not to be understood, however, as the kind of self-expression a modern architect might pursue in imposing his personal style on a monument. It would be more coherent with what we have seen as Herrera's attitudes and life-history to think that he made the building his own because he was the one who understood his master's intentions most fully and was best able to provide them with architectural form.

PHILIP II'S PROGRAM FOR THE ESCORIAL

In the early accounts the Escorial is Philip's building. There are even modern scholars who feel that, in so far as the Escorial had one author, Philip was more or less his own architect, 'for it was Philip himself who inspired and directed the architecture of the Escorial.'[5] From the point of view of architecture, properly speaking, this is highly dubious, but, as far as program goes, the Escorial is surely the king's. The issue is to what extend did this program shape the building. José de Sigüenza, the great contemporary historian of the building, promoted the idea that the Escorial was built exactly the way Philip wanted it. By quoting from the royal letter of foundation at the beginning of his account of construction, he gave the impression that it was virtually designed in the king's mind before Juan Bautista started to work, but by the time the letter of foundation was presented for approval in 1567, the Escorial had been under construction for nearly four years.[6]

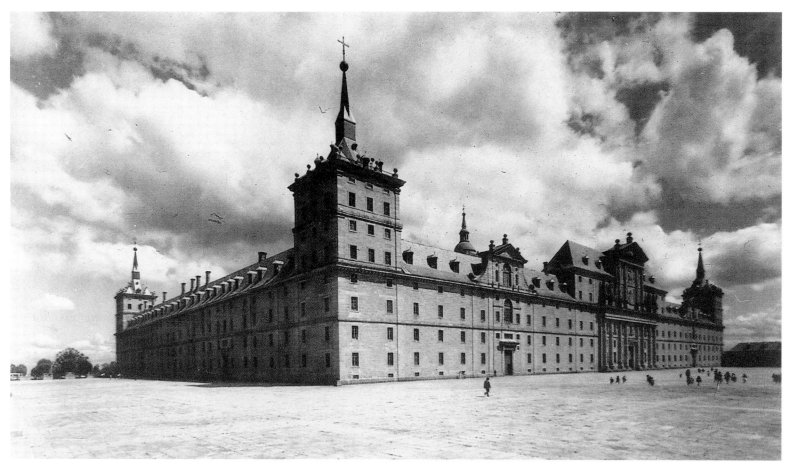

91 The royal monastery of St Lawrence at the Escorial, 1563–84

The Escorial is unique as an institution (Pl. 91). Although simply called a monastery, its final program incorporates a dynastic memorial church, the tombs of the Spanish Habsburgs, a royal palace, a royal library, and a college. By 1561, Philip had initiated the foundation of an Hieronymite monastery dedicated to St Lawrence, the Spanish martyr, on whose feast day in 1557 Philip won the battle against the French at St Quentin. Another motive, however, was the need for a suitable memorial and sepulchre for Philip's parents, Charles V and Isabella of Portugal. By the terms of the emperor's will, the final burial arrangements were left to his son.[7] José de Sigüenza saw the Escorial as a memorial to Charles V and the Spanish Habsburg dynasty. Such a commemorative intention was not exceptional and similar royal foundations can be found all over Europe from the early middle ages.[8] By the sixteenth century in Spain, however, the Hieronymite order had achieved particular prominence as the custodians of the shrine at Guadalupe, and a number of their monasteries were favored royal retreats. In choosing to build a monastery, specifically a Hieronymite monastery, Philip was operating within a well-established Spanish royal tradition.

Philip was also affirming a Habsburg image of piety. Charles V chose the Hieronymite monastery at Yuste as the site for his retirement after his abdication and died there in 1559. Philip's well-known reverence for his father has encouraged historians to see the Escorial as a magnified version of the modest arrangements at Yuste.[9] It is likely, however, that the king was looking beyond his father's retreat to the program that had inspired it, the monastery founded at Brou by Margaret of Austria, who also planned to retire there. Brou was a dynastic foundation, as Yuste was not, and contained the tombs of Margaret, her husband, and the latter's mother. Margaret had raised Charles, and the emperor himself had his aunt's project in mind when he moved to Yuste. Philip's foundation was, in this sense, a successor to Brou, as well as to the Portuguese Belem, the Valencian San Miguel de los Reyes, and Yuste itself.[10]

Memorial was the most prominent function in Philip's final program. The monks at the Escorial were to

plead and intercede with God for us and for the kings our ancestors and successors and for the good of our souls and the conservation of our royal estate, having also the aim and consideration that the emperor and king, my father . . . committed and remanded to us all that concerning his tomb . . . it being the just and decent thing that their bodies be honorably entombed and that commemoration and memorials be established and continuous prayers and sacrifices be said for their souls. . . . For these reasons do we establish and build the royal monastery of St Lawrence, near the town of the Escorial.[11]

The comparison with Brou, however, signals an important differ-

ence between the Escorial and earlier monasteries with apparently similar purposes. The king clearly thought of the monks as the staff to execute the rituals and ceremonies for dead and living Habsburgs. He was appropriating a religious institution for royal use. Earlier kings and queens were demanding patrons, but their monastic foundations were royal gifts; the services that the monks performed were gifts in return. If kings and queens retired to such a monastery, it was to humble themselves. Secular and religious prerogatives were distinct, even if the distinction was sometimes rather fictional.

Philip bowed to this tradition but undermined its meaning. In the early phases of the project, the Hieronymites believed that they were simply being given the money to build a magnificent monastery. Soon they discovered that decisions which they were accustomed to make for themselves had to be made with the king. The final choice of the site, the architects, the working methods, and the designs all lay with Philip and it is even more surprising to find that the institutional structure, regulations, choir books, music, and rituals were also worked out under the king's supervision and often according to his orders.

It is by the unusual grouping together of functions that Philip put his stamp on the project, and his insistence that they all fit in a single building shows his express desire to shape the complex as he wanted it. That this kind of innovative appropriation did not go without resistance comes out most clearly in the addition of a college to the program. The Hieronymite order was known for its devotion to cult celebrations; the members spent at least eight hours a day in choir, and while they engaged in almsgiving, teaching played no part in their activities.[12] Philip's college closely followed the dictates of the Council of Trent, which obliged bishops to found schools for the training of priests in their dioceses, and the king intended to staff it with regular clergy and university teachers.[13] Thirty seminarians between nine and thirteen years of age would study Catholic doctrine, Latin, grammar, and singing. After four years of study, twenty-four students might go on in a course in theology and arts based on Thomas Aquinas for another four years in order to prepare for ordination. The college had a rector and three professors, to be drawn from the universities of Alcalá, Salamanca, or Valladolid.[14] As the king put it, the college was devoted to the service of God 'to strengthen His holy Catholic religion,' but it was open to secular students as well.

Sigüenza says that the king always planned to include the college in the Escorial. In fact, we hear little about any of this until 1565, when the college was mentioned in a draft of the foundation letter as part of the Escorial. On 7 December 1566 the papal bull arrived authorizing the annexation of the Augustinian abbey of Nuestra Senora de Párraces to the Escorial. Both college and library were included in the letter of foundation the following year.[15]

The Hieronymites were not happy with these arrangements. As late as 1565, when building was well under way, the general of the order was urging the king to put his college at the University of Alcalá de Henares. On 26 April 1567, when the provisions of the king's letter of foundation were read out to the general meeting of the Hieronymite order, the assembly voiced its acceptance of every provision until asked if the rector of the college, who was to be subject to the prior of the monastery, should be allowed to have a vote in the general chapter. 'Everyone replied no;' he could not come as priest and prior to the chapter because he was 'simply a vicar who is to remain subject to the prior of San Lorenzo.'[16] The Hieronymites grudgingly accepted a college associated with them.

It was Philip who brought different functions – royal palace, monastery, and college – together in the Escorial and so created something new. The monastic tradition, which was a source for much of the program, is even more important as a contrast that allows us to see the degree to which the king shaped the Escorial for his own ends. In its final form of 1565, the Escorial did not fit any institutional type; it united functions that had not been assertively brought together on such a scale since Charlemagne had grouped the clergy around his palace at Aachen.

This amalgamation of functions was strongly asserted in the final building. Earlier royal monasteries – Brou, Yuste, or Belem – distinguished their various functions architecturally and then grouped them together. The plain façades of the Escorial envelop all functions, merging and consolidating them. This wholeness of the Escorial is a striking expression of its programmatic singularity.

JUAN BAUTISTA DE TOLEDO'S PROJECTS

The Hieronymites met to begin planning the Escorial in December 1561, but when Juan Bautista arrived at their meeting he told them that he had already given his designs to the king.[17] Philip himself, however, was still evaluating the plans of other Spanish monasteries and comparing them with those of his architect.[18] At this time, he may have been weighing the virtues of a more loosely organized plan.

Quite soon, however, it was determined that the Escorial should be a unified whole. One of the first features of Juan Bautista's Escorial to emerge was the integrity of the block, *el cuadro*, as Sigüenza called it: the enclosed, block-like design that declares the integration of all the various functions and confines them all within a single image. This was evident already in 1561 and affirmed in 1562, when other aspects of the design were still very much under discussion.

Juan Bautista placed the main cloister and conventual buildings on the south side of the church in a typical arrangement, but the monastic scheme had to be modified in order to accomodate the other features. Monastic churches were normally placed at the perimeter of monastic complexes in order to provide for public access (pl. 92), but Juan Bautista embedded the basilica in the block, where it was screened from public view, and enfolded it within two arms of the royal palace between the private apartments of the king and queen. His placement of the basilica conveyed the semi-private status traditionally associated with tomb chapels and with palace chapels, like the one in the Alcázar in Madrid.[19] The central position of the basilica was created by adding the royal courtyard on the northern side and by duplicating the plan of the monastic buildings on the northwest. This section was intended to be used for service buildings for the palace. The left-over space in front of the basilica became an enclosed courtyard, the later Court-yard of the Kings.

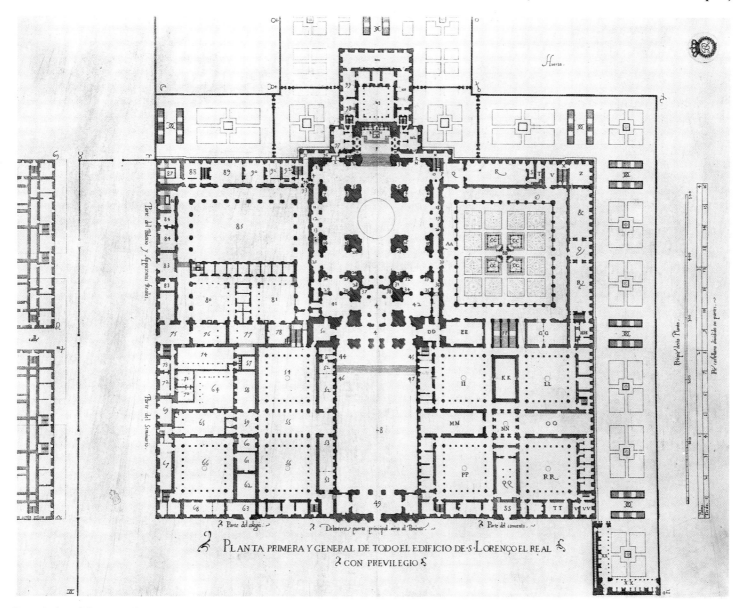

PLANTA PRIMERA Y GENERAL DE TODO EL EDIFICIO DE·S·LORENÇO EL REAL
CON PREVILEGIO

92 Ground plan of the Escorial, engraved by Pedro Perret after a drawing by Herrera or assistants and published as the First Design of Herrera's *Las Estampas de la Fábrica de San Lorenzo el Real de El Escorial*, 1589. (Madrid, Biblioteca Nacional)

The basilica was the only element to integrate features of the program which were otherwise institutionally independent (pl. 93). Sigüenza described the basilica as a royal house, palace chapel [*capilla real*], and mausoleum of the Habsburg dynasty, even though it was also both a monastic and a public church.[20] As part of the monastery, it was accessible to the monks from the south, and a passage led from the monastic quarters to the raised choir at the western end. The sanctuary, however, lay within the palace complex at the opposite end from the choir, where it was accessible from the royal oratories and from the palace. The basilica was conceived as a mausoleum on a centralized plan with a commemorative dome. The public church was installed at the western end beneath the choir.

Everything was brought within one envelope. As Sigüenza described it:

In the middle of this was to be the temple where those who celebrate the divine ofices and those who listen to them would come together. For this reason, the architect Juan Bautista divided the square or rectangle into three principal parts; that in the middle he left for the temple and main entrance.

By early 1562, architect and king were touring the site, design in hand, and a few months later this design had been worked up into the *traza universal*, which was also made up in a wooden model. No drawings can be identified with the *traza universal* and the model has long since disappeared, but Sigüenza described the first design as being:

Not very different from the present one; [except that] the elevation was much changed, because the four squares or cloisters were only one ground story and one upper story and with only two ranges of windows on the

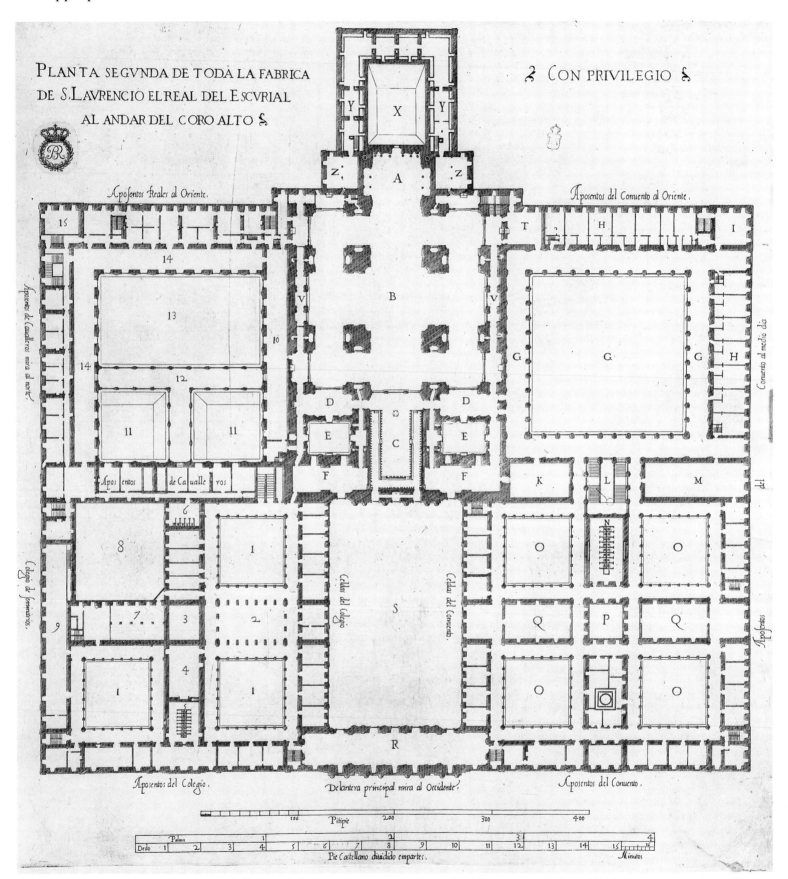

PLANTA SEGVNDA DE TODA LA FABRICA
DE S. LAVRENCIO EL REAL DEL ESCVRIAL
AL ANDAR DEL CORO ALTO

CON PRIVILEGIO

Aposentos Reales al Oriente.

Aposentos del Conuento al Oriente.

Aposentos de Cavalleros mira al norte.

Conuento al medio dia

Aposentos de Cavalleros

Aposentos

Colegio de Seminarios.

Celdas del Colegio

Celdas del Conuento.

del

Aposentos del Colegio.

Delantera principal mira al Occidente.

Aposentos del Conuento.

Pitipie

Palmo

Dedo

Pie Castellano diuidido empartes.

Minutos

93 Plan of the Escorial at the level of the upper choir, engraved by Pedro Perret from a drawing by Herrera or an assistant and published as Second Design of Herrera's *Estampas*, 1589. (Madrid, Biblioteca Nacional)

exterior.... Apart from the four towers at the corners that one sees today, there were two others: one in the middle of the southern facade... and the other on the northern facade.... There were two others at the main entrance to the whole building and two at the sides of the sanctuary of the church over the royal apartment, where the bells were to go, as one can see in the design and wooden model which is now kept in the monastery.[21]

In these early designs, the Escorial appeared as a vast enclosed quadrant, bristling with towers like a royal fortress protecting its domed and towered shrine. This Escorial must have looked a little like Diocletian's palace at Spalato, the palace compound in Constantinople, Filarete's hospital, a French chateau, and Raphael's and Sangallo's designs for St Peter's, all rolled in one.

Fascination with possible prototypes for the Escorial can obscure the novelty of Juan Bautista's scheme. A semi-fortified monastery with no fewer than twelve towers is extraordinary and so exceptional in Renaissance architecture as to seem amateurish, making one wonder if Philip perhaps had formal as well as institutional ideas to offer, not to say impose on, his architect. On the other hand, Juan Bautista's design was carefully organized according to accepted notions of hierarchy and symmetry. The Courtyard of the Kings is the spine, dominating the symmetrical groups of smaller courtyards on either side and balancing the large Courtyard of the Evangelists and palace courtyard at the back of the building. The western parts of the building were lower in front of the basilica and so the effects of enclosed and unified monumentality of Italian palace architecture were combined with contemporary French taste for dramatic massing in chateaux.

Juan Bautista's first design was the basis for a modified design whose foundation stone was ceremoniously laid on 23 April 1563 but, as Sigüenza observed, the architect:

was always embellishing and improving, seeking what might be the most fitting for [monastic] usage and habits, as it is most difficult to achieve so many things at one time.[22]

There was little choice in the matter. The Escorial was no sooner under construction than it was decided that it should be enlarged. In 1564, the Hieronymite community was doubled from fifty to a hundred monks and, after much discussion, it was decided to raise the entire front section two stories in order to create more space. According to Sigüenza, this 'solution' came from Antonio de Villacastín. Other 'improvements' were forced upon Juan Bautista by the monks, especially by the strong-minded prior, Juan de Huete, who had his own idea of the Escorial, modelled on monasteries of his order like Guadalupe and Lupiana. The moment Juan Bautista proposed a design for some part of the building, prior, king, and their many advisors fell to discussing its merits and disadvantages.[23]

These events are usually treated as an inevitable part of the design process, as typical of what happens when a complex set of functions must be defined in architectural form, but the debates of 1564 reflected a serious conflict that caused a blizzard of paper work, stalled construction, and prompted a complete reworking of the elevation. There is reason to believe that there was more at stake than square footage.

Describing the first plan, Sigüenza explained that the king wished to create a monastery for a maximum of fifty monks and, attached to this, a palace for himself and for his queen, their courtiers and servants. There was no college in this design. Sigüenza describes the north-west quadrant, now occupied by the college, as given over to 'offices for the convent and royal house, kitchens, stables, granaries,' etc.[24]

At some point between 1561 and 1564, the program was changed. The service quarters were moved out of the north-west quadrant, which was instead reserved for the college. This was the plan when, according to Sigüenza, Philip suddenly decided that 'a convent of Saint Jerome of fifty monks was a rather ordinary thing,' and moved to double its size.[25] Sigüenza's account does not ring quite true. Philip was committed to building a splendid foundation, but he was always thrifty, and, on the whole, the evidence shows him keeping as lean a staff as possible. It is not in character for him to want a hundred monks to do a job he had originally conceived for fifty. Even if we assume that he felt the convent should be enlarged, one does not see why it should be exactly doubled. More significantly, why should a change of this magnitude have suddenly become necessary, more than a year after the building was under way? Changes in program do occur occasionally during building, but Philip was against them in principle; and he was particularly wary of anything that was likely to be costly or to delay construction when he was desperate to hasten it.

On the other hand, the prior, Juan de Huete, was openly dissatisfied with the monastic section. He wrote memoranda, lobbied, complained about Juan Bautista, and commissioned designs from other architects trying to change the plans. As a result of his efforts, five Spanish masters were called in for a critique of Juan Bautista's designs in 1564. The suggestion to raise the height of the frontal section first appears in their report.[26] The prior was perhaps not as concerned as the king with keeping costs down or with the construction schedule, and he definitely had the status of his order at heart. He thought the four cloisters of his monastery were 'such a small thing that they are as nothing and have no authority at all.'[27] He wanted larger cells and better rooms, but it is not clear why he should he have wanted twice as many monks.

The obvious explanation is that the prior hoped to get rid of the college. The evidence is circumstantial but significant, and we must consider it in some detail. We recall that Sigüenza connected the monastery of fifty monks with an Escorial that did not include the college. The college, however, was already part of the plans for the Escorial in 1564 when the trouble began. This is clear from the king's responses to a memorandum from the prior in which he specifically questioned the aptness of the prior's revisions to the college.[28]

Any increase in the number of monks put pressure on the college because Philip decreed that 'there should be no change nor greater extension of the site beyond the block of the whole house as it has been defined from the beginning.'[29] The college had to go, or more space for the monks would have to be found within the monastic section, which the prior already found inadequate.

The Hieronymites naturally thought of the Escorial as their own. The fact that half of it was to be a royal palace and that the basilica was as much a palace chapel as a monastic church may have

disturbed them far less than the prospect of regular clergy encamped within their walls. It would not be surprising if Juan de Huete was concerned that monastery and college might have to compete for royal patronage or if he feared that his monastery might be eclipsed by the college. Before the enlargement, the two institutions were comparable – fifty monks to fifty-four students, three professors, and the rector – and their parity was represented in the symmetry of the frontal section, where two virtually identical cruciform blocks were placed on either side of the Courtyard of the Kings.[30]

The foundation letter of 1567 marks the end of this struggle. Juan de Huete was dead and compromises had been reached: the college (and the royal library above the entrance vestibule on the west) remained, but the monastery was now twice as big as the college. Except for the hospital wing and service buildings, the program had been kept within a single building as Philip wanted.

The king stood firm throughout the difficult discussions of 1564. He dealt with the prior himself and matched him plan for plan, square foot for square foot, as they haggled over the building. He doubled the monastic community, almost certainly under pressure from the prior, but it is a measure of his resolve that he endured the rehandling of the entire elevation rather than give up either the college or the unified plan.[31]

The entire episode shows the degree to which Philip shaped the Escorial to his own purposes, just as it also reveals limitations on his power. Philip did not want a traditional monastery. He planned to adapt a monastic institution to his own vision. The college was the Escorial's most radical programmatic feature, blending two different kinds of religious institutions and shifting the emphasis from a monastery, which sheltered the king and celebrated his dynasty, to a royal work protecting and fostering true religion on all fronts. Sigüenza recognized the novelty, calling the Escorial 'an aggregate or combination of so many things and a mixture so new, that I cannot think of any ancient or modern example with which it can be compared.'[32]

As a result of the changes in program the original, block-like integrity of the Escorial was somewhat broken up. Descriptions of the early designs suggest a building with a powerful east/west axis and symmetrical side façades. In the final design, each façade is a distinct composition. Juan Bautista's matching towers, the remains of which Herrera emphasized in his elevation of the southern façade, would have unified the exterior (pl. 94). As it is, the uniformity of the Escorial is an illusion (pl. 95). The composition is opened up by the addition of the Sun Corridors, pharmacy, and passageway to the service building on its southern side and by the Casas de Oficios on the north (pl. 96 and 97).

HERRERA'S REGIME

The program and design of the Escorial evolved together in stages over nearly five years. Juan Bautista had been tormented by criticism and interference; alterations and revisions had been imposed on him, but when he died in 1567, he left a design that, with the exception of the basilica, satisfied the king. Considering Philip's habits, it is amazing it was achieved. The overall plan, its major units, their relationship to each other, even the essential ornamental

vocabulary of the Escorial, had been brought to architectural definition. Juan Bautista left the *traza universal*, bundles of drawings, and a few models. He also left a building under way. The foundations were dug, work was in progress on the southern façade, the royal palace was laid out and more. The image of the Escorial had been defined. The massive, towered building with its great dome which dominates the landscape at the foot of the Guadarrama mountains outside Madrid is, to this extent, Juan Bautista's work. Sigüenza thought, and one can only agree, that Juan Bautista's general conception of the Escorial guided construction to the end.[33]

What was left for Herrera to do? The greatest task was building. Herrera saw two-thirds of the Escorial built from 1575 through 1584 and claimed full credit for it. He was, as he said, the instrument that made it possible 'for his majesty to see this work completed in his own happy lifetime, a thing that is beyond price.'[34] Building the Escorial was a stunning achievement. In 1567, it was by no means clear that it would ever be finished; by 1572 it was still a fragment whose principal feature – the basilica – was not even under construction.

The Escorial might have remained, like other vast projects of the sixteenth century – the Farnese palace in Piacenza or the Pilotta in Parma are examples – an unbuildable legacy for later generations to deal with. As it was, construction did not gain its full momentum until 1575 and only the most strenuous efforts brought the block to completion in 1584. The building process was streamlined to the point that a single assistant architect, the *aparejador* of stone work, Juan de Minjares, replaced two *aparejadores* and, in the next eight years, supervised twice as much in half the time of the earlier construction. Design, materials, money, and labor were all efficiently translated into building. The design and building process did not change; once fully under way, it did not stop until the end. Experimentation and consultation were largely over as Philip turned his mind to building. This patron, who had employed consultation and committee to the despair of his architect, consulted no more or only rarely with any architect besides Herrera.

Building the Escorial was one way in which Herrera could make it his own, but how much could the process of construction affect the character, appearance, and significance of the building? Herrera prepared the drawings for the Escorial; did he also provide the *designs* that were represented in those drawings?

Written evidence alone cannot answer these questions because it reveals that, while Juan Bautista prepared an overall design, some decisions awaited a penultimate stage before construction when Herrera made the final drawings. Exceptionally changes might be made in the course of construction itself. Sigüenza summed up the situation by saying that Herrera 'reworked and in some instances improved' Juan Bautista's designs, but, since the original drawings have mostly disappeared, it is difficult to know the extent of such revisions and improvements.[35]

Herrera himself claimed to have designed very little of the Escorial. The principal piece of evidence on this subject is a memorandum he wrote to Philip in 1584 listing some of his accomplishments. Herrera said nothing about redesigning any part of the Escorial and some authors have pointed to the memorandum as

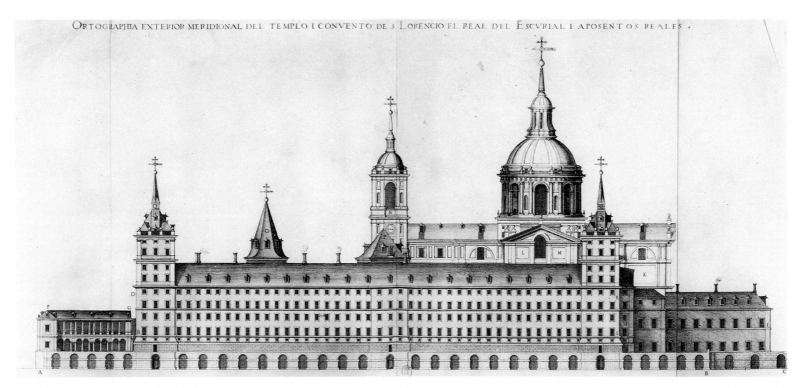

94 Elevation of the southern façade of the basilica, convent and royal apartments of the Escorial, engraved by Pedro Perret after drawing by Herrera and published as Sixth Design of Herrera's *Estampas*, 1589. (Paris, Bibliothèque Nationale)

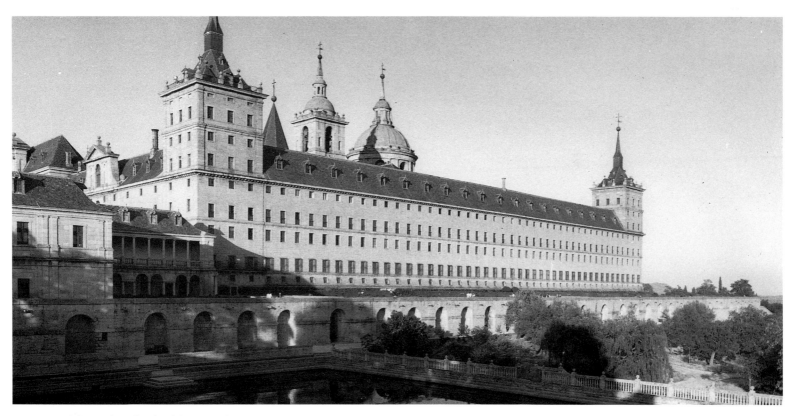

95 View of the southern façade of the Escorial

96 Exterior of the hospital and passageway to Compaña at the Escorial

97 Passageway to the Compaña

evidence that he designed almost nothing. The only part he claimed as his own was the roofs. He wrote:

Juan Bautista de Toledo having died, leaving neither a memorandum nor a design for the roofs of the [upper] rooms of San Lorenzo, and Gaspar de Vega having been ordered to prepare a design [*modelo*] of these roofs – which was extremely expensive to build and to maintain – I gave the design for making them with the least possible cost and so that the building would be more beautiful and practical; and in this more than two hundred thousand ducats were saved.[36]

On the whole, Herrera's assertions about the roofs are confirmed by external evidence and even those who minimize Herrera's role have accepted his authorship, but they have seen his explicit claim as virtual proof that he had nothing else left to do. Since there is no reason to believe that Herrera was especially shy or reluctant to assert his accomplishments, does his silence in the memorandum indeed imply that he was responsible for no more than the roofs? In order to answer this, we must understand the purpose of the memorandum itself.

It was addressed to the king as an appeal for money in addition to Herrera's regular remuneration on the basis of special services,

and expenses incurred, for which he had never been paid over the course of his career. As Juan Bautista's assistant and during the period before he was fully appointed royal architect, it was his job to prepare drawings from his master's ideas and this, especially after the latter's death, could imply revisions. The king did not pay his servants twice for doing the same job, and, once there was a design, what came later were revisions, no matter how drastic. This is why Herrera insists on the fact that Juan Bautista had left no drawing or instruction for the roofs.

The question that remains is why Herrera mentions the roofs and not other designs – hardly anyone doubts, for instance, that he designed the unmentioned large tabernacle or the fountain in the Courtyard of the Evangelists – why he thought he had been paid for these and not for the roof design. The most likely explanation is this: the roofs must have been designed soon after Gaspar de Vega's design proved unworkable, that is, late in 1568 or shortly thereafter.[37] At that time Herrera was not yet royal architect, he was not in charge of design, and he probably justifiably believed that such design had not been part of his job as it would be at a later date. In any case, the memorandum of 1584 should not be understood as a statement of Herrera's architectural activity but as

a plea for unpaid services. Its silences are evidence of Herrera's payment and nothing further.[38]

THE ROOFS AND THE MAIN FAÇADE

Herrera's pride in his roofs was fully justified. The complex slate spires on the towers define the silhouette and architectural volume of the Escorial, but nowhere are the roofs more important than on the main façade (pl. 98). In the frontispiece, the prismatic volume of the roof establishes the scale of the composition, links the upper and lower parts, and slices down through the temple front, binding the parts into a whole and echoing the geometry of the pediment above and the obelisks on the entablature below. The sharp conjunction of planes in the roof is the most monumental feature of the façade. It even affected smaller-scale decoration: the side portals, for example, echo in granite the bold geometry of the slate (pl. 99). Within the present discussion, the important point is that these roofs had an impact on the design of the main façade as it was built. More generally, the façade is an excellent test case if we wish to assess the extent of Herrera's revisions and to understand how and how much he made the building his own.

We know something about Juan Bautista's ideas for this façade because a pair of drawings of alternate projects for the main frontispiece on the west survive which, although neither is signed nor dated, clearly belong to an early stage, but after the decision to raise the height of the frontal section in 1564 (pl. 100 and 101). They are usually considered the work of Juan Bautista de Toledo, although perhaps not in his own hand, and it is difficult to imagine who else might have made them. The drawings show the same sculptural classicism as his autograph drawings for the Alcázar in Madrid.[39]

Juan Bautista's two façade projects do not show any roof, apart from the semi-circular cupolas on the towers. We often think of Juan Bautista's projects for the Escorial with slate roofs like Herrera's because we take the roofs for granted and it is difficult to imagine the building without them.[40] But Herrera's statement to the king is explicit: Juan Bautista had not left a design for the roof, not even verbal instructions. Putting slate roofs on either of Juan Bautista's façade projects would be most incongruous; and if we try and imagine his projects with some sort of unobtrusive roofing in the Italian manner, which is probably what he had in mind, then we suddenly realize how important Herrera's contribution was. His roofs are a major architectural element and the key to his revision of the main façade.

Juan Bautista's façades were hybrids. Their imagery was partly religious, partly palatial, like his first plan. In one project, the

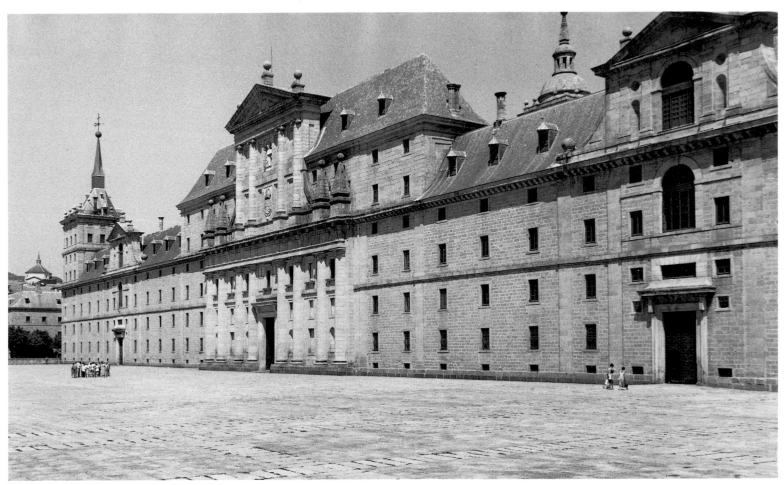

98 The western façade of the Escorial

99 Detail of the portal to the convent on the main façade

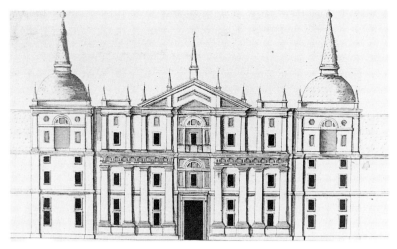

100 Juan Bautista de Toledo, design for the western façade of the Escorial, before 1567. (Madrid, Biblioteca del Palacio Real)

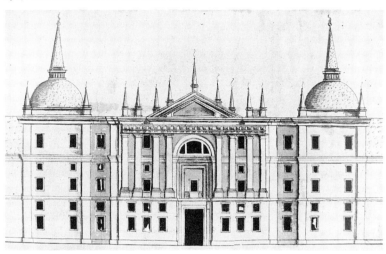

101 Juan Bautista de Toledo, design for the western façade of the Escorial, before 1567. (Madrid, Biblioteca del Palacio Real)

colossal order is raised upon a plain base, as in Herrera's later façades at the Alcázar in Toledo and the royal palace in Lisbon. But the temple front suggests a church, and both designs, with their gaping centers and towers, recall projects for St Peter's in Rome. Juan Bautista tried to express the character of the Escorial by using motifs – temple front, serliana, towers – that were meaningful in both religious and secular architecture, but his designs are not very satisfactory. His frontispieces are colossal but they would have been dwarfed by the vast length of the main façade. Their focused order contrasts uncomfortably with the stark extension of the whole.

Herrera's final façade, which was built between 1572 and 1583, has a new authority and power.[41] Keeping most of the architectural elements from the earlier projects, he made them coherent. He clarified the conception by retaining only the corner towers, which he raised two stories and topped with high-pitched roofs instead of cupolas. He eliminated Juan Bautista's two towers flanking the frontispiece and replaced them with a high pavilion which dramatizes the roof and serves as a backdrop to the temple front (pl. 102). He made the massing both bolder and simpler and he scaled the frontispiece to the whole façade.[42]

The façade of the Escorial is often discussed as if it were nothing but a temple front derived from Serlio, but Herrera did not simply replace a palace façade with the façade of a church, as a view of the entire western façade makes plain. The windows, which interpenetrate with the columns, make the frontispiece continuous with the main body of the façade and give it something of the character

of a palace. Some of Serlio's earlier projects for secular buildings developed this idea of a temple-fronted palace; we have already seen that Herrera himself used it in his designs for the façade of the royal palace at Aranjuez. In both cases the avant-corps of French chateaux seem to have been the source of inspiration.

THE MAIN CLOISTER, ITS STAIRCASE, AND THE FOUNTAIN OF THE EVANGELISTS

The Courtyard of the Evangelists is the main cloister and the only monastic feature of the Escorial to be architecturally distinguished, since the conventual buildings are almost utilitarian (pl. 103). Drawings were finished to Juan Bautista's satisfaction by 1565 but, as it happened, construction did not begin for four years more.[43] We do not know how detailed the early drawings were, although we should recall that Juan Bautista did not consider them sufficient for building without his personal supervision.[44] Herrera probably modified those drawings to some extent, adding, for instance, a five-and-a-half-foot parapet between the piers on both

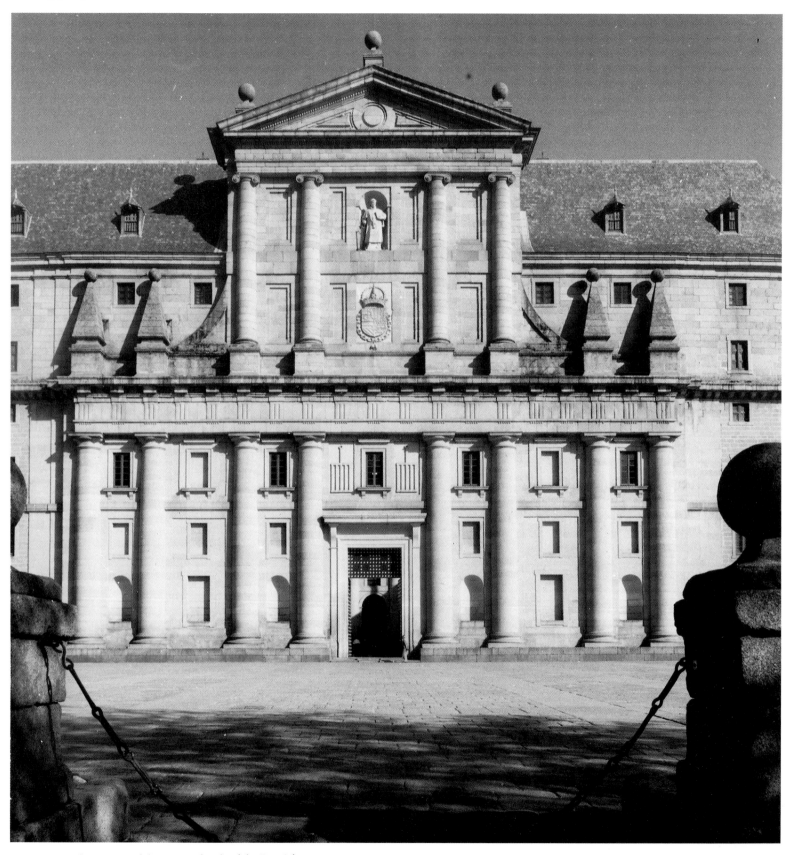

102 Herrera, frontispiece of the western façade of the Escorial, c. 1575

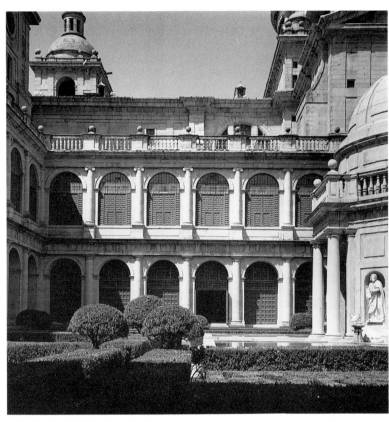

103 Juan Bautista de Toledo and Herrera, the Courtyard of the Evangelists in the Escorial, 1563–84

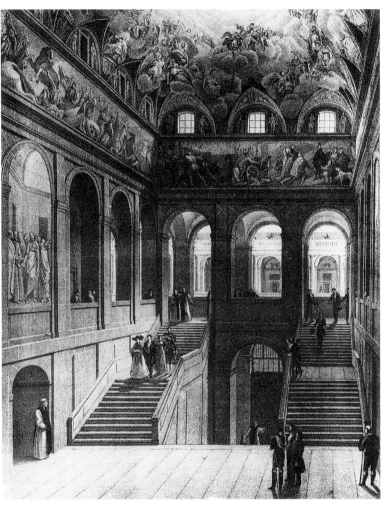

104 Herrera, main staircase at the Escorial

stories which bound the columns into a mural surface. Nevertheless, in the course of more than a decade of construction, he respected Juan Bautista's overall design. The courtyard, loosely modelled on the first two stories of the courtyard of the Palazzo Farnese, is the most Italianate part of the Escorial.

Two elements of this composition, however, are by Herrera and, interestingly enough, both depart from monastic usage in the direction of secular, specifically royal imagery. The staircase, which connects the cloister galleries, is a celebrated set-piece of the Escorial. Overscaled and imposing, its majestic flights create a spectacle of measured grandeur that makes one feel that this is a staircase worthy of the most solomn processions (pl. 104).

As we have seen already, staircases were a prominent feature of Spanish monastic and palatial architecture and an occasion for virtuosity in courtyard compositions. Juan Bautista's project fitted within this tradition. An early drawing, attributed to him, shows part of the original double columns of the arcade of the Courtyard of the Kings and the western side of the Courtyard of the Evangelists (pl. 105). The main staircase occupies an enclosed stairwell equivalent to three bays of the cloister arcade and opens off the gallery into an open stairwell with a fountain framed by four flights of stairs following a Spanish type that had become popular in the early years of the sixteenth century in Castile and Andalucia. The staircase in the palace of La Calahorra near Jaen is one of the earliest and best-known examples.[45] By 1560, however, monumental staircases composed with symmetrical flights

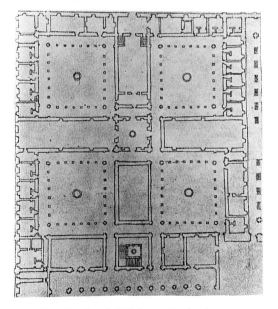

105 Juan Bautista de Toledo, project for the monastic section showing the staircase and part of the Courtyard of the Evangelists in the Escorial, before 1567. (Madrid, Biblioteca del Real Palacio)

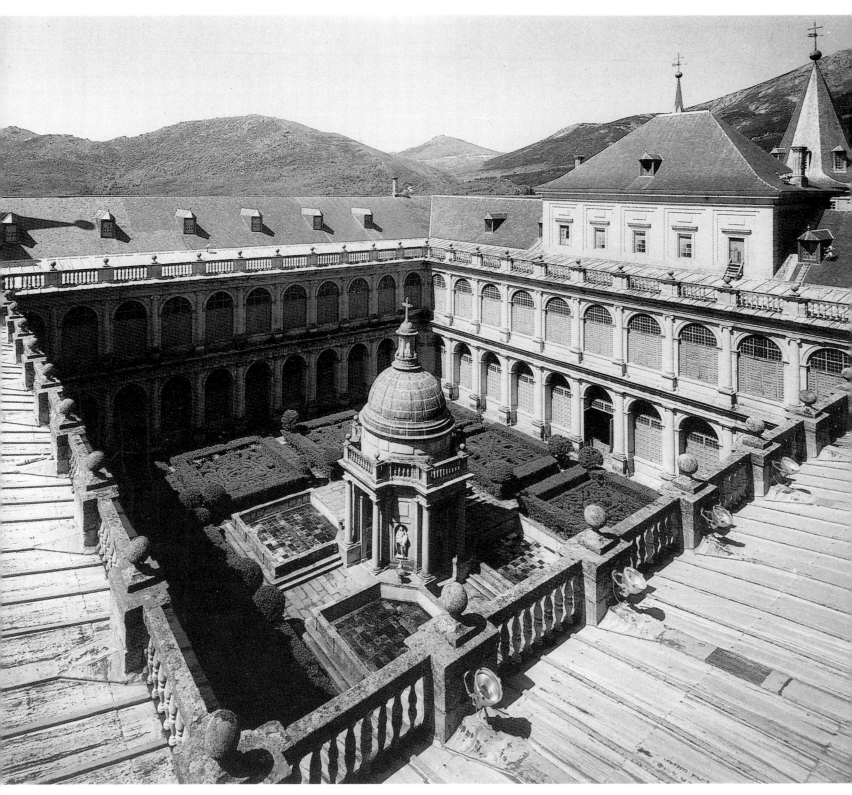

106 The Courtyard of the Evangelists in the Escorial

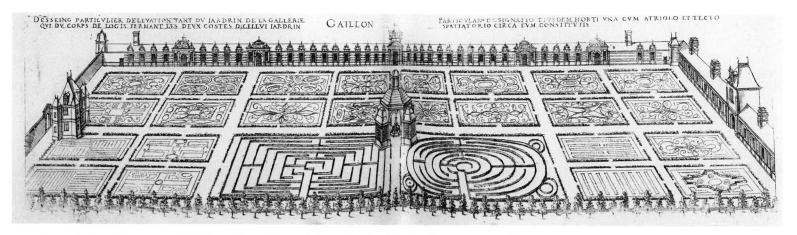

107 Jacques Androuet Ducerceau, detail of a garden pavilion at Gaillon, from *Les Plvs Excellents Bastiments de France*, 1576

were becoming fashionable in European palaces generally, and in Spain Alonso de Covarrubias produced a brilliant series of symmetrical open-well designs, like the ones at the Alcázar in Madrid or planned for the Alcázar in Toledo and for San Miguel de los Reyes in Valencia.[46] No one knew this better than Philip, who showed a personal interest in this architectural theme. Juan Bautista's design was conservative and, after some construction, it was finally discarded.

The present staircase was built under Herrera from 1571 to 1573. The walls of the original stairwell were left intact and the size of the bays, the height of stories, and the material were given by extant construction, but Herrera provided a new design. His inspiration came from palace architecture, where the theme had originally developed, and deliberately recalls the kingly ceremonial staircases in the alcázares in Madrid and Toledo. Taking up Covarrubias's symmetrical open-well designs, Herrera compressed them to their simplest form: three parallel flights in the open stairwell. He monumentalized the space of the stairwell, making it a magnificent setting for the play of the axes of the flights. The result was a new type of staircase, later significantly called the 'imperial' type, which became a popular form of monumental staircase. Herrera himself called it a composition of great authority and grandeur.[47]

The Courtyard of the Evangelists and its staircase were part of the monastery, but Sigüenza seems to have thought that they were not completely monastic. The monks used the main cloister only on major feast days; other processions and burials of members of the community were relegated to two of the small cloisters in the convent. The main cloister did not really belong to the monks if they could not use it for their most intimate rituals, and one feels in Sigüenza's account – for all its respectful tone – an undercurrent of disappointment and more than a trace of resentment.

Sigüenza's sense of dispossession comes out in his account of Herrera's fountain in the center of the courtyard. His praise of the monument turns to veiled criticism and ends in outright rejection:

Many dislike seeing this small temple in the middle of this cloister, because it is so large, being thirty feet wide and in diameter, and rises so high, reaching the height of the balustrade and railing of the cloister, that it fills the view, blocking and even diminishing the majesty of the cloister itself, and – what is worse – it has no use or purpose.

The temple/fountain, with its benches inside for sitting, is inappropriate 'because, as members of a religious order, we are never free to speak in the cloisters, so it is superfluous to build a conversation place there' (Sigüenza calls it a *parlatorio*). It is even worse as lay people come there and talk all the time, disturbing the silence. The result is that 'it has been a long time since a monk has gone there or that I have seen anyone, and so it sits, virtually wasted and useless.'[48]

Herrera's *parlatorio* had no place in a monastery and, as if to underscore its real purpose, Sigüenza followed his critique with what can be read only as a mischievously ironic account of his own proposal for its decoration. Sigüenza imagined the cloister garden as a mystical terrestrial paradise watered by four rivers representing the four continents: Asia, Africa, Europe, and America. To represent Philip's Catholic rule of all this, Sigüenza proposed that the figure of Christ be placed on top, the four Evangelists in the exterior niches, and their symbols on the fountain bases. In the middle of the basins, however, were to be four nymphs, symbolizing the continents, each holding a shield with the royal arms.

Women of flesh and blood, of whatever social station, were forbidden in the cloister; but Sigüenza claims to have offered his plan for allegorical statues of nymphs (decorously dressed? nude?) to Philip, who he says 'liked some parts of the project but not all.' In the final work, the dome is surmounted by a cross and the statues of the Evangelists are accompanied only by their symbols.[49] The final decoration is perfectly suitable but Sigüenza exposed an underlying iconographic agenda of the fountain that was more secular than religious.

Herrera's fountain did not need the nymphs to articulate its meaning: the form of a centralized church, deliberately recalling the tabernacle on the main altar, has been reworked until it resembles a garden pavilion (pl. 106). Herrera's building belongs with the fanciful centralized structures that appear in the gardens of Du Cerceau's French chateaux (pl. 107) or with Pirro Ligorio's reconstruction of Varro's aviary (pl. 108). Its Spanish ancestor is the pavilion in the gardens of the Alcázar of Seville. Philip particularly

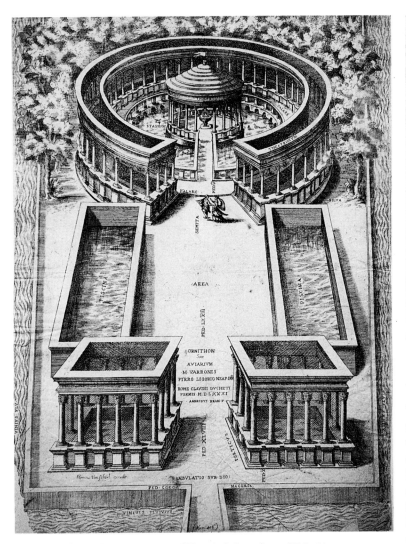

108 Pirro Ligorio's reconstructon of Varro's Aviary, first published in 1558, reissued in 1581 by Claude Duchet

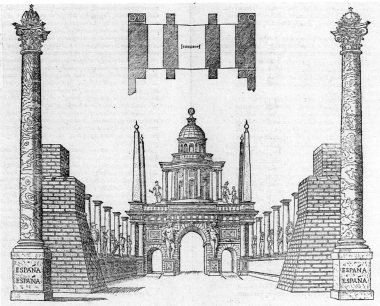

109 The Spanish arch erected at Antwerp for Prince Philip's entry in 1549

liked garden buildings: there was one in the gardens at La Fresneda, where a covered pavilion, intended for outdoor dining, was placed on an island in the middle of the large pond. Garden buildings were associated with pleasure, relaxation, and romance, and Sigüenza's nymphs would have been quite at home in them.

Herrera's design is characteristic of his style: his temple is modelled on Bramante's tempietto and his own tabernacle on the main altar of the basilica, but it is no longer self-contained: the square turns into an octagon whose doorways, framed by columns, establish the cross axes of the square setting of the building and its basins. The fragmentation of architectural forms signals their reconstitution with a different meaning as religious imagery is recast as royal iconography. Herrera's building is the prototype for the later mixtures of pleasure and piety in the hermitages in the royal gardens at the Buen Retiro, but the tempietto had been adapted to imperial imagery already in the temporary monument erected by the Spanish for Philip's entry into Antwerp in 1549 (pl. 109).[50]

THE COURTYARD OF THE KINGS

The other monumental courtyard at the Escorial, the Courtyard of the Kings, was one of the last parts of the Escorial to be built and was paved only in 1586. Drawings by Juan Bautista show that he originally thought of the space in front of the basilica as enclosed by arcades in the manner of early Christian atria.[51] The Courtyard of the Kings might have recalled the palaces at Constantinople and Spalato as well as old St Peter's and Bramante's projects for Loreto had it been built according to these plans, but quite early there were doubts about its aesthetic effect. When the Florentine Accademia del Disegno was asked to evaluate designs for the Escorial in 1567, one of the queries concerned the design of this courtyard, to which the Italians replied that 'the courtyard is bad, badly proportioned with low arcades.'[52]

Herrera redesigned the courtyard after 1567, removing the offending arcades, but thereby accentuating its narrow proportions. As revised by him, the space lost the character of a courtyard. There is no center or feeling of enclosure, no protection from heat or cold, no place to rest. Plain windows stare out of the bleak side façades into the paved space. The courtyard became a foyer, a plain perspective box whose orthogonals converged upon the basilica's façade (pl. 110). Passing through the vestibule on the west, one enters a space made wholly to display this imposing building and lead us to it. The basilica is protected and enshrined in its private space; and a sacralized atmosphere, which is normally experienced inside churches, is recreated outside, so that the basilica is approached like an enormous reliquary, under controlled conditions which discipline the visitor's experience (pl. 111).

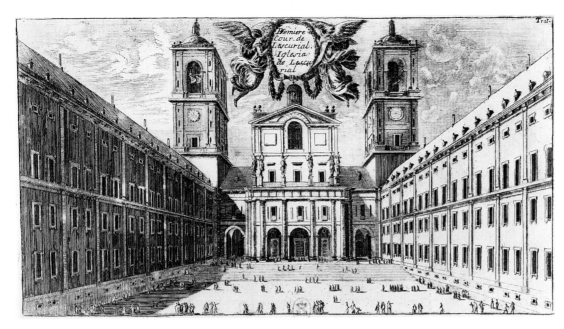

110 Herrera, the Courtyard of the Kings at the Escorial

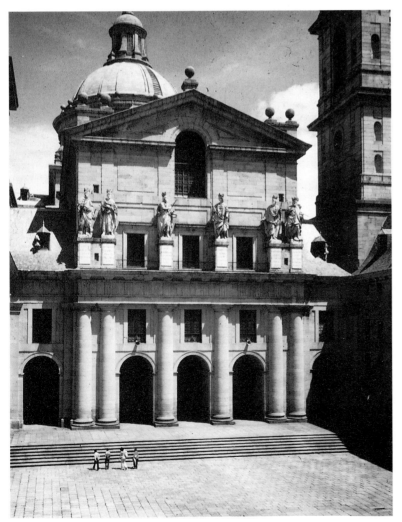

111 Herrera, the façade of the basilica of the Escorial

THE BASILICA

The basilica was the functional and symbolic core of the Escorial and it was always intended that this should be expressed in the architecture (pl. 112, 113). Philip seems to have wanted his basilica to rival the greatest modern churches, most particularly St Peter's in Rome, but it proved very difficult to devise a plan that fully satisfied him. Between 1561 and the beginning of construction in 1575, designs were repeatedly revised and refined as architects tried to reconcile the demands of the program with the standards of modern classicism. Herrera was the key figure in this effort, even if his role cannot be understood apart from earlier projects by other architects.

There is evidence of several competing projects before Herrera took charge, although almost all the drawings of them have disappeared. Juan Bautista seems to have experimented with different possibilities. An early rough sketch (almost a doodle), published by Rivera, suggests that the king and Juan Bautista were originally thinking of an oval plan.[53] By 1561, however, he had produced a design for a church with a central dome and four towers, which was made up in the model of the *traza universal* and was probably the design that was criticized by Philip's Italian architect and engineer, Francesco Paciotto, in 1562. Paciotto's critique reveals that Juan Bautista planned to have the monks' choir on the west, a small *soto-coro* (literally under-choir) beneath it, a tall main dome, smaller domes, and oval vaults. At the king's request, Paciotto drafted a design of his own to correct the 'faults' in Juan Bautista's project.[54] Paciotto suggested that the whole church be made square, but this was not immediately accepted. A section of the basilica, which must have been made after the monastery was enlarged in 1564, shows a half dome over a raised sanctuary (pl. 114).[55] The sanctuary appears as semicircular in other undated plans. Designs were not final when the symbolic first stone of the basilica was laid on 20 August 1563.[56]

The appropriation of the Escorial

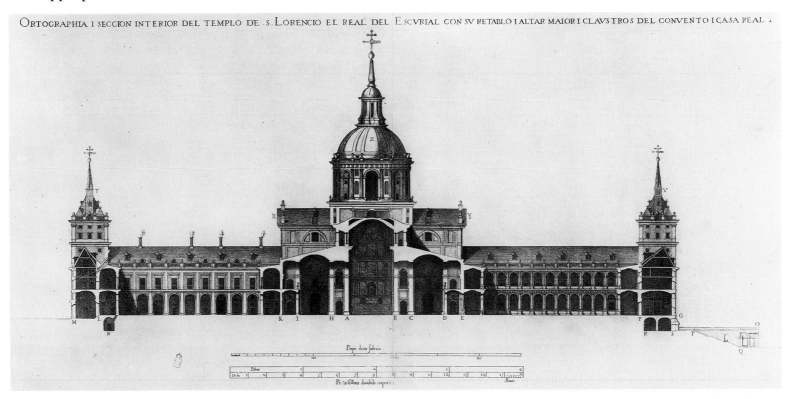

112 Elevation and cross section through the interior of the basilica showing the retable on the main altar, the convent and palace, engraved by Pedro Perret from a drawing by Herrera or assistant and published as the Fourth Design of Herrera's *Estampas*, 1589. (Paris, Bibliothèque Nationale)

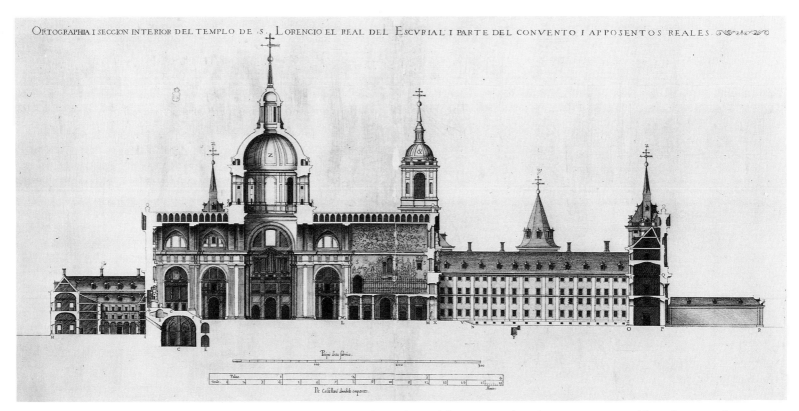

113 Longitudinal section through the Escorial showing the interior of the basilica and part of the convent and royal apartments, engraved by Pedro Perret after a drawing by Herrera or an assistant in 1587 and published as the Fifth Design of Herrera's *Estampas*, 1589. (Paris, Bibliothèque Nationale)

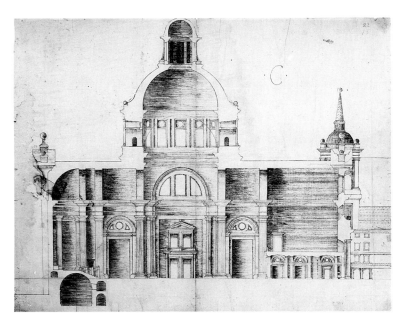

114 Juan Bautista de Toledo, section through the basilica of the Escorial, prepared before 1567. (Madrid, Biblioteca del Palacio Real)

This situation was not resolved when Juan Bautista died in 1567. In this year, the Academy of Design in Florence received a set of twenty-nine drawings of the Escorial, including at least three different projects for the basilica, and a list of specific questions to guide their evaluation. Some of the questions recall the issues raised by Paciotto four years earlier. Architects in Italy also became concerned in the project about this time. Work at the Escorial on a new model of the basilica was stopped in 1570, perhaps to wait until Italian designs, which had been commissioned from Galeazzo Alessi and Vignola among others, were sent to Spain.

The Italian drawings arrived in February of 1573. The king, casting his eye over them, dismissed them briefly: 'the drawings of the church that were expected from Italy have finally come, but I don't think there is much to be taken from them.'[57] Philip and Herrera had finally made up their minds. In 1573, contracts for the foundations of the dome were written up. In 1574, the king published the specifications for the contracts in major cities and a sculptor began to build a new wooden model of the basilica. On 7 March 1575 a few stones were ceremoniously hauled into place as part of a splendid pageant that announced the beginning of construction.[58] In fact, foundation work and some of the nave piers had began several years earlier, and the actual bidding for contracts did not take place until later in the year, but this date marks the end of major planning: once the contracts were signed and the ten teams of workmen began raising the basilica the following January, no major changes to the architecture were possible.

Two conclusions may be drawn from this sequence of events. The first must be that Herrera did not single-handedly design the basilica of the Escorial. Its raised choir, *soto coro*, central dome, raised sanctuary and crypt were Juan Bautista's ideas. They were criticized by Paciotto in 1562 but retained in the early section drawing, which reflects Juan Bautista's project after 1564, and were still present in at least one of the projects submitted to

the Florentine Academy of Design in 1567. Juan Bautista established the relationships among the major elements of the basilica. Paciotto's contribution was not insignificant, however. He noted in his report that he favored a square plan 'for many reasons, such as its meeting the straight lines of the monastery with agreeable consequences.'[59] The sense of this is obvious in the plan at the 30' level, where the basilica is locked into the geometry of the overall design in a way that seems inevitable. It is hard to imagine how the basilica could have escaped being square, or at least rectangular, or that Juan Bautista could ever have thought otherwise. The secondary domes were eliminated and the semicircular sanctuary was made rectangular, but not all Paciotto's suggestions were adopted.

Paciotto claimed to have designed the basilica at the Escorial and he lived just long enough (until 1591) to have checked this against the *Estampas*, which were published in 1589. José de Sigüenza considered him responsible for the plan, which he criticized as just a squared-off version of St Peter's in Rome. Paciotto cannot have submitted drawings of an entirely new church; his project was more of a revision of Juan Bautista's design.[60] It is not clear whether the later drawings by Italian architects were based on Juan Bautista's drawings or were completely independent, but by the time they arrived the design of the basilica had been decided.[61]

The presence of many competing projects implies a second conclusion: although Herrera did not invent the basilica, he was responsible for the design which was built. A decade of activity had brought the plans to a high level of resolution before he took charge and certain features had been decided upon, but there is no evidence that a synthesis of the various projects had been arrived at before 1570. By this time, Herrera was virtually in charge of designs for the Escorial. In March 1571 the king ordered that Herrera be given a house at the Escorial where he could stay and keep 'the plans and other papers in his charge.'[62] From this time, there is evidence of his work on designs for the basilica. The drawings that survive seem mostly to be from this period, and they reveal that the raised choir, central plan, crypt, and raised sanctuary from Juan Bautista's early designs were combined with Paciotto's ideas for a rectangular church. Herrera reworked the proportions, although the main dome was still tall with respect to its diameter, and altered decorative elements. Herrera may have contributed less to the invention of the basilica than to any other major feature of the architecture of the Escorial, but the significance of his decisions – and this is reason that we may speak of the basilica as his work – is to have orchestrated many different and competing architectural ideas into a unified and dramatically successful whole.

Agustín Bustamante and Fernando Marias have reconstructed the façade of the basilica that appears in Juan Bautista's section drawing, and their elevation makes the extent of Herrera's modifications obvious.[63] Herrera's composition is bolder and simpler, its elements more powerfully knit together; it is also significantly more abstract. This abstraction was compromised in the final façade, which Herrera originally planned to decorate with the obelisks that appear in his project drawing, when, in December 1580, Juan Bautista de Monegro contracted to carve the six statues of Old Testament kings that now stand on the pedestals intended for the

obelisks.[64] Apart from the statue of St Lawrence, also by Monegro, above Philip II's coat of arms on the main façade, these statues are the only monumental sculpture on the exterior of the Escorial.

Statues of Solomon and David (Old Testament surrogates for Philip and Charles V) flank the entrance to the basilica, suggesting the equation of the Escorial with the Temple, and René Taylor's hypothesis that this was the generating image of the entire building has been widely accepted.[65] This association may not date from much before the 1570s, however, when Arias Montano published his reconstruction of the Temple.[66] The statues were contracted in the same year that Jerónimo Pardo and Juan Bautista Villalpando teamed up to begin their preparation of a rival reconstruction of the Temple based on the text in the Bible. Herrera was involved in their project, and, while his interest in the Temple may have been of longstanding, the introduction of the statues of Old Testament kings so late in the program suggests that the parallel between Philip II and Solomon and of the Escorial with the Temple was a late interpolation whose aptness had only recently become apparent, perhaps as a consequence of Arias Montano's reconstruction.[67]

The basilica as a whole is extraordinarily impressive, but it is not the ultimate Renaissance church that Philip hoped it would be. The façade is not entirely successful, looking to modern eyes as much like a hall of justice as a church, and, seen from certain angles, the sheer massing on the east is peculiar rather than beautiful (pl. 115). The dome, with its huge niches and coupled columns, lacks the vitality of Michelangelo's dome of St Peter's and the static volume of Alessi's dome of S. Maria di Carignano in Genoa. The interior of the basilica of the Escorial, however, is one of the most solemn and beautiful in all of Renaissance architecture. The sober harmony of all the parts, which was so often sought by Renaissance architects, is here achieved at majestic scale. Architecture, painting, and sculpture unite with a clarity of purpose that is rare in buildings of any period and unique in sixteenth-century churches, where the decoration seems often to be competing with the architecture. The unity and homogeneity of this interior is the result of Herrera's consideration of all the elements according to their role in the total effect and his determined subjection of architecture to the staging of a spectacle (pl. 116).

The severe classicism of the body of the church is made the frame for the richness of the sanctuary, where monochrome granite is exchanged for colored jaspers, gilded bronze, and paintings. In a deliberate contrast with the rest of the building, the entire sanctuary was raised nine feet above the main floor level so that it could shine like a jewel in a simple setting. The main altarpiece rises in four tiers more than ninety feet to the vault. Its materials are of an unprecedented richness. As Herrera himself described it:

This entire podium is of jasper with some compartments of different colored jaspers, upon which is seated the whole construction of the altarpiece all of whose columns are free-standing against their pilasters of green and red jasper, and the columns are all of a jasper tending to deep red. The bases and capitals are of fire gilt metal.[68]

The tabernacle was of special stones whose 'hardness and fineness were such that in order to work them it was necessary to turn them with diamonds.' Inside the tabernacle, the custodia was of four columns of finest jasper, the capitals and bases of gold and enamel, the triglyphs of the frieze that surrounds the custodia are gold and the metopes of emerald; the pedestals on which the columns are supported are of the same jasper and decorated with golden moldings.[69]

A great topaz crowned the dome. The richness of material and the stupendous effort required to shape it testified to an almost super-human power.

A switch can now flood the sanctuary with light, bleaching out its colors, but so much brilliance was not intended. Philip wanted the altarpiece to be legible from a distance, but Herrera contrived to make it also appear mysterious. Special lighting from a window behind the large tabernacle of the Sacrament, for example, was screened with different colored silks so that sunlight would illuminate the shrine in different colors according to the ritual calendar. Such effects required dim light. Remoteness and majesty were essential to the mood of the basilica. On special feasts and ceremonies, when the altarpiece was set with candles, the polished colored surfaces showed to greatest effect. Philip may have wished to save full splendor for these occasions; under normal conditions, the interior was probably meant to appear subdued as it does now, as if waiting to spring to life.

The dramatic potential of this composition is deliberate. The basilica of the Escorial was a kind of theatre planned as a stage for an eternal spectacle, renewed daily by changing actors in a fixed cast. Like all theatre, it was designed to be seen and heard, and the public view, in some ways the least privileged, was the best. From the cramped auditorium of the soto-coro, Philip's subjects could look through wrought-iron grilles at the magnificent, nearly empty stage (pl. 117). A hundred and fifty feet away in the sanctuary, lights flickered on the polished stone and metal, an invisible choir sang, an inaudible sermon was preached, a few distant figures moved through the ritual of the mass. Far away, miraculous relics were displayed, mysterious blessings called down, thanks offered up.

Philip's enterprise had much in common with the spectacles of his fellow European kings and queens in being essentially a demonstration of his power, with the difference that the spectacle at the Escorial was meant to be real.[70] Renaissance court theatre accepted and traded openly in illusion, transforming a queen into Diana or Venus and back to a queen again, in order to enhance the image of the ruler, but in trying to elide two systems of authority – divine and Habsburg – Philip had to dispense with this kind of illusion. At the sides of the main altar monumental effigies of the Habsburg kings and queens faced the celebration enacted for them and for God. Only slivers of the backs of these bronze figures were visible, but their presence was felt. The spectator, after all, was looking into their private space. Sheltered from prying eyes in their niches, these figures were chief spectators and the immobile actors in the play that the ordinary person was watching. Somewhere, within the walls of the sanctuary, was an unseen, living king. Like a tableau vivant in a festival entry or, more pertinently, like a chapel in a sacro monte, the spectator contemplated figures frozen in the enactment of a sacred text. Twice a day, every day and forever, this spectacle was put on or was meant to be, and, although there were other feasts or special festivals and regular masses at the secondary

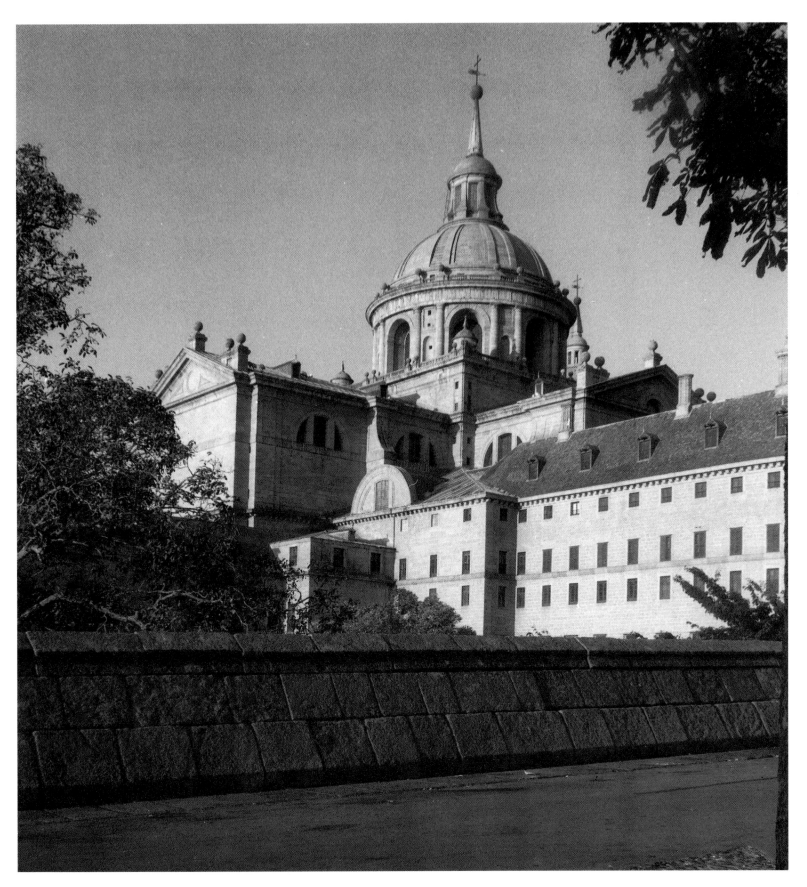

Exterior of the basilica of the Escorial from the north-east

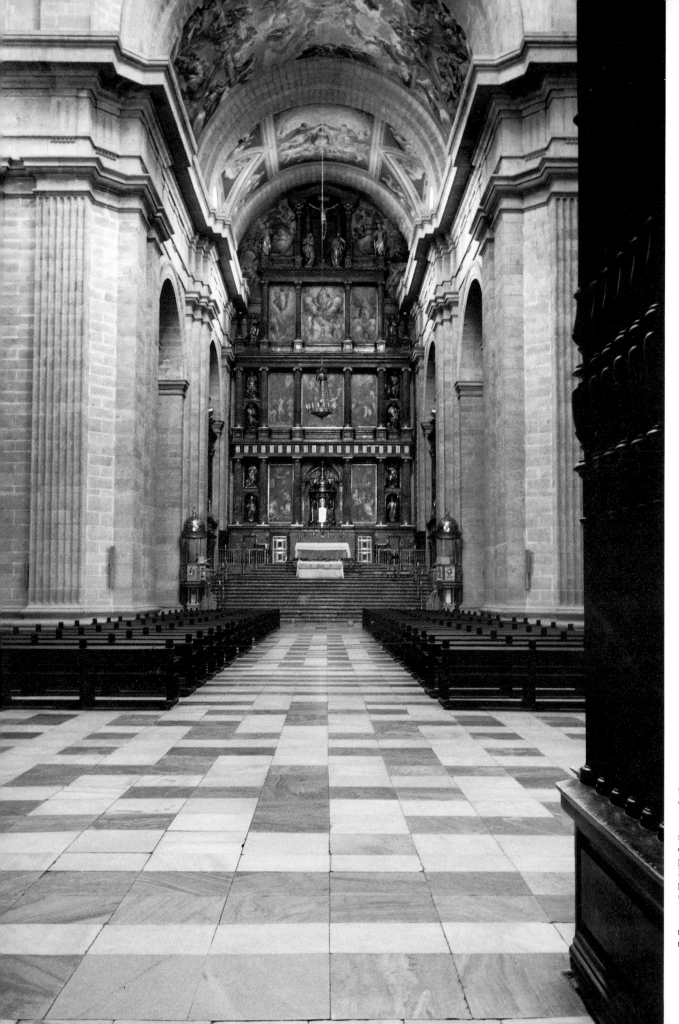

116 Interior of the basilica of the Escorial seen from the soto coro

117 Perspective view of the sanctuary of the basilica, engraved by Pedro Perret probably after a drawing by Herrera or assistants and published separately in 1598. (Paris, Bibliothèque Nationale)

118 View of the interior of the sanctuary of the basilica of the Escorial

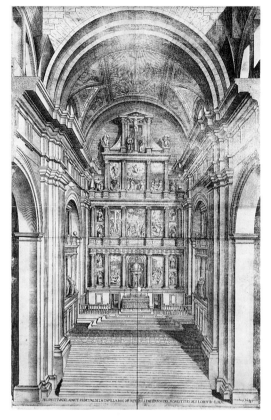

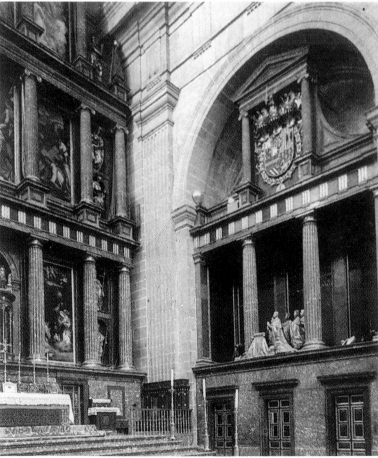

altars, the basilica was designed for mass at the high altar in the sanctuary.[71]

THE HABSBURG MEMORIALS

On either side of the main altar, Leoni's effigies of the Habsburgs are set on monumental stages (pl. 118). Nearly a century earlier at Brou, Margaret of Austria and her husband had been similarly represented kneeling at prayer in the windows and Siloe's figures of Ferdinand and Isabella also kneel to face the altar in their chapel at Granada. The compositions at the Escorial, however, are freely adapted from the later stained glass windows showing Charles V adoring the Trinity in the windows of St Gudule in Brussels.[72] Only the imagery of the earlier foundations has been raised to a higher power at the Escorial, as Habsburgs appear in perpetual adoration of the Eucharist in front of them, protectors of the divinity which shelters them.

These effigies are the official *dramatis personae* of the Escorial and, inevitably in such a setting, the dynastic message outweighes the funerary theme. Not all the statues were of dead Habsburgs, and not all whom Philip buried at the Escorial appear in the sanctuary.[73] By the 1590s, seventeen family members lay in the burial vault below the pavement. Only nine were commemorated in statues, the tenth being Philip himself. Neither the king's illegitimate half-brother and military commander, Don Juan of Austria, Philip's many small children (already dead) nor his beloved, living daughters, Isabella and Catalina, were included. All the statues were ruling kings and queens except Carlos who, as the king's first-born son, would have been his heir.

The solomn scene in the sanctuary was official, but its message was no less personal for that. Above the heads of the figures and on either side of the groups are monumental inscriptions that name the personages with their titles and relation to Charles V or Philip II. There is no date of birth or death. The inscriptions in the side panels allude to death but address the future not the past. The inscription to the right of Charles is a challenge:

If any of the descendants of Charles V excels the glory of his heroic deeds, he may take this place first. Let the others abstain in reverence.

To the left of the emperor:

The providence and care of the descendants leave this space empty for the sons and grandsons who after living many years pay the natural debt of death.

On the opposite wall, pendant inscriptions have a complementary meaning. The inscription to the left of Philip reads:

That place is reserved for the most deserving among the descendants, to whom abstains from it and hence is given it through virtue; the other is exempt.

Behind the group, the inscription stated that the space was reserved as a memorial for the descendants of Philip II.

These texts conspicuously lack the triumphal tone of an imperial monument. Charles V is held up to future Habsburgs as founder of the dynasty, but the composition declares he will never be equalled.

The appropriation of the Escorial

There will never be another Habsburg to take this place or another emperor as king of Spain. The stage, destined to remain forever vacant, matches the opposite space in front of Philip which, according to the inscription, can never be occupied, because the right to it can be demonstrated only by leaving it empty. The reticent virtue that future Habsburgs are to strive for is the corollary to an imperial glory that they can never attain. Empty places waiting to be filled, forever incapable of being filled; these compositions are definitive. Nothing could be further from the mood of the Escorial than a clutter of individual monuments or the jostling of competing personalities.

The incriptions must reflect Philip's sentiments; who else could speak this way of Habsburgs in this place?[74] Greatness contrasted with modesty and virtue summed up his view of his father and himself, and so qualified a prediction of Habsburg future was not out of character either, but it was harsh. No one but Philip, ever willing to face his losses, could have chosen to sum up his family in such final terms, or to lay upon his successors a perpetual future to be lived out in the shadow of their former greatness. Perfect order does not change; it can only be maintained against change. The inscriptions were a proclamation (no less sincere for being written in large bronze letters) to Philip's son and future Habsburgs of the personal implications of the position he had defined for them.

HERRERA'S ROLE

The presentation of this spectacle is almost entirely Herrera's achievement. The memorial theme of the basilica at the Escorial was not articulated until 1565, although it was probably part of the program earlier, nor do Habsburg memorials appear in early drawings for the basilica. Only the crypt, which imitated the austere and saintly simplicity of early Christian catacombs, appears in the drawings. It is remarkable, in fact, that no verbal or visual documentation of the basilica represents a funerary monument before the 1570s. Yet Philip and Juan Bautista must have considered the issue of a suitable memorial.

The sanctuary was designed when Herrera prepared the final designs for the basilica.[75] At this time, a square plan was adopted for the sanctuary and the memorials designed for niches on the sides. Construction began on the walls in 1576. Finally, in 1578, Herrera and Villacastín rejected a tabernacle which was then being executed by Jacopo del Duca after designs by Michelangelo in Naples and which Philip had been considering buying for the high altar since 1571. Herrera's tabernacle was substituted for it. In 1579, Jacopo da Trezzo, Giovanni Battista Comane, and Leoni and Pompeo Leoni contracted for the architecture of the main altarpiece and the Habsburg monuments.[76]

In its final form, the sanctuary is a unified composition. Altarpiece and memorials were completely integrated with the architecture; in a sense they are the architecture. The sanctuary is a complete stage set, with the scene and lighting prepared and the costumed actors in place, awaiting only the officiating priest to begin the drama of the mass. But this stage projects a scene that is larger, more highly charged and significant, than anything in real life or real theatre and, in the course of execution, it was decided that the figures should be gilded rather than painted naturalistically. The impassive, golden faces of Leoni's Habsburgs belong to the supernatural world of the gilded saints on the altarpiece and share the mysterious splendor radiating from the tabernacle.[77]

Herrera created a space transfigured by divine authority and he so completely integrated Philip into it that it seems that only here, in the sanctuary, is the king truly at home. Since the main altar is within a few meters of his bedroom in the heart of his palace, this is literally the case. The individual components of this composition were not new. The patron's bedroom in proximity to the altar was favored in the Renaissance and appeared already at Yuste. The atmosphere of Herrera's sanctuary can be seen also as an extension of the mood of heightened religiosity that characterized earlier Spanish Renaissance altarpieces; nor was it unusual to associated memorial statues with the altarpiece. Charles V himself adumbrated the basic theme of the sanctuary when, in the codicil to his last will in 1558, he stipulated that, if buried at Yuste, his body be placed in a crypt below the space in front of the altar and that statues of himself and the Empress Isabella be placed on either side of the altarpiece.

Herrera's dramatic environment, however, was entirely new. The sanctuary is carefully prepared as the culminating moment in the Escorial. The main façade of the monastery, the façade of the basilica, and the sanctuary are related compositions lying along a single axis, so that, moving from the western portal through the building to the *soto coro*, there is a metamorphosis of the temple from monumental simplicity to mysterious splendor in progression toward the tabernacle of the Sacrament. There is a parallel revelation of the king himself: Philip II, represented abstractly in his coat of arms on the main facade and symbolically in the statue of Solomon on the façade of the basilica, is finally revealed in adoration of the Eucharist at the heart of the complex.

THE *ESTAMPAS* AND THE *SUMARIO*

The fact that Herrera made the Escorial so completely into Philip II's building does not mean that it was any the less his own. Herrera was not modest, nor did he lack a sense of individual artistic accomplishment, and after thirty years of day-by-day involvement, he probably thought of the Escorial as his building too. But his reputation as its principal architect seems to have arisen independently of the archival and visual evidence. What sealed Herrera's relation to the Escorial was his publication.

In 1589, Herrera published the *Sumario y Breve Declaraciō delos diseños y estampas de la Fabrica de san Lorencio el Real del Escurial* to accompany his series of eleven magnificent folio sheets with copperplate engravings.[78] The *Sumario* lists each engraving by its title and discusses it according to reference letters and symbols which appear on the prints. The preface states Herrera's aim:

In order to satisfy those wishing to know about the greatness of the building of San Lorenzo el Real del Escurial, I have undertaken, although with much labor and expense, to publish this building in various drawings representing many of its parts, so that everything that is in it and its organization may be seen more fully and with greater clarity.[79]

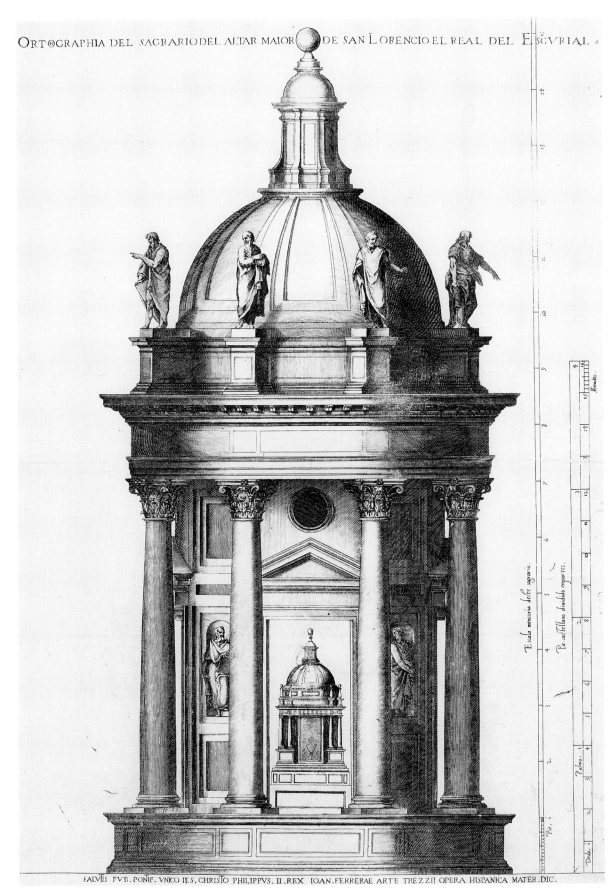

ORTOGRAPHIA DEL SAGRARIODEL ALTAR MAIOR DE SAN LORENCIO EL REAL DEL ESCVRIAL

SALVTIS PVB.PONIF. VNICO IES. CHRISTO PHILIPPVS. II.REX IOAN.FERRERAE ARTE TREZZIJ OPERA HISPANICA MATER.DIC.

119 Herrera, elevation of the large
tabernacle on the main altar of the
basilica of the Escorial, engraved by
Pedro Perret from a drawing by
Herrera or assistants in 1583 and
published as the Ninth Design of the
Estampas, 1589. (Paris, Bibliothèque
Nationale)

The appropriation of the Escorial

The *Sumario* names only one architect, the author: 'Juan de Herrera, Architecto General de su Magestad, Aposentador de su Real Palacio.' Herrera claimed the authorship of the pamphlet, but the reader's inference that the king's architect is also the architect of the building is perfectly natural. Herrera appropriated the design of the Escorial in the *Sumario* by omitting the name of any architect other than his own.

Herrera is not absent from the engravings, but his presence there is more circumscribed. Jacopo da Trezzo, the sculptor and medalist who executed the tabernacle, is named in the ninth print, where Herrera's name appears also in the inscription (pl. 119).

SALVTIS PVB. PONTIF. VNICO IES CHRISTO PHILIPPVS II REX IOAN FERRERAE ARTE TREZZIJ OPERA HISPANICA MATER DIC:

In form and language, Herrera's text purports to be the inscription of the tabernacle. The actual inscription, however, names only Trezzo:

JESVCHRISTO SACERDOTI AC VITMAE PHILIPPVS II. REX. D. OPVS JACOBI TRENCI MEDIOLANENS TOTVM HISPANO E LAPIDE[80]

According to Sigüenza, it was composed by Arias Montano.[81]

We may well wonder why, if Herrera was willing to associated himself with the whole building in the *Sumario*, he put his name on only one engraving, and why should it have been this one. The *Estampas* project was under way, and Perret had already engraved this print, when Herrera wrote his memorandum to Philip in 1584.[82] If we apply its standards of authorship to the engravings, then we might say that Herrera identified himself as the designer of the portions of the Escorial for which there was no pre-existing design by Juan Bautista de Toledo or other architects. The uniqueness of the inscription further suggests that this was the only composition illustrated that was entirely his own. In fact, since Sigüenza few have doubted that Herrera designed the tabernacle.[83]

The actual inscription is one of the rare instances in Renaissance art in which the maker is celebrated over the designer. Jacopo da Trezzo worked seven years on the tabernacle and its inner *custodia*, inventing machines for the prodigiously difficult task of carving the hard stones and gems, and he stressed the enormity of his technical achievement in letters to the king. Herrera fully acknowledged the importance of Jacopo's role in the *Sumario*.[84] The tribute to Jacopo on the final work was a statement that – in this case – execution was more important than design, but Herrera's inscription in his print was a reinstatement of the architect as author.

The foregoing discussion of Herrera's claims to authorship may seem excessively legalistic, but Herrera was a careful man. The *Estampas* and *Sumario* were official works, issued under royal license after the text had been meticulously checked by the king and the Council of Castile. Herrera was even obliged to resubmit the approved draft of the *Sumario*, together with the final printed text, before the prints and pamphlet could be sold. He could not claim a design that was not his. The standards that allowed Herrera to claim the tabernacle required him not to put his name to plans, elevations, and sections of the building whose design history was, as we have seen, much more complicated.

The images of the tabernacle, however, subvert this precise and qualified approach to authorship. The ninth engraving is the most artistic print in the set, the only one to treat the architecture as if it were sculpture whose forms are pictorially dramatized by careful modeling. Moreover, there are additional prints of the plan and section of both tabernacle and *custodia*, making it the most completely represented part of the building (pl. 120 and 121).

The tabernacle appears to stand for the Escorial itself, but it stands also for Herrera's style. Herrera represented the tabernacle as if it were a full-scale building, not as the over-scaled church furnishing that it actually is. Furthermore, he made it look like canonical Renaissance architecture. With its central plan, dome, and outer ring of columns, the tabernacle recalls Bramante's Tempietto in Rome – the modern building which since Serlio, was routinely illustrated in treatises on architecture as the prime example of a modern 'classic' (pl. 122).

From the moment of their publication in 1589, the *Estampas* became the visual text of the Escorial. Both Jehan Lhermitte and Sigüenza, who were living at the Escorial at the end of sixteenth century, wrote with the engravings in front of them, and every later writer has found them equally indispensable. The authority of the *Estampas* is not due exclusively to the fidelity and detail of the individual prints but as well to their combined assertion of completeness. The seventh engraving has special status in this context (pl. 123). Showing the building set in the limitless landscape of Castile, it represents the totality of the Escorial from a high bird's-eye perspective. This type of perspective construction was rarely used for architecture in the sixteenth century. Dupérac's views of Michelangelo's project for the Capitoline and the gardens of the villa d'Este at Tivoli are exceptional, although a high view point was later used by Du Cerceau for his more abstract perspectives of chateaux. Bird's-eye perspective was more frequent in topographical and commemorative illustration. Herrera's print follows in this tradition in being a faithful portrait of the building and its surroundings while nevertheless requires a viewpoint high in the air above the building that would not normally be possible.[85] Its realism of detail and visionary completeness are comparable to one other remarkable representation of the Escorial, the famous perspective of the Escorial under construction drawn about 1576 and now preserved at Hatfield house (pl. 124).[86] The hallucinatory effect is if anything greater in the drawing because the panorama that reveals the totality also shows its fragmentary state and the processes of completion in the laboring of the cranes and hoists and the tiny figures who swarm about the structure. Pedro Navascués has rightly stressed that such a view of the building process can be paralleled only for legendary or lost buildings – like the tower of Babel – in Renaissance illustration, but the Hatfield drawing and Herrera's perspective in the *Estampas* are in a sense pendants: two views in the same style of draftsmanship that represent the entire building from an imaginary vantage point, the one a view of the great labor seen from the east, the other a view of the final achievement taken from the west to reveal the main façade.

This is the visionary Escorial that was copied again and again – not to publicize its architecture, but as an emblem of Philip II, of his Christian kingship, of the Spanish state: *omnis caesareo cedat labor*. (pl. 125).[87] Herrera made a real building look like a vision,

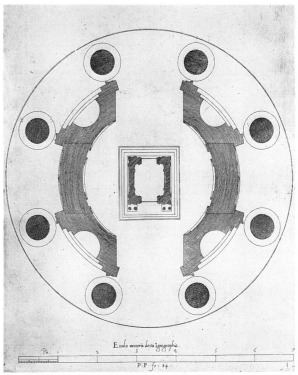

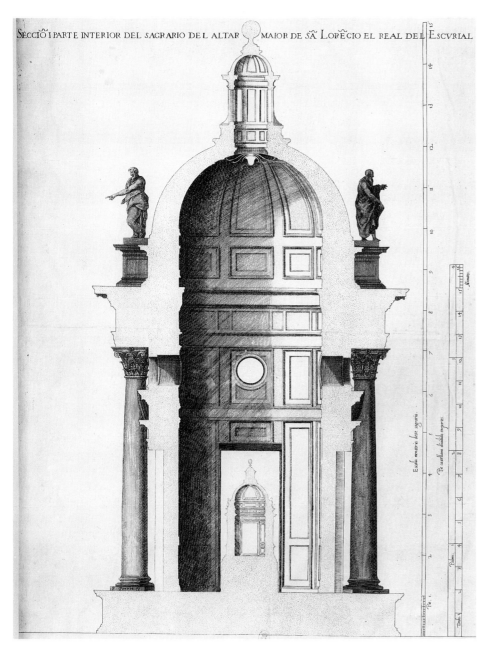

120 Herrera, section and view of the interior of the tabernacle on the main altar of the basilica of the Escorial, engraved by Pedro Perret after a drawing by Herrera or assistants in 1583 and published as the Tenth Design of the *Estampas*, 1589. (Paris, Bibliothèque Nationale)

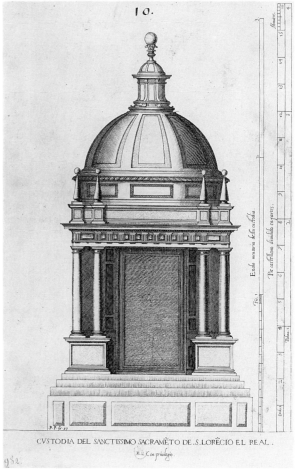

121 a and b Herrera, plan and elevation of the custodia inside the tabernacle both engraved on the same sheet by Pedro Perret from a drawing by Herrera or assistants in 1583 and published as the Eleventh Design of the *Estampas*, 1589. (Paris, Bibliothèque Nationale)

The appropriation of the Escorial

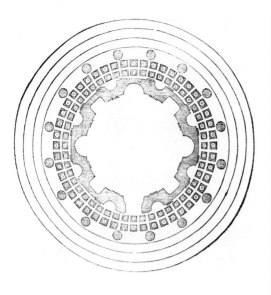

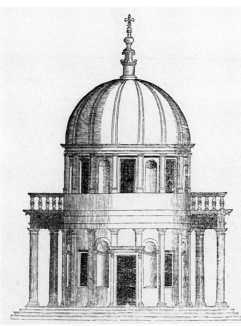

122 Bramante's Tempietto at San Pietro in Montorio, illustrated by Sebastiano Serlio from the Spanish translation by Francisco Villalpando, 1552

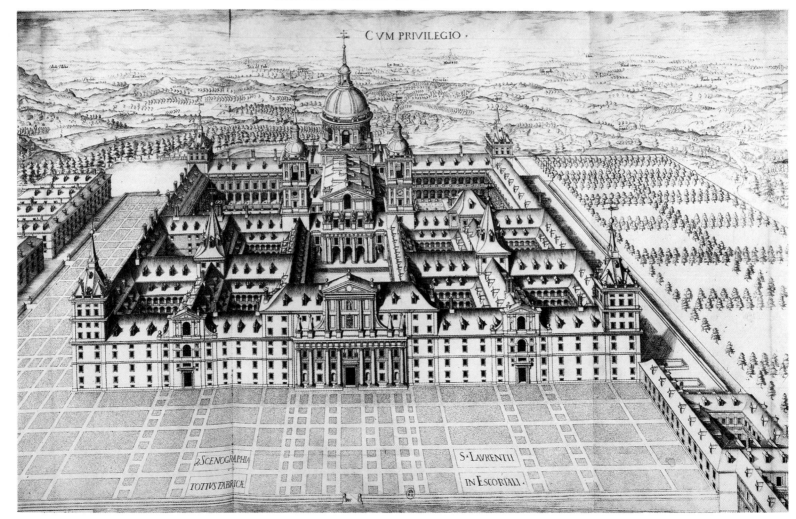

123 Perspective of the Escorial, engraved by Pedro Perret after a drawing by Herrera or assistants and published as the Seventh Design of Herrera's *Estampas*, 1589. (Madrid, Biblioteca Nacional)

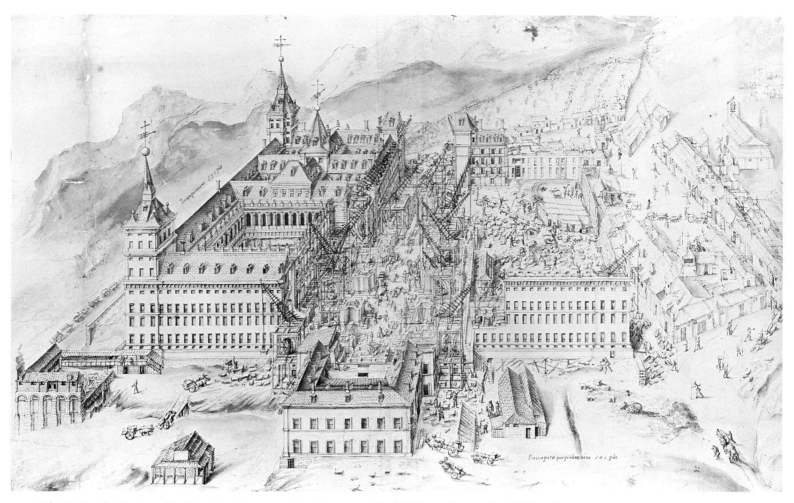

124 Fabricio Castello (?), view of the Escorial under construction, about 1576. (Hatfield House, Courtesy Lord Salisbury)

but this vision was also real, at least to a seventeenth-century Hieronymite, Francisco de Los Santos:

The perspective, which is represented in the engraving, is that of the building itself, seen from the slopes of the mountain. . . . From there, everything is revealed, like the City of the Apocalypse which, with a higher vision and more mysterious perspective was laid out in a block. Let us go around the four outside façades before we go in.[88]

Los Santos is describing the visionary experience of architecture: the Escorial is like the New Jerusalem of the Apolcalypse (or the Temple of Solomon) not only because of its towers, but because it is encountered in the same way. To see the Escorial is to go beyond ordinary life and perception. Speaking of the elements of the architecture, Los Santos declared that

they have a curious effect on the sensibility of those looking at them. No one can go into this courtyard [of the Kings] without undergoing the same experience as when we unexpectedly hear music of consonant harmony; and this is what the architecture does here; it touches the sight as music does the ear, and causes a happy suspension in the soul that enjoys, broadens, and enlarges it; because these things, ordered with reason, art and measure, belong to [the soul's] internal structure and accord closely with the human spirit which was created to be a temple of God.[89]

Earlier, in 1594, Juan Alonso de Almela summed up the Escorial as an earthly paradise:

No man, no matter how hard or unbelieving his heart, who enters here to see it and to live in it, if he looks with care at its miraculous parts – at the elegance of the building and at the variety of its most pious oil paintings painted by most accomplished craftsment of various narratives of the Old Testament as well as of the New, of martyrs and confessors, and holy virgins and celibates, and other blessed views of gardens, various fountains, and at the innumerable variety of riches and ornaments – will not say to himself, his heart filling with tenderness: Oh immense and merciful God! What will your holy glory in heaven be, if such can be depicted for us on earth![90]

Both descriptions – and this is what gives them their curious tone – combine allusive language of mysticism with the frankly pedestrian activity of walking around a building; and both insist on the subjective nature of this latter physical experience. For Los Santos and Almela there can be no neutral looking to be followed by mental reflection, interpretation, or understanding. Seeing the Escorial is to enter another world – a perspective for Los Santos, a painting for Almela – in which everything from actual stones and fountains to paintings of virgins is real; but where the building, like the Apocalyptic vision or a painting, is primarily a mental reality.

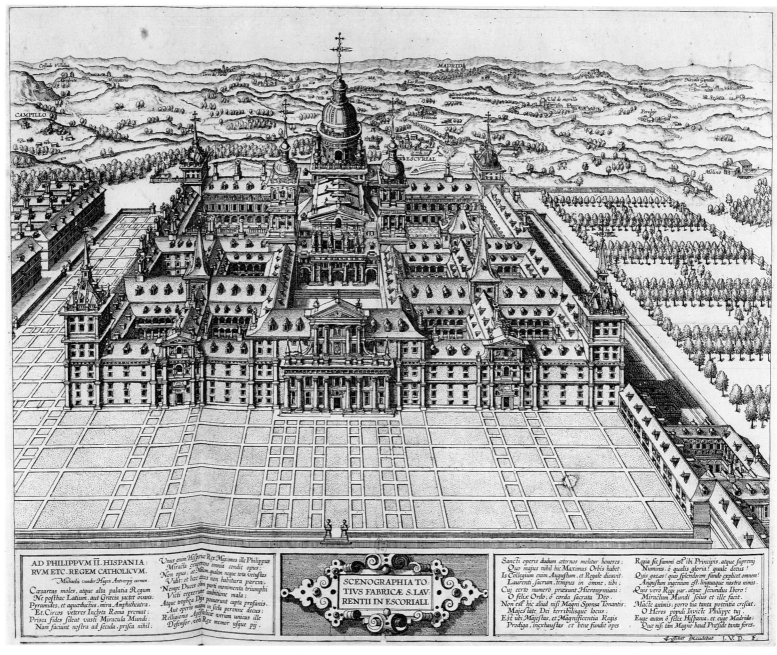

125 Perspective of the Escorial based on the seventh print of Herrera's *Estampas*. (Paris, Bibliothèque Nationale)

The dialogue between reality and illusion was well established in Spanish culture in the Golden Age, and writers who engaged in it were sometimes indulging in verbal posturing. But descriptions of the Escorial were not necessarily only literary conceits, and it is legitimate to view them as an attempt to articulate experience. Others who wrote about the Escorial in the sixteenth and seventeenth centuries described it in similar terms.[91] Whether writers were comparing it to the Temple of Solomon, the Temple of Diana at Ephesus, or the other seven wonders of the ancient world, the Escorial belonged with the lost, the destroyed, the legendary; but never had the legendary been so concrete. The Temple of Solomon was frequently invoked as a prototype for ambitious buildings, but

never was this comparison so meticulously and so architecturally explained as for the Escorial. No one compared the Escorial to the Vatican or any other extant church or monastery. In contemporary writings about the Escorial, other real buildings do not exist. The vanished Temple set the stage for the real 'eighth wonder': the building that has to be imagined as it is being seen.

The *Estampas* reveal how Philip II and Herrera saw their accomplishment and wished it to be seen. They also convey an important quality of its architecture. The Escorial presents itself as a single, gigantic building, a free-standing monument within a carefully contrived setting. The building fills an immense rectangle, approximately 740′ by 575′, which is treated as an enclosed block.

This is one of the largest building complexes of the sixteenth century, comparable in scale to the Vatican and the most ambitious projects for the Louvre.

Philip II's emblematic image of total order under divine authority required completeness, and the powerful assertion of the architecture was necessary to connect this order with the power required to produce it. The Escorial was brought to symbolic completion in just over thirty years, by 1584, so that when Philip died at the Escorial on 13 September 1598, his building was finished.[92]

Herrera was right to remind the king that this was largely his accomplishment:

for having built the church and the rest that has been built since the church was begun according to the new regulations that I gave, saved the treasury as much, and even more, as has been spent on everything built since the new regulations. And, what has been of more consequence – and should be even more greatly appreciated – is to have built in eight years what it would have been impossible to execute in eighty according to the old regulations.[93]

Governed by the highest standards of execution, forms and their meaning were woven together as if from a single thought. Unlike many Renaissance architects, Herrera lived to see his ideas respected, his drawings carried out, and every stone surface smoothed to his personal satisfaction. Except for the dome of the basilica, which is missing fifteen feet of the drum that he intended for it, the Escorial was assembled the way he wished.

The Escorial was designed to be a homogeneous whole. This too is in large part Herrera's achievement. Juan Bautista had been able to unify a composite program, but Herrera, who changed the essential elements of this project very little, brought a new and extraordinary sense of the appropriateness of architectural elements to the imaging of royal authority. Everything that he revised looked to the same goal, to assert the character and aims of its patron. This is not a modern view that we impose on the building; it was felt strongly by contemporaries, and it is due to Herrera's unerring sense of how architectural forms could be made expressive.

Herrera did not have the freedom that we usually associate with great architects, but, different as they were in most respects, he resembles no one so much as Michelangelo, who as an old man came late to St Peter's where he was bound to a great extent by the construction of his predecessors. Michelangelo did not hesitate to rethink the entire work, going back, as he said, to Bramante's central plan, and going on to create his own building. Michelangelo imposed his design of St Peter's on the whole, even the parts that were not his. Herrera's achievement at the Escorial was similar. Working under limitations even more constraining than those at St Peter's, he reworked the architecture in his own imagination.

Renaissance architects rarely tried to give buildings the personality of their patrons, except in an incidental way, although Alberti had suggested that they should, and we usually think of the client as merely the sufficient cause of an architect's work, so it may seem paradoxical to say that Herrera made it possible for the Escorial to be Philip's building; but the personal stamp of the king's authorship, which everyone since Sigüenza has seen in the Escorial, is finally due to the singularity of Herrera's style. Abstraction and severity set it apart from the styles of other Renaissance architects, including the classicism of Juan Bautista which was in many ways more accomplished. Impersonality and detachment are conveyed by rich materials, used simply and worked beautifully, by restrained and obviously purified decoration, and by an abstraction too extreme for most architects. Herrera created the architectural equivalents for Philip's chosen style of kingship. Severe deportment, prudent judgement, and simplicity so extreme as to imply complete authority over oneself and others were the outward signs of Philip's royal persona.

7
The Cathedral of Valladolid and Herrera's legacy

HERERRA'S CHURCH

THE COLLEGIATE CHURCH, now Cathedral, of Valladolid is Herrera's building according to an accepted standard: we know that he made the designs for it, and, what is more, at least six of his original drawings survive, together with copies of his lost originals (pl. 126 and 127).[1] As a group they provide a coherent design, making the Cathedral his most completely documented building. Futhermore, a set of original drawings (even if incomplete) by Herrera exists for no other work; of his remaining drawings – most of them for the Escorial – many are revisions of previous designs, so it is not always possible to decide how much in a drawing is his and how much is based on the work of other architects. There is no doubt that the drawings for the Cathedral of Valladolid represent Herrera's ideas.

Amancio Portables Pichel mentioned Valladolid only twice, in passing, in his first polemical book. Clearly, Herrera, the soldier who knew how to draw but had never designed anything himself,

could never have produced this.[2] Portables admitted that Herrera made the drawings but declared that his design 'lacked originality', implying that it was nothing more than an echo of Paciotto's project for the Escorial. This is so patently specious that even Portables did not pursue it. Paciotto's designs are lost. Portables' conviction was that they matched the basilica at the Escorial as Herrera built it (although unproved this may well be true), but the differences between the Escorial and the Cathedral of Valladolid are so striking that to present one as an imitation of the other is paradoxical. Our concern here will be precisely the profound difference in conception between these two churches.

The present Cathedral of Valladolid was begun as a collegiate church on the site of a building which had been planned in consultation with five masters by Diego de Riaño in 1527. Work was continued by Rodrigo Gil de Hontañón from 1536, but since his death in 1577 little had been done. In the 1580s existing masonry was demolished or rehandled in order to make way for Herrera's building. A new building was a rare circumstance in Herrera's

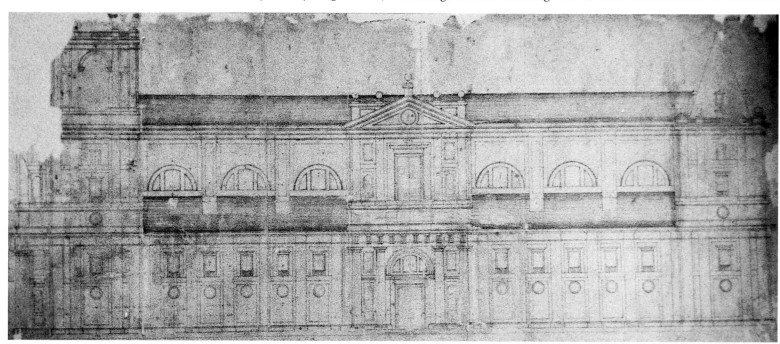

126 Herrera, drawing of the elevation of the southern façade of the Cathedral of Valladolid c. 1580. (Valladolid, archive of the Cathedral)

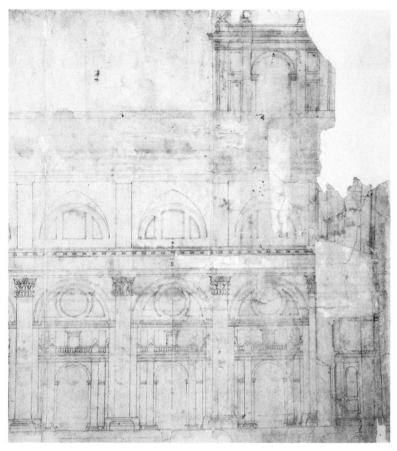

127 Herrera, drawing of the interior elevation of the nave of the cathedral of Valladolid, detail of verso of pl. 126. (Valladolid, archive of the Cathedral)

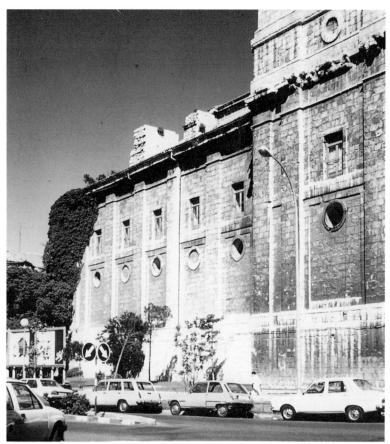

128 Northern façade of the cathedral of Valladolid

career; many of his works were based on pre-existing designs, and all his other church projects involved other architects. As we have seen, the basilica of the Escorial is Herrera's work in a sense, but he was not free to change major components, and, important as his contributions to the basilica were, they were nevertheless revisions. His designs for other churches were similar reworkings of existing plans or were subjected to transformation by later architects. Only at Valladolid does Herrera seem to have been definitely responsible for the entire conception of the church: its plan, elevation, and detail.

Herrera's church remained a gigantic fragment (pl. 128). Its bulk towers over the city, but the elevation is disfigured: walls are half-finished and old masonry from two earlier churches still clusters incongruously around the sanctuary, which is located approximately where the crossing ought to be. The cathedral looks like a building suddenly abandoned hundreds of years ago and left to decay (pl. 129). The workmanship of varying quality and periods does little to allay this impression. The northern flank reveals a sheer cliff of masonry where the cloister was never built. Inside the vast interior, the vaults are clearly later, and where a sanctuary and chapels were cobbled together, the work was not meant to be permanent.

There is, however, something immeasurably grand about the cathedral as it stands, which makes its imperfections poignant. The huge volume dominates the inconsistencies in workmanship and style, as if later and lesser generations had scrabbled about upon the vast structure, driven by the immensity of the challenge, until, exhausted, they abandoned it. The conjunction between an imaginary splendor and an imperfect reality is mutually reinforcing. The Cathedral of Valladolid has some of the melancholy charm of a ruin that time has weathered, but very little that later architects have done seems to affect it. Even the second story of the main frontispiece (1730), which was designed by a distinguished architect, Alberto Churriguera, seems flimsy.

This imperfect state is partly the result of a very long period of construction and a succession of supervising architects. Herrera prepared designs sometime between 1578 and 1582.[3] Building began in 1582 and continued through 1596, when the new piers of the nave were finished and some chapels vaulted, but when the collegiate church was finally designated a cathedral by papal bull in 1595, it was still a building yard. Lower portions of the main façade were started in 1600. The vaulting of other chapels and the nave was not undertaken until the 1620s and continued into the 1650s. The second half of the church was never begun.

The effect of the present building is due also to qualities inherent in the original conception. This church was planned on a colossal

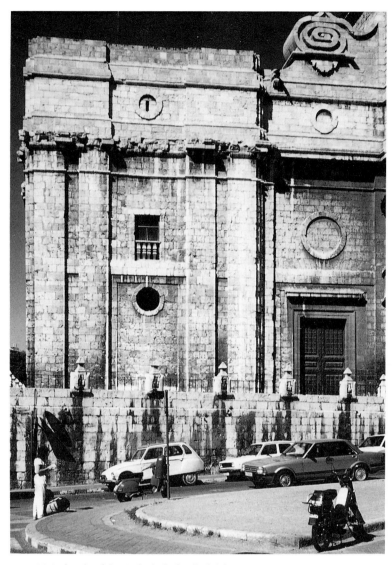

129 Main façade of the Cathedral of Valladolid

As we might expect, architects felt less bound to Herrera's designs as time went on, and probably less confident in interpreting his style. Nevertheless, later architects felt Herrera's presence strongly when they copied his drawings, and when they altered designs, as in the seventeenth-century model, their modifications were consistent with what they thought he would have done. The cupola with its huge windows and domed lantern recalls the Lisbon palace, and the symmetrical towers were based on the basilica at the Escorial.

Later generations 'escorialized' the cathedral even more, if only in words or images, in order to make it compatible with their conception of its architect. Herrera, the 'genius invented by Llaguno and others' that so enraged Portables, was first and foremost known as the architect of the Escorial, so it was natural to use the Escorial to fill in his design for Valladolid. Otto Schubert used the model as the basis of his reconstruction of Herrera's project.[5] Few have been as reckless as Portables, but many see the ghost of the Escorial in the forms of Valladolid. Even Fernando Chueca, who is extremely sensitive to the character of Herrera's project and scrupulous in his reconstruction, and who was also the first strongly to contrast the two buildings – even he did not avoid adding details from the Escorial to his reconstruction of Herrera's project.[6]

The Cathedral of Valladolid is not a version of the basilica at the Escorial but it fits comfortably neither in the Italian classical tradition nor in the development of indigenous churches. It was clearly an attempt to create something new, but it is not an oddity within Herrera's work. Other projects show evidence of his continuing concern with the architectural issue of the modern church, and the result at Valladolid is entirely consistent with this ongoing thought before and after he made the drawings that are so fortunately preserved.

scale with a length of over 400 feet. Great size alone is no impediment to architectural unity, nor, as we can see from a number of Gothic churches, does an unfinished state necessarily spoil a design, but Herrera's architecture is particularly dependent on formal completeness and, at such a scale, it does not make a handsome fragment.

The early supervising architects were trained at the Escorial, like Pedro de Tolosa, or were followers of Herrera, like Diego de Praves, who directed the project between 1582 and his death in 1620.[4] When Praves's son Francisco took over as master of the works in the 1620s, the building passed to an architect who had never known Herrera. No architectural drawings, not even Herrera's, are completely adequate for construction. At Valladolid, the stonework is sometimes coarse, and ornamental motifs were mishandled. The supervising architects tried to remain faithful to Herrera's original designs until about the middle of the seventeenth century. At this time a model was built which shows a cupola added to the crossing and higher towers (pl. 130).

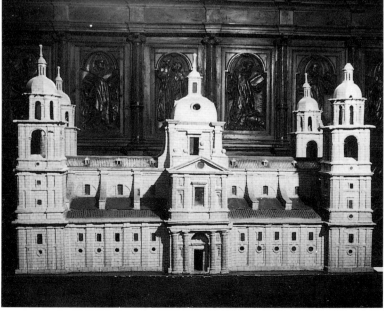

130 Seventeenth-century model of the Cathedral of Valladolid. (Valladolid, Cathedral Museum)

THE PERFECT RENAISSANCE CHURCH

Renaissance architects thought a church should represent the consonance between divine and natural order and associated this with a cupola and a centralized plan.[7] It was not always possible to put this ideal into practice and there was often strong resistance from the ecclesiastical establishment, but the theme was the major preoccupation of Italian architects for most of what we call the Renaissance. The most exalted Italian designs, whether those of Leonardo, Bramante, Michelangelo, or Palladio, began from its premises.[8] It was natural that the architects of the basilica at the Escorial should attempt to realize the Renaissance ideal and that Herrera should maintain the theme of the centralized church in the tabernacle and adapt it for the fountain in the Courtyard of the Evangelists.

The Cathedral of Valladolid departs from this ideal, if not – as we shall see later – entirely from Renaissance ideas. It has neither a central plan nor an exterior dome. It is instead an immense rectangle, roughly twice as long as it is wide. The nave is flanked by aisles and beyond them are a series of chapels that run the entire length of the building. The non-projecting transept divides the church into symmetrical halves. The four piers at the crossing are more widely spaced and designed to carry a shallow saucer-like dome covered by a very low-pitched roof, as we can see from Herrera's section drawing (pl. 131).

Many Renaissance architects designed longitudinal churches which, like Alberti's Sant' Andrea in Mantua, Vignola's Gesù in Rome, and Palladio's San Giorgio and Il Redentore in Venice, nevertheless, accommodate Renaissance principles: they are hierarchical compositions of parts, their interior organization is reflected in the exterior massing, and the whole composition is resolved in a dome. Herrera's church is a giant box anchored at the four corners by towers. At the eastern end, the towers stop at the roof line, where they are capped with simple pyramidal roofs which appear in Herrera's side elevation. On the main façade, the towers are one story higher. Fourteen massive piers separate the nave from the aisles along its length, dividing the space into a series of identical units, and the side chapels have narrow entrances separating them from the aisles.

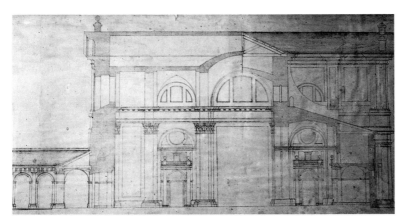

131 Late-sixteenth-century copy of Herrera's section of the Cathedral of Valladolid. (Valladolid, archive of the Cathedral)

Renaissance writers articulated theoretical ideas on church building in relation to architectural forms in a clear and compelling way, so we may ask: Why did Herrera discard the most prominent features of their program? Given his interest in geometry, his mathematical bent, and his passion for mathematical symbolism, it is surprising that he was not attracted by the architectural theme that combined them all. Fernando Chueca was the first to argue persuasively that Herrera's design was of Gothic origin.[9] But is it really, and, if it is, why should an architect as deeply committed to classical style as Herrera undoubtedly was turn to Gothic? The answer is not obvious and requires first of all that we briefly consider the status of the Gothic in sixteenth-century Spain.

THE SURVIVAL OF THE GOTHIC

Gothic began in Spain in the thirteenth and continued well into the seventeenth century. Its popularity was at its height when, in 1401, Lorenzo Ghiberti won the competition for the new doors for the baptistry in Florence and inaugurated Renaissance style in Italy. Seville was just then beginning a Gothic cathedral so vast that a canon is supposed to have said: 'we will build a church so big that, when it is finished, people will think we were crazy.'[10] Florentine ambitions were not so different at that moment, and Italian artists came to Seville to work on the cathedral's terracotta decoration.

By 6 October 1506, however, when the last stone was laid in Seville's magnificent crossing tower designed by Simon de Colonia, the situation had changed. Brunelleschi's dome of the cathedral of Florence – Gothic in its structure but immediately adopted as the symbol of the total rejection of Gothic – had been standing for over seventy years. In Italy the Gothic was under attack as early as 1450; by 1500, it was a dead style, even though Leonardo and others were preparing designs for the crossing tower to the Cathedral of Milan. Gothic might be occasionally resurrected for special purposes, but such Gothic revivals in the sixteenth century were in the hands of classicizing architects like Peruzzi or Palladio, who were neither well informed nor sympathetic.[11] Seville celebrated her triumph a scarce six months after Bramante and Julius II laid the founding stone of their new St Peter's in Rome. By this time in Italy the gap between Gothic and Renaissance had grown unbridgeable.

In 1511 the great tower of Seville crashed to the ground, but this did nothing to dampen the enthusiasm for Gothic. In 1510, the masters of the cathedrals of Seville and Toledo had met together to draw up the plans for the new Cathedral in Salamanca; it was to be built alongside the old church, which now seemed to the canons 'very old, dark, and low.' As Salamanca was under way, the first stone of a new Cathedral of Segovia was laid in 1526. Plascencia was founded earlier in 1498. The construction of these churches in Gothic style extended through the sixteenth century and beyond. Rodrigo Gil de Hontañón was finishing the vaults of Salamanca's nave in 1546. He returned to the Cathedral of Segovia in 1563. The second half of Salamanca was resumed in 1589.[12] In the 1580s, when Herrera was preparing designs for Valladolid, these churches were new and some, like Segovia and Salamanca, were under construction: Gothic was still viable.

Was the classicist, Herrera, perhaps constrained to follow a

The Cathedral of Valladolid

Gothic plan at Valladolid? Two arguments are usually advanced to explain why Renaissance architects sometimes chose to employ Gothic style, and both could be relevant to Herrera's circumstances in Valladolid. The first, and most general, is that ecclesiastical patrons were conservative and, since a church is determined by a certain ethos, they naturally preferred traditional – in the case of Spain – Gothic buildings. Italian architects, working out of the powerful tradition of early Christian basilicas and the Romanesque buildings derived from it, seldom had to deal with patrons who wanted Gothic, but they, too, often found it difficult to convince their clients that centralized plans could accommodate their liturgical practices. In Spain, where public religious observance was closely associated with Gothic spaces, Renaissance style would have been more startling than in Italy.

Herrera was sensitive to ecclesiastical requirements. In 1589, some ten years after he had prepared the drawings for Valladolid, the canons of the Cathedral of Salamanca wrote to him for advice on how to continue their church. Herrera replied emphatically:

> ... because the problem is one of enlarging this holy temple, it would be well if first they look to the things that will be necessary to it and to how it is to be when all the work is considered complete, finished with all the things that it needs and are suitable to it. And these resolutions [should be taken] by persons who have experience in what a tempie like this one needs in order to be well-served and provided with what is necessary for the divine services that will be held in it.[13]

Indeed, Herrera modified traditional arrangements at Valladolid by placing the choir behind the main altar so that the altar would be visible from the nave. This was in response to the decrees of the Council of Trent, which stipulated that the Holy Sacrament on the altar be visible to the entire congregation.[14]

Usage is only part of the story, however and we ought probably to include the more intangible significance that Gothic possessed in Spain, where it was the dominant style of religious buildings. The effect of these buildings is quite different from a classicizing church, as Renaissance architects were well aware. Alberti had written about how the architecture of a church should inspire awe and facilitate meditation. In his view, the perfection of the architecture was a devotional aid. Yet there is no doubt that the piety envisaged by humanists was of a peculiarly intellectual and philosophical sort. Alberti, for example, minimized figural decoration and argued for pure, light-filled spaces. In sixteenth-century Spain, where the Church was particularly attentive to her hold on congregations, unfamiliar spaces and the novel arrangements they would require might have seemed an added risk that was not worth taking when Gothic style was an accepted housing of religiosity. These arguments are plausible, and conservatism was probably a factor in the survival of a taste for Gothic.

Patrons were not always conservative, however, nor was Gothic necessarily a conservative choice. The new Cathedral of Salamanca had been started early in the sixteenth century, but the crossing, choir, and apse were still unbuilt in 1588 when the canons asked a number of architects to prepare designs for the crossing, the part of the church which they hoped to build next. When these projects were brought to Herrera, he replied that:

A general design should be made of all this, finished and showing to perfection the manner in which this building should appear. And, this being made, whatever is most convenient of each part may be undertaken whenever it is desired to build something. Because if this is not done, and the temple is begun now without this general resolution, as time goes on there will be many errors, which in buildings are difficult to put right and putting them right [is] expensive. Making this drawing and finishing it as it should be is, as I know, laborious and time-consuming work, but one gains by doing it.

Herrera knew what he was talking about, and his advice seems obvious to us because this has been standard practice for a long time, but preparing a full set of detailed drawings for a building before construction begins was a Renaissance practice that was still relatively unfamiliar.

Herrera's advice also forced the canons to face a Renaissance problem, one they were only beginning to realize they had: their new cathedral had been designed by the best masters, but it was Gothic.[15] By 1589, the pre-eminence of the Gothic style was no longer evident, and the canons were clearly hoping to go on in a more fashionable style, hence their application to Herrera, but, as they soon discovered, although good design might call for classicism, architectural unity called for Gothic. Any drawing of the entire building was going to make this obvious. Herrera may have said as much to their representative, for, as soon as his report was received, the canons met to debate the issue and decided unanimously to continue the cathedral 'in modern style, like the parts already completed (pl. 132)'.

The evidence from Salamanca reverses what we assume to have been the usual state of affairs between patrons and architects. In this case, at least, it was not the patrons who wanted traditional Gothic; on the contrary, they hoped to have classical style. Their repeated invitations to Herrera (they asked him at least twice) seem to prove it, for they must have known he was no Gothic architect. The outcome of their discussions with him was to continue in Gothic, but they did not quite give up on classicism: after their meeting, the canons appointed a classicizing follower of Herrera, Juan del Ribero Rada, to be their architect and sought copies of Herrera's designs for the Cathedral of Valladolid.

We could dismiss the entire incident – since it had no effect on Herrera's designs for Valladolid – were it not that it raises an

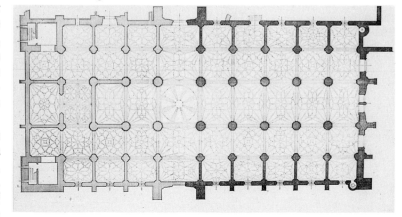

132 Plan of the Cathedral of Salamanca (after Chueca-Goitia)

important point: unless the canons were prepared to invest in a third – classical – cathedral to go alongside the old Romanesque and partially completed Gothic buildings that they already had, the new parts of the building would have to accommodate themselves to the Gothic church. Herrera recognized this difficulty: he said that he would not make any specific proposals without coming to Salamanca for 'otherwise I would not dare to do anything.'

In the end, he did not come; he was tired and his gout was troubling him, and the project may not have been to his taste. He wrote that he hoped the canons would find 'persons that have the ability that such a building requires' but warned 'that Spain lacked these as well as many others [experts] that she needs, and, even though we call them by the name of architects, I think we could better call them patchworkers and destroyers of good architecture' – strong words from a reticent, perhaps also a disillusioned, man. At this date the 'patchworkers,' whoever they were, were not likely to have been Gothic architects. Herrera was probably thinking of those who combined styles or who applied classicism too freely in the light of his own rigorous standards. Whatever Herrera's reasons for bowing out, what is important here is the fact that he seriously considered taking on the project and that he saw himself as the best man for the job.

Clearly, Herrera was not personally antagonistic to Gothic architecture, but this has not solved our problem and has in fact complicated it. Herrera rejected the Renaissance ideal and used an aisled basilical plan that looks Gothic for his Cathedral of Valladolid, but the evidence from Salamanca suggests that assuming that conservative patrons imposed this on him is simplistic. Moreover, there was something about Herrera's design for Valladolid that made it suitable for the Gothic church of Salamanca, although the behavior of the canons implies that what they hoped to find in his plans for Valladolid was classicism.

The second reason to employ Gothic style was prior construction. The canons at Salamanca chose to continue in the style of the parts of the church that were already built. Adapting to existing construction was an important factor in all Renaissance architecture, and the enormous cost of building, which constantly rose in Spain during the sixteenth century, dictated that the best use be made of existing masonry. The fact that buildings often took many years and a succession of masters to build meant that architects often faced this problem.

Herrera's church was designed to replace the earlier Gothic construction, and there is reason to believe that it rose partly upon existing foundations. No plan of the earlier building survives, but a drawing submitted to Herrera by Diego de Praves shows what had been already built. Part of a tower on the main façade, the exterior walls and divisions for two side chapels were standing in addition to at least one pier of the nave. This was the beginning of a nave, side aisles, and a series of square side chapels opening on to the aisles, although it is impossible to tell what was planned for the crossing and sanctuary. It is obvious that Herrera's designs incorporated much of this construction. Praves's drawing showed Herrera's piers and chapels on the opposite side of the nave, which, though not identical – the side chapels are shallow rectangular spaces rather than square spaces roughly equal to the width of the aisle, and the piers are not aligned with the earlier work – are obviously related.

Herrera's project may have been superimposed on the foundations of a similar church, but, if this could be proved, would it follow that Herrera's church looks Gothic because he was constrained to follow existing foundations? The double square was the typical format of Spanish Gothic cathedrals, and it is not impossible that Riaño and Gil were planning a rectangular church. This was Chueca's view and it has been generally accepted. Without further evidence of the earlier design, however, it is impossible to know.

Herrera's church was the fourth building on this site. An earlier Romanesque church and a larger Gothic building were already standing when, in 1527, it was decided to build a third, much larger, church with a different orientation. A plan of the site, dating probably from the late seventeenth century, shows the disposition of all four buildings: the two earlier churches, the beginnings of the third Gothic church, and Herrera's building.[16] In the earlier sixteenth century, the two churches were left standing (one was even repaired) while construction was under way on the third church. Spanish patrons were not averse to starting over again when it suited them; in a sense, this is what they did when they commissioned new plans from Herrera. Very little of the third collegiate church had been built by 1577. There may have been compelling pressures from the clients that caused Herrera to adopt a Gothic plan type; or there may have been none at all. Herrera was at this period a famous architect whose designs commanded very high prices and he could probably have convinced his patrons at Valladolid to build a church like that at the Escorial had he himself wished to do so.

To insist on Herrera's freedom to design the Cathedral of Valladolid more or less as he chose may seem arbitrary since buildings, more than most works of art, are collective efforts to which important contributions were, and still are, made by non-architects. Whoever was responsible for choosing a Gothic plan-type for Valladolid, however, it was Herrera who had to make architecture out of this choice. Were his design simply a Renaissance building rising upon an earlier Gothic plan, we would be justified in viewing the plan as a constraint imposed from without. There is no reason to believe that this was the case at Valladolid and, even if the earlier plans were similar to Herrera's, it would not explain why he chose to follow them. Whatever Herrera took from the earlier building was only so much as he felt necessary. The rest of the masonry, some of it standing twelve meters high, was demolished or encased in new construction.

If the Gothic aspects of Herrera's design were not the consequence of outside pressures, there is no reason to view them as an unwelcome residue that diluted a design that would be otherwise have been more purely classical. His cathedral is not Gothic, nor is it a traditional structure in classical dress, but the plan is one allusion to the medieval past that has been separated from any direct reference to Gothic style. Gothic survived in Herrera's design as a significant component of its classicism. This is a surprising choice for a classicist as pure as Herrera, but it becomes understandable in the context of the Spanish situation.

The Cathedral of Valladolid

Gothic was challenged already in the early sixteenth century. Within the churches, the altarpieces – the great carved wooden or stone *retablos* typical throughout Spain – were definitively transformed in the late 1520s under the impact of sculptors like Diego de Siloe and Alonso Berruguete, who returned from Italy with a new architectural vocabulary as well as a monumental, Italianate figure style. From 1526, when Diego de Sagredo published *Las Medidas del Romano*, Renaissance style was commonly referred to as work 'a lo romano', while Gothic was 'a lo moderno.'[17]

Herrera did not favor the mixture of styles, and his comments about 'patchworkers' suggest that he subscribed to the Italian view that classical and Gothic are fundamentally incompatible because they belong to different historical periods. This truly Renaissance view appeared among Spanish practitioners in the 1580s. Even though Spaniards had spoken much earlier of Roman and modern (Gothic) as contrasting styles, only in Herrera's time did they come to see them as historically different.[18] In 1586 Juan de Arfe, who had worked at the Escorial, characterized Gothic as a barbarous style that developed after the fall of Rome:

Barbaric style, called masonry, *cresteria*, or according to others: modern style, was introduced, in which they built the cathedral of Toledo, Leon, and those of Salamanca, Burgos, Plasencia, Avila, Segovia, and Seville.

Modern style was antiquated:

This barbaric style had already come to its end was beginning to fall into disuse in our own times, when the ancient style of the Greeks and Romans was introduced, and although it was revived earlier by the diligence and investigations of Bramante (master of the works of St Peter's in Rome), Baltassare Peruzzi, and Leone Battista Alberti – architects famous in Spain – it also began to flourish with . . . Alonso de Covarrubias, master of the works at the cathedral of Toledo and royal Alcázar . . . and Diego de Siloe, master of the Cathedral and Alcázar in Granada.[19]

Arfe tried to push Gothic into the past, and one would not guess from his text that some of the cathedrals he mentions were still under construction.

Arfe's idea of the succession of architectural styles derives from the same Italian sources that have shaped our modern ideas about the Renaissance, but Arfe was not easy in his mind. Like Philibert de L'Orme earlier in France, he was reluctant to condemn the style in which he had been brought up. The Gothic still seemed to him ingenious and beautiful: 'they built many temples in this which are visible still today, solid and with handsome elevations and graceful and subtle ornament.' Italians, who looked upon Gothic as a foriegn importation, seldom shared such feelings. Alberti had allowed the old parts of the façade of Santa Maria Novella in Florence to remain and so mixed Gothic and classical style, but he noted in his treatise that in principle 'if a building cannot be improved without changing every line, the best remedy is demolition, to make way for something new.'[20] Later Italian architects rejected stylistic mixture, and, when required to complete Gothic buildings, were obliged to chose one of two solutions: they could continue in Gothic and preserve stylistic homogeneity; or they could reclothe the building in classicism. The former was never an attractive option. Struggling

to design a Gothic façade that would be compatible with the old church of San Petronio, Palladio finally concluded that the old construction utterly contradicted the 'well-proportioned relationships' and 'harmonic correspondences that contain majesty and decorum' of good architecture and recommended demolition of the old façade.[21] In his treatise, Serlio was frankly for reclothing old buildings, and Palladio and his patrons chose to encase the old basilica in Vicenza in a new classicizing architecture.[22]

Among Renaissance architects, only Philibert de L'Orme in France offered a different but equally modern solution. He argued that the truly skillful architect would allow old structures to remain intact and encorporate them in classicizing compositions, the greatest challenge to the architect being to affirm, not efface, the contrast between past and present. The aggressive historicism of Philibert's theory of accomodation is at odds with the Italian view although it is an entirely modern notion that became one of the most persistent and characteristic features of French architecture.[23] To judge from his comments on the designs for the Cathedral of Salamanca, Herrera seems closer to the Italian belief that stylistic unity should be maintained, even at the cost of imitating Gothic if a building could not be redone.

CLASSICIZING THE GOTHIC

Juan de Arfe thought that the earliest essays in Renassance style in Spain were a mixture of old and new. He recognized Alonso de Covarrubias and Diego de Siloe as the founders of the new manner, but found their style imperfect: 'for there is always a certain mixture with the modern style, which they were unable completely to forget.'[24] Gothic was a habit that adulterated classicism. The idea that an old style survives within a imperfect comprehension of the new is familiar in accounts of stylistic evolution, but it is not fully adequate to the Spanish situation. Combining Gothic and classical – an idea that was intrinsically distasteful to Italians – was the deliberate choice of Spain's most brilliant Renaissance architects. Early in the sixteenth century Spanish architects chose to classicize vaulted buildings by substituting classical elements for traditional piers. This was done at the Lonja in Zaragoza, whose pillared hall was based on the earlier Gothic exchanges in Valencia and Palma de Mallorca. Classical columns successfully replaced Gothic piers partly because such a hall was easily adapted to classical norms; only the rib vaults posed a problem, and the transition between columns and vaults at Zaragoza had to be concealed by sculpture. Spanish architects later adopted this idea in hall churches.[25]

Diego de Siloe's design for the Cathedral of Granada was more ambitious.[26] This was program on the scale of the enormous cathedral of Seville and, beginning in 1528 when Siloe took over as master of the works, he transformed a five-aisled Gothic cathedral begun by Enrique Egas into a classicizing building. He replaced piers with clusters of columns raised upon cylindrical bases, adding an upper order of pilasters in order to reach the vaults, and he redesigned the chevet as a vast rotunda, creating a centralized, domed space attached to the nave. Siloe's structural use of the

orders was an inspired interpretation of the classical system – Earl Rosenthal was able to find classical precedents for almost every feature – and it was enormously influential. The cathedrals of Málaga, Guadix, and Baeza were all based on substituting the orders, classical piers with attached columns, and round arches for Gothic elements. Andrés de Vandelvira adopted Siloe's system for the Cathedral of Jaen begun in 1548.[27]

Architects like Siloe and Vandelvira obviously wished to retain some of the qualities of Gothic interiors, and they developed their classicism around the principle of using the orders as a structural system. Something similar occurred at St Etienne-du-Mont in Paris, which combines columns with a balustrade in a composition that is both classicizing like a reconstruction of a basilica from Vitruvius and responsive to the space of the late Gothic choir. Such inspired adaptations of the classical system to Gothic spaces in France and Spain are not a simple application of classical ornament to a Gothic armature; they attempt to create a classical analogy to Gothic. Siloe's and Vandelvira's ornament is so rich in its echoes of antiquity and so splendidly assured in its handling of ancient and naturalistic ornament that it can be described only in the terms of Renaissance classicism.

Siloe's and Vandelvira's cathedrals were brilliant combinations of Gothic and classical systems. Like beautiful hybridized flowers, they combine the best features of their ancestry in an original creation, but like all hybrids they are variants of pre-existing organizations. Siloe combined a traditional nave with a classicizing rotunda derived from the early Christian rotunda of the Anastasis.[28] A different mixture, this time emphasizing Gothic, appeared at the Cathedral of Segovia and new Cathedral at Salamanca, when magnificent Renaissance cupolas were grafted on the bodies of churches in late Gothic style.[29]

Herrera rejected such hybridized solutions. His attitude was probably much like Arfe's. In fact, Arfe's book, which was published in 1586, is the first Spanish treatise to assert a truly Renaissance conception of the relation between Gothic and classical, and the first to define earlier classicizing architects like Siloe and Covarrubias as precursors in a Spanish quest for classicism. Arfe's views were reiterated by José de Sigüenza at the end of the century, and it seems legitimate to connect both authors with Herrera's ideas. It should be stressed, however, that the incompatibility of Gothic and classical is not the only, nor even the main, issue. Arfe is contrasting two kinds of classicism: an adulturate style perceived as classicism that has not been fully mastered with the authentic classicism that has superseded it in his own time. It is this framework that allows us to see Herrera's designs for Valladolid both as a rejection of the earlier classicism of Siloe and Vandelvira and as a continuation of their efforts to devise a classical style in cathedral buildings that preserved something of the Spanish Gothic heritage.

VALLADOLID, A MODERN CATHEDRAL

It had been nearly sixty years since Siloe designed Granada, but three generations of cathedral building had done little to change the terms of his solution. Valladolid was Herrera's answer to Siloe and Vandelvira, framed as a total rejection of stylistic compromise. He cast aside both the structural and the decorative components of Gothic, embalming a medieval image in a classicizing building that resembles Cesariano's reconstruction of a Vitruvian pseudodipteral temple.[30]

The scale of Herrera's project for Valladolid, like the cathedrals designed by Siloe and Vandelvira, recalls the Cathedral of Seville, begun almost two hundred years before. The desire to echo the largest of the Spanish cathedrals may have been already present when Herrera stepped in. The third collegiate church in Valladolid was founded a few months after the birth of Prince Philip near the city on 27 May 1527 and was associated with the new sense of importance which this gave to the city. When it came to building an imposing urban church, Spaniards thought naturally of Seville, and the similiarity between the dimensions of Valladolid and Seville is probably deliberate. Herrera showed the nave as 50' wide, only slightly less than Seville's.[31]

In taking up the challenge to reconcile Gothic and classical architecture, Herrera altered the nature of the enterprise. He did not combine Gothic and classicizing plans. If he did not develop a powerful centralized space like Siloe's rotunda, neither did he use a ring of radiating chapels or a Gothic nave and aisles. The stepped chevet and lowerside aisles of Granada recall earlier 'High' Gothic style and Siloe's classicism generally depends on the direct substitution of a classicized structure for this kind of Gothic. Herrera showed no interest in High Gothic; instead he focused on a later phase of Gothic architecture.

In the fifteenth century in Spain, architects designed monumental box-like churches with few windows and little exterior ornament. Juan Guas's San Juan de los Reyes in Toledo is a good example (pl. 133, 134). The impressive effect of Segovia and Salamanca cathedrals, which rest like colossal arks above their towns, derives from the grandeur of their simple massing, an effect seldom equalled in earlier Gothic or in later classicized churches. Only Vandelvira's Jaen, which is a hall church, rivals them with its sheer walls and the flat façade and sanctuary. Herrera also turned to late Gothic in a deliberate and aggressive way. The massive towers and flat ele-

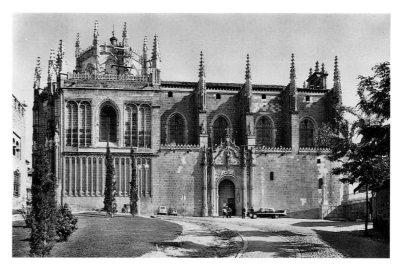

133 Juan Guas, San Juan de Los Reyes in Toledo, late fifteenth century

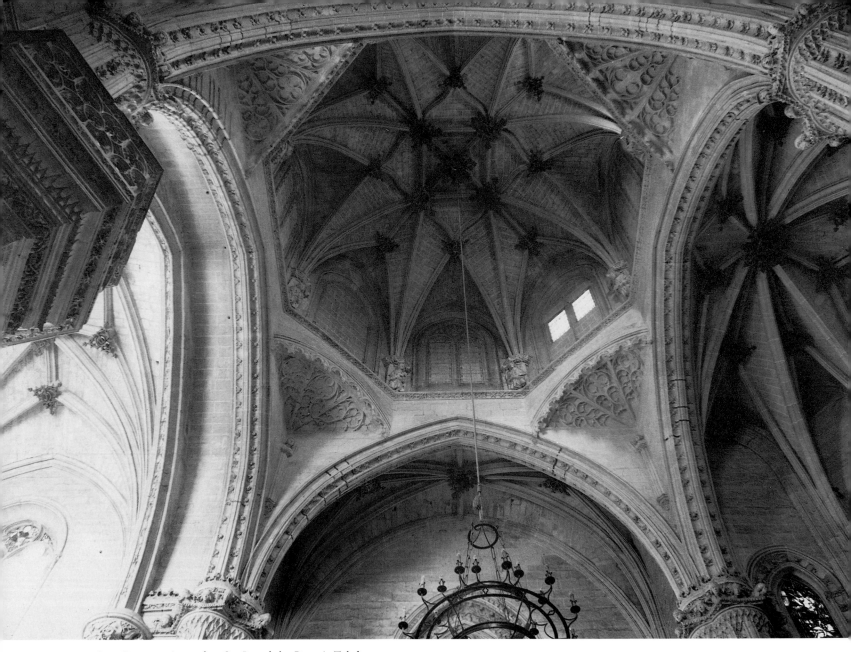

134 Juan Guas, crossing vault at San Juan de los Reyes in Toledo

vations are an obvious complement to the bold and overscaled geometry of Gil's late Gothic porch of San Benito in Valladolid on the opposite side of town (pl. 135).

Valladolid is not what we would expect from the architect of the basilica of the Escorial, but we must accept that it is what Herrera wished, and its medievalism cannot be dismissed as a classicist's reluctant accommodation to an alien style, much less as the inevitable result of using the pre-existing masonry in the foundations of the church. We may nevertheless have some lingering doubts since we do not know exactly what the design for the earlier collegiate church looked like and there is much we do not know about the circumstances of Herrera's commission. How can we be sure that he was not constrained to produce a medievalizing design? The answer comes from Herrera's other ecclesiastical projects which show clearly that the Cathedral of Valladolid was more representative of his concerns that was the basilica of the Escorial. The evidence, though fragmentary, shows Herrera prepared to depart from accepted Renaissance standards and ready to dismantle

Renaissance features of another's design: the Escorial, not Valladolid, was the exception in his work.

SANTO DOMINGO EL ANTIGUO IN TOLEDO

The first plans for Santo Domingo el Antiguo were drawn up early in the spring of 1576 by Nicolás de Vergara el Mozo, a prominent architect in Toledo. Contracts had already been let to the workmen when, for reasons that are not known, Diego de Castilla, who was administering the project, invited Herrera to rework Vergara's plans. New contracts were drawn up so that construction could proceed according to Herrera's designs. Diego de Alcántara and Juan Bautista de Monegro joined the works under Vergara, presumably to see to it that Herrera's ideas were faithfully carried out. In fact, the design was changed again, apparently by Herrera and then by Vergara, before the church was finished in September 1579.[32]

Vergara designed a centralized church with an exterior cupola

124

over the crossing and a short nave with side chapels. Herrera altered this in ways that may seem contradictory: he corrected the designs from a classicist's point of view, adding three feet to the width of the entablature, which was certainly much too narrow in the earlier project, and eliminating the ornament that Vergara planned to apply to the vaults and arches. On the other hand, he removed the monumental portal, changed the apse from a classicizing hemicycle to a rectangular niche covered by a barrel vault, and suppressed Vergara's dome, putting an octagonal wooden *boveda de camones* (a French *comble*) in its place. Herrera's crossing was not built; an interior cupola was reinstated and a different roof executed (pl. 136).

One can appreciate the difference between Vergara's and Herrara's projects by comparing the sheer, block-like exterior of Santo Domingo el Antiguo (pl. 137 and 138) with Vergara's semi-

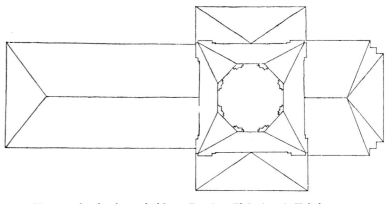

136 Herrera, plan for the roof of Santo Domingo El Antiguo in Toledo, 1576. (Madrid, Biblioteca del Palacio Real)

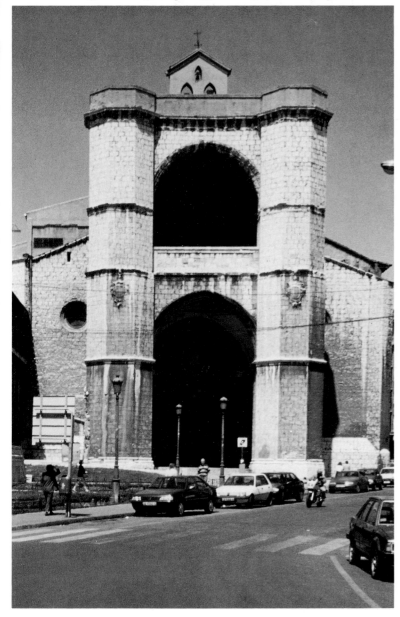

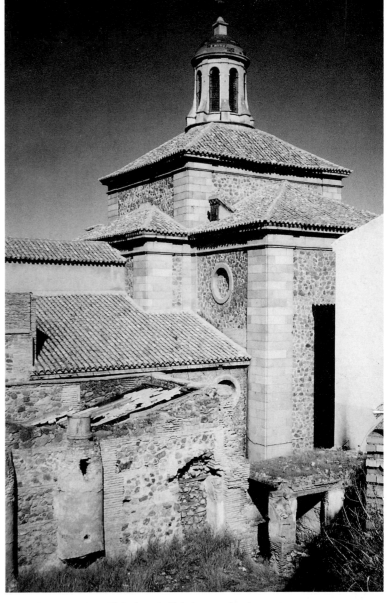

135 Rodrigo Gil de Hontañón, porch of San Benito in Valladolid, 1569–72

137 Santo Domingo El Antiguo in Toledo, completed 1579

The Cathedral of Valladolid

138 Detail of the exterior of Santo Domingo El Antiguo in Toledo

SANTA MARIA DE LA ALHAMBRA

Herrera was also responsible for a revision of Juan de Orea's designs for Santa Maria de la Alhambra about 1574, but, as these plans were again revised in 1595 by Francisco de Mora, who was in charge when construction finally began in 1618, it is very difficult to determine what Herrera contributed to the building. An undated plan by Herrera, published by Ruiz de Arcaute, gives us an idea of his intentions, but may also reflect some of Orea's prior ideas (pl. 139 and 140).[34]

The church has a three-bay nave with rectangular chapels opening on either side: a traditionally Spanish plan. The eastern end is as deep as the nave is long, but wider, and so fits inside a square. The interior, however, is not centralized; the crossing is extended in shallow transepts, and behind the main altar a narrow retro-choir and two symmetrical rooms are carved out of a mass of masonry. The piers of the nave suggest barrel vaults, like those used later by Francisco de Mora at San Barnabé in the town of El Escorial, and the massive piers decorated by pilasters at the crossing imply a significant superstructure.

circular apse for the church of the Tavera hospital outside the walls of Toledo, which was built a few years later.[33] Vergara's classicism is conventional; Herrera's giant corner pilasters framing the rubble walls of Santo Domingo el Antiguo are far more monumental but less classical by comparison. Herrera replaced the typical forms of Renaissance classicism by a traditional Spanish rectangular apse and a French roof. Obviously he preferred its complex geometry to the more perfect exterior form of a dome, and this block-like exterior, which is overscaled for its restricted setting, is a rehearsal for the effects of Valladolid.

On the interior Herrera projected an octagonal lantern covered by a vault in eight sections and supported by small piers with pilasters around the base of the octagon, somewhat like Juan Guas's late-fifteenth-century vault for San Juan de los Reyes in Toledo (see pl. 134).

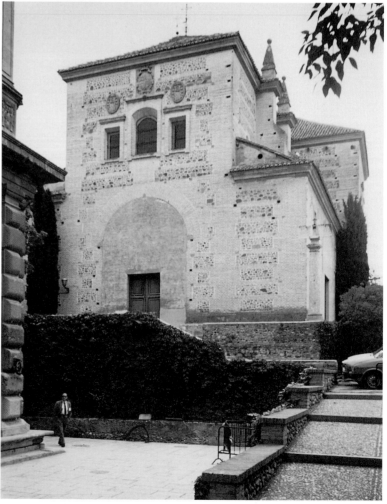

139 Juan de Orea and Herrera, Santa María de la Alhambra in Granada

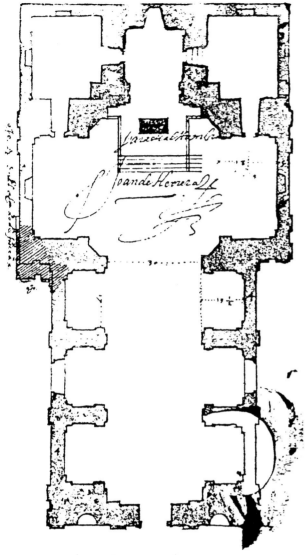

140 Juan de Orea and Herrera, plan of Santa María de la Alhambra, Granada, c. 1582 (after Ruiz de Arcaute)

Herrera's designs for Toledo and Granada are not particularly Italianate. In neither building was he inclined to follow the typology of the Escorial, which would – in the case of Toledo – have been appropriate to the memorial function of the church. While the designs are not overtly medievalizing, they resemble Valladolid in their massive geometric exteriors.

SÃO VICENTE DE FORA IN LISBON

If the basilica of the Escorial was to be imitated anywhere, it should have been in Lisbon. São Vicente de Fora was Philip II's foundation, a gift to his new subjects. Furthermore, it was a monastic church, and, apart from the royal palace, the most prominent monument of the Spanish Habsburgs in Lisbon. Yet it is a completely different kind of building from the Escorial. The first stone of the new building was laid by Cardinal Archduke Albert on 25 August 1582, but construction did not begin until 1590, when Philip II authorized the funds. On 28 June of that year, the king appointed Felipe Terzi master of the royal works. After Terzi's death in 1597, building seems to have continued under Baltasar Alvares until it was completed in 1629.[35]

Terzi was an Italian architect and military engineer, who had trained in Urbino and worked in Pesaro. According to George Kubler, he was a follower of Palladio.[36] It would be surprising, therefore, if he were entirely responsible for São Vicente de Fora (pl. 141). The three-bay nave with rectangular side chapels recalls

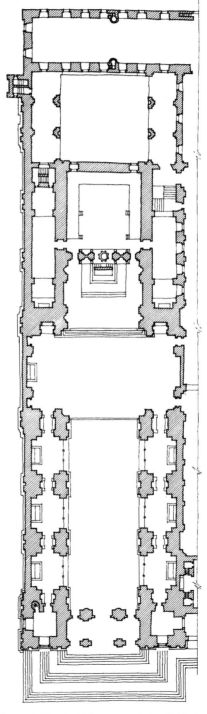

141 Plan of São Vicente de Fora in Lisbon, 1590 (after Kubler)

Vignola's Gesú in Rome and Palladio's San Giorgio Maggiore, where the naves lead to dramatic crossings, but, unlike these plans, there is not even the suggestion of a transept. The depth of the chapels, which are interconnected as at the Gesú, is simply continued into the crossing, creating a large rectangular space across the axis of the nave. The sanctuary is rectangular and there is a square retro-choir behind the main altar, as in Santa Maria de la Alhambra and at Valladolid. The entire building is enclosed within a rectangular envelope and the dome of the crossing is covered by a low wooden roof, like the one which Herrera planned for Valladolid.

The space of São Vicente de Fora is unified by the repetition of identical units inside the rectangle, as if striving to be a whole without any identifiable parts. The interior elevation recalls Alberti's Sant' Andrea in Mantua, but the eccentric coffering of the vault (pl. 142), in which the shapes of the coffers were determined by extending bands upward from the pilasters and triglyphs of the entablature below, creates an unsettled pattern. Italians normally stressed the difference between the lower structure and the vaults, partly because the classical orders are a post and lintel system, which cannot logically be extended into vaulting, and partly because a clear sense of spatial units is essential to Renaissance composition. Even Philibert de L'Orme, who used irregularly shaped coffers, kept pilasters separate from his vaults. To continue the classical membering into the vault, if only fictively, is bizarre. It recalls, without duplicating, the continuity between the elements of a pier and the ribs of a vault in Gothic architecture, but may also reflect Vitruvius's discussion of vault structure.

Although its simple shape and colossal scale recall Galeazzo Alessi's church outside Assisi, São Vicente de Fora is more rigid and volumetric. Unfortunately nothing is known of Terzi's personal style apart from this church and the royal palace where Herrera was also involved. The church was attributed to Herrera, however, as early as 1626 and, although no documentary evidence of his participation has come to light, the circumstances are strongly suggestive of it.[37]

When in the spring of 1580 Herrera came to Badajoz with Philip, he was the king's official architect, and he exploited his title and his authority to the full. When he revised the plans for the Alhambra palace of Charles V, he signed plans as 'the architect of all the king's works.' We know that Philip requested plans for royal buildings in Lisbon and that these were under consideration at about the same time, and it is hard to see why the king would have decided not to ask his architect to prepare or revise plans for São Vicente. The strongest argument for Herrera's participation in the design of São Vicente de Fora, however, is its resemblance to the designs for Valladolid. Both churches are strikingly rectangular with relatively flat façades and side elevations. The domes planned for the crossings are low and covered by plain wooden roofs. It would be unlikely that two such exceptional buildings, designed within a few years of each other, should not be connected.

It is not certain, although it is highly probable, that Herrera's designs for Valladolid were complete before he left for Portugal. If they were, then his participation would account for the similiarities between the two churches. Herrera's authorship of the design for

São Vicente is consistent with what we know of his role in the other royal buildings at the time. The contrary proposition that Terzi created the master plan of São Vicente is more difficult to sustain. Terzi could not have known the related designs for Granada until 1580. The plans for São Vicente were complete by 26 January 1582, when Philip II authorized construction and specified that the approved plan be followed without any change whatever.[38] In May 1582, Pedro de Tolosa was named *maestro mayor* with Diego de Praves as principal contractor of the new building in Valladolid, by which time some of Herrera's designs were certainly in Valladolid. It would be difficult to argue that Herrera had time to prepare a version of Terzi's building for Valladolid. Even supposing plans for São Vicente were ready somewhat earlier, in the absence of new evidence, it seems prudent to accept the hypothesis that favors Herrera's authorship for the basic design.

It is not surprising, however, that São Vicente de Fora was thought to be by Terzi, who was appointed 'master of the king's works' in Lisbon in 1590. People were not necessarily aware of the distinction between architect and master of the works that existed at Philip's court and might have assumed that Terzi's position meant he was the designer. Herrera was sometimes called the king's *maestro mayor* by people who did not know better, because the term was commonly used to designate an architect, but the visual evidence is also important. São Vicente de Fora is not entirely Herreran; contributions by an architect other than Herrera would have to be assumed, and Terzi is the obvious candidate.

There are many parallels with Herrera's other buildings: the large entablature and the handling of the crossing piers recall the basilica of the Escorial, as do the geometric panels on the walls; but the capitals are more elaborate than those of the Escorial or Valladolid and ornamental details are sharply focused and more angular. The balustrade on the towers, for example, derives from Herrera's at the Alcázar in Toledo and the merchants' exchange in Seville, but the individual balusters and pyramids have more angular shapes. The main façade with its pedimented windows may reflect an idea by Herrera – it recalls the façade of the Torreão – but its ornamental details are more sculptural and fanciful than anything Herrera would have used. Either Terzi was strongly influenced by Herrera, as Kubler argued, or as seems more probable, Herrera prepared a design which later became the scaffolding on which Terzi hung his own more personalized ornament (pl. 143).

HERRERA AND SPANISH ECCLESIASTICAL BUILDING

The churches in Toledo, Granada, and Lisbon have complicated histories, but, even if all the details of Herrera's contributions cannot be determined, taken together these projects provide evidence of his continuing thought about ecclesiastical architecture and show that he rejected the obvious conventions of Italian Renaissance planning, just as he also rejected Gothic vaults and ornament. With the possible exception of a design for a convent which is attributed to him, none of Herrera's projects for churches was as confident an application of Renaissance ideas as Siloe's San

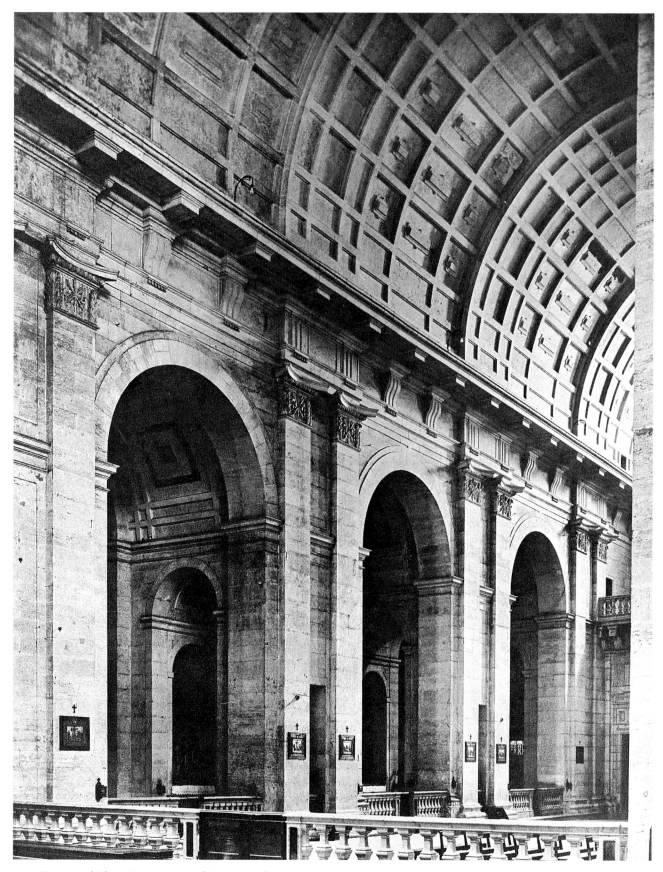

142 Herrera and Filippo Terzi, interior of São Vicente de Fora in Lisbon

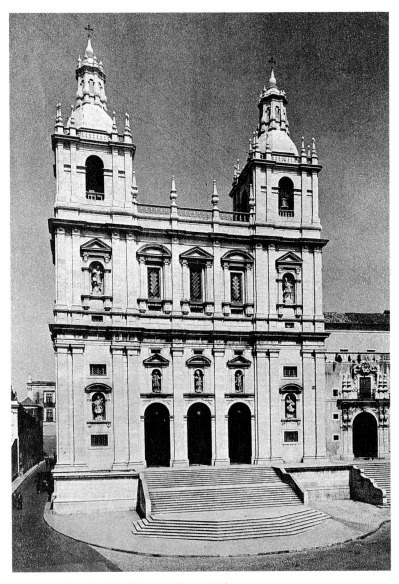

143 Main façade of São Vicente de Fora in Lisbon

itself in a grudging acknowledgment of dependency, but it might also turn to rejection.

Juan de Arfe was circumspect when he touched on the 'backwardness' of his countrymen:

I wanted to take up this work to please those of my profession who would like to succeed in it, since I perceived that up to now in Spain there has been a dearth of people willing to write about it – although many could have done it, imitating other nations, mainly the Italians and the French, who were not unmindful of the interest of their countries.[41]

But he made it clear that Spaniards did not have to depend on the writings of foreigners. Aligning himself with silent Spanish practitioners, Arfe signaled the difference between his work and the translations of foreign books, like Villalpando's edition of Serlio, which had filled a void left by the absence of indigenous architectural writing. Following the format of Villalpando's translation, Arfe emphasized instead geometrical design techniques and illustrated his designs for ecclesiastical silver work. It is not unreasonable to see his professionalism, with its insistence upon the realities of practice, as self-consciously hispanicizing:

And although others with less work and a better result could have collected all the precepts which are dispersed in so many writers...I have rather taken advantage of the knowledge of my parents and teachers and profited from the study in which they spent their lives, and I the greater part of my own, to understand and to pass on this specialized knowledge.[42]

Independence emerges in other Spanish architectural writers, too. Virtually all original Spanish treatises value practice over abstract theory, and many simply ignore theoretical discussions. Alonso de Vandelvira (died 1605), for example, was the son of Andrés de Vandelvira, who trained him in the Renaissance tradition. Alonso was enough of a classicist to take over work on Herrera's exchange in Seville. When he turned to writing, however, he produced a tightly argued treatise on stereotomy which never mentioned the ancients, Italy, or classicism. He began:

Drawing, although it can signify other things in the science of architecture, is the whole matter in the closing of arches, squinches, *capialzados*, circular staircases, windows, and cut-stone vaults.[43]

A strain of anti-Italianism runs through Spanish architectural culture from the 1550s. Herrera's aggressive purity is open to interpretation as a show of independence and as a challenge to Italian dominance. More important was his affirmation of Spanish tradition. Gothic was not generally perceived, as it was in Italy, as a foreign importation. In the middle of the seventeenth century, the classicizing architect, Fray Lorencio de San Nicolás, recommended the cathedrals of Toledo, Seville, and 'our Spanish churches which are just as worthy of imitation as foreign models', as if these represented an indigenous style.[44]

Fernando Chueca once characterized Spain's late Gothic cathedrals as the key monuments of a national style.[45] These buildings are indeed different from contemporary Gothic elsewhere, even though most of their architects were of Flemish, German, or French origin, just as they are different from the high Gothic which was imported from France in the thirteenth century. They were associated with the unification of Spain and the period of her political ascendency in Europe, making them obvious candidates to be

Salvador in Úbeda, designed fifty years earlier.[39] Herrera's projects show instead his concern for geometric volumes, for wholeness as opposed to the articulation of individual parts, for the repetition of identical units that one finds at Valladolid. His unclassical interests led him to experiment with a French type of superstructure for Santo Domingo el Antiguo and in Lisbon to distort Albertian ideas.

We should not discount the possibility that Herrera rejected Italianism simply because it was Italian. Spaniards of Herrera's generation often compared themselves unfavorably with other Europeans. Comparing his countrymen to Germans, for example, Sigüenza complained that Spaniards 'would rather solve a problem with their bare hands than invent a machine' to do the labor.[40] Herrera was equally harsh on those whom he considered willfully incapable of appreciating the value of technical expertise. He thought 'patchworkers and destroyers of good architecture' were passing for architects, as if only in Spain was such stupidity rife. This self-imposed sense of inferiority rankled. It often expressed

symbols of a national self-consciousness. It is natural to wonder, therefore, if Herrera shared such feelings and if his choice of a late Gothic image for Valladolid was ideologically motivated.

Fragmentary though it is, Herrera's church has an undeniable place in the sequence of great Spanish cathedrals, and its allusion to late Gothic style calls attention to the Castilian and Andalucian buildings, giving the group an appearance of coherence which it might otherwise not possess. Had Valladolid been very different, we might not feel so strongly the indigenous character of Spanish late Gothic. It may seem quixotic to suggest that Herrera of all people was responsible for the survival of Gothic, but there are a few things which are difficult to explain in any other way.

Salamanca is a case in point. It took courage to go on with the Gothic in 1589 when the Escorial was standing and Herrera's engravings of the building were being published. No one in Spain could be unaware of the Escorial. Had the classicism of the Escorial been as powerful as some have suggested – rupturing the ties with tradition, discrediting Gothic – it would have been not merely *retardataire* to continue in Gothic, it would have been barbarous. Even if later ecclesiastical building shows the Escorial to have been a less than despotic force in Spanish architecture, the fact that Salamanca was confidently resumed and completed in late Gothic (this well into the seventeenth century) suggests that the style possessed a legitimacy that protected it from the onslaughts of classicism. Herrera's Valladolid played a crucial role in establishing this. Salamanca was classicized on the model of Valladolid without changing its ornamental vocabulary. The plan was regularized and made nearly symmetrical, the geometric volume defined, the ornament standardized. Reversing Siloe's procedure, Juan del Ribero Rada made Salamanca conform to Herrera's canon without altering the pointed arches, rib vaults, and complex moldings of its Gothic style.

The solidarity of the Cathedral of Valladolid with the earlier Spanish cathedrals may explain its influence, which would otherwise be difficult to account for. As Chueca recognized, the Cathedral of Mexico City (begun in 1563, redesigned in 1585), the Cathedral of Puebla (c. 1585) and the Pilar at Zaragoza were directly inspired by Herrera's project.[46] But an unfinished building, even one by an architect of Herrera's prestige, is seldom so influential. There would have been no cause to adopt Valladolid as a model, had it not seemed singularly appropriate. Yet what made it so suitable? Chueca insisted on the late Gothic aspects of these buildings, but if late Gothic was the object, why choose Valladolid? Why not Segovia or Salamanca or even Jaen? Most have assumed that the classicist Herrera could not have willingly promoted a design that directly recalled late Gothic practice. We have seen, however, that he did just that, and the attraction of his design may have lain precisely in the fact that, rather than effacing Gothic beneath the weight of classicism, he affirmed its presence.

It took less than five years for Herrera's designs to cross the Atlantic, and those responsible in Mexico must have made a considerable effort to acquire them. If they wanted to be both Spanish and up to date, Herrera's design for Valladolid showed the way, and its influence can be felt as late as the eighteenth century in buildings which no longer recall the Gothic directly but continue to seek out the rectilinear massing and geometric clarity in plan which link them, through Valladolid, to the Spanish late Gothic accomplishment.

Herrera dissociated an architectural style, or more precisely an aspect of that style, from its matrix of practice. Late Gothic in Spain had been sustained by the web of alliances among the masters of the works, who collaborated on most large projects. The close-knit succession from fathers to sons or younger colleagues, and – as the older architects died off – the ubiquitous presence of Rodrigo Gil de Hontañón at almost all the large programs in Castile, unified architectural practice for more than a hundred years. There could have been no Spanish tradition without the extended moment of late Gothic during which so many churches were built, but traditions are also established by discontinuities. At moments when a seemingly continuous present is perceived as belonging to the past, something can be salvaged and reconstituted in a way that sets what is preserved against a larger field of change. The open interior space of Valladolid, which placed the choir behind the altar and so allowed the congregation to see the Host in the tabernacle during the mass, conformed to the decrees of the Council of Trent which were then being promulgated in Spain. Among Spanish cathedrals, only Siloe's Granada prefigured this idea (pl. 144).[47] Breaking with Gothic practice and all it stood for, Herrera's medievalism was profoundly modern. He recast the late Gothic image of the Cathedral of Valladolid as a classical building and so insured the pre-eminent place of late Gothic in the traditions of Hispanic architecture (pl. 145).

HERRERA'S LEGACY

The direct influence of Valladolid was restricted to a few comparable programs, one might say to the genre of cathedrals; but Herrera, more precisely his stripped style, has been credited with a much broader impact. Indeed, within a decade of the completion of the Escorial and the designs for Valladolid, a sober classicism had all but replaced Gothic and decorated Renaissance as the preferred style for churches and monasteries and, by the end of the century, the architectural landscape of central Spain had been transformed. Buildings from modest parish churches to ambitious monastic programs appeared with classicizing façades, slate-roofed towers, and plain interiors with pilasters. In the general triumph of classicism, earlier Renaissance decorative carving as well as elaborate Gothic ribbed vaults were largely abandoned in favor of the classical orders and domical vaults. This is the development that authors like Portables had in mind when speaking of the extinction of indigenous styles and their replacement by Herrera's repetitive and abstract manner.

But how much did Herrera personally have to do with this phenomenon? A sober and more Italianate classicism was becoming generally fashionable in Spain in the later sixteenth century and, although this taste was stimulated by Herrera's work, it was not necessarily dependent on it. Classical style was being explored independently in Toledo and Seville, for example.[48] The simplified orders, geometric panelling, thermal windows, and slate-roofed

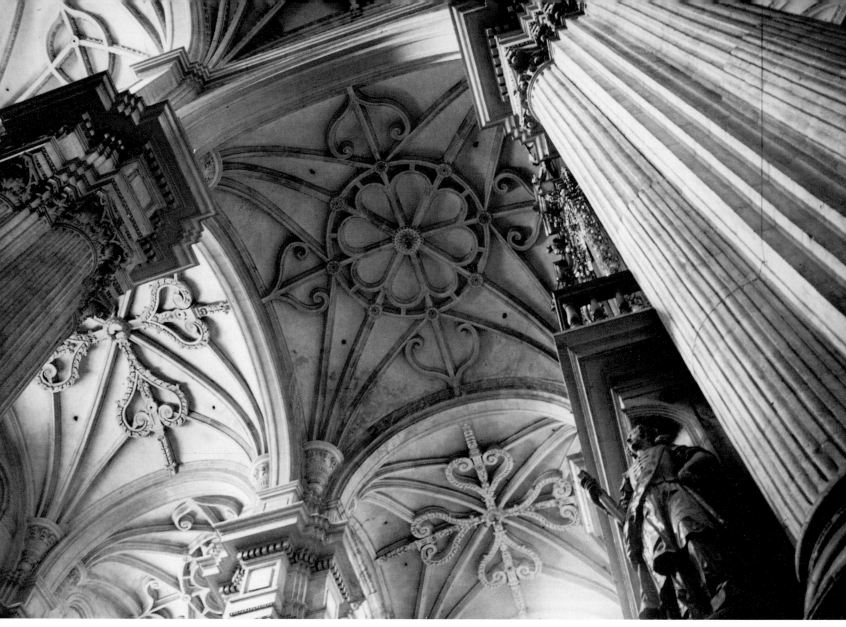

144 Diego de Siloe, interior of the Cathedral of Granada, designed 1529, with seventeenth-century vaulting

towers that directly recall Herrera's manner were transmitted by various means.

Simplified classicism was maintained in the royal programs, as Francisco de Mora's work at the Alcázar in Segovia shows, and Herrera's disciples were already working in his style by the late 1580s. Francisco de Mora's church of San Barnabé in the town of El Escorial is representative (pl. 146). Herrera's style was identified with the king, so it seems natural that it would be imitated by architects who worked as executants of his designs and took on or were consulted by other building programs where Herrera was not directly involved. This may explain the thermal windows of the interior and the pilaster strips decorating the exterior of the nave of the church of the Hospital de la Sangre in Seville, since it is known that Juan de Minjares was consulted on the roofs.[49] Some of the decoration at the convent of Uclés has a similar kinship and was probably executed by Diego de Alcantara, Herrera's assistant architect in Toledo, who later became master of the works (pl. 147). But Herrera's assistants produced few buildings of their own. Apart from one commission for the Cathedral of Seville, Minjares spent

his career after 1584 on the royal payroll completing the king projects in Seville and Granada. At no point did he have a priva practice.[50] These men contributed something to the spread of specifically Herreran classicism, but they had neither the time n the authority to impose it everywhere they went.

There were also those who considered themselves followers Herrera, like Juan Bautista Villalpando, or those who consult him on specific projects as did several other Jesuit architects.[51] Th helped to diffuse Herrera's ideas and, in the case of Villalpand inspired emulation, but they were exploring various possibiliti within classicism and were not merely Herrera's epigone.

The rapid spread of the style of the Escorial in Castile in t 1580s and 1590s is a phenomenon of a different order that probably related to the enormous workforce required to build t monastery. The method of building everything simultanous required an unprecedented number of skilled practitioners: t basilica of the Escorial alone employed 20 masters and 400 skill stonemasons. When these men came from various cities in 157 they brought their own styles with them, but, when the basilica w

145 Herrera, interior of the Cathedral of Valladolid

146 Francisco de Mora, interior of San Barnabé, town of El Escorial

147 Convent at Uclès

finished a decade later, they were released back into the profession as trained builders in Herrera's style.

The individual careers of these workers have not been systematically studied, but many, though not all, went on to become independent architects, and their numbers make it possible to understand how a new style could penetrate quickly to all levels of architectural practice – how, for example, the modest parish church at Valdemorillo near Madrid could so quickly and confidently adopt motifs from the Escorial. It was transformed between 1590 and 1600 by a stonemason from the Escorial, Bartolomé de Elorriaga (pl. 148).[52]

Each drew from the Escorial according to his particular talent and circumstances.[53] Pedro de Tolosa, Juan Bautista's original *aparejador*, left the Escorial in 1576 to become master of the works at Uclés. He had adopted a conservative version of the style of Juan Bautista de Toledo, which he passed on to his son, Alonso, who was later active in Palencia and Valladolid.[54] Men who came later

148 Bartolomé de Elorriaga, parish church at Valdemorillo

to work at the Escorial, particularly those who contracted to build the basilica, were directly subject to Herrera's manner. Given the number of professional builders at the Escorial, the effects of its classicism were bound to be as varied as the churches at Villacastín and Uclés, which are only generally related to each other although they are both stylistically connected to the Escorial. The stylistic impact of the Escorial, which is often taken as a sign of Philip's and Herrera's attempt to eradicate indigenous architecture, was more the consequence of fashion and economics than of any architectural politics. In the hands of practitioners, it soon ceased to be associated with Herrera's rigorous and personal aesthetic and, reduced to formulas, was integrated into habits of the building profession.

The character of Herrera's decoration also facilitated its assimilation (pl. 149). His flattened motifs, geometric moldings, and panels were more easily combined with the forms of late Gothic architecture which also stressed geometrical divisions of the wall surface and a simplified, even standardized, system of ornament, than with the naturalistic and antique sculpture that characterized earlier Spanish classicism.

149 Tower of the church at Colmenar de Oreja

8
Building the well-ordered state

IN 1548/9 Prince Philip traveled to meet his father in Flanders. The emperor wished to present his son to his future subjects. Along his route through Italy and Germany into the Netherlands designated cities prepared to receive him with their streets transformed by festive constructions *all' antica*. Triumphal arches, fake façades, statues and decorations created a timeless if temporary urban environment in which to enact an ideal: the encounter between a perfect prince and his equally perfect subjects. For Philip's entry into Antwerp more than two thousand classical piers festooned with flowers lined a triumphal way from the monastery of Saint Michael to the pavilion in the main market square, and a series of arches with tableaux vivants identified this urban splendor with an era of peace and prosperity under his authority (pl. 150).[1] The spectacle of the festive entry – and spectacle it definitely was – allowed cities to raise real issues and to state their needs through classicized images of loyalty, trade, and civic freedom.

The triumphal entry was the one form of Renaissance pageantry in which the responsibilities as well as the attributes of royal power were explicitly stated. The content of the Antwerp decorations was not new, but Philip experienced it for the first time on such a scale. At the age of twenty-one he was making his first excursion outside the Iberian peninsula, leaving his relatively frugal upbringing and going to meet his father in a European setting that had been decked out in all the splendor that the sixteenth century could muster. Philip would not see the like of this again. To a young man raised on a humanist ideal of power and schooled to rule the largest empire since antiquity, the possibility of realizing this ideal in permanent cities must have seemed not only attractive but feasible. 'We decorate our property as much to distinguish family and country as for any personal display (and who would deny this to be the responsibility of a good citizen?)'[2] In writing this, Alberti defined a Renaissance conception of architecture in which all buildings are in some way public. Henceforth, to build for one's community as much as for oneself became the obligation of every enlightened patron. Renaissance writers, like the utopian architect Filarete or the Erasmian moralist Juan Luis Vives, elaborated on Alberti's vision for the benefit of their princes, urging them to create new city services. In their imaginations the city, simulacrum and embodiment of social order, was the artefact of its prince.

Philip was brought up to think of architecture as one of his responsibilities, but when the anonymous author mentioned earlier produced a pared down and sterner version of Alberti's text in a treatise for him about this time, he omitted most princely buildings (a palace appears only once, in a brief chapter on a royal fortress, and monasteries not at all) and directed his attention instead to the town and its various institutions and useful undertakings like roads, bridges, sewers, docks and the creation of navigable rivers, and he perceived the reform of public architecture in Spain as a royal project.[3] When, some twenty years after the treatise, Philip finally turned to public building, he concentrated on city services. By this time architectural style had changed drastically in Spain, but his final views were remarkably close to the spirit of these early recommendations.

Philip, who has become notorious among historians for procrastination and indecision, usually called prudence by his flatterers, was not at all indecisive in regard to building. Memoranda on architecture which were sent to him are covered with his comments to hurry, to finish, to build; he took decisions as they came, and

150 Palace and gallery in the market square erected for Philip's entry into Antwerp in 1549

neither forgot nor regretted them. He could be realistic even when his most cherished projects were at stake. Commenting on Paciotto's criticisms of Juan Bautista's designs for the Escorial, he noted: 'I see that the entrance to my apartment is not good, but I don't care. As to the other things, seek the remedy. . . . If it can be done, very good; but if not, no.'[4] In the sphere of architecture, at least, Philip was an able administrator who usually knew what he wanted and knew how to let others realize his aims.

The appropriation of civic institutions as symbols of royal authority was not a new idea but, it will be argued here, its implementation in a distinctive public architecture was a phenomenon of the later sixteenth and earlier seventeenth centuries. Philip was one of the first to undertake it in a comprehensive way, transforming institutions which had long been associated with an independent civic status and dignity into symbols of kingly *liberalitas*. This is a bold claim. Philip's authoritarian rule, absolutely and irrevocably committed to Catholic unity, appears to us so fully embodied in the Escorial that by comparison his other building ventures are likely to seem marginal, and this is especially true of his public projects, most of which were not executed while he lived and some never built at all. The buildings are poorly documented and the evidence is scattered. Perhaps most difficult, it is necessary to consider in the same sweep works that seem disparate and disproportionate in both kind and importance. Does it make sense to compare the Escorial to a bakery? Or to see a new architecture adumbrated in irrigation ditches and lines of trees? Can one speak of a new, cohesive view of building when there is no explicit program for it? These reservations must be kept in mind. Nevertheless, a new view of building need not originate with fully articulated ideas. An implicit program can be the product of an on-going process. As the king's urge to build developed with the royal projects, it seems to have created its own momentum and definition.

The legend current in the nineteenth century that Herrera and Philip sat down together twice each week to pass judgment on designs for all public buildings in Spain was spun from the remembrance of Philip's public works. As far as we know, legend it is: in the later sixteenth century, most public buildings were designed and built without Herrera's approval. But the underlying assumption of the story – that Herrera created public buildings in a royal style – is true; and had it been within his power to impose uniformity, he probably would have done so.

In fact, Herrera's opportunities were limited. Philip's resources were prodigious but so were his expenses, and he could not afford to build entire cities. Moreover there were legal limitations on his power to dictate to Castilian towns, which were jealous of their independence and ancient privileges. As a result, Philip did little to alter the structure of civic institutions and the royal will was rarely accomplished through decree. With the exception of Madrid – and then only after all other means had failed – his civic patronage was conducted obliquely through influence and subsidies that maneuvered local officials into paying for buildings designed by Herrera and approved by the king. But even if Philip was not the patron in the strictest sense, the public works that Herrera designed for him so completely identified the king with the city as to almost erase any distinction between royal and civic authority.

The new public architecture was most fully realized in the rebuilding of Madrid, which will be discussed at the end of this chapter (pl. 151). Herrera was closely involved in the evolution of the king's ideas. Taking over the role that Philip had originally destined for Juan Bautista de Toledo and drawing upon his experience in the royal works, he devised an architectural language in which Philip's wishes could be articulated. To be sure, this achievement was not Herrera's only; many architects, engineers, and builders were involved over a number of years, but it is necessary to emphasize the roles of Herrera and Philip if the character of their project is to be understood. Philip's reforms were oriented toward large-scale order from the beginning and soon focused on the architecture of cities; Herrera's contribution cannot be understood without the king's, although the originality of their ideas cannot be appreciated without putting them into relation with other urbanistic themes.

PRAGMATIC CLASSICISM

The Escorial is an impressive monument in the grand tradition of prestigious building. This is the stuff that standard histories of architecture are made of, but such buildings were not at the core of Philip's and Herrera's vision, which focused instead on utilitarian constructions that seldom figure in a history of architecture. Practical buildings are often plainly built of very ordinary materials, and undecorated. Even when designed by architects, drains, canals, streets, or fortifications seem almost the antithesis of our idea of architecture. Sometimes they are not actually visible and, even when above ground and visible, their symbolic charge seems weak. We do not think of paved streets as expressive monuments. They seem to belong merely to the most basic conditions of building and to have little to do with the aesthetic qualities that we associate with architecture.

The Renaissance position on this issue was, on the whole, very like our own. On the scale of architectural value, as expressed in Alberti's Vitruvian triad of *necessitas*, *commoditas*, and *venustas*, the first category of sound construction is the most basic but also the lowest. The second level, function, is much broader than practical use and includes symbolic and psychological purposes, while beauty brings these to full expression.[5] Utilitarian building, in Alberti's view, addressed essential needs in the most economical, direct way, while architecture was concerned with higher values. We still respect his distinction and expect a parking garage to be well engineered and built, but not beautiful. Our standards are flexible, and allow for the exceptional utilitarian building which, because of its striking design, is classed with architecture, but we still feel, as Alberti felt, that a monumental building is more significant than any utilitarian structure.

There have been moments, however, when utilitarian construction powerfully impinged on and altered the course of architecture precisely because it did not belong to it. Iron and glass construction, after being introduced in temporary exhibition halls and industrial buildings, spread quickly and revolutionized style in the late nineteenth century. Such moments are often associated with technological change – with a new use of materials or new engineering

151 Plaza Mayor in Madrid

techniques – but this is not a necessary condition. In one of the most abrupt stylistic changes ever to occur in European art, the designers of the first monumental Christian basilicas in Rome in the fourth century rejected the style of contemporary imperial architecture and turned to the generalized utilitarian warehouse of the Roman empire. They adopted apparent brickwork and timber roofs, and re-used columns and capitals: the stuff of cheap, rapid, and practical construction.

A change of this nature, although not of such magnitude, occurred in Philip's public works, where Herrera applied strategies developed in utilitarian construction to the design of the city and public space. This represented a significant shift in point of view on the part of both Herrera and the king, requiring the rejection of some accepted principles as well as the application of new ideas. It seems unlikely that it would have happened had not patron and architect been intimately acquainted with ordinary building and had they not admired in it qualities different from those in prestigious monuments.

Neither would it have happened without a powerful ideological impetus. Utilitarian constructions are as value-laden as other forms of building. To bring them forward as architecture is necessarily to place their sphere of meaning in direct confrontation with the latter's symbolic associations – whether social, economic, or religious. Nineteenth-century iron and glass construction developed as part of an image of modernity defined in terms of technology, historical progress as reflected in the industrial revolution, and it posed an explicit challenge to the values symbolized by high style. Something similar happened in the fourth century. In choosing the multi-purpose basilica, Christian architects were not simply creating economical buildings, they were rejecting imperial architecture and its pagan values. At the same time they were appropriating the administrative and practical symbolism of the ordinary buildings of the empire. Re-used imperial columns and capitals displayed their re-use, and thereby expressed the partial absorption of an old social structure in a new order. The ambitions of Philip and Herrera were similar, and here, as in the development of monumental Christian architecture, the significance of this enterprise lies in the forms of the new buildings, not in any written program.

Philip's interest in utilitarian construction manifested itself first in gardens and waterworks. There is a carefully proportioned design in his own hand for part of the gardens at Valsaín dating from the late 1550s.[6] Soon he was ordering fountains and pools from his architects and gardeners. When Juan Bautista arrived, he was put to work on the plans for the palace and gardens at Aranjuez as well as on designs for the Escorial. Hydraulic work began at the Alcázar in Madrid under Gaspar de Vega. Philip was kept informed of progress and approved designs, as was already his custom, but these projects were technically more complex and larger in scale than anything he had commissioned before.

Herrera, for his part, was predisposed to take a broad view of building, and his knowledge of mechanics probably included engineering. He learned more about drainage, sewers, fountains, and water supply from Juan Bautista de Toledo, and he came in contact with the specialists – fountain-makers, gardeners, and hydraulic engineers – who were working under Juan Bautista's general direction but often submitted designs of their own.[7] By

the time Juan Bautista died, Herrera's practical experience of large-scale engineering was considerable, even if he had done little designing of engineering or architecture himself.

In the following years, Herrera oversaw the completion of the Escorial's water system, which was supplied from cisterns that collected rain water from the roofs and by pipes from reservoirs on the slopes of the mountains to the west.[8] After 1576, the work was the primary responsibility of Francisco de Montalbán, a well-known specialist who also worked at Aranjuez. The waterworks of the Escorial were a marvel of sixteenth-century technology, and, while there is no reason to attribute the system entirely to Herrera (who was comfortable relying on others' expertise), it is important to stress his involvement.

The Escorial, located far from an urban center, required ordinary buildings for a variety of purposes: temporary buildings at the construction site and housing for the monastic community, workforce and their families. In 1565, Philip set limits to the town, ordered the construction of a pond and fulling mill and another mill and machine for working marble.[9] Philip also needed way stations along the roads from Madrid where he could break the journey to the Escorial and his other country palaces, and he continued to acquire farming and hunting lands in the region. The palace at Aceca on the road from Aranjuez to Toledo is a good example of the vernacular style that the king adopted for such construction.[10]

The direction of the king's interests was already evident at La Fresneda, which was begun in 1566 when the king completed the purchase of a large tract of land surrounding a hamlet where there was an old palace formerly belonging to Alonso Osorio de Cáceres. This was remodeled into temporary quarters for the monks, and a small building for members of the royal family was constructed. The buildings were elegantly but simply planned and built of common materials. In contrast with the buildings, Philip lavished great care and expense on the landscape. Around the buildings was a system of pools, fountains, and narrow canals that fed elaborate gardens filled with all kinds of trees, fruit, and flowers. Large pools were the core of the composition. Sigüenza described La Fresneda as a garden of paradise on earth.[11] La Fresneda is an exception, and Philip and his architects generally kept architecture separate from engineering and utilitarian building in the 1560s. Later Herrera took a different view: the distinctions between architecture and ordinary building became less important and, in a few remarkable projects, fused.

Philip and Herrera were attracted to simple buildings, although perhaps for different reasons. The king was always on the lookout for frugal solutions, even when he was spending a fortune on gardens and fishponds; this had an ideological foundation, both ethical and political, that suited his image of authority. He also liked large transformations of the landscape, as much as or more than buildings. For his part, Herrera was interested in creating a universal classicism. His monumental style had something in common with other kinds of building. Its radical abstraction had created a visible bond with other types of order: with military order, for example, which shared the geometry of his severe decoration and planning, or with utilitarian building, which was intrinsically plain, as his buildings also appeared to be.

Herrera's principles were already so abstract that they could be applied to more modest structures. The order and proportion which underlay his designs could be conveyed in the simplest ornamentation: by the plainest of pilasters, a strip of molding, or a carefully placed range of windows. This is nowhere more apparent than in the Casas de Oficios bordering the northern plaza at the Escorial. These buildings were required to match the Escorial, to enhance the dignity of the plaza, and yet to remain discreetly secondary to the monastery. The proportions and intervals between moldings and windows provided the means to link the monastery and its service buildings in an architectural whole.

It is worth stressing the novelty of this kind of architecture and the range of possibilities that it opened up. Juan Bautista's simplified classicism was a precedent for it, but Herrera, unlike his predecessor, designed utilitarian structures the way he designed monumental works. For the first time in the Renaissance tradition, there was a way to link sumptuous building with ordinary construction. Even Alberti, who had pondered the common elements as well as the diversity of human institutions and buildings, had failed to envisage a formal system that embraced them all; his love of individuality in buildings was perhaps too great. Nor did other Italian architects strive to impose consistency.

Renaissance architects rarely brought their classicizing principles to bear upon modest or purely utilitarian structures. In theoretical writing, Serlio's treatise on private housing, Palladio's designs for farm buildings, Philibert de l'Orme's illustration of a small house and Du Cerceau's treatise are exceptional, and, with the exception of Palladio, their modest buildings look quite different from their monumental commissions. This was intentional. Alberti, who urged restraint and modesty on wealthy architectural patrons, nevertheless stressed that houses for the rich were necessarily different in style from those for persons of lower rank and means. Serlio insisted on differences among buildings and on the different sorts of ornamentation appropriate to various levels of society.[12] Following his lead, later architects continued to adapt the vernacular for utilitarian building.

Two exceptions come to mind. Palladio sought and achieved stylistic continuity between monumental and modest building in his designs for villas. The main house, farm, and storage buildings were conceived in the same style and the main house was often starkly simple. Michelangelo, in his projects for the fortification of Florence, approached a utilitarian program in the spirit though not in the vocabulary of high-style architecture. But neither Palladio or Michelangelo exploited the implications that were latent in a formal relation between monumental and utilitarian building; there was perhaps no occasion to do so.

Philip II's and Herrera's concerns were different. Herrera's classicism, stretched and attenuated to the limits of plausibility, could finally embrace any and all building. Not only did it become possible to design a fishpond and a bakery in the style of the palace, and so give ordinary buildings the expressive content hitherto available only to monumental architecture; it also became possible for prestigious building to symbolize the qualities associated with ordinary construction. In the sixteenth century, simplicity was associated with utilitarian structures. Humble buildings make no claim

152 Pirro Ligorio, reconstruction of the Roman port at Ostia, engraving, first published in 1554

to individuality; they are severe because there is no reason to ornament them; they are anonymous, plain, and ordinary because that is how their society conceives of their functions.[13] Herrera's universalized abstraction established a common ground of resemblance between monumental and utilitarian buildings and consequently the possibility of a relation between the beautiful and the useful that allowed one to be reflected in the other.

In José de Sigüenza's eyes, the simplicity of the Escorial was a sign of virtue an imitation of 'the simplicity of Nature which abhors all superfluity.'[14] Its counterpart in modest buildings was grandeur, a celebration of the virtue that was intrinsic to useful functions and the dignity of ordinary life. Sigüenza praised the Appian Way, its great, plain stones worn by the traffic of centuries, but when confronted by such assertive austerity in a contemporary building, the breach of Renaissance decorum shocked him. Sigüenza found the Casas de Oficios at the Escorial too grand for their purpose, thinking 'that if there is a fault to these buildings, it is in their being so fine that what is made for service rivals what it has been made to serve.' There was no need for them to be either 'so finely finished nor so similar' to the monastery.[15] For the same reasons, in the later seventeenth century, Juan de Tapia objected to the rebuilding of the Panadería in Madrid with its original market stalls because 'this is a royal building and should not have shops in it.'[16]

Aggrandizing the ordinary was a novel idea, but the ancient

precedents for it were probably very much in the minds of the king and his architect, as they were in Sigüenza's. Although we tend to associate classicism with richly decorated monuments, its other side is suggested by the aggressive plainness of Herrera's style. Roman industrial buildings – aqueducts, markets, apartment houses, warehouses, roads, and harbors – were impressive works whose effects were quite different from those of decorated temples and villas. Their beauty derived from massive construction and extended order. Disciplined workmanship on a tremendous scale and the deployment of regular, proportioned design created a different sort of monumentality.

Alberti did not consider such undecorated construction the highest expression of classicism – although some buildings, like amphitheaters, would seem to belong both to architecture and to utilitarian building – but he considered it beautiful, and by the middle of the sixteenth century architects and antiquarians like Pirro Ligorio were popularizing this aspect of ancient classicism with engraved reconstructions of Roman industrial sites like the port of Ostia (pl. 152).

Philip liked such construction. His projects for canals have not been investigated systematically, and much of what was executed is today destroyed or in a poor state of repair, but we can get a good idea of the intended effect from surviving drawings for this type of work. The illustrations in the psuedo-Turriano manuscript, for example, present dams and retaining walls in sweeping perspectives

153 Francesco de' Marchi, Bastion from *De Architectvra militari libri tre*, 1599

that dramatize the man-made against a background of natural landscape.[17] Fortification drawings that Francesco de' Marchi, Antonelli, and others made for Philip emphasize large-scale geometrical order (pl. 153). These were not images of artistic architecture, but they made the sheer power of building explicit, and by the later sixteenth century they were recognized as a form of classicism. Writing about the king's hydraulic projects in Aragon, Giovanni Francesco Sitoni compared them to the projects of Julius Caesar and Hadrian.[18]

THE PARK AT ARANJUEZ

The park at Aranjuez was the king's first attempt to create a modern equivalent of the great works of Roman engineering, and his workshop of ideas about large-scale design; but the immediate inspiration for Aranjuez was not antiquarian but northern. Philip had remained in Flanders with Charles V, enjoying Flemish cities, royal palaces, their parks and gardens, until 1551, and he returned again in 1557-59. The experience marked his taste for ever; the slate roofs, colonnades, open galleries, pools, and splendid parks of Flemish palace architecture found an echo in his Spanish projects. He seems to have admired the orderly, industrious, and commercial

life of his northern cities, too, and considered them a model for what could be built in Spain. Ever afterwards the king loved processional ways – long avenues shaded by porticos or trees – and wished them for his subjects as well as for himself.

Philip's palace and gardens at Aranjuez were born from this experience. Aranjuez could have been the centerpiece of the king's secular palace program – as ambitious as the Escorial, it was in some ways a greater opportunity for the king's architect, Juan Bautista, who was given a huge project without the constraints of earlier construction or the interference of committees or groups with special interests such as plagued him at the Escorial. Yet it was ill-fated: the palace was built slowly; it was not completed according to Juan Bautista's plans, and it was remodelled and extended in the eighteenth century. The gardens and park which were the king's pride and the most magnificent in the kingdom, were rehandled in the style of Versailles, and only a fraction of this recast layout remains. Even so, they are considered among the grandest in Spain (pl. 154).

Perhaps the fate of the palace lay in the king's conception of the site. Aranjuez stands on a bend in the Tagus river, not far from the Jarama River, where rich soil and abundant water permit extensive gardening, and the possibility of creating a designed landscape was the attraction of the site. As early as 1556, Philip ordered 4500 black poplar trees planted in a processional avenue across the landscape. The king mentioned that whatever was lacking in the planting of 'the big street and its plaza' should be filled in.[19] He was referring to the road east of the present palace. This layout had no strict relation to the old palace or to the new building, as yet unplanned. It was the king's own idea, probably his own design, and it is a remarkably original vision of expanded order. Philip was making large-scale transformations to the landscape on the model of the parks of Flemish palaces, like that in Brussels; he was thinking of long avenues and squares defined by trees and of what might be made of the river curving gently through the fields (pl. 155). At the beginning, Philip was landscaping, not building, and, even at the end of the reign, the palace was merely an appendage to its gardens.[20]

Juan Bautista's gardens for the Casa de Campo and the Jardín de la Isla at Aranjuez were Italian Mannerist designs transplanted to Spain, with elaborate fountains on classical themes (Venus, Diana, and Neptune at the Casa de Campo) set in geometric patterns of planting (pl. 156).[21] Had Juan Bautista done all he wished, Philip's royal gardens might have been in the style of the gardens at the Villa d'Este at Tivoli or at the Vatican (pl. 157). But Philip wanted more than this for Aranjuez.

Only French and Flemish gardens could provide a model for a landscaping at expanded scale (pl. 158). Philip wanted vistas and he sought models in the north as well as in Italy. When his gardener, Jerónimo Algora, died near the end of May 1567, the king immediately sent for an inventory of his papers in order to collect the designs that belonged to the crown. In going over the list, he noted that one need not bother with the Serlios for 'there are lots of those, [but] better take the one that says it is of the gardens of Italy, even though I think that it isn't, but is rather of [the gardens of] France and England, that he made when I sent him to see them'.[22]

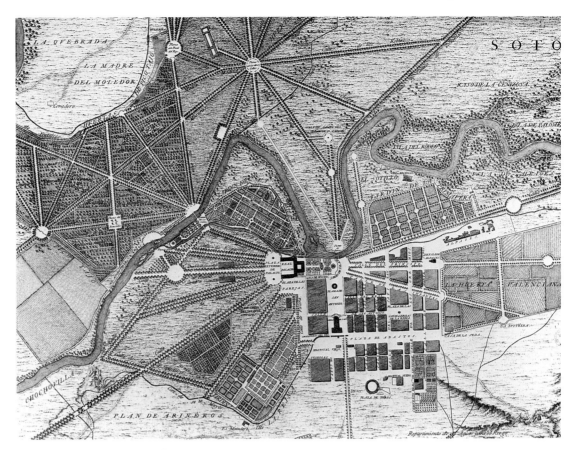

154 Plan of the palace and gardens at Aranjuez

155 The royal hunting domain of Aranjuez
in 1579. (Simancas, Archivo General)

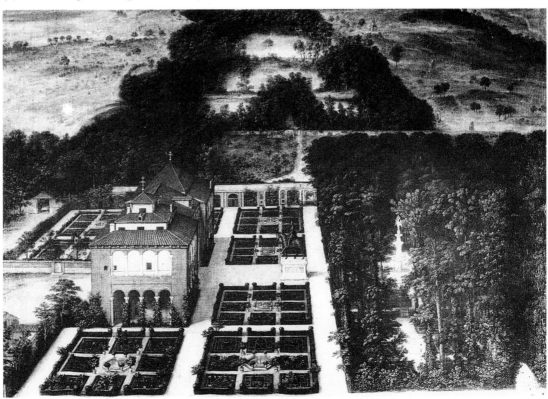

156 View of the gardens at the Casa de Campo, Madrid, designed by Juan Bautista de Toledo before 1567.
(Madrid, Museo Municipal)

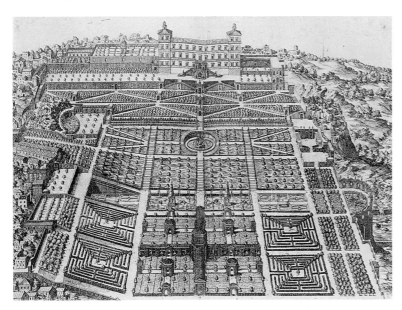

157 Etienne Dupérac, Villa d'Este and its gardens at Tivoli, etching published in 1573 by Lafrery (New York City, Metropolitan Museum of Art)

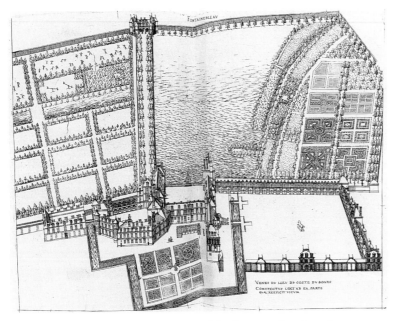

158 Jacques Androuet Du Cerceau, view of the chateau and gardens of Fontainebleau, in *Les Tres Excellents Bastiments de France*, 1576

It is the king, more than his architects, who emerges as the major figure in the design of the gardens at Aranjuez. In no other project was his personal taste so marked or his instructions to his designers so specific and unambiguous. As early as 1557, for example, he was ordering hedges planted 'in the manner of Flemish hedgerows' and he chose his own trees to surround an open plaza: 'three rows of pines: one inside the poplars, up to the house, the other outside the poplars and one in the middle, alternating one with another.'23 He knew the effects he wanted. In planting the row of trees up to the Tagus, he insisted that 'this roadway has to be aligned with the

bridge so that from any part of it, one sees the entire street and, from the street, the entire bridge.'24

Was the king his own garden architect? To a large extent, he was. Philip chose the type of park he wanted and supervised the planting of the first avenues of trees. Juan Bautista continued under his close supervision. Philip liked classical mythology as much as the next cultivated Renaissance prince, and Titian provided him with it. No doubt he was pleased to have the monumental fountains and classical sculpture that Juan Bautista placed in his gardens, but he never relinquished his objective of ordering the entire landscape of Aranjuez. All the while that Juan Bautista was preparing his formal gardens and constructing a festival barge to float on the waters around the palace, Philip was urging his architect and his engineers to subdue the water, to construct drainage ditches and dikes, and to make the Tagus navigable as far as Toledo. When Juan Bautista was no longer around, the king did not fill the woods with classical statuary. Jehan Lhermitte's view of Aranjuez about 1590 shows plainly that he planted instead (pl. 159).25 Philip's choice is, after all, understandable, for what is a figural allegory of power compared to a landscape transformed?

Rehandling the landscape proved to be far more difficult than anyone had imagined. The low-lying land was subject to constant flooding and, between 1561 and 1567, Juan Bautista, together with a number of engineers, worked on hydraulic projects to establish an efficient system of drainage. Francesco Sitoni was later employed to work on the canal bordering the palace. Most likely, the design of Aranjuez evolved from the king's original conception of long tree-lined avenues into Juan Bautista's more formal conception and was finally extended into the geometric system of the park.

The park at Aranjuez was extraordinary, a vast system of streets and squares, a veritable urbanization of the landscape, as many have rightly called it. Grand avenues of magnificent trees, irrigation canals, and smaller plots of gardens, fruits, and flowers spread over the site, creating a variety of vistas and environments that struck foreign visitors as truly splendid and unique. It is not obvious, however, that the king conceived the comprehensive geometric system which was the most novel feature of this landscape. On the evidence of La Isla and the gardens of the Casa de Campo, it seems

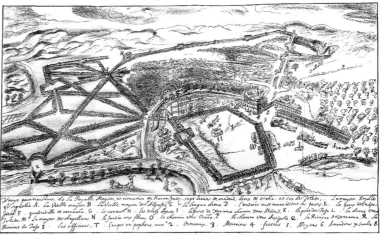

159 Jehan Lhermitte, view of Aranjuez, from his *Passetemps* (Brussels, Bibliothèque royale)

doubtful that Juan Bautista did so. Perhaps Algora was a more important figure than we think.[26] Perhaps the king's northern gardeners contributed. A number of people were involved in designing the gardens of Aranjuez and it is not always possible to determine what their individual contributions may have been. There was collaboration, but there was also an overall conception of the site from an early date. In 1562, Philip noted that he wanted Juan Bautista, Paciotto, and Pietro Janson to meet with him to 'discuss

everything about the Jarama and then about the Tagus, so that what can and should be done about the ditches and ponds can be be settled once and for all.'[27]

A geometry of interconnected avenues appeared first, as far as is known, in Herrera's plan for the Picotajo, the large area of land lying north of the Jardin de la Isla (pl. 160 and 161). In the 1570s, when drainage was brought under control, the plantings could be extended to the Picotajo.[28] Most of what appears in the plan of

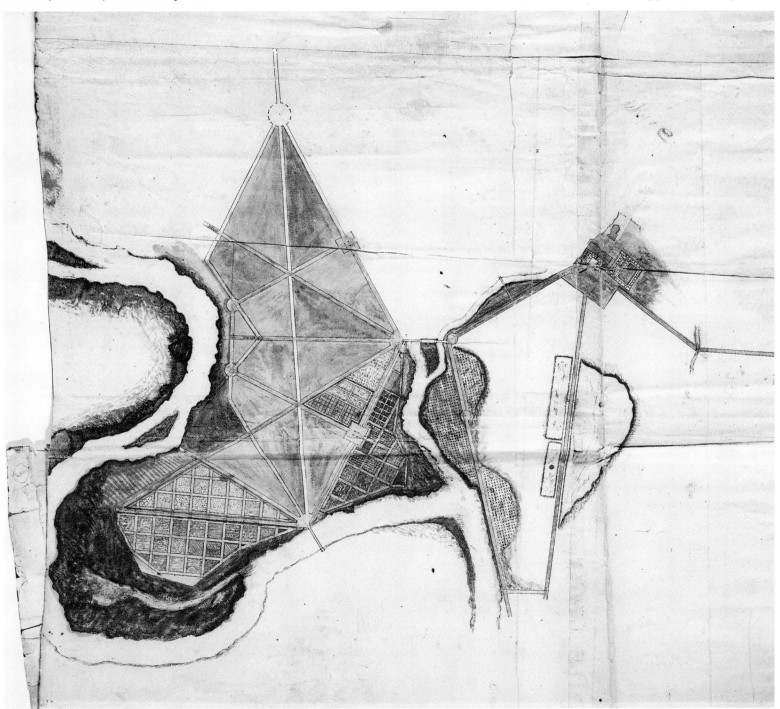

160 Herrera's plan for the Picotajo in the park at Aranjuez c. 1580. (Madrid, Biblioteca del Palacio Real)

161 Holbeque, undated design for planting in the park at Aranjuez. (Simancas, Archivo General)

any large Renaissance garden was urbanistic to some degree, and one need only compare Herrera's design to a sixteenth-century map of Rome to see a similarity (pl. 162). The importance of Aranjuez, however, was not in the fact that the plan of the park was urbanistic, but rather that the formal vocabulary which appeared so fully there was a novel form of urbanism. Unlike other Renaissance gardens or city plans, the park at Aranjuez was not focused on architecture or sculpture. Although it could accommodate fountains in open squares and bridges at the ends of avenues, it was not designed for or in relation to buildings; and it ignored controlled enclosure and perspectives aligned with buildings. The architecture was rather the network, the geometric order of the landscape. Its materials were those of ordinary construction and nature. Canals in brick and stone, irrigation ditches, lines of trees, hedges, and fields were its formal elements, and its effects were achieved through their repetition and extension in an orderly system.

1581 was executed during Herrera's tenure as Philip's architect and is usually attributed to him.[29] Herrera knew the king's idea – perhaps none of his architects understood it better, for he had been with Philip in Flanders, and he had inherited all the designs by Juan Bautista, Algora, and others; he assumed the implications of the site and took them for his own.

We may never know the steps that led to Herrera's conception of the Picotajo, but the final form of the park was in his style: large in scale with roads and plazas connected in an open arrangement of intersecting geometric patterns. North-east of the palace was a great twelve-rayed star. Open squares served as points of convergence for the system of avenues, creating vast crossing diagonals in the landscape. The avenues of contemporary Italian gardens were perspectives cut through undifferentiated woods; Aranjuez is closer to French and Flemish parks. Like the hunting parks of northern chateaux, but unlike Italian parks where the wild *bosco* and garden were enclosed by walls, the park at Aranjuez was conceived on the scale of the seigneurial domain (see pl. 155).

What is strikingly new at Aranjuez is Philip's and Herrera's conception of this domain as a designed territory where kingly avenues are intended for hunting and promenades are superimposed on cultivated land. There were no wild woods at Aranjuez. Apart from the first avenues of trees, planted by Philip in the 1550s, along the roads from Madrid and Toledo, the avenues of the park were not dictated by existing roads. Herrera's geometrical system of avenues re-ordered and reshaped the fields, whose crops are indicated by different colors on his plan of the Picotajo, so that the utilitarian, productive aspect of the domain is brought together in a new image of royal order.[30] Aranjuez marked the beginning of the tree-lined avenue as a monumental form. The Picotajo was a comprehensive system – geometrical order on a gigantic scale and architectural perspectives laid out in vegetation.

With its regular layout, geometrical *parterres*, and open plazas,

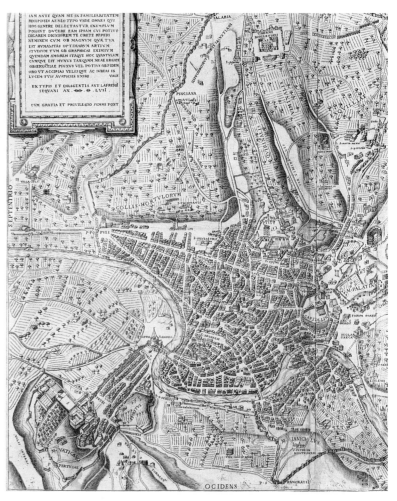

162 Francesco Paciotto, plan of Rome, engraved by Nicolas Béatrizet and published by Lafrery in 1557

163 Fountain at Ocaña, c. 1574

164 Detail of the fountain at Ocaña

THE FUENTE NUEVA AT OCAÑA

The implications of Herrera's designs for Aranjuez may be seen in a nearby project at Ocaña, which, though not documented as Herrera's work, is a small variant in stone on the style of the park.[31] Work was well advanced in 1576 when, in replying to Philip's questionnaire to Castilian towns, Ocaña noted the new fountain, which 'is being sumptuously built out of well-cut stone' and seems to have been completed by 1578. Ocaña belonged to the crown. Its proximity to the waterworks at Aranjuez and Colmenar de Oreja, and the fact that the two engineers seem to be men who were also working under Gaspar de Vega in Madrid, strongly suggest that this was in some sense a royal project. The likelihood of Herrera's involvement follows from these connections, although Gaspar de Vega, Pietro Janson, and Francisco de Montalbán were also in the king's employ. Only Herrera, however, can be identified with its classical style.

Located north and just outside of Ocaña's walls, the fountain provided both clean water and washing services from an underground reservoir that fed water into basins at the fountain house and circulated it into washing and rinsing pools (pl. 163). A traditional program was here given new monumentality: a large open plaza, sunk below the level of the hill, is framed by plain walls cut by monumental staircases and paved in a striking grid pattern (pl. 164). Pavement and walls are played against each other in an artificial landscape of three-dimensional geometry.

Architecture at Ocaña was made from utilitarian elements (pl. 165). Plain walls of rubble and dressed stone and simply framed pools are the major elements in the composition of levels and volumes; a drainage channel serves as a decorative element in the paving. The purely utilitarian is asserted as aesthetic, an effect that must have been even stronger in the sixteenth century when basins and pools were filled with running water. Engineering has been aestheticized and architecture technologized so that there is no significant distinction between them. The abstract relationships of

165 Detail of the fountain at Ocaña

geometry and proportion, which so often underlie Renaissance architectural designs, appear unclothed, so that geometry ceases to be merely a principle of design and emerges as an architectural value.

THE MINT AT SEGOVIA

The royal mint at Segovia, built in the early 1580s, may have been another attempt to monumentalize utilitarian functions. The simple building was a shell for its monumental machinery, whose water wheels, channels, and pools are still visible in the ruins, while the system of dams and channels extended the architecture into the river. Unfortunately the effects of this composition can no longer be judged.[32]

166 Plaza Mayor in Valladolid

THE PLAZA MAYOR IN VALLADOLID

The avenues of Aranjuez and the simple walls of Ocaña's fountain were a rehearsal for Herrera's urban architecture, but the king's and Herrera's ideas were also shaped by their experience of real cities. In September of 1561, just as Juan Bautista was struggling with drainage problems at Aranjuez, the center of Valladolid was destroyed by fire. The city immediately commissioned two plans from a local architect, Francisco de Salamanca: a plan of the Plaza Mayor as it existed before the fire and another plan for its rebuilding. The city also sent a representative to Madrid, and within weeks of the disaster Philip was involved in the project. Before the end of the year, Salamanca had prepared two alternative plans for rebuilding, one of which the city preferred. He took them to Madrid for consultation with the king, who approved the city's choice in March of 1562.[33] At the same time Philip set up a royal administration to work with the local government to arrange the financing of reconstruction. Over the next fifteen years, the plaza was rebuilt according to Salamanca's designs.

The commercial city square – or plaza mayor as it is usually called – is the celebrated creation of Hispanic Renaissance urbanism. Regular, enclosed, and tending to uniform architectural treatment, Spanish main squares have survived as the predominant form of monumental civic space in the Hispanic world. In Spain, the plaza mayor was traditionally a commercial center, occupied by merchants and artisans like the main square in a medieval bastide, and was used also for civic festivals. It was a muncipal institution to which a city hall was sometimes added. The Plaza Mayor in Valladolid is considered the first of the Spanish Renaissance squares based on this tradition. Unfortunately, Salamanca's original designs have disappeared and, apart from a recently discovered plan of a small square adjacent to the Plaza Mayor (pl. 166), only some later drawings of individual buildings and later maps of the city survive.[34] The present square, although retaining much of its original layout, has been largely rebuilt, and none of Salamanca's sixteenth-century buildings remains intact (pl. 167).

The new square in Valladolid was a rebuilding of the old. Its commercial and festive functions did not change, although the city envisaged adding a city hall on the northern side, which was finally accomplished in the 1580s. The traditional porticos, which also lined adjacent streets, were rebuilt. The plan of the square and surrounding streets was not radically different from what had existed before. Some land had to be confiscated in order to widen the streets and regularize the space of the square, but apparently only one new street and a small secondary plaza were added in the original plans.

Salamanca's combination of regularity and standardization of the buildings, however, was novel. It is impossible to say whether this uniformity was his idea or was imposed by the king and his architects in Madrid, but it was already established by the spring of

167 Juan de Salamanca, project for merchants' square in Valladolid, c. 1572. (Simancas, Archivo General)

1562, when the king's instructions specified that all façades were to be the same: a window with a balcony and iron railing on the second floor, a plain window above it, and two smaller windows on the top floor. The heights of the windows were fixed, creating a uniform level for all the new buildings. Materials were also standardized: brick with stone porticos and stone bases at the corners of the houses, and firewalls at regular intervals. The concern for uniformity, regularity, and practicality come through strongly in Philip II's directives.[35]

The formal unity of the final rebuilding struck contemporaries as its most impressive feature. About 1582, Damasio de Frías wrote an extended description in praise of this quality:

The Plaza Mayor . . . is such that when foreigners and locals see it . . . they say it is without doubt the most beautiful piece of building that there is in the world; because, my lord, all is level, all at one height, all of brick, the doors all of the same size, that is fourteen feet high, out of three pieces of Cadeñosa stone.[36]

The uniformity that so impressed contemporaries suggests that every detail of the architecture was planned from the beginning, but this was apparently not so. The decision to extend the house types to the entire square, replacing buildings that had not been destroyed in the fire, was not taken until 1564. The design of the city hall was not finally determined until the 1580s. Nor was there necessarily an elevation design of the entire plaza. Each proprietor was responsible for rebuilding his house according to the approved design but could vary the widths of the windows according to the width of the property, which suggests that Salamanca provided a sample façade that could be adjusted according to need. In fact, the only visual evidence of the original elevation is a copy of an early drawing for just such a sample house (pl. 168).[37]

Herrera's name does not appear in the early documents and he may not have been involved in the 1560s, although he was, by his own account, at work on designs for Madrid at the time. In the 1580s, however, he was hired to prepare designs for the city's water system and probably to advise on designs for the city hall, bakery, and meat market. In June 1584, a city official went to Madrid

to request Herrera's assistance. The king sent Benito de Morales instead; when the city again requested Herrera, they were given Francisco de Montalbán. City officials persisted, however, and, finally, in August 1585, Herrera went to Valladolid to inspect the works. He submitted plans for the water system on 9 January 1586, for which the city paid him 1000 ducats. The system was executed according to his, and perhaps also Montalbán's, specifications and, by 1603, it was bringing water to public fountains in Valladolid. Several of the buildings survive. If Valladolid hoped for a visible monument (like Ocaña?), they were disappointed, but the individual buildings, plain and elegant, look much like those provided for the canal of the Jarama River or at the Escorial.[38]

The new meat market may also have been Herrera's work. Only a crude drawing of its elevation survives, showing a simple brick and stone structure built over the river. The windows were unornamented but, assuming the drawing is accurate, they were carefully spaced, with four of them grouped above the framed portal. The building must have achieved its monumental effect virtually without decoration; but it was considered one of the sights of Valladolid.

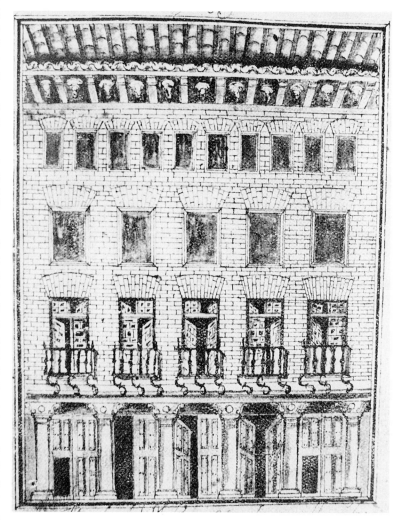

168 Elevation of a house for the Plaza Mayor in Valladolid (after Arribas Aranz)

Building the well-ordered state

Philip drew lessons from his experience of Aranjuez and Valladolid in 1573, when he issued the *Royal Ordinances For New Towns*, a massive set of instructions for the governance of the New World which included specifications for the design of cities. The core of the town, its first building and principal element, is the main square from which radiated the streets leading out to the countryside with fields for grazing and agriculture:

[Ord. 114] From the plaza shall begin four main streets, one [shall be] from the middle of each side, and two streets from each corner of the plaza; the four corners of the plaza shall face the four principal winds... [Ord. 115] Around the plaza as well as along the four principal streets which begin there, there shall be porticos, for these are of considerable convenience to the merchants who generally gather there; the eight streets running from the plaza at the four corners shall open on the plaza without any porticos, which shall be kept back in order that there may be sidewalks even with the streets and plaza... [Ord. 117] The streets shall run from the main plaza in such a manner that even if the town increases considerably in size, it will not result in some inconvenience that will make ugly what needs to be rebuilt, or endanger its defense or comfort.[39]

The heart of these new towns is not a vague idea. The brief text describes a design: a rectangle in the proportion of 2:3, like the square in Valladolid, the minimum size being 200' 'by 300' (pl. 169). It is not a rigid plan – it would have been unreasonable to impose one on the unknown topography of these unborn cities. It was rather a formula for creating what Philip imagined was the best and most functional urban environment. Nor do the *Ordinances* leave any doubt about the intended aesthetic: architect and settlers 'shall try as far as possible to have the buildings all of one form for the sake of the beauty of the town.' The uniform architecture of the plaza mayor was not disturbed by monuments. The main church was placed in its own square in a commanding and visible

169 Reconstruction of the main plaza described in Philip II's *Ordinances* of 1573

position, but independent of the commercial center, and government buildings were near but not on the main square. The *Ordinances* also required a plan of the city that showed every building lot.

Herrera is not documented as being involved in drafting the *Ordinances*, but it is difficult to imagine who else – other than the king himself – could have been responsible for the city plan. Herrera was Philip's principal architect at the time and at work on urban designs for Madrid. It is his style of planning, the style of the *Picotajo* at Aranjuez, with vistas along porticoed avenues. These are not the streets of Valladolid, where the main squares was carved out from a dense urban fabric, but a vision of an urban system in which the main square, geometrically ordered, clear, simple, and standardized, is the nucleus of a town conceived as an expanding entity.

Far away, where the king would never see them, there would be towns much like Valladolid, but new and improved from their Castilian model. The issue of financing and the thorny legal and financial problems that arose in Valladolid, and were often forwarded up to the king himself, were avoided. The city square stood on public land, its building financed by a sales tax, its construction the first duty of the citizens.

All this sounds very practical, yet there is an undeniably utopian aspect to the *Ordinances*, whose cities are imagined as industrious little islands in a peaceful countryside, models of responsible government:

[Ord. 136] If the natives should resolve to take a defensive position toward the [new] settlement, they should be made aware of how we intend to settle, not to do damage to them nor to take away their lands, but instead to gain their friendship and teach them how to live civilly, and also teach them to know our God, so that they learn His law through which they will be saved... but if they still do not want to concur after having been summoned repeatedly by various means, the settlers should build their town without taking what belongs to the Indians and without doing them more harm than would be necessary for the protection of the town in order that the settlers are not disturbed.[40]

In this world the crops grow and the cattle multiply in the hands of an industrious and upright populace.

The *Ordinances* promulgated a humanist ideal of social life that would have been difficult to practice at any time and portrayed a society far more orderly, virtuous, and peaceful than the one Philip knew. But the *Ordinances* were not fantastic like the utopias, even if the king's vision of architectural and social conformity on such a scale may strike us as somewhat surreal. There were no unfamiliar buildings or institutions in the New World towns. Nor does the city plan have the characteristics of utopian designs: there is no central monument, other than the town square, whose empty space contrasts with the visible hierarchy of authority embodied in the temples or palaces of the rulers in utopian treatises. Far from fitting neatly into a geometrical figure, as ideal cities do, the city of the *Ordinances* has no predetermined shape. Alberti, one of the few writers not to impose a geometric figure on the city, nevertheless imagined it as an organic whole bounded by walls.[41] In Philip's ideal city, the lack of fortification (except for the sea-coast towns) and the purely civic space of the plaza represent the peaceful and

prosperous order that the *Ordinances* were designed to implement.

The *Ordinances* embody an idealized program for civic life in a pragmatic design. Philip's choice of the city itself as the object of architectural patronage may well have been motivated by new expressive possibilities for civic building that were first articulated in utopian writing but had not been given visual actuality in illustrations or architectural descriptions. The *Ordinances* recast a traditional Castilian square according to Alberti and Vitruvius.[42] But the reluctance to affirm authority at the center of the town is striking, especially considering that nowhere is this more visible than in the new cities of the Americas where, apparently without exception, the twin symbols of authority – church and government building – faced the main square. These towns were mostly laid out at least a generation before the *Ordinances* were written and so could not be expected to follow Philip's directives, but the discrepancy between reality and his legislation can scarcely have escaped the king and so it should be seen, in architecture as in governance, as a program for reform.

The spare text of the *Ordinances* suggests regular, uniform, and practical buildings built of whatever materials are at hand. Monuments seem beside the point; perhaps the buildings were not designed, there is no evidence that the text was illustrated. But Philip was not interested merely in ground plans; already with his first plantings at Aranjuez, he was thinking of the visual effects of large-scale designs, and the rebuilding of Valladolid had taught him that urbanism is a very much a matter of three-dimensional space and real buildings.

URBAN RENEWAL AND BUILDING AT MADRID

It is one thing to plan parks and to imagine cities rising on virgin land and another to engage in urban renewal. City building is too complex and too expensive for any single patron. Cities are collective institutions, shaped by countless incremental decisions which in the aggregate are more powerful than any single will. In his mind's eye, Philip could erect cities in the New World and people them with model citizens, but rebuilding Madrid (not to mention reforming its citizens) according to any ordered agenda was impossible. So it is not surprising that he, like those with similar ambitions before and after him, should fail to realize such a project. What is astonishing is that Madrid should have come as close as it did to realizing his ideas. The scope of Philip's project, the stages of its development, and the exact role that Herrera played in it are far from clear in spite of years of investigation. Further archival research may clarify some issues. Still, it seems possible to sketch out the character of the king's aims and to make some hypotheses about Herrera's share in them.

Much has been written about why, in 1561, Philip II chose to settle the court at Madrid, rather than continue the itinerant style of his predecessors, and why he rejected the claims of more prestigious cities like Valladolid and Toledo and chose the least of his Castilian royal seats to be, effectively if not officially, his capital. Many explanations have been given. Madrid was in the geographical center of the peninsula; it was close to the Escorial and to the king's other country estates; it was free of a strong ecclesiastical presence.

All these factors probably played a role, but another reason may have been Madrid's ample terrain and relatively modest size. Madrid was not a new town but it was not densely built. If Philip wanted to build a capital of his own Madrid was a good site.

Philip was thinking of the urban renewal of Madrid from the time he took up residence. He was probably inspired initially by the orderly urban prosperity of northern cities that he had visited in 1549 and by reports of Paris, capital city of the French monarchy. Madrid must have seemed ripe for similar development. When Anton van den Wyngaerde drew the view that the king commissioned in the first years of his residence, it was a modest market town still partly surrounded by its old walls and dominated by the mass of the Alcázar (pl. 170).[43] It was admired for its fresh water and pastoral setting in the fields along the little Manzanares River.

Reality soon outstripped whatever vision the king may have had of an agreeable, well-organized capital; thirty years later its old walls were gone, consumed by development on the periphery as the population increased alarmingly, even if we cannot be precise about the numbers involved. Built to serve perhaps twenty thousand inhabitants at mid-century, Madrid swelled each year with court functionaries who required lodgings and services. The open fields that Wyngaerde saw were swallowed up, built over with the houses of those who served in or administered to the needs of the royal bureaucracy. An increasing population of semi-transients – merchants, food-sellers, servants, and workmen – and an ever-growing number of anonymous poor converged on the capital in the hope of picking up a living.

Neither the king nor the city government were prepared for the disorganized, overpopulated, and under-built city that each day sprawled more alarmingly before their eyes. In 1566 Philip set new limits to Madrid, slightly larger than those that existed in 1565, and solemnly declared these new boundaries 'ample and sufficient for the population of this town.'[44] But in 1590 the evidence of a report by Pedro Tamayo reveals that the city had nearly doubled in area (pl. 171). Pressure outward was constant. In the later sixteenth century Madrid was a city exploding outward from its core in an unwieldy expansion. Although growth continued for about thirty years more to the maximum in the early modern period shown in

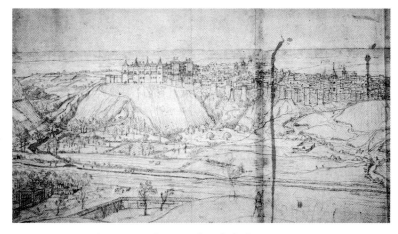

170 Anton Van den Wyngaerde, view of Madrid, about 1562. (Vienna, National-Bibliothek)

Building the well-ordered state

171 Reconstruction of the expansion of Madrid between 1565 and 1590

Pedro de Texeira's map of 1656, the years between 1561 and 1590 transformed Madrid from the pleasant town Philip had known in his youth into a sixteenth-century metropolis (pl. 172).[45]

Philip had failed to contain the city in 1566. In 1590 he tried again: in an abrupt and decisive move, he took the administration of urban affairs out of the hands of the city officials who had been struggling with its problems and set up his own royal commission. In May his junta presented him with a summary of its ambitious agenda for ordering the urban fabric: Madrid was given new boundaries with a set of six major gates and six minor gates on the periphery. Any development beyond these was forbidden. The sprawling suburbs that had grown up beyond the limits were now inside the city.[46]

Philip was determined to bring Madrid to order. Much of the city's growing population was on the lower levels of society and concentrated precisely in the newly-built-up areas that surrounded the old boundaries of 1565. The king was understandably concerned about unruly cities: the specter of Naples – swollen by poverty-stricken immigrants, exposed and vulnerable to epidemic, famine, and lawlessness, struggling with inadequate public services – haunted the imagination. No one wanted Madrid to become another Naples.[47] Yet Madrid's problems were similar, or were felt to be so. People looked back nostalgically at the pleasant town they believed Madrid to have been before it became a capital and anxiously at the filthy, overcrowded city that they lived in and appealed to the king for help. In the later 1590s, Cristóbal Pérez de Herrera begged the king to reform the city, rebuild its services and stabilize its social structure.[48]

Enormous, disfunctional cities were characteristic of the later sixteenth century, and Madrid was no exception. But Madrid's problems were in a sense Philip's creation. By 1590 its status as a capital, the administrative seat of the largest government in the western world, was a physical fact. Nor could the political dimension of this be lost on the king, who needed only to look north to Paris, long the symbolic capital of France, to see the worst possible consequence of the Madrid he had brought about. Paris, the largest city in Christendom, was the most obvious example of what could go terribly wrong when a capital turned against its king. Philip had watched the city rise against his brother-in-law, Henry III. Philip saw a fellow king fleeing his capital, and later assassinated. In the terrible months of 1589/90, he watched Paris besieged by his enemy, Henry of Navarre. This was cause for a sobering conclusion: concentrating the functions of government in a capital city made the capital as necessary to the king as he was to it. Without Paris, Henry IV was not king of France. Spain was by no means as centralized as France but, having created a capital, Philip had become vulnerable to it.

The Renaissance correlation between social order and its architectural representation took on new meaning in the context of late-sixteenth-century cities like Paris, Naples, and Madrid. Alberti's conviction that architecture expressed the social order, reiterated differently in public festivals and utopian writings, provided the ethical imperative for the state patronage of urban projects, but the cities that most urgently required reform defied the basic tenets of Renaissance city design. These cities were becoming densely populated; their urban environments were being established on different principles. It would have been impossible to impose a contained regular order on Madrid in 1590. The city was too complex to be recast in this way, but its needs for adequate water, sewage disposal, paved streets, market areas, housing, and hospitals were too pressing to be satisfied by anything less than a comprehensive plan. In 1590 the king accepted the city that Madrid had become and imposed a model of expansive planning. The city was divided into districts. Major roads from the countryside, shaped into streets and plazas, became the basis of organization and monumentality. Legislation requiring architectural uniformity, public safety, and the orderly distribution of water, food, and goods was promulgated. Backed by the king, the junta plunged into its work with enthusiasm, working simultaneously at all aspects of the reform.

By the end of the century, the city had taken the shape they had envisaged: a main artery crossed it from west to east, forming a processional way from the Alcázar to the monastery of San Jerónimo. Madrid's principal civic spaces – the Puerta del Sol, the Puerta de Guadalajara, and the magnificent Plaza Mayor (designed but not yet built) – were loosely strung along it. Other major arteries converged towards it: Fuencarral and Hortaleza merged at the Red de San Luis into a straight street which ran into the Puerta del Sol; Atocha ran up from the hospital of Anton Martín to the Plaza Mayor; Toledo led from the Puerta de Toledo into the Plaza Mayor on the south. On the west, the new Calle de la Puente from the Segovia bridge was planned to cut a straight path through the old city to the Puerta Cerrada near the Plaza Mayor. Leganitos and Convalecientes reached toward the center from the north-west.

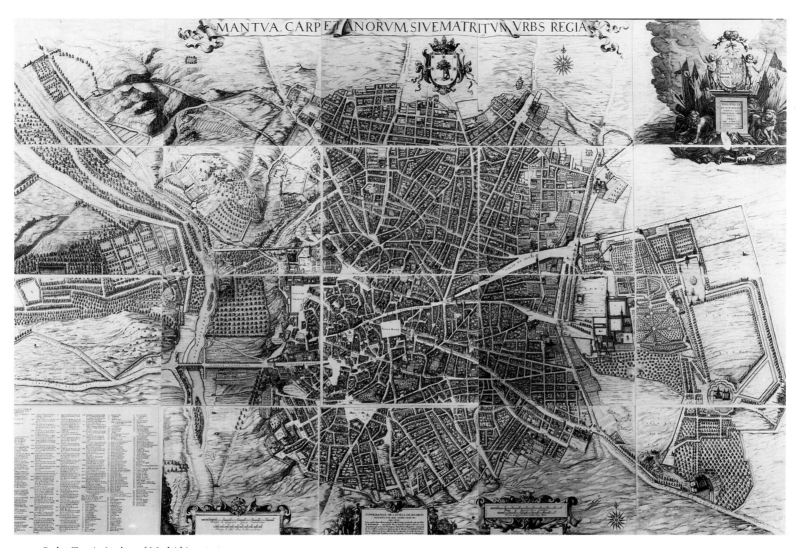

MANTVA. CARPETANORVM.SIVEMATRITVM.VRBS REGIA

172 Pedro Texeira's plan of Madrid in 1656

Madrid was being recast to function with a network of major streets that led in from the countryside, traversed the city, and connected the various open spaces designed along or adjacent to them. Its services were still inadequate, but projects were then in hand to provide it with a new image of clean and orderly prosperity.

The stages in the evolution of Philip's enterprise are by no means clear. When he first turned his attention to Madrid, he may have hoped to beautify it without radically altering its character. In the early 1560s, Juan Bautista was put to work on the main façade of the Alcázar and to designing royal stables around the square in front of the palace.[49] The king was also encouraging development in the center, distributing land near the palace.

The only evidence of a comprehensive project for urban reform at this early period is a report from the city which was presented to the king some time before 1567. It outlines the need for the conventional institutions of a model city: a principal church (either a collegiate church or cathedral), schools, city hospital, city hall, and prison. But it also recommends some specific urban reforms: a new street to run from the Segovia bridge to the Puerta Cerrada; a new street at right angles to it running to the square in front of the Alcázar; rehandling of the street running between Puerta de Guadalajara and the Puerta del Sol; and straightening of the arteries of Atocha and San Jerónimo. The report also revives an old project, the rebuilding of the city square with a fish market, bakery, and meat market. Philip never gave Madrid a cathedral or collegiate church, although he did found a general hospital, but the early recommendations for a system of streets and the Plaza Mayor became the nucleus of the transformation that took shape between 1580 and 1590.[50]

We do not know how advanced plans were or who was responsible for such designs as had been made when the report was written. The king was no doubt hoping that the city would take charge of the projects and their financing, leaving the approval of designs to him. The report repeatedly requests the king to order Juan Bautista de Toledo to prepare designs for the various buildings. Herrera, too, was involved with Madrid at this time. In 1586, he certified that he had:

drawn up for and in the service of this town many designs [*trazas*] and specifications: for the work on the new royal bridge which is being built on the river as for the houses of the *manzana* of Santa Cruz, Puerta de Guadalajara, a plan [*planta*] of this city and design [*traza*] for its Plaza Mayor as well as for everything else that he has offered to the city from the time the court and the king came here until now.[51]

If we take Herrera at his word – and there is no reason not to – he had been planning Madrid since 1561, even before he was named an assistant to Juan Bautista. We do not know precisely what he was doing, but the city needed a map of existing property and buildings in areas being considered for urban renewal, like the one which Francisco de Salamanca made of the burned-out area of Valladolid. Herrera may well have been assigned to prepare such a map, perhaps the one he mentions. He must have been working on the planning of Madrid (whether under Juan Bautista's direction or independently) when the undated report was presented to the king.

Herrera remained involved with the planning of Madrid, but there is little evidence of large-scale building before the late 1570s. Such designs as Juan Bautista de Toledo and Herrera made were probably filed for later use. Whether specific designs from this period were finally implemented, revised, or simply discarded it is not always possible to decide. Years might elapse between the preparation of a design and its implementation, as building waited on financing. In June 1590, for example, the king's junta mentioned a collection of plans which must have included Herrera's drawings. Some of these were used: the junta noted that the street from Santa Maria to the square of San Salvador and on to the Puerta de Guadalajara was to continue 'according to the old plan without changing any thing whatever.'[52] Before 1591 Juan de Valencia (under Herrera's direction?) prepared a general plan of the areas considered for remodelling that was still being used as a reference point in 1597 by Francisco de Mora.[53] But new plans were also drawn up: the junta's report mentions work on 'the new street' running from the church of Santa Maria to the Puerta de Guadalajara and a new straight street from the church of San Ginés to Las Descalzas Reales. Plans were seldom fixed until construction began and even then were liable to last-minute alterations. It seems safe to assume that additions and changes to existing designs were contemplated in 1590; otherwise the junta would not have been submitting plans to the king for his approval; but without detailed evidence it is not possible to say what these changes were.

The ongoing, collaborative character of work on Madrid and the lack of visual evidence of its progress make it difficult to pinpoint Herrera's contribution to more than a few specific projects. Nevertheless, existing documentation permits one generalization: by his own account, Herrera was Madrid's city planner for more than twenty years and, even if we do not know the exact nature of his contribution to the design of every street (how much was designed by Juan Bautista before 1567 or what was revised by Herrera's assistants and successors after 1590), he was evidently the principal architect involved in realizing Philip's vision of his capital.

THE SEGOVIA BRIDGE

The first monument of Philip's new capital was a bridge: the Puente Real Nueva de Segovia (Puente Segoviana) which connects the two banks of the Manzanares River on the western edge of central Madrid, near the foot of the present royal palace, the site of the old Alcázar (pl. 173). This was the major bridge leading north and west out of the city in the sixteenth century, replacing a stone bridge on the same site that had existed since the time of the Catholic kings. The building history is complicated, but the evidence of his request for payment in 1586 makes Herrera's authorship virtually certain.[54]

His designs, which are lost, may be dated between 1575 and 1583, when construction appears to have begun under the direction of Pedro de Nates. Almost all the work was designed, contracted or

173 Herrera, Segovia bridge in Madrid, completed in 1585 (remodelled)

under way by 1585, although it continued until 1588.[55] The final bridge, shown in Texeira's map, has nine round arches like that of the earlier bridge that appears in Anton van den Wyngaerde's view.[56] It is executed in cut stone with bulky semi-circular buttresses and sloping cone-shaped caps decorated with stone tiles.

Herrera was active as a bridge designer, but, contrary to what we might expect from one so attracted to mechanics, his bridges do not look daring, even when they are large in scale. Herrera never designed a bridge as structurally adventurous or visually exciting as Ammannati's Ponte S. Trinità in Florence, whose three elliptical arches spring lightly across the Arno. His small bridge over the Guadarrama River is simple and straightforward. At Madrid he followed Roman models like those illustrated in Serlio or surviving at Mérida.[57] This formula became the basis for other bridges, among them Juan Gómez de Mora's design of 1629 for the Puente de Toledo in Madrid and, much later, the Puente de Retamar, which was built on the road from Madrid to Brunete in the reign of Charles III.[58]

The stone balls called bolas (one hundred and forty-two of them!) that decorate the bridge and its esplanade were not a new motif. Juan Bautista used them on virtually all the royal projects, and Herrera continued to employ them as the signature of royal style (pl. 174). He used bolas for the wall framing the plazas on the north and west of the Escorial, and on the façades of the palaces at Aranjuez and Lisbon; at the Escorial bolas and balustrades were almost the only elements of decoration allowed to remain intrinsically sculptural (pl. 175).

The real future of the bola, however, lay in civic architecture. Simple and monumental, adaptable to almost any scale or composition, capable of being mass-produced and thus relatively inexpensive, bolas could decorate any structure. At Ocaña they punctuate the entrance to the staircases and accent the piers of the fountain house. Originally conceived for monumental architecture, bolas could dignify more modest construction by association; and

175 Bolas framing the plaza at the Escorial

the more buildings were decorated with bolas, the more they seemed to share in a common style. Taking up an element that was virtually confined to royal buildings in Spain, Herrera employed it on the façade of the city hall in Toledo, inside the cathedral of Valladolid, and in the courtyard of the merchants' exchange in Seville. Later architects working for the Habsburgs in Madrid continued to use bolas just as they continued to use slate roofs. Juan Gómez de Mora's design of 1642 for the Puerta de Fuencarral is decorated with bolas; Juan Diaz's design for a fountain in the Prado de San Jerónimo consists of a giant bola on a pedestal.[59]

The bolas on the Segovia bridge acquire their authority from repetition and the unprecedented scale of the bridge and its esplanade, the latter the most original feature of Herrera's composition. Wyngaerde's view shows that the land between the city and the old bridge was undeveloped. Herrera introduced a wide esplanade running in a straight line from the bridge to the new Puerta de la Puente at the entrance to the city. From a rectangular open plaza, an avenue bordered by trees cut south along the city.

In the final design, the bridge itself was one element in an extended composition that imposed geometrical order on the landscape (pl. 176). The esplanade was raised above the level of the fields by heavy buttresses marked by pairs of bolas on its high parapet and its splayed parapet joined a small polygonal plaza on the west. The system, rather than the individual structures, was monumentalized. The Segovia bridge, like Henry IV's later Pont Neuf in Paris, was planned at a colossal scale that dwarfed all other building in its vicinity. In spite of modern development which has built over the fields along the river, rehandled the esplanade and even the bridge itself, the composition remains and impresses.

The Segovia bridge was an urban conception, designed to give Madrid an entrance worthy of a capital, but it was also part of a larger plan, one might say a total system, encompassing the city and its surrounding landscape. Along the river, Philip ordered plantings of trees in regular patterns that complement the stone construction. Later the wide Calle de la Puente was built beyond the Puerta de la Puente to run into the heart of the city. The Segovia bridge and

174 Retaining wall of the king's garden at the Escorial

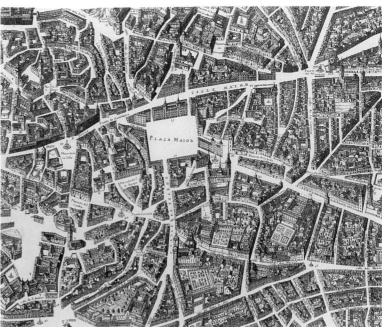

176 The Segovia Bridge, detail of Texeira's map of Madrid, 1656

177 Plaza Mayor from Texeira's map of Madrid, 1656

esplanade called for extension and were the underlying skeleton for Madrid's development, but this does not necessarily mean that Herrera, or anyone else, prepared a master plan showing every new building in detail. The important point is rather that he designed single structures to imply a comprehensive urban order and to help bring one into being.[60]

THE PLAZA MAYOR IN MADRID

The Segovia bridge set the style and scale for the other projects for the capital, and most importantly for the Plaza Mayor, the city's major civic space, that lay near the convergence of the new avenues at the heart of the expanded city (pl. 177).

The present Plaza Mayor is not Herrera's but the work of Juan de Villanueva, who rebuilt all but the bakery in the center of the northern side after a disastrous fire in 1791 (pl. 178). His design was based on the Plaza Mayor built earlier by Juan Gómez de Mora in 1617 and partially rebuilt by him after a fire in 1636. The original bakery (which will be considered shortly) burned in 1672 and was replaced by the present building. Juan de Villanueva and Juan Gómez de Mora each made the Plaza Mayor into an original work of his own but both were dependent on what had gone before.[61] Herrera is important in this long history, however, because his contribution came at a crucial point and was decisive.

The city had long wished to refurbish its old Plaza del Arrabal or Plaza Mayor, which had been used for royal and civic festivals as well as commerce ever since the fifteenth century. Regularization of the space was envisioned in the report on Madrid addressed to the king in the 1560s (not for the first time), but as far as is known, nothing much was done until about 1580. Two plans drawn up in these years survive, showing the existing square and a proposal for remodelling it (pl. 179). The plan of the site shows the large

irregular space framed by buildings, while the design proposes to regularize this space by removing the two blocks of houses that sat inside the northern boundary and placing the equivalent square footage in slightly thinner and longer buildings along the eastern side of the square. The new square would be enclosed by porticos similar to those that already lined the western side of the Calle Mayor beyond the square to the north and both sides of the Calle de Toledo on the southern side.

The proposed remodelling left the southern and western boundaries of the square unchanged, probably for economic reasons. Regularizing this space would have meant expropriating a large triangular piece of land. Furthermore, the Plaza Mayor was not on level ground but sloped down toward the west. Leveling an enormous rectangle must have seemed a difficult and expensive enterprise, and so it proved to be. Anyone who has visited the Plaza Mayor has seen how it sits on a vast artificial platform, isolated from the levels of all but a few streets. The project preserved in the drawing offered a less expensive alternative: the new, regularized eastern half of the square was divided from the lower and irregular western section by a range of columns beginning at the far side of the Calle de Toledo and extending north across the square. The Plaza Mayor was arranged as two adjacent plazas: a formal rectangle and an adjacent triangular space.

The report that accompanied these plans has also survived, and it is typical of its kind.[62] No one who was trying to convince Philip of something ever gave him the project straight: Herrera justified a crane with a little treatise on mechanics; Giovanni Francesco Sitoni's account of his canal projects is so laced with economics that it has been catalogued as a treatise on finances; about 1580 Giovanni Antonelli embedded his proposals for hydraulics in a work on the virtues of navigable rivers.[63] One would think that the king would have wearied of this moralizing, but perhaps he did not

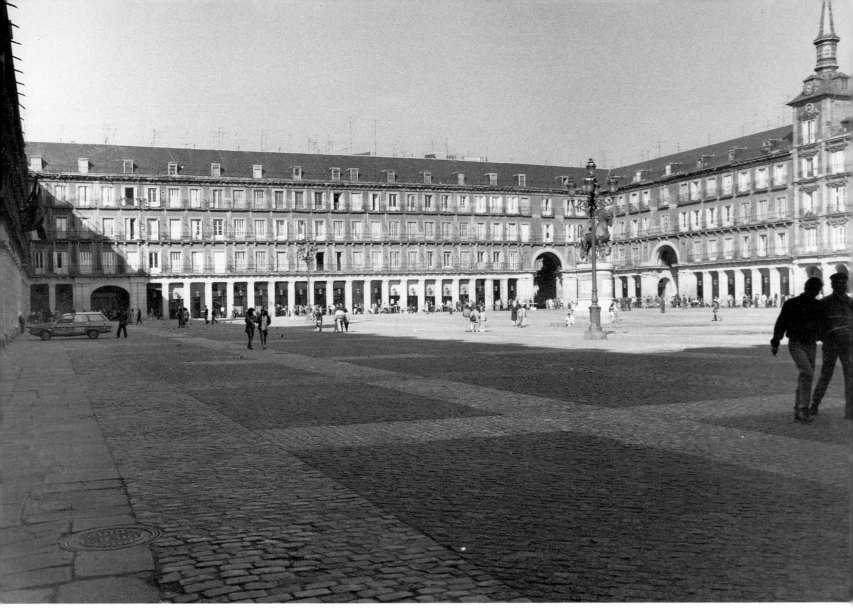

178 Plaza Mayor in Madrid as rebuilt by Juan de Villanueva in 1790–2

179 Herrera's plan of Plaza Mayor in Madrid about 1580 and his proposal for remodelling (redrawn)

– or if he did, his servants never knew – for they continued to introduce their projects as works of unimpeachable public benefit. The report on the Plaza Mayor stresses utility and thrift as well as beauty and explains the logic of the proposed design: the removal of the blocks of houses on the north would permit an unimpeded view of the square that was needed for festivals, and the new houses along the east would be healthier, cleaner, and better-looking because the architecture would be uniform:

Moving the said houses to the part that is shown [on the plan] in which there is space and ground to give each one of them as much footage as before, they improve the site . . . as much by what is built as by what is taken down, for two reasons: the first, because of the proximity of these houses in the plaza, there is no good view during festivals, except through the middle. The second, because on their far side there is a dark, dirty, and narrow little street without any use at all. And moved to the other side, the houses would have the Plaza Mayor in front of them and Santa Cruz behind them, which has a lot of business [and] in this manner they are built with two equal accesses of value and convenience and clean and healthy for habitation, and they are to be built uniformly and handsomely [con buen ornato].

The plaza would be regular in the part which was ugliest and most out of proportion; best of all it would pay for itself:

it is not necessary, according to this report, that the City spend any maravedis in taking away and demolishing these houses, and the plaza remains free of the impediment and ugliness that they cause and squared up in the part that was most out of proportion, and the only thing that will remain for it to be completely perfect is a future need to square up the side or angle that is toward the lower part and the street that runs to the Puerta de Guadalajara, which can be accommodated by making there a triangular exchange for merchants, as the site demands, keeping the two entrances to the streets and the alignment of the Calle de Toledo and the [Calle de] la Ropería, and the plaza will result square and perfect. Although this second is not proposed at the present time, but rather to make a demonstration of the intent of the design, and so it is shown with dotted lines.[64]

Since Francisco Iñiguez Almech discovered and published the plans with the committee's report, few have doubted his attribution of the designs if not the actual drawings to Herrera.[65] The report echoes Herrera's style of reasoning, too, and we may suppose that these were among the designs of the Plaza Mayor and Santa Cruz that he mentioned a few years later, in 1586. They were made for the city, although they were also for Philip II. The Plaza Mayor was a royal project, although the king did not plan to pay for it.

Herrera's Plaza Mayor was an offspring of the town square in the Ordinances, regular in plan, uniform in its architecture, clear and ordered, but not rigidly enclosed. While the design in the Ordinances is an idealized version of Francisco de Salamanca's plan for Valladolid, Herrera's plan for the Plaza Mayor is a realistic application of the principles in the Ordinances. The square is conceived as a node in a street system, and continuity between the square and major streets was stressed by their common porticos, but there is an equally strong sense of the square as a building, an enclosed space.

This Plaza Mayor was not destined to be built. By 1590 it was obviously too small to accommodate the population for public

spectacles and perhaps inadequate to the king's idea of the principal civic space in his capital. The main square recommended for large towns in the Ordinances was 400' by 600', much larger than that proposed for Madrid where the final dimensions were only 304' by 434' in Gómez de Mora's plan. So the triangular merchant's exchange was eventually eliminated (as the report had envisaged) and work was undertaken to level the rectangle for the larger, unified space. (pl. 180).

In 1609 Luis Cabrera de Córdoba spoke of the Plaza Mayor, whose construction was then beginning, as projected according to a 'new design' which had just been approved. But how new was this project really? The plan for the square that included the merchants' lonja in the Plaza Mayor (as in the report of c. 1580) was still under consideration by the junta in the spring of 1590. Their report states a preference for putting it in a square at the Puerta de Guadalajara and, therefore, for unifying the Plaza Mayor. This change might have been proposed by Juan de Valencia, who was then serving as architect on the junta, but a unified square was already considered desirable (if too costly) in the 1580s, and Herrera may well have drafted designs for it. He mentioned his designs for the area around the Puerta de Guadalajara (for a merchants' exchange?) in 1586. In any case, the 'new' square that Luis Cabrera de Córdoba reported on in 1609 and saw rising in 1613 was in some respects at least as old as the spring of 1590.[66] In the final design, the play between contrasting levels and geometric spaces was eliminated, and the levelling of the square increased its isolation from the surrounding streets. Herrera's earlier balance between enclosure and extension was tipped in favor of enclosure, so that the Plaza Mayor assumed some of the coherence of a single building.

Herrera's participation in the design of the final square is not documented, and Francisco Iñiguez Almech suggested that by 1590 Herrera was too sick to undertake new responsibilities.[67] But

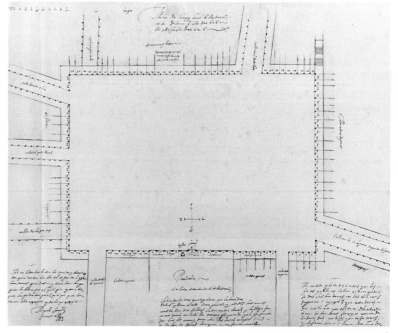

180 Juan Gómez de Mora, Plaza Mayor in Madrid in 1636. (Madrid, Museo Municipal)

Herrera's gout, about which he frequently complained, did not prevent him from acting as the designer of major projects: only a few months before work began at the Plaza Mayor, he prepared a set of plans for the rebuilding of the Plaza de Zocodover in Toledo, and the previous summer he declined but left open the possibility that he would design the new cathedral of Salamanca (see chapter 7). It was not designing that Herrera could not or would not undertake, but supervision: never once in his entire career had he acted as a *maestro mayor*. The practical responsibilities of the architect who served on Philip's junta were onerous: site evaluations for expropriation, review of proposals by private developers, work with contractors, etc. It is unlikely that Herrera would have done the site work at any time; at the end of his career and at the height of his eminence, he could afford to leave the drudgery in the hands of men like Juan de Valencia and Francisco de Mora, who acted as his executants. This does not mean that Francisco de Mora and, later, Gómez de Mora could not have altered Herrera's designs, and without new evidence it is not possible to know who was responsible for the details of the final project; but Herrera cannot be kept out of the picture.

THE BAKERY IN THE PLAZA MAYOR

Cabrera de Córdoba saw the architecture surrounding the Plaza Mayor as determined by the style of its bakery.[68] This was the first new building on the square, occupying the space opened up by the destruction of the two blocks of houses on the northern side. The building was designed by 13 June 1590, when the junta met to approve the specifications for the builder, Diego de Sillero.[69] By the early 1590s the two old houses on the north were finally demolished so that new construction could begin. Building continued through the 1590s; the lower vaults were built by 1601, and recent investigations suggest that the entire building was complete at this time; it was finished by 1608.[70] In the seventeenth century Juan Gómez de Mora and others modified the building somewhat; in 1672 fire destroyed all but the basement vaults, and the bakery was rebuilt on a revised design by Tomás Román. Possibly rehandled by Gómez de Mora, burnt, and later rebuilt by other architects, the Panadería that exists today is not the one that Sillero began in 1590.

Fortunately the essentials of the original plan may be reconstructed from later drawings and from two brief but nearly identical descriptions written by Jerónimo Quintana and Juan de Tapia (pl. 181).[71] These describe an obsessively regular building, 124′ long and 56′ deep, consisting of eleven bays facing the square and five bays deep toward the Calle Mayor on the north. The ground floor, constructed over a vaulted basement and supported by 54 piers, was almost entirely open since 30 piers and 24 columns (corresponding to the piers on the basement level) supported the upper stories and framed an open patio in the middle. The final bays toward the square on either end of the main façade opened on passageways leading to the Calle Mayor on the north. In adjacent bays, two staircases led to the royal hall which faced the square on the second floor. Behind the building there were apparently access ramps to the storage cellars below.[72] The bakery was thus a

181 Plan of the bakery on Plaza Mayor in Madrid, c. 1600. (Madrid, Museo Municipal)

rectangular and geometric building whose ground floor was largely open to the street. The modular design is so regular and so simple that it suggests two possible sources from opposite ends of the architectural spectrum: a Vitruvian temple from Cesariano and Filarete's project for a reservoir, although it probably owes its open character and function to northern market buildings and its classicism to Serlio's projects for the city hall in Lyon.

The brick and stone architecture, slate roofs, towers, and eleven-bay façade of the present Panadería are descended from the original bakery, whose façade is known principally from Juan Gómez de Mora's elevation of the entire Plaza Mayor of 1636 and from a painting by Juan de la Corte of 1623 (pl. 182).[73] The four-story façade above the ground floor was brick with a single cornice running the entire length of the façade and two corner towers, with spires simpler than the present ones, were integrated in the building. There was a continuous wrought-iron balcony in front of the windows on the main floor and individual balconies at the windows in the upper stories. An attic structure sat above the cornice, its seven windows corresponding to the seven central bays of the ground floor whose arched bays with piers and engaged columns were framed by two rectangular bays at each end.

More than 120′ along its front façade, four stories tall, and bearing the towers and slate roofs that were emblems of the royal palaces, the bakery borrowed its dignity from the royal works from which it drew its scale and ornamentation, but it was a monumental work with none of the usual trappings of prestigious

182 Juan de la Corte, *Festival in the Plaza Mayor*, Madrid, in honor of the Prince of Wales in 1623, showing original façade of the bakery. (Madrid, Museo Municipal)

architecture. Brick, if not the least expensive building material in Madrid, was the stuff of inexpensive and rapid construction. If the painting is accurate, there was nothing, not even a coat of arms, to signal the royal presence, except a tapestry hung out for the festival. The bakery brought the materials and design of utilitarian construction to bear on the design of a prestigious building. Cheap materials and thrifty design strategies like repetition and standardization were celebrated for themselves.

On the ground floor – the utilitarian part of the building given over to the bakery – the granite piers with their engaged Doric columns were an unmistakable reference to royal architecture. In fact, the composition adapts Herrera's façade of the basilica of the Escorial. The Renaissance practice of using the orders to signal the noble part of the building makes the market noble. Pilasters, columns and arches, which contrast with their plain brick setting, are brought to dignify humble services which are otherwise asserted in all their humility. Classicism is associated with the useful without relinquishing its link with power and prestige.

Bread is always symbolic; at the bakery it becomes the means of representing a nurturing authority that restates the old festival theme of the ideal relation between the king and his subjects. The Plaza Mayor provided Madrid with bread and circuses under royal patronage. A royal apartment on the main floor faced the square, with a balcony for the king to view the spectacles staged in the square below, while its ground floor served as the main food market of Madrid, and the city meat market faced it across the square.[74] By the mid-seventeenth century, the bakery had become the city's principal monument, an object of civic pride and emotional attachment. Jerónimo Quintana praised it as 'the most sumptuous building for this purpose that exists anywhere in Spain'; and it has retained its name like a talisman, even though the original structure and its function disappeared long ago.[75]

There is no proof of Herrera's involvement in the design of the bakery, but it is probable that bakery and square were conceived together. The likelihood of Herrera's involvement at Madrid in the 1590s is supported by the evidence of his designs for the Plaza de Zocodover in Toledo, which have survived in eighteenth-century copies.[76] A digression on this project is necessary to show that, whether or not Herrera was directly involved in the final design of the Plaza Mayor at Madrid, as we may suspect he was, he developed the new kind of architecture in which the square at Madrid was eventually executed.

THE PLAZA DE ZOCODOVER IN TOLEDO

Zocodover is Toledo's largest civic space (pl. 183 and 184). When the old square was destroyed in a fire on 29 October 1589, Philip immediately instructed Herrera to prepare plans for its remodelling.

183 Plaza de Zocodover in Toledo

These were in the hands of city officials in Toledo by 9 January 1590.[77] The eighteenth-century copies of these drawings show that he proposed to regularize the plaza by making it either a broad or slightly narrower rectangle (pl. 185, 186, 187). This was never done, because the cathedral chapter refused to give up its land on the square.

Zocodover was to be geometrically ordered and framed by porticoes. Its major north/south axis lay along the entrance to the city from the Puerta de Visagra up the hill to the Alcázar beyond the square. Herrera emphasized this processional way by porticoed gateways, three columns deep, at the southern and northern entrances to the square. The elevations of the buildings show that the architecture of Zocodover was to be made up of nearly identical units: stone columns and lintels at ground level and plain windows and balconies in brick walls, but the number of stories varied from three to five, and the long façades were broken by the higher arched gateways. Herrera was not proposing total uniformity, but rather a carefully cadenced visual geometry. Some of the indended effect is still preserved in the plaza as it was eventually executed.

Herrera's project for the architecture of the Plaza de Zocodover combined classicism and vernacular by stressing the architectural elements that they had in common and by eliminating features that could not be subjected to his reductive abstraction. Renaissance notions of ancient practice cannot be discounted. The writer of the treatise on architecture had contrasted the unattractive squares of his own day with those in antiquity many years earlier ('Those in our time have not made squares according to measure or well decorated, but the ancients took great care to see that this space was the most adorned and best designed in all the city, being as it was the most often seen by the people and the most noticed by foreigners'). His description of an ancient forum, and Alberti's text that lies behind it, were a general model for the program in Toledo.[78] The uniform buildings with their porticos and monumental arches at the entrances to the square match the buildings evoked by Alberti's text:

Apart from being properly paved and thoroughly clean, the roads within a city should be elegantly lined with porticos of equal lineaments, and houses that are matched by line and level.... The forum is but an enlarged crossroad.... The most suitable place to build an arch is at the point where a road meets a square or forum, especially if it is a *royal* road (the term I use for the most important road in the city). An arch, not unlike a bridge, contains three lanes.... But the greatest ornament to a forum or crossroad

184 The western side of Plaza de Zocodover

185 Eighteenth-century copy of Herrera's design for the arch and buildings on the southern side of Plaza de Zocodover in 1590. (Madrid, Archivo Histórico Nacional)

186 Eighteenth-century copy of Herrera's drawings of houses on the western side of the Plaza de Zocodover, 1590. (Madrid, Archivo Histórico Nacional)

187 Eighteenth-century copy of Herrera's drawings of houses for Plaza de Zocodover, 1590. (Madrid, Archivo Histórico Nacional)

would be to have an arch at the mouth of each road. For the arch is a gate that is continually open. Its invention I ascribe to those who enlarged the empire; according to Tacitus, they were the ones traditionally responsible for extending the boundaries of the city.[79]

But texts are not architecture, and neither Alberti nor the writer of the treatise envisaged the loose geometrical organization that Herrera wished to articulate. The expansive geometry of Herrera's urban planning is closer to ancient practice, as in Rome, where the shape of the city was defined by the roads that led in from the empire and turned into the monumental avenues of the capital. The Romans often used brick for utilitarian construction. But Herrera did not adopt the rich materials and ornamental statues, reliefs, and inscriptions which Alberti admired in Roman architecture, and which were still considered hallmarks of classical style, nor did he attempt to find equivalents for the public institutions – basilica and temples – that were associated with the forum in antiquity. Herrera's project for Zocodover is a recreation of an ancient forum, more properly of the Renaissance idea of one, in the limited sense that its classicism recalls the images of civic order and good government that Alberti and others associated with Roman public space.

Herrera's design has as much in common with the main commercial square in medieval *bastides* and with existing porticoed Spanish commercial squares as with any ancient prototype. The synthesis of antiquity with a medieval, vernacular past must have been intended. Herrera's use of square columns with architraves to make up the porticos is classical as well as vernacular. Spanish main squares were often built with wooden beams, as at Colmenar de Oreja, although arches and piers or columns in brick and stone were used when towns could afford the additional expense (pl.

188 Plaza Mayor at Colmenar de Oreja, seventeenth century

188).[80] In Toledo and Madrid, where the danger of fire was a serious concern, it made sense to keep wood to a minimum. As earlier at Valladolid, the columns of the porticos of Zocodover carry lintels; arches were reserved for the monumental gateways. In the Plaza Mayor in Madrid stone lintels were used for all but the bays except those of the Panadería.[81]

References to northern architecture are the most explicit. The market squares that Herrera and Philip had seen in northern towns provided a contemporary model of architectural uniformity. Herrera's slate roofs, towers, and dormers, which were adapted from northern building, reflect the desire on the part of Philip as well as Herrera to synthesize differing building traditions (pl. 189). Such synthesis was a conservative enterprise, although its expression was novel, which may explain why Herrera's plaza designs re-

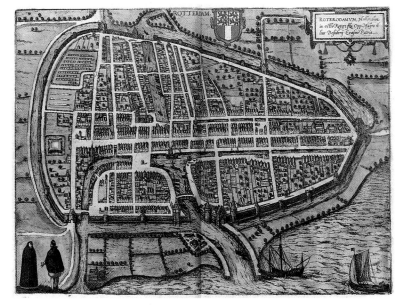

189 Jacob van Deventer, map of Rotterdam commisioned by Philip II in 1558 and published in Braun and Hogenberg, *Civitatis Orbis Terrarum*, vol. IV, c. 1588

mained relatively enclosed compositions like the earlier Renaissance idea of a forum and like earlier northern and Spanish squares, and why he avoided a plaza with streets cutting perspectives through the sides of a square or branching out radically from them such as he had used at Aranjuez.

The project for Zocodover resembled that for Valladolid, but its underlying principle was different. The unity of the Plaza Mayor in Valladolid depended on the repetition of individual if similar buildings around the square. The unity of Zocodover was established by the extension of uniform façades, which are varied by the differences in height and punctuated by the gateways. Windows and balconies were carefully proportioned to each other and to the height of the stories throughout the square. The space of Zocodover was regular and coherent, or would have been if Herrera's plan had been executed, and its architecture was uniform and homogeneous, like that of a building; but Renaissance principles of architectural composition no longer applied to it. The buildings for Zocodover lack an overall symmetry and an organic relation of parts; they have no identity separate from the space they enclose.

THE EXTENDED FAÇADE

This was the design strategy that was finally adopted for the Plaza Mayor in Madrid. The Panadería, occupying the center of the northern side, was the only distinctive element in a uniform architecture. The meat market opposite it was concealed behind the porticos and brick façades that surrounded the entire square, as we can see in Juan Gómez de Mora's drawing of 1626 (pl. 190). Adjacent streets either continued the porticos of the square and so extended the space of the square beyond the rectangle, or, like the Calle Imperial, were masked by columns. Herrera's projects for Zocodover had recast utilitarian buildings as urban monuments. At Madrid, the simple materials, repetitive series of windows and standardized ornament became the basis of an infinitely variable but homogeneous urban building.

Contemporaries were highly conscious of the novelty of Madrid's main square. Gómez de Mora included it in his collection of drawings of the royal buildings. One need only compare Herrera's project for Zocodover or Gómez de Mora's elevation of the Plaza Mayor in Madrid to a monumental Italian Renaissance square, like Michelangelo's Capitol, Vignola's Portico dei Banchi, or even the homogeneous architecture of the Piazza San Marco in Venice, to see how different Herrera's conception was from Italian Renaissance planning (pl. 191). Herrera's projects not only lack monumental buildings; the buildings themselves have no individual character. Herrera's façades could go on forever; in a sense, they were meant to do this, for these buildings were an architecture of the street even when they faced a square. The effect of the Herreran parts of Zocodover are more like nineteenth-century Paris than an Italian *piazza*.

An architecture based on the deployment of a large-scale pattern made new demands upon an architect. The isolated building must give way to its environment, and what counts is the total effect. The building must shape itself to an abstract plan if the larger order is to be revealed. Earlier Renaissance architects, who concentrated their

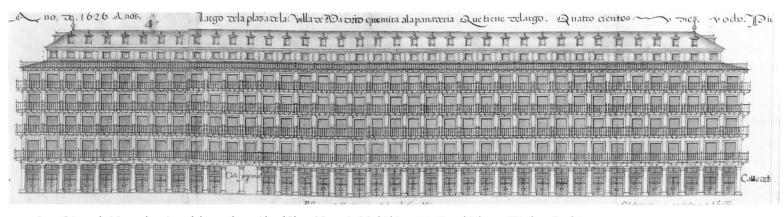

190 Juan Gómez de Mora, elevation of the southern side of Plaza Mayor in Madrid in 1626. (Royal Library, Windsor Castle)

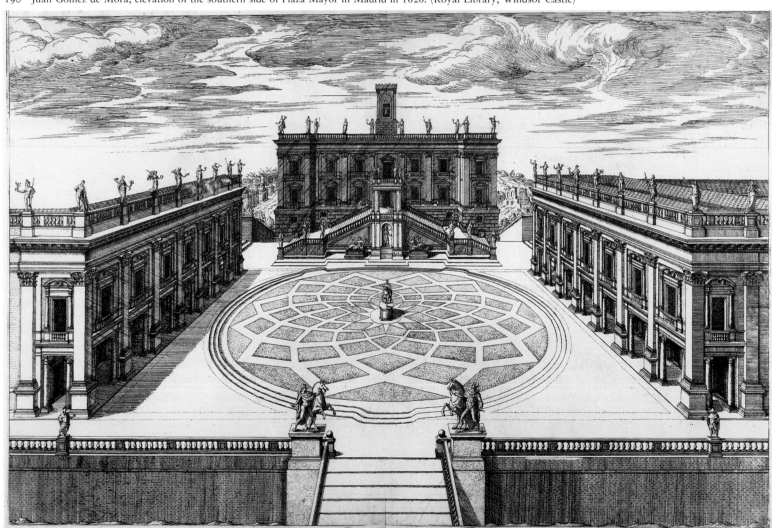

191 Etienne Dupérac, Michelangelo's design for the Roman Capitol, etching published in 1569 by Lafrery (Santa Monica, California, The J. P. Getty Center for the History of Art and the Humanities)

efforts on the integrity of the single building even when they were composing a group of buildings, seldom thought in such terms.[82] Their urban plans were organized according to principles appropriate to a single building or in geometrical patterns that were usually not visualized as constructions. Only in military architec-

ture, where the character of the site was crucial for the design of firing lines and defensive works, was three-dimensional representation absolutely necessary. Concern for the site also explains the exploded geometry of late-sixteenth-century fortifications, with their multiplication of detached outworks and variation in levels

which parallel Herrera's expanded designs.

Outside the domains of theory and the practice of military architecture and engineering, design at huge scale was a new task for a Renaissance architect, although the demand for it was increasing. Philip was not the only ruler to contemplate rehandling an entire city. The urban renewal of Rome undertaken by Domenico Fontana for Sixtus V between 1585 and 1589 and Henry IV's building program in Paris in the early seventeenth century were of comparable scale and of similar ideology.

The comparison with the famous contemporary renewal of Rome is instructive. Fontana was an engineer as well as an architect, and his work for the pope included the design of new streets, a water system, fountains, and even projects for workers' housing. Earlier popes had sponsored urban projects in Rome, but Sixtus undertook work of unprecedented scale. He added four long streets to connect principal churches and papal buildings. These streets generated their own pattern as they opened up new vistas through the city.[83]

The ambitions of Sixtus V and Philip may have been similar, but Fontana and Herrera had different conceptions of urban order. Fontana's street system was organized in relation to existing monuments, and new monuments were added as markers at the end of perspectives or in existing squares; he installed ancient obelisks at Santa Maria Maggiore, at the Lateran, in St Peter's square and the Piazza del Popolo. The aim to unify the Holy City around its pilgrimage sites and ancient churches appears clearly in a stylized view of Rome celebrating Sixtus's transformations reissued in 1590 (pl. 192). Fontana created perspective vistas through the city by cutting streets through from monument to monument, but he did

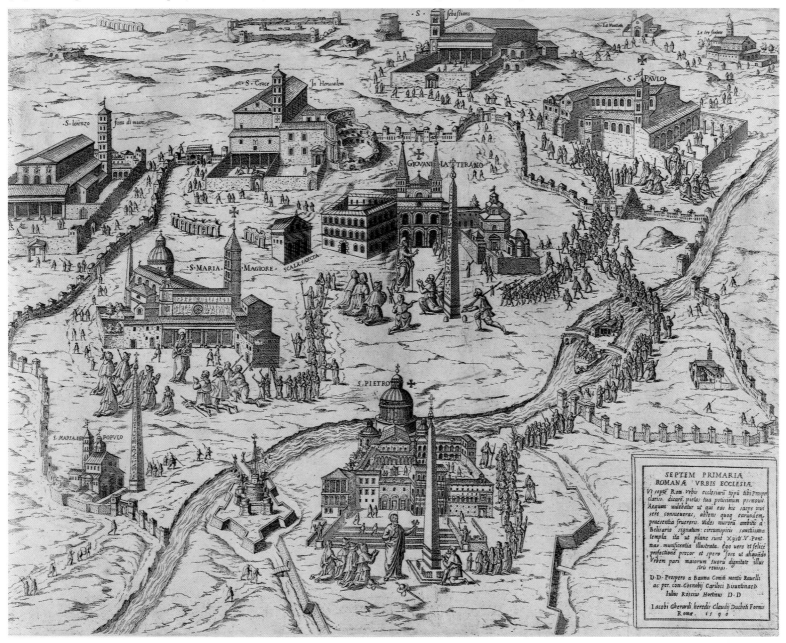

192 Pilgrimage churches and obelisks in Rome, published in 1590. (New Haven, Connecticut, Paul Mellon Center for British Art, Yale University)

not attempt to make architecture out of the street itself. The continuous buildings of Herrera's Zocodover would have been alien to Fontana's kind of urbanism.

Behind Herrera's designs for Toledo and Madrid lie the design strategies of utilitarian construction. The infinitely extendable building adapted itself to streets and squares, and could be sliced into single units or arranged in blocks. Herrera devised an architecture that depended almost solely on its orderly extension to achieve monumentality. His idea of a fabric from which to cut and construct the city's buildings was related to the standardized forms of the simplest building. Canals, drainage systems, and roads also achieved their effects through the repetition of elements in undifferentiated extension. In Herrera's projects for Zocodover – and eventually at Madrid – utilitarian design became the basis of an urban architecture.

PRAGMATIC UTOPIANISM

Philip II was the most powerful monarch in Spanish history, and any style of architecture he patronized would probably have become associated at some time with his name and authority. Had Juan Bautista de Toledo lived or architects other than Herrera taken his place, the style of the reign could have looked quite different, but the character of this architecture was at least partly determined by the king's aims and concerns. Philip loved architecture but, more than this, he was a patron of architectural reform, and he thought on a colossal scale. Here was a king who contemplated swallowing up France and tried to annex England. Building was no less a matter of large-scale improvements: subduing rivers, irrigating plains, organizing territories. In the same years that Philip was building his palace at Aranjuez, his architects and engineers were working on hydraulic projects, like that to make the Tagus navigable as far as Toledo and even on to Portugal.[84] The irrigation ditches in the royal park had a counterpart in the network of irrigation canals and dams that Philip wished to build. The Jarema irrigation system, for example, begun in 1578, was designed to serve communities over more than seventy kilometers. Sitoni planned canals and dams in Aragon. The king never completely relinquished these public works, even those that proved impractical or too expensive.

Philip's various projects to set his vast realm in order seem often directed to similar ends. The royal survey of the Spanish population, sent out in 1575, was typical in seeking standardized information to be matched by informed and comprehensive governance.[85] The project to establish public mathematical schools envisioned a standardized program. The geographical surveys undertaken at the beginning of the reign and the commission for views of Spanish cities from Anton van den Wyngaerde in 1561 show that Philip wanted visual as well as statistical information, that he had a spatial as well as an abstract vision of his power. In later years, he kept all the designs and views of royal buildings in a special room near his quarters in the Alcázar.[86]

There is something unreal about any vision of comprehensive order, and organized city building is always at least partly a utopian undertaking. Yet Philip pursued his vast schemes in a spirit of indefatigable pragmatism which is nowhere so evident as in the history of Madrid.

One does not plant avenues of trees only for oneself, for one will never see them fully grown. Philip was always thinking of future development: the *Ordinances* looked to the growth of New World towns, specifying an orderly development that envisaged rebuilding. In line with this policy, Herrera noted what could be done first and what left for later in his plan for the Plaza Mayor in Madrid. A total design, fixed and complete in all its parts, was not what the king wanted even for completely new towns, and it would have been utterly impractical for the reform of existing cities like Madrid. Herrera had to provide plans that could be developed and extended in flexible responses to future circumstances, hence the importance of developing streets and squares as points of focus in large-scale designs.

Herrera gave Philip II an architecture to meet these needs, an economical kind of building whose public utility was beyond question. Most important of all, he devised a style to give visual unity and architectural value to avenues as well as town squares, to a bakery as well as a monastery. His distinctive manner made it possible to associate these buildings with the king's patronage, even when Philip had not personally commissioned or paid for them. Herrera made architecture into an image of the king's authority. This was not simply an architectural image of order, but the image of a particular kind of order: a government that did not feed on its citizens (even though Philip bled his subjects through taxation and war) but one that provided for them (even though Philip discovered that within his priorities he could not afford it). This image of a beneficent state lies behind Herrera's appropriation of utilitarian building.

Alberti had integrated ordinary building into his theory of architecture, but the meaning of such construction was by no means simple in the sixteenth century, being a collection of associations which included Albertian references to social organization, Vitruvian and contemporary images of technological progress, and Christian notions of divine order.[87] Ever since Alberti, however, utilitarian construction signified the useful, essential, and economical as opposed to the beautiful, exceptional, and costly. Utilitarian buildings are collective, for everyone: by definition, they provide for the necessities of social life. Architecture looked to higher values but, as Alberti repeatedly warned his readers, it could all too easily run to luxury, egotism, and self-indulgence.

When Herrera and the king adopted utilitarian forms for public buildings, they appropriated their values. The virtues of ordinary building were modesty, lack of ostentation, utility, frugality, the same virtues that Philip took upon himself and that contemporaries perceived in him.[88] These moral associations provided the symbolic framework for Herrera's formal vocabulary and gave him the means to cast the virtues of the king on the heroic scale of the built environment. Plainness became virtuous and virtue was monumentalized as they confronted (and triumphed over) the vices and temptations that lurked within 'beautiful' architecture.[89]

Herrera's transference of utilitarian images to the highest level of design was one of the more ambitious appropriations of meaning in the Renaissance, and it is a measure of its power that it profoundly

affected the interpretation of conventional monuments. Sigüenza's discussion of the Escorial – a building that conforms in every particular to Alberti's conception of prestigious architecture – insisted on its utility, sobriety, frugality. In what soon became an ongoing comparison between the Escorial and ancient buildings, Philip was praised for his rejection of the egotism and extravagence which was at the root of so much ancient architecture, some of it, like the Golden House of Nero, 'completely reckless, crazy, vain, full of pride and ostentatious adornment.'[90]

But Sigüenza was careful to exclude from censure 'those celebrated [buildings] of the Romans . . . like the aqueducts which provided water in great abundance to the city, or the roads, the bridges, and the other buildings of this kind that beautify and are so useful to the republic,' and he tried to justify the cost of the Escorial in utilitarian terms. How much better, he argued, that Philip fed useful, productive citizens who were employed in building the Escorial, rather than wasting his money on starving vagrants. It was not sufficient to build the Escorial in a purified, true, and divinely inspired style; it had to be ethically accountable. But the Escorial was not useful like an aqueduct or a Roman road; nor was it built for the many who paid with their labor in building it, and still less for the anonymous poor. The Escorial was a royal building which even Sigüenza could not transform into the symbol of the king's concern for the welfare of his people which was represented by the Panadería in Madrid. Still, Sigüenza managed to find a justification for the project in the social improvements it had provided to Spain. The expenditure had created:

countless fine artisans, architects, draftsmen, masons, carpenters, joiners, plasterers, painters, embroiderers, and a hundred other arts and crafts and skills [*ingenios*] that are now known and practiced here as well as anywhere in the world . . . all thanks to the alms the King gave these thirty eight years.[91]

Power and responsibility were inseparable in Philip's mind, even if the results of this conviction were dark. By the end of his reign, he had destroyed or impoverished more cities in his wars with the Dutch than he could ever have dreamed of building. Proud Antwerp, who had greeted her prince in splendor forty years before, bitterly mourned her lost prosperity: 'I, who touched the clouds with my greatness . . . I, who was so rich in people and in goods/I, [who was] once so splendid and so fair to see . . . What am I now, what have I become?'[92] In his pursuit of an ideal of order, this frugal, prudent king had squandered the wealth of the richest state in the world. In trying to do right, Philip was often tragically destructive, and yet the consuming authority, which was all too evident to those who hovered nervously on the borders of his policies, was the counterpart of a sense of duty that was entirely in the spirit of Renaissance humanism.

Philip meant to provide services that made cities more practical and more beautiful, and Herrera's designs for public buildings came into being to fulfill as well as to symbolize the king's idea of these responsibilities. The town squares were not royal monuments like the king's palaces or the Escorial; they were not meant primarily to be illusions of power, however convincing, or agencies of authority, however real. They were above all *civic* monuments, part of a general program to provide clean water, spacious streets, good roads, and bridges for public benefit. Philip accepted the implicit social contract proclaimed in the language of the festival by his Flemish cities at his initiation into kingship in 1549: 'Where a good prince is present all things are prosperous and happy.' It was through building, and perhaps only through building, that over the next fifty years he tried to fulfill his side of the bargain.

At the end of the reign his new Madrid may have been more imaginary than real from a social point of view. Never more than a few streets and buildings, the legal complexities and staggering costs of completing even these were such that his empowered junta faltered after a few years. But the union of royal and popular imagery in the bakery and its Plaza Mayor gave the image of the king as the patron of the city a momentum of its own. Once launched, the reform of Madrid's streets and squares became an established royal project. Philip III and Philip IV continued to preside, if only symbolically, over work which was taken up by subsequent royal architects and executed by countless patrons, entrepreneurs, and builders. From Juan de Valencia to Francisco de Mora to his nephew and successor, Juan Gómez de Mora, the project descended apparently without fundamental alterations in scope or goals. Except for the years between 1601 and 1606, when Philip III's court was in Valladolid, the urban renewal of Madrid proceeded continuously from 1590 to the middle of the seventeenth century.

Philip's chosen capital elected to fulfill its role as a representation of his monarchy and built itself in the king's style. Brick and stone and slate-roofed uniformity set the tone for Madrid's urban environment, so much so that when Philip IV built his new Palace of the Buen Retiro in the 1630s, he was virtually obliged to build in the style of the bakery if he was not to disrupt the visual unity of the city.[93] After four hundred years and innumerable changes, Madrid is still a city in which conventional monuments of the Renaissance type are uncomfortable: the equestrian statue of Philip IV in the Plaza Mayor, placed there in the nineteenth century, looks lost.

The example of Madrid was a stimulus to others who wished to express their power by building virtuously. Early in the seventeenth century, the Duke of Lerma, favorite of Philip III, rebuilt the entire town of Lerma and furnished it with convents in the new plain classicism, while, in Guadix, far from Madrid, the main square was rebuilt as a royal monument. The associations of the style proved more difficult to transfer, however, and neither the Duke of Lerma nor his successor, Count-Duke Olivares, could recreate in their own respective rulers the moral authority that had surrounded Philip II, and the 'virtues' in simple classicism eluded them. Far from seeing a symbol of royal restraint in the Buen Retiro, for example, the people of Madrid ridiculed its simplicity by calling it a 'chicken coop.' Royal modesty was no longer in vogue and, in the difficult times that followed, did not have its earlier resonance.

Herrera's classicism remained a favorite whenever Spanish architects were called upon to evoke an image of beneficent authority in support of a regime. In the eighteenth century the Bourbons turned to public works and their architects revived Herreran style, even as Franco revived it after the Civil War (pl. 193). This was not simply

193 Plaza Mayor at Brunete

or even primarily because Herrera was the major architect in building the Escorial. Even if we are accustomed to associate his style with that one building and to read the doctrines of the Catholic Counter-Reformation in its severe motifs – and this is not necessarily wrong – simplified classicism was never an exclusively religious style; its royal symbolism survived, above all, in secular building where plain, geometric, and repetitive architecture remained associated with EL Rey Prudente.

Postscript

IN THE 1590s Herrera could look back on a remarkable career: he had participated in some of the greatest building projects of his age and, when he put the stresses of the court behind him and retired after nearly thirty years of service in Madrid, he enjoyed an eminence no Spanish architect before him had ever known. He could nurse his ailments with his collection of magic stones and enjoy his prestige. It was only much later, however, that he came to be known as a great architect who had been personally responsible for establishing the classicical style in Spain. For all his fame, he never played the role of an artistic personality and always signed himself 'his majesty's servant, head chamberlain of his royal palace, and general architect of all his works.' Architect was the least prestigious of his titles in this society, even if it was the most important, and Herrera was probably perceived by his contemporaries as a royal servant above all else.

The ambiguity of Herrera's position as an artist is matched by the prominence of his patron as a builder. It was Philip II, rather than Herrera, who was most closely identified with the Escorial, the landscape of Aranjuez, and the urbanization of Madrid (pl. 194). Patrons have always played a crucial role in building, and most monuments of Renaissance architecture are due in part to the passion of the men who commissioned them, but it would not occur to anyone that Julius II rather than Bramante designed St Peter's or that Michelangelo's palaces on the Capitoline Hill in Rome are really the work of Paul III. In the Renaissance view, art was the domain of the artist to whom the patron was beholden to glorify his power and perpetuate his fame, and, by the mid-sixteenth century, art itself had become a symbol of power as patrons competed to build beautiful buildings.[1] Paul III is supposed to have said he had waited years to become pope just to be able to employ Michelangelo; a few years later, Francisco Villalpando reminded Philip that a prince needed architects because his buildings would be kingly deeds, more permanent and visible than those commemorated in written history. By the end of the century, however, patrons like Philip II, Sixtus V, and Henry IV eclipse their architects.

These all-powerful men cast their architects into the shade. We cannot be certain who the architects of Henry IV's most innovative projects were, and the dynamic king takes most of the credit for the urban renewal of Paris at the beginning of the seventeenth century.[2] In Rome, Sixtus V's sweeping vision of his capital was in the hands of Domenico Fontana, an architect whose dull buildings seem hardly equal to the audacity of the Pope's urban scheme. Philip's involvement in the Escorial goes even further, to the point that

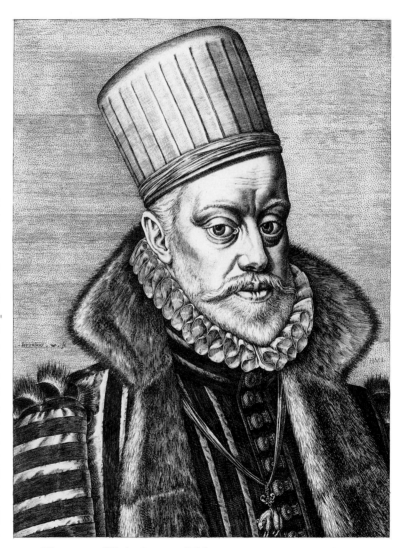

194 Hieronymous Wierix, *Portrait of Philip II*, 1586. (Boston, Massachusetts, Boston Museum of Fine Arts)

it has been claimed repeatedly that his architects were merely executants of his ideas.

Philip's role and much to do with his desire to be identified with his buildings. The merchants' exchange, for example, was his major architectural project in Seville, and he was probably more deeply involved than most earlier patrons had been in their projects. Paul III left Michelangelo so free at St Peter's in the 1540s that the

committee charged with overseeing construction was not even sure what his plans were. Philip considered architecture too important to be left to architects, but whatever his competence – and this was considerable – he did not himself prepare the designs for the exchange. Herrera may have been obliged to revise until the king was satisfied, but the plans were his, and he was paid for them. Philip was not the architect of the exchange in a modern sense, but the desire to incorporate buildings as symbols in a power structure implied their identification with the most powerful person responsible. The exchange was Philip's building in the same way as, in the seventeenth century, the new Louvre was Henry IV's and Richelieu was Cardinal Richelieu's: each was the personal creation of its powerful prince.

Effacement of the competing individuality of the architect was the corollary to the willed ascendency of the patron over the building and Herrera, who was not a flamboyant artistic personality seems to have been willing enough to subordinate himself. His relations with Philip are not the only issue, however. Herrera was a post-Vignolan architect who, like most of his Italian contemporaries, looked to the past to provide him with an authorized canon. He belonged to a generation that was burdened by the immense stature of Michelangelo, who, according to Vasari, had achieved perfection in art. When Michelangelo died in 1564, however, Herrera was only beginning to practice architecture, and, unlike Vasari (born in 1511), he could not fancy himself as belonging to the world of 'Il Divino.' The accomplishments of Michelangelo, Vignola, and Vasari himself were already history and the way to an ideal classicism had been paved. This may be why many architects who came to maturity in this period treated the *Regola* of Vignola (born 1507, his treatise was published in 1562) as if it were a book of set rules for classicism, when it was never intended to be one. Architects were anxious to retain a link with an heroic age that was each day receding into the past.

Herrera worked under the shadow of Vasari's ideal, and there is no doubt that he was profoundly affected. His tabernacle on the main altar of the Escorial looks to us, as it did to the Italian painter Federico Zuccaro, like Bramante's Tempietto that had been designed seventy years before.[3] When José de Sigüenza wished to praise the style of the Escorial he also described it as descended from the architecture of Bramante.

The Roman buildings of Bramante and his successors were models in the Renaissance, but they could be models for very different things. Herrera's façade of the royal library (pl. 195) facing the Courtyard of the Kings in the Escorial and Pierre Lescot's façade of the Louvre in the Cour Carrée in Paris (pl. 196) both allude to Bramante's paired pilasters framing niches in the Belvedere Courtyard in the Vatican (pl. 197), but Herrera and Lescot each used Bramante to launch a classicism of his own. Herrera's façade – which also includes references to Michelangelo's project for the courtyard of the Farnese Palace and perhaps also to Lescot's earlier Louvre – has little in common with Lescot's richly decorated façade. Herrera treats classical elements abstractly as if they belonged to a flat, geometrical drawing; Lescot integrates his superposed orders with a three-dimensional structural system, which he

handles with the refinement of figural sculpture. Both are classicizing compositions partially indebted to the same sources, but each is a distinctive and original interpretation.

The fundamental difference between these two compositions, however, involves more than variation in personal style: Herrera observed the outward forms of classicism, simplifying and petrifying details, while Lescot embarked upon a richly decorated façade that is frankly more 'artistic' in the sense of being more inventive, original, and personalized than Herrera's austere design. It is significant that Lescot trained as a painter and that his design was executed by the sculptor, Jean Goujon, who used to be considered a collaborator in the design, because the façade of the Cour Carrée, although entirely architectural, has many of the qualities of Renaissance painting and sculpture.[4] Herrera banished such references from his composition which seeks universality rather than individual artistic expression.

Seen in isolation, the salient aspects of Herrera's architectural practice might be interpreted as signs of a growing conservatism at the end of the sixteenth century. The pre-eminence of the patron and corresponding effacement of the architect, together with the relative impersonality and rigidity of architectural style (relative in Herrera's case because his architecture is, one might say, individualized by this quality) are indeed opposed to the personalized inventiveness of architects of the earlier Renaissance, but taken together, these qualities also appear related to a broader shift in architectural culture: a desire to locate the artistic value of architecture in the art of building, and hence a need to distance architecture from painting and sculpture and to discard the aesthetic values and design techniques that were dependent upon these relations.

Herrera separated architecture from its sister arts of sculpture and painting and thereby freed his classicism from their authority. Personal creativity, so highly prized by earlier Renaissance architects and expressed in the cultivation of individualized compositions, was sacrificed to simplicity and abstraction. In doing this Herrera did more than assert the value of plain building, he neutralized a major point of reference for inventiveness and personal authorship. Neither architect nor building could any longer be judged by the ingenuity of his formal inventions or the richness of his ornamental displays. The ornamentation of a 'subject' through subtle variations and skillful inventions, by which artistic prowess had been judged since Alberti's time, was eliminated and obstensibly canonical motifs – standard, well known, and approved by all – took its place.

Herrera's search for a more abstract, inclusive order led him to give up many of the devices of Renaissance composition. An Italian Renaissance building is a sculptural object and a self-framed unit. Even when Italian architects designed the environment around a building, this was conceived like a scenographic perspective, a stage set.[5] In the sixteenth century, French archtects were also experimenting with grouping high pavilions and long, low buildings in scenographic compositions. All these architectural visions, even those on a large scale, are centered, symmetrically organized, closed and ultimately refer to a perspective picture.

The devices of pictorial composition – symmetry of figures,

195 Herrera, façade of the library facing the Courtyard of the Kings at the Escorial

a balanced grouping of bodies, the representation of volume, and perspective views into space – are no longer very relevant to Herrera's designs. Nor can one imagine him making clay models, like those Alberti and Michelangelo used to work out their designs, because all sense of the building as a carved and modelled artefact has disappeared and a model would be nothing but a block. The relations between plan and elevation in Herrera's merchants' exchange, for example, cannot be rendered in a painter's illusionistic drawing; only a technical drawing can do justice to the abstract order of its geometric layout. His Casas de Oficios, built between 1583 and 1588 at the Escorial, are placed asymmetrically so that they open the composition, and their beauty derives from their placement, scale, and workmanship.[6] Herrera's drawings demonstrate how exactly he worked out the relationships of a composition in which the visible shape of every stone was part of the architecture (pl. 198).

Herrera's artistry has little to do with the other fine arts as these were understood in the Renaissance; but it was artistry nonetheless.

Domenico Fontana chose to commemorate his creative genius with a book about an engineering feat, the setting up of an Egyptian obelisk in front of St Peter's; by that he seems to be reverting to a fifteenth-century attitude: the artist-engineer who frees himself from his patron through technical expertise.[7] Herrera, with as much engineering experience as anyone, chose to publish as his memorial a set of prints illustrating the Escorial. Herrera conceived of himself as an artist, and fulfilled Alberti's ideal of the architect as designer, but his artistry was more specifically geared to building. His is a less metaphorical, less anthropomorphic, architecture than anything in the Renaissance tradition, but at the same time, it is visual to an extreme degree. By simplifying and emphasizing abstract geometric relationships he dramatized their appearance in a kind of epiphany of mathematics and order.

It would be simplistic to define the new views merely as a means of escape from the burden of the past, although Philip and Herrera desired to be modern and to undertake projects of a new and inventive character, but defining architecture exclusively as an art of

196 Pierre Lescot, façade of the Cour Carrée of the Louvre in Paris, engraved by Jacques Androuet Du Cerceau in *Les Plvs Excellents Bastiments de France,* 1576

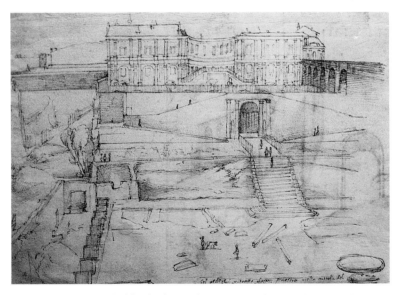

197 Bramante, Cortile del Belvedere in the Vatican, mid-sixteenth-century drawing attributed to Bartolommeo Ammanati. (Cambridge, Massachusetts, Fogg Art Museum, Harvard University)

building exposed a whole range of hitherto unimportant relationships between different kinds of buildings, and it made these associations available as potential carriers of meaning. Herrera's use of simplicity as a symbol for virtue was grounded in a recognized continuity, as well as a contrast, between the ordinary and the prestigious. Aestheticizing works of engineering and incorporating the effects of engineering into architecture required a vision that could see possibilities for symbolic expression in different types of construction and in materials that had no meaning in the context of painting or sculpture. These concerns may explain Herrera's interest in Vitruvius (who had little sympathy for the figural arts); and they come through in the work of Herrera's pupil, Juan Bautista Villalpando. Even the collaboration and participation of non-architects becomes understandable in a situation that did not privilege individuality. Herrera's and the king's conception of the city as a complete artifact made up of modest houses and streets as well as singular buildings was probably unimaginable without a unified notion of architecture, even if this was implicit rather than deliberately articulated.

There is no reason to believe that Herrera and Philip were unique; views similar to theirs were gaining adherents elsewhere in Europe at the end of the sixteenth century. If Herrera was one of the first architects to displace artistic values from those of painting and sculpture to those of building, however, this was due in part to the exceptional circumstances that Philip had created for architecture at his court, where his love of buildings of all kinds acted like a magnet on engineers and architects, drawing them towards him and inspiring extravagant hopes and projects. Even the aged Michelangelo was tempted to design for Philip; the Florentine academy and Vignola in Rome pored over designs for the Escorial, and the younger Vignola offered the king an exclusive option on a new fortification system. The designs flowing into Madrid meant that the latest architectural ideas were represented more fully at Philip's court than anywhere else in Europe. Herrera, whose architectural training was set in the midst of the fevered collecting and planning of buildings that were generated by Philip's first great projects in the 1560s, saw all the designs that were submitted to the king. Philip's love for northern buildings and for the orderly urban environments of northern cities provided a unique challenge to his architects to create an international classicism and they stimulated innovation. Had Herrera spent his life in Italy, he might have remained hostage to the past, like Domenico Fontana in Rome, or spent his time devising utopic projects like Pellegrino Tibaldi's for a Counter-Reformation rebuilding of Milan.[8] As it was, Philip's vision of a total, comprehensive power enveloped in sobriety and modesty stimulated an original architecture that became part of a new frame of reference for architectural practice.

In a longer historical view, Herrera's emancipation of architecture had drastic implications that cannot be considered here. Many of its ramifications found expression in the seventeenth century. In 1647, for example, the French architect, Pierre Le Muet, treated the architecture of domestic buildings from the simplest to the largest using the same vocabulary for all his designs, except chateaux, and Jacques Le Mercier's design for Richelieu, like Henry IV's Place de France, was based on the same principle.

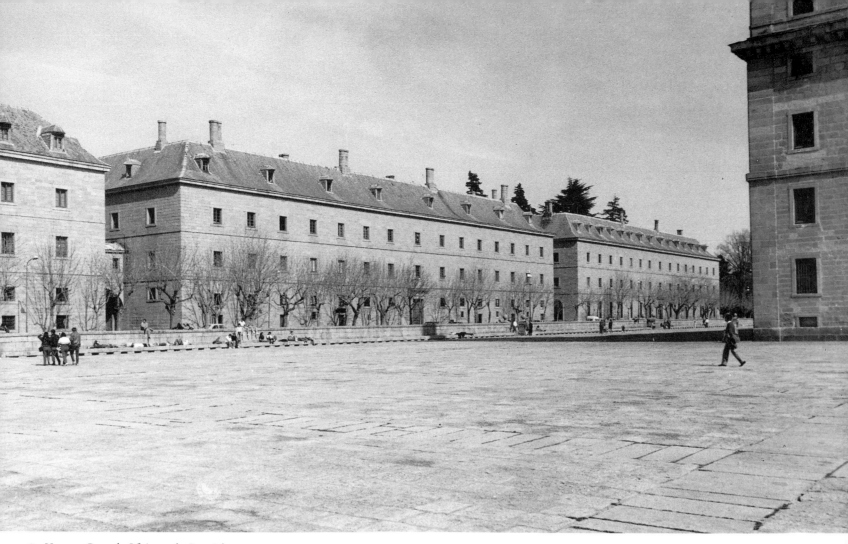

198 Herrera, Casas de Oficios at the Escorial

The later relation between Vasari's three arts of design is complex, but it is striking that the values that Herrera represented could eventually become an object of envy for painting itself. The very name 'Constructivism' makes it clear that in our century it was painting that came to be in some sense subservient to architecture, and Mondrian made no secret of the fact that he conceived of his abstract neoplasticist paintings as architectural, above all as related to a utopian project, models of a livable world to be. Herrera and Mondrian lived in different worlds and aimed at different ideals, but their conception of art, its vocation, its means, and its power may not have been so very different.

Abbreviations

Archives and Libraries

AA	Archivo de la Alhambra
AGI	Archivo General de Indias, Seville
AGS	Archivo General de Simancas
	CS Casas y Sitios Reales
	MPD Mapas, Planos y Dibujos
AHN	Archivo Histórico Nacional, Madrid
AHP	Archivo Histórico de Protocolos, Madrid
AMAE	Archives du Ministère des Affaires Etrangères, Paris
APM	Archivo del Palacio Real, Madrid
AVM	Archivo de la Villa de Madrid
BNM	Biblioteca Nacional, Madrid
BNP	Bibliothèque Nationale, Paris
BPM	Biblioteca del Palacio, Madrid
RAH	Real Academia de la Historia, Madrid

Other abbreviations

AB	*Art Bulletin*
Academia	*Boletín de la Real Academia de Bellas Artes de San Fernando*
AEA	*Archivo Español de Arte*
AIEM	*Anales del Instituto de Estudios Madrileños*
Alberti	Leon Battista Alberti, *On the Art of Building in Ten Books* (see bibliography)
BSEAA	*Boletín del Seminario de Estudios de Arte y Arqueología, Universidad de Valladolid*
Cervera Vera, *Colección*	Luis Cervera Vera, *Colección de documentos para la historia del arte en España* (see bibliography)
Cervera Vera, *Inventario*	Luis Cervera Vera, *Inventario de los Bienes de Juan de Herrera* (see bibliography)
Iñiguez, *Casas reales*	Francisco Iñiguez Almech, *Casas reales y jardines de Felipe II* (see bibliography)
Kubler	George Kubler, *Building the Escorial* (see bibliography)
Llaguno	Eugenio Llaguno y Amirola and Juan Agustín Ceán Bermúdez, *Noticias de los arquitectos y arquitectura de España desde su restauración* (see bibliography)
Portables, MM	Amancio Portables Pichel, *Maestros mayores, arquitectos y aparejadores de El Escorial* (see bibliography)
Portables, VA	Amancio Portables Pichel, *Los Verdaderos Artífices de El Escorial* (see bibliography)
RABM	*Revista de Archivos, Bibliotecas y Museos*
Sigüenza, *Historia*	José de Sigüenza, *Historia de la orden de San Geronimo* (see bibliography)
Sigüenza, *La Fundación*	José de Sigüenza, *La Fundación del Monasterio de El Escorial* (see bibliography)
Ruiz de Arcaute	Agustín Ruiz de Arcaute, *Juan de Herrera* (see bibliography)
RS	*Reales Sitios*
Villalpando	Juan Bautista Villalpando, *In Ezechielem Explanationes*, vol. 2 (see bibliography)
Wittkower	Rudolf Wittkower, *Architectural Principles in the Age of Humanism* (see bibliography)

Notes

Foreword

1 *Los Verdaderos Artífices de El Escorial y el estilo indebidamente llamado Herreriano* (1945) and *Maestros mayores y aparejadores de El Escorial* (1952).

2 Juan Bautista Villalpando, *El Tratado de la arquitectura perfecta en la ultima vision del Profesa Ezequiel*, trans. from the Latin by Luciano Rubio, Madrid, 1990, tomo II, Explicaciones parte II, cap. xx, 188. Villalpando evokes royal collections: 'Por eso afluían a él sapientísimos arquitectos, unos buscados y otros por iniciativa propría, atraídos por la esperanza de ganancías y de gloria, Por ello ocurría que todos éstos, índices de su arte o industria, presentaban al rey las formas más cuidadas de templos o de otros edificios, no sólo de aquellos que habían existido, sino también de otros que habían podido alcanzar con su inteligencia, pensados únicamente para arrebatar a la admiración el ánimo del rey. Se deleitaba tanto en examinar tales esquemas y concebía con la mente formas tan perfectas de edificios que elegué a saber, como me lo afirmó a mí mismo Juan de Herrera, que en este punto que es difícil fueron vencidos por el rey esos mismos peritísimos arquitectos. Yo mismo examiné muchas veces, ante esta arquitecto regio, no sólo arcas llenas de tales esquemas, sino tambien in cluso habitaciones llenísimas.'

1. The making of a royal architect

1 An engraving by Pedro Perret after a design by Otto van Veen. For later portraits of Herrera see Luis Cervera Vera, *El Retrato de Juan de Herrera dibujado por Maea y grabado por Brandi*, Valencia, 1977.

2 Herrera's birthdate is presumed to have been about 1530, but he may have been born somewhat later since he reported that he was too young to join the army in 1551; it seems unlikely that he would have said this if he had been twenty-one years old. Biographies of Herrera chiefly depend on the memorandum of 1584, whose text is reproduced in Llaguno, vol. 2, XXII, no. 10, 332–9, 'Copia de una memoria original, que Juan de Herrera envió á Mateo Vazquez...', but interpret it differently. See Ruiz de Arcaute; Luis Cervera Vera, 'Semblanza de Juan de Herrera,' *IVo Centenario de la fundación del monasterio de San Lorenzo el Real. El Escorial, 1563–1963*, 2 vols., Madrid, 1963, vol. 2, 7–103; Luis Cervera Vera, 'Esquema biográfico de Juan de Herrera, arquitecto humanista, interprete de los canones vitruvianos,' in *Homenaje a Juan de Herrera*, Fundación Juan de Herrera, Santander, 1988, 13–34; and John Bury, 'Juan de Herrera and the Escorial,' *Art History*, IX, 1986, 428–49.

3 Quoted from Cervera Vera, *Colección*, I, 'Segundo testamento ortogado por Juan de Herrera,' Madrid, 2 February 1579, 263, 367–84, p. 383.

4 AMAE, Mémoires et Documents, Fonds Divers, vol. 225, fol. 340r–343v: 'Relación de los criados que el Emperador Carlos V tenía al tiempo que deshizo su casa por el mes de junio de 1556' lists the members of the household.

5 Llaguno, vol. 2, XXII, no. 10, 332–9, 'Copia de una memoria original, que Juan de Herrera envió á Mateo Vazquez....'

6 Cervera Vera, *Colección*, I, 121, 179–80, 'Escritura de obligación y promesa de dote otorgada por Juan de Herrera y María de Alvaro para el matrimonio de Pedro de Baños con Luisa de Herrera,' Madrid, 3 February 1575, AHP, Cristóbal de Riaño, prot. 171, nf.

7 Cervera Vera, *Colección*, I, 227, 328–34, 'Testamento Mancommunado de María de Alvaro con Juan de Herrera,' Madrid 20 August 1576, AHP, Cristóbal de Riaño, prot. 173, nf.

8 See Llaguno, vol. 2, XXII, no. 10, 334.

9 Luis Cervera Vera, *María de Alvaro, primera mujer de Juan de Herrera*, Madrid, 1974, has traced her fortune and family connections.

10 Cervera Vera, *Colección*, I, 59, 102–4, 'Carta de cesión otorgada por Diego Fernández de Movellán a favor de Juan de Herrera de la casa vieja de Movellán y otras heredades,' Madrid, 15 November 1573, AHP, Cristóbal de Riaño, prot. 168, fol. 842v, explains the situation as it stood in 1573: 'y es ansi que los dichos bienes, de suso declarados, son e pertenezen al señor Juan de Herrera, criado de su magestad, que reside en su corte, como heredero y en nombre de Pedro Gutiérrez de Maliaño y María Fernández [sic] de la Vega, su muger, sus padre e madre, defuntos, que sean en gloria, vecinos del dicho Conçejo de Roiz, el qual, como tal heredero, a puesto pleito sobre estos dichos bienes, y´otros muchos que le pertenezen, contra los herederos de Juan de Linares y María Gutiérrez de Guereda, y otras muchas personas que ynjustamente poseen bienes pertenezientes a la cosa y solar del dicho Juan de Herrera y sus padres'.

11 Cervera Vera, *Colección*, I, 148, 220–2, 'Traslado del poder otorgado por María Gutiérrez de Jereda a favor de Julián Sánchez de Linares, su hijo, para el pleito con Juan de Herrera y su hermana sobre bienes raíces de la herencia de Pedro Gutiérez de Maliaño,' Concejo de Treceño, 18 July 1575, AHP, Pedro de Salazar, prot. 899, fol. 692; and 161, 235–8, 'Carta de pago otorgada por Julián Sánchez de Linares a favor de Juan de Herrera y de María de Herrera, su hermana, de trescientos ducados, en concepto de mejoras en bienes raíces de su padre y terminación de pleito,' Madrid, 9

February 1575, AHP, Pedro de Salazar, prot. 899, fol. 694.

12 Cervera Vera, *Colección*, I, 227, 328–34, 'Testamento Mancomunado de María de Alvaro con Juan de Herrera,' and 228, 334–5, 'Escritura otorgada por Juan de Herrera aceptando la herencia de María de Alvaro, difunta,' Monasterio de Nuestra Señora de Atocha, Madrid, 24 August 1576, AHP, Cristóbal de Riaño, prot. 173, nf.

13 Cervera Vera, *Colección*, I, 263, 367–84, 'Segundo testamento otorgado por Juan de Herrera,' Madrid, 20 February 1579, AHP, Cristóbal de Riaño, prot. 177, fol. 317.

14 Ibid., 383: 'digo que por quanto yo e criado a Luisa de Herrera, muger de Pedro de Baños, alguazil de la casa y corte de su magestad, e la e criado en nombre de mi hija lo qual yo... digo y declaro que no tiene acción ni derecho a ninguna casa de mis bienes porque ninguna cosa de ellos hereda ni puede eredar por ninguna bía que sea.'

15 Herrera himself gave this estimate in 1584.

16 Herrera's will of 6 December 1584 is transcribed in Llaguno, vol. 2, XXII, no. 12, 342–57. AHP, Pedro Salazar, prot. 2793, fol. 1ff, contains a series of documents relating to Herrera's estate. Herrera made a will in 1579 (AHP, Pedro Salazar, prot. 177, fol. 313ff) and another on 6 December 1584, leaving the bulk of his property for a pious foundation in Maliaño. A transcription of a copy existing in the Libro de Cuentas de la Obra Pia de Maliaño in the Archivo Histórico Provincial de Cantabria, Sección de Estudios Montañeses, has been published in *Homenaje a Juan de Herrera*, 119–51. Herrera's nephew Pedro del Liermo and Doctor Rojas, as executors of his estate, attempted to carry out the provisions of this will. AHP, Christ. Gálvez de Heredia, prot. 2793, fols. 10v–201, contains a transcription of the 1584 will with provisions for Maliaño, statements from Pedro del Liermo and others, inventory of the estate in 1608–10, charges to the estate including Herrera's funeral expenses, and final settlement and sale of his possessions. However, Pedro de Bustamante and his wife Catalina claimed that Herrera had made another will at the very end of his life: 'aun que se dixo que el dho Joan de Herrera a hiço otro testamento despues del de sus sorreferido en que nonbraua por sus testamentarios a antonio boto guarda xoyas de su Magd y a guillermo bodenan como tales hicieron ynventario de sus bienes y el ynventario hecho por los dichos ante boto y guillermo bodenan delos bienes quedaron del dho juan de herrera ay la posesion que dellos se dio al dicho pedro del yermo por mandado dela justicia ordinaria desta uilla de md [fol. 18]... dicimos que por quanto joan de herrera, aposentador mayor de palacio hiço y otorgo su testamento en

seis dias del mes de diciembre del año pasado del mill y quinientos y ochnta y quatro ante pedro de Salazar escri. en el qual dexo toda su hazienda para obras pias y por patron dela casa señor y dela casa de herrera de Maliaño en virtud del qual dicho testamento yo el dicho Po del Yermo como sucesor y señor dela dha casa E pretendido y pretendiendo que soy sucesor y patrono de toda la hacienda e memorial que ansi dexo el dicho joan de herrera e el dicho don pedro de bustamante a pretendido y pretende que el dicho joan de herrera a por otro testamento que dicen hiço y otorgo ante Luis galuez escriuano del numero que fue del tauica en tres dias del mes de enero del año pasado de mill quinientos e noventa y siete le dexo por su heredero e patrono delas memorias que en el dexo ynstituyas.... [fol. 23v]' According to Pedro del Liermo, Bustamante wrote out the will himself and presented it without witnesses to Herrera as he lay blind on his deathbed. The king decided in favor of Herrera's nephew, Pedro. As a result of the lawsuit, Herrera's property was inventoried and re-evaluated for liquidation. Most of the silver and gold had disappeared by then, but the total value of the estate, before charges, is listed as 13,608,920 maravedis or 36,291 ducats.

17 In the inventory attached to his will of 1579 (AHP, Pedro Salazar, prot. 177, fol. 320), Herrera listed 'una cadena de oro nueva q pesa casi trescientos ducados.' This was grossly undervalued at 420 reales in the inventory taken at Herrera's death (see transcription of 'Inventario de los bienes de Juan de Herrera, que realizaron sus testamentarios Antonio Voto y Guillermo Bodenan en Madrid durante los días 17 enero de 1597 al 27 de febrero siguiente,' AHP, Francisco de Montoya, prot. 1290, fol. 10ff, in Cervera Vera, Inventario, 124f, which lists the precious objects in Herrera's collection at the time of his death in 1597 (nos. 1–23); by 1608, when the final inventory was made, it was gone (AHP, Christ-Gálvez de Heredia, prot. 2793, fol. 106v).

18 Cervera Vera, Inventario, 195, no. 1177: 'vna fee escripta de mano, en pergamino, signada de escriuano, de la probança ad perpetuan que el dicho Joan de Herrera hizo en su vida de su nobleza, ante los señores alcaldes de hijosdalgo de la real chanzillería de Valladolid.'

19 Llaguno, vol. 2, XXII no. 11, 339–42, 'Dos cartas de Juan de Herrera al secretario Mateo Vazquez, y un memorial al Rey,' 339–40, 'Primera carta al dicho secretario Vazquez,' 12 October 1584: 'Mi pretension, resolviéndome con V. es, que S. M. por mis servicios, y por haber gastado cerca de veinte mil ducados en su servicio, fuera de los gages y mercedes que de S. M. he recibido de catorce años á esta parte, siéndome forzoso el hacerlo, porque sin comodidad, como V. sabe, puédese mal servir á los príncipes: con los cuales viente mil ducados pudiera haber comprado, por lo menos, mil de renta perpetuos; y ansí S. M. está obligado, pues se han gastado en su servicio, á la remuneracion dellos.'

20 Ibid., 340: 'y de la situacion que tenga agora de cuatrocientos ducados en el Escorial, y cuatrocientos en las obras de Madrid, V. no haga caso, porque á cualquier accidente cesa lo uno y lo otro, porque en Madrid no hay situado nada para las fábricas, ni yo lo quiero en ellas; y lo otro mañana se acabará lo del Escorial, y alli no hay nada, y fuera desto otras mil cosas que suelen subceder; y ansi lo que yo puedo declararme y decir en este mi particular, y que sé que me justifico todo lo que es posible, es esto, y que si no se hace conmigo como

lo pido, ó me es forzoco á la vejez, y de aqui adelante morir de hambre, ó recogerme en parte donde no venga en tanta necesidad.'

21 'Que de tantos servicios paresce será justo que yo tuviese alguna merced señalada, en que el mundo conosciese el haber sido gratos á S. M., y que con justicia se me hacia, y que para despues de mis días pudiese dejar el premio de mis trabajos para testimonio de que con ellos y con la virtud se adquiere algun renombre, y tambien para dejar á mis hijos, si Dios fuere servido de me los dar, y cuando no á mi alma en especial, que en mi vida todo ha de ser para servir á S. M.' Quoted from Llaguno, vol. 2, XXII no. 10, 336.

22 Herrera was described as 'cavaller que fue de el avito de Santiago, aposentador de su Magd' in the documents relating to his estate in 1608. I have found no other reference to Herrera being a knight of Santiago, unless the copy of the proof of his nobility was connected with such an appointment. Like Baccio Bandinelli earlier and Velázquez later, Herrera would have been required to demonstrate his noble lineage for admission to the order.

23 See John Douglas Hoag, Rodrigo Gil de Hontañón: His Work and Writings, Late Medieval and Renaissance Architecture in Sixteenth-century Spain, PhD. Yale University, 1958, trans. with revised bibliography in Spanish as Rodrigo Gil de Hontañón, Madrid, 1985; and also the recent monograph by Antonio Casaseca Casaseca, Rodrigo Gil de Hontañón (Rascafría, 1500-Segovia, 1577), Salamanca, 1988.

24 Alberti, bk IX, ch. xi, 318.

25 Diego de Sagredo, Medidas del Romano necessarias alos oficiales que quieren seguir las formaciones delas Basas, Colunas, Capiteles, y otras pieças delos edificios antiguos, Toledo, 1526. See 2000 Anni di Vitruvio, Studi e Documenti di Architettura, VIII, 1978, ed. L. Vagnetti, for the various editions.

26 See Alfonso Rodríguez G. de Ceballos, 'El P. Bustamante, inciador de la arquitectura jesuítica en España (1501–1570)', Archivum Historicum Societatis Iesu, XXXII, 1963, 3–102; his Bartolomé de Bustamante (1501–1570) y los orígenes de la arquitectura jesuítica en España, Rome, 1966; and my Hospital of Cardinal Tavera in Toledo, PhD dissertation, Yale University, 1968.

27 Covarrubias's career has been discussed most recently by Fernando Marías, La Arquitectura del Renacimiento en Toledo (1541–1631), 4 vols., Toledo and Madrid, 1984–6.

28 Parts of Rodrigo's treatise are preserved in Simon García's Compendio de arquitectura y simetria de los templos conforme a la medida del cuerpo humano, con algunas demonstraciones de geometria; año 1681, recogido de dibersos autores naturales y extrangeros por Simon García, architecto, natural de Salamanca, BNM ms. 8824. The only complete edition has been edited by Carlos Chanfón, Mexico, D. F., 1979.

29 Tercero y Qvarto Libro de Architectura de Sebastian Serlio Boloñes...agora nueuamente trduzido de Toscano en Romance Castellano por Francisco de Villalpando Architecto, Toledo, 1552.

30 The Tratado anonimo de arquitectura dedicado at Principe D. Felipe III [sic], BNM ms. 9681 is discussed by Fernando Marías, 'Un Tratado inédito de arquitectura de hacia 1550,' Boletín del Museo e Instituo 'Camon Aznar,' XIII, 1983, 41–57; and in my 'Planning a Style for the Escorial: An Architectural Treatise for Philip II of Spain,' Journal of the

Society of Architectural Historians, XLIV, 1985, 37–47.

31 Tratado, fol. 3vf: 'la mayor parte de la gente con bibe creiendo que nadie puede ser buen architeto que no aya sido official como ala verdad sera gran marauilla que Hombre que aviese sido official pudiesse llegar a ser buen architeto pues para poderlo ser a de aber aprendido muchas artes deque con gran difficultad Podrian tener noticia los que bien sempleado lo mayor parte de su tiempo en eprender y executar el officio que tienen pues no hay officio algo mecanico que de si solo no traiga mucha occupacion.'

32 Tratado, fol. 3v: 'por que si Profesa el arte de architectura no siendo official que tenga endurecidas las manos y hechos callos en ellas de aber tratado muchos anos las Herramientas de tal manera lebanta contra si la vniuersidad de los officiales y aun de muchos otros que no lo son.'

33 Tratado, fol. 5: 'si algunos officiales tubieron y tienen Al presente nombre de arquitetes en estos Reynos son los que an seguido el orden o ymbencion de los sobre dichos señores, en los hedificios que son mandamiento del emperador y Rey nuestro señor. vro. an mandado, hazer y si los officiales no quisieron exceder los limites de su facultad, no podemos negar que ay muchos muy buenos artifices mas como segun dice Leon bautista segundo a Platon sean en manos del architeto.'

34 Quoted from Llaguno, vol. 2, XIV, no. 7, 23of.

35 See José Javier Rivera Blanco, Juan Bautista de Toledo y Felipe II, La Implantación del clasicismo en España, Valladolid, 1984, for a full discussion of his career.

36 Sigüenza, Fundación, parte I, discurso III, 20, described Juan Bautista as 'Architecto mayor, que ya a este tiempo iba haciendo la idea y el diseño desta fábrica; hombre de muchas partes, escultor, y que entendía bien el dibujo; sabía lengua latina y griega, tenía mucha noticia de Filosofía, y Mathematicas; hallábanse al fin en él muchas de las partes que Vitruvio, príncipe de los arquitectos, quiere que tengan los que han de exercitar la arquitectura y llamarse maestros en ella' and summed him up in discurso XII, 95, as 'maestro español, como hombre de alto juicio en la Arquitectura, digno que le igualemos con Brabante, y con qualquiera otro valiente....'

37 Llaguno, vol. 2, XIV, no. 7, 231: 'Y porque nuestra voluntad es que demas y allende de aquellos se le paguen otros doscientos ducados en cada un año, para que con ellos tenga y sostenga de ordinario dos discípulos, que sean hábiles y suficientes para que le ayuden á hacer las trazas y modelos que ordenáremos y se hubiesen de hacer para nuestras obras, y á las demas cosas del oficio de la arquitectura, y para que en su lugar asistan en las obras y cosas que él les mandase.'

38 Llaguno, vol. 2, XXII, no. 2, 273: 'habiendo tenido relacion de la habilidad que Joan de Herrera tiene en cosas de arquitactura, le hemos recibido, como por la presente le recibimos, para que nos haya de servir y sirva en todo lo que fuere mandado, dependiente de la dicha su profesion, y se le ordenare por Juan Bautista de Toledo, nuestro arquitecto, á quien ha de acudir á tomar la orden de las obras y cosas que conviniere hacerese para nuestro servicio;' and in vol. 3, XIII, 237: 'que habiendo tenido relacion de la habilidad que Juan de Valencia teine en cosas de arquitectura, y acatando lo que Luis de Vega, ya difunto, nos sirvió, en cuya compañia se crió, y por ser hijo de su muger, nos había suplicado nos sirviésemos de él,

le habemos recibido, como por la presente le recibimos, para que nos haya de servir y sirva en todo lo que fuere mandado, dependiente de dicha profesion, y se le ordenare por Juan Bautista de Toledo, nuestro arquitecto, á quien ha de acudir á tomar la orden de las obras y cosas á que hubiere de asistir, y trazas y modelos que conviniese hacer para nuestro servicio, y especialmente en las obras del alcázar desta villa de Madrid y casa del Pardo, y otras que en dicha villa y su contorno se fabricaren.'

39 Llaguno, vol. 2, XXII no. 12, 342–57: 'Testamento de Juan de Herrera.' Herrera's military experience has been stressed (rightly in my opinion) by John Bury, 'Juan de Herrera and the Escorial.'

40 Honorato Juan is still a mysterious figure, but see José M. March, *Niñez y juventud de Felipe II*, 2 vols, Madrid, 1941, esp. I, 108, 221, 257, 313 and II, 76; and *Colección de documentos inéditos para la historia de España*, ed. M. Salvá and P. Sainz de Baranda, XXVI, Madrid, 1855, reprinted Madrid, 1985, which contains letters between Honorato Juan and Philip II in the 1550s (395, 479, 396, 398) the naming of him tutor to Don Carlos (395); letters regarding his pension in 1563 (400–6). The intellectual environment around Honorato Juan during the youth of Philip II has been reconstructed by Alfonso Rodríguez G. de Ceballos, 'En Torno a Felipe II y la arquitectura,' *Real Monasterio Palacio de El Escorial: Estudios inéditos en el IV Centenario de la terminacion de las obras*, Madrid, 1987, 107–25.

41 A letter from Andrés de Almaguer to the king of 23 September 1563 (AGS, Obras y Bosques, Escorial, leg. 6) reports that the machinery designed by Juan Bautista 'y el del soldado de la guardia alemana de v. Magd' will be useful for raising stones. Francisco Iñiguez Almech, 'Los Ingenios de Juan de Herrera,' *El Escorial 1563–1963. IVo Centenario*, Madrid, 1963, vol. 2, 181–214; and 'Los Ingenios de Juan de Herrera, Notas Marginales,' RABM, LXXI, 1963, 163–70 identifies Herrera with the 'soldier of the German guard.'

42 Document cited by Kubler, 21.

43 Herrera seems to have been in charge of the drawings of details by November 1565 when the king refers to him in a marginal note (AGS, CS, leg. 2, fol. 163, transcribed in Portables, *MM*, 219). A few months later, the king noted 'hazed a Herrera que saque vna copia de la que tiene Juan Bautista y embiadsela' (228). F. Iñiguez Almech, 'Los Ingenios de Juan de Herrera,' 190, 196, cites evidence of the king's increasing reliance on Herrera: re Juan Bautista's plans, Philip noted 'fue bien darle la prisa y mañana veremos sí cumple su palabra y creo que quedará para esotro, y yo he hecho hacer otras cosas a Herrera que veréis un día por acá.' Philip even bypassed his architect and gave direct orders to Herrera: 'A Herrera he ordenado hoy vaya al Escorial a algunas cosas que era menester avisar allí.'

44 Document transcribed in Llaguno, vol. 2, XXII, no. 2, 274: 'y porque acatando su habilidad le habemos hecho merced de acrecentarle, como por la presente le acrecentamos, otros ciento cincuenta ducados mas, que todos sean doscientos cincuenta ducados al año...de los cuales ha de empezar á gozar desde I.º de enero de este presente año de 1567 en adelante, por todo el tiempo que fuere nuestra voluntad, con obligacion que haya de servir y sirva en todo lo que por Nos y nuestros ministros le fuere ordenado y mandado, dependiente de su profesion, y haya de residir donde se le mandare, y

acudir y salir adonde y á las partes que menester fuere, sin que por razon de estas salidas y caminos haya de pedir, ni se le dé otra cosa alguna.' The payments were made from the accounts of the Alcázar in Madrid and Casa del Pardo.

45 'Extraordinary' services were those not part of regular duties. A note from the king of 19 March 1568 states 'En boluiendo Gaspar de Vega será menester determinar esto de los tejados...entre tanto por ganar tienpo he dicho a Herrera que haga un modelillo' (published by Portables Pichel, *MM*, 82).

46 See Luis Cervera Vera, *Juan de Herrera y su aposento en la villa de El Escorial*, El Escorial, 1949, esp. appendice III.

47 The texts are printed by Julián Zarco Cuevas, *Documentos para la historia del Monasterio de San Lorenzo el Real de El Escorial*, III, *Instrucciones de Felipe II para la fábrica y obra de San Lorenzo el Real*, Madrid, 1918.

48 For documents of Herrera's involvement at Simancas, see Ruiz de Arcaute, 46, 60ff, 81ff and 180f. Herrera wrote to Ayala: 'yo, que he hecho en esto más de lo que hera obligado, de aquí adelante v. mrd. me mande en lo que sirva y me tenga excusado en lo tocante a esa obra, que estoy ya tan cansado de unas y de otras que si fuere posible de todas me querría eximir, porque en todas ay tantos que las entienden, que poco soy yo menester con lo poco que entiendo.' (83).

49 Document dated 14 September 1577 in Llaguno, vol. 2, XII, no. 2, 275.

50 See Jean Babelon, *Jacopo da Trezzo et la construction de l'Escorial. Essai sur les arts à la cour de Philippe II, 1519–1589*, Bordeaux, 1922; and Alvarez Ossorio, *Catálogo de las medallas de los siglos XV y XVI, conservado en el Museo Arqueológico Nacional*, Madrid, 1963, no. 275, 172–3.

51 The document of Herrera's appointment has not been found, but L. Cervera Vera, 'Semblanza de Juan de Herrera,' 38f, cites the evidence of Herrera's will of 20 February 1579 in which he refers to himself as 'criado de su Magestad e su architecto' as evidence. The appointment of Francisco de Mora to the king's service and as Herrera's assistant on 22 August 1579 describes Herrera as 'nuestro arquitecto y aposentador de palacio' (in Llaguno, vol. 3, XXIV, no. 1, 342).

52 This was the title Herrera used in 1583 to authorize Lucian de Negrón to collect the money owed him for his designs of the merchants exchange. See Luis Cervera Vera, 'Juan de Herrera diseña la Lonja de Sevilla,' *Academia*, 1981, 163–84, 165 and 177f n19.

53 See Cervera Vera, *Colección*, I, no. 270, 392f: Herrera's request to the king, dated 17 August 1579, that he should 'resçiua en su serviçio dos mançebos que hazen profesión de architectura y mathemáticas, los quales están adelante en muchas cosas y tienen ingenio para pasar muy más adelante, llámase el uno de ellas Francisco de Mora, y es de edad de veynte y quatro o veinte y seis años, y el otro se llama Pedro de Liermo, y es de hedad de hasta veinte y dos o veinte y quatro años....' The king responded favorably: 'Dize su magestad que tiene por bien que se señalen a estos dos cada çient ducados al año...entre tanto que se emplean en otra cosa, y con obligacion que siruan y se ocupen en lo que Juan de Herrera les ordenare del seruicio de su magestad....'

54 The text reproduced in Llaguno, vol. 2, XXII, no. 10, 332–9 with two additional letters from Herrera

to Mateo Vazquez amplifying his needs (339–42).

55 Documents concerning Francisco de Mora in Llaguno, vol. 3, XXXIV, 342–8. See also the studies by L. Cervera Vera concerning Lerma listed in his *Lerma, Síntesis histórico-monumental*, Lerma, 1982; and 'Obras y trabajos de Francisco de Mora en Avila,' AEA, LX, 1987, 401–17 on his religious commissions.

56 On Juan Gomez de Mora see Virginia Tovar Martín, *Arquitectura madrileña del siglo XVII*, Madrid, 1983; and Madrid, Museo Municipal, *Juan Gomez de Mora (1586–1648), arquitecto y trazador del Rey, maestro mayor de la villa de Madrid*, with essay and catalogue by V. Tovar Martín, Madrid, 1986.

57 See Jonathan Brown, *Velázquez*, New Haven and London, 1989.

2. Architecture between science and art

1 Christóbal de Rojas, *Compendio y breve resolucion de fortificacion conforme a los tiempos presentes, con algunas demandas curiosas provandolas con demonstracioness Mathematicas, y algunas cosas militares; por el capitán Cristoval de Rojas, ingeniero militar de su Magestad*, Madrid, 1613. In the title of this chapter and throughout my discussion, I use the word art in its modern sense of fine art rather than in the ancient or medieval sense as practical skill of any kind.

2 Esquivel began his project 1566. It was continued by Diego de Guevara until the latter's death, when Philip II ordered the papers given to Herrera 'porque no se pierdan y se pueda continuar la carta de España que él hacia, en que creo yo podría entender Herrera.' Quoted by José M. López Piñero, *Ciencia y técnica en la sociedad española de los siglos XYI y XVII*, Barcelona, 1979, 221; for discussion of Philip's cartographic projects, see *Spanish Cities of the Golden Age: the views of Anton van den Wyngaerde*, ed. Richard Kagan, Berkeley, Los Angeles, and London, 1990, esp. Kagan, 'Philip and the Geographers,' 40–53; and López Piñero, 212–28.

3 Herrera was given a royal licence in 1560 to smelt copper ore from undeveloped resources in the Indies (Ruiz de Arcaute, 17). He mentions copper mining in his memorandum of 1584. In 1589 he invented a device for processing iron bars and formed a company to build a factory to exploit his invention (see Luis Cervera Vera, *El 'Ingenio' creado por Juan de Herrera para cortar hierro*, Madrid, 1972). In 1573, he had been granted a royal privilege to market 'some navigational instruments for finding latitude and longitude' which were officially approved and forwarded to the Council of the Indies and to the Spanish navy; Spanish pilots desperately needed precise instruments for sailing to the colonies, but Herrera's were probably not very effective since there is no indication his device incorporated a reliable clock. The device is discussed by Ruiz de Arcaute, 55. Lopez Piñero, *Ciencia y técnica*, 196–209 reviews the problem and the various solutions proposed during Philip II's reign.

4 In addition to the cranes, there was a machine to manufacture nails in 1568, a water heater for the Escorial's kitchen in 1571, and a flour mill known from drawings made in the 1590s by Herrera's assistant and successor, Francisco de Mora. F. I. Almech, 'Los Ingenios de Juan de Herrera,' *El Escorial 1563–1963. IVo Centenario*, Madrid, 1963, vol. 2, 181–214; and 'Los Ingenios de Juan

de Herrera, Notas Marginales,' *RABM*, LXXI, 1963, 163–70, consider these inventions. On the large crane, see more recently N. Garcìa Tapia, 'Juan de Herrera y la ingeniería clasicista: el manuscrito "Architectura y Machinas" sobre el fundamento de las grúas,' Palacio de Santa Cruz, Valladolid, *Herrera y el clasicismo, ensayos, catálogo y dibujos en torno a la arquitectura en clave clasicista*, ed. Javier Rivera, Valladolid, 1986, 45–55.

5 In 1566, Herrera and Pietre Janson, El Holandés, planned canalization for Jerez. Later he was involved in planning the waterworks for the Escorial, Valladolid, Colmenar de Oreja, and probably Ocaña. A report dated 16 March 1571 shows that Philip II's staff collaborated on most technical projects: 'Hauiendo visto el conde de chinchon, joan de Herrera, Gaspar de Vega y francisco de Montaluan la relacion que ha embiado fray Hernando de Ciudad Real, les pareçe....' There follows a point-by-point discussion of the design of the water system for the Escorial with marginal notes in Herrera's hand (AGS, CS, leg. 260, fol. 168). Herrera appears to have been overseeing the project but he was probably not its principal designer. In 1584, he noted about the irrigation project for Colmenar de Oreja: 'si no fuera por mí se gastáran mas de cuarenta mil ducados sin provecho ninguno, y hice aprovechamiento de mas de sesenta mil' (Llaguno, vol. 2, XXII, no. 10, 335).

6 Llaguno, vol. 2, XXII, no. 10, 336: 'Item, entiendo haber hecho particulares servicios en haber desengañado de muchas máquinas, que algunas personas no fundadas en ellas han traido á estos reinos y á S. M., ofreciendo con ellas cosas imposibles y no concedidas de la natura; y por mi causa en muchas dellas no se ha puesto la mano, porque se hubiera perdido la hacienda, tiempo y reputación, y el conocimiento de estas cosas ensañándolo á muchos, que de aqui adelante podrán hacer lo que yo.'

7 Luis Cabrera de Córdoba, *Historia de Felipe Segundo, rey de España*, Madrid, 1619, reprinted Madrid, 1976, vol. 2, 567: 'A la fama de la grandeza y riqueza de D. Felipe acudieron á la Corte artífices, y de engaños, mostrando su ingenio, y favorecidos de la ignorancia y vanidad, para ganar entrada con el Rey y, exercitar sus deseos para si ganancia. Enviôle desde Valencia el Duque de Nájara, virey, á Pachete, morisco, gran hebolario, para que le curarse de la gota.... No fue menor el número de chímicos que hizo su experiencia, acreditados de Juan de Herrera, arquitecto mayor, con gasto de mucho dinero en sus conversiones, y con su engaño y desengaño solamente se vió quejado ó fijado el Mercurio en plata finísima reducido con tan poca ganancia, que no quedó en el uso.'

8 Herera involved himself in searching for buried treasure in the hills around Toledo and prepared drawings for a cave retreat against a Muslim invasion predicted by a crazy visionary, Lucretia de Leon. See Richard Kagan, *Lucrecia's Dreams: politics and prophecy*, Berkeley, 1990.

9 Herrera was marginally involved in the vast project of Dr Francisco Hernández to write the natural history of the New World. After years of investigation, publication of the complete corpus appeared too costly and Herrera was charged with arranging for an abridged edition of the medicinal plants. See Lopez Piñero, *Ciencia y técnica*, 286–90; and David C. Goodman, *Power and Penury: Government, Technology and Science in Philip II's Spain*,

Cambridge, 1988, 234–8. Additional literature cited in Brown University, Department of Art, *Philip II and the Escorial: Technology and the Representation of Architecture*, Providence, RI, 1990, no. 28, 74f.

10 Cervera Vera, *Inventario*, reproduces the inventory of Herrera's books, nos. 461 through 1156, 158–92. See also F. J. Sánchez Cantón, *La librería de Juan de Herrera*, Madrid, 1941.

11 For the libraries of other architects see Fernando Marías, 'Juan Bautista de Monegro, su biblioteca y *De Divina proportione*,' *Academia*, 53, 1981, 91–117; and Alfonso Rodríguez G. de Ceballos, 'La Librería del arquitecto Juan del Ribero Rada,' *Academia*, 62, 1986, 123–54. Both Monegro and Ribero Rada were close to Herrera. The library of Jacopo da Trezzo had few scientific books: see the inventory of his possessions, AHP, Salazar, leg. 922, 1589. For a painter's library see F. J. Sánchez Cantón, 'La Librería de Velázquez,' *Homenaje a Menéndez Pidal*, Madrid, 1925, vol. 3, 379–406.

12 See Llaguno, vol. 2, 141–45 and XXII, no. 14, 358–64; F. Picatoste y Rodríguez, *Apuntes para una biblioteca científica española del siglo XVI*, Madrid, 1891; and Rafael Moreira, 'A Aula de arquitectura do Paço da Ribeira e a academia de matemáticas de Madrid,' *As Relações artísticas entre Portugal e Espanha na época dos descobrimentos*, vol. 2, Simpósio Luso-espanhol de História de Arte, Coimbra, 1987, 65–78. A full history of the academy, which would trace those involved and their published and unpublished works, remains to be written, but Lopez Piñero, *Ciencia y técnica*, 204, 249 discusses some of the principal figures; see also David C. Goodman, 'Philip II's Patronage of Science and Engineering,' *British Journal for the History of Science*, XVI, 1983, 49–66, for a brief account of the academy's program.

13 The appointments were authorized by Herrera.

14 Herrera had a hand in sponsoring translations of Euclid and Archimedes – and set up lectures on practical subjects such as geography, mechanics, and fortification. In addition to Christóbal de Rojas' treatise (cited above, n. 1; and a manuscript in BNM, ms, 9286: *Sumario de la milicia antigua y moderna y un tratado de Artilleria*, dated 1607) the following publications and manuscripts may be associated with the academy: Juan Bautista Lavaña's *Regimento Navtico*, Lisbon, 1606; *Viagem de Catholica Real Magestad del Rey D. Felipe N. S. ao Reyno de Portugal*, Madrid, 1622; Juan Bautista Lavaña's *Breue compendio delas cosas de España*, Escorial, ms, 1616; and an unfinished *Architectura naval*, cited by Lopez Piñero, *Ciencia y técnica*, 212. Ondériz published *La Perpectiva y especularia de Euclides*, Madrid, 1585. Ginés de Rocamora y Torrano published *Sphera del universo*, Madrid, 1599, in which he mentions some of the other participants in the academy, including Julian Firrufino, *Platica manual y breve compendio de artilleria*, Madrid, 1626; Bernardino de Mendoza, *Theorica y práctica de guerra*, Madrid, 1595; and Juan Cedillo Diaz, whose works remained in manuscript. These include: *Traducción castellana del arte de navegar de Pedro Núñez*; *Traducción de los seis primeros libros de la geométria de Euclides*; *Tres libros de la idea astronómica de la fábrica del mundo y movimiento de los cuerpos cellestes* and sketches for *Delos aspectos de los planetos* (1620); *Tratado primero de Artilleria*; *Corobastes* (1599); *Del Trinormo, tratado breve vtil y acomodado para los Ingenieros, Agrimensorres, Marineros, Architetos*

y *Artilleros*; and *como se a de comunicar al rio guaraguivir con qualavete* (BNM, ms 9019–3). Francisco Arias de Bobadilla, conde de Puñonrostro, and the Italian engineer, Tribulcio Spanochi, were also present in the 1590s. Spanochi left *Sobre reparar las inundaciones que en Sevilla causa el Guadalquivir*; *Descripcion de las marinas de todo el regno de Sicilia* (BNM, ms 788) and *Discurso sobre la conquista de Inglaterra*, (BNM, ms 1750).

15 See *Actas de las Cortes de Castilla*, Madrid, 15 vols., 1862–1919. On 7 December 1586 it was decided that the king's order to establish such schools in cities throughout Castile be examined further (vol. 9, 1885, 245); on 29 January 1588 the Cortes accepted what was probably the king's and Herrera's formula for their operation: 'cada ciudad vea si quieere que se lean en ella, y adivertan de lo que les parece; y que donde se leyeren, se ha de poner un preceptor, al qual se le ha de dar casa en que viva, y sitio y lugar donde se puedan leer, y cien mill maravedis de salario en cada una año, y que esto ha de ser por tiempo de ocho años; porque despues, con el aprovechamiento de los oficios públicos que resultaran de la misma ciencia, como son los alarifes y otros, se podrá pagar y satisfacer al preceptor.' The king had agreed to help with costs by authorizing the cities to raise revenue. (vol. 9, 1885, 312–13). On 15 December 1588 Herrera himself appeared: 'Juan de Herrera, criado de vuestra Magestad, dice: que vuestra Magestad mandó tratar en las Cortes pasadas, se diese órden cómo en algunas ciudades de España, se leyesen las ciencias de las matemáticas, á fin que con ellas se habituasen los hombres en las cosas pertenecientes á buenos ingenieros, arquitectos, cosmógrafos, pilotos, artilleros y otras artes dependientes de las dichas matemáticas, y muy útiles á la buena policía de la república, y en las dichas Cortes se escriuió á las dichas ciudades lo que sobre esto se hauia propuesto y hasta ahora no se ha respondido nada á ello...' (vol. 10, 1886, 367). Burgos agreed it was a good idea and promised support; Leon suggested that getting Theatine monks to teach mathematics would be cheaper; Segovia flatly refused because of the cost, and Granada pleaded poverty. Only Salamanca, with its university, replied that they had a chair of mathematics already (vol. 11, 1886, 60–3, 132, 227).

16 Compare the discussion of a similar academy in England by Roy Strong, *Henry Prince of Wales and England's Lost Renaissance*, New York, 1986.

17 Vitruvius, *The Ten Books on Architecture*, trans. Morris Hicky Morgan, New York, 1960, 16.

18 Editions listed in *2000 Anni di Vitruvio*, ed. L. Vagnetti, *Documenti di Architettura*, VIII, 1978.

19 Andrea Palladio, *I Quattro Libri dell'Architettura*, Venice, 1570, quoted from Isaac Ware's translation, *The Four Books of Andrea Palladio's Architecture*, London, 1738, reprint with introduction by Adolf Placzek, New York, 1965, preface.

20 Palladio, *I Quattro Libri*, bk III, ch. iv–xv.

21 On some of the other differences between Alberti and Vitruvius see Richard Krautheimer, 'Alberti and Vitruvius,' *Studies in Early Christian, Medieval and Renaissance Art*, New York and London, 1969, 323–32; and Françoise Choay, 'Alberti and Vitruvius,' *Architectural Design*, XLIX, nd., 26–35.

22 Cervera Vera, *Inventario*, nos. 519, 651, 674, 690, 691, 708, 714, 723, 725, 729, 737, 738, 750, 758, 910.

23 Leon Battista Alberti, *Della pittura*, ed. L. Mallè,

Florence, 1950; and *On Painting and Sculpture*, ed. and trans. with introduction by Cecil Grayson, London, 1972.

24 Sylvie Deswarte, 'Les "De Aetatibus Mundi Imagines" de Francisco de Holanda,' *Monuments et Mémoires publiés par l'Academie des Inscriptions et Belles-lettres*, LXVI, 1983, 67–190.

25 Giorgio Vasari, *Le Vite de più eccellenti pitttori, scultori et architetti, scritte et di nuovo ampliate da Giorgio Vasari*, Florence, 1568, 9 vols., ed. G. Milanesi, Florence, 1878–85, vol. 1.

26 For the significance of the rhetorical model see Michael Baxandall, *Giotto and the Orators: Humanist Observors of Painting in Italy and the Discovery of Pictortial Composition 1350–1450*, Oxford, 1971, esp. 121–39.

27 Alberti gives his definition of the architect and of building in his preface; see bk VI, ch. 1, 154, for criticism of Vitruvius's text.

28 Diego de Sagredo, *Medidas del Romano*. Toledo, 1526, facsimile ed., Valencia, 1976, and Madrid, 1986, with introduction by Agustín Bustamante and Fernando Marías.

29 An annotated copy of Guillaume Philandrier, *M. Vitruvij Polionis De Architectura Libri X*, Lyon, 1552, in the library of the Real Academia de las Bellas Artes de San Fernando in Madrid, probably comes from Herrera's circle. The marginal notes show a consistent concern to relate Vitruvius's ideas to contemporary practice.

30 On Vitruvius's science see A. G. Drachmann, *The Mechanical Technology of Greek and Roman Antiquity*, Copenhagen, 1963; and Marshall Clagett, *Greek Science in Antiquity*, New York, 1965, 105–6. Vitruvius's theory is discussed by Frank E. Brown, 'Vitruvius and the Liberal Art of Architecture,' *Bucknell Review*, 11, 4, 1963, 99ff. The importance of his science in Renaissance discussions is treated by V. Zubov, 'Vitruve et ses commentateurs du XVIe siècle,' *La Science au XVIe Siècle, Colloque de Royaumont*, Paris, 1956, 69–90.

31 Glanville Downey, 'Pappus of Alexandria on Architectural Studies,' *Isis*, XXXVIII, 1947, 197–200, provides a translation of the crucial passage: 'The mechanicians of Heron's school say that mechanics can be divided into a theoretical and a manual part; the theoretical part is composed of geometry, arithmetic, astronomy, and physics, the manual of work in metals, construction work, carpentering, and the art of painting, and the manual execution of these things. The man who has been trained from his youth in the aforesaid sciences as well as practised in the aforesaid arts, and in addition has a versatile mind, will be, they say, the best builder and inventor of mechanical devices;' See also his 'Byzantine Architects and their Training,' *Byzantion*, XVII, 1948, 99–118.

32 The fifth-century Neo-platonic philosopher, Proclus, proposed a related classification that he attributed to the school of Geminus. See Proclus, *A Commentary on the First Book of Euclid's Elements*, trans. with an introduction by G. R. Morrow, Princeton, NJ, 1970, 31–5.

33 Hugh of St Victor, *Didascalion* (1141), ed. C. H. Buttimer, Washington, DC, 1939; and J. Taylor, *The Didascalion of Hugh of St. Victor*, New York, 1969. Hugh's treatise is a tightly-argued classification of knowledge, according to four branches: theoretical, practical, mechanical, and logical. There are twenty-one sciences, including the seven liberal arts (the quadrivium: arithmetic, music, geometry, and astronomy; and the trivium: grammar,

rhetoric, and dialectic) which made up the medieval curriculum. Against these he opposed seven mechanical arts. The first of these, armament ('those things under which we take cover or by which we strike'), was divided into the constructional and the craftly. Building, as part of the constructional, belonged to armament because it was a kind of protection. 'The constructional is divided into the building of walls, which is the business of the wood-worker and carpenter, and of other craftsmen of both these sorts, who work with mattocks and hutaches, the file and beam, the saw and auger, planes, vices, the trowel and the level, smoothing, hewing, cutting, fillíng, carving, joining, dabbing in every sort of material – clay, stone, wood, bone, gravel, lime, gypsum, and other materials that may exist of this kind,' adding that 'These sciences are called mechanical, that is, adulterate, because their concern is with the artificer's product, which borrows its form from nature. Similarly, the other seven are called liberal either because they require minds that are liberal, that is liberated and practiced (for these sciences pursue subtle inquiries into the causes of things), or because in antiquity only free and noble men were accustomed to study them, while the populace and sons of men not free sought operative skill in things mechanical.' (Book II, XX, of Taylor's translation, 'The Division of the Mechanical Sciences into Seven').

34 See G. Beaujouan, *L'Interdépendance entre la science scolastique et les techniques utilitaires*, Paris, 1957; more recently, Alistair C. Crombie's comments on R. Hall, 'The Scholar and the Craftsman in the Scientific Revolution,' *Critical Problems in the History of Science*, ed. M. Clagett, Madison, Wis, 1962, 33-23 and 73ff; and, more generally, A. Crombie, *Robert Grosseteste and the Origins of Experimental Science 1100–1700*, Oxford, 1953.

35 Marshall Clagett, 'Some General Aspects of Physics in the Middle Ages,' *Isis*, XXXIX, 1948, 29–44; and Ludwig Baur, 'Domenicus Gundissalinus: De Diuisione philosophiae,' *Beitrage zur Geschichte der Philosophie des Mittelalters*, IV, 1903. Alfarbi's text on mechanics which served Gundisalvo is translated in an excellent article by George Saliba, 'The Function of Mechanical Devices in Medieval Islamic Society,' *Annals of the New York Academy of Sciences*, CCCXLI, 141–51, esp. 146. Saliba focuses much-needed attention on the practical treatises in medieval culture. I used the Spanish translation of Alfarabi's work: Al-Farabi, *Catálogo de las Ciencias*, ed. and trans. A. González Palencia, Madrid, 1953.

36 As for example Vincent de Beauvais, *Speculum doctrinale*, Douai, 1624, reprinted Graz, 1965, bks XI and XVI.

37 The Renaissance rediscovery of mechanics is a subject beyond my competence: I wish merely to underscore Herrera's participation in the general revival. For the mathematical and technical issues involved see: S. Drake and I. E. Drabkin, *Mechanics in Sixteenth-Century Italy*, Madison, Milwaukee and London, 1969; Paul L. Rose, *The Italian Renaissance of Mathematics: Studies on Humanists and Mathematicians from Petrarch to Galileo*, Geneva, 1976; Marshall Clagett, *Archimedes in the Middle Ages*, vol. 3, Philadelphia, 1978, 784, n23. The new outlook is described by Paolo Rossi, *I Filosophie e le macchine*, Milan, 1962, trans. as *Philosophy, Technology and the Arts in the Early Modern Era* by S. Attensasio and ed. B. Nelson, New York, Evanston and London, 1970; W. R. Laird, 'The Scope of Renaissance Mechanics,'

Osiris, 2nd series, II, 1986, 46–68; his 'Archimedes among the Humanists,' *Isis*, LXXXII, 1991, 629–38; and his 'Patronage of Mechanics and Theories of Impact in sixteenth-century Italy,' *Patronage and Institutions*, Woodbridge, UK, 1991, 51–66. I wish to thank Prof. Laird for his helpful criticism of this chapter.

38 Alberti (bk x) was highly sensitive to the scientific tradition; he was even an expert whom a later writer mentioned second, after the medieval mathematician, Jordanus, as having revived the ancient science of mechanics. He was firm on the importance of mathematics, for example: 'Mathematics and painting,' he wrote, 'are what he [the architect] can no more be without, than a Poet can be without the Knowledge of Feet and Syllables; neither do I know whether it be enough for him to be only moderately tinctured with them.' But he insisted equally on the architect's need for drawing.

39 Quoted in M. Clagett, *Archimedes in the Middle Ages*, vol. 3, 813.

40 Niccolo Tartaglia, *Nova Scientia*, Venice, 1537; and *Euclide Megarense philosopho solo introduttore delle scientie mathematice*, Venice, 1543.

41 Quoted in S. Drake and I. E. Drabkin, *Mechanics in Sixteenth-Century Italy*, 256f.

42 Simon Stevin, *De Sterctenbouwing*, Leyden, 1594 reprinted with English translation in *The Principal Works of Simon Stevin*, vol. 4, ed. W. H. Schhukking, Amsterdam, 1964, preface, 25–7. Stevins' views parallel Tartaglia's. See A. G. Keller, 'Mathematicians, Mechanics, and Experimental Machines in Northern Italy in the Sixteenth Century,' *The Emergence of Science in Western Europe*, ed. M. Crosland, New York, 1976, 15–34.

43 Pigafetta's Preface to Guido Ubaldo, *Mechanicorum Liber*, Pesaro, 1577, trans. in S. Drake and I. Drabkin, *Mechanics in Sixteenth-Century Italy*, 256f.

44 See John R. Hale, 'The Development of the Bastion: An Italian Chronology,' *Europe in the Late Middle Ages*, ed. J. R. Hale, R. Highfield, B. Smalley, Evanston Ill., 1965, 466–94. An early version of my discussion in 'Renaissance Treatises on Military Architecture and the Science of Mechanics,' *Les Traités d'Architecture de la Renaissance*, ed. A. Chastel and J. Guillaume, Paris, 1988, 467–76.

45 Both Palladio and Serlio prepared illustrated commentaries on Polybius which were focussed on ancient planning. Their treatises remained unpublished. See P. Marconi and Pier Nicola Pagliara, 'Un Progetto di città militare,' *Controspazio*, I, 1969; and Francesco Paolo Fiore, 'Sebastiano e il manuscritto dell'Ottavo Libro,' 216–21, and Nicolas Adams, 'Sebastiano Serlio, Military Architect?' 222–7, both in *Sebastiano Serlio, Sesto Seminario Internazionale di Storia dell'Architettura, Centro Internazionale di Studi di Architettura 'Andrea Palladio' di Vicenza*, ed. Christof Thoenes, Milan, 1989. Palladio's reconstruction is examined by John R. Hale, 'Andrea Palladio, Polybius and Julius Caesar,' *Journal of the Warburg and Courtauld Institutes*, XL, 1972, 240–5. For an overview of major publications on military architecture see Horst de la Croix, 'The Literature on Fortification in Renaissance Italy,' *Technology and Culture*, IV, 1963, 30–50; John B. Bury, 'Renaissance Architectural Treatises and Architectural Books: a Bibliography,' *Les Traités d'Architecture de la Renaissance*, 485–503; and his 'Early Writings on fortification and siegecraft,'

Fort (the Journal of the Fortress Study Group, Liverpool University), XIII, 1985, 5–48. *Architectural Theory and Practice from Alberti to Ledoux*, ed. D. Wiebenson, Chicago, 1983 includes some later material. Vicenzo Scamozzi's *Idea della architettura universale*, Venice, 1615 is exceptional in integrating military with civil building.

46 See R. Recht, 'Théorie et "traités pratiques" d'architecture au Moyen Age,' *Les Traités d'Architecture de la Renaissance*, 19–30. It worth noting that Archimedes is the only ancient writer cited by name in Villard's manuscript.

47 There is a large literature on medieval architectural practice. A good beginning and guide to further scholarship by Lon B. Shelby, *Gothic Design Techniques*, Carbondale and Edwardsville, Ill., 1977; 'The geometrical Knowledge of Medieval Master Masons,' *Speculum*, XL, 1972, 395–421; and 'The Secret of Medieval Masons,' in *On Pre-Modern Technology and Science: A Volume of Studies in Honor of Lynn White Jr.*, ed. B. S. Hall and D. C. West, *Humana Civilitas: Sources and Studies Relating to the Middle Ages and the Renaissance*, vol. I, 1976, 201–19. More recently the problem has been taken up by Joseph Rykwert, 'On the Oral Transmission of Architectural Theory,' *Les Traités d'Architecture de la Renaissance*, 31–48.

48 The fourteenth-century debates concerning the design of the Cathedral of Milan are published in *Annali della Fabbrica del Duomo di Milano, dall'origine fino al presente*, appendice, I, Milan, 1883. On the differences in aesthetics see James Ackerman, 'Ars Sine Scientia Nihil Est: Gothic Theory of Architecture at the Cathedral of Milan,' *AB*, XXXI, 1949, 84–111.

49 See K. Stephen, *Practical Geometry in the High Middle Ages*, Philadelphia, 1979.

50 See Frank D. Prager and Giustina Scalia, *Brunelleschi, Studies of His Technology and Inventions*, Cambridge, Mass., 1970. For a contemporary assessment of Brunelleschi, see Antonio Manetti, *The Life of Brunelleschi*, introduction and noted by Howard Saalman, trans. Catherine Engass, University Park, Penn., and London, 1970.

51 See Frank D. Prager and Giustina Scaglia, *Mariano Taccola and His Book De Ingeneiis*, Cambridge, Mass., 1972; and Lon R. Shelby, 'Mariano Taccola and his Books on Engines and Machines,' *Technology and Culture*, 1975, XVI, 466–75. An overview of Renaissance engineering leading up to Leonardo da Vinci by Bertrand Gille, *Les Ingénieurs de la Renaissance*, Évreux, 1964.

52 As a guide to the vast literature on Leonardo see the catalogue of exhibition at Musée des Beaux Arts, Montréal, *Léonard de Vinci, ingénieur et architecte*, ed. P. Galluzzi and J. Guillaume, with essays by various authors, Montréal, 1987.

53 John R. Hale, *Renaissance Fortification: Art or Engineering*, London, 1977 considers the role of artist-architects; see also his 'Early Development of the bastion.'

54 Michelangelo's comments are cited in James Ackerman, *The Architecture of Michelangelo*, London, 1961, 113f.

55 Kubler, 47ff; and his *Francesco Paciotto, Architect*,' *Essays in Memory of Karl Lehmann*, ed. Lucy F. Sandler, New York, 1964, 176–89, and Paciotto's own testimony in his 'Memorie cavate da un giornale fatto di proprio mano del Conte Francesco Paciotto,' in Carlo Promis, 'La Vita di Francesco Paciotto da Urbino, architetto civile e militare del secolo XVI,' *Miscelanea di storia italiana*, 4, Turin, 1863, 361–442, esp. 437–8.

56 Francesco de'Marchi, *Della Architettura militare*, Brescia, 1599.

57 The overview of Italians and their works in Spain by L. A Maggiorotti, *Architetti e architetture militari*, 3, *Gli Architetti militari nella Spagna, nel Portogallo e nelle loro colonie*, Rome, 1939, has little documentation. See Diego Angulo Iñiguez, *Bautista Antonelli: las fortificaciones americanas del siglo XVI*, Madrid, 1942; and José A. García Diego, 'Giovanni Sitoni, an Hydraulic Engineer of the Renaissance,' *History of Technology*, London, 1984, 103–25 and his and A. G. Keller's *Giovanni Francesco Sitoni*, Madrid, 1990.

58 Herrera's undated letters on the subject are reproduced in Ruiz de Arcaute, 176f.

59 Giovanni Sitoni's unpublished reports, are preserved in mansucript in the Bibliothèque Mazarine, Paris, 'Juan Fran. Siton, Mémoires au Roi Catholique sur les finances de l'Espagne' in *Recueil de pièces imprimées et manuscrites relatives à l'histoire d'Espagne*, ms 1907.

60 Herrera wrote at least some mathematical works, which I have not been able to trace but are listed in the inventory of his possessions (Cervera Vera, *Inventario*, 192, no. 1153, 'vn quaderno que contiene dibersas cosas de las matemáticas sobre escripto de Juan de Herrera').

61 Herrera's letter to Diego de Ayala of 6 November 1576 is reprinted in Ruiz de Arcaute, 62f: '...la nación española tenemos lo que ninguna otra nación, que nos parece que los oficiales y artífices son hombres fuera de na especie, y que el día que uno sabe algo no se puede fiar el que no sabe de él, y no consideran que vale más un hombre y çapatero que un hombrre solo, y que las calidades apropriadas adornan mucho al hombre, no en cuanto ser de hombre si no en cuanto calidad, y no respondo a esto como artífice, porque no lo soy, sino como medio proporcional entre artífice y no artífice, y que sabe la deferencia que ay del ser artífice y el no ser artífice.'

62 Text reprinted in Ruiz de Arcaute, 36–8, and E. Simons and R. Godoy, *Discurso del Sr. Juan de Herrera aposentador mayor de S.M. sobre la figura cúbica*, Madrid, 1976, 169–74 from the manuscript in AGS, CS, leg. 258, fol. 488. See also Nicolás García Tapia, 'Juan de Herrera y la ingeniería clasicista: el Manuscrito "Architectura y Machinas"' *Herrera y el clasicismo*, 45–55. Herrera based his explanation on the pseudo-Aristotelian Mechanical Problems. See W. R. Laird, 'Giuseppe Moleletti's "Dialogue on Mechanics" (1576),' *Renaissance Quarterly*, XL, 1987, 209–23, for the role of this text in the sixteenth century. See also n37 above.

63 See Ruiz de Arcaute, 36–8.

64 Pedro Simón Abril, *Apuntamientos de Cómo se deben reformar las doctrinas, y la manera de enseñallas*, Madrid, 1589, quoted in López Piñero, *Ciencia y técnica*, 169: 'the great lack of engineers for military operations, pilots for navigation, and architects for buildings and fortifications has come from not having to study mathematics, all of which is a great damage to the republic and the service of his royal majesty and the shame of the whole nation.'

65 An example is Rodrigo Gil de Hontañón's treatise (see ch. 1, n28 for reference). In addition: José Camón Aznar, 'La intervención de Rodrigo Gil en el manuscrito de Simón Garcia,' *AEA*, XIV, 1941, 300–5; Sergio L. Sanabria, 'The Mechanization of Design in the Sixteenth Century: The Structural Formulae of Rodrigo Gil de Hontañón,' *Journal of the Society of Architectural Historians*, XLI, 1982, 281–93, and George Kubler, 'A late Gothic Computation of Rib Vault Thrusts,' *Gazette des Beaux Arts*, XXVI, 1944, 135–48, discuss Rodrigo's methods.

66 Philibert de L'Orme, *Le Premier tome de l'architecture*, Paris, 1567, Livre III, ch. v, 57 and ch. vi, 61 in *Traités d'architecture: Nouvelles Inventions pour bien bastir et à petits fraiz (1561) et Premier Tome de l'Architecture (1567)*, ed. Jean-Marie Pérouse de Montclos, Paris, 1988. On stereotomy see Jean-Marie Pérouse de Montclos, *Architecture à la française*, Paris, 1982. The Spanish treatise by Alonso de Vandelvira, *Tratado de arquitectura*, ed. G. Barbé-Coquelin de Lisle, 2 vols., Albacete, 1977, is entirely concerned with stereotomy but lacks Philibert's theoretical articulation. Stereotomy remained of interest to architects in the seventeenth and eighteenth centuries in Spain as in France: as for example for Fray Lorencio de San Nicolás, *Arte y vso de architectvra*, Madrid, 1639, reprinted with *Segunda parte del arte y vso de architectvra*, Madrid, 1663 as *Arte y vso de architectvra, primera y segunda parte*, 2 vols., with introduction by Juan José Martín Gonzàlez, Madrid, 1989.

67 See Agustín Bustamante and Fernando Marías, *Las Ideas artisticas de el Greco*, Madrid, 1981.

68 This dicussion is based on my 'Observations on Herrera's Views on Architecture,' *Studies in the History of Art*, National Gallery, Washington, DC, XIII, 1984, 181–7. Francisco Loçano translating Alberti. *Los Diez Libros de Arquitectura*, Madrid, 1582, reprint ed. José María de Azcárate, Valencia, 1977 designates architecture as the master of all the arts in his dedication: '...como si dixeráquel que vsaua esta arte era el principal, o el principe de todos los artifices, o la arte Architectonica, o Architectura, que es lo mismo que sciencia juzgadora delas otras artes? This edition was approved by Herrera and probably represents the views El Greco objected to.

69 Jeronimo Prado and Juan Bautista Villalpando, *In Ezechielem Explanationes et Apparatus Urbis ac Templi Hierosolytani*, 3 vols., Rome, 1596 (vol. I) and 1604. The second volume was produced by Villalpando after Prado's death, *De postrema Ezechielis Prophetae Visione... Tomi Secundi Explanationvm pars secvnda*. On the whole project, see René Taylor, 'El padre Villalpando (1552–1608) y sus ideas estéticas,' *Academia*, 1–2, 1952, 410–73.

70 J. Caramuel de Lobkowitz, *Architectura civil, recta y obliqua considerada y dibuxada en el templo de Ierusalen*, Vigevano, 1678. Fray Lorencio de San Nicolás, *De arte y vso de la arquitectura*, vol. I, cap. XXII, fol. 28f, also discussed the Temple in conjunction with church design.

71 Juan de Torija, *Breve tratado de todo genero de bovedas asi regulares como irregulares*, Madrid, 1660, reprinted and with introduction by G. Barbé-Coquelin de Lisle, Valencia, 1981; and *Tratado breve sobre las ordenanzas de la villa de Madrid y polizia della*, Madrid, 1661.

3. Measure and design

1 Sigüenza, *La Fundación*, prologo, 5: 'Pretendo, pues, agora en el postrero libro desta historia, mostrar la verdad y prueba desto, dando cumplida noticia de la ilustre fábrica del monasterio de S. Lorenzo el Real, que, sin agraviar a ninguna osaré dezir que es de las más bien entendidas y consideradas que se han visto en muchos siglos, y que

podemos cotejarla con las más preciosas de las antiguas, y tan semejante con ellas que parecen parto de vna misma idea.'

2 *ibid*: 'Hallarse han aquí juntas casi todas las grandezas que se han celebrado por tales en el discurso de los siglos, quitado todo lo superfluo, y lo que en ellas no seruía más que a la ambición y al fausto. De suerte que quien viere este edificio ... viere la muchedumbre, proporción, comodidad, respeto, y buen oficio de sus partes, podrá dezir lo que dijo Galeno en su libro del uso de las partes del cuerpo humano, que después de bien consideradas, leyendo en tan celestial armonía y correspondencia mucho de la sabiduría divina ...'

3 Sigüenza, *La Fundación*, discurso XII, parte I, 95: 'Esto de los modelos es tan importante en las fábricas, que oso afirmar debérseles en esta el todo, de salir tan acertada sin remiendos ni tachas, y si algunas tiene, nacieron de hauerse mudado los modelos y las trazas o no hauerse hecho; luan Bautista de Toledo, maestro español, como hombre de alto juicio en la Architetura, digno que le igualemos con Brabante, y con cualquiera otro valiente, hizo modelo general, de madera aunque en forma harto pequeña para toda la planta y montea, a que llaman Genografía y Sgenografía; Alteró aquello en muchas partes, como vimos en otro discurso, su discípulo luan de Herrera, aunque sin daño y aun al parecer de muchos con perfección de la fábrica.'

4 Juan de Arphe y Villafañe, *De Varia commensvracion para la escvptura y architectura*, Seville, 1585, facsimile with introduction by Francisco Iñiguez Almech, Valencia, 1979, bk IV, f. 3f: 'En la Fabrica del te[m]plo de san Lore[n]ço el Real que oy se edifica cerca de la villa del Escurial, por orden del poderoso, y Catholico Rey Phelipe Segundo señor nuestro se acabò de poner en su punto el arte de architectura, por loan Baptista natural de Toledo, que fue el primero maestro de aquella famosa traça ... Murio loan Baptista a tiempo que se començavan a subir las monteas de este famoso edificio, causo su muerte mucha tristeza y confusio[n] por la desconficança q̃ se tenia de hallar otro hombre tal, Mas luego sucedio en su lugar loan de Herrera, Monatañes, natural de la villa de Camargo en la merindad de Trasmiera, entre Vizcaya y Asturias de Santillana, en quien se hallo vn ingenio tan promto y singular q̃ proseguir y levantar toda esta fabrica con gran prosperidad añadie[n]do cosas al servicio de los moradores necessarias que no pueden percebirse hasta que la necessidad las enseña.'

5 Llaguno, vol. 1, xxxviii.
6 Llaguno, vol. 1, xi.
7 Llaguno, vol. 3, 339f.
8 Llaguno, vol. 1, xxxvi.
9 Quoted from Karl Baedecker, *Spain and Portugal Handbook for Travellers*, Leipzig, 1898, 110, trans. from Carl Justi, 'Philip II als Kunstfreund,' *Miscellanëen aus drei Jahrhunderten spanischen Kunstlebens*, 2, Berlin, 1908, 3–36 (and trans. into Spanish by R. Casinos-Assens, 'Felipe II Amigo del arte,' *Estudios de Arte Español*, II, 1–46).
10 C. Justi in K. Baedecker, *Spain and Portugal*, 110.
11 Art historians and critics take for granted that the body of an architect's work is unified by his style, but the notion of artistic style is a notoriously problematic concept, which has given rise to involved discussions of everything from the problem of intention to the periodization of history. This is not the place to enter into these debates. I use the word here as a shorthand for the set of

characteristics that Herrera's buildings were and are perceived to have, for a kind of physiognomic character that makes Herrera's buildings recognizably his, and that we can to some extent ground in a set of formal features and procedures.

12 Portables, VA, 41.
13 Portables, VA, 154: 'Felipe II fué victima de Juan de Herrera, personalidad ingente, cuyo nombre sombra y es representativa, ya que su papel es de ser una guillotina, un tajo del arte español.'
14 Portables, VA, 154 and 171.
15 Kubler, '*Estilo Desornamentado* and Plain Style as Labels,' 126–8; and Kubler, *Portuguese Plain Architecture: Between Spices and Diamonds (1521–1706)*, Middletown, Conn., 1972.
16 John Summerson, *The Classical Language of Architecture* (lectures delivered in 1963), Cambridge, Mass., 1987, 8.
17 Alberti bk VII, ch. 7, 202ff, describes characteristic forms of Doric, Ionic, and Corithinian capitals and bases. See Erik Forssman, *Dorico, Ionico, Corinthio en la arquitectura del renacimiento*, trans. Carmen Marchante with introduction by Fernando Marías, Bilbao, 1983; and James Ackerman, 'The Tuscan/Rustic Order: A study in the Metaphorical Language of Architecture,' *Journal of the Society of Architectural Historians*, XLII, 1983, 15–34.
18 Sebastiano Serlio, *Libro IV: Regole generali di architectura*, Venice, 1537. On the symbolic associations of Serlio's orders see John Onians, *Bearers of Meaning, the Classical Orders in Antiquity, the Middle Ages and the Renaissance*, Princeton, NJ, 1990, esp. ch. XIX, 263ff; on usage: Hubertus Gunther, 'Serlio e gli ordini architettonici,' *Sebastiano Serlio*, ed. Christof Thoenes, Milan, 1989, 154–68. Serlio's impact on French practice is discussed by Yves Pauwels, *Théorie et pratique des ordres au mileu du XVIeme siècle: de L'Orme, Goujon, Lescot, Bullant*, 3 vols., Diplome de Doctorat, Université François Rabelais, et Centre d'Etudes Supérieures de la Renaissance, Tours, 1991.
19 Philandrier's life and sources have been studied most recently by Frédérique Lemerle-Pauwels, *Architecture et Humanisme au milieu du XVIe siècle: les Annotations de Guillaume Philandrier, Introduction, traduction et commentaire, Livres I–V*, 3 vols., Diplome de Doctorat, Université François Rabelais and Centre d'Etudes Supérieures de la Renaissance, Tours, 1990. See also Dora Wiebenson, 'Guillaume Philander's Annotations to Vitruvius,' *Les Traités d'architecture de la Renaissance*, ed. André Chastel and Jean Guillaume, Paris, 1988, 67–72. Philandrier's procedure for calculating the proportions of the orders is explained in vol. 1, lxviff. Herrera owned Philandrier's commentary (Cervera Vera, *Inventario*, no. 714).
20 In spite of their dogmatic tone and appearance, Philandrier's and Vignola's rules were not intended to constrain architects. Philandrier was explicit, saying 'I do not wish that my writings be sacred to the point that one could not deviate from them by as much as a hair's breadth. Nor do I wish the opposite: that one would object that ancient architects have not always followed the divisions or proportions that I have set forth.' He believed that 'it is up to the architect to have enough experience and ability to cut back or add to that which is prescribed.' My translation from the French text of the Digression by F. Lemerle-Pauwels, *Architecture et Humanisme*, vol. 1, part 2, 328. Vignola's *Regola* was not so much intended to limit an

architect's freedom as to provide him with a basic working vocabulary as explained by Christof Thoenes, 'La *Regola delli cinque ordini* del Vignola,' *Les Traités d'architecture de la Renaissance*, 269–79; see also Henri Zerner, 'Du Mot à l'image: le rôle de la gravure sur cuivre' in the same volume, 281–94.
21 Roman Vitruvianism of these years is discussed by Pier Nicola Pagliara, 'Studi e pratica vitruviana di Antonio da Sangallo il Giovane e di suo fratello Giovanni Battista,' *Les Traités d'Architecture de la Renaissance*, 179–206.
22 This point is made by C. Thoenes, 'La *Regola delli Cinque Ordini*' and by H. Zerner, 'Du Mot à l'image.'
23 The Florentine painter Patritio Caxesi published a Spanish translation of Vignola's *Regola* in Madrid in 1619 (with a title-page engraved in 1593) which he claimed to have begun in 1567, the year he entered the service of Philip II. His translation had Herrera's endorsement.
24 Juan José Martín González, 'Tipología e iconografía del retablo español del Renacimiento,' *BSEAA*, xxx, 1964, 5–66; and 'Estructura y tipología del retablo mayor del monasterio de El Escorial, in '*Real Monasterio-Palacio de El Escorial: Estudios inéditos en el IV Centenario de la terminación des las obras*, ed. Eliza Bermejo, Madrid, 1987, 203–20, attribute the architecture to Herrera, but Philip's orders for paintings for the retable in 1564 suggests that a design was already in existence at that date (see Annie Cloulas, 'Les Peintures du grand retable au monastère de l'Escurial,' *Mélanges de la Casa de Velázquez*, IV, 1968, 173–202, for dimensions of the paintings).
25 Sigüenza, *Fundación*, parte II, discurso XIV, 332, noted that the retable was made up of 'each of the types of Good Architecture, except the Tuscan which does not apply in this case,' confident that his readers would be able to identify the orders and note their correct superposition from the simplest (Doric) at the bottom to the most ornate (Composite) at the top [my translation].
26 See the translation of Paciotto's text and discussion in Kubler, 47ff. Juan Bautista's elevations may have been in the *sesquialtera* proportion (2:3) that Sigüenza notes was applied to the compartments of the retable and Paciotto says was used for the secondary arches of the basilica.
27 See the excellent discussion by Agustín Bustamante and Fernando Marías, 'El Escorial y la cultura arquitectónica de su tiempo,' in BNM *El Escorial en la Biblioteca Nacional*, ed. Elena Santiago Páez, Madrid, 1986, 117–47, esp. 133ff.
28 The possible impact on Herrera of the simple classicism favored by Ferrante Gonzaga and especially by Vespasiano Gonzaga at Sabbioneta should be considered.
29 Illustrated in Philibert de l'Orme, *Le Premier tome de l'architecture de Philibert de l'Orme*, Paris, 1567, in *Traités d'architecture*, ed. Jean-Marie Pérouse de Montclos, Paris, 1988, fol. 188. Philibert showed the Corinthian capital as it should be executed with its full dress of vegetal ornament in another plate. Herrera's capital was intended for execution, although his design was not followed precisely.
30 See Wittkower.
31 On Giulio's abstraction see Colin Rowe, 'Grid/Frame/Lattice/Web: Giulio Romano's Palazzo Maccarani and the Sixteenth Century,' *The Cornell Journal of Architecture*, Fall 1990, 6–21.
32 This plan has been convincingly dated between

1590 and 1600 by José Ramón Perez in an unpublished paper, 'A propósito de una lámina del manuscrito atribuido al arquitecto Jerónimo de Guzman: La Lonja de Contratación de Sevilla' at the Escuela Technica Superior de Arquitectura of the University of Seville. My thanks to Professor Vicente Lleó Cañal for sharing a copy with me. See also BNM, *Dibujos de Arquitectura y ornamentacion de la Biblioteca Nacional: siglos XVI y XVII*, ed. Elena Santiago Páez, Madrid, 1991, no. 52 (B152–201, fol. 48v) and dated c. 1590 by Agustín Bustamante and Fernando Marías.

33 The basis for modern interpretations of the use and significance of mathematics in Renaissance architecture is Wittkower but important differences in the way mathematics was used in building have been discussed by James Ackerman, *Palladio*, New York, 1966, 160–84 and Deborah Howard and Malcolm Longair, 'Harmonic Proportion and Palladio's *Quattro Libri*,' *Journal of the Society of Architectural Historians*, XLI, 1982, 116–43.

34 Vasari used these organic metaphors in describing a design of a palace.

35 Comparing the elevation and section of the building shows that every pair of pilasters on the exterior frames a taller pilaster which faces it on the pier of the nave inside, but this can be perceived only in the drawings.

36 Cesare Cesariano, *Di Lucio Vitruvio Pollione De Architectura libri Dece traducti de Latino in Vulgare Affigurati*...Como, 1521, lib. X, fol. clxxvi. Herrera was particularly interested in Vitruvius's tenth book and asked a friend in Venice to try to obtain a commentary on it for the Academy of mathematics (see Llaguno, vol. 2, XXII, no. 14, 361).

37 Quoted from a letter to Diego de Ayala, 5 November 1575, published by Ruiz de Arcaute, 62f: '. . . y no responde a esto como artífice, porque no lo soy, sino como medio proporcional entre artífice y no artífice, y que sabe la diferencia que ay del ser artífice y el no ser artífice. . . .'

38 See my analysis 'Proportion in Practice: Juan de Herrera's Design for the Façade of the Basilica of the Escorial,' *AB*, LXVII, 1985, 229–42.

39 Wittkower, 109, defined this type of relationship as follows: 'What we now call three terms in "harmonic" proportion is defined in the *Timaeus* (36) as "the mean exceeding one extreme and being exceeded by the other by the same fraction of the extremes." In other words, three terms are in "harmonic" proportion when the distance of the two extremes from the mean is the same fraction of their own quantity. In Palladio's example 6:8:12 the mean exceeds 6 by 13 of 6 and is exceeded by 12 by 13 of 12.'

40 A geometrical proportion is one in which the second term or mean is equal to the square root of the product of the first and second terms.

41 Alberti, bk IX, ch. vi.

42 Fernando Chueca Goitia, *La Catedral de Valladolid, una página del siglo de oro de la arquitectura española*, Madrid, 1947.

43 Juan de Herrera, *Discurso del Sr. Juan de Herrera aposentador mayor de S. M. sobre la figura cúbica*, ed. Edison Simons and Roberto Godoy, Madrid, 1976, 142. A whole set of relations are necessary to every created thing 'porque faltaran las differencias de las relaçiones de unidad a unidad, y de pluralidad a pluralidad y de unidad a pluralidad. en Raçon de la proporçion y en Raçon de comparaçion en que consiste toda la harmonia

del uniberso y porque faltando la Relaçion faltaran las corespondençias del criador y de las criatures en si y entre si.'

44 For a Spanish elaboration of the theme see R. Taylor, 'El Padre Villalpando (1552–1608) y sus ideas estéticas,' *Academia*, I, III, 1952, 1–65, where Villalpando's theory and use of proportion are explained and the relationship of his temple to the style of the Escorial is discussed.

45 Michel Foucault, *Les Mots et les Choses*, Paris, 1966. For the evidence of the growing empiricism and reorganization of system of knowledge see Paolo Rossi, *I Filosofi e le Macchine*, Milan, 1962.

46 See *Pedro Circuelo's A Treatise Reproving all Superstitions and forms of Witchcraft very necessary and useful for All Good Christians zealous for their Salvation*, trans. E. A. Maio and D'Orsay W. Pearson, London and Princeton, NJ, 1977 written in the 1530s.

47 J. N. Hilgarth, *Ramon Lull and Lullism in 14th Century France*, Oxford, 1971, provides an excellent introduction to Lull and to the extensive scholarship on his work. On Lull's relevance to science see López Piñero, *Ciencia y técnica*, 244f. On Lull's mysticism see Frances Yates, 'The Art of Ramón Lull: An Approach to it through Lull's theory of the elements; "Ramon Lull and John Scotus Ercigena," in the same journal, XXIII, 1960, 1–44;' *Journal of the Warburg and Courtauld Institutes*, XVII, 1964, 115–73 and *Theatre of the World*, London, 1969, especially for Herrera's similarity to John Dee.

48 A good example of Lull's approach to scientific subjects is his Nova Geometria written in Paris in 1299 (*El Libro de la 'Nova Geometria' de Ramón Lull*, ed. J. M. Millás Vallicrosa, Barcelona, 1953) in which mystical symbolism is combined with empirical geometry. Lull gives an outline of the science of geometry and diagrams for the quadrature of the circle and triangulation of the square, and proceeds to sketch out their application to the design of fortifications, towers, churches, palaces, and houses. On the latter he says: 'Diximus de modo mensurarum que competunt edificiis secundum figuris de quibus oportet quod deriventur per modum proportionis et utilitatis, et per illam que diximus per figuras antedictas potest haberi doctrina ad figurandum domos, portalia et plateas, que ad edificium competunt, et ista doctrina utilis est pro illis qui pulcra diligunt edificia et bene proporcionata (p. 82).'

49 'y es mi voluntad que la dicha memoria se haga en mi tierra, en el valle de Valdalliga, a donde mejor pareçiere estar, la qual dicha memoria sea de cosa que los del dicho valle se puedan apouechar en doctrina y saber que con ello conozcan y entiendaan de ser cristianos y como se a de seruir y loar nuestro Señor que por falta de enseñadores de esto biuen en toda esta muy brutal y ignorantemente, de que es de tener mucha lastima y compasión, y pido y encargo al señor doctor Isidro Caxa que si tal que de ella se pueda sacar algún fruto que sea en serujcio de nuestro Señor que dé horden como de la dicha mi hazienda se constituya y hordene alguna lectura del a la dicha doctrina, porque yo e sido afiçionadissimo al dicho autor Raymundo por la piedad y buen çelo que en él e conosçido, de que todos sean grandes sieruos de el Señor,' Segundo testamento otorgado por Juan de Herrera, Madrid, 20 de febrero de 1579 in Cervera Vera, *Colección*, I, no. 263, 367–84, esp. item 188. See also Joaquím, 'El Lullisme de Juan de Herrera,' *Miscellanea Puig y

Cadafalch*, Barcelona, 1947–51, I, 41ff.

50 See Herrera, *Discurso de la figura cúbica*, ed. J. Rey Pastor, Madrid, 1935, and the more recent Lullist text and discussion by E. Simons and R. Godoy, *Discurso del Sr. Juan de Herrera aposentador mayor de S. M. sobre la figura cúbica*. Herrera's treatise was not published in his lifetime, although it probably circulated in manuscript; several contemporary copies survive.

51 René Taylor, 'Architecture and Magic, Considerations on the Idea of the Escorial,' *Essays in the History of Architecture Presented to Rudolf Wittkower*, ed. Howard Hibbard, London, 1967, vol. 2, 81–109, interpreted Herrera's Lullism as evidence for his involvement in magic, divination, and alchemy, and concluded that Herrera was a *magus* who led the king through secret magical practices. Herrera certainly knew John Dee's work and owned the works of other authors in the hermetic tradition: Pico della Mirandola, Giulio Camillo, Giordano Bruno, Cornelius Agrippa, etc. Late-sixteenth-century thought was particularly inclined toward magic and astrology, and to cabbalist and hermetic thinking; the revival of Lull's ideas, as Yates has shown, played an important role in this development.

52 Pedro de Guevara, *Arte General y breve en dos instrumentos para todas las sciencias, recopilado del arte Magna y Arbor scientiae del doctor Raymundo Lullio*, Madrid, 1586, fol. 3v: 'Your Majesty having...established at this court an Academy where all kinds of mathematics and philosophy may be read, placing there such eminent masters and such experience and erudition, I have put [this work] in our Castilian language it being the will of your Magesty that your Academy read all the sciences in this language [my translation].' Guevara was a Lullist theologian whom Philip II put in charge of the education of his daughters and a prolific author. See the entry in *Enclyclopedia Universal*. Philip II and Herrera have often been linked to alchemical experiments. Philip was anxious to develop indigenous technology to improve the Castilian standard of living and to provide a source of revenue. He was also always desperate for money and at one point he hoped that alchemists might fabricate the gold to pay his debts (see Goodman, *Power and Penury*, 1–19, who notes that the king's correspondent in the exchange on alchemy which Kubler, appendix 4, 140, attributed to Herrera was the royal secretary, Antonio Graçían). Whether he thought this would be actual gold or merely some metal that would satisfy his troops is not clear, but the king was fundamentally realistic and, more than most contemporary rulers, he tended to be skeptical rather than credulous. Herrera's views on alchemy are unknown, apart from his belief in the medical efficacy of various stones, which was virtually universal at the time.

53 J. de Herrera, *Discurso*, 133: 'Porque assi como en la naturaleça y ser interior no basta aya forma y materia sino ay union operativa perfecta de ambos, Asi tambien en toda la exterior harmonia no basta aver activos y passivos sino ay connexivos. Los quales connexivos son los medios de extremidades o proporçiones que atan a los activos con los passivos. Las quales proporçiones proçeden de los mismos activos y passivos porque la proporçion o nexo es medio de extremidades partiçipantes.'

54 Lull, *El Libro de la Nova Geometria*, 91: De conclusionibus que seguntur per principia figure . . . VIII: Dictum est quod nullum ens tamen formas

representat et differencias substanciarum sicut figura, unde sequitur quod potencia visiva sit magis vicina potencia ymaginacioni per figuram quam aliqua alia potencia sensitiva. IX: Dictum est quod ita est figura similtudo materie, unde sequitur quod sciencia ante incipit per potenciam visivam quam per aliquam potenciam sensitivam, cum ita sit quod forma et superficies representantur magis persone visive quam alteri persone. I am grateful to Marjorie Grene for discussing the philosphical point of view of these passages with me and to Rachel Zerner for translation.

55 The façade is divided into four vertical units. The dimension of the units at either end (36′) is taken from the end of the wall to the center of the second window. Two other units (35′), are established from the centers of the windows. The relation of the height of the second story (15′), the height of the first story without its plinth (21′), and the width of one of the two central units of the façade (35′) are in harmonic proportion (15:21:35). Half this unit (17.5), which is the distance between two windows on center in the middle of the façade, is also bound to the height of the first story in an harmonic relation: 15:17.5:21. The height of the second story (15′) is also the width from the end wall to the center of the first window, while the height of the first story (21′) is the width between the first two windows on center, moving in from the outer wall of the façade, for a total of 36′. This establishes one of the main vertical divisions of the composition, and determines the sizes and placement of the windows and moldings.

4. Drawings

1 See Alberti, bk II, ch. I, 34: 'The difference between the drawings of the painter and those of the architect is this: the former takes pains to emphasize the relief of objects in paintings with shadings and diminishing lines and angles; the architect rejects shading, but takes his projections from the ground plan and, without altering the lines and by maintaining true angles, reveals the extent and shape of each elevation and side – he is one who desires his work to be judged not by deceptive appearances but according to certain calculated standards. It is advisable then to construct models of this kind, and to inspect and re-examine them time and time again, both on your own and with others, so thoroughly that there is little or nothing within the work whose identity, nature, likely position and size, and prospective use you do not grasp.'

2 Wolfgang Lotz, 'Das Raumbild in der Architekturzeichnung der italiennschen Renaissance,' *Mitteilungen des Kunsthhistorischen Institutes in Florenz*, VII, 1956, 193–226, reprinted as 'The Rendering of the Interior in Architectural Drawings of the Renaissance' in W. Lotz, *Studies in Italian Renaissance Architecture*, Cambridge, Mass., and London, 1977, 1–65. James Ackerman, 'Architectural Practice in the Italian Renaissance,' *Journal of the Society of Architectural Historians*, XIII, 1954, 3–11, reprinted in *Renaissance Art*, ed. C. Gilbert, New York, Evanston, and London, 1970, 148–71 stressed the limited use made of drawings in the High Renaissance. See Marjorie Licht, *L'edificio a pianta centrale. Lo sviluppo del disegno architettonico nel Rinascimento*, Florence, Gabinetto Disegni e Stampe degli Uffizi, LXI, 1984; Hubertius Günther, *Das Studium der Antiken Architecktur in den Zeichnungen der Hochrenais-

sance*, Tübingen, 1988; and Arnold Nesselrath, 'Raphael's Archaeological Method,' *Raffaello a Roma, il Convegno del 1983*, Rome, 1986, 357–71. On Brunelleschi's invention of perspective, see Samuel Egerton, *The Renaissance Rediscovery of Linear Perspective*, Ithaca, NY, 1976 and Rudolf Wittkower, 'Brunelleschi and Proportion in Architecture,' *Journal of the Warburg and Courtauld Institutes*, XVI, 1953, 275ff. Alberti published an account of Brunelleschi's perspective construction in *Della Pittura* and urged architects to use this technique.

3 Orthogonal projection was widely used in northern, Gothic drawings, as Lotz points out. On the earlier techniques see Robert Branner, 'Villard de Honnecourt, Reims, and the Origin of Gothic Architectural Drawing,' *Gazette des Beaux Arts*, LVI, 1963, 129–46.

4 Alberti, bk I, ch. I, 33f: 'For this reason I will always commend the time-honored custom, practiced by the best builders, of preparing not only drawings and sketches but also models of wood or any other material. These will enable us to weigh up repeatedly and examine, with the advice of experts, the work as a whole and the individual dimensions of all the parts. . . .'

5 Examples of earlier Spanish drawings in my *Hospital of Cardinal Tavera in Toledo*, PhD Yale University, 1968; and Fernando Marías, *La Arquitectura del Renacimiento en Toledo (1541–1631)*, vol. 2, Madrid, 1985, figs. 215–18.

6 Reprinted by Luis Cervera Vera, *Las Estampas y el Sumario de el Escorial por Juan de Herrera*, Madrid, 1954; BNM, *El Escorial en La Biblioteca Nacional, IVo Centenario del Monasterio de El Escorial*, ed. Elena Santiago Páez, Madrid, 1986, esp. E. Páez and others, 'El Escorial, historia de una imagén,' 223–348, which follows the tradition of views from the *Estampas* through the nineteenth century; John B. Bury, 'Early Printed References to the Escorial,' *Iberia, Literary and Historical Issues: Studies in Honor of Harold V. Livermore*, ed. R. O. W. Goertz, Calgary, 1985, 89–106, provides new material; and Brown University, Department of Art, *Philip II and the Escorial*, Providence, RI, 1990, reproduces Herrera's prints and the text of his *Sumario*. In a review article, Bury, 'Philip II and the Escorial,' *Print Quarterly*, VIII, 1991, 77–82, succinctly describes the project and offers some new interpretations.

7 On the Italian prints see F. Ehrle, *Roma prima de Sixto V. La pianta di Roma du Pérac-Lafréry del 1577*, Vatican City, 1908; Christian Huelson, 'Das Speculum Romanae Magnificentiae des Antonio Lafreri,' *Collectanea Variae Doctrinae Festschrift für Leoni Olschki*, Munich, 1921, 121–70; Bates Lowry, 'Notes on the Speculum Romanae Magnificentiae and Related Publications.' *AB*, XXXIV, 1952, 46–50; and Lawrence R. McGinniss, *Catalogue of the Earl of Crawford's Speculum Romanae Magnificentiae*, New York, 1976. The novelty of Salamanca's early publications is brought out by Sylvie Deswarte-Rosa, 'Les gravures de monuments antiques d'Antonio Salamanca à l'origine de *Speculum Romae Magnificentiae*,' *Annali di Architettura, Revista del Centro Internazionale di Studi di Architettura 'Andrea Palladio'*, I, 1989, 47–62. Labacco engraved the façade (Bartsch, I, 130), longitudinal section (Bartsch, I, 131), and side elevation of Sangallo's project on separate sheets which were published by Antonio Lafrery in 1548. The plan (anonymous) was published separately in 1549 but probably

belongs to the set (L. R. McGinnis, *Catalogue*, nos. 222, 223, 224, 225). See also the entries by Susan J. Garrett in *Philip II and the Escorial*, cat. nos. 51–3, 122–7. On Dupérac; see Matthias Winner, 'Neues zu Dupérac in Rome, '*Kunstchronik*, XIX, 1966, 308–9; Henry A. Millon and Craig Hugh Smyth, 'Michelangelo and St Peter's: I: Notes on a Plan of the Attic as Originally Built on the South Hemicycle,' *The Burlington Magazine*, CXI, 1969, 484–501, and 'Observations on the Interior of the Apses, a Model of the Apse Vault, and Related Drawings,' *Römisches Jahrbuch für Kunstgeschichte*, XVI, 1976, 137–206. Bird's eye (cavalier) and oblique perspective views were used by Jacques Androuet Du Cerceau, *Les Plvs Excellents Bastiments de France*, vol. 1, Paris, 1576, and vol. 2, Paris, 1579, modern ed. and commentary by David Thompson, *Androuet Du Cerceau, Les Plvs Excellents Bastiments de France*, Paris, 1988. Du Cerceau was a prolific illustrator of architecture, perspective, and decoration as well as an architect. His techniques of representation have not been studied as such but see David Thompson, *Jacques Androuet du Cerceau*, PhD dissertation, London, 1976 (which I have not been able to consult); Françoise Boudon, 'Les Livres d'architecture de Jacques Androuet Du Cerceau,' *Les Traités d'architecture de la Renaissance, De Architectura*, ed. André Chastel and Jean Guillaume, Paris, 1988, 367–96; and Françoise Boudon and Hélène Couzy, 'Les Plus Excellents Bâtiments de France. Une anthologie de châteaux à la fin de la Renaissance,' *L'information d'histoire de l'art*, 1974, 8–12 and 102–14; and Myra Nan Rosenfeld, 'From Drawn to Printed Model Book: Jacques Androuet Du Cerceau and the Transmission of Ideas from Designer to Patron, Master Mason and Architect in the Renaissance,' *Revue d'art canadienne/Canadian Art Review*, XVI, 1989, 131–46. See also Jean Guillaume's interesting brief note on Du Cerceau's drafting techniques: 'L'apparence et la réalité des choses,' *L'Architecture en Repnrésentation*, Ministère de la Culture, Paris, n.d., 31–4.

8 Preparation of the final drawings for the basilica was a complicated affair. See Kubler, ch. 6: 'Assembling the Basilica,' 75–86. The drawings were Herrera's responsibility. See for example Cervera Vera, *Colección*, I, 266f, no. 185, from a postscript to a letter from the prior to Philip's secretary Martin de Gaztelu, 5 December 1575: 'Estas cartas me dvo Escalante, y dize que, importan para hacer lo que toca a su officio, se le enbie la traça, porque no puede dar a los sacadores de la piedra la forma, hasta que se le enbie, y ymporta mucho que se dé toda furia en sacar la piedra.' Herrera was holding up production as everyone waited for his drawings: *ibid*, 267, no. 187, 11 December 1575 the prior wrote again to Gaztelu 'Ya vuestra merced habrá entendido como Escalante fue a Madrid para informarse de Juan de Herrera de la traça de la yglesia, para poder dar orden en la piedra que se ha de sacar . . .'.

9 Herrera's *Estampas* and the text of the *Sumario* make it clear that this is an actual building as well as a set of designs. The first 'pitipie desta fabrica' illustrates a scale from one to three or four hundred Castilian feet, depending on the architecture being illustrated. The second scale, 'pie castellano diuidido en partes,' represents the Castilian foot divided into 4 *palmos* each of which is divided into 4 *dedos*, divided into 8 *minutos*. One *minuto* is equal to 18 *dedo* ¹⁄₁₂₈th of a Castilian foot, a dimension of 2.18 millimeters. This latter scale is of no use with

the prints, detailed as they are, but it reinforces the impression that they are accurate representations.

10 My translation is from Juan Bautista Villalpando, *El Tratado de la Arquitectura Perfecta en la Ultima Vision del Profeta Ezequiel*, 2 vols. trans. from the Latin by Luciano Rubio and edited by José Corral Jam with essays by J. Corral Jam and L. Rubio, Madrid, 1990, vol. 2, lib. 2, cap. 13, 172. Their reconstruction was based on Ezekiel's vision of the Temple. Over the next fifteen years, Pardo prepared the textual exegesis while Villalpando labored on the architectural reconstructions. Pardo died in 1595, shortly before the appearance of the first volume, which was largely his work which contains his reconstruction, and a third volume that includes a reconstruction of Jerusalem and its major buildings. The publication had been financed by Philip II in its earlier stages. Luciano Rubio, 'El Tratado de Villalpando: origen, vicisitudes y contenido,' 73–99, of the translation explains the history of the composition and publication; see also José Corral Jam, 'Arquitectura y canon, el proyecto de Villalpando para el templo de Jerusalen,' 1–72.

11 Villalpando described their relation thus: 'Y él ciertamente prometíase esto a sí mismo, tal vez por haberse formado de mí la opinión de que tenía alguna erudición y preparación en las disciplinas de matemáticas y de arquitectura. artes con las cuales, habiéndomelas enseñado Juan de Herrera, arquitecto supremo del Rey Católico, varón ingeniosísimo y peritísimo, yo había intentado equipar, en cuanto lo permitieran mis fuerzas, los estudios de las sagradas letras que había cultivado casi desde el comienzo de la edad,' p. 116 of *El Tratado de la arquitectura perfecta*. According to L. Rubio, Villalpando's apprenticeship was most probably at the Escorial, shortly before 1580.

12 The view of the Escorial as a reconstruction of the Temple of Solomon was first and most fully argued by René Taylor, 'Architecture and Magic.' See also Taylor, 'Hermeticism and mystical architecture in the Society of Jesus,' *Baroque Art: The Jesuit Contribution*, ed. Rudolf Wittkower and B. B. Jaffe, New York, 1972, 63–97; and Alfonso Rodríguez G. de Ceballos, 'Juan de Herrera y los jesuitas Villalpando, Valeriani, Ruiz, Tolosa,' *Archivum Historicum Societatis Iesu*, XXXV, 1966, 291–5 and 316–18. Villalpando's list of these engravings in vol. 2, *De Postrema Ezechielis Prophetae Visione*, 88. The original publication also includes other engravings: 'Prospectvs Cvbucvlorvm qvae Templi Parietbvs Concivdebantvr et Antis' (281–2); 'Candelabrvm Templi Avrevm qvod Vidit Zarcharias Perenni Olivarvm Oleo Depasci qvo etiam Sacerdotes et Reges Invngebantvr' (356–7); 'Altare Holocavstirv Aenevm in qvo Ignis e Caelo Delapsvs Assidva Sacerdotvm Cvra Servabatvr' (388); 'Sacrae Architectvrae Partes earvmque Mensvrae et Ornamenta' (420); 'Basvs Cilvmnarvm Templi Salomonis' (421); 'Mare Aenevm qvod Erat in Atrio Templi Interiore vbi Sacerdotes Lavabatvr' (488); 'Basivm Acpelvivm Aenearvm qvibvs Sacrificia Lavabantvr Accvrata Delineatio' (491–2) in vol. 2 and 'Vera Hierosolymae Veteris Imago' (68f) and 'Forma Aerei Congii qvo ab Antiqvis Romanis Mensvrae et Pondera Exigebantvr Accvrate ad Exemplvm Ovorvm Similivm qvos Romae Habvimvs Expressa' (501–2) of vol. 3.

13 Translated from Rubio's translation of vol. 2, lib. 1, Introductorio, 129. Villalpando reports that he showed some of his drawings, including the side elevation, to Philip II in 1590 (vol. 2, lib. 2, Introductorio, 188), but Herrera may have seen them earlier.

14 Ibid., vol. 2, lib. 2, caps. 1–13.

15 Ibid., vol. 2, lib. 2, cap. 3, 144.

16 Ibid., vol. 2, lib. 2, cap. 1, 139.

17 19 Ibid.

18 Ibid.

19 Wittkower, *Architectural Principles*, 122.

20 See Llaguno, vol. 2, XIV, no. 7, 230: 'es nuestra merced y voluntad que agora y de aqui adelante para en toda vuestra vida seais nustro arquitecto, y que como tal nos hayais de servir y sirvais en hacer las trazas y modelos que os mandáremos...' See also Javier Rivera, *Juan Bautista de Toledo y Felipe II: La implantación del clasicismo en España*, Valladolid, 1984, for the most complete study of the architect to date. This section is based on my 'Building from Drawings at the Escorial,' *Les Chantiers de la Renaissance*, ed. André Chastel and Jean Guillaume, Paris, 1991, 263–78. See also Veroníque Gerard Powell, 'L'Organization des chantiers royaux en Espagne au XVIe siècle,' 155–63; and, on practice at St Peter's, Christoph Frommel, 'Il cantiere di S. Pietro prima di Michelangelo,' 175–83 of the same volume.

21 The king envisaged the duties of the assistants in 1563: 'Y porque nuestra voluntad es que demas y allende de aquellos se le paguen otros doscientos ducados en cada un año, para que con ellos tenga y sostenga de ordinario dos discipulos, que sean hábiles y suficientes para que le ayuden á hacer las trazas y modelos que ordenáremos,' in Llaguno, vol. 2, XXII, no. 6, 231. Parchment and paper purchased for Juan Bautista de Toledo to prepare drawings for the Escorial are noted in the 'extraordinary' expenses for March 1563: AGS, CS, Escorial, leg. 1530, fol. 2: 'A Juan bautista de toledo architecto de su Mg. y nuestro mayordomo dela fabrica del dho monesterio...un conpas muy grande para la canteria y seis pieles de pergamino para disignos y seis quadrernos de papel de marca mayor para el modelo.'

22 See Julián Zarco Cuevas, *Documentos para la historia del Monasterio de San Lorenzo el Real de El Escorial*, III, Madrid, 1918, for text of the building regulations.

23 Philip had cause for annoyance, since he had given these same orders in 1563. They were originally intended to protect Juan Bautista against interference, although it was Juan Bautista himself who broke the rules. The Instructions of 1569 in Zarco Cuevas, *Documentos*, III, 'Cedula por la cual su majestad altera algunos capitulos de los de la instrucción de los que tiene dada para la obra del monasterio de sant Lorenzo el Real,' caps. 8–10.

24 The instructions note that the *aparejadores* were to be on duty from 6 am to 11 am and from 1 pm until sunset, but, since they would be making drawings much of the time, they could be excused from being present at the site for the entire period. This was awkward for the supervisor appointed to check up on them. He did not like going to their homes to make sure that they were actually drafting. It was finally decided that the *aparejadores* should make their drawings in quarters at the site. For the text see Zarco Cuevas, *Documentos*, III, 33–62: 'Instrucción para el gobierno y prosecución de la fábrica y obra del monasterio de Sanct Lorenzo el Real.' El dicho prior terná siempre en su poder...una copia sacada en limpio de todas las dichas trazas' and 'no sea mudar algunas de las cosas que por las dichas trazas tenemos ordenado o ordenáremos que en tal caso queremos que primero que se mude se Nos consulte.'

25 Zarco Cuevas, *Documentos*, III, 61ff.

26 For example the following extract from the building accounts of the Escorial, AME, III, 69, specifications for construction of the main façade before 1575: '...la planta principal que tiene de ancho a la puerta del colegio ciento y treynta y ocho pies y medio poco mas o menos segun por la dha planta paresze con todas sus particularidades. Sin exzeder cossa alguna y elixida q sea y señalada la dha planta sobre donde sea la formarla propria obra el Maestro o maestros destaxeros labraran y asentaran sobre el dho elegimiento la primera hilada de toda esta obra segun si calidad en toda con todas las particularidades q se ben y estan en las plantas y monteas y perfil para q con mas zertidumbre y buen conçierto.' See my 'Proportion in Practice: Juan de Herrera's Design for the Façade of the Basilica of the Escorial,' *AB*, LXVII, 1985, 239–42.

27 Matilde López Serrano, *Catálago de Dibujos I, Trazas de Juan de Herrera y sus seguidores para el monasterio del Escorial*, Patrimonio Nacional, BPM, Madrid, 1944.

28 Nor does the drawing exactly match the measurements noted on it, being a revision in progress of an earlier design.

29 AME, IV, 1, Specifications for the main facade, 9 November 1574: 'Se guardan sus numeros que se ven por ellas al pie de la letra. Ansy en los anchos de las pieças como gruesos de las paredes como en todo lo demas que se ve por las dichas plantas y monteas.'

30 López Serrano, *Trazas*, xlvi.

31 López Serrano, *Trazas*, xxvi.

32 The instruction of 1572 (Zarco Cuevas, *Documentos*, III, 40), item 12 describes templates: '...y asímismo de dar los aparejadores los contramoldes y medidas más grandes de los que son menester.' The Relación, 19 October 1573 (ibid., 71) makes it clear that wooden templates were made from drawings: 'Al quinto capítulo, que trate que los aparejadores de cantería tienen cada uno un oficial de carpintería en las casas de su traza y conviene que no los tengan, sino que los contramoldes se hagan en el taller del aparejador de carpinteria, ... Parece a la Congregación, que los oficiales que fueren necesarios ocuparse en hacer contramoldes concernía se les mandase hacerlos en la casa mayor de traza donde se pueden ayudar el uno al otro y ser visitados del aparejador de carpintería y sobrestantes.' See also AME, II-90, 1570?, specifications for work on the main staircase: 'Ase les de dar al tal oficial o/o ofiçiales destaxeros un baybel y planta y un molde de cada genero de molduras esto hecho a costa de su Magestad y si mas baybeles o plantas o moldes ovieren neçesidad los hara el destaxero a su costa.'

33 Philibert de L'Orme, *Le Premier Tome de l'architecture*, Paris, 1567, esp. livre III. This kind of drawing is discussed by Jean-Marie Pérouse de Montclos, *L'Architecture à la française*, Paris, 1982. Stereotomy was also current in Spain, especially among classicizing architects in Andalucia (although the earliest surviving Spanish treatise on the subject would seem to be Alonso de Vandelvira's of about 1590, *Tratado de arquitectura de Alonso de Vandelvira*, 2 vols., ed. G. Barbé-Coquelin de Lisle, Albacete, 1977).

34 See F. García Salinero, *Léxico de alarifes de los siglos de oro*, Madrid, 1968: 'baibel', 'contra-molde', and 'galgo' for definitions.

35 The document is printed in Cervera Vera, *Colección*, I, no. 141, 213 (from Madrid, AHP, Pedro González de la Vega, prot. 1768, fol. 247) in which Herrera states that 'los dichos divujos, dixo que todos ellos eran de su magestad y que no tenía

parte en ellos el dicho Jusepe Flecha ni sus herederos porque los auía fecho el dicho Jusepe Flecha por orden del dicho Juan de Herrera, y ansî los retubo en sí....' The estate was required to return all drawings to Herrera. The same procedure (although apparently without litigation) was followed at the death of Gaspar de Vega in 1576, when Herrera demanded the return of 'las traças que quedaron de Gaspar de Vega, ansî el palacio de Madrid como de El Pardo y casa de el Bosque de Segovia y alcázar de Segovia, se entregasen a Valencia el clérigo, para que tuuiese cuenta con ellas, y que las que hallase ser de el alcázar de Segovia que luego imbiase vuestra merced aquí, y demás de esto que vuestra merced mandase que las traças que el dicho Gaspar de Vega tenía de Uclés que se entregasen a Pedro de Tolosa...' (no. 221, 324 from AGS, CS, leg. 261, fol. 130, dated 24 June 1576).

36 See Kubler 36, 74. Documents in Portables, *VA*, xciif.

37 See my 'Proportion in Practice,' 236f.

38 The division of labor on the basilica is discussed by Kubler, 81–4.

39 See my 'Building from Drawings at the Escorial,' 271 n26.

40 Contracts of 1573 specified the use of drawings and the exact measurement of stones and courses three years before Herrera ordered stone finished at the quarries. For example: AME, III, 68, 26 November 1574: 'de estas piedras todas en general a de ser tan bueno que no paresca nygun golpe de escoda ny cosa Alguna syno liso q pareszca brunydo.'

41 Sigüenza, *La Fundación*, parte I, discurso IX, 67, after speaking of the savings of time and money that the dressing of stone at the quarry represented wrote: 'Solo quedaba una dificultad, que era el escodar la Iglesia después de acabada y pulida por la faz, quitándole aquel gruesso de cordel en los paramentos llanos, porque todo lo que era cornijas o molduras se asentó labrado de todo punto, y veíase por el efeto ser cosa fácil y de ningún detenimiento. Al fin su Magestad se resoluió a que las piedras viniesen medio labradas de la cantera, y se siguiese el orden del Architecto.' On the effect of polishing, he wrote, parte I, discurso XIII, 99: 'Ibase también en este tiempo retundiendo la Iglesia, y quitándole aquel grueso de cordel, que dijimos trahían por debastar las piedras, para que hiciesen más firmes asientos sobre los lechos, y para que la fábrica fuese más una, y más degadas y finas juntas y quedase como quedó, de tal suerte, que no pareciese todo el templo hecho de diversas piezas, sino que se había acabado dentro de una peña, por la grande uniformidad del color, grano y junta de sus piedras, y aunque esto, como dije, pareció al principio que había de ser cosa difícil y de costa, ni hubo uno, ni otro, sino gran facilidad.' Sigüenza's words recall Josephus' description of the towers of the Temple of Solomon whose enormous blocks of white marble were so 'perfectly united that each tower looked like a single rock, sent up by mother earth and later cut and polished by artists' hands into shape and angles; so invisible from any viewpoint was the fitting of the joints' (*The Jewish War*, trans. G. A. Williamson, Baltimore, MA, 1960, 390).

42 On 4 June 1569 the specifications and drawings for the foundations of the basilica were ordered prepared for shipment to twelve major cities of Castile so contractors there could bid on them (AGS, CS, Escorial, leg. 260, fol. 307).

43 'En todo lo demás se siga la traça de la dicha obra, guardando lo que ella muestra, porque si esto se guarda no avra falta en ninguna cosa della. Juan de Herrera' in Cervera Vera, *Colección*, I, no. 113: 'Advertencia autógrafa de Juan de Herrera para la mejor ejecución de la obra de las casas del Ayuntamiento de la ciudad de Toledo,' c. 1574, 172f.

44 AHP, Pedro de Salazar, prot. 911, fol. iiiivvxxj, 13 November 1583, published by Cervera Vera, 'Juan de Herrera diseña la Lonja de Sevilla,' *Academia*, n119, 177ff.

45 Archivo Municipal Toledo, Obras del Ayuntamiento: 'Relacion autógrafa de Juan de Herrera describiendo los planos y documentos que realizó para las casas del Ayuntamiento de la ciudad de Toledo' in Cervera Vera, *Coleción*, I, no. 110, 169f.

46 There may have been some additional drawings, but even with hypothetical additions the complete set is unlikely to have had more than twenty drawings.

47 See below ch. I, n. 7, for list of the drawings.

48 Most of the surviving drawings for the Escorial, now in the archives of the Royal Palace in Madrid, have been published by Lopez Serrano, *Trazas*. Herrera's drawing for the cathedral of Valladolid are included in Fernando Chueca Goitia, *La Catedral de Valladolid*, Madrid, 1947, 59–64.

49 Undated document in Archivo del Instituto de Valencia de Don Juan, envio 61, no. 388: 'Haced que Herrera esté a comer allí el jueves y lleve las trazas de allí, y las monteas de las escaleras que ví el otro día,' quoted in Francisco Iñiguez Almech, *Las Trazas del Monasterio de S. Lorenzo de El Escorial*, Madrid, 1965, 42.

50 AGS, CS, Escorial, leg. I, 12 May 1570: 'Procure v. m. que Herrera embie la traça de las fuentes de los claustros que estan hechos por que no se puede acabar hasta que Su Magd. determine la forma que han de tener' quoted in Portables, *VA*, cx.

51 AA, leg. 21, 3, 10 June 1580, item d: 'Yten, que el tejado se haga y prosiga con la horden y forma que se verá en un modelillo de papel que para él se hizo y mostró a su magestad, y va firmado de Juan de Herrera, su architecto mayor'; and 'Las traças que Joan de Orea, maestro mayor de la Alhambra de Granada, trujó á Badajoz y su magestad bio y en ellas resoluió lo arriva contenido, son seis y todas seis van firmaddes de mi nombre. Juan de Herrera' in Earl Rosenthal, *The Palace of Charles V in Granada*, Princeton, NJ, 1985, doc. 213, 293f. Herrera's modifications were apparently made directly on Orea's drawings.

52 AA, leg. 152, fol. 3 of 22 April 1623 in Rosenthal, *The Palace of Charles V*, doc. 167, 304f.

53 'Copia de la traza hecha por Juan de Herrera, Aposentador de Su Magestad, para la Sta. Iglesia Cathedral de la Ciudad de Valladolid por la que se expresa el estado que tiene la continuación de su fábrica y lo que resta assentar hasta su entera conclusión', legend quoted in Chueca Goitia, *La Catedral de Valladolid*, 62.

54 See Kubler, 21 and Portables, *VA*, xvif for the architects' opinions of Toledo's designs. AGS, CS, leg. 1530, fol. 15, 'Gastos Extraordinarios' includes payments: 'A fernan González maestro de cantaría Vezino de la çiudad de toledo treinta y dos ducados que montan doze mill marabedis que los ha de auer por ocho dias que se ocupó en el camino que hizo por llamamiento de nos frai Juan de huete prior del dho monesterio ... desde la dha ciudad de toledo a la dha obra enla benida y estada y buelta Para ber e dar su Paresçer con otros maestros sobre algunas

cosas dela dha obra y edificios a Razón de quatro ducados cada dia.' Rodrigo Gil de Hontañón was paid 24 ducats for coming from Segovia (15v).

55 Cervera Vera, 'Juan de Herrera Diseña la Lonja de Sevilla,' *Academia*, 177f, n. 19. In 1583 Herrera requested the payment of the 'mill ducados' that were still owed him 'por el tiempo que me ocupado desde el año pasado de mill e quinientos e setenta e dos años fasta diez y nuebe de setiembre de este presente año de quinientos ochenta e tres, en hazer las trazas y disignos y otros memoriales e pinturas de la dicha Lonja, que vltimamente hize vno por el qual, por mandado de su Magestad, se va haziendo y fabricando la dicha Lonja...' (from AHP, Pedro de Salazar, prot. 911, fol. iijxxj). It is not clear whether this was the entire fee or merely the last installment.

5. Creating a royal style for Philip II's palaces and public buildings

1 Francisco de Villalpando, *Sebastían Serlio, Tercero y quarto libro de architectura*, 1552, reprinted Valencia, 1977, with introduction by George Kubler, 'El Interprete al Lector, fol. 2vf: 'Y si en hōrarlos los principes teniā razō veamos quiē perpetuo sus memorias onorablemete, los thesoros q̄ dexarō o los edificios q̄ cōellos edificarō. Quiē fue causa pricipal de q̄ ganassen tātas victorias y cōquistassen tātas prouincias y reynos, sino las machinas y industrias delos arquitectos?...Estos haziā sus tā perfectas estatuas y adornauā y autorizauā sus triūphos, y les hazian las inexpugnables fortalezas pa en tiēpo de guerra, y los regalados edificos y aposentos cō tātas differēcias de jardines, y deleytes para en tiēpo de paz. Y avnq̄ ouo muchos q̄ perpetuarō sus memorias cō palabras admirablemēte escriptas, los architectos cō superbissimos edificios: porque si leyēdo vna hystoria o Coronica de vn principe, paresce q̄ enella se oyē sus hechos, en el architectura se veē, porq̄ ver hecho vn edificio de vn tēplo, de vna ciudad, de vna fortaleza, devn palacio, devn puerto de mar, de vn arco triūphal, de vn pōtō, de vn arqueducto, de vn Mausoleo o sepulcro, o otras q̄lesquier maneras de edificios, avnque con lo escripto este muy autorizado lo estara mas cō las armas o estatuas delos fundadores, porq̄ parece q̄ cada piedra y cada madero y cada pintura esta diziēdo y representado la persona, la magestad, el pōtificado y autoridad del fundador.'

2 Alberti, bk v, ch. 3, 121f.

3 See Antonio Averlino Il Filarete, *Trattato di architettura*, ed. A. M. Finoli and Liliana Grassi, 2 vols. Milan, 1972.

4 Ludwig H. Heydenreich and Wolfgang Lotz, *Architecture in Italy 1400–1600*, Baltimore, 1974, 126. Heydenreich mentions the Nova Domus in Mantua as a contemporary rival. Sebastiano Serlio, *Libro III, Le Antiquità di Roma*, Venice, 1540, illustrated Poggioreale with a plan and section through the main building and in a variant plan of his own. Subsequent editions and translations of Serlio's treatise (by Pieter Coeck van Aelst, Antwerp, 1546, in Flemish, and Antwerp, 1550, in French; and by Francisco de Villalpando insured its fame in the sixteenth century.

5 The exterior of manzanares El Real is illustrated in Leopoldo Torres Balbás, *Arquitectura Gótica, Ars Hispaniae*, vol. 7, Madrid, 1952, 366f. On Spanish palaces in the first half of the sixteenth century see Fernando Chueca Goitia, *Arquitectura del siglo XVI, Ars Hispaniae*, vol. 11, Madrid, 1956; and Victor Nieto, Alfredo J. Morales, and Fernando

Checa Cremades, *Arquitectura del renacimiento en España, 1488–1599*, Madrid, 1989.

6 John Bury drew attention to an important parallel with Borgia castles in Italy in a paper at La Calahorra in 1989; most recently see Fernando Marías, 'Sobre el Castillo de la Calahorra y el Codex Escurialensis,' *Anuario del Departmento de Historia y Teoría de Arte*, Universidad Autonoma, Madrid, II, 1990, 117–30.

7 Serlio's sixth book was written while he was at Fontainebleau in the 1540s; Jacopo Strada purchased the manscuripts from the author in Lyon in 1550. Book VI remained unpublished in the Renaissance; see contemporary manuscript copies: at New York, Columbia University, Avery Library (Sebastiano Serlio, *Libro VI, Gli Habitationi di tutti li gradi degli homini*, ed. Myra Nan Rosenfeld, New York, 1978); and in Munich, Staatsbibliothek (Sebastiano Serlio, *Libro VI, Habitationi di tutti li gradi degli homini*, 2 vols., ed. Marco Rosci, Milan, 1966).

8 Earl Rosenthal, *The Palace of Charles V*, reconstructs the building history and Italian sources of the design in detail and considers the princely aspects of its style, 245–64; and his 'El Programa iconográfico-arquitectónico del Palacio de Carlos V en Granada,' in *Seminario sobre arquitectura imperial*, ed. Ignacio Henares Cuéllar, Granada, 1988, 159–77, offers further observations on the iconography of the circular courtyard.

9 On Philip II's royal residences see Iñiguez, *Casas reales*, and J. Miguel Morán Turina and Fernando Checa Cremades, *Las Casas del rey: casas de campo, cazaderos y jardines siglos XVI y XVII*, Madrid, 1986. See also Fernando Checa Cremades, 'Imperio universal y monarquía católica en la arquitectura aúlica española del siglo XVI,' in *Seminario sobre arquitectura imperial*, 11–43; 'Las Construcciones del principe Felipe,' in El Escorial, *Ideas y Diseño, la arquitectura, Esposición, IV Centenario*, Madrid, 1986, 23–45. The complex history of the Alcázar in Madrid has been admirably clarified by Véronique Gerard, *De Castillo a palacio: El Alcázar de Madrid en el siglo XVI*, Madrid, 1984; and by Juan José Martín González, 'El Alcázar de Madrid en el siglo XVI,' *AEA*, XXXV, 1962, 1–19 and 237–52.

10 We usually think of Philip II's patronage as directed almost entirely towards Italy. This is true of painting and sculpture and, at first glance, it appears to be true also of architecture. Philip II was the principal buyer of Titian's paintings in the artist's later years; he had the best Italian sculptors, bronze workers, and jewelers working for him at home and abroad; and he bought a great deal of central Italian painting to decorate the Escorial. Except for the paintings by Hieronymous Bosch, the nothern works in his collections – chiefly landscapes, scientific illustrations, city views, and portraits – were minor acquisitions. The works he purchased by Spanish artists were strongly Italianate. See Jonathan Brown, 'Felipe II, mecenas y coleccionista,' *RS*, XXIV, 1987, 37–56; and Brown, *The Golden Age of Spanish Painting*, New Haven and London, 1991, ch. 2, 39–67.

11 Philip had not been to France, but he sent his architect, Gaspar de Vega, to spy out the architecture of the new Louvre, Fontainebleau, and the other chateaux near Paris in 1557. The text of Vega's report printed in Iñiguez, *Casas reales*, appendice primero, 165–74.

12 Jehan Lhermitte, *Le Passetemps*, ed. C. Ruelens, 2 vols., Antwerp, 1890–6, vol. I, 127 (Valsaín).

13 See Juan José Martín González, 'El Palacio de "El Pardo" en el siglo XVI,' *BSEAA*, XXXVI, 1970, 5–41.

14 See Morán Turina and Checa Cremades, *Las Casas del rey*, 198.

15 See Carl Justi, 'Der königliche palast zu Madrid,' *Zeitschrift für bildende Kunst*, 1893–4, 51–60; Martín González, 'El Alcázar de Madrid en el siglo XVI,' 7f; Luis Cervera Vera, 'Carlos V mejora el Alcázar madrileño,' *RBAM*, LXXXII, 1979, 59–150; and Gerard, *De Castillo a Palacio*. At the death of Luis de Vega in 1563, Juan Bautista was appointed master of the works at the Alcázar in Madrid, but according to Gerard he was in charge of designs from 1559.

16 Veronique Gerard, 'La Fachada del Alcázar de Madrid,' *Cuadernos de Investigación Histórica*, II, 1978, 237–51, has reconstructed and doumented this program. See Virginia Tovar Martín, *Arquitectura Madrileña del siglo XVII*, Madrid, 1983, 341–6 for later work.

17 The history of Aranjuez is documented and discussed in two fundamental studies by Iñiguez, *Casas reales*; and Juan José Martín González, 'El Palacio de Aranjuez en el siglo XVI,' *AEA*, XXXV, 1962, 237–52. More recently see Javier Rivera Blanco, *Juan Bautista de Toledo y Felipe II: la implantación del clasicismo en España*, Valladolid, 1984, esp. 122–83; and Morán Turina and Checa Cremades, *Las Casas del rey*, esp. 93ff and 134ff.

18 See Martín González, 'El Palacio de Aranjuez,' 237, citing AGP. Registro de Cédulas, II, fol. 119r. The model of the chapel was finished in 1564 and construction was underway by January of the following year and continued until 1567, when the first level was finished. See Iñiguez, 114f, citing Madrid, Archivo del Instituto de Valencia de Don Juan, envío 61, no. 132, and 115 citing Madrid, Archivo de Zabálburu, Caja 146, no. 48, no. 23. At this time, there was a plan for the whole complex since a memorandum, dated 19 April 1567, refers to the 'chapel of the palace' as mentioned by Portables, *VA*, appendix 3, clxxi–clxxiii, citing AGS, CS, Escorial, no. 1, 'Memorial y orden que Joan Baptista de Toledo, maestro Mayor dexo para la obra de la capilla de Aranjuez: Capilla del palacio que Su Mgd. manda hazer en Aranjuez.'

19 The changes are discussed by Martín González, 'El Palacio de Aranjuez,' 241. The third story was begun in 1572.

20 The western wing ('el cuarto nuevo') was begun in 1573 by Gilli, but Herrera had installed his own men by 1574 (Martín González, 'El Palacio de Aranjuez,' 245, citing AGS, Aranjuez, leg. 6, fol. 126, letter of Alonso de Mesa to Martín de Gaztelu, 24 September 1574). In 1577 Herrera provided final plans for the roof. By the end of 1580, the rooms of the western wing were complete. Opinion is divided on the authorship of the palace. Llaguno, vol. 2, 131f; Ruiz de Arcaute, 114; and Luis Cervera Vera, 'Semblanza de Juan de Herrera,' 48, give most of the credit to Herrera; Iñiguez, *Casas reales*, is inclined to see substantial revisions to Juan Bautista's plans under Herrera's direction, while Martín González, 'El Palacio de Aranjuez,' judiciously suggests that Herrera designed in the spirit of Juan Bautista's earlier style. Rivera Blanco, *Juan Bautista de Toledo*, 157–72, especially 160, gives an unequivocal attribution to Juan Bautista: 'Toledo planificó totalmente la idea del nuevo palacio y se puede afirmar que en lo referente a la planta se siguió con exactitud.'

21 Juan Gómez de Mora's were prepared in the 1620s and are part of his 'Relación de las Cassas que Tiene el Rey de España y de Algunas de Ellas se an Echo Tracas que se an de Ber con Esta Relación. Ano de 1626,' Biblioteca Vaticana, *Barb. Lat.* 4372, discussed in detail by Iñiguez, *Casas reales*; text and illustrations are reproduced in Madrid, Museo Municipal, *Juan Gómez de Mora (1586–1648): Arquitecto y Trazador del Rey y Maestro Mayor de Obras de la Villa de Madrid*, with essays and catalogue by Virginia Tovar Martín, 1986, Madrid, cat. nos. 28, 29 and 379–97; cat. nos. 30–5 reproduce later seventeenth- and eighteenth-century plans for the palace.

22 The open loggias of Poggioreale, which may have been inspired by Filarete's palace in the *Tratatto*, may have found an echo in the projects that Giuliano da Sangallo prepared for Lorenzo de'Medici. Giuliano showed a similar project to Charles VIII in France in 1494. Francis I's first work at Blois was the construction of a public façade of arcaded loggias facing the city (1515) which were based on Bramante's loggias of the Vatican, but one of the early projects for Chambord was for a square building with four circular corner towers surrounded by open arcades on the lower floor, a startling feature in a design that visually recalls a medieval *donjon*. The project was prepared between 1519 and 1526 and executed in a wooden model whose plan and elevation were drawn by André Félibien in 1660. Poggioreale's relation to Chambord has been noted by Jean-Marie Pérouse de Montclos, *histoire de l'architecture française de la Renaissance à la Revolution*. Paris, 1989, 44f and 66. However, F. Marías in an article to appear in *La Revue de l'Art*, argues that the Casa de Campo influenced the loggia façade of Francis I's chateau of Madrid. On the chateau of Madrid (outside Paris) see Monique Chatenet, *Le Chateau de Madrid*, Paris, 1987; and Chatenet and François Charles James, 'Les Expériences de la région parisienne 1525–1540,' in *Le Chateau en France*, ed. Jean Pierre Babelon, Paris, 1986, 191–204. Between this project and the final designs for Chambord, Francis I, taken captive at the battle of Pavia, spent several months in the Alcázar of Madrid where he could have looked out upon open arcades of the Casa de Campo, a small, regularly planned pleasure building. Shortly after his liberation, Francis I began the chateau known as Madrid whose arcaded façade suggested 'the Casa de Campo that your Majesty has in Madrid' to Gaspar de Vega when he saw it (document in Almech, *Casa reales*, 166). It would seem that Philip continued this habit of cross-referencing among royal palaces.

23 Aranjuez also resembles Domencio Giunti's Villa Simonetta which was rebuilt for Ferrante Gonzaga, viceroy of Milan, after 1547. See Heydenrich and Lotz, *Architecture in Italy, 1400–1600*, 292f and pl. 316.

24 For royal architecture as an image of humanist *magnificentia* and *liberalitas* see Martin Warnke, *Hofkünstler. Zur Vorgeschichte des modernen Künstlers.* Cologne, 1985, trans. Sabine Bollack, *L'Artiste et la cour: aux origines de l'artiste moderne*, Paris, 1989, 225f; and Felix Gilbert, 'The Humanist Concept of the Prince and 'The

Prince' of Machiavelli,' *Journal of Modern History*, XI, 1939, 449–83.

25 There is evidence that Philip was uncertain of the kind of palace he wanted, and was never fully satisfied with the designs. I am dealing with this in a separate study.

26 The assertion by Morán Turina and Checa Cremades, *Las Casas del rey*, ch. viii, 'La Decoración en las casas de campo,' 151–9, that Philip II's decorative programs were as ambitious as those in Italy and France seems overstated.

27 Visual evidence for the state of the palace in the sixteenth century is scanty. Llaguno vol. 2, 281, mentions a plan of the western wing and a large plan of the chapel in AGP. A drawing of the Picotajo of about 1581, attributed to Herrera by Iñiguez, *Casas reales*, 143, figs. 51, 52, 53, includes a small plan of the palace and service buildings. The plan is in a.g.p. Biblioteca. An idealized perspective painting (collection of Patrimonio Nacional) first published by Iñiguez, shows a different version which he attributed to Herrera. It does not match Gomez de Mora's plans but clearly derives from them, and, since Herrera took charge of designs after his master's death, the attribution is reasonable.

28 Jacques Androuet Du Cerceau, *Les Plus Excellents Bastiments de France*, vol. 1, Paris 1576 and vol. 2, Paris, 1579, in one-volume modern edition by David Thompson, Paris, 1988. It is not known whether Philip owned any of Du Cerceau's drawings of French chateaux which exist in multiple copies and must have been widely circulated. The 'tratado de estanpas de edifiçios' listed in the inventory of Herrera's library (see Cervera Vera, *Inventario*, 168, no. 689) might possibly have been Du Cerceau's architectural books and prints.

29 Herrera did not (perhaps could not) modify the grouping of the buildings at Aranjuez, which is asymmetrical and curiously informal. Only in the eighteenth century did Herrera's Casa de Oficios become part of a coherent composition when Juan de Villanueva matched it with another block of buildings and a plaza along the axis of the road from Madrid. Service buildings and stables were mentioned as early as 1563, but nothing is known of any designs at this stage, as noted by Rivera Blanco, *Juan Bautista de Toledo*, 161, citing AGS, CS, leg. 252–3, fol. 28. The present service block, to the south of the main palace, was Herrera's work Martín González notes that the Casas de Oficios may have been designed as early as 1577. A second unit was added by Juan Gomez de Mora. (Martín González, 'El Palacio de Aranjuez,' 247–50 and Llaguno, vol. 2, 132 and XXII, no. 3, 282). Herrera's Casas de Oficios appear in the plan of 1581, construction began in 1585 and, in 1586, a contract was let for construction of the courtyard, at which time the exterior arcades facing the royal palace were complete. The service building is independent and connected to the palace by a gallery with a walkway on top, like those one finds in the engraved projects of Vredeman de Vries.

30 On the Alcázar in Toledo see Fernando Marías, *La Arquitectura del Renacimiento en Toledo (1541–1631)*, 4 vols., Toledo, 1983–6, esp. vol. 4, 51–82, which covers the building history of the building and cites previous scholarship; but see also Juan José Martín González, 'Nuevos Datos sobre la construcción del Alcázar de Toledo,' *RABM*, LXVIII, 1960, 271–86. The Alcázar has

been partially destroyed and rebuilt several times, most recently in the twentieth century. Herrera's southern façade and monumental staircase are largely modern but careful reconstructions. Thanks to intensive archival research, the history of the building and Herrera's share in it are now reasonably clear.

31 This drawing was first published by Martín González, 'El Alcázar de Madrid en el siglo XVI.' Its style and purpose has been elucidated by Gerard, *De Castillo a Palacio*, 83f. Most recently, Rivera, *Juan Bautista de Toledo*, 284, relates the drawing to Herrera's designs at Toledo.

32 On the work at La Calahorra see John Shearman, 'Raphael, Rome and the Codex Escurialensis,' *Master Drawings*, XV, 1977, 107–46; and my 'La Calahorra and the Spanish Renaissance Staircase,' *L'Escalier à la Renaissance*, ed. André Chastel and Jean Guillaume, Paris, 1985, 153–60. See also Marías, 'Sobre el Castillo de la Calahorra y el Codex Escurialensis,' *Anuario del Departamento de Historia del Arte y Teoría del Arte*, II, 1990, 117–130.

33 At this point the central flight was widened to three bays and was to have is exits 'at the fronts of the upper corridors,' that is facing the courtyard as before. This suggested to me ('The Escorial and the Invention of the Imperial Staircase,' *AB*, LVII, 1975, 83–90) that only the central flight was widened, adding two more bays to the stairwell in order to accomodate the wider central flight, making it seven bays long, while Herrera added yet two more bays to the length bringing the total to nine in the final design. Fernando Marías in *Arquitectura del renacimiento en Toledo*, and 'La Escalera Imperial en España,' in *L'Escalier dans L'Architecture de la Renaissance*, believes that the stairwell was extended to nine bays in 1553 because the flights would thus have been aligned with the upper corridors, and I think this is correct.

34 Covarrubias's rich and small-scale carving may be seen in his staircase for the Hospital of Santa Cruz in Toledo.

35 The staircase is described in admiring detail by Fray Lorencio de San Nicolás, *Arte y vso de architectvra*, Madrid, 1639, reprinted with *Segvnda parte del arte y vso de architectvra*, Madrid, 1663, as *Arte y vso de architectvra, primera y segunda parte*, 2 vols., Madrid, 1989, with introduction by Martín González, 1, cap. LXIII, 'Trata de las escaleras, fábrica, y cortes, por sus demonstraciones,' fols. 116v–118; also included (fols. 118v–120) is a description of a staircase like that of Chambord. It was partly inspired by Palladio's description and illustration but Fray Lorencio writes as if he knew other examples.

36 The history of the project and its sources in Italian architecture are thoroughly dealt with by Rosenthal, *The Palace of Charles V*, esp. 124–43 and document no. 132 for Herrera's share.

37 Rosenthal, *The Palace of Charles V*, pl. 74, who notes that 'Juan de Orea returned to the Alhambra in 1572 with a severe architectural style that differed from the Siloesque manner characteristic of his architecture in Almería in the 1550s' (p. 129).

38 The cut-stone annular vault is one of the few elements of Machuca's design that is compatible with Herrera's style. Rosenthal, *The Palace of Charles V*, 116f and 217f, dates its construction to before 1569 during Luis Machuca's tenure. It is

compatible with the Herreran stereotomy used in the vestibule. Fray Lorencio de San Nicolás, *Arte y vso de architectvra*, fol. 92v, praises this vault in his discussion of stereotomy. 'Puede ofrecerse auer de hazer vna bobeda circular alrededor de vn claustro redondo, como la tiene el Alhambra de Granada; fabrica que empeçó la Magestad del Emperador Carlos V. que es vna obra dificultosisima, y de grande ingenio.'

39 Herrera may also have been trying to get extra space under the roof.

40 The plans were sent by the Duke of Alba on 13 and 18 November 1580 (*Colección de documentos inéditos para la historia de España*, XXXIII, 1859, 326–32). See also Julio de Castilho, *A Ribera de Lisboa*, Lisbon, 3 vols., 1940–4, vols. 1 and 2 on Portuguese palaces. The Lisbon palace is discussed by Kubler, *Portuguese Plain Architecture: Between Spices and Diamonds*, Middletown, Conn., 1972, 77–9; Fernando Chueca Goitia, *El Escorial Piedra Profética*, Madrid, 1986, ch. X: 'El Estilo herreriano y la arquitectura portuguesa,' 161–93; and Agustín Bustamante and F. Marías, 'Francisco de Mora y la arquitectura portuguesa,' *As Relaçoes artísticas entre Portugal e Espanha na época dos descobrimientos*, Coimbra, 1987, 277–318. See also José Eduardo Horta Correia, 'Le mécénat de Philippe II et l'architecture portugaise,' 69–75; and Krista de Jonge, 'Rencontres portugaises: l'Art de la Fête au Portugal et au Pays-Bas méridionaux au XVIe et au début du XVIIe siècle,' 85–101, both in Bruxelles, Musées Royaux des Beaux-Arts de Belgique, *Portugal et Flandres; Visions de l'Europe 1550–1680*, 1991. Nothing survives of the palace; the only known plans are those discovered by Rafael Moreira, 'O Torreão do Paço da Ribeira,' *Mundo da Arte*, XIV, 1983, 43–8. Previous scholarship and new material on the interior arrangements and decoration in Barbara von Barghahn, *Age of Gold, Age of Iron: Renaissance Spain and the Symbols of Monarchy*, 2, vols., Lanham, New York and London, 1985, 'The Spanish Monarchy and Portugal,' 90–9; and Annemarie Jordan, *Archduke Albert of Austria in Lisbon (1281–1593): A question of patronage or emulation?*, unpublished MA thesis, Brown University, Department of Art, 1985, whom I thank for sharing her knowledge of the palace with me. Van Barghahn and Jordan stress Philip II's concern to make Lisbon into a new *umbilicus mundi*.

41 Terzi was an important figure in Portuguese architecture and Kubler has attributed the design of the Torreão to him, rather than to Herrera. Terzi was the site architect for construction, just as Minjares was site architect for Herrera's designs for the merchants' exchange in Seville. By 1580, Philip's pattern of operations was well established.

42 Herrera owned a copy of Philibert's treatise on a technique for constructing a wooden roof in which short pieces of wood function like the voussoirs of an arch, *Nouvelles Inventions pour bien bastir et à petits fraiz*, Paris, 1561 (Cervera Vera, *Inventario*, 170, no. 728, 'nuebas ynbenziones de batir por Filiberto Dellorme, en francés').

43 Philip II wore a traditional brocaded gown in Lisbon to please his Portuguese subjects. Isidro Velásquez Salamantino, *La Entrada que en el reino de Portugal hizo a S. C. R. M. de don Philippe Invictissimo Rey de las Españas, segundo deste nombre, primero de Portugal, assi con su*

Real presencia como con el exercito de su felice campo, Lisbon, 1583. (I thank Anne Marie Jordan for bringing this to my attention).

44 Juan Gomez de Mora's description of the Lisbon palace in 'Relación de las Cassas' (see above, n. 21), reproduced in Madrid, 395. See also descriptions by Duarte de Sanda, 'Lisboa em 1584, primera embaixada do Japão a Europe,' *Archivo Pittoresco*, Lisbon, 1863, VI, 77–9, cited by A. Jordan, 'Archduke Albert'; and Lorenzo Magalotti's description of 1668/9 in A. Sanchez Rivero and A. M. Sanchez Rivero, *Viaje de Cosme III por España y Portugal*, Madrid, 1933.

45 Quoted in Kubler, *Portuguese Plain Architecture*, 78.

46 On Bernini's designs for the Louvre see Anthony Blunt, *Art and Architecture in France, 1500–1700*, 2nd edn., Harmondsworth, 1970, 197ff; and J. M. Pérouse de Montclos, *Histoire de l'architecture française*, 256–61, refs to studies by Jean Pierre Babelon cited p. 490.

47 Construction began in February 1575 under the direction of Nicolas de Vergara, while Diego de Alcántara and two other stonemasons contracted for the main façade. Herrera's drawings were respected at least until 1580, but the building was still unfinished when construction stopped in 1605. The central pediment and high towers, were added later when construction was resumed in 1612. El Greco's son, Jorge Manuel, contracted to complete the towers that frame the façade. This work was finished by 1618 but the slate roofs and lanterns of the towers were built by Teodoro Ardemans between 1690 and 1704. Specifications for construction of Herrera's original facade do not match the present building and suggest that Jorge Manuel added the central pediment and another story and cupolas to the towers, omitting the pediments that Herrera had originally designed for them. See Fernando Marías, *La Arquitectura del renacimiento en Toledo (1541–1631)*, vol. 2, Toledo, Madrid, 1985, fig. 61, and vol. 4, Madrid, 1986, 4–12, for his reconstruction of the original design. A reconstruction of the building history and the bibliography of previous scholarship, among which M. B. Cossío, 'Más Documentos inéditos para la historia del arte español: La Casa ayuntamiento,' *La Lectura*, V, 1905, and Cervera Vera, *Colección*, I, nos. 97–105 and 109–117 are of particular importance. The document describing Herrera's façade is in Toledo, Archivo Municipal, no. 310, Escrituras 1584–1645, sf.

48 The Merchants' Exchange is now the Archivo General de Indias. The building was restored and its interior was rehandled by Lucas Cintoro (1786) and Juan de Astorga (1830) as discussed by C. Bermúdez Plata, *La Casa de la Contratación, la Casa Lonja y el Archivo General de Indias*, Seville, n.d., 17–21. Lucas Cintora was responsible for the heavy, colored marble decoration of the staircase. Cintora's work was attacked as a brutal, even heretical, assault upon a great work of classicism and the architect was stung into publishing a defense of his transformations (*Carta apologética en que se vindia la obra que se está haciendo en la Lonja de Sevilla*, Seville, 1786). Documents concerning Herrera's designs and an account of the building are given by José Gestoso y Pérez, *Sevilla Monumental y artistica: historia y descripción de todos los edificios notables, religiosos y civiles que existan actualmente en esta ciudad y noticia de las preciosidades artísticas y arqueológicas que en ella

se conservan*, 3 vols., Seville, 1892 (reprint Seville, 1984), vol. 3, 214–35. See also Luis Cervera Vera, 'Juan de Herrera diseña la Lonja de Sevilla,' *Academia*, 52, 1981, 162–184; C. Méndez Zubiría, 'La Casa Lonja de Sevilla,' *Aparejadores*, Seville, 1981, 11–15; and the discussion by Agustín Bustamante and Fernando Marías in Madrid, Biblioteca Nacional, *Dibujos de arquitectura y ornamentación, Siglos XVI y XVII*, ed. Elena Santiago Páez, Madrid, 1990, cat. no. 52, 33–4, who cite additionally Ana Marín Fidalgo, *El Alcázar de Sevilla bajo los Austrias*, vol. 2, Sevilla, 1990 (which I have not seen); and Alonso Pleguezuelo Hernández, 'La Lonja de mercaderes de Sevilla: de los proyectos a la ejecución, *AEA*, LXIII, 1990, 15–42.

49 Document in AHP, Pedro de Salazar, prot. 911, fol. iijUxxj; 'vltimamente hizo vno por el qual, por mandado de su Magestad, se va haziendo y fabricando la dicha Lonja' published by Cervera Vera, 'Juan de Herrera diseña la Lonja de Sevilla,' 162–84.

50 Minjares was appointed to the works in both Granada and Seville on 19 November 1583 as reported by Earl Rosenthal, *The Palace of Charles V*, 132, n. 18 (citing AGP, Sección Casas Reales, vol. 162, años 1582 a 1656, fol. 13r and 13v and doc. 133, 294). He was assisted in Seville by Alonso de Vandelvira, who may have designed the remarkable series of vaults in the second story rooms. The little that is known about Alonso is summarized in Alonso de Vandelvira, *Tratado de arquitectura de Alonso de Vandelvira*, 2 vols., ed. and introduction by G. Barbé-Coquelin de Lisle, Albacete, 1977, 1. About 1611 Miguel de Zumárraga built the upper vaults and added more entrances to the façades.

51 The inscription reads in part: 'El Catholico y Mvy Alto y Poderoso Don Phelipe Segvndo Rei de las Españas Mando Hazer esta Lonja a Costa de la Vnibersidad de Los Mercaderes... en 14 dias de el mes de Agosto de 1598 Anos', quoted from J. Gestoso y Pérez, *Sevilla monumental*, vol. 3, 229. Construction was financed by a tax on the merchants' goods.

52 This aspect of the Exchange is described and integrated with other sevillian urban projects by Vicente Lleó Cañal, *Nueva Roma: mitologia y humanismo en el renacimiento sevillano*, Seville, 1979, 185–201.

53 J. Gestoso y Pérez, *Sevilla Monumental*, vol. 3, 215f.

54 Fernando Chueca y Goitia, 'Sobre Juan Bautista de Toledo y Juan de Herrera: Carta abierta a Javier Rivera, historiador de la arquitectura,' in *Herrera y el clasicismo*, Valladolid, 1986, 56–61, sees a greater Italianism in Herrera's architecture than is presented here.

55 Obelisks with similar tapering but plain were projected for the gates in the wall surrouding the park at the Escorial. See Matilde López Serrano, *Catálogo de Dibujos I, Trazas de Juan de Herrera y sus Seguidores para el Monasterio del Escorial*, Patrimonio Nacional Biblioteca del Palacio, Madrid, 1944.

56 See Pleguezuelo Hernandez, 'La Lonja' for citation of some of the relevant documents preserved in AGS and AGI, esp. leg. 1125. The administration appears to have intended until the last moment to go ahead with the timber work for the roof. In 1590 a carpenter, Melchior Gutiérrez, who was 'muy pratico en las moldes y contramoldes y obras de carpintería' was hired on 25 May. Alonso

Vandelvira was taken on as a second aparejador in November. Construction stalled after Minjares died in 1599. The administrators' decision in favor of stone vaults instead of the roof was taken on 7 September 1609 (fol. 184). Everyone was clearly more comfortable with the exposed cupolas, like those used at the adjacent cathedral, in spite of the fact that at least part of the wood had already been cut to size for the timberwork. I am preparing a separate study of the construction and restoration of the exchange.

6. The appropriation of the Escorial

1 See *Descripción de la Octava Maravilla del Mundo ... compuesto por el Doctor luan Alonso de Almela, médico, natural y vecino de Murcia, dirigido a la Real Magestad del Rey Don Felipe*, in *Documentos para la Historia del Monasterio de San Lorenzo el Real de El Escorial*, VI, P. Gregorio de Andrés, Madrid, 1962, 12–98. The bibliography of writings concerned with the Escorial has become too large to be included here. Sigüenza's history remains fundamental. A general bibliography of works to 1980 may be found in Kubler, (trans. as *La Obra de El Ecorial*, Madrid, 1982). See also Matilde López Serrano, 'Bibliografía Escurialense complemento (1963–1966),' *RABM*, LXXI, 1963, 485–95; and the comprehensive bibliography of the exhibition held at the BNM, *El Escorial en la Biblioteca Nacional, IV Centenario del Monasterio de El Escorial*, ed. Elena Santiago Páez, Madrid, 1986, 573–81, esp. essays by Agustín Bustamante and Fernando Marías, 'El Escorial y la cultura arquitectónica de su tiempo,' 115–220, and Elena Santiago Páez, 'El Escorial, historia de una imagen,' 221–366. John B. Bury, 'Juan de Herrera and the Escorial,' *Art History*, IX, 1986, 427–49, attributes the design of the main façade to Philip II. *Real Monasterio-palacio de El Escorial, Estudios inéditos en conmemoración del IV centenario de la terminación de las obras*, ed. Elisa Bermejo, Madrid, 1987, is an excellent collection of essays concerning the architecture and decoration of the Escorial (individual articles are cited in the following notes). The symbolic meaning of the Escorial and Herrera's role in shaping it has been much discussed. See René Taylor, 'Architecture and Magic: Considerations on the *Idea* of the Escorial,' *Essays in the History of Architecture Presented to Rudolf Wittkower*, ed. Howard Hibbard, New York, 1967, 82–109; Taylor, 'Hermeticism and mystical architecture in the Society of Jesus,' *Baroque Art: The Jesuit Contribution*, New York, 1972, ed. Rudolf Wittkower and B. B. Jaffe, 63–97. Maria Calí, *Da Michelangelo all' Escurial: momenti del dibabattito religioso nell'arte del cinquecento*, Turin, 1980, expands Taylor's interpretation and explores aspects of the relation to the Counter-Reformation articulated earlier by Romeo di Maio, *Michelangelo e la Contrariforma*, Rome and Bari, 1978. Cornelia von der Osten Sacken, *San Lorenzo el Real de el Escorial. Studien zur Baugeschichte und Ikonologie* (1979) *El Escorial Estudio iconológico*, trans. María Dolores Abalos with an introduction by Alfonso Rodríguez G. de Ceballos, Madrid, 1984, modifies these interpretations. Most recently Fernando Marías, 'El Escorial de Felipe II y la sabiduría divina,' *Annali di architettura, Revista del Centro Internazionale di Studi di Architettura 'Andrea Palladio'*, I, 1989, 63–76, examines the relation between Vitruvian classicism and theories of proportion in the Escorial.

See Gregorio de Andrés, 'Inventario de documentos sobre la construcción y ornato del Monasterio del Escorial,' *AEA*, 1972–9 for a guide to documents. Matilde López Serrano, *Trazas de Juan de Herrera y sus seguidores para el Monasterio del Escorial*, Madrid, 1944, is the basic reference for the collection of Herrera's existing drawings now in the collections of BPM.

2 Juan de San Gerónimo, *Memorias de Fray Juan de San Gerónimo, monge que fué, primero de Guisando, y después del Escorial sobre varios sucesos del reinado de Felipe II* in *Colección de Documentos inéditos para la historia de España*, vol. VII, ed. M. Salvá and P. Sainz de Baranda, Madrid, 1845 (reprinted Madrid, 1985).

3 Fray Antonio de Villacastín (1512–1603) was a lay brother, *obrero mayor* at the Escorial, and representative of the monastic community in the building operations from the beginning of construction to the end. His account was published by P. Julián Zarco Cuevas, *Memorias de Fray Antonio de Villacastín, Documentos para la Historia del Monasterio de San Lorenzo el Real de El Escorial*, I, 2nd edn, Madrid, 1985.

4 'Descripción de la Octava Maravilla del Mundo compuesto por el Doctor Iuan Alonso de Almela, 40: 'Andase en la altura de los 30 pies, como está dicho, toda esta gran máquina, como lo reprsenta curiosamente el excelente y genial arquitecto de Su Magestad, Juan de Herrera.'

5 Hugh Trevor-Roper, *Princes and Artists: Patronage and Ideology at Four Habsburg Courts 1517–1633*, New York, Hagerstown, San Francisco, and London, 1976, 54. This is also the view of Luis Cervera Vera, 'Semblanza de Juan de Herrera.'

6 Sigüenza, *La Fundación*, discurso 12f, quotes the letter of foundation as a preamble to the cleronological account of the program and building. He reports that Philip II had approached the Hieronymites in 1561 when he invited several monks to participate in the choosing of the site and design of 'the monastery of Saint Lawrence that We wish to build and which has been received into your order.' See also Fray San Gerónimo, *Memorias*, 11f.

7 The significance of the battle has been much debated but there is now general agreement that the dedication to St Lawrence was commemorative of the victory and did not otherwise determine the program. On the foundation see especially: *Documentos para la historia del Monasterio de San Lorenzo El Real de el Escorial*, vol. II, ed. Julián Zarco Cuevas, Madrid, 1917, which includes the letter of foundation, 'Carta de Privilegio y Merced, otorgada por el Católico Rey Don Felipe, Segundo de este Nombre en 8 Abril de 1565, a favor de El Escorial,' 191–202, and other documents pertaining to the program; Luciano Rubio, 'Cronología y topografía de la fundación y Construcción del Monasterio de San Lorenzo el Real,' *Monasterio de San Lorenzo el Real el Escorial. En el cuarto centenario de su fundación, 1563–1963*, Biblioteca La Ciudad de Dios, vol. 10, El Escorial, 1964, 11–70; F. J. Campos Fernández de Sevilla, 'Carta de Fundación y Dotación de San Lorenzo el Real, 22-iv-1567,' *Real Monasterio de El Escorial: Estudios en el IV Centenario de la terminación del Monasterio de San Lorenzo el Real de El Escorial*, San Lorenzo El Escorial, 1984, 295–382; and, in the same volume; Luciano Rubio, 'El Monasterio de San Lorenzo el Real I: Ideales que presidieron la fundación. II: Su Estilo,' 223–93. It is not clear when exactly Philip decided to include the mausoleum in the program. William

Eisler in an article to appear in the *Journal of the Society of Architectural Historians* suggests that the king intended to use the Capilla Real in Granada, although Fernando Marías in a paper delivered at a Colloque at the Centre des Etudes Supérieurs de la Renaissance, Tours, 1989, argued that the mausoleum was intended from the beginning.

8 This theme was brilliantly treated by Fernando Chueca Goitia, *Casas reales en monasterios españoles*, Madrid, 1966. See also the discussion by van der Osten Sacken, *El Escorial, Estudio Iconológico*, 121ff.

9 Charles chose Yuste in 1548, when he was already planning his abdication and the building was extensively remodelled under his son's direction in the 1550s. Apartments were refurbished for the emperor, including a bedroom arranged so that he would be able to observe the mass, a feature which was repeated at the Escorial. Charles also brought his books and favorite paintings with him, as Philip II was later to bring them and much of his own collection to the Escorial. For a comparison of the two programs see Juan José Martín González, 'Yuste y El Escorial,' *Monasterio de San Lorenzo el Real El Escorial en el cuarto centenario de su fundación 1563–1963*, Biblioteca Ciudad de Dios, vol. 10, *Real Monasterio de El Escorial*, 1964, 99–123; and, by the same author, 'El Palacio de Carlos V en Yuste,' *AEA* XXIII 1950, 27–51 and 235–51, and XXIV 1951, 125–40.

10 See Chueca Goitia, *Casas reales*. Sigüenza, *Historia*, described both Belem (libro primero, XVII, 69–74) and San Miguel de los Reyes in Valencia (libro primero, XXXII–XXXIIII, 127–39) at length and brought out their similarity to the Escorial.

11 Sigüenza, *La Fundación*, parte I, discurso I, 12: 'Entendiendo con esto cuanto sea delante de Dios pía y agradable y grato testimonio y reconocimiento de los dichos beneficios el edificar y fundar iglesias y monasterios, donde su santo Nombre se bendice y alaba, e su santa fe con la doctrina y ejemplo de los religiosos siervos de Dios se conserva y aumenta, y para que asimismo se ruegue e interceda a Dios por nos e por los Reyes nuestros antecesores y sucesores e por el bien de nuestras ánimas e la conservación de nuestro estado real, teniendo asimismo fin e consideración a que el Emperador y Rey mi señor y padre, después que renunció en mí estos sus Reinos e los otros sus estados, e se retiró en el monasterio de San Jerónimo de Yuste, que es de la Orden de San Jerónimo, donde falleció y está su cuerpo depositado, en el codicilo que últimamente hizo nos cometió y remitió lo que tocaba a su sepultura, y al lugar y parte donde su cuerpo y el de la Emperatriz y Reina mi señora y madre habían de ser puestos y colocados, siendo cosa justa y decente que sus cuerpos sean muy honorablemente sepultados, e por sus cuerpos sean muy honorablemente sepultados, e por sus ánimas se hagan e digan continuas oraciones, sacrificios, conmemoraciones e memorias. E porque otrosí nos habemos determinado, cuando Dios Nuestro Señor fuere servido de nos llevar para sí, que nuestro cuerpo sea sepultado en la misma parte y lugar, juntamente con el de la serenísima Princesa doña Maria, nuestra muy cara y muy amada mujer, que sea en gloría, e de la serenísima Reina doña Isabel, nuestra muy cara y muy amada mujer, que asimismo tiene determinado...de se enterrar juntamente en el dicho monasterio, e que sean trasladados los cuerpos de los Infantes don Fernando y don Juan, nuestros hermanos, e de las Reinas doña Leonor e doña María, nuestras tías...Por la

cuales consideraciones fundamos y edificamos el monasterio de San Lorencio el Real, cerca de la villa de El Escorial, en la diócesis y Arzobispado de Toledo; el cual fundamos a dedicación y en nombre del bienaventurado San Lorencio, por la particular devoción que, como dicho es, tenemos a este glorioso santo. Y en memoria de la merced y victorias que en el día de su festividad de Dios comenzamos a recibir. E otrosí, le fundamos de la Orden de San Jerónimo, por la particular afección y devoción que a esta Orden tenemos, y le tuvo el Emperador y Rey mi señor. E además desto, habemos acordado instituir y fundar un colegio en que se enseñen y lean las Artes y santa Teología, y que se críen e instituyan algunos niños a manera de Seminario, etc. Todas las cuales obras esperamos en Dios serán para su santo servicio, e de que se conseguirá y resultará mucho fruto e beneficio al pueblo cristiano, etc.'

12 There was a precedent for a college in the unrealized program for the Hieronymite monastery of San Miguel de los Reyes in Valencia which Chueca Goitia, *Cases reales*, 188–93, has rightly called a 'true prefiguration of the Escorial.' Founded by Fernando, Duke of Calabria, and his wife Germaine da Foix in 1538 as a burial foundation, it included a college and magnificent library, although the college was never established. San Miguel de los Reyes did not include a palace. Sigüenza, *Historia*, is the main source for the program, but see also the contract with Alonso de Covarrubias for the monastery and church in AHN, cod. 443B, 'Historia de la fundación del monasterio Bernardo e Institución en su lugar del de San Miguel de los Reyes....'

13 This is discussed by von der Osten Sacken, *El Escorial*, 92–6, who does not, however, relate the college to changes in plans. For the college's regulations see Miguel Modino de Lucas, 'Constituciones del Colegio de S. Lorenzo el Real,' *Documentos para la historia del Monasterio de S. Lorenzo*, V, 129–225.

14 See Sigüenza, *La Fundación*, parte I, discurso V, 34f, and discurso VIII, 58–61.

15 The ecclesiastical jurisdiction over these institutions is discussed by G. del Estal, 'El Escorial en la transición de San Jerónimo a San Agustín,' *Monasterio de San Lorenzo el Real El Escorial. En el cuarto centenario de su fundación 1563–1963*, Biblioteca 'La Ciudad de Dios', I, El Escorial, 1964, 561–615, esp. 568–78.

16 Quoted by Fray Juan de San Gerónimo, *Memorias*, VII, 39.

17 See construction history in Kubler, 60f. The collection of documents published by Portables *VA* and *MM*, are still indispensable, although much new material was added and many of Portables' assertions corrected in the excellent study by F. Iñiguez Almech, *Las Trazas del Monasterio de S. Lorenzo de el Escorial*, Madrid, 1965. A recent survey of the design history with new documentation by Javier Rivera Blanco, *Juan Bautista de Toledo y Felipe II: la implantación del classicismo en España*, Valladolid, 1984, 285–317, attributes virtually all designs to Juan Bautista. See further discussion in Javier Rivera Blanco, 'De Juan Bautista de Toledo a Juan de Herrera,' *Herrera y el Classicismo, Ensayos, catálogo y dibujos en torno a la arquitectura en clave clasicista*, Valladolid, 1986, 69–83, a response to Fernando Chueca Goitia, 'Sobre Juan Bautista de Toledo y Juan de Herrera,' in the same volume, 56–61, and Fernando Marías, *El Largo siglo XVI, conceptos fundamentales en la*

historía del arte español, Madrid, 1989, 518ff.

18 See Iñiguez Almech, *Las Trazas*, 13–16. Fray Juan de San Jerónimo quotes two letters, written in November 1561, requestion plans of existing buildings (*Memorias*, 11ff).

19 The same disposition of courtyard, stairs, and chapel occurs at the palace of the kings of Mallorca in Perpignan in the fourteenth century, in an early design by Alonso de Covarrubias for Tavera's hospital of St John the Baptist in Toledo, at the palace at Viso el Marqués, and at the Alcázar in Toledo.

20 Sigüenza, *La Fundación*, parte II, discurso XII, 306: 'Porque tal fue el intento de su dueño: hacer una hermosa capilla para oír los oficios divinos done se pudiesen celebrar misas y sacrificios en grande número y donde, como en capilla real, no pudiesen entrar indiferentemente todos.'

21 Passages quoted from Sigüenza, *La Fundación*, parte I, discurso IV, 30f: 'Pretendió el Rey hacer una casa para cinquenta religiosos no más, y junto con ella otra casa para sí, donde se aposentasen suficientemente no sólo el y La Reina y otras personas reales, sino sus caballeros y damas; en medio de estas dos casas había de ponerse el templo, donde concurriesen unos a celebrar el oficio divino y otros a oírlo; para esto dividió el arquitecto Juan Bautista el cuadro o cuadrángulo en tres partes principales: la de en medio quedó para el templo y entrada general. El lado que mira al Mediodía dividió en cinco claustros, uno grande y cuatro pequeños, que juntos fuesen tanto como el grande. La otra parte tercera dividió en dos principales: en la una hizo el aposento para damas y caballeros, y la otra quedó para que sirviese de oficinas a la Casa Real y al convento, cocinas, caballerizas, graneros, hornos y otros menesteres, y en la parte que mira al Oriente sacó fuera de la línea y fundamentos, que vinieron corriendo de Norte a Sur, la casa o aposento real, para que abrazasen por los dos lados la capilla mayor de la iglesia y pudiesen hacerse oratorios y ventanas que estuviesen cerca del altar mayor. Esta es así en común la primera planta del edificio que trajo Juan Bautista, que hace poca diferencia de la de ahora; la montea se trocó mucho, porque los cuatro cuadros o claustros no tenían más de un suelo levantado y de un alto y con sólo dos órdenes de ventanas por de fuera, y el claustro grande tenia tres órdenes, aunque las unas eran fingidas, y en el remate del claustro grande, porque las agujas de los tejados no eran iguales hacía dos torres, de suerte que, fuera de las cuatro torres de las esquinas que, se ven ahora, tenía otras dos: una en medio del lienzo del Mediodia, que dividía el claustro grande de los cuatro pequeños, y otra, en el lienzo del Norte, que dividía la casa de los caballeros de las oficinas comunes. Sin éstas tenía otras dos torres a la entrada principal de toda la casa en el lienzo de Poniente, y otras dos a los lados de la capilla, mayor de la iglesia, que caían sobre el aposento real, donde se habían de poner las campanas, como se ve en la traza y modelo de madera que hoy se guarda en este convento.'

22 Sigüenza, *La Fundación*, parte I, discurso III, 21f: speaking of events in the spring of 1562, noted: 'De allí a pocos días tornó Su Majestad, acompañado con los mismos que arriba dijimos, trayendo consigo a su Arquitecto, Juan Bautista de Toledo, que tenía ya hecha la planta de los principales miembros del edificio, aunque se fue siempre puliendo y mejorando, procurando se pusiesen lo mas acomodado a los usos y menesteres,

que es dificultoso acertar de primera vez tantas cosas.'

23 These events summarized by Kubler, 62–71.

24 Sigüenza, *La Fundación*, parte I, discurso IV, 30, quoted above n21.

25 Sigüenza, *La Fundación*, parte I, discurso IV, 31: 'Parecióle luego al Rey que no igualaba esta traza a sus deseos, que era cosa ordinaria un convento de San Jerónimo de cinquenta religiosos, y que conforme a sus intentos y la majestad del oficio divino que pretendía resplandeciese aquí y para las memorias que se habían de hacer por sus padres era pequeño número, acordó que fuesen los religiosos ciento, y el convento fuese el más ilustre que hubiese en España, no sólo de religiosos de San Jerónimo, sino de las ordenes monacales'. The need for additional monks, although not for twice as many, might be logical had Philip only just decided to bury his parents at the Escorial. Were this the case, however, Sigüenza would have known and he presents the memorial as present from the outset.

26 Noted by Kubler, 65. Sigüenza, *La Fundación*, parte I, discurso IV, 31, attributed the solution to Antonio de Villacastín.

27 Quoted from the correspondence of Juan de Huete and Philip II reprinted in M. Modino de Lucas, 'Los Priores de La Construcción de San Lorenzo en Su Correspondencia con el Rey y Sus Secretarios,' *Monasterio de San Lorenzo el Real El Escorial, en el cuarto centenario de su fundación 1563–1963*, 237, citing AGS, CS, El Escorial, leg. 2, fol. 87.

28 J. de San Gerónimo, *Memorias*, 35, reports that Pope Paul IV (1555–9) had issued a bull to annex the Augustinian abbey of Párraces to the city of Madrid, and perhaps the king originally planned to put the college in the capital. The king's instructions published by Portables, *MM*, 178, citing AGS, CS, El Escorial, leg. 2, July 1564 suggest that the college was the issue: 'Este patio que el Prior señalaua para el Collegio, se mire si sería mejor para esto, o para ospederia, y el otro que esta mas çerca del convento, para estudio, creo que todavia sera mejor para estudio por hauer en el lugar para mas çeldas que en el otro, y en este caso a la parte del Poniente podría hauer la Aula para leer las liçiones por que allí sera mas clara y alguna çelda, y a la parte del Norte el Refitorio de los estudiantes y otros seruiçios, y en los entresuelos sobre esto çeldas para ellos con vna escalera donde esta en la traça para subir a ellas y a la torre que alli ha de hauer, y desde ella paso por ençima de la puerta prinçipal del primer patio al andar de los entresuelos.' In another memorandum written about the same time in the same collection (177f), the king listed the points concerning the new plan that he wished explained to the prior so that the latter could respond. He noted however that 'De lo que toca a la libreria y capitulo, pareçe que no hay que tratar pues no se pueden poner en mejor parte de la que estan ni pueden ser mas claras y alegres pieças, y le falta de Cappillas (de mas de que en la iglesia avra y puede hauer muchos altares) se puede suplir haziendo doz por donde agora estaba traçada la roperia....' Other exchanges between the king and the prior, see Portables, *MM*, 171–91.

29 Portables, *MM*, 175f, citing AGS, CS, El Escorial, leg. 6, from the prior 15 July 1564: 'se entienda como en lo que agora esta edificado, no se haze ni ha de aver mudança ni mas estension de sitio del cuadro de toda la casa que esta definado desde el principio.'

30 That the frontal section derives from Antonio Averlino il Fllaratte's plan for the Ospedale

Maggiore in Milan, begun in 1456, was first pointed out by Secundino Zuazo Ugalde, 'Antecedentes arquitectónicos del Monasterio de El Escorial,' *El Escorial 1563–1963, IVo Centenario*, vol. 2, 105–54; and *Los Orígenes arquitectónicos del Real Monasterio de San Lorenzo del Escorial*, Madrid, 1948.

31 The revisions are usually treated as a purely architectural problem (e.g. by Kubler, 64–6, and Iñiguez Almech, *Las Trazas*, 16–40). Juan de Huete's activities are discussed by M. Modino de Lucas, 'Los priores de la construcción de San Lorenzo', 217–45 (see n. 27 for full reference) who, in contrast to most writers, recognized the prior as instigating the expansion. Juan Bautista's marginal position at this point becomes understandable. The problem was an institutional one and the king needed to negotiate directly with the prior. Some of the documents are published and discussed by Portables, *MM*, 53–61, and *VA*, documentos, apéndice núm. 2, cxliv–clvii. The Hieronymites were given authority over the whole at the end of the reign when the king allowed the prior to appoint professors to the college from his own order. See the codicil to Philip II's testament of 15 August 1598 in *Documentos para La historia del monasterio de San Lorenzo. El Real de El Escorial*, ed. J. Zarco Cuevas, vol. II Madrid 1917, 52, 62. For the organization of the college see P. Miguel Modino S. A., 'Constituciones del Colegio de S. Lorenzo el Real dadas por Felipe II en el año 1579,' *Documentos para la historia del Monasterio de San Lorenzo*, vol. V, El Escorial, 1962, 9–15.

32 Sigüenza, *La Fundación*, parte I, discurso V, 33f, introduces his discussion of the college in an equivocal fashion, stressing the complexity of the king's institution: 'Las fábricas grandes tienen partes y miembros grandes, y no se pueden dejar en olvido sin hacerles agravio. En ésta hay mucho de esto, porque, dejada aparte su grandeza, es un agregado o junta de tantas cosas y una mezcla tan nueva, que no sé ejemplo ninguno de los antiguos y modernos con quien compararlo ni de dónde tomar estilo. Así tambien voy procediendo de una manera desusada, guardando, por una parte la leyes de historia, que pide se cuenten las cosas como fueron sucediendo, y, por otra, tengo necesidad de adelantarme y de posponerme y hacer del pintor y del arquitecto, salir a cosas de Palacio y retirarme a la Iglesia, pasarme a las casas reales y recogerme en el coro, tocar las cosas de las armas y acudir luego a las letras, Como saldré de tantos laberintos? No sé. Procuraré, a lo menos, que no quede cosa entrincada ni oscura, así para mis religiiosos, a quien paticularmente enderecé esta historia desde sus principios... Dije que desde sus principios tuvo intento nuestro gran Fundador en que esta su casa hubiese ejercicio de letras, no sólo humanas y filosóficas, sino tambien teológicas, así de las que se llaman de escuelas como de las positivas y Escrituras Sacra.' The prior, Juan de Huete, was less accepting and seems to have blamed the architect, Juan Bautista, for what he considered poor planning. On 23 August 1564 he wrote to the king's secretary: 'Vna cosa quiero que V. md entienda y es que aunque Juan Bautista sea quien a gran oficial como es y si supiese el solo lo que todos los artifices Romanos supieron no podra alcançar las particulares cosas que en vn monesterio son necesarias ni como ni en que lugar ni con que seruicios ni los inconvenientes que puede aver en yr de vna manera o de otra, y desseo yo mucho,

aunque no lo espero ver questa obra que Su Magd, manda hazer y haze pues ha de ser el mas señalado edificio que haya entre cristianos y como de mano y orden de tan grande y soberano Principe que tambien en el repartimiento y pieças del no hallase nadie en que poner defecto sino que todas las cosas estuviesen tan en orden y en sus proprios lugares que pareciese que ni ay superfluo ni cosa que parezca falta…' (quoted from Portables, *MM*, 190, citing AGS, CS, Escorial, leg. 2, fol. 102.)

33 On Juan Bautista's role see Carlos Vicuña, 'Juan Bautista de Toledo, principal arquitecto del Monasterio de El Escorial,' *Monasterio de San Lorenzo el Real*, vol. 2, 71–97 and 125–93; Kubler, 20–2; and more recent discussion by Rivera Blanco, *Juan Bautista de Toledo*.

34 Quoted from Herrera's memorandum to Mateo Vazquez, published by Llaguno, vol. 2, XXII, no. 10, 335f: 'Demas desto el haber sido instrumento para que S. M. haya ahorrado de hacienda de la fábrica de Sant Lorenzo cerca de un millión, fuera de lo que merece el haber dado medios para que S. M. haya visto en sus felicísimos dias acabada la dicha fábrica, que esto no tiene precio, y las otras cosas que á V. por escrito teengo representado, que son de harto momento.'

35 Sigüenza, *La Fundación*, parte I, discurso XII, 95 quoted above chap. 3, n. 3; and II, discurso I, 199 describes Herrera as 'discípulo del primero [Juan Bautista] y el que ejecutó lo principal vasta el cabo'; and parte II, discurso III, 218f: 'Dije al principio (si no me acuerdo mal) que la planta de este edificio, que es de Juan Bautista de Toledo, que despues se alteró en muchas cosas por Juan de Herrera y fray Antonio de Villacastín, se parte en cinco partes principales.

36 Llaguno, vol. 2, XXII, no. 10, 332f: 'Copia de una memoria original, que Juan de Herrera envió á Mateo Vazquez.': 'Habiendo muerto Juan Baptista de Toledo, y no dejando declaracion ni traza de los tejados de los cuartos de S. Lorenzo, y habiéndose mandado hacer á Gaspar de Vega un modelo de los dichos tejados, costosísimos de hacer y de sustentar, yo dí orden y forma para los hacer con la menos costa posible y con que el edificio quedase mas hermoso y provechoso; y en que se ahorraron pasados de doscientos mil ducados.'

37 The roofs are considered Herrera's work by Kubler, 26, but Portables, *MM*, 79–83, questions this, citing the note of 19 March 1568 from the king to his secretary: 'En boluiendo Gaspar de Vega será menester determinar esto de los tejados, y antes que nada sera menester que vos lo tomeis y hagais vn guion sobrello por que suele algunas vezes ser vn poco allegado a su parescer entre tanto por ganar tiempo he dicho a Herrera que haga un modelillo.' Gaspar de Vega was concerned with the construction of the roofs through the summer of 1568 and apparently until 1570, but, given Herrera's assertion to the king, he must have been building them according to Herrera's designs. John Bury, 'Juan de Herrera and the Escorial,' argues that Herrera designed the roofs and tabernacle but nothing else.

38 In 1584 Herrera was writing to the king about money and asking for compensation for services beyond the normal duties of his position for which he was officially employed and recieved a substantial salary. Jacopo da Trezzo wrote a similar plea when he finished the tabernacle for the main altar. Philip II's servants often wrote memoranda asking for more money, but it was accepted procedure to ask for special compensation when a project was finished or when one was leaving royal service.

39 The drawings of the main façade were published and attributed to Juan Bautista de Toledo by Ruiz de Arcaute, facing 17 and facing 32, and are discussed by Iñiguez Almech, *Las Trazas*, 44f, 127 n83, and fig. 6. Kubler, 95, accepts the attribution to Juan Bautista. Rivera Blanco, *Juan Bautista de Toledo y Felipe II*, 312, however, considers the drawings as possibly by Paciotto or some other, unknown, architect.

40 See, for example, the reconstructions of Juan Bautista's first design by S. Zuazo Ugalde, *Los Orígenes*, cited in n30 above.

41 Construction dates in Kubler, 95ff. Specifications for the building of the present façade were drawn up in 1573 but the contracts for work were not prepared until 1576. The façade itself was one of the last sections of the building to be built since the center section on the west was left until after the construction of the basilica, so that stone could be conveniently hauled inside the complex. This is shown in the Hatfield drawing dated by Kubler to c. 1576 (79, n21; see also below n86).

42 Sigüenza described the central portal as 138' wide backed by the pavilion 230' across and set into a façade 640' long. (parte I, discurso I, 199–206)

43 Construction dates in Kubler, 74–5, and Iñiguez Almech, *Las Trazas*, 56–8. Pedro Navascués Palacio, 'El Patio y templete de los Evangelistas de El Escorial,' *Real monasterio-palacio de El Escorial. Estudios inéditos en el IV Centenario de la terminación de las obras*, Madrid, 1987, 61–74, presents evidence for Juan Bautista's authorship, discusses the Spanish antecedents for the courtyard, and notes the similarity of the fountain to a garden pavilion. On the symbolic significance of the fountain see also George Kubler, 'The Claustral "Fons Vitae" in Spain and Portugal,' *Traza y Baza*, II, 1972, 7–14.

44 In an anguished letter to the king, Juan Bautista protested that the monks wanted 'to take the cloister out of my hands and out of the hands of my assistants' and that they were 'going to give it over to a bunch of ignorant people to build' (document in Portables, *MM*, XLIV). See my 'Building from Drawings at the Escorial,' cited above, ch. 4 n20, for discussion.

45 See my *The Hospital of Cardinal Tavera in Toledo*, PhD dissertation, Yale University, 1968, and 'The Escorial and the Invention of the Imperial Staircase,' *AB*, LVII, 1975, 65–90, for discussion of the Escorial and its sources in earlier Spanish designs; and Fernando Marías, 'La Escalera imperial en España,' in *L'Escalier dans l'Architecture de la Renaissance*, ed. A. Chastel and J. Guillaume, Paris, 1985, 165–70. See also my ibid., 153–60.

46 Covarrubias's imperial design for San Miguel de los Reyes is reconstructed in my *Hospital of Cardinal Tavera*, and in F. Marías', article noted above. Reconstructions are based on the description that accompanied the plans for the building in 1545 in AHN, cod. 443B.

47 See Juan de Herrera, *Sumario y Breve declaraciõ delos diseños y estampas de la Fabrica de san Lorencio el Real del Escurial*, Madrid, 1589, reprinted as separate booklet by Luis Cervera Vera, *Las Estampas y el sumario de el Escorial por Juan de Herrera*, Madrid, 1954; BNM, *El Escorial*, C1a, 244; and Brown Unversity, *Philip II and the Escorial*, cat. 1, 16. The final design was attributed to the Italian fresco painter and architect, Giovanni Castello el Bergamasco, who was then working for Philip by de Sigüenza (*La Fundación*, parte II, discurso IV, 228f). Given Sigüenza's knowledge of the building, his attribution cannot be rejected casually; nevertheless Bergamasco was not regularly employed as an architect by Philip, and his staircases for other patrons in palaces in Genoa and at Viso del Marqués in Spain, while influenced by Covarrubias's designs, have closed, frescoed stair-wells in the Italian tradition, so that even if Bergamasco invented the flight plan of the Escorial's staircase before his death in 1569, he is unlikely to have conceived the present composition. Iñiguez Almech, *Las Trazas*, considered the final staircase to be by Herrera, but both Bury, 'Juan de Herrera and the Escorial,' 440ff, and Rivera Blanco, *Juan Bautista de Toledo*, 312–14, support the attribution to Bergamasco. Fernando Marías, *El Largo Siglo XVI*, Madrid, 1989, 542, plausibly identifies the work taken down in 1571 with a project by Bergamasco but attributes the final design to Herrera.

48 Sigüenza, *La Fundación*, parte II, discurso V, 242f: 'A muchas les pesa ver este templete en medio de este claustro, porque, como es tan grande, que tiene de ancho y de diámetro trienta pies, y sube tan alto, que iguala con los pasamanos y balustres del claustro, ocupa mucho la vista, embaraza y aun apoca la majestad del claustro, y, lo que es peor, que no tiene uso ni fruto. Lo que principalmente se ha de mirar aun en los adornos de las fábricas, porque como los religiosos nunca tenemos libertad de hablar en los claustros sino con nuestra pena, fue cosa superflua hacer allí un parlatorio, y para los seglares peor, porque, como hablan sin recato, turban nuestro silencio. Y pásase mucho tiempo que no llega allí un religioso ni lo ve, y así está casi perdido sin uso.'

49 Sigüenza, *La Fundación*, parte II, discurso V, 243.

50 P. Navascués Palacio, 'El Patio y Templete de los Evangelistas de El Escorial,' in 61–74, has drawn attention to the parallels between Herrera's fountain and garden pavillions. On the Retiro see Jonathan Brown and J. H. Elliott, *A Palace for a King*, New Haven and London, 1979, 77–81.

51 Design history discussed by Iñiguez Almech, *Las Trazas*, and Kubler, 95–7, who draws attention to Alessi's forecourt for Santa Maria presso San Celso in Milan. Early Christian examples are discussed by Richard Krautheimer, *Early Christian and Byzantine Architecture*, Baltimore, 1965.

52 The Italian text was published by Vera Daddi-Giovannozzi, 'L'Accademia fiorentina e l'Escuriale,' *Revista d'Arte*, second series, VII, 1935, 423–7. See also Iñiguez Almech, *Las Trazas*, 74ff. The relevant question put to the Academy was: 'Se il cortile dinanzi la chiesa cosí lungo sta bene, et se le logge intorno, non potendosi alzre piü da quindici incirca, possono stare seza difetto,' to which they replied: 'Sopra il primo dubbio l'Accademia delibera che il cortile della pianta A sta male, mala proporzione et le logge basse' (quoted from Iñiguez Almech, *Las Trazas*, 133f, n134).

53 Rivera has associated this with Hagia Sophia but it might also have been influenced by Michelangelo's early project for an oval tomb chamber of Julius II at St Peter's or by Vignola's Sant' Andrea in Via Flaminia in Rome. But Herrera was especially interested in Constantinople and owned a copy of Procopius's *On the Buildings of Justinian* and a manuscript description of the city (Cervera Vera, *Inventario*, cat. 720, 736) which may possibly have belonged to his master.

54 See Kubler, 47–51, and 'Francesco Paciotto,

Architect,' *Essays in Memory of Karl Lehmann*, ed. L. F. Sandler, New York, 1964, 176–89.

55 The section labelled 'C' was attributed to Juan Bautista with corrections by Herrera by Matilde López Serrano, *Trazas de Juan de Herrera*, 21f; by Iñiguez Almech, *Las Trazas*, 34, and Kubler, 62f.

56 See J. de San Gerónimo, *Memorias*, 25.

57 Llaguno, vol. 2, 310. On the importance of this Italian participation see Kubler, 52f. The exchange shows that leaders in the Italian architectural community were well informed. Spanish ideas had gone with the plans to Italy and, once in the hands of Vignola, may have stimulated Italians. Vignola's pupil, Francesco Capriani da Volterra's designs of the early 1590s for the church of the hospital of San Giacomo degli Incurabili in Rome show a sanctuary flanked by towers which may recall the early projects for the Escorial (see Heydenreich and Lotz, *Architecture in Italy 1500–1600*, 282ff). In northern Italy, Ascanio Vitozzi's final oval design with towers for the pilgrimage church and mausoleum of Savoy at Vicoforte di Mondovi, begun in 1596, is likely to have been influenced by the Escorial project (see Heydenreich and Lotz, *Architecture in Italy 1500–1600*, 301f). See also Alfonso Rodríguez G. de Ceballos, 'La planta elíptica, de El Escorial al clasicismo español,' *Anuario del Departamento de Historia y Teoría del arte* (Universided Autonoma, Madrid), II, 1990, 151–72.

58 J. de San Gerónimo, *Memorias*, 121.

59 Kubler, 48.

60 Both Herrera and Sigüenza compared the plan of the basilica to the *soto coro* as if they were twins of different sizes. The plan of the basilica is much less coherent at ground level where the *sotocoro*, light wells, and lateral spaces of the public church lack the simple geometry of the second story.

61 Kubler, 51f and 'Galeazzo Alezzi e L'Escuriale,' in *Galeazzo Alessi e del cinquecento*, ed. C. Maltese, Genoa, 1975, 599–603 has rightly stressed the influence of Alessi's plan for Santa Maria in Carignano in Genoa as well as the presence of other Italian elements.

62 Llaguno, vol. 2, XXII, no. 2, 274. See also L. Cervera Vera, 'Juan de Herrera y su aposento en la villa de El Escorial,' extract from *La Ciudad de Dios*, 1949, 1–31.

63 See A. Bustamante and F. Marías, 'El Escorial y la cultura arquitectónica de su tiempo,' *El Escorial en la Biblioteca Nacional*, 117–220. The same conclusion may be drawn from their reconstruction of the various proposals for the nave pilasters. It is not possible to say exactly what role Paciotto played in the formation of Herrera's personal style, but the façade of the Descalzas Reales in Madrid is relevant. Paciotto claimed to have designed the Descalzas, and his work at the fortifications of Lucca makes this plausible. Herrera's treatment of the basilica may reflect Paciotto's lost designs more fully than can now be proved.

64 Kubler, 42.

65 Taylor, 'Architecture and Magic.'

66 The reconstructions were engraved by Ian Wierix and Pieter Huys in *Biblia Poliglota*, vol. 8, ed. Arias Montano, Antwerp, 1572. Plantin's publication was partly financed by Philip. See *El Escorial en la Biblioteca Nacional*, cat. A52–A54, and Brown University, *Philip II and the Escorial*, cat. 18, 55.

67 Herrera later owned a manuscript copy of a treatise on the Temple of Solomon, probably Villalpando's (Cervera Vera, *Inventario*, 166, no. 644). Alfonso Rodríguez G. de Ceballos, 'Juan de Herrera y los Jesuitas Villalpando, Valeriani, Ruiz, Tolosa,' *Archivum Historicum Societatis Iesu*, XXXV, 1966, 1–37, provides important documentation on Herrera's relations with the Jesuits.

68 See the descriptions in J. de Herrera, *Sumario, of the retable* fols. 28–29r, 'G': 'Podio sobre que carga y esta assētado todo el retablo y custodia, o tabernaculo grāde. Todo este Podio es de jaspe cō algunos cōpartimētos de diuersos colores d jaspes, sobre el carga esta machina del retablo cuyas colunas son todas en isla cō sus pilastras detras dellas de jaspe verde y colorado, y las colunas todas son de jaspes colorados q̄ tira a leonado, los capiteles y vasas sō de metal dorado al fuego, los triglyfos y dēticulos y modilliones q̄ ay eneste dicho retablo, sō otro si de metal dorado, las metopas son d diuersos jaspes finissimos...' etc.

69 Ibid.: 'Esta Custodia es vna linda pieça, las quatro colūnas son de jaspes finissimos, los capiteles y basas destas colūnas son de oro y esmalte, los triglifos del friso q̄ circūda la Custodia, son otrosi de oro, y las metopas de esmeraldas, los pedestales sobre que cargā las colūnas son del mesmo jaspe q̄ ellos, y guarnecidos cō molduras de oro, las tres fajas q̄ estā debaxo delos pedestales son de plata dorada...etc.'

70 Stephen Orgel, *The Illusion of Power*, Berkeley, 1978, considers this exchange between real and fictional in the iconography of secular festivals.

71 Sigüenza writes (*La Fundación*, parte II, discurso XIV, 334f) that from the raised choir the altarpiece looks flat, its perspective corrections which increase the size of the figures in ascending order are unsettling, and the interior is too dark.

72 My thanks to Michael Mezzatesta for sharing with me his 'Charles V and the Tradition of Habsburg devotion to the Eucharist' which discusses the source of the funeral compositions in the Brussels windows, and 'The Leoni and Habsburg Iconography 1550–1600: Charles V, Augustus and the Eucharist' (in press).

73 To the left of the altar are the emperor Charles V, the empress Isabella, their daughter Maria and his two sisters, Queen Eleanor of France and Queen Maria of Hungary. On the right of the altar is the family group of Philip with his fourth wife Anna, his third wife, Elizabeth, and his first wife Maria, and son, Carlos.

74 Sigüenza (*La Fundacón*, parte II, discurso XIV, 342ff) gives the Latin texts, noting the inscriptions 'están hechos más al gusto del Rey, que tan amigo era de modestia, que no al sabor de la antigüedad.' The inscriptions for the empty spaces flanking the emperor read: 'Hunc locum siquis poster. Carol V. habitam gloriam rerum gestarum splendore superaveris, ipse solus occupato, caeteri reverenter abstineti' and 'provida posteritatis cura in liberorum nepotumque gratia atque vsum relictus locus post longam annorum seriem cum debitum naturae persolverint, occupandus,' while those corresponding to Philip read: 'Hic locus digniori inter posteros, illo qui vltro ab eo abstinuit, virtuti ergo asservatvr, alter inmunis esto' and 'solerti liberorum studio posteris post diutina spatia, ad vsum destinatus locus claris, quum naturae concesserint monumentis decorandus.'

75 J. de San Gerónimo, *Memorias*, 25 reported that, when the symbolic 'first stone' of the basilica was laid on 20 August 1563, three altars were set up in the eastern end of the future sanctuary. The central altar, with a large wooden cross, symbolized the future high altar. On either side was an altar with the cross of Charles V and another with the image of the Virgin. These three altars still appear in plans showing the Habsburg memorials which were executed during Herrera's regime.

76 In 1564, Philip began to concern himself with paintings for the altarpiece and ordered the *Martyrdom of Saint Lawrence* from Titian. See Annie Cloulas, 'Les Peintures du Grand Retable au Monastère de l'Escurial,' *Mélanges de la Casa de Velázquerz*, IV, 1968, 175–202. The king impatiently awaited the completion of this painting until late in 1567. Some design for the high altar must have existed at this time, since Titian had dimensions to work from.

77 An expressionless face was a sign of grace. Fray Juan de Bernal's sermon, preached in Seville, in connection with the esequies for Philip, printed in F. de Ariño, *Sucesos de Sevilla de 1592 á 1604*, Seville, 1873, 545f, describes the king's emblems: 'Un Angel con rostro cual el le tuvo, y por orla, *Nec benedictione, nec maledictione*. Ni con bendicion, ni con maldicion. Angel en la firmeza sin mudanza. O un leon coronado con letra, *Absque terrore*. Sin temor ni sobresalto. O pintamos un cielo sereno, que tal era la serenidad de su alma... Como cielo sereno, señal cierta que su alma era trono de el Rey de gloria...O pintemos un sol claro (que siempre ha sido simbolo de Reyes) con letra, *Manet sicut Sol*. Permanece como el Sol firme y sin mudanza, ó la que Dios tiene en sus armas. *Super bonos et malos*. Sobre buenos y sobre malos. Pues este Sol á todos hizo bien.'

78 See Juan de Herrera, *Sumario y Breve declaració delos diseños y estampas de la Fabrica de san Lorencio el Real del Escurial*, Madrid, 1589, reprinted as separate booklet by Luis Cervera Vera, *Las Estampas y el sumario de el Escorial por Juan de Herrera*, Madrid, 1954; BNM, *El Escorial en la Biblioteca Nacional*; Brown Unversity, *Philip II and the Escorial*; review article by John Bury, 'Philip II and the Escorial,' *Print Quarterly*, VIII, 1991, 77–82, and his 'Early Printed References to the Escorial,' *Iberia, Literary and Historical Issues: Studies in Honor of Harold V. Livermore*, ed. R. O. Goertz, Calgary, 1985, 89–106.

79 Herrera, *Sumario*, fol. 4: 'Por hazer participantes a los deseosos de saber la grandeza de la fabrica de san Lorecio el Real del Escurial he procurado, aunque con mucho trabajo y costa estampar la dicha fabrica en diuersos diseños hechos de muchas partes della, para q mejor y con mas claridad, veá todo lo q enella ay, y sus repartimietos. El primero es laplta baxa general de toda esta machina....'

80 Quoted by Sigüenza, *La Fundación*, parte II, discurso XIV, 338.

81 It may be translated: 'To Jesus Christ, priest and sacrificial victim, King Philip II dedicates this work [made] wholly of Spanish stone by Jacopo da Trezzo of Milan.' By contrast, Herrera's Latin appears to read: 'King Philip II by Jesus Christ sole protector of the common welfare dedicates to the Mother [this tabernacle made] according to the design of Juan de Herrera and the Spanish workmanship of Jacopo da Trezzo.' Whatever the defects of Herrera's composition, his addition of his own name is unambiguous: the three 'authors' of the tabernacle are the king, Herrera, and Jacopo da Trezzo, those responsible for its commission, design, and execution respectively. See Bury, 'early Printed References to the Escorial.'

82 Herrera's ninth (*Alzado del Sagrario del altar mayor*) and tenth plates (*Sección longitudinal del interior del sagrario*) are dated 1583; the eleventh

(*Planta del sagrario y la custodia* and *Alzado de la custodia*) is dated 1584. See Cervera Vera, *Las Estampas*; and BNM, *El Escorial en la Biblioteca Nacional*, 249f, C1, i, j, k.

83 Herrera could not claim the tabernacle as an 'extraordinary' service in the memorandum because, at the time it was undertaken in 1579, he had succeeded to Juan Bautista's position and was Philip's architect. Sigüenza, *La Fundación*, parte II, discurso XIV, 338: 'La invención y arquitectura es de Juan de Herrera; la labor y manos es de aquel excelentísimo escultor y lapidario Jacobo da Trezo.' The sequence of events after Juan Bautista's death supports this. In 1571, the king was negotiating with his representatives in Italy for a tabernacle, originally designed by Michelangelo, and then being executed by Jacopo del Duca in Naples. Philip hoped to use this on the main altar, but rejected it in 1578, after Herrera and Villacastín reviewed drawings of it. Herrera's tabernacle was begun immediately afterwards. See J. Babelon, *Jacopo da Trezzo et la construction de l'Escurial: essai sur les arts á la cour de Philippe II*, *Bibliothèque de l'Ecole des Hautes Etudes Hispaniques*, III, Bordeaux and Paris, 1922, 134–9.

84 Herrera called the tabernacle 'una de las mas raras pieças, que se han hecho en el mūdo de fabríca. Labrose con industria del excelēte scutor y lapidario Iacome de Trezzo, q̄ para tornear y sacar las pieças ... iñueto grādes diuersídades de machinas nūca vistas, y cō la industriā e ingenios dichos se a cabo en menos de 7 āños' (from the *Sumario*, commentary on the ninth plate).

85 It must be possible to get a view similar to Herrera's from a position on the slopes of mountains on the west in front of the building. On Dupérac see Henri Zerner, *Etienne Dupérac en Italie* unpublished thesis, Ecole Practique des Hautes Études, Paris, 1963 and later bibliography in Brown University, *Philip II and the Escorial* entries 47–49 by Christine Brown. For bibliography on the techniques used by cartographers and artists of topographical views see entries nos. 23 and 31 by Evelyn Staudinger Lane. See also Juergen Schulz, 'Jacopo de' Barbaro's View of Venice: Map Making, City Views and Moralized Geography Before the Year 1500,' *AB*, IX, 1978, 425–474; J. Schulz, 'Maps as Metaphors; Mural Cycles of the Renaissance,' in *Art and Cartography*, ed. David Woodward, Chicago, 1987, 97–122 and Richard Kagan, 'Philip II and the Geographers' and Egbert Haverkamp-Begemann, 'The Spanish viéws of Anton van den Wyngaerde,' in *Spanish Cities of the Golden Age*, ed. R. Kagan, Berkeley, less Angeles, London, 1990, 40–53 and 54–67 which deal with Philip's close involvement with map making generally and with his commission of views of Spanish cities from Wyngaerde.

86 The magnificent drawing now at Hatfield house has been variously attributed by Kulber to Fabricio Castello (79n21); L. Cervera Vera, 'Desarrollo y organización de las obras de San Lorenzo El Real de El Escorial,' in *Fábricas y orden constructiva*, Madrid, 1986, 19–81 to Juan de Herrera, but the striking originality of the work and its documentary significance have been brought out by Pedro Navascués de Palacio, 'La obra como espectáculo, el dibujo Hatfield,' in *Las casas Reales*; *El Palacio*, IV Centenario del Monasterio de El Escorial patrimonio Nacional, Madrid, 1986, 55–67. Navascués argues convincingly for northern authorship of the drawing. It is not impossible that some one connected with Esquivel's mapping

project, which passed to Herrera in 1577, might have made it.

87 The motto is from Sebastián de Covarrubias's *Emblemas morales*, no. 36, quoted in Santiago Sebastián López, 'El Escorial como Palacio emblematico,' in *Real Monasterio-Palacio del El Escorial*, 95–106. Contemporaries caught the meaning of the Escorial from the *Estampas*, especially from this print which was frequently copied, often with a commentary. The poem of Michael Van der Hagen, AD PHILIPPUM II HISPANIARUM ETC REGEM CATHOLICUM printed on the copy of the perspective view in 1591, verbalized Herrera's powerful visual equation between classicism and royal authority in an extended song of praise: 'He surpasses the pyramids, the aquaducts, the walls and amphitheatres that encircle renowned Rome.... But no ancient built this building. Rather it was Philip alone, the great king of Spain, surpassing all wonders. Not a mere building, but a monument such as all antiquity never saw. And no equal of this shall be. Generals of old, no doubt, having conquered someone, erected triumphal monuments out of wicked ambition, and placed the trophies they seized before their profane gods that the hornor of their deed might last through the ages. But this sole and true Defender of Apostolic Religion – a king ever mindful of his vow to piety – has long labored at endless acts of holy work, such that the Great One in this world has nothing greater than this ...' and it ends 'O happy order! O heart consecrated to God! There is nothing here but the bridge of the great Thunderer. A place terrible with the majesty of God; a place where there is majesty and magnificent generosity has poured out limitless riches.... Who shall sing of our king? And then of Spain? He alone has produced this marvel of the world. Blessed in spirit, may your power ever increase. O Philip the Invincible! and O blessed Madrid Which has never before had such great eminence at your gates!' We might compare this to an early Byzantine inscription: 'I am the Palace of the fam'd Anastastius/The Scourge of Tyrants; none surpasses me/In Beauty, and in wonderful Contrivance/When the Surveyors view'd my mighty Bulk/My Height, my Length, and my extensive Breadth/'Twas thought beyond the Reach of human Power/To roof at Top my widely gaping walls/But young Aetherius, ancient in his Art/This Building finish'd and an Offering made To our good Emperor ...'. quoted from Pierre Gilles, *The Antiquities of Constantinople*, trans. Ball, London, 1729, 136–7.

88 P. Francisco de los Santos, *Descripción breve del Monasterio de S. Lorenzo el Real del Escorial. Vnica maravilla del mvndo*, Madrid, 1657, fols. 8r, verso: 'La Perspectiua, qui significa la estampa, es la que haze la Fabrica, mirada desde la labera del Monte, que llaman de Malagon, que està superior à ella al Poniente. Desde alli se descubre toda, a semejança de aquella Ciudad del Apocalipsi, que con mas alta vision, y misteriosa perspectiua, se descubria puesta en Quadri. Vamos dando buelta a las quatro Fachadas exteriores, antes que entremos dentro.'

89 Op. cit., fol. 12r: 'Efecto de Architectura: Vense grandes Colunas, y intercolunios; Arcos siberuios; Estatuas Regias; fuertes Cornisamentos; ay rosas Pilastras; multiplicado ventanaje, en bien compartidos ordenes; y al fin vna mezcla de grandezas, que haze vn efecto estraño en la curiosidad de quien las mira. Nadie entra en este Patio, que no le suceda lo que quando impensadamente oye vna

ordenada musica de consonante armonia; y es, que la tiene aqui la Architectura, toca en la vista, como la Musica en el oydo, y causa vna gustosa suspension en el alma, que la recrea, ensancha, y engrandece; que estas cosas puestas en razon, arte, y medida, son muy de su fabrica interior, y simbolizan mucho con el espiritu, que fue criado para Templo de Dios.'

90 'Descripción de la Octava Maravilla del Mundo,' 22: 'Porque cierto es este santo edificio y casa tan regalada y de tanta admiración y contemplación que en suma es un paraíso terrenal, y no habrá hombre que entre en ella para verla y habitarla, por duro e indevoto corazón que tenga, que si contempla y con cuidado mira sus milagrosas partes, así de elegancia de edificio, como de variedad de devotísimos cuadros al óleo de varias historias por curiosísimos artífices pintadas, así del Testamento Viego como de Nuevo, como de otras santas contemplaciones de hermosos jardines, varias fuentes y muchas innumerables variedades de riquezas y ornamentos, que no diga entre sí mismo, con dulzura de su corazón:! Que sera, oh inmenso y misericordioso Dios, vuestra santa gloria del cielo, pues que tal se nos pudo pintar en el suelo!'

91 See Saturnino Alvarez Turienzo, *El Escorial en las Letras Españolas*, Madrid, Editorial Patrinonio Nacional, 1985, for selections from writers from the sixteenth to the twentieth century.

92 Only the royal Pantheon, below the main altar, can be considered a major later addition. It was designed and executed in the seventeenth century.

93 See Llaguno, *Noticias*, vol. 2, XXII, no. 10, 335: 'Item, por se haber hecho la fábrica de la iglesia y lo mas que se ha fabricado dende que se tomó á hacer la dicha iglesia por la orden que yo dí, e ha ahorrado de hacienda por el ahorro de los manejos tanto como ha costado todo lo que se ha gastado en todo lo hecho despues de la nueva orden, y aun algo mas, y lo que de mas momento ha seido, y mas se debe estimar, es haber hecho en ocho años lo que era impossible hacerse en ochenta por la orden antigua.'

7. The Cathedral of Valladolid and Herrera's legacy

1 The history of the cathedral is admirably told by Fernando Chueca Goitia, *La Catedral de Valladolid*, Valladolid, 1947. Agustín Bustamante García, *La Arquitectura clasicista del foco vallisoletano (1561–1640)*, Valladolid, 1983, discusses discoveries since Chueca's book and places the cathedral in relation to the architectural developments of the region. The drawings for the project are kept in the archive of the cathedral and listed by Chueca, 59f. Six are signed by Herrera: (1) plan of the church and its cloister (Chueca no. 1, Bustamante dib. XV); (2) side elevation on the side toward the Plaza de Santa Maria (Chueca no. 2, Bustamante dib. XXVI); (3) elevation of a side chapel seem from the front (Chueca no. 4, Bustamante dib. XXVIII); (4) plan and elevation of a side chapel (Chueca no. 6, Bustamante dib. XXIX); (5) plan of a crossing pier (Chueca no. 7, Bustamante dib. XXX); and (6) Corithinian capital with its attic base (Chueca no. 9, Bustamante dib. XXXI). In addition there is a drawing of the profiles of a cornice annotated by Herrera (Chueca no. 8) and two unsigned drawings: a cross-section. 'Seccion orthographica y perfil del interior alzado, original de Juan de Herrera;' and a longitudinal section of the interior (Chueca nos. 3 and 4), that

both Chueca (60) and Bustamante (131f) attribute to Herrera. On the verso of Herrera's side elevation is his longitudinal section, which is carefully aligned with the recto. There are also copies of various drawings inventoried by Chueca, among them: 'Delantera de S. Maria y copia dela original de Juan de Herrera' which is unsigned and undated; and 'Cornisas y impostas y Basas hechas por Ju. de herrera y sacada del original por di. de praues.' Several additional drawings may be added to the group: (1) 'cornisas y basas para las colunas y pilastras dela delantera principal y plaza de Santa Maria que es a los sesenta pies de alto suelo;' (2) 'basa para las medias colunas delas portados enla delantera pl. y plaça de Sancta Maria. H.;' (3) 'G. Basa para los pilastros de las torres y los demas todo arededor;' at lower left: 'Estas cornijas son para las ympostas delos archos delas naves colaterales come se ue en la montea señalada con los letras F y A y tanbien sirve para las ympostas delos archos que vienen enzima delos dos puertos principales enla delantera y plaza de Sancta maria' and lower right: 'cornijas para las ympostas delas capillas por dentro y fuera como se ven en las monteas señaladas con la letra E y D;' There is also an unsigned, undated 'Copia solamente dela planta dela sta Yglesia sacada del original de Juan de Herrera;' 'Copia dela Orthographia Geometrica y perfil del alzado correspondiente a la Plazuela de Sta Maria sacada del original de Juan de Herrera;' 'Planta dela Yglesia catedral de Valld y puntual copia del Original de Juan de Herrera;' 'Copia de la traza hecha por Juan de Herrera Aposentador de su Magd para la st Iglesia Cathedral dela Ciudad de Valladolid para que se expresa el estado que tiene la continuacion de su fabrica. y lo que resta executar hasta su entera conclusion explicas la distribucion de sus partes en forma siguiente' (Chueca, 62, dates this drawing to the end of the seventeenth or beginning of the eighteenth century). Diego de Praves also executed a plan of the first half of the church, a cross section, a plan of the foundations, a complete plan, and drawings of ornamental details. 'Alzado exterior que da a la Plazuela de Sta Maria dela Yglesia Cathedral de Valladolid' follows Herrera's project. Other late drawings for the church, including seventeenth-century projects for the façade by Blas Martínez de Obregón and Alberto de Churriguera, are listed by Chueca, 62–5). The archive also contains some of the projects entered in the Concurso Nacional de Arquitectura of 1942 for completion of the cathedral. Some of the sixteenth-century drawings were recently conserved and shown in the exhibition in Valladolid, Palacio de Santa Cruz, *Herrera y el Clasicismo: ensayos, catálogo y dibujos en torno a la arquitectura en clave clasicista*, Valladolid, 1986, ed. Javier Rivera Blanco, cat. 10, 11, 12.

2 Portables, *VA*, 135: 'Está demonstrado que la iglesia de El Escorial se hizo según planos de Paccioto. Pues bien; compárase la fachada de la catedral de Valladolid, delineada por Herrera, y la de El Escorial, y véase cómo en la composición una viene a ser un recuerdo de la otra, notándose que en la de Valladolid se copian hasta minimos detalles de la de El Escorial, habiendo, por lo tanto, en el proyecto falta de originalidad' and 147. But in *MM*, 51, he went further: 'De Herrera también hay planos de la catedral de Valladolid, que en parte, fueron publicados en *Los Verdaderos artífices*, y que vienen a ser una copia de la basílica de El Escorial.' He was presumably referring here

to Blas Martínez de Obregón's façade project.

3 Bustamante, *La Arquitectura clasicista*, 113–60 (especially 120–4), suggested that Herrera's plans should be dated to c. 1578. In May 1580, the canons requested money from the city in order to work on the new church, because the old building was in disrepair. Later in the year, the city requested money from the king, who agreed to help finance the completion of the new church in March 1581. Herrera had visited Valladolid in 1578 and could have discussed plans for a new church at that time. It is conceivable that the documents of 1580/81 refer to the church designed by Riaño and Hontañón, which was still unfinished and was 'new' with respect to the earlier churches on the site. As Bustamante has pointed out, however, it would be unlikely that the canons would solicit money, and the king agree to provide it, to continue an old design in 1581 only to switch to an entirely new project by Herrera a year later.

4 Ibid. Pedro de Tolosa was appointed *maestro mayor* of the works in 1582 but died a little over a year later. He was succeeded by his son, Alonso, who took over as *aparejador* until 1586. The style of Alonso de Tolosa was closer to Juan Bautista de Toledo, as may be seen from his drawings for the collegiate church at Villagarcía de Campos. See Martín Gonzalez, 'La colegiata de Villagarcía de Campos y la arquitectura Herrereriana,' *BSEAA*, XXIII, 1957, 19–40; and Alfonso Rodríguez G. de Ceballos, 'Planos para la colegiata de Villagarcía de Campos,' *BSEAA*, XXXVI, 1970, 493–5. Praves was not as close an associate of Herrera, nor as familiar with Herrera's standards of workmanship, as either Diego de Alcántara, nor Juan de Minjares.

5 See Otto Schubert, *Geschichte des Barock in Spanien* trans. as *Historia del barroco en España*, Madrid, 1924.

6 Herrera's damaged side elevation does not show anything above the balustrade of the towers of the main façade; the towers at the eastern end have simple spires, not cupolas.

7 See Wittkower, 3–32: 'The Centrally Planned Church and the Renaissance.'

8 On Leonardo's experiments with central plans see Montréal, Musée des Beaux-arts de Montréal, *Léonard de Vinci, ingénieur et architecte*, ed. J. Guillaume et al., Montréal, 1987, esp. 222–48 where Leonardo's plans are discussed in detail as well as illustrated in modern plans and photographs of models prepared for the exhibition.

9 Chueca, *La Catedral de Valladolid*, 89–101.

10 The legend is quoted from José Guerrero Lovillo, *La Catedral de Sevilla*, Madrid, 1981, 16. See also José Gestoso y Pérez, *Sevilla monumental y artística*, 2 vols., Seville, 1890–2, vol. 2, and Leopoldo Torres Balbás, *Arquitectura gótica*, Ars Hispaniae, VII, Madrid, 1952, 281–8. The tower was decorated with glazed tiles and monumental glazed terracotta statues executed by Italians.

11 On the question see Rudolf Wittkower, *Gothic vs Classic: Architectural Projects in Seventeenth-Century Italy*, New York, 1974.

12 See John D. Hoag, *Rodrigo Gil de Hontañón, gótica y renacimiento en la arquitectura española del siglo XVI*, Madrid, 1986; and Antonio Casaseca Casaseca, *Rodrigo Gil de Hontañón*, Salamancà, 1988. Fernando Chueca Goitia, *La Catedral nueva de Salamanca*, Salamanca, 1951, remains the standard monograph on the building.

13 Quoted from the excellent article by A. Rodríguez G. de Ceballos and A. Casaseca, 'Juan del Ribeto Rada y la introducción del clasicismo en Salamanca

y Zamora,' *Herrera y el Clasicismo*, Valladolid, 1986, 95–109 (citing Archive Cathedral of Salamanca, caja 66 bis, leg. 3, no. 26), where the documentation of Herrera's exchanges with Salamanca is included and the influence of Herrera's plans for Valladolid on the designs for Salamanca discussed. Quotations are translations from this document.

14 See Alfonso Rodríguez G. de Ceballos, 'Liturgía y configuración del espacio en la arquitectura española y portuguesa a raíz del Concillo de Trento,' *Anuario del Departamento de Historia y Teoría del Arte*, Facultad de Filosofía y Letras, Universidad Autonoma, Madrid, III, 1991, 43–52, presented earlier as a paper at the colloquiun on the architecture of the church at the Centre Etudes Supérieures de la Renaissance in Tours.

15 It was begun on revised designs by Juan Gil about 1520, and continued by Rodrigo Gil de Hontañón from 1538 to 1577.

16 First published by José Agapito y Revilla, 'Tres trazados de la iglesia mayor de Valladolid en un dibujo,' *Diario Regional*, Valladolid, 28 April 1943, and discussed by Chueca, *La Catedral de Valladolid*, 34, and A. Bustamante, *La arquitectura clasicista*, 114, dib. XI.

17 Diego de Sagredo, *Medidas del romano*, Toledo, 1526, reprint ed. Agustín Bustmante and Fernando Marías, Madrid, 1986. See Earl Rosenthal, 'The Image of Roman Architecture in Renaissance Spain,' *Gazette des Beaux Arts*, LII, 1958, 329–46 for discussion of the term; Nigel Llewellyn, 'Two Notes on Diego da Sagredo. I: The Cornice and the Face,' and 'II: The Baluster and the Pomegranate,' *Journal of the Warburg and Courtauld Institutes*, XXXVII, 1977, 292–300; and John B. Bury, 'The Stylistic Term "Plateresque,"' *Journal of the Warburg and Courtauld Institutes*, XXXIX, 1979, 199–230. There are many examples of choices made between modern and Roman style. For one example that concerns Rodrigo Gil de Hontañón see Alfonso Rodríguez G. de Ceballos' *La Iglesia y el convento de San Esteban de Salamanca, estudio documentatdo de su construcción*, Salamanca, 1987.

18 The Renaissance view was succinctly stated by Erwin Panofsky, 'The First Page of Vasari's "Libro," A study on the Gothic Style in the Judgment of the Italian Renaissance with an Excursus on Two Façade Designs by Domenico Beccafumi,' *Meaning in the Visual Arts*, New York, 1955, 169–253, quoted from page 189: 'Thus the Italian Renaissance – in a first, great retrospective view which dared to divide the development of Western art into three great periods – defined for itself a *locus standi* from which it could look back at the art of classical antiquity (alien in time but related in style) as well as at the art of the Middle Ages (related in time but alien in style): each of these two could be measured, as it were, by and against the other. Unjust though this method of evaluation may appear to us, it meant that, from then on, periods of civilization and art could be understood as individualities and totalities.'

19 Joan de Arfe y Villafañe, *De Varia Commensvracion para la escvltvra y architectura*, Seville, 1585, reprinted with introduction by Francisco Iñiguez Almech, Valencia, 1979. See also the edition with introduction by Antonio Bonet Correa in Colección Primeras Ediciones, 4, Madrid, 1978.

20 Alberti, bk X, ch. 1, 321.

21 Quoted from Wittkower, *Gothic vs Classic*, 76.

22 Sebastiano Serlio, *Tutte le opere d'architettura*,

Vicenza, 1619, settimo libro, cap. 62, 156ff. Serlio's *Settimo Libro d'architettura nel qual se tratta di molti accidenti* was published posthumously in Frankfort in 1575 from a manuscript that Jacopo Strada bought from the author in Lyon in 1550. See *Sebastiano Serlio on Domestic Architecture*, Cambridge, Mass., and London, 1978, 26; and, more recently, Renato Cevese, 'La "riformatione" delle case vecchie secondo Sabastiano Serlio,' in *Sebastiano Serlio*, ed. Christof Thoenes, Seminario Internationale di Storia dell'Architettura, Centro Internazionale di Studi 'Andrea Palladio' di Vicenza, Milan, 1989, 196–202. Serlio's text on remodelling is quoted 200, n6.

23 Philibert's remarkable theory of accomodation is forcefully and repeatedly articulated in his *Premier Tome de l'Architecture*, Paris, 1567, included in Philibert de L'Orme, *Traités d'Architecture*, ed. Jean-Marie Pérouse de Montclos, Paris, 1988. See especially liv. I, ch. ii, fol. 8v; ch. xv, fol. 27; ch. ix, fol. 20vff; liv. II, ch. vi, fol. 43; liv. III, ch. iiii, fol. 57v; ch. viii, fol. 65; ch. xvii, fol. 84ff; liv. IV, ch. viii, fol. 107 and fol. 231. Philibert's 'obsession' has been noted by Pérouse de Montclos, who considers it one of the contradictions that characterize Philibert's divided loyalties between the classical ideals he admires and the Gothic tradition he loves, but it seems equally valid to interpret it as a self-consciously historicizing albeit un-Italian view. This would be consistent with Philibert's combative nationalism in architectural matters.

24 J. de Arfe, *De Varia Commensvracion*, lib. IV, fol. 2vf.

25 See Georg Weise, 'Die Hallenkirchen der Spätgotikk und Renaissance in Spanien,' *Zeitschrift für Kunstgeschichte*, IV, 1935, 214–27; and his 'Die spätgotischen Wandpfeilerkirchen mit zentralisirender Ostpartie als Vorläufeer der barocken Kirchenanlagen vom Typus des Gesù,' in *Studien zur spanischen Architektur der Spätgotik*, Reutlingen, 1933, 311ff. Kubler, *Portuguese Plain Architecture*, 28–42, describes the range of this type of construction and explains its particular character in Portugal.

26 Program, design and construction history are discussed in Earl Rosenthal, *The Cathedral of Granada*, Princeton, NJ, 1962. See also Fernando Marías, 'De Iglesia a templo: notas sobre la arquitectura religiosa del siglo XVI,' in *Seminario sobre arquitectura imperial*, Granada, 1988, 113–36.

27 See Fernando Chueca Goitia, *Alonso de Vandelvira Arquitecto*, Jaen, 1972.

28 For this image and other sources see Rosenthal, *The Cathedral of Granada*.

29 Sometimes architects chose to unify the composition around a contrast of styles: Alonso de Covarrubias's portal for the chapel of St John the Baptist in the cathedral of Toledo has a classicizing portal surrounded by a semi-circular ring of Gothic tracery. Covarrubias's remodelling was begun in 1536. See Sixto Ramón Parro, *Toledo en la mano*, 2 vols., Toledo, 1857, reprinted Toledo, 1978, I, 239–48; and Fernando Marías, *La Arquitectura del Renacimiento en Toledo (1541–1631)*, 4 vols., Toledo, 1983–7, I, 195–274, for Covarrubias's biography.

30 Illustrated in Cesare Cesariano, *Di Lucio Virtuvio Pollione de architectura libri dece traducti de latino in vulgare affigurati: comentati: et con mirando ordine insigniti … Como, 1521*, facsimile ed. New York, 1968.

31 Herrera did not note a dimension for the width of entire façade, but his dimensions may be added up: Two corner towers as 55' square + twice 32' (aisle width) + twice 13' (pier) + 50' (nave) is 250'. Chueca, *La Catedral de Valladolid*, 96f, gives the interior dimensions as 204' by 411'. The total length of the church as projected in Herrera's plan is uncertain. The dimensions noted on Herrera's side elevation (not all the dimensions were noted on Chueca's redrawn elevation, 132, fig. 28) give the length of the side façade between the tower and the side portal as 128'. The width of the side portal may be calculated from Herrera's notation that the distance from the center of the doorway to the outer of the four engaged columns is 38', to which must be added the width of the columns behind these, which is noted as 1.75'. Thus the width of the side portal is 79.5'. On the elevation drawing, the width of the tower is designated as 57.5'.

32 See Llaguno, *Noticias*, vol. 3, 138f. The documents of this project including Herrera's contributions to it were published by V. García Rey, 'El Deán don Diego de Castilla y la reconstrucción de Santo. Domingo el Antiguo,' *Boletín de la Real Academia de Bellas Artes y Ciencias Históricas de Toledo*, v, 1924, 28–209; but the entire history has been reviewed by Fernando Marías, *La Arquitectura del renacimiento en Toledo*, vol. 3, 161–71 and, most recently, Marías, 'Sobre un Dibujo de Juan de Herrera: de El Escorial a Toledo,' in *Real Monasterio-Palacio de El Escorial: Estudios inéditos en conmemoración de IV Centenario de la terminación de las obras*, ed. Elisa Bermejo, Madrid, 1987, 167–77, in which a drawing by Herrera for roofs, previously thought to be for the Escorial, is convincingly connected to this project. The new church for the Cistercian convent of Santo Domingo el Antiguo was planned as a memorial chapel for María de Silva, who died in 1575, leaving the money and selection of the architect in the hands of Diego de Castilla, dean of the cathedral. My discussion is based on Marías's reconstruction of Herrera's project.

33 See Alfonso Rodríguez G. de Ceballos, *Bartolomé de Bustamante (1507–1570) y los orígenes de la arquitectura jesuítica en España*, Madrid, 1966; Marías, *La Arquitectura del renacimiento en Toledo*, vol. 3, 248–80; and Marías, 'Proporciones y órdenes: Juan de Herrera y la arquitectura clasicista en Toledo,' in *Herrera y el Clasicismo*, 126–37.

34 Santa María del Alhambra was a remodelled mosque that was in urgent need of repair in 1574, when Juan de Orea, architect of the palace of Charles V, consulted with Herrera. Juan de Orea designed a new church in 1575 and Herrera revised his plans, but construction did not begin until or shortly after 1581. See Rosenthal, *The Palace of Charles V*, 128–30; and Manuel Gómez Moreno y Martínez, 'Juan de Herrera y Francisco de Mora en Santa María de la Alhambra,' *AEA*, XIV, 1940–1, 6–7.

35 See Kubler, *Portuguese Plain Architecture*, 80–2, for a resumé of the program and construction history. Kubler credited Terzi with the design, but Jorge Segurado, *Da Obra Filipina de São Vicente de Fora*, Lisbon, 1976, 37, and more recently 'Juan de Herrera em Portugal,' *As Relações artísticas entre Portugal e Espanha na época dos descobrimentos*, Coimbra, 1987, 99–112, favors Herrera's authorship. See also Agustín Bustamante and Fernando Marías, 'Francisco de Mora y la arquitectura portuguesa,' in the same volume, 277–318, for comments on Herrera's role.

Segurado has stressed the importance of the earliest known plan for the complex, a drawing preserved in the Academia Nacional de Belas-Artes, dated 1590 with an inscription: 'Planta segunda do pavimento de oficias e igreja de S. Sebastião a S. Vicente pela qual mando que se faça a obra. No Pardo a XVI de Novembro de M.D.X.C. Rey.' This supports the other evidence that Philip II was closely concerned in the project and that final approval of the designs rested with him. Fernando Chueca Goitia, *El Escorial, piedra profética*, Madrid, 1986, 181–5, has argued cogently for Herrera's authorship on this basis.

36 Kubler, *Portuguese Plain Architecture*, 76–82; and Guido Batelli, *Felipo Terzi*, Florence, 1935.

37 See Segurado, *Da Obra filipina*, 26.

38 Cited by Chueca, *El Escorial*, 182.

39 One design may be exceptional in this respect. Ruiz de Arcaute, 138, published a tracing of a plan of a large monastery, including a church with a monastic cloister and secondary cloister attached to one side, which he attributed to Herrera's circle, suggesting that it was perhaps for Uclés (Cuenca). The project was usually attributed to Herrera, although the identification with Uclés was not accepted, until Rivera Blanco, *Juan Bautista de Toledo y Felipe II*, 340–4, attributed it to Juan Bautista de Toledo, identifying it with the destroyed Franciscan monastery of Nuestra Señora El Real de la Esperanza, near Ocaña (Toledo), which Philip II rebuilt from 1563 to c. 1570. The original of Ruiz de Arcaute's tracing is in BPM. It is odd that the documents make no mention of the church, which derives from the basilica at the Escorial. The abstract geometry and severity of the layout is opposed to what Rivera called the 'grace and liveliness of Toledo's designs' (1984, 339). The convent staircase between the two cloisters consists of two traditional staircases opposed and overlapping in the stairwell. The elaborate pattern of the flights would be unprecedented in the works of Juan Bautista, who remained faithful to the traditional Spanish design of flights forming a U around a plain open stairwell and is the strongest argument for Herrera's authorship.

40 Sigüenza, *La Fundación*, parte I, discurso XIII, 103: 'que la nación española no se amaña estos ingenios ni tiene paciencia para ellos, y lo que puede ser fácilmente y sin trabajo gusta más de hacerlo a fuerza de brazos.'

41 J. de Arfe, *De Varia Commensvracion*, A los lectores: 'He querido tomar este trabajo y aprovechar alos hombres de mi arte que quisieren acertar enella, por ver la falta q̃ hasta aora á avido en España de gente curiosa de escrivir, aviendo muchos que lo pudierá aver hecho, imitando a otras naciones, princpalmente a los Italianos y Franceses, que no an sido descuydados de la curiosidad de sus tierras.'

42 Ibid., prologo: 'Y aunque otros muchos pudieran con menor trabajo y mejor, recoger todos los preceptos esparzidos en tantos autores, con aquella claridad y dispusicion que se requiere para enseñar a los artífices que estan mas exercitados enla pratica de la labor, que en discursos dela razon y demonstraciones mathematicas, è yo querido librar a todos de este trabajo, enel qual si algo e podido, no quiero piẽse nadie q̃ fue como quiera, sino aprovechándome de la doctrina de mis padres y maestros, gozádo delos estudios de toda su vida y gastádo grá parte dela mia, en ver y comunicar cosas tan particulares.'

43 Alonso de Vandelvira's treatise was probably

written about 1590 but remained unpublished until recently: *Tratado de arquitectura de Alonso de Vandelvira*, 2 vols., ed. G. Barbé-Coquelin de Lisle, Albacete, 1977, I, 39, fol. 3r of ms: 'Traza aunque puede significar más cosas en la ciencia de Arquitectura es toda cosa que consiste en cerramientos de arcos, pechinas, capialzados, caracoles, troneras y capillas.' (*Capialzados* is a technical term referring to arches: see 197.)

44 See Fray Lorencio de San Nicolás, *Arte y vso de architectura*, Madrid, 1639, facsimile edition as *Arte y vso de architectvra*, 2 vols., with introduction by Juan José Martín González, Madrid, 1989, vol. I, primera parte, cap. XXII, fol. 28r and v: 'Demas destos Templos de vna naue, y de tres, ay otros de cinco naues, que son Iglesias Catedrales, como la de Toledo, Seuilla, y otros, que no menos son dignos de memoria nuestros Templos de España, que los de los estrangeros: y porque a su imitacion puedas disponer, y traçar otros, referirè algunos con sus particulares medidas...Y quando se te ofreciere el traçar algun Templo semejante, seria de parecer guardasses las medidas de la de Toledo en su planta. que por ser tan perfecta la llaman perla, y caxa della a la de Seuilla.'

45 Fernando Chueca, *La Catedral Nueva de Salamanca*.

46 The relationship was brought out by Chueca, *La Catedral de Valladolid*, 178–94.

47 See Alfonso Rodríguez G. de Ceballos, 'Liturgia y configuración del espacio en la arquitectura epañola y portuguese a raíz del Concilo de Trento'.

48 See Victor Nieto, Alfredo J. Morales and Fernando Checa, *Arquitectura del renacimiento en España, 1488–1599*, Madrid, 1989, and Fernando Marías, *El Largo siglo XVI*, Madrid, 1989, for an overview of other developments. See also Vicente Lleó Cañal, *Nueva Roma: Mitologia y humanismo en el reanicimiento sevillano*, Seville, 1979.

49 Copy of Minjares' report of 14 March 1590 in Archive of the Diputacion Provincial de Sevilla, *Sangre: Actas Capitulares*, 1591, carpeta 207, fol. 15, on wooden roofing.

50 Minjares' later career is examined by Rosenthal, *The Palace of Charles V*, 198f; my 'Juan de Minjares and the Reform of Spanish Architecture,' *Journal of the Society of Architectural Historians*, 1975, 122–32, for his activities before 1570. Herreran style is discussed by Fernando Chueca Goitia, 'Herrera y herrerianismo,' *Goya*, 56–7, 1963, 98–115.

51 See A. Rodríguez G. de Ceballos, 'Juan de Herrera y los Jesuitas: Villalpando, Valeriani, Ruiz, Tolosa. '*Archivum Societatis Iesu*,' XXXV, 1966, 1–37.

52 Gregorio de Andrés, 'La construcción de la iglesia de Valdemorillo y el Castillo de Villaviciosa de ódon según las trazas de Bartolome de Elorriaga,' AIEM, XIII, 1976, 61–78, demonstrates that the architect was from Villaseca de la Sagra and had worked at the Escorial where he helped to build the fountain in the Courtyard of the Evangelists.

53 There may have been an attempt to get builders who worked in a classicizing style to build the basilica. This is suggested by an undated document of c. 1570 (Archivo del Monasterio de El Escorial, 2–120) published by José Rivera Blanco, 'De Juan Bta de Toledo a Juan de Herrera,' *Herrera y el clasicismo*, 79f, which lists a number of Andalucian *maestro mayores* and comments on their works.

54 See *Herrera y el clasicismo*, cat. 15 and 16, 227–9. Alonso's career is also discussed by Bustamante, *La Arquitectura clasicista*, 167–74.

8. Building the well-ordered State

1 The decorations are illustrated in *La tresadmirable, tressmagnificque, & triumphante entree, du treshault & trespuissant Prince Philipes, Prince d'Espaignes, filz de lempereur Charles Ve., ensemble la vraye description des Spectacles, theatres, archz triumphaulx. &C. lesquelz ont este faictz & bastis a sa tresdesiree reception en la tresnommee florisante ville dAnuers. Anno 1549*, Antwerp 1549, and described by Juan Christóbal Calvete de Estrella, *El Felicíssimo viaje del muy alto y muy poderoso príncipe don Felipe...desde España a sus tierras de la baja Alemania*, reprinted in 2 vols., Madrid, 1930. On the iconography of entries see André Chastel, 'Le Lieu de la fête,' in Jean Jacquot, ed., *Les Fêtes de la Renaissance au Temps de Charles Quint*, 2 vols., Paris, 1955, vol. I, 419–23; and Jean Jacquot and Elie Konigson, eds., *Les Fêtes de la Renaissance*, III, Quinzième colloque international d'études humanistes, Paris, 1975, and Konigson, 'Entrées de Charles VIII (1484–1486),' 55–69, for contractual aspect of these ceremonies.

2 Alberti, bk IX, ch. 4, 292.

3 BNM, ms 9681, *Tratado anonimo de arquitectura dedicado al Principe D. Felipe III* [sic] is discussed above in ch. 1, p. 6 and n.30. The city hall, for example, should be placed in the city center near the church and approached through wide streets. If possible, it should be adjacent to a public square so that 'the officials may be treated with honor by the populace and so come to love the city.' See caps. 92–4, fols. 80v–85v: 'se pone en medio de la ciudad porque hacia todas partes suelen mirar. los Regidores della y cerca del consistorio conuiene que aya comunmente —— mas rreligios yendo a su consejo demanden a Dios lumbre y entendimiento para lo que deuon [fol. 82r] Hacer....La salida de alguna Plaça principal del pueblo sea costumbre aber los rregidores como personas Principales y a quien deben obedecer y ellos siendo acatados y orrados Tomen amor al Pueblo y procuron bien sus cosas [fol. 85v].'

4 Quoted from Kubler's (p. 48) translation of the king's comments on a memorandum from his secretary, Pedro de Hoyo, in July 1562.

5 See Françoise Choay, *La Régle et le modèle: sur la théorie de l'architecture et de l'urbanisme*, Paris, 1980; and Choay, 'Le De re aedificatoria comme texte inaugural,' *Les Traités d'Architecture de la Renaissance*, ed. A. Chastel and J. Guillaume, Paris, 1988, 83–90.

6 Philip's drawing and the evidence of his architectural expertise are documented and examined by Alfonso Rodríguez G. de Ceballos, 'En Torno a Felipe II y la arquitectura,' *Real Monasterio-Palacio de El Escorial: Estudios en el IV centenario de la terminación de las obras*, Madrid, 1987, 107–25. See also F. Checa Cremades, 'El Monasterio de El Escorial y los palacios reales de Felipe II, *Fragmentos*, 1985, nos. 4–5, 13; and F. Checa 'Las Constructions del Principe Felipe,' *IV Centenario del Monasterio de El Escorial, Ideas y Diseño*, Madrid, 1986, 23–43, both cited by Ceballos.

7 See the discussion by Javier Rivera Blanco, *Juan Bautista de Toledo y Felipe II, La Implantación del Clasicismo en España*, Valladolid, 1984, 98–100.

8 Luis Cervera Vera, 'Conjuntos y caminos en torno al Monasterio de San Lorenzo el Real,' in *Población y Monasterio: El Entorno*, Casa de Cultura de San Lorenzo de El Escorial, 1986, 48–50; and Kubler, 110–13.

9 Luciano Rubio, 'Cronología y topografía de la fundación y construcción del monasterio de San Lorenzo El Real,' *Monasterio de San Lorenzo el Real El Escorial en el cuarto centenario de su fundación, 1563–1963*, Biblioteca 'La Ciudad de Dios,' 10, Real Monasterio de El Escorial, 1964, 25.

10 See L. Cervera Vera, 'Conjuntos y caminos', 58–61, on El Campillo and Monastir.

11 Sigüenza, *La Fundación*, parte II, discurso XIX, 396ff. The program of La Fresneda is described by Kubler, 73, 89, 158, fig. 41; L. Cervera Vera, 'Conjuntos y caminos,' 53–8; and Luis Cervera Vera, 'El Conjunto monacal y cortesano de la Fresneda en El Escorial,' *Academia*, 1987, 51–135. Designs for the remodelling of the buildings at La Fresneda were probably prepared by Gaspar de Vega. Fray Marcos de Cardona, a Hieronymite monk from Yuste, began work on the gardens which was continued by Pietro Janson, the king's Flemish garden designer, who added the system of pools. Herrera may well have had a share in the planning but his role has not been documented. The last and largest pool was built in 1597.

12 For example Alberti, bk V, ch. XVIII, and bk IX, ch. I. On Sebastiano Serlio's *Libro VI: Habitationi di tutti li gradi degli homini*, see chap. 5 n. 7 above. The orders could express such differences. See John Onians, 'Filarete and the "qualità": Architectural and Social,' *Arte Lombarda*, XXXVIII–IX, 1973, 116–28.

13 Alberti, bk VIII, ch. 1, 244, wrote in praise of Roman roads, for example: 'The countryside along a route may be a considerable ornament to a military road, provided it is well maintained and cultivated....If the road is neither steep, nor tortuous, nor obstructed, but rolling as it were, level, and quite clear, it will also be an ornament. Indeed, what measure did the ancients not take to achieve this?...All along these military roads there are examples to be seen of rocks pierced, mountains cropped, hills excavated, and valleys leveled – works of incredible expense and extraordinary labor; clearly each provides not only for utility but also for ornament.' Simon Stevin, *De Sterctenbovwing*, Leyden, 1594, trans. in *The Principal Works of Simon Stevin*, vol. 4, *The Art of War*, ed. W. H. Schukking, Amsterdam, 1964, 187, wrote against ornament: 'Gates that project outside the wall, with pillars and other costly garnishing, some esteem (as I do) not to be advantageous, saying that good assurance in a fortress is the best garnishing, for such projections hinder the perfect scouring of the curtains, and they may provide cover to the assailing enemy.'

14 Sigüenza, *La Fundación*, parte II, discurso XII, 307: 'La forma y orden de la arquitectura es dórica; la razón dijimos arriba de sentencia de Vitruvio y de todos los antiguos, que, por la valentía y nobleza que en sí muestra, se dedica a los valerosos y fuertes, y, a mi juicio y lo ha de ser al de todos, el que más imita la simplicidad de la Naturaleza, que aborrece lo superfluo; y así no hay en este orden más partes y miembros de los que precisamente el fin del edificio pide.'

15 Sigüenza, *La Fundación*, parte II, discurso XIX, 394: 'y si tiene alguna falta, es estar tan bueno, que se iguala lo que se hizo para servicio con lo que es lo primero, y así es, que no había de estar tan acabado ni tan semejante.'

16 Juan de Tapiaś comments cited by Francisco Iñiguez Almech, 'La Casa Real de la Panadería,' *RABM*, XXII, 1948, 135.

17 Psuedo Juanelo Turriano, *Los Ventiún libros de los*

ingenios y de las máquinas, with introduction by José A. García Diego, 2 vols., Madrid, 1983.

18 Giovanni Francesco Sitoni, *Juan Fran. Siton, Mémoires au Roi Catolique sur les finances de l'Espagne*, Paris, Bibliothèque Mazarine, ms 1907, fols. 151–178v. The text is a collection of accounts of Sitoni's activities and of his proposals for hydraulic works in Spain and Milan. It was probably compiled shortly before he left Spain in 1578. Portions transcribed in my entry on Sitoni's treatise, *Delle Virtù et proprietà delle acque, del trouarle, eleggarle, liuellarle, et condule et di alcuni altri circonstanze. Opera et inuentione di Gio. Francesco Sitoni, Ingegnero del Catolico Don Felippo d'Austria, di questo nome secondo, Re di Spagna, et Duca di Milano*, Milan, 1599, ms in the collection of the Burndy Library, Norwalk, Conn., in Brown University, Department of Art, *Philip II and the Escorial: Technology and the Representation of Architecture*, Providence, RI, 1990, cat. 13, 39–44. See also José García Diego's study and his and A. G. Keller's edition of the treatise cited ch. 2 n57 above.

19 See J. Rivera Blanco, *Juan Bautista de Toledo*, 117; and Llaguno vol. 2, 163–4, citing AGS, CS, leg. 257: 1, fol. 40. Charles V had ordered some landscaping already in the 1530s.

20 The tightly controlled organization of La Isla had nothing in common with the far-flung avenues of the king's earlier work in the gardens. It was, rather, close to the style of Juan Bautista's plan for the Spanish Quarter near the Castel Nuovo in Naples and to the gardens of the Casa de Campo on the west bank of the Manzanares, just outside Madrid. See Iñiguez, *Casas reales*, 177 and J. Morán Turina and F. Checa Cremades, *Las Casas del Rey*, Madrid, 1986, 107.

21 This aspect has been emphasized by J. Rivera Blanco, *Juan Bautista de Toledo*, 243–252.

22 Quoted from Iñiguez, *Casas reales*, 203 citing Archivo de Zabálburu, caja 128, no. 18, Madrid, n.d.: 'los libros dice allí de Serlio ne seran menester, que ay ya muchos dellos; uno que dice que es de jardines de Italia, buena sera tomar, aunque yo creo que no es sino de Francia y Inglaterra, que hizo cuando yo le enbie a ver los unos y los otros.'

23 Iñiguez, *Casas reales*, 191f citing Archivo Zabálburu, caja 146, no. 35, Aranjuez, n.d.'

24 Iñiguez, *Casas reales*, 192: 'Ha de ser esta ida frente de la puente, que desde qualquiera parte della se vea toda la calle y desde la calle toda la puente.'

25 Jehan Lhermitte, *Le Passetemps*, ed. Charles Ruelens, 2 vols., Antwerp, 1890, plate 16. Lhermitte's description of Aranjuez including the tally of 222,695 trees of various species planted in the gardens is on pp. 103–109.

26 That Algora may have been preparing designs is suggested by a note from Philip II in 1567: 'Creo que Algora tenia traças y pinturas de la huerta y fuentes, y de otros jardines de Francia y Inglaterra y Flandes y otras partes, y otras cosas que yo le mande hazer, y aun podria ser que de Aranjuez y el Escorial. Sera bien que todo lo hagais poner en cobro hasta que lo veamos.' Document quoted by Iñiguez, *Casas reales*, 202 citing Archivo de Zabálburu, caja 46, no. 69, Madrid, n.d.

27 See Iñiguez, *Casas reales*, 185 citing Archivo del Instituto Valencia de Don Juan, envió 61, no. 22, Madrid 29 May 1562: 'vamos' viendo todo lo de Xarama y despues lo de Taxo, Para quede asentado de una vez por todos lo que en estas asequias y estanques se puede y deve de hazer.'

28 See Iñiguez, *Casas reales*, 147.

29 As for example by Luis Cervera Vera, 'Semblanza de Juan de Herrera,' *El Escorial*, 1963, vol. 2, 48 and Kubler, 27. Philip II employed a number of engineers and gardeners at Aranjuez over more than twenty years and their contributions have not been fully sorted out. Herrera was apparently responsible for overseeing and revising designs from 1568 (Llaguno, vol. 2, 276 XXII, 3, Cédula to Juan de Ayala: 'He visto las trazas que habeis enviado de la pared del estanque grande [de Hontígola]: y Gaztelu os envió las que hizo Herrera despues de llegado aqui, en que, como habeis visto, moderó algunas cosas de los que ahí se platicó, por parecer que eran superfluas).

30 I dealt with the originality of Aranjuez with respect to French and Flemish parks in 'Convergences européennes: Philippe II et le parc d'Aranjuez,' for *L'Environment du chateau et de la villa* at the Centre d'Études Supérieures de la Renaissance, Tours, June 1992 to appear in the series *De Architectura*, ed. Jean Guillaume, Paris and at the colloque 'Architecture et Jardins,' at Domaine Departementale de la Garenne-Lemot, Nantes. On French garden design see *Histoire des jardins de la Renaissance à nos jours*, ed. Monique Mosser and Georges Teyssot, Paris, 1990 esp essays by Françoise Boudon, 'Images de jardins au XVIᵉ siècle: "les plus excellents bastiments de France,"' pp. 96–8 and 'Histoire des jardins et cartographie en France,' pp. 121–30.

31 Antonio Ponz, *Viaje de España*, 1763, reprinted Madrid, 1947. ed. Castro María del Rivero, I, v, 66, 102, suggested Herrera as designer of the project but R. Coppel Areizaga and A. Almagro Gorbea 'La Fuente Grande de Ocaña: una posible obra de Juan de Herrera.' *RABM*, LXXX, 1977, 335–76, have compiled documentation and made more convincing this traditional attribution. Their arguments were accepted by Fernando Marías, *La Arquitectura del Renacimiento en Toledo (1541–1631)*, 4 vols., Toledo and Madrid, 1983–6, vol. 2, 12f; and vol. 3, 191f. More recently, however, Palacio de Santa Cruz, Valladolid, *Herrera y el clasicismo: ensayos catálogo y dibujos en torno a la arquitectura en clave clasicista*, catalogue ed. Javier Rivera with essays by others, Valladolid, 1986, Lams. XXVIII–XXXII, 338–47 published modern drawings of the complex as an 'atribución dudosa' to Herrera. Excavation for a new water system began in 1573 after the city had consulted with a Diego de Orejon, 'an expert who is knowledgeable in such things' from Madrid. This is presumably the same person who appeared with Jacopo da Trezzo as guarantor for Juan Antonio Sormano's contract to execute seven arches of the old Puente Segoviana in Madrid on 14 September 1574 (cited by Agustín Bustamante García, 'En Torno a Juan de Herrera y la arquitectura,' BSAA, XLII, 1976, 227–50, esp. 235f, citing AHP, Escribano Francisco Martínez, leg. 411). He was then 'fontanero de la villa de Madrid' working under Gaspar de Vega on the water system for the Alcázar (see Portables, *VA*, 116f, citing AGS, CS, Alcázar de Madrid y Casa de Campo, leg. 1.) Construction at Ocaña was undertaken by Blas Hernández, 'master of the works,' who was also occupied on the fountains at the Alcázar in Madrid in 1574 (See Portables, *VA*, 117f, citing AGS, CS, Memoriales de Partes, leg. 1). He later worked for the junta in Madrid. The masons Lucas and Pedro de Villa, were active at Aranjuez in the 1580s (as documented by Juan José Martín González, 'El

Palacio de Aranjuez en el siglo XVI,' *AEA*, 1962, 237–52, and F. Marías, *La Arquitectura del Renacimiento en Toledo*, vol. 4, 191).

32 See I. González Tascón, *Fábricas Hidraulicas Españolas*, Madrid, 1987, 111–21 and Sigüenza, *La Fundación*, parte I, discurso XIII, 102f: 'llegó a Segovia, por ver aquel excelente ingenio de hacer moneda, invención del Archíduque de Austria; menea el agua una rueda, y aquélla, en los lados contrarios con el agua, mueve otras dos (que es principio de las mecánicas de Aristóteles), pasando por entre los dos ejes o ruedos de éstas que son de acero, en que están dibujadas y abiertas las armas reales, como las vemos en la moneda, el uno la faz y el otro, el reverso, un riel, como una cinta de plata del grueso que ha de tener la moneda, la deja como estampada o esculpida por una parte y por otra, a la larga, hecha reales, y éstos después se van cortando en otro torno en redondo con facilidad; excelente ingenio con que se ahorra mucha costa, ingenio y tiempo, sino que la nación española no se amaña estos ingenios, ni tiene paciencia para ellos, y lo que puede ser fácilmente y sin trabajo gusta más de hacerlo a fuerza de brazos; hase labrado alguna plata en él; agora se labra poca o ninguna, porque dizen tiene algunos inconvenientes, porque dicen tiene algunos inconvenientes o porque no la dejan lograr ni que llegue a Segovia.' Both Enrique Cock, *Jornada de Felipe II en 1592*, 9, and Jehan Lhermitte, *Le Passetemps*, vol. 1, 130, describe the building on the occasion of the king's visit in 1592, On the earlier project to establish a mint at Madrid see María del Rivero Castro, 'Orígenes de la Çeca de Madrid,' *RBAM*, I, 1924, 129–37. Philip II had borrowed a team of German mechanical engineers and craftsmen from Archduke Ferdinand of Austria and put them to designing machinery for a mint on the Manzanares River at Madrid. When the water power proved insufficient, the team moved to the alternate site at Segovia. Sigüenza described Philip's visit to the building late in 1583, when most, if not all, the machinery was in place; the rest was finished by 1585, Diego de Matienzo was paid an installment for the stonework, which had been estimated by Juan de Minjares in 1585 as documented by Portabies, *MM*, 299f citing AGS, CS, Casa de Moneda de Segovia Leg. 2. Matienzo was from Segovia but worked at the Escorial from 1576 when he and Gregorio de la Puente built the southeast section of the basilica see Kubler, 82, and Llaguno, vol. 2, 125; in 1580, Matienzo contracted to execute a church for a convent at Moya according to designs drawn by his brother-in-law, Pedro de Tolosa (cited by Llaguno, vol. 3, 74). Thus Diego de Matienzo was well-connected to the Escorial, which is probably why he was chosen to work on the mint and the Alcázar in Segovia. His role is difficult to reconcile with the claim by Herrera's assistant, Francisco de Mora, that he designed the building. Llaguno, vol. 3, 125 and XXIV, no. 2, 344, dated the work between 1586 and 1598 and attributed the design to Mora, working under Herrera's direction because an eighteenth-century description of a series of now-lost documents claimed to prove Mora's authorship: 'una certificacion que está al fin de dicha relacion, firmada del citado arquitecto Francisco de Mora en S. Lorenzo el Real el día último de agosto de 1598, y escrita toda de su mano, en que asegura que todas las obras modernas hechas en el alcázar y casa de moneda se hicieron por traza é ideas suyas y mandado de S. M., quien le habia dado á él algunas órdenes de palabra, y otras al conde de

Chinchon.' Sigüenza's description and the payments to Diego de Matienzo both imply that the mint was finished by 1585. Ruiz de Arcaute, 121f, attributed the mint to Herrera, citing a cédula of 2 December 1583 (no source given) in which Herrera authorized payment of 3000 ducats for the completed work.

33 See the excellent study by Filemón Arribas Arranz, *El Incendio de Valladolid en 1561*, Universidad de Valladolid, Facultad de Filosofía y Letras, Estudio e Documentos, no. 17, Valladolid, 1960. Other material in Bartolomé Bennassar, *Valladolid au siècle d'or: une ville de Castille et sa compagne au XVIe siècle*, Paris, 1967; and E. García Chico, *Documentos para el estudio del Arte en Castilla*, vol. 1, *Arquitectura*, Valladolid, 1940. On the general significance of the project see Antonio Bonet Correa, *Morfología y ciudad: urbanismo y arquitectura durante el antiguo régimen en España*, Collección Arquitectura y Crítica, ed. Ignasi Solá-Morales Rubio, 1978, 40; and 'Le Concept de Plaza Mayor en Espagne depuis de XVIe siècle,' *Forum et Plaza Mayor dans le Monde Hispanique, publications de la Casa de Velázquez, série 'Recherches en sciences sociales'*, fasc. IV, Paris, 1978, 79–106; Juan José Martín González, 'Notas Vallisoletanas: anotaciones sobre la Plaza Mayor de Valladolid,' *BSAA*, XXV, 1959, 161–8 and Juan José Martín González, 'Urbanismo y arquitectura de Valladolid durante el Renacimiento,' in *Corazon del mundo hispanico. siglo XVI*, Historia de Valladolid, vol. 3, Valladolid, 1981; Robert Ricard, 'La plaza mayor en L. Torres Balbás, and Espagne et en Amerique espagnole,' *Annales*, XIX, 1947, 433–8; *Resumen histórico del urbanismo en España*, 2nd edn, Madrid, 1968, with essays by Luis Cervera Vera, 'La Epoca de los Austrias,' 173–209 and Fernando Chueca Goitia, 'La Epoca de los Borbones,' 213–48; Bruno Vayssière and Jean Paul Le Flem, 'La Plaza Mayor dans l'urbanisme hispanique: essai de typologie,' *Forum et Plaza Mayor dans le Monde Hispanique*, 43–78; Fernando Marías, 'City Planning in Sixteenth-century Spain,' in *Spanish Cities of the Golden Age*, ed. Richard Kagan, Berkeley, 1990, 84–105.

34 See the exhibition catalogue *Herrera y el classicismo*, cat. no. 8, 213–15, for discussion of Juan de Salamanca's drawing in AGS, Cámara de Castilla, leg. 412, M. P. y D. XXXIX-54. Juan suceeded his father Francisco as director of the project and this drawing is dated c. 1572. The inscription describes him as 'Criado de Su magd trazador de las obras de la villa de Vallid' which, together with the drawing's presence in the royal archive of Simancas, suggests that Philip II and Herrera were closely following the reconstruction.

35 Most believe that Juan Bautista de Toledo was involved to some extent in the conception of the plaza mayor in Valladolid, although he does not appear in the documents. His design of the Spanish Quarter in Naples qualified him for this type of work; see Cesare de' Seta, *Cartografia della città di Napoli, lineamenti dell'evoluzione urbana*, 3 vols., Naples, 1969, esp. vol. 1, pp. 109–45.

36 See Damasio de Frias, *Diálogo en alabança de Valladolid*, written by 1582: '. . . la Plaça Mayor, la qual con todo lo de la nueva traça que fue quanto se quemó y mas mucho que haviendolo derribado se ha edificado, conforme a esto, es tal que extrangeros y naturales, italianos, flamencos, franceses, alemanes, finalmente quantos el nuevo edificio veen, que seran como ochocientas casas,

dizen que es sin duda el más vistoso pedaço de edificio que se sabe en el mundo; porque, señor, todo él es cordel todo a una altura, todo de ladrillo, las puertas todas de un tamaño que son de catorce pies de alto de cada tres piedras de Cardeñosa, sin que entre puerta y puerta de quantas os digo en tanta multitud de casas haya un dedo de pared. Tiene despues d'esto cada casa tres ordenes de un tan ancho, las pimeras puertas ventanas con sus medias rexas todas, la segunda orden es de ventanas, la tercia parte menores. La tercera es mas disminuyda, que vienen con las primeras en proporcion doblada; van sobre todos los tejados levantadas unas açoteas con una mesma ygualdad de mucha hermosura y servicio. La Plaça, si no es lo que ocupan las Casas de Consistorio, que solamente estan levantadas quatro estados en alto, siendo de traça por cierto hermosissima, todo lo demas en redondo es de portales sobre columnas de Cardeñosa con tapas y chapiteles de la misma piedra, de diametro de tres palmos, redondas, salvo las que estan en esquinas que son ahovadas y de mas grosor. Corren estos portales por toda la Acera y Cereria, por los Guarnicioneros y Especeria, que por el numero de las columnas que pasan de treszientas y tantas, entendereis lo que ocupan los portales, haviendo entre columna y columna en la que menos espacio diez pies, en otras catorce, segun el suelo de la casa. La Plaça tiene tal proporcion, que siendo la tercia parte mas larga que ancha, teniendo de ancho dozientos pasos, es tal y tan hermosa, que jamas se vio theatro qual ella. Ni es menos vistoso el Ochavo, la Costanilla, La Hazero, Especiaria, con todo lo demas nuevo.' Quoted in Arribas Arranz, *El Incendio de Valladolid*, 124. Describing the square at the time of the king's visit in 1592, Henrique Cock, *Jornada de Tarazona hecha por Felipe II en 1592 pasando por Segovia, Valladolid, Palencia, Burgos, Logroño, Pamplona y Tudela*, 21: 'La casa del ayuntamiento y la Carnicería se labra de nuevo, la plaça mayor es grande y quadrada, y los edificios della todos de una manera, como ansí las calles allí vezinas, que como en el año de 68 [sic] se quemasse gran parte desta villa, fue ordenado se labrasse con orden y concierto, ayudando la villa para ello á los que fabricavan: que cosa es de veer tantas casas de un altor y manera de labranza.'

37 See A. Agapito y García, *Valladolid, ciudad sus origines*, Valladolid, n.d., 191 and F. Arribas Arranz, *El Incendio de Valladolid*.

38 The city bakery and meat market have both been destroyed. Herrera designed the meat market to replace the earlier structure which burned in 1587. To judge from the eighteenth-century drawing, the lower part was built of stone over the Esgueva River, the upper parts in brick although there was a rusticated portal in stone. It was a simple building, made monumental by its site and perhaps by its scale. Herrera may also been concerned in rebuilding of the Puente Mayor, which was begun in 1584 by Juan de Nates, the same architect who had directed construction of Herrera's designs for the Puente de Segovia in Madrid. Old views of the bridge suggest it was a similiar design. Illustrations and discussion in Juan José Martín González, 'Dibujos de monumentos antiguos vallisoletanos,' *BSEAA*, XIX, 1953, 23–49, and Lams. II, 6 and VI, 23.

39 Quoted from Dora Crouch, *Spanish City Planning in North America*, Cambridge, Mass., 1982, 14 who provides a new translation of part of the text based on *Ordenanzas de Descubrimiento, Nueva*

Población y Pacificación de las Indias dadas por Felipe II en 1573 (AGI, Indiferente General, leg. 247, libro XIX, Fols. 63–93) and a discussion of their impact on city design into the twentieth century. I have substituted 'porticos' as a translation for the Spanish *portales* for Crouch's 'portals' and Nuttall's 'arcades.' The text of the ordinances incorporated in *Recopilación de leyes de los Reinos de Indias*, 4 vols., Madrid, 1681 (reprinted from 1791 ed., Madrid, 1953). The Importance of the text was first noted by Zelia Nuttall, 'Royal Ordinances Concerning the Laying Out of New Towns,' *Hispanic American Historical Review*, IV, 1921, 743–53, with translations of ordinances concerning city design. The legislation's impact (or lack of it) discussed in the useful essays collected in *La Ciudad Iberoamericana, Actas del Seminario Buenos Aires*, Centro de Estudios Experimentación, Buenos Aires, 1985; and Erwin Walter Palm, 'Los origenes del urbanismo imperial en America,' *Instituto Panamericana de Geografía e Historia*, 1951; and François Chevalier, 'La "Plaza Mayor" en amerique espagnole, espaces et mentalités: un essai,' *Forum et plaza mayor dans le monde hispanique*, 107–22. See also Valerie Fraser, *The Architecture of Conquest, Building the Viceroyalty of Peru 1535–1635*, Cambridge, 1989.

40 Quoted from Crouch, *Spanish City Planning*, 18. Slightly different translation in Z. Nuttall, 'Royal Ordinances,' 752f.

41 Utopian writers often rely on descriptions of architecture to express the structure of their ideal societies. See Robert Klein, *Form and Meaning*, Princeton, N.J., 1981, ch. 5: 'Utopian Urban Planning,' 89–101, who rightly remarked that utopian planning transforms its author into a kind of magus.

42 The instructions for regularity, architectural uniformity, and useful institutions follow Alberti's recommendations in *De re aedificatoria*, even to the siting of the church.

43 See *Spanish Cities of the Golden Age*, ed. Richard Kagan, with essays by Jonathan Brown, R. Kagan, Egbert Haverkamp Begemann, and Fernando Marías, Berkeley, Los Angeles, and London, 1989. There is a large literature on the capitalhood and urban development of Madrid. See the bibliography on the Plaza Mayor cited below n. 61 and Miguel Molina Campuzano, *Planos de Madrid de los siglos XVII y XVIII*, Madrid, 1960, for plans. Claudia Sieber's *The Invention of a Capital: Philip II and the First Reform of Madrid*, PhD. dissertation, The Johns Hopkins University, 1986 provides an excellent history of the administration under Philip. On the social history see A. Domínquez Ortiz, *La Sociedad española en el siglo XVII*, I, Madrid, 1964. On the buildings generally: Fernando Chueca Goitia, *Madrid y Sitios Reales*, Barcelona, 1958; Manuel Fernández Alvarez and Elias Tormó, 'La capitalidad: Como Madrid es Corte,' *RBAM*, VI, 1929, 420–55; and Manuel Fernández Alvarez, *Madrid en el siglo XVI. El establecimeinto de la capitalidad en Madrid*, Madrid, 1960; and Alfredo Alvar Esquerra, *El Nacimiento de una capital europea: Madrid entre 1561 y 1601*, Madrid, 1989. Specialized studies are cited in the following notes.

44 Quoted from Francisco Iñiguez Almech, 'Limites y Ordenanzas de 1567 para la Villa de Madrid,' *RBAM*, XXIV, 1955, 3–38, 4, citing Madrid, Archivo Municipal, l.a, I, 48: 'por la cual mandamos que de aquí adelante no se pueda hacer edificar alguno de nuevo ni acabarse los que

estuvieren comenzados fuera de las partes y límites por donde la dicha Villa de Madrid estuvo cerrada con puertas y cercada con casas y tapias el año próximo pasado de mil y quinientos y sesenta y seis, para guardar que en ella no entrase persona alguna de los que viniesen de las partes y lugares donde se tenía noticia que había enfermedad contagiosa o pestilencia, porque somos informados que es buen y bastante sitio para la población desa dicha Villa, el cual se limitió y cerró por las partes y señales que se siguen.' On the earlier urbanization of Madrid see Fernando Urgorri Casado, 'El Ensanche de Madrid en tiempos de Enrique IV y Juan II. La urbanización de las cavas,' RBAM, XXIII, 1954, 3–63; and for sixteenth-century expansion and regulation: Agustín Gómez Iglesias, 'Transformación de Madrid durante el reinado de Felipe II y la creación de la primera junta de urbanismo,' Villa de Madrid, XXII, 1967; Ramón García Pérez 'Descripción topografica de Madrid en el siglo XVI,' RBAM, IV, 1927, 85–8; A. González de Amerzúa, "Las Primeras ordenanzas municipales de la villa y corte de Madrid,' RBAM, III, 1926, 401–29; F. Aguilar Piñal, 'Dos manuscritas referentes a la historia de Madrid,' AIEM, II, 1967, 174ff.

45 Texeira's project discussed by Miguel Molina Campuzano, Planos de Madrid de los Siglos XVII y XVIII, 245–81.

46 The old city walls were torn down at least in part as a public policy to accomodate the new view of Madrid as spacious and open. The city probably also made money from the stone that could be salvaged and from the land near the walls which they claimed (see the text in n50 below). Madrid's lack of fortifications is striking. No other European capital demolished its walls in the sixteenth century. The division of the city into districts, which do not accord with pre-established parish boundaries, is another indication of the new view of Madrid as a physical entity. The tentative attempts at zoning undertaken by the junta – restriction of certain kinds of commerce and other urban activities to particular areas – remains to be investigated. This reconstruction is based on Pedro Tamayo's report of 1 January 1590, published by A. Morel Fatio, 'Memorial de Pedro Tamayo de la guarda a pie de Su Majestad,' RBAM, I, 1924, 286–325, from a manuscript copy in Paris, Bibliothèque Mazarine, ms 1907. Also useful are the city ordinances and various later surveys of services and populace. See A. González de Amerzúa, 'El Bando de policía de 1591 y el pregón general de 1613 para la villa de Madrid,' RBAM, X, 1933, 141–79; María del Carmen González Muñoz, 'Datos para un estudio de Madrid en la primera mitad del siglo XVII,' AIEM, XVIII, 1981, 149–86; Claude Larquié, 'Barrios y parroquias urbanas: el exemplo de Madrid en el siglo XVII,' AIEM, XII, 1976, 33–63; and J. Fayard and C. Larquié, 'Hotels madrilenes et démographie urbaine au XVIIe siècle,' Mélanges de la Casa de Velázquez, IV, 1968, 229–58.

47 Naples' development and situation under Spanish rule is traced by Cesare de' Seta, Cartografia della Città di Napoli, vol. I, 109–54.

48 The writings of Cristóbal Pérez de Herrera were particularly eloquent on the need for reform. See for example his Discursos del amparo de los legítimos pobres, y reducción de los fingidos: y de la fundación y principio de los albergues destos reynos, y amparo de la milicia dellos, ed. Michel Cavillac, Madrid, 1975; Discurso a la católica y

real magestad del rey don Felipe nuestro señor, en que se le suplica, que considerando las muchas calidades y grandezas de la villa de Madrid, se sirva de ver si convendria honrarla, y adornarla de muralla, y otras cosas que se proponen, con que mereciesse ser corte perpetua, y assistencia de su gran monarchia, Madrid, 1597; A la católica real magestad del rey don Felipe III, nuestro senor: cerca de la forma y traza, como parece podrían remediarse algunos pedcados, excessos, y desórdenes, en que los tratos, bastimentos, y otras cosas, de que esta villa de Madrid al presente tiene falta, y de que suerte se podrían restaurar y reparar su necessidades de Castilla la vieja, Madrid, 1600. C. Sieber, The Invention of a Capital, 252–92, describes the economic and social issues behind many of the anxieties of the later sixteenth and early seventeenth centuries. Much has been made of the 'casas de la malicia,' one-story houses which were supposedly built by the residents of Madrid in order to avoid their obligation to provide housing for members of the court, but this was clearly not the only factor in Madrid's expansion, nor were the king's reforms primarily directed against it. The threats posed by vagrancy, epidemic, lawlessness and inadequate city services were more important to the royal administration.

49 The urban implications of the Alcázar have been treated by Veronique Gerard, De Castillo a Palacio: El Alcázar de Madrid en el Siglo XVI, Madrid, 1984, see esp. part 3, 119–53.

50 On the hospital projects see María Jimenéz Salas, Historia de la asistencia social en España en la edad moderna, Madrid, 1958. V. Gerard, De castillo a Palacio, 141 n1, citing AGS, CS, leg. 247/1, fol. 257ff, was the first to mention the report on city services; her discussion of the program is followed by J. Rivera Blanco, Juan Bautista de Toledo, 192ff and 323–34, and by Alfredo Alvar Esquerra, El Nacimiento de una capital europea: Madrid entre 1561 y 1601, Madrid, 1989, 192ff. Since the document has not been published the relevant portions on public building are transcribed here: 'Obras publicas: Cerca delas obras publicas de mas delas comendadas dire de algunas por la orden arriba dicha para que vista esta memoria por V. Magt mande lo que en ello mas fuere servido y si lo fuere de rremitirlo alguna persona con quien yo lo pueda tratar mas en particular por no cansar a V. Magt mas de lo que hago conesta – [margin: q̄ v.m.t si fuere servido remita a alguno cõ quien lo trate] lo que toda ala calle Real nueba quebaxa desde la puerta cerrada hasta la puente v.m.t lo mande acabar ya Juan Bautista que haga la traca dela calle que baxa desde las caballerizas hasta esta calle rreal para que desde luego se pueda meter mano en ellas y dar servicio a palacio. [margin: La calle Real nuera q. Jũ bautista aga la traça de la calle de las caval-lerízas]

Y todos aguellos varrios prosupuesto que sea de cerrar la puerta dela bega y para ayuda alos grandes gastos quentrabis a dos Calles se an de hazer que V. Magt sea servido que presupuesto que sea de hazer la puente y puerta en la dha calle que todo pasara de cient mill ducados que V. Magt nos conçeda lo que le esta suplicado por esta villa y por V. Magt dada cedula para que sobrello se platique Presupuesto que sin la md. y sabor de V. Magt no se pueden Acabar tan grandes obras. Y ansi mismo V. Magt mande a Juan bautista su obrero maior que juntamente con los alarifes desta villa bean las siete fuentes del peral y hagan vna traca

como combiniere para que se Acaben conforme alocomençado [margin: q. Jũ bautista vea las fuentes del Peral i aga traça para q se acaben]

Y que visto y dado su parescer cercadelo que falta deminar en las dhas fuentes se mande continuar satisfaziendo el daño si alguna se hiziere no temiendo consideracion ni rrespecto a ningun particular por que a esta causa a abido alguna dilacion y enbaracos por tocar al contador peralta ques rregidor y sacar sea mucha mas agua acabado de minar. Vna delas cosas de que mayor necesidad tiene esta villa y que mas autoridad le daran es hazer vnas casas de la villa que tengan su autoridad y ansi tiene sitio muy aparejado para poder lo hazer y encorporandose en ellas la carcel ques vna delas cosas mas necesarias hazerse y de mayor lastima ver la que ay y lo que en ella padescen los pobres presos yola avia comencado a hazer para que sirbiese de presente con moderado gasto y por pasiones particulares de algunos rregidores por tocar algunos deudos y amigos suyos lo an enbaracado y açesado la dicha obra que ya estubiera hecha Su pª a V. Magt mande a Juan bautista bea el dho suelo y dispusicion y haga vna traça que rrepresente por de fuera mucha Magt como conbiene y por de dentro se rreparte como al presente pueda pasar Remediendo solamente la nescesidad presente [margin: casas de aiuntamiento]

Paraesto podra sirvir para ayuda a los gastos lo que se diere por la carcel ques al presente que baldra mas de quatro cientas myll m̄rs. y lo demas que de presente se obiere de gastar sea la mitad de sobras dencabeça m̄ÿs y la otra mitad de proprios, [margin: de donde se podra sacar aiuda] hecha la dha carcel conbiene Sacarse del sitio donde sea de hazer el peso dela harina que se biene a vender defuera parte y pasarse juntamente [margin: alondigor i casa de arina]

Con el trigo y cebada A las troges della villa E yn corporarse con las dhas troges y comprar una casilla questa cabo ella y meter dentro este peso y lo demas y el otro questa fuera y encima delos dhos pesos hazer vna troge ques nescesaria y en una delas vaxas que ahora sirben hazer alhondiga para meter dentro el trigo y la cebada y se guarde y de por noguna y rrazon Porque ahora no la ay E para questen guardados delas aguas y sol y en la otra trox baxa se haga cabellerizas para ____ las bestias que truxeren probisión al alhondiga y ansi mismo conbiene derribarse lo q̄ es ahora peso dela harina Para hazer plaça delante dela dha alhondiga Para que quepan los carros y bestias todo esto no costara dos mill ducados y el deposito del pan gana rrenta en que ansi se haga y ansi mismo es muy nescesario haberse para ensanchar las dhas troges y el deposito tiene dineros con que hazerse [margin: de donde se podra pagar] [margin: casa del pescado] V. Magt a mandado y ansi mismo su consejo que se saque la casa del pescado donde esta ques cosa que conbiene mucho ansi ala Salud desta villa como a la pulicia y buena gouernacion y porque ansi mismo el agua q̄ della sale ansi por su mal olor como por la sal y bascosidad que lleba del pescado haze grandaño en los jardines de V. Magt. El mismo ynconbeny̅ tienien las casas delos pescadores questan en la calle de las fuentes y conbiene ansi mismo sacarse fuera y hazerse en el campo casa para el pescado y en parte donde no haga daño ní perjuizio [margin: matadero] Porque ansi mismo Resultan El mismo ynconbenente destar la casa del matadero dela carne dentro desta villa Supco a V. Magt sea servido mande que las dhas dos casas se junten en una en unas tenerias

questan en vaxo de vn palomar que cahe hazia San franᶜᵒ.

Que son de morales cartidor las quales tienen muy buen sitio y dispusicion para ensancharse y hedificarse como convernan para entranbos hedificios y tienen agua de pie que es cosa muy nescessaria y la casa del pescado y ansi mismo el matadero. Podran Ayundar conciertos suelos questan junto a el para la costa del comprar y hedificar las casas para los dhos oficios y lo que faltare se pague la mitad a costa delos proprios desta villa pues a de ser para ella la rrenta y la otra mitad de sobras de _____ pues toca albien Vniversal dela dha villa. [margin: casa publica] tanbien paresçe que seria cosa muy nescessaria que la casa delas mugeres enamoradas que al presente esta dentro dela villa en parte muy publica y perjudicial que se sacase de donde ahora esta y se pusiese en donde ahora esta el matadero con quel a puerta y seruicio della dha casa Saliese al campo y no ala villa enesta parte y sitio conveniente para hazerla y con lo que es ahora matadero podria sirvir con poco mas quela villa gastase en ello y el gasto que en ello se hiziere que sea de proprios con que v.mᵗ haga md. aesta dha villa del aprobechamiento que dello se sacare sin enbargo de qualqmera pretension que por algunas personas particulares se tenga atento el gran servicio q̃ a dios y a V. Magᵗ se haze y a bien desta Republica. [margin: Las casas de la mançana en la plaça] Por muchas vezes sea tratado enesta villa que vnas casas questan en la plaça della q̃ llaman la mancana se derribasen para ensanchar dha plaça lo qual seria cosa de gran importancia y que de mas de ser nescessario para las fiestas lo es para los mantenimiento que se bienen a vender y ansi mismo para el hornato y puliçia porque las dhas casas son viejas y de mal parescer y depoco hedificio y aposento en que se pierde poco de derriballas avn que no se consiguiesen los demas frutos de hazerse y avn que las dichas casas costaran mucho por estan en el sitio que estan las questan detras dellas lo ganan todo y para ayuda alo que costaren la villa podra ayudar con alguna parte E conque ansi mismo tiene alli dos otras casas delas quesean de derribar y pues el beneficio es tan grande ansi para la las casas de detras como para toda la Plaça y todos los vezinos dela plaça contribuyeron para esta obra los ser tan nescesceria [margin: casas cabe la puerta guadalajara q̃ se deriban] ya delante de la Puerta de guadalajara ala mano hizquierda como salen dela Villa estan vnas casas que salen fuera delas otras _____ que no se paresca desde la puerta del sol dela de guadalajara y si estas se quitasen la calle quedaria muy principal y vistosa Podria la Villa siendo V. Magᵗ servido ayudar con la quarta parte y lo demas se rrepartrese por todos los Vˢ dela dha calle hasta el espital rreal atento que todos los vezinos dela dha calle gozan del benefᵒ y que son rricas. [margin: qe se abra la calle de la cava] A la otra mano frontero destas casas esta tratado por mano del doctor durango del consejo de V. Magᵗ que se derriben dos casas hasta llegar ala calle dela caba para que aquella calle que ahora no sirbe sino de yn mundiçias sirba de calle principal y de tiendas las que cayeren cabe la puerta sera de muy gran probecho V. Magᵗ siendo seruido podra mandar quela vílla ayude con la quarta parte y los vezinos conlo demas Atento el gran probecho que seles siguen de derribar la dicha calle. [margin: q se acrecinta las carnicerias] la carniceria desta Villa es muy pequña de cuya causa las carnicerias dela corte no pueden caber dentro y dello rresultan

grandes ynconvenientes ansi enlo que toca a los pesos y rrepesos por no poderse visitar como convernien como por estar al sol y al ayre. Y alguna y las

Carnes no conla limpieza que se Requiere En las carnicerias dela, villa ay aparejo para poderse acresentar y abrir otra puerta hazia las casas del francᵒ del prado seria cosa muy nescessaria en quela villa ganara Por que encima delo quese acrecentasen las carnicerios podria aver casas de bibienda como lo aya ahora. Sobre lo queson carnicerias y esto acosta delos proprios Pues el probecho es para ellos. [margin: red y panaderira] Ansi mismo por lo que toca al hornato dela plaça y ala buena gouernacion y Pulicia desta villa Conbiene que aya rred a donde se bendan los pescados frescos y que aya Panaderia adonde este el para limpio y rrecogido y esto se puede hazer muy bien desde las casas de mari gomez hasta adonde suele estar la puerta los dias de toros dexando dos calles anchas vna ala una parte y otra ala otra y encima casas de aposento y estas se podria hazer a costa la mitad de sobras de rrentas y la olta mitad de proprios.

Tambien paresce que convenia mucho que la calle de Sant geronimo como biene derecha hasta la casa que es de calatayud ansi lo fuese hasta el cabo delas huertas junto ala puente nueba y que se cortasen de vnos corrales y casillas de poco precio lo que fue se menester para que sebiese el monestᵒ de san gerᵐᵒ desde de donde esta dho y la calle fuese drᵃ esto se podria pagar de sobras dencabeca myᵒ pues toca atodos y la costa seria poca. [margin: Calle de S Jũ i santiago] Ansi mismo en la calle queba entre san Juan y Santiago ansi por ser la calle muy angosta como por de esconçes se hazen en ella Vno conlas parceles del monestrᵒ de Sancta clara de vn corral y otro de vna esquina de vnas casas de don pedro de Ludena por Ser calle tan principal converma ensancharse A costa delas sobras dencabecamientos _____ lo mismo paresce que conberma quitarse las casillas vaxas y de poco precio que Salan de todas las otras en medio dela calle de atocha en la _____ que haze en las quatro calles esto costara muy poco y haze mucha fealdad en vna calle tan principal y la costa siendo V. Magᵗ servido podria ser de sobras de rrentas [margin: casas en la calle de atocha se quitan] Por mandado de V. Magᵗ el secretario pedro de hoyo me dixo que V. Magᵗ _____ era servid q̃ se abriese la puerta de balnadu y se enderecase la calle hasta la puerta de santo domingo Juan bautista lo a visto y aecho la traca si V. Magᵗ fuere seruido podra tratarse dello y la villa servir a V. Magᵗ con alguna parte dello sobras de rrentas [margin: puerta de valnadu] Ansi mismo me dixo el dho Pedro de Hoyo que V. Magᵗ mandaba que se hiziese la puerta de moros y se _____ una alcantarilla dela puente questa delante della para ensancharse la plaça y quela salida quedase Ilana Esto se podria hazer a poca costa por que con la piedra de la puerta de moros derribandose casi baldria la costa poco menos de lo que costase esta obra y seria muy nescessaria para aquella salida, [margin: puerta de moros]. Ansi mismo paresce seria cosa conbeniente abrir una puerta ala moreria bieja que saliese frontero de san francᵒ a donde esta platicado quese abriese para todo aquel barrio seria mucho provecho y gran servicio aquel barrio y a toda la Villa mayormente como esta abierta la calle nueba rreal y lo que costaria sera muy poco por q̃ solo se toma una casa vieja y de poco valor

lo mismo Paresce que se podra hazer detras de San Miguel abrir otra puerta en la muralla vieja

que salga ala calle dela caba que arriba esta dha que se abre Por junto a la puerta de guadalajara esta puerta a estado abierto muchos dias y seria de gran servicio y poca costa para esta villa. [margin: puerta de San Miguel] Ansimismo Paresce se de bria abrir otra puerta dela muralla vieja que saliese en medio de la calle de las fuentes la qual seria de gran provecho para todos aquellos barrios que estan dentro dela villa para serricio delas fuentes y esta costaria poco a abrir y estas puertas en tiempo que fuese nescessario guardarse el lugar que daban ynclusas enla cerca de afuera. [margin: puerta a la calle de las fuentes] Para ayuda A la costa delo questa dho podria servir dando V. Magᵗ licencia aesta Villa que derribar la torre de alasprernas y otra muralla que ba desde el arco de santa maria obra de cinquenta pasos adetante y la piedra valdria dineros para ello tambien siendo V. Magᵗ Servido podria ser gran ayuda a esta Villa hazerla V. Magᵗ merced dedarle vna cedula concediendole licencia para que todas las casas questan labradas y hedificadas por de dentro y por de fuera dela muralla desta villa dentro de los pasos contenidos en las leyes destos rreynos questa Villa se pudiese concertar con los dueños delas tales casas dandoles acenso lo que ansi tienen tomado Por vn precio moderado atento que a muchos dias que tienen labradas las dichas casas y las posen y que seria gran ynconbeniyente derribar los dhos hedificios presupuesto

que se podria hazer por no tener titulo como nin guno tiene para ello y los que no quisieren Concer tarse V. Magᵗ mande Por la dha cedula proceder contra ellos conforme ala ley de Toledo Pues esto es conforme a justicia y dello sesacaria buena ayuda para los proprios desta villa y para ayuda alas Obras arriba dhas. [margin: q podria servir para estas aindas] Tambien Podria V. Magᵗ hazer md. aesta villa de dar licencia de poder arrendar ciertos Pedacos de tierra que se dizen _____ que piden los vezinos de majadahonda y esta villa ganaria trezientas hanegas de pan de rrenta poco mas o menos y alos vezinos de majadahonda haria V. Magᵗ gran md que se les diesen por ques _____ dexos y en parte adonde los benados les haran poco daño. Ansi mismo Podria V. Magᵗ siendo servido hazer muy gran md desta villa en que las tierras que se dieron a Joan de Vitoria yaguadiel a _____ de las que se les tomaron q V. Magᵗ mandase tasar el valor delas dhas tierras del vno y del otro y selas satisfiziese el balor delas dhas tierras poresta villa a dinero y se les diese la quinta parte mas delo en que fue sentasadas y las tierras que se les dieron en lo dela villa quedasen para esta villa y las pudiesen arrendar y aprobecharse del balor dellas.

51 The report leaves no doubt as to the extended period of Herrera's activities for the city: 'Madrid 19 Abril 1586 el sr Juan de Herrera maestro mayor de obras de su magd e su aposentador de palacio e dixo quel a hecho para esta villa y en su seruicio muchas trazas en condiciones ansi para la obra de la puente real nueua que se haze en el rrio della como para las casas de la manzana de sta cruz puerta de guadalajara planta desta va y traza de la plaça mayor della e para todo lo demas que se le a ofrecido despues que esta en esta a va la corte de Su magd hasta agora y en todo lo demas que la dha va le a querido ocupar por lo qual et tenía pretension contra la dha va ...' quoted from Agustín Bustamante García, 'En Torno a Juan de Herrera,' 228, n3, citing AHP, Escribano Francisco Martínez, leg. 421, fol. 269v.

52 On the activities of the junta see Francisco Iñiguez

Almech, 'Juan de Herrera y las Reformas en el Madrid de Felipe II', *RBAM*, XIX, 1950, 3–108; the excellent study by Gregorio de Andrés, 'Ordenación urbanistica de Madrid dada por Felipe II en 1590,' *AIEM*, XIII, 1976, 15–31 for the text and analysis of the junta's consulta of 28 June 1590 in the Instituto de Valencia de Don Juan, caja 49, no. 295. The on-going character of the planning process is clear from the text of the report: 'y en cuanto a la dicha calle lo que hay desde la plaza de San Salvador hasta la puerta de Guadalajara se continue conforme a la planta antigua, sin inovar cosa alguna; y desde allí hasta la puerta de la Pestilencia adelante de los caños de Alcalá, se acomode, quitando en cuentros y añadiendo en partes; y desde las Vallecas adelante, pues es tan ancha la calle se podrá dividir en dos, de ancho suficiente, dejando plaza en partes cómodas, como en la planta parece, enmendando lo que pereciere que conviene y hacer de todo planta precise y envirla a su majestad para que vea lo que más convenga.'

53 See *Juan Gomez de Mora*, 255, cat. no. 90. Francisco de Mora noted that he was following 'la traça antigua de Ju de Valencia' for the porticoes of a street on his own plan for the area around the Puerta de Guadalajara.

54 Llaguno vol. 2, 136 attributed the design to Herrera and dated it to 1584. This was accepted by Ruiz de Arcaute 120; Iñiguez Almech, 'Juan de Herrera y las reformas en le Madrid de Felipe II,' 17–19; Luis Cervera Vera, 'Semblanza de Juan de Herrera,' in *El Escorial, IV Centenario de la fundación del monasterio de San Lorenzo el Real*, 2 vols., Madrid, 1964, vol. 2, 71–103, and by others in spite of the fact that Portables, MM, 132–9, contested it, citing a series of documents that demonstrated that an old bridge had existed on the same site before 1568 and that designs for a new one were solicited from Rodrigo Gil de Hontañón in 1572 (136f). See n. 51 above for Herrera's request for payment for the designs. Herrera would be unlikely to claim payment for designs by other architects. Furthermore, Bustamante (238–41) has shown that, far from being complete as Portables had claimed, the bridge was under construction in 1586 under the supervision of Pedro de Nates, Diego Martínez del Barrio, and Agustín de Argüello, who had been in charge since 1583.

55 Bustamante, 'En Torno a Juan de Herrera,' 240f, citing AHP, Escribano Francisco Martínez, leg. 432, fol. 117. See also Carlos Fernández Casado, 'Historia de los puentes de Madrid,' *RBAM*, XXIII, 1954, 65–84. Philip II ordered reconstruction of the Puente de Toledo in 1579 (p. 70f), but it was not built until the seventeenth century.

56 Herrera's bridge also appears in *Viaje de Cosme de Medicis por España y Portugal*, ed. Angel Sanchez Rivero and Angela Mariutti Rivero, 2 vols., Madrid, 1933. Wyngaerde's two views of Madrid that show the old bridge are illustrated in *Spanish Cities of the Golden Age*, 111–12 and 115–17.

57 One of Herrera's bridges is over the Guadarrama River at Galapagar near Torredolones, some twenty kilometers outside Madrid. Philip needed a bridge at this point to cross the river on one of his routes to the Escorial and wrote from Lisbon in 1582 to order its construction, specifying that Herrera would send designs. The bridge was complete on his return and he went to inspect it. Sigüenza, *La Fundación*, parte I, discurso XIII, 101, described the visit on 27 March 1583: 'pasó el puente que había mandado hacer en el río Guadarrama, en nombre de San Lorenzo, poniéndosele

sus parillas, que se acababa entonces.' Herrera's authorship was documented by Llaguno, vol. 2, 137 and 313, XXII, no. 4, 'El Rey. – Venerable y devoto padre prior &c. . . . Porque habemos acordado que se haga un puente de piedra para pasar el rio de Guadarrama entre el lugar de Torre de Lodones y Galapagar en el sitio y parte que está señalado para ello, os encargamos y mandamos proveais y deis orden, que se haga luego la dicha obra conforme a la traza, que para ello dará Joan de Herrera, nuestro arquitecto y aposentador de palacio,' from Lisbon 20 January 1582 (Reg. del Escorial, fol. 220). Ruiz de Arcaute, 120, illustrated and discussed the bridge briefly, but the most complete study is by Luis Cervera Vera, *Juan de Herrera diseña el puente sobre el Rio Guadarrama*, Madrid 1985. This type of bridge was adopted for similar bridges elsewhere and the bridge at Galapagar looks much like another small bridge, perhaps also by Herrera, nearer to the Escorial and like another near the mint outside Segovia. Herrera also designed a bridge over the Guadarrama River near Brunete, which lay along an alternate route from Madrid to the Escorial. A contract for building 'according to the design, specifications, and a sketch' by Herrera was signed by Pedro de Nates in 1588 but construction was not begun immediately. In 1590, Pedro was succeeded by his brother Juan and new arrangements were made for the work in 1592 and again in 1593. See Bustamante, 'En Torno a Juan de Herrera y la arquitectura,' 246f citing AHP, Escribano Francisco Martínez, leg. 425, fol. 279: 'Madrid 30 Mayo 1588, Pedro de nates maestro de canteria estante al presente en esta va de Madrid y corte de su magd como principal deudor y obligado . . . por quanto en el dho pedro de nates se remato de hultimo remate la puente que se a de hazer en el rrio de guadarrama en el termino de la villa de brunete en prescio de doze mill y doscientos ducados con doscientos ducados de prometido para la hazer conforme a la traça y conditiones y un rrasguño que dello hico Juan de herrera criado de su magd e a las demas que en su declaracion hicierõ Antonio e diego Sillero alarifes desta villa de madrid como todo ello mas largo parece por los papeles pregones y rrematos a que se rrefirio . . . ortogo el dho pedro de nates que se obligaua y obligo . . . hara la dha puente conforme a la dha traza e conditiones e rrascuño [sic] y declaraciones de condiciones fechas por los dhos antonio e diego sillero.' Antonio and Diego Sillero also worked for the junta as builders in 1590. Pedro's brother, Juan de Nates, had an important career as a classicizing architect and follower of Herrera's style in Valladolid. See Agustín Bustamante Garcia, *La Arquitectura clasicista del foco vallisoletano (1561–1640)*, Valladolid, 1983, 218ff. At Herrera's death in 1597 the bridge was still incomplete, but work began again in 1606 under Francisco de Praves, who presumably completed the work destroyed. On Herreran bridges see Pedro Navascués Palacio, 'Puentes de acceso a El Escorial,' *AEA*, LVIII, 1985, 97–107.

58 The Puente de las Palmas over the Guadiana River in Badajoz has sometimes been attributed to Herrera. It was finished in 1596 and, although Herrera was in Badajoz in 1580, the attribution appears unlikely. The new Puente Mayor (destroyed) in Valladolid, begun by Juan de Nates in 1584 over the Pisuerga, adopted the high parapet, heavy arches, and bolas of Herrera's bridge in Madrid according to an old drawing published by Juan

José Martín González, 'Dibujos de monumentos antiguos vallisoletanos,' *BSEAA*, XIX, 1953, 23–49, fig. 23. Gomez de Mora's project is illustrated in *Juan Gomez de Mora*, 272f, cat. no. 110. On the bridge at Retamar see *Población y Monasterio*, 1986, 163; and Carmen Andrés, *Puentes historicos de la comunidad de Madrid*, Madrid, 1989, 103ff, and for similar bridges built in the reign of Charles III.

59 Illustrated in *Juan Gómez de Mora*, 268, cat. no. 105 and 271, cat. no. 109.

60 There is a tradition, extending from the Renaissance to our own day, of viewing bridges as architecture, and they may have been the one building type which remained both architecture and engineering in spite of the emerging specialization of the later sixteenth century. Renaissance architects, even those who were not otherwise attracted by technology, turned easily to bridge design. Ammannati's Ponte S. Trinità has always been admired as architecture. It is within this tradition that nineteenth-century iron bridges were included as among the first monuments of modern architecture. Alberti considered bridges along with drains as part of street design: 'We should construct the bridge in the same way as the wide road' even as he stressed their architectural importance: 'the parts of the road the need to be particularly distinguished by ornament are these: bridges, crossroads, fora and show buildings.' (see Alberti, bk VIII, ch. 6, 261ff).

61 On the early history of the Plaza Mayor see M. Montero Vallejo, ' "Laguna" a la Plaza Mayor, la Plaza del Arrabal,' *AIEM*, XXIV, 1987, 203–15; on its later phases at Madrid: Antonio Bonet Correa, 'Concepto de Plaza Mayor en España desde el siglo XVI hasta nuestros días' and 'El Plano de Gomez de Mora de la Plaza Mayor de Madrid en 1636,' both in *Morfología y ciudad. Urbanismo y arquitectura durante el Antiguo Régimen en España*, 33–63 and 65–91 (this reprinted from the article of the same title in *AIEM*, IX, 1973, 15–53); and 'Las ciudades españolas del Renacimiento al Barroco,' *Vivienda y Urbanismo en España*, Madrid, 1982, 105–35. See also Gregorio de Andrés, 'Ordenación urbanistica de Madrid dada por Felipe II en 1590,' Agustín Bustamante García, 'En Torno a Juan de Herrera y la arquitectura,' Julián Gállego, 'L'Urbanisme de Madrid au XVIIe siècle,' *L'Urbanisme de Paris et de l'Europe 1600–1800*, ed. Pierre Francastel, Paris, 1969, 251–66; F. Iñiguez Almech, 'Juan de Herrera y las Reformas en el madrid de Felipe II.' See Virginia Tovar Martín, *Arquitectura Madrileña del Siglo XVII*, Instituto de Estudios Madrileños, Madrid, 1983, for the work of Juan Gomez de Mora, although the writer attributes more originality to Mora than I suggest here. See Pedro Moleón Gavilanes, *La Arquitectura de Juan de Villanueva: el proceso del proyecto*, Madrid, 1988, esp. 180–200 for Villanueva's contributions.

62 Iñiguez Almech, 'Juan de Herrera y las Reformas,' 24–7, published the key document 'Relacion en la qual se declara el intento del arbitrio y medio que el Corregidor de la villa de Madrid ha propuesto para quitar y derribar las casas que llaman de la mançana, que estan edificado de tiempo antiguo en la plaça de la dicha Villa, en gran perjuiçio della, como se muestra por el diseño y planta de como had de quedar, que el uno y el otro can con esta relación, para que su Mgd. los mande ver.' This report accompanied the plans of 1581, both in Archivo de Zabálburu, caja 219, nos. 100–2:

Traças.-Madrid-para quitar y derribar las casas que llaman de la mançana. Año 1581.

63 Juan Bautista Antonelli's, *Relacíon verdadera de la navegación de los Rios de España, propuesta y hecha por Juan Bautista Antoneli Ingeniero de S. M. Catolica*, BNM, ms 3036-J-59 was presented to Philip II on 20 May 1581 at Tomar and approved on 23 June 1581. An additional outline of the project, dated 15 December 1582, is included with the report.

64 The report cited in n. 62 above continues: 'Mudando las dichas casas a la parte que va señalada, en la qual hay sitio y suelo para dar a cada uno otros tantos pies como dexa y quedan gratificados del sitio con mucha ventaja por lo que haçe al que se derriba, por dos razonez: la una porque la açera que estas casas tenian en la plaça, en las fiestas no tenían vista, sino para la mitad della. Lo segundo porque la açera que tenían a las espaldas caya a un callejon muy sombrio, sucio y angosto y sin ningun provecho; y mudadas a la otra parte, por delante tienen la Plaza Mayor y por detras la de Santa Cruz, que es de much comerçio, de manera que edificaran a dos aces iguales de valor y aprovechamiento y delimpia y sana habitación, y han de lbrar uniformemente, con buen ornato.... De manera que queda declarado y concludído que no es neçessario, conforme a esta relaçion, que la Villa gaste ningunos maravedis en quitar y derribar la dicha mançana de casas, y que la plaça queda desembaraçada del impedimento y fealdad que le causaban y quadrada por la parte que era mas sin proportion, y solo le quedara para ser en toda perfection, neçessidad adelante, de ponder en cuadro el viaje [esviaje] o angulo que haçe açia la parte de la baxada y calle que va a la puerta de Guadalajara, lo qual se puede acomodar y enmendar haçiendo alli una lonja triangulada de merçderes, como lo pide el sitio, guardando las dos bocas de calles y líneas de la calle de Toldeo a la de la Ropeería, y quedaria la plaça quadrada y perecta. Aunque esto segundo de la lonja no se propone para agora de presente, sino para haçer demonstraçion del intento de la traça, y assi va señalada con tres lineas de punctos menudos, que no es obra que fuerça ni obliga a que se haga, ni hay la façilidad en ella que se representa y diçe del derribar de la dicha mançana de casas de que agora se trata.'

65 Javier Rivera Blanco, *Juan Bautista de Toledo*, 331ff, considers the evidence of the report on Madrid submitted in the 1560s, which describes a regularization of the Plaza Mayor, enough to warrant the attribution of the undated plans to Juan Bautista; but he does not mention the evidence that Herrera was at this time employed on the planning of Madrid. See text of the document in n50 above. It seems clear that the intention to remove the two houses was of long standing already in the 1560s. See the text of the report in n. 50 above.

66 Luis Cabrera de Córdoba, *Relaciones de las cosas sucedidas en la corte de España desde 1599 hasta 1614*, Madrid, 1857, 359, writing on 17 January 1609 described the new design: 'Tambien se da órden que todas las delanteras de las casas que caen á la plaza mayor, sean de nueva traza como está hecha la Panadería, para que estén mas lucidas; y asimesmo que se derribe y añada lo que fuere menester para hacerla cuadrada, con que de las fiestas de toros y recocijos que hubiere se pueda gozar mejor.' Four years later, on 24 August 1613, construction had just begun: 'Esta Villa de Madrid ha puesto en ejecución la traza que estaba dada

muchos dias había, de enderezar la calle de la Platería, desde la torre de San Salvador; y asi se derriban las Casas que salen mas que la torre, la cual han de quedar descubierta hasta la puerta de Guadalajara, sacando afuera las que allí estan retiradas, y tambien quieren derribar los soportales que estan en la dicha puerta de Guadalajara de fronte de la Plaza, y hacer allí una placetilla y poner la plaza mayor cuadrada, y que todas las casas delanteras se hagan conforme la nueva traza de la pulicía (p. 528).' The relevant portion of the junta's report is transcribed by G. de Andrés, 'Ordenación de Madrid dada por Felipe II,' 28: 'Y pues se trata de lonja, hay un buen sitio y parte cómoda para ella, por ser en la puerta de Guadalajara, entre todos los mercaderes y no en la plaza más cerca de ella y donde concurren todos los pasos principales de la Villa; y aunque se habá echado ojo en la manzana de Cartagena y de Prado el cordonero y en las manzanas de las casas de don Juan de Vitoria, que tienen las mismas calidades, parece este más a propósito, por el haberse desbaratar la manzana de los mercaderes para la plaza y para la calle que viene de la calle nueva; que pues se empieza a hacer daño, por mucho que sea en una parte, no es tan costosa como en muchas; y para el daño que recibe el Conde de Barajas, leserá consuelo el que toda la cerca de la Villa que toca en sus casas y aún en las demás hasta la puerta de Guadalajara, quedan los corales y traseras a calles públicas y principales, donde pueden sacar puertas y ventanas, como por la planta se verá; que aunque viéndola así de repente, parece que espanta, considerado todo lo arriba dicho, de que la villa tiene necesidad forzosa de proveer y el buen cómodo y ornato que la plaza recibe, se verá no ser dificultoso ni más costoso que haciéndose en otras partes diferentes. Y aunque se han visto todas las plantas tocantes a la dicha plaza y panadería, así viejas como las que de nuevo se han hecho y las dificultades y comodidades y consultas sobre ellas hechas, ha parecido ésta mejor; y demás cómodos y ornatos, así en la dicha plaza como en las calles que allá concurren, por lo cual aunque fuese más costosa contiene señalado para panadería, se podrá vender al que más diere por ellos y se quietarán los vecinos que les tomaban sus casas y lo recibían por pesadumbre.'

67 Iñiguez Almech, 'Herrera y las Reformas.'

68 See n. 66 above.

69 Iñiguez Almech, 'Herrera y Las Reformas,' 84.

70 The architectural history of the bakery has been much debated. See particularly F. Iñiguez Almech, 'La Casa Real de la Panadería' *RBAM*, XXII, 1948, 129–55; Iñiguez, 'Herrera y las reformas,' 84; Gregorio de Andrés, 'Ordenación urbanistica de Madrid dada por Felipe II en 1590,' Antonio Bonet Correa, 'El Plano de Juan Gómez de Mora de la Plaza Mayor de Madrid en 1636,' S. Pérez Arroyo, 'La Casa de la Panadería. Apuntes para una reconstrución de su evolución typológia,' *Villa Madrid*, XXIII, 1985/6, 44–52; Claudia Sieber, *The Invention of a Capital: Philip II and the First Reform of Madrid*; and Agustín Gomez Iglesias, 'El Alcaide de la Casa Panadería y la mudanza del peso real,' *RBAM*, XII, 1944, 193–215. Iñiguez believed that the bakery was completed about 1619 and so left open the possibility that Juan Gómez de Mora reworked designs made by Francisco de Mora in 1590/1 when he took over his uncle's responsibilities as city architect at the latter's death in 1610. Virginia Tovar Martín, *Arquitectura Madrileña del siglo XVII*, 400–13, and *Ivan Gómez de Mora*,

cat. nos. 119–21, 286–7, maintains that Gomez de Mora designed and built the first bakery. The evidence discovered by C. Sieber (*The Invention of a Capital*, 336, fig. 16, and 383 n85) of a sketch in the Archivo de la Villa, sec. 1-167-1 and report on the plaza shows conclusively that the bakery was complete by 1608 before Francisco de Mora's death. It would seem that the plan of 1590 was definitive. Diego de Sillero, who was in charge of construction, was clearing the site on the northern side of the city square through 1592. Iñiguez Almech, 'Las Reformas,' 97, cites a document of 13 May 1592 that 'se haga conforme a la traça y montea dadas de antes.' In 1594, Sillero requested additional funding since construction was proving more expensive than anticipated. Evidence from the junta's report of 28 June, 1590, published by Gregorio de Andrés, 'Ordenación urbanistica de Madrid dada por Felipe II en 1590,' 28f, however, makes it clear that the bakery and the surrounding buildings on the Plaza Mayor were planned by that date and the brief account of the bakery matches the building that was executed.

71 Jerónimo Quintana, *A la muy noble, antigua y coronada villa de Madrid, Historia de su antigüedad*, nobleza y grandeza, Madrid, 1629, reprinted, Madrid, 1954.

72 The evidence of a plan for the addition of a royal staircase by Gómez de Mora's former assistant, José de Villareal (died 1662), in the Archivo de la Villa de Madrid ASA 3-92-21 which is dated 1654 (Tovar Martín, *Ivan Gómez de Mora*, cat. no. 119, 286) represents the four westernmost bays of the façade and the entire depth of the bakery. The passageway to the Calle Mayor is labelled ('Passo desde la plaça a la calle Mayor') but was destined to be filled by the new staircase. The depth of the original building is defined by walls and labelled ('Ronda detras de la panadería'). The remodelling required constructing walls between the existing piers and some of the columns but four of the original columns are clearly visible and the placement of four more is shown under the ink wash that indicates the projected new walls. Assuming a symmetrical building, the distribution of the 54 piers in the basement and the 30 piers and 24 columns on the ground floor can be reconstructed. The resulting plan corresponds to the placement of the patio and the distribution of the bays shown in two plans that are usually considered projects for the rebuilding after the fire of 1672, but tentatively dated c. 1653 by Virginia Tovar Martín in *Ivan Gómez de Mora*, cat nos. 120, 121 in the Archive of the Ayuntamiento, ASA 3-91-24v. The rebuilding proposed to use the old foundations but to (1) reduce the length of the building by a bay at either end, eliminating the passageways to the Calle Mayor; (2) extend the building on the north by the depth of three days along its entire length; and (3) displace the open-well staircases, which originally occupied one bay next to the passageways at either end of the building, one bay inwards.

73 Madrid, Museo Municipal, inv. 3422.

74 The royal hall and balcony recall the function of a large window and the later galleries in the façade of the Alcázar which overlooked the square in front of the palace. The bustling courtyard of the royal Alcázar with offices and shops was a precedent for combining royal and commercial functions in a single building, but merchants and peddlers were never completely welcome in the Alcázar.

75 J. Quintana, *A la muy noble, antigua y coronada villa de Madrid*, cap. LVI, 375: 'En esta gran plaza

a la parte del Septentrion en el medio de aquel lienço está el suntuoso edificio de la Panadería que con razon le damos este nombre por ser la mas grandiosa fábrica que para este ministerio ay en toda España. Tiene ciento y veinte y quatro pies de delantera y de fondo cinquenta y seis; carga esta grandeza sobre cinquenta y quatro pilastras cuadradas de piedra berroqueña que debaxo de tierra sustentan una boveda hecha de rosca de ladrillo fuerte donde los panaderos que can a vender pan tiene guardadas sus cavalgaduras en lo que llevan. Sobre estas se levantan 24 colunas redondas y 30 pilastras quadradas con sus capiteles.' Juan de Tapía's description is similar. Both descriptions are quoted in E. Guerra Sánchez-Moreno, 'La Casa de Panadería,' 391.

76 On the history of the project see Fernando Marías, 'Juan de Herrera y la obra urbana de Zocodover en Toledo,' *BSEAA*, 1977, 173–8; and F. Marías, *La Arquitectura del Renacimiento en Toledo*, 2, 20–4 and 4, 37–48. The plans, found by Thomas F. Reese, are in AHN, consejos 7017, leg. 625, no. 6: 'Planos pertenecientes a las pruebas de un pleito entre el cabildo catedralicio y el ayuntamiento sobre el usufructo de balcones, ventanas y salidas de las casas con motivo de los negocijos públicos, 1766.'

77 F. Marías, *Arquitectura del Renaciemiento en Toledo.*

78 The anonymous writer of *Tratado anónimo de arquitectura* devoted three short chapters to the design of squares on fols. 85v–86v: 'De las Plaças de los Pueblos', based on Alberti, bk VIII, ch. vi, 262–5. Necessario es en medio de Los Pueblos aber plaças donde puedan conuenir y mucha gente a…a fiestas o a mercados a ferias apregones de cosas pertenecientes al bien [85v] Publico y a otras vsis semejantes Los quales deben ser de tal gandeza que sean bastantes para lo que son y no mas tendidas que al pueblo conuiene por que abiendo enellas poca gente no parezcan de siertas. Los de nro tiempo no an curado de hazer las Plaças con medida ni ornamentos mas los antiguos Tenian desto mucho cuydado porqueel espacio quees cosa mas adornada y mas puestas en Razon de Toda La ciudad de ber la ques mas vista del pueblo y do mas toman mente acuden Los estrangeros los quales suelen Lleuar de la Relacion deLas ciudades a otras tierras estranas oir tanto dir ____ de La forma de las Plaças segun Los antiguos. Los gruesos quadradas. De las medidas y ornamentos de las Plaças de los griegos y latinos: [86] Los griegos Hacian la plaça quadrada y al rrededor de Toda ella vn portal con dos ordenes de colunas vnas en la delantera y otras por medio del ancho del portal y sobre estas colunas ponian la banda arquitrabe y encima hacian corredores mas Los Latinos abiendo Respecto alos Juegos que Hacian en Las plaças Las hicieron que en Luengo tubiesen tanto como el ancho y la mitad y en todo cerredor Las Portales an de ser anchas como son altas Las colunas con sus capiteles y las colunas de arriba y las otras pieças como Requiere la comun medida La quarta parte menos que las de abajo y el suelo delos portales a hacian Portales de colunas esparcidas en La delantera sin poner otras en medio y sobre el estos portal hacian vnos corredores que fuesen miradores cuyas colunas y todas las ortras pieças heran menores que las de abajo vna quarta como arriba diximos conbenir a Las obras sobre puestas en Losportales bajos abra tiendas de Lindas mercadurias como de sedas y panos o de artifices polidas como platera y otros

tales y en los corredores abra Lugares y cosas pertenecientes a los [86v] que cogen las Rentas y para otras cosas Publicas. De Otra forma de plaças en todas sus Partes medida: Podria se Hazer vna muy hermosa plaça en esta manera el Luengo a de ser dos trantos queel ancho porque ansi abria lugar aquel altura de Los portales y corredores tuuiesen cierta medida en el espacio de en medio Los quales an de ser alo menos tan altos como la quinta parte del anchura de la Plaza ya los mas como la Tercia [87] Los Portales an de ser tan anchas como son altas las colunas con sus capiteles y las colunas arrriba y las otras pieças como Requiere la comun medida la quarta parte menos que las de abajo yel suelo delos portales a der ser tanto mas alto ques tda La Plaça quanto vna quinta parte aeste suelo a de aber las grandas que conuiniere para subir ael en el alto de la obra dela obra de las colunas sha dehazer vn poyuelo tan alta como es vna octaua Parte del altura del corredor estos Portrales y corredores que enLas Plaças sehazen tenian admirable gracia y hermosura para que alli se Recogiese el pueblo si alguna ___ lublialos echase de la plaça y para que de alli mirasen Los [87v] Juegos en Las dias de Plazer y tambien por que los hombres ancianos holgasen de yr a la plaça sabiendo que abran de hallar tan buen aparejo quepara esta enella Lo qual mucho perternecer alas buenas costumbres del pueblo por queestando presentes Los Hombres dignos de acatamiento Los otras se guardarian de hazer cosas muy feas en aquel lugal do ay mas soltura. De Las Plaças: sin Las Plaças principales suelen aber otras plaças en los encuentros de las calles di se solian hazer Los mismos atabios y ornamentos por que en Todas partes la ciudad tuuiese [88].' Compare Alberti, bk VIII, ch. vi, 262–5.

79 See Alberti, bk VIII, ch. vi, 262, 264.

80 The plaza in Colmenar de Oreja is a good example of a designed square executed in vernacular style in the seventeenth century. See Luis Cervera Vera, *La Plaza Mayor y estructura urbana de Colmenar de Oreja (Madrid)*, Madrid, 1985.

81 In 1590, the junta stressed the value of fireproof construction in the bakery, but their comments suggest that wooden lintels may have been originally planned for the rest of the square, or perhaps that they assumed that the lintels in the drawing would be executed in woods: 'Y en cuanto a la fachada de la delantera parece convenir sea toda la fábrica y con las menos maderas posibles, por donde no parece que conviene sean pilastras y vigas encima sino pilastras y arcos de albañería … por lo cual parece convendrá, conforme a la fachada que Valencia trajo rubricada de la Junta, siendo con arcos y non con vigas, como la anotación dice y es fábrica que se puede ahora ejecutar en todo lo que se hace de nuevo, así en la panadería como en la lonja y demás manzanas' from Instituto Valencia de Don Juan, caja 47, no. 295, transcribed in G. de Andrés, 'Ordenación urbanistica de Madrid dada por Felipe II en 1590,' 29.

82 Bramante's square at Vigevano is unified like a building, like his later Belvedere Courtyard. See Wolfgang Lotz, 'The Piazza Ducale in Vigevano: a Princely Forum of the Late Fifteenth Century,' *Studies in Italian Renaissance Architecture*, Cambridge, Mass., 1977, 117–39; and 'Sixteenth century Italian Squares,' in the same volume, 74–92.

83 See Ludwig Heydenrich and Wolfgang Lotz, *Architecture in Italy 1400–1600*, Harmondsworth and Baltimore, 1974, 278–86. Domencio Fontana

noted some of the projects in *Della Trasportatione dell'obelisco Vaticano, et della fabriche di Nostro Signore Papa Sisto V*, Rome, 1590.

84 In spite of almost insuperable difficulties, Giovanni Battista Antonelli was still at work on this problem in the 1580s and managed to send some boats to Lisbon.

85 See for example C. Viñas y Mey and R. Paz, *Relaciones histórico-geográfico-estadísticas de los pueblos de España hechas por intención de Felipe II: I Provincias de Madrid*, Madrid, 1951; and *Il Reino de Toledo*, Madrid, 1951.

86 See Steven N. Orso, *Philip IV and the Decoration of the Alcázar of Madrid*, Princeton, N.J., 1986, for discussion of the uses of rooms in the Alcázar. The room of architectural drawings is mentioned on p. 21.

87 Alberti bk IX, 10, 316: 'They say that the architects employed by Nero were so prodigal that they would conceive of nothing that did not push to the very limits of human capacity. I cannot approve of them, and much prefer someone who gives the impression that he will always make utility and frugality his primary concern in anything. Even if everything has to be done for the sake of ornament, yet he should furnish the building in such a way that you could not deny that utility was the principal motive.'

88 For a celebration of Philip's virtues see Christóbal Perez de Herrera's *Elogio a las esclarecidas virtudes de la C. R. M. del Rey N. S. Don Felipe II, que está en el cielo…*, Valladolid, 1604, reprinted in Luis Cabrera de Córdoba, *Felipe Segundo Rey de España*, segunda parte, vol. 4, Madrid, 1877, 335–402.

89 No one expressed the moral dimension of architecture better than Alberti, for whom an outward simplicity, in buildings as in persons, is a sign of ethical rectitude: 'For every aspect of building, if you think of it rightly, is born of necessity, nourished by convenience, dignified by use; and only in the end is pleasure provided for, while pleasure itself never fails to shun every excess. Let the building then be such that its members want no more than they already have, and what they have can in no way be faulted.' (Alberti, bk I, 9, 24).

90 Sigüenza, *La Fundación*, parte II, discurso XXII, 'La comparación y conferencia de este templo y casa con otros edificios famosos, principalmente con el templo de Salomón,' 418.

91 Sigüenza, *La Fundación*, parte II, discurso XXI, 'El dinero que se ha gastado en esta fábrica, desde los primeros maravedis que para ella se libraron, y las tasaciones de las más principales cosas de ella,' 410f: 'Si este pio Monarca, desde que comenzó esta fábrica hasta que le dío fin, llamara a la puerta de su palacio cada día cuatro mil pobres, gente honrada, y les diera dos reales de limosna para que se sustenaran, siquiera honesta mente, aunque se pasearan por Madrid, ¿ no dijeran que era esta una obra heroica y nunca oída? ¿ No le besaran la ropa por santo? Pues esto mismo he hecho con mejor orden, con más prudencia y de mayores provechos; porque con aquella primera limosna no hiciera más de sustentar gente ociosa, holgazana, criar carnes y vicios, y con ésta se ha hecho un efecto tan admirable, tan hermoso y de tan buenos usos, frutos y fines; hanse criado en España tantos y tan buenos artífices, arquitectos, trazadores, canteros, carpinteros, ensambladores, albañiles, pintores, bordadores y otras cien artes y oficios e ingenios, que se saben y ejercitan con tan to primor en ella como en todo el mundo, por el uso y maestría que

aquí ha habido de ellos, y todo con la limosna que el Rey hizo estos treinta y ocho años. Y lo que es de mayor consideración, que no sólo se quedan aquí las obras, los ingenios y los modelos vivos; más aún: se queda la misma limosna viva. Aquella primera que se hizo a gente ociosa, en acabando se muriera; ésta comenzó cuando se hizo, dura ahora y vivirá mil siglos que ciento cuarenta religiosos que aquí se mantendrań en tan santa vida, perpetuos capellanes de los Reyes y del mundo, cuarenta niños que se crían en tanta santidad, hijos son de españoles ... tantos oficiales y mozos de servicio bien ocupados, españoles son, y en ellos vive la limosna y la renta, pues en ellos o en otros como ellos se había de gastar aquí o en otra parte.'

92 From Leo de Meyere, *Prosopopée d'Anvers* of 1594 quoted from Elizabeth McGrath, 'Le Déclin d'Anvers et les Décorations de Rubens pour l'entrée du Prince Ferdinand en 1635,' *Les Fêtes de la Renaissance*, III, ed. Jean Jacquot and Elie Konigson, Paris, 1972, 173–86.

93 On the Buen Retiro see Jonathan Brown and John Elliott, *A Palace for a King: the Buen Retiro and the Court of Philip IV*, New Haven and London, 1980. Some of the material is included in my 'Madrid in 1590/91,' *Kritische berichte, Zeitschrift für kunstund kultur wissen schaften*, I, 1992, 93–105. I would like to thank Laurie Nussdorfer Philip Benedict and Florent Tesnier for their helpful comments on the argument.

Postscript

1 The relations between the aesthetic aspect of architecture and political power in Rome in the 1540s is brought out by Christoph Frommel, 'Papal Policy: The Planning of Rome during the Renaissance', *Art and History: Images and Their Meaning*, ed. Robert I. Rotberg and Theodore K. Rabb, Cambridge, 1986, 39–65.

2 See Jean-Pierre Babelon, 'L'Urbanisme d'Henri IV et de Sully à Paris,' *L'Urbanisme de Paris et l'Europe 1600–1680*, ed. Pierre Francastel, Paris, 1969, 47–60; and most recently Hilary Ballon, *The Paris of Henri IV: Architecture and Urbanism*, Cambridge, Mass., and London, 1991.

3 Speaking of the retable of the Escorial, Zuccaro noted 'Questo retavolo ha un finimento di mischi e bronzi singularissimi con 18 colonne in tre ordini di 22 piedi in circa alte, ma quello che è d'ammiratione notabile quivi, et una si puol dire delle cose più principali e notabile che in tal genere siano giamai state fatte che è una custodia del Santissimo Sacramento dall' Eccellentissimo Sigr. Jacomo da Trezzo ... questa custodia è un tempietto rotondo simile a quel di Bramante a S. Pietro Montorio ...' quoted from J. Domínguez Bordona, 'Federico Zuccaro en España,' *AEA*, VII, 1927, 77–89, from 'Raggvaglio di Frederico Zuccaro dell' Escuriale di Arangouis e di Tolledo,' 81–9.

4 See Henri Zerner's forthcoming *Le Grand Tournant*.

5 The static quality of mid-century Italian architecture was described by Wolfgang Lotz, 'Italian Architecture in the Later Sixteenth Century,' *College Art Journal*, XVII, 1958, 129–39, reprinted in his *Studies in Italian Renaissance Architecture*, Cambridge, Mass., and London, 1977, 152–58.

6 Kubler, 101f, notes that the first Casa de Oficios on the northeast, begun in 1583, was originally called the casa de los doctores catedráticos and intended for the secular professors of the college. By 1589 Herrera described both buildings in his *Sumario* 'primera planta,' as 'casa para officios de boca del seruicio Real, y para aposentos d officiales de boca, este es vn edificio q̃ tiene seys patios, y tiene d anchura .200. pies, y de largo lo q̃ se vee por el pedaço de platã q̃ aqui va señalado, porq̃ no cupo mas en la lamina,' quoted from Juan de Herrera, *Svmario y Breve Declaraciõ delos diseños y estampas dela Fabrica de san Lorencio el Real del Escurial*, Madrid, 1589, reprinted by Luis Cervera Vera, Madrid, 1952. Herrera did not include in his prints the Compaña, which was built between 1590 and 1594 under the direction of Francisco de Mora. Of the original Compaña of nine courtyards, only the main building with a central county and survives.

7 Domenico Fontana, *Della trasportatione dell'obelisco Vaticano et delle fabriche di Nostro Signore Papa Sisto V*, Rome, 1590.

8 Pellegrino Tibaldi wrote his treatise in the 1590s after having been in Spain. See Aurora Scotti, 'Pellegrino Tibaldi ed il suo Discorso d'architettura,' *Fra Rinascimiento, Manierismo e Realtà. Scritti di Storia dell'arte in memoria di Anna Maria Brizio*, Florence, 1984, and 'Il Trattato sull'Architettura de Pellegrino Tibaldi,' in *Les Traités d'Architecture de la Renaissance*, ed. André Chastel and Jean Guillaume, Paris, 1988, 263–8. See also the articles by various authors in *Arte Lombarda*, new series, III–IV, 1990, devoted to Pellegrino Tibaldi. On Pierre Le Muet, *Maniere de bien bastir pour toutes sortes de personnes*, Paris, 1647 see the modern facsimile with introduction by Claude Mignot, Paris, 1981. The interior courtyards of the more prestigious urban buildings are allowed a more individualized decoration, and the royal chateau is, of course, exempted from the continuum, reminding one of L. Savot's (*L'architecture Française des batiments particuliers*, 1642) evocative description of the special status accorded royal and princely architecture: 'Il n'est pas possible de décrire tout ce qu'il faut pour loger un grand Prince, une ville n'y serait pas quelque fois suffisante: et comme l'étandue de sa souveraineté ne se peut borner que par la mort, aussi la grandeur de sa cour, et par même moyen de son palais, et du logement des officiers, ne peut recevoir de description. Tellement que les logis des grands Rois ne sont jamais tels que l'architecte les voulait ordonner, mais seulement comme il a plu à euxmêmes de les vouloir prescrire: Etant presque aussi déraisonable de les assujettir à certaines mesures que de leur vouloir donner des lois et borner leur puissance.' quoted by Philippe Boudon, *La Ville de Richelieu*, Paris, 1972.

Selected bibliography

Abril, Pedro Simón, *Apuntamientos de cómo se deben reformar las doctrinas, y la manera de enseñallas*, Madrid, 1589

Ackerman, James, 'Ars Sine Scientia Nihil Est: Gothic Theory of Architecture at the Cathedral of Milan,' *Art Bulletin*, XXXI, 1949, 84–111

Ackerman, James, 'Architectural Practice in the Italian Renaissance,' *Journal of the Society of Architectural Historians*, XIII, 1954, 3–11, reprinted in *Renaissance Art*, ed. C. Gilbert, New York, Evanston and London, 1970, 148–71

Ackerman, James, *The Architecture of Michelangelo, Studies in Architecture*, 2 vols., revised edn., London, 1964–6

Ackerman, James, *Palladio*, New York, 1966

Ackerman, James, 'The Tuscan/Rustic Order: A Study in the Metaphorical Language of Architecture,' *Journal of the Society of Architectural Historians*, XLII, 1983, 15–34

Actas de las Cortes de Castilla, 15 vols., Madrid, 1862–1919

Adams, Nicolas, 'Sebastiano Serlio, Military Architect?' in *Sebastiano Serlio, Sesto Seminario Internazionale di Storia dell'Architectura, Centro Internazionale di Studi di Architettura 'Andrea Palladio' di Vicenza*, ed. Christof Theones, Milan, 1989, 222–7

Adams, V. H., *The French Garden 1500–1800*, New York, 1979

Agapito y García, A., *Valladolid, ciudad sus origines*, Valladolid, n.d.

Agapito y Revilla, José, 'Tres trazados de la iglesia mayor de Valladolid en un dibujo,' *Diario Regional*, Valladolid, 28 April 1943

Aguilar Piñal, F., 'Dos manuscritas referentes a la historia de Madrid,' *Anales del Instituto de Estudios Madrileños*, II, 1967, 174ff

Acalá de Henares, Comunidad de Madrid, *Madrid en el Renacimiento*, 1986 (catalogue with essays by various authors)

Al-Farabi, *Catálogo de las Ciencias*, ed. and trans. A. González Palencia, Madrid, 1953

Alberti, Leon Battista, *Della pittura*, ed. L. Mallé, Florence, 1950

Alberti, Leon Battista, *On Painting and Sculpture*, ed. and trans. with introduction by Cecil Grayson, London, 1972

Alberti, Leon Battista, *On the Art of Building in Ten Books*, trans. Joseph Rykwert, Neil Leach, Robert Tavernor, Cambridge, Mass., and London, 1988

Almela, Iuan Alonso de, 'Description de la Octava Maravilla del Mundo... compuesto por el Doctor Iuan Alonso de Almela, médico, natural y vecino de Murcia, dirigido a la Real Magestad del Rey Don Felipe,' in *Documentos para la Historia del Monasterio de San Lorenzo el Real de El Escorial*, ed. Gregorio de Andrés, VI, Madrid, 1962, 12–98

Alvar Esquerra, Alfredo, 'Madrid en el siglo XVI: entre el anacronismo y la realidad,' in Alcalá de Henares, *Madrid en el Renacimiento*, 1986, 11–48

Alvar Esquerra, Alfredo, *El Nacimiento de una capital europea: Madrid entre 1561 y 1601*, Madrid, 1989

Alvarez Osorio, *Catálogo de las medallas de los siglos XV y XVI conservado en el Museo Arqueológico Nacional*, Madrid, 1963

Alvarez Turienzo, Saturnino, *El Escorial en las letras españolas*, Madrid, 1985

Andrés, Carmen, *Puentes historicos de la comunidad de Madrid*, Madrid, 1989

Andrés, Gregorio de, 'Ordenación urbanistica de Madrid dada por Felipe II en 1590,' *Anales del Instituto de Estudios Madrileños*, XII, 1975, 15–31

Andrés, Gregorio de, 'La construtión de la iglesia de Valdemorillo y el Castillo de Villaviciosa de Odón segun las trazas de Bartolomé de Elorriaga,' *Anales del Instituto de Estudios Madrileñas*, XIII, 1976, 61–78

Andrés, Gregorio de, 'Inventario de documentos sobre la construcción y ornato del Monasterio del Escorial,' annexes, *Archivo Español de Arte*, 1972–9

Andrés, Gregorio de, *Inventario de documentos del siglo XVI sobre el Escorial que se conservan en el Archivo del Instituto 'Valencia de Don Juan'*, Madrid, n.d.

Andrés, Gregorio de: see also *Documentos para la Historia del Monasterio de San Lorenzo de El Escorial*, vols. 5–8

Androuet Du Cerceau, Jacques, *Les Plus Excellents Bastiments de France*, 2 vols., Paris, 1576, 1579; in 1 vol. ed. David Thompson, Paris, 1988

Androuet Du Cerceau, Jacques, *Livre d'Architecture*, Paris, 1582

Angulo Iñiguez, Diego, *Bautista Antonelli: las fortificaciones americans del siglo XVI*, Madrid, 1942

Annali della Fabbrica del Duomo di Milano, dall'origine fino al presente, vol. 1, Milan, 1877; *Appendice*, vol. 1, Milan, 1883

Antonelli, Juan Bautista, *Relación verdadera de la navegación de los Rios de España, propuesta y hecha por Juan Bautista Antoneli Ingeniero de S. M. Catolica*, Madrid, Biblioteca Nacional, ms. 3036

Archivo General de Simancas, *Mapas, planos y dibujos (años 1503–1805)*, vol. 1, ed. Maria Concepción Alvarez Terán, Valladolid, 1980

Arfe [Arphe] y Villafañe, Juan de, *De Varia Commensvracion para la escvltvra y architectura*, Seville, 1585, reprint with introduction by Antonio Bonet Correa, Madrid, 1978

Arfe [Arphe] y Villafañe, Juan de, *De Varia Commensvracion para la escvltvra y architectura*, Seville, 1585, reprint with introduction by Francisco Iñiguez Almech, Valencia, 1979

Ariño, Francisco, de, *Sucesos de Sevilla de 1592 á 1594*, Seville, 1873

Arribas Arranz, Filemón, *El Incendio de Valladolid*

en 1561, Universidad de Valladolid, Facultad de Filosofia y Letras, Estudio e Documentos, no. 17, Valladolid, 1960

Babelon, Jean, *Jacopo da Trezzo et la Construction de l'Escurial, Bibliothèque de l'Ecole des Hautes Etudes Hispanques*, III, Bordeaux, 1922

Babelon, Jean Pierre, 'L'Urbanisme d'Henri IV et de Sully à Paris,' in *L'Urbanisme de Paris et l'Europe 1600–1680*, ed. Pierre Francastel, Paris, 1969, 47–60

Baedecker, Karl, *Spain and Portugal, Handbook for Travellers*, Leipsig, 1898

Ballon, Hilary, *The Paris of Henri IV: Architecture and Urbanism*, Cambridge, Mass., and London, 1991

Barghahn, Barbara von, *Age of Gold, Age of Iron: Renaissance Spain and the Symbols of Monarchy*, 2 vols., Lanham, New York, and London, 1985

Batelli, Guido, *Felipo Terzi*, Florence, 1935

Baur, Ludwig, 'Domenicus Gundissalinus: De Diuisione philosophiae,' in *Beitrage zur Geschichte der Philosphie des Mittelalters*, IV, 1903

Baxandall, Michael, *Giotto and the Orators: Humanist Observers of Painting in Italy and the Discovery of Pictorial Composition 1350–1450*, Oxford, 1971

Beaujouan, G., *L'Interdépendance entre la science scolastique et les techniques utilitaires*, Paris, 1957

Beckmann, Roland, *Villard de Honnecourt: la pensée technique au XIIIe siècle et sa communication*, Paris, 1991

Bennassar, Bartolomé, *Valladolid au siècle d'or: une ville de Castille et sa compagne au XVIe siècle*, Paris, 1967

Bermúdez Plata, C., *La Casa de la Contratación, la Casa Lonja y el Archivo General de Indias*, Seville, n.d.

Blasco Castiñeyra, Selina, 'La Descripción de El Escorial de fray José de Sigüenza,' in *El Escorial: arte, poder y cultura en la corte de Felipe II*, El Escorial, 1988, 37–62

Blunt, Anthony, *Art and Architecture in France, 1500–1700*, 2nd edn., Harmondsworth, 1970

Bonet Correa, Antonio, 'El Plano de Juan Gómez de Mora de la Plaza Mayor de Madrid in 1636,' *Anales del Instituto de Estudios Madrileños*, IX, 1966, 1–39

Bonet Correa, Antonio, 'El Plano de Gómez de Mora de la Plaza Mayor de Madrid en 1636,' *Anales del Instituto de Estudios Madrileños*, IX, 1973, 15–53

Bonet Correa, Antonio, 'Le Concept de Plaza Mayor en Espagne depuis de XVIe siècle,' *Forum et Plaza Mayor dans le Monde Hispanique, publications de la Casa de Velázquez, série "Recherches en sciences sociales"*, fasc. IV, Paris, 1978, 79–106

Bonet Correa, Antonio, *Morfología y ciudad: urbanismo y arquitectura durante el antiguo régimen en España, Collectión Arquitectura y Crítica*, ed. Ignasi Solà-Morales Rubio, Barcelona, 1978

Bonet Correa, Antonio, ed., *Bibliografía de arqui-*

Bibliography

tectura, ingeneria y urbanismo en Espana (1498–1880), 2 vols., Madrid, 1980

Bonet Correa, Antonio, 'Las Ciudades españolas del Renacimiento al Barroco,' Vivienda y Urbanismo en España, Madrid, 1982

Bonet Correa, Antonio, 'El Entorno urbano en Madrid en el Siglo XVI,' in Alcalá de Henares, Madrid en el Renacimiento, 1986, 49–60

Boudon, Françoise, 'Les Livres d'architecture de Jacques Androuet Du Cerceau,' Les Traités d'architecture de la Renaissance, ed. André Chastel and Jean Guillaume, Paris, 1988, 367–96

Boudon, Françoise, 'Images de jardins au XVI siècle: les "Plus Excellents Bastiments de France",' Histoire des jardins de la renaissance à nos jours, ed. Monique Mosser and Georges Teyssot, Paris, 1990, 121–30

Boudon, Françoise and Hélène Couzy, 'Les Plus Excellents Bâtiments de France. Une anthologie de châteaux à la fin de la Renaisance,' L'Information d'histoire de l'art, 1974, 8–12 and 102–14

Boudon, Philippe, La Ville de Richelieu, Paris, 1972

Branner, Robert, 'Villard de Honnecourt, Reims, and the Origin of Gothic Architectural Drawing,' Gazette des Beaux Arts, LVI, 1963, 129–46

Brown University, Department of Art, Philip II and the Escorial: Technology and the Representation of Architecture, Providence, R.I., 1990

Brown, Jonathan, 'Felipe II, mecenas y coleccionista,' Reales Sitios: Revista del Patrimonio Nacional, XXIV, 1987, 37–56

Brown, Jonathan, Velázquez, New Haven and London, 1989

Brown, Jonathan, The Golden Age of Spanish Painting, New Haven and London, 1991

Brown, Jonathan and John Elliott, A Palace for a King. The Buen Retiro and the Court of Philip IV, New Haven and London, 1980

Brown, Frank E., 'Vitruvius and the Liberal Art of Architecture,' Bucknell Review, II, 4, 1963, 99ff

Bury, John B., 'The Stylistic Term "Plateresque",' Journal of the Warburg and Courtauld Institutes, XXXIX, 1979, 199–230

Bury, John B., 'Early Printed References to the Escorial,' Iberia, Literary and Historical Issues: Studies in Honor of Harold V. Livermore, ed. R. O. Goertz, Calgary, 1985, 89–106

Bury, John B., 'Early Writings on fortification and siegecraft,' Fort (the Journal of the Fortress Study Group, Liverpool University), XIII, 1985, 5–48

Bury, John B., 'Juan de Herrera and the Escorial,' Art History, IX, 1986, 427–49

Bury, John B., 'Las Contribuciones de Juan de Herrera al proyecto de El Escorial,' Goya, 192, 1986, 330–5

Bury, John B., 'Las "Galerías Largas" de El Escorial,' Las Casas reales: El Palacio, IV Centenario del Monasterio de El Escorial, Patrimonio Nacional, Madrid, 1986, 21–34

Bury, John B., 'Renaissance Architectural Treatises and Architectural Books: a Bibliography,' Les Traités d'architecture de la Renaissance, ed. André Chastel and Jean Guillaume, Paris, 1988, 485–503

Bury, John B., 'Serlio: Some Bibliographical Notes,' in Sebastiano Serlio, Centro Internazionale di Studi di Architettura "Andrea Palladio" di Vicenza, ed. Christof Theones, Milan, 1989, 92–101

Bury, John B., 'Philip II and the Escorial,' Print Quarterly, VIII, 1991, 77–82

Bustamante García, Agustín, 'En Torno a Juan de Herrera y la arquitectura,' Boletín del Seminario de Estudios de Arte y Arqueología, University of Valladolid, XLII, 1976, 227–50

Bustamante García, Agustín La Arquitectura clasicista del foco vallisoletano (1561–1640), Valladolid, 1983

Bustamante García, Agustín and Fernando Marías, Las Ideas artisticas de el Greco, Madrid, 1981

Bustamante, Agustín and Fernando Marías, 'El Escorial y la cultura arquitectónica de su tiempo,' in Madrid, Biblioteca Nacional, El Escorial en la Biblioteca Nacional, IV Centenario del Monasterio de El Escorial, ed. Elena Santiago Páez, Madrid, 1986, 115–220

Bustamante García, Agustín and Fernando Marías, 'La Révolution classique: de Vitruve á l'Escorial,' Revue de l'Art, no. 70, 1986, 29–40

Bustamante García, Agustín and Fernando Marías, 'Francisco de Mora y la arquitectura portuguesa,' As Relacoes artísticas entre Portugal e Espanha na época dos descobrimentos, Coimbra, 1987, 277–318

Cabrera de Córdoba, Luis, Relaciones de las cosas sucedidas en la corte de España desde 1599 hasta 1614, Madrid, 1857

Cabrera de Córdoba, Luis, Historia de Felipe Segundo, rey de España, Madrid, 1619, reprinted Madrid, 1976

Calì, Maria, Da Michelangelo all' Escurial: momenti del dibabattito religioso nell'arte del cinquecento, Turin, 1980

Calvete de Estrella, Juan Christóbal, El Felicíssimo viaje del muy alto y muy poderoso príncipe don Felipe ... desde España a sus tierras de la baja Alemania, reprint, 2 vols., Madrid, 1930

Camón Aznar, José, 'La intervención de Rodrigo Gil en el manuscrito de Simón Garcia,' Archivo Español de Arte, XIV, 1941, 300–5

Campos Fernández de Sevilla, F. J., 'Carta de Fundación y Dotación de San Lorenzo el Real, 22-iv-1567,' Real Monasterio de El Escorial: Estudios en el IV Centenario de la terminación del Monasterio de San Lorenzo el Real de El Escorial, San Lorenzo El Escorial, 1984, 295–382

Cantone, Gaetana, La Città di marmo: da Alberti a Serlio. La Storia tra progettazione e restauro, Rome, 1978

Caramuel de Lobkowitz, J., Architectura civil, recta y obliqua considerada y dibuxada en el templo de Ierusalen, Vigevano, 1678

Casaseca Casaseca, Antonio, Rodrigo Gil de Hontañón, Salamanca, 1988

Castilho, Julio de, A Ribera de Lisboa, Lisbon, 3 vols., 1940–4

Castro, Maria del Rivero, 'Orígenes de la Ceca de Madrid,' Revista de la Biblioteca, Archivo y Museo del Ayuntamiento de Madrid, I, 1924, 129–37

Caxes, Patricio, Regla de las cinco ordenes de Architectura de Iacome Vignola Agora de nuevo traduzido de Toscano en Romance por Patritio Caxesi, Madrid, 1593

Cedillo Diaz, Juan, Traducción castellana del arte de nevegar de Pedro Núñez; Traducción de los seis primeros libros de la geométria de Euclides; Tres libros de la idea astronómica de la fábrica del mundo y movimiento de los cuerpos cellestes and sketches for Delos aspectos de los planetos (1620); Tratado primero de Artillería; Corobastes (1599); Del Trinormo, tratado breve vtil y acomodado para los Ingenieros, Agrimensorres, Marineros, Architetos y Artilleros; and como se a de comunicar al rio guaraquivir con qualavete, Madrid, Biblioteca Nacional, mss. 9091–3

Cervera Vera, Luis, 'La Iglesia parrochial de San Bernabé en El Escorial, obra de Francisco de Mora,' Archivo Español de Arte, XVI, 1943, 351–79

Cervera Vera, Luis, 'Juan de Herrera y su aposento en la villa de El Escorial,' La Ciudad de Dios, El Escorial, 1949, 1–31

Cervera Vera, Luis, 'Libros del arquitecto Juan Bautista de Toledo,' La Ciudad de Dios, CLII, 1950, 583–622, and CLIII, 1951, 161–8

Cervera Vera, Luis, Las Estampas y el sumario de el Escorial por Juan de Herrera, Madrid, 1954

Cervera Vera, Luis, 'Semblanza de Juan de Herrera,' in El Escorial 1563–1963, IV Centenario de la fundación del monasterio de San Lorenzo el Real, 2 vols., Madrid, 1964, vol. 2, 71–103

Cervera Vera, Luis, 'La Epoca de los Austrias, in Leopoldo Torres Balbás, Resumen histórico del urbanismo en España, 2nd edn., Madrid, 1968, 173–209

Cervera Vera, Luis, El 'Ingenio' creado por Juan de Herrera para cortar hierro, Madrid, 1972

Cervera Vera, Luis, María de Alvaro, primera mujer de Juan de Herrera, Madrid, 1974

Cervera Vera, Luis, Inventario de los bienes de Juan de Herrera, Valencia, 1977

Cervera Vera, Luis, El Retrato de Juan de Herrera dibujado por Masa y grabado por Brandi, Valencia, 1977

Cervera Vera, Luis, 'Carlos V mejora el Alcázar madrileño,' Revista de la Biblioteca, Archivo, y Museo de Madrid, 1979, LXXXII, 59–150

Cervera Vera, Luis, Coleción de documentos para la historia del arte en España, I: Documentos biográficos de Juan de Herrera (1572–1582), 2 vols., Madrid and Zaragoza, 1981–7

Cervera Vera, Luis, 'Juan de Herrera diseña la Lonja de Sevilla,' Academia, Boletín de la Real Academia de Bellas Artes de San Fernando, 1981, 164–84

Cervera Vera, Luis, Lerma, Síntesis histórico-monumental, Lerma, 1982

Cervera Vera, Luis, 'Privilegio concedido por Gregorio XIII a Juan de Herrera para imprimir y vender sus estampas de el Escorial,' Academia, Boletín de la Real Academia de Bellas Artes de San Fernando, 1984, 77–100

Cervera Vera, Luis, 'Apuntes biográfico-familiares del arquitecto Francisco de Mora,' Academia, Boletín de la Real Academia de Bellas Artes de San Fernando, 1985, 49–135

Cervera Vera, Luis, La Plaza Mayor y estructura urbana de Colmenar de Oreja (Madrid), Madrid, 1985

Cervera Vera, Luis, Juan de Herrera diseña el puente sobre el Rio Guadarrama, Madrid, 1985

Cervera Vera, Luis, 'Conjuntos y caminos en torno al Monasterio de San Lorenzo el Real,' in Población y Monasterio: El Entorno, Casa del Cultura de San Lorenzo de El Escorial, 1986, 48–50

Cervera Vera, Luis, 'Desarrollo y organización de las obras de San Lorenzo El Real de El Escorial,' in Fábricas y orden Constructivo, Madrid, 1986, 19–81

Cervera Vera, Luis, 'Obras y trabajos de Francisco de Mora en Avila,' Archivo Español de Arte, LX, 1987, 401–17

Cervera Vera, Luis, 'El Conjunto monacal y cortesano de la Fresneda en El Escorial,' Academia, Boletín de la Real Academia de Bellas Artes de San Fernando, 1987, 51–135

Cervera Vera, Luis, 'Esquema biográfico de Juan de Herrera, arquitecto humanista, interprete de los canones vitruvianos,' in Homenaje a Juan de Herrera, Santander, 1988, 13–34

Cesariano, Cesare, Di Lucio Virtuvio Pollione de architectura libri dece traducti de latino in vulgare affigurati: comentati: et con mirando ordine insigniti ..., Como, 1521, facsimile edn., New York, 1968

Cevese, Renato, 'La "riformatione" delle case vecchie secondo Sebastiano Serlio,' in Sebastiano Serlio, Seminario Internationale di Storia dell'Architettura, Centro Internazionale di Studi 'Andrea Palladio' di

Vicenza, ed. Christof Thoenes, Milan, 1989, 196–202

Chastel, André, 'Le Lieu de la fête,' in *Les Fêtes de la Renaissance au Temps de Charles Quint*, ed. Jean Jacquot, 2 vols., Paris, 1955, vol. I, 419–23

Chatnet, Monique, *Le Château de Madrid*, Paris, 1987

Chatenet, Monique and François Charles James, 'Les Expériences de la région parisienne 1525–1540,' in *Le Château en France*, ed. Jean Pierre Babelon, Paris, 1986, 191–204

Checa Cremades, Fernando, 'Felipe II y la ordenación del territorio entorno a la corte,' *Archivo Español de Arte*, LVIII, 1985, 392–8

Checa Cremades, Fernando, 'El Monasterio de El Escorial y los palacios reales de Felipe II,' *Fragmentos*, IV–V, 1985, 5–19

Checa Cremades, Fernando, 'Las Construcciones del principe Felipe,' in *El Escorial, Ideas y Diseño, la arquitectura, Esposición, IV Centenario*, Madrid, 1986, 23–45

Checa Cremades, Fernando, 'Felipe II y la Formulacion del clasicismo aulico,' in Alcalá de Henares, *Madrid en el Renacimiento*, 1986, 171–202

Checa Cremades, Fernando, 'El Monasterio de El Escorial, Vitruvio y los fundamentos de la arquitectura,' *Fragmentos*, VIII–IX, 1986, 49–63

Checa Cremades, Fernando, 'Felipe II en el Escorial,' in *El Escorial: Arte, poder y cultura en la corte de Felipe II*, El Escorial, 1988, 7–26

Checa Cremades, Fernando, 'Imperio universal y monarquía católica en la arquitectura aúllica española del siglo XVI,' in *Seminario sobre arquitectura imperial*, ed. Ignacio Henares Cuéllar, Granada, 1988, 11–43

Chevalier, François, 'La "Plaza Mayor" en amerique espagnole, espaces et mentalités: un essai,' in *Forum et plaza mayor dans le monde hispanique, Publications de la Casa de Velázquez, série Recherches en Sciences Sociales*, facs. IV, Paris, 1978, 107–22

Choay, Françoise, *La Règle et le modèle: sur la théorie de l'architecture et de l'urbanisme*, Paris, 1980

Choay, Françoise, 'Le De re aedificatoria comme texte inaugural,' *Les Traités d'Architecture de la Renaissance*, ed. A. Chastel and J. Guillaume, Paris, 1988, 83–90

Choay, Françoise, 'Alberti and Vitruvius,' *Architectural Design*, XLIX, n.d., 26–35

Chueca Goitia, Fernando, *La Catedral de Valladolid, una página del Siglo de Oro de la arquitectura española*, Valladolid, 1947

Chueca Goitia, Fernando, *La Catedral nueva de Salamanca, historia documental de su construcción*, Salamanca, 1951

Chueca Goitia, Fernando, *Arquitectura del siglo XVI, Ars Hispaniae*, vol. II, Madrid, 1953

Chueca Goitia, Fernando, *Madrid y Sitios Reales*, Barcelona, 1958

Chueca Goitia, Fernando, 'Herrera y el herrerianismo,' *Goya*, nos. 56–7, 1963, 98–115

Chueca Goitia, Fernando, 'El Estilo Herreriano y la arquitectura portuguesa,' *El Escorial 1563–1963, IVo Centenario de la fundación del Monasterio de San Lorenzo el Real*, 2 vols., Madrid, 1964, vol. 2, 215–62

Chueca Goitia, Fernando, *Casas reales en monasterios españoles*, Madrid, 1966

Chueca Goitia, Fernando, 'La Epoca de los Borbones,' in Leopoldo Torres Balbás, *Resumen histórico del urbanismo en España*, 2nd edn., Madrid, 1968, 213–48

Chueca Goitia, Fernando, *Invariantes castizos de la arquitectura española*, Madrid, 1971

Chueca Goitia, Fernando, *Alonso de Vandelvira Arquitecto*, Jaen, 1972

Chueca Goitia, Fernando, *El Escorial, Piedra Profética*, Madrid, 1986

Chueca Goitia, Fernando, 'Sobre Juan Bautista de Toledo y Juan de Herrera,' in Valladolid, Palacio de Santa Cruz, *Herrera y el Classicismo, Ensayos, catálogo y dibujos en torno a la arquitectura en clave clasicista*, Valladolid, 1986, 56–61

Circuelo, Pedro, *A Treatise Reproving all Superstitions and forms of Witchcraft very necessary and useful for All Good Christians zealous for their Salvation*, trans. E. A. Maio and D'Orsay W. Pearson, Princeton, N.J., and London, 1977

Ciudad Iberoamericana, La, Actas del Seminario Buenos Aires, Buenos Aires, 1985

Clagett, Marshall, 'Some General Aspects of Physics in the Middle Ages,' *Isis*, XXXIX, 1948, 29–44

Clagett, Marshall, *Greek Science in Antiquity*, New York, 1965

Clagett, Marshall, *Archimedes in the Middle Ages*, III, part 3, Philadelphia, 1978

Cloulas, Annie, 'Documents concernant Titien conservés à Simancas,' *Melanges de la Casa de Velázquez*, III, 1967, 197–288

Cloulas, Annie, 'Les Peintures du Grand Retable au Monastère de l'Escurial,' *Mélanges de la Casa de Velázquez*, IV, 1968, 175–202

Cock, Henrique, *Jornada de Tarazona hecha por Felipe II en 1592 pasando por Segovia, Valladolid, Palencia, Burgos, Logroño, Pamplona y Tudela*, ed. Alfredo Morel-Fatiò and Antonio Rodriquez Villa, Madrid, 1879

Colección de documentos ineditos para la historia de España, XXXIII, 1859

Coppel Areizaga, Rosario and Antonio Almagro Gorbea, 'La Fuente Grande de Ocaña: una posible obra de Juan de Herrera,' *Revista de Archivos, Bibliotecas, y Museos*, LXXX, 1977, 335–76

Cossío, Manuel B., 'Más Documentos inéditos para la historia del arte español: la Casa ayuntamiento,' *La Lectura*, V, 1905

Croix, Horst de la, 'The Literature on Fortification in Renaissance Italy,' *Technology and Culture*, IV, 1963, 30–50

Crombie, Alistair C., *Robert Grosseteste and the Origins of Experimental Science 1100–1700*, Oxford, 1953

Crombie, Alistair C., remarks on R. Hall, 'The Scholar and the Craftsman in the Scientific Revolution,' *Critical Problems in the History of Science*, ed. M. Clagett, Madison, Wis., 1962, 33ff and 73ff

Crouch, Dora, *Spanish City Planning in North America*, Cambridge, Mass., 1982

Daddi-Giovannozzi, Vera, 'L'Accademia fiorentina e l'Escuriale,' *Revista d'Arte*, 2nd series. VII, 1935, 423–7

Delorme, Philibert: see L'Orme, Philibert de

Deswarte-Rosa, Sylvie, 'Les "De Aetatibus Mundi Imagines" de Francisco de Holanda,' *Monuments et Mémoires publiés par l'Academie des Inscriptions et Belles-lettres*, LXVI, 1983, 67–190

Deswarte-Rosa, Sylvie, 'Les gravures de monuments antiques d'Antonio Salamanca à l'origine de Speculum Romae Magnificentiae,' *Annali di Architettura, Revista del Centro Internazionale di Studi di Architettura 'Andrea Palladio' di Vicenza*, I, 1989, 47–62

Documentos para la Historia del Monasterio de San Lorenzo el Real de El Escorial, vol. 1, ed. Julián Zarco Cuevas, Madrid, 1916

Documentos para la historia del Monasterio de San Lorenzo El Real de el Escorial, vol. 2, ed. Julián Zarco Cuevas, Madrid, 1917

Documentos para la Historia del Monasterio de San Lorenzo el Real el El Escorial, vol. 3, ed. Julián Zarco Cuevas, Madrid, 1918

Documentos para la Historia del Monasterio de San Lorenzo el Real de El Escorial, vol. 4, ed. Julián Zarco Cuevas, Madrid, 1924

Documentos para la Historia del Monasterio de San Lorenzo el Real de El Escorial, vol. 5, ed. Gregorio de Andrés, Monasterio de San Lorenzo El Real, 1962

Documentos para la Historia del Monasterio de San Lorenzo el Real de El Escorial, vol. 6, ed. Gregorio de Andrés, Monasterio de San Lorenzo El Real, 1962

Documentos para la Historia del Monasterio de San Lorenzo el Real de El Escorial, vol. 7, ed. Gregorio de Andrés, Madrid, 1964

Documentos para la Historia del Monasterio de San Lorenzo el Real de El Escorial, vol. 8, ed. Gregorio de Andrés, Monasterio de San Lorenzo El Real, 1965

Du Cerceau, Jacques: see Androuet Du Cerceau, Jacques

Dominguez Bordona, J., 'Federico Zuccaro en España,' *Archivo Español de Arte*, VII, 1927, 77–89

Domínguez Ortiz, A., *La Sociedad española en el siglo XVII*, I, Madrid, 1964

Downey, Glanville, 'Byzantine Architects and their Training,' *Byzantion*, XVII, 1948, 99–118

Downey, Glanville, 'Pappus of Alexandria on Architectural Studies,' *Isis*, XXXVIII, 1947, 197–200

Drachmann, A. G., *The Mechanical Technology of Greek and Roman Antiquity*, Copenhagen, 1963

Drake, S. and I. E. Drabkin, *Mechanics in Sixteenth-Century Italy*, Madison, Milwaukee, and London, 1969

Duarte de Sanda, 'Lisboa em 1584, primera embaixada do Japão a· Europe,' *Archivo Pittoresco*, Lisbon, 1863, VI, 77–9

Egerton, Samuel, *The Renaissance Rediscovery of Linear Perspective*, Ithaca, N.Y., 1976

Ehrle, Franz, *Roma prima di Sixto V. La pianta di Roma DuPérac-Lafréry del 1577*, Vatican City, 1908

Estal, G. del, 'El Escorial en la transición de San Jerónimo a San Agustín,' *Monasterio de San Lorenzo el Real El Escorial. En el cuatro centenario de su fundacion 1563–1963, Biblioteca 'La Ciudad de Dios'*, I, El Escorial, 1964, 561–615

Fayard, J. and C. Larquié, 'Hôtels madrilenes et démographie urbaine au XVIIe siècle,' *Mélanges de la Casa de Velázquez*, IV, 1968, 229–58

Fernández Alvarez, Manuel, *Madrid en el siglo XVI. El establecimeinto de la capitalidad en Madrid*, Madrid, 1960

Fernández Alvarez, Manuel and Elias Tormó, 'La capitalidad: como Madrid es Corte,' *Revista de la Biblioteca, Archivo y Muso del Ayuntamiento de Madrid*, VI, 1929, 420–55

Fernández Casado, Carlos, 'Historia de los puentes de Madrid,' *Revista de la Biblioteca, Archivo y museo del Ayuntamiento de Madrid*, XXIII, 1954, 65–84

Fiore, Francesco Paolo, 'Sebastiano Serlio e il manuscritto dell'Ottavo Libro,' in *Sebastiano Serlio, Sesto Seminario Internazionale di Storia dell'Architettura, Centro Internazionale di Studi di Architettura 'Andrea Palladio' di Vicenza*, ed. Christof Theones, Milan, 1989, 216–21

Firrufino, Julian, *Platica manual y breve compendio de artilleria*, Madrid, 1626

Fontana, Domencio, *Della Trasportatione dell'obelisco Vaticano, et delle fabriche di Nostro Signore Papa Sisto V*, Rome, 1590

Foucault, Michel, *Les Mots et les Choses*, Paris, 1966

Frankl, Paul, *The Gothic*, Princeton, N.J., 1960

Fraser, Valerie, *The Architecture of Conquest, Building the Viceroyalty of Peru 1535–1635*, Cambridge, 1989

Frago Gracia, Juan A. and José A. Garcia Diego, *Un Autor aragonés para los ventíun libros de los ingenios y de las máquinas*, Zaragoza, 1988

Bibliography

Frommel, Christoph, 'Il cantiere di S. Pietro prima di Michelangelo,' *Les Chantiers de la Renaissance*, ed. André Chastel and Jean Guillaume, Paris, 1991, 175–83

Gállego, Julián, 'L'Urbanisme de Madrid au XVIIe siècle,' *L'Urbanisme de Paris et de l'Europe 1600–1800*, ed. Pierre Francastel, Paris, 1969, 251–66

Garcia Chico, E., *Documentos para el estudio del Arte en Castilla*, vol. 1, *Arquitectura*, Valladolid, 1940

García-Diego, José A., 'Giovanni Sitoni, an Hydraulic Engineer of the Renaissance,' *History of Technology*, IX, 1984, 103–25

García-Diego, José A. (ed.), *Psuedo Juanelo Turriano Los Ventiún libros de los ingenios y de las maquinas*, 2 vols., Madrid, 1983

García-Diego, José A., *Juanelo Turriano Charles V's Clockmaker: The Man and His Legend*, trans. Charles David Ley, Madrid, 1986

García-Diego, José A. and Alexander G. Keller, *Giovanni Francesco Sitoni, Ingeniero renacentista al servicio de la Corona de España*, Fundación Juanelo Turriano, 1990

García Pérez, Ramón, 'Descripción topografica de Madrid en el siglo XVI,' *Revista de la Biblioteca, Archivo y Museo del Ayuntamiento de Madrid*, IV, 1927, 85–8

Garcia Rey, V., 'El Deán don Diego de Castilla y la reconstrucción de Santo Domingo el Antiguo,' *Boletín de la Real Academia de Bellas Artes y Ciencias Históricas de Toledo*, IV–V, 1923, 28–109, 129–89

Garcia Salinero, F., *Léxico de alarifes de los siglos de oro*, Madrid, 1968

García, Simon, *Compendio de arquitectura y simetría de los templos*, ed. J. Camón Aznar, Salamanca, 1941; complete ed. Carlo Chanfón, Mexico, 1979

García Tapia, Nicolás, 'Juan de Herrera y la ingeniería clasicista: el manuscrito "Architectura y Machinas" sobre el fundamento de las grúas,' Valladolid, Palacio de Santa Cruz, *Herrera y el clasicismo*, Valladolid, 1986, 45–55

Gerard, Veronique, *De Castillo a Palacio: El Alcázar de Madrid en el Siglo XVI*, Madrid, 1984

Gerard, Veronique, 'La Fachada del Alcázar de Madrid,' *Cuadernos de Investigación Histórica*, II, 1978, 237–51

Gerard Powell, Veronique, 'L'Organization des chantiers royaux en Espagne au XVIe siècle,' *Les Chantiers de la Renaissance*, ed. André Chastel and Jean Guillaume, Paris, 1991, 155–63

Gestoso y Pérez, José, *Sevilla monumental y artística: historia y descripción de todos los edificios notables, religiosos y civiles que existan actualmente en esta ciudad y noticia de las preciosidades artístias y arqueológicas que en ella se conservan*, 3 vols., Seville, 1890–2, reprint Seville, 1984

Gilbert, Felix, 'The Humanist Concept of the Prince and "The Prince" of Machiavelli,' *Journal of Modern History*, XI, 1939, 449–83

Gille, Bertrand, *Les Ingénieurs de la Renaissance*, Évreux, 1964

Gilles, Pierre, *The Antiquities of Constantinople*, Ball trans., London, 1729

Ginés de Rocamora y Torrano, *Sphera del universo*, Madrid, 1599

Gómez de Mora, Juan, *Relación de las cassas que tiene el Rey de España y de algunas de ellas se an echo traças que se an de ber con esta relación. Año de 1626*, Vatican City, Biblioteca Vaticana, ms. Barb. Lat. 4372

Gómez Iglesias, Agustín, 'Transformacion de Madrid durante el reinado de Felipe II y la creación de la primera junta de urbanismo,' *Villa de Madrid*, XXII, 1967

Gómez Iglesias, Agustín, 'El Alcaide de la Casa Panadería y la mudanza del peso real,' *Revista de la Biblioteca, Archivo y Museo del Ayuntamiento de Madrid*, XII, 1944, 193–215

Gómez Iglesias, Agustín, 'Algunos aspectos referentes al abastecimientos de carne a la villa de Madrid (1481–1877),' *Anales del Instituto de Estudios Madrileños*, VII, 1971, 19–57

Gómez Moreno y Martinez, Manuel, 'Juan de Herrera y Francisco de Mora en Santa Maria de la Alhambra,' *Archivo Español de Arte*, XIV, 1940–1, 6–7

González de Amerzúa, A., 'El Bando de policía de 1591 y el pregón general de 1613 para la villa de Madrid,' *Revista de la Biblioteca Archivo y museo del Ayuntamiento de Madrid*, X, 1933, 141–79

González de Amerzúa, A., 'Las Primeras ordenanzas municipales de la villa y corte de Madrid,' *Revista de la Biblioteca, Archivo y museo del Ayuntamiento de Madrid*, III, 1926, 401–29

González Muñoz, María del Carmen, 'Datos para un estudio de Madrid en la primera mitad del siglo XVII,' *Anales del Instituto de Estudios Madrileños*, XVIII, 1981, 149–86

González Tascón, I., *Fabricas Hidraulicas Españolas*, Madrid, 1987

Goodman, David C., 'Philip II's Patronage of Science and Engineering,' *British Journal for the History of Science*, XVI, 1983, 49–66

Goodman, David C., *Power and Penury: Government, Technology and Science in Philip II's Spain*, Cambridge, 1988

Guerra Sánchez-Moreno, Esperanza, 'La Casa de Panadería,' *Revista de la Biblioteca, Archivo y Museo del Ayuntamiento de Madrid*, VIII, 1931, 363–91

Guerrero Lovillo, José, *La Catedral de Sevilla*, Madrid, 1981

Guinard, Paul, 'Aux sources de L'art baroque,' in *L'Espagne au Temps de Philippe II*, ed. Jacques Goimard, Paris, 1965, 243–83

Gutiérrez, Ramón, *Notas para una bibliografia Hispanoamericana de arquitectura (1526–1875): Libros, folletos e impresos sobre arquitectura civil y militar, urbanismo, ingenería, topografía y ciencias auxiliares, editados en España y América entre 1526 y 1875*, Departamento de Historia de Arquitectura, Universidad de Buenos Aires, n.d.

Guevara, Pedro de, *Arte General y breve en dos instrumentos para todas las sciencias, recopilado del arte Magna y Arbor scientiae del doctor Raymundo Lullio*, Madrid, 1586

Guillaume, Jean, 'L'apparence et la realité des choses,' *L'Architecture en représentation*, Paris, n.d., 31–4

Günther, Hubertus, *Das Studium der Antiken Architecktur in den Zeichnungen der Hochrenaissance*, Tübingen, 1988

Hale, J. R., 'Andrea Palladio, Polybius, and Julius Caesar,' *Journal of the Warburg and Courtauld Institutes*, XL, 1972, 240–55

Hale, John R., 'The Development of the Bastion: An Italian Chronology,' *Europe in the Late Middle Ages*, ed. J. R. Hale, R. Highfield, B. Smalley, London, 1965, 466–94

Hale, John R., *Renaissance Fortification: Art or Engineering*, London, 1977

Haverkamp-Begemann, Egbert, 'The Spanish Views of Anton van den Wyngaerde,' in *Spanish Cities of the Golden Age*, ed. R. Kagan, Berkeley, Los Angeles, and London, 1990, 54–67

Herrera, Juan de, *Sumario y Breve declaraciõ delos diseños y estampas de la Fabrica de san Lorenzio el Real del Escurial*, Madrid, 1589

Herrera, Juan de, *Discurso del Sr. Juan de Herrera aposentador mayor de S. M. sobre la Figura Cúbica*, ed. Edison Simons and Roberto Godoy, Madrid, 1976

Herrera, Juan de, *Discurso de la figura cúbica*, ed. J. Rey Pastor, Madrid, 1935

Heydenrich, Ludwig and Wolfgang Lotz, *Architecture in Italy 1400–1600*, Harmondsworth, Middlesex, and Baltimore, Md, 1974

Hilgarth, J. N., *Ramon Lull and Lullism in 14th Century France*, Oxford, 1971

Hoag, John D., *Rodrigo Gil de Hontañón: His Work and Writings, Late Medieval and Renaissance Architecture in Sixteenth-Century Spain*, dissertation Yale University, 1958, trans. *Rodrigo Gil de Hontañón, gótica y renacimiento en la arquitectura española del siglo XVI*, Madrid, 1986

Horta Correia, José Eduardo, 'Le mécénat de Philippe II et l'architecture portugaise,' in Brussels, Musées Royaux des Beaux Arts de Belgique, *Portugal et Flandre: visions de l'Europe 1550–1680*, Brussels, 1991, 69–75

Huelson, Christian, 'Das Speculum Romanae Magnificentiae des Antonio Lafreri,' in *Collectanea Variae Doctrinae Festschrift für Leoni Olschki*, Munich, 1921, 121–70

Hugh of St Victor, *Didascalion*, ed. C. H. Buttimer, Washington, DC, 1939

Iñiguez Almech, Francisco, 'La Casa Real de la Panadería,' *Revista de la Biblioteca, Archivo y Museos del Ayuntamiento de Madrid*, XXII, 1948, 129–55

Iñiguez Almech, Francisco, 'Juan de Herrera y las reformas en el Madrid de Felipe II,' *Revista de la Biblioteca, Archivo, y Museo, Ayuntamiento de Madrid*, XIX, 1950, 3–108

Iñiguez Almech, Francisco, *Casas reales y jardines de Felipe II*, Rome, 1952

Iñiguez Almech, Francisco, 'Limites y Ordenanzas de 1567 para la Villa de Madrid,' *Revista de la Biblioteca, Archivo y Museo del Ayuntamiento de Madrid*, XXIV, 1955, 3–38

Iñiguez Almech, Francisco, 'Los Ingenios de Juan de Herrera,' *El Escorial 1563–1963. IVo Centenario*, Madrid, 1963, vol. 2, 181–214

Iñiguez Almech, Francisco, 'Los Ingenios de Juan de Herrera, Notas Marginales,' *Revista de Archivos, Bibliotecas, y Museos*, LXXI, 1963, 163–70

Iñiguez Almech, Francisco, *Las Trazas del Monasterio de S. Lorenzo de el Escorial*, Madrid, 1965

Jacquot, Jean and Elie Konigson, eds., *Les Fêtes de la Renaissance, Quinzième colloque international d'études humanistes*, 3 vols., Paris, 1975

Jimenez Salas, Maria, *Historia de la asistencia social en España en la edad moderna*, Madrid, 1958

Joaquím, 'El Lullisme de Juan de Herrera,' *Miscellanea Puig y Cadafalch*, Barcelona, 1947–51

Jonge, Krista de, 'Rencontres portugaises: l'art de la fête au Portugal et aux Pays Bas,' Brussels, Musées Royaux des Beaux Arts de Belgique, *Portugal et Flandre: visions de l'Europe 1550–1680*, Bruxelles, 1991, 85–101

Jordan, Annemarie, *Archduke Albert of Austria in Lisbon (1581–1593): A question of patronage or Emulation?*, unpublished MA thesis, Brown University, 1985

Justi, Carl, 'Der königliche palast zu Madrid,' *Zeitschrift für bildende Kunst*, 1893–4, 51–60

Justi, Carl, 'Philip II als Kunstfreund,' *Miscellaneen aus drei Jahrhunderten spanischen Kunstlebens*, 2 vols., Berlin, 1908, vol. 2, 3–36; trans. R. Casinos-Assens, 'Felipe II Amigo del arte,' *Estudios de Arte Español*, II, 1–46

Kagan, Richard, 'La Profecia y la política en la España de Felipe II,' in *El Escorial: arte, poder y cultura en*

la corte de Felipe II, El Escorial, 1988, 63–80

Kagan, Richard, ed., *Ciudades del siglo de oro. Las vistas españolas de Anton van den Wyngaerde*, Madrid, 1986; translated as *Spanish Cities of the Golden Age*, with essays by Jonathan Brown, R. Kagan, Egbert Haverkamp Begemann, and Fernando Marías, Berkeley, Los Angeles and London, 1990

Kagan, Richard, 'Philip II and the Geographers,' in *Spanish Cities of the Golden Age*, ed. R. Kagan, Berkeley, Los Angeles and London, 1990, 40–53

Kagan, Ricahard, *Lucrecia's Dreams: Politics and Prophecy*, Berkeley, 1990

Keller, A. G., 'Mathematicians, Mechanics, and Experimental Machines in Northern Italy in the Sixteenth Century,' in *The Emergence of Science in Western Europe*, ed. M. Crosland, New York, 1976, 15–34

Konigson, Elie, 'Entrées de Charles VIII (1484–1486),' in *Les Fêtes de la Renaissance, Quinzième colloque international d'études humanistes*, ed. Jean Jacquot and Elie Konigson, 3 vols., Paris, 1975, 55–69

Krautheimer, Richard, 'Alberti and Virtuvius,' *Studies in Early Christian, Medieval and Renaissance Art*, New York and London, 1969, 323–32

Krautheimer, Richard, *Early Christian and Byzantine Architecture*, Baltimore, 1965

Kubler, George, 'A Late Gothic Computation of Rib Vault Thrusts,' *Gazette des Beaux Arts*, XXVI, 1944, 135–48

Kubler, George, *Mexican Architecture of the Sixteenth Century*, 2 vols., New Haven and London, 1948

Kubler, George, *Arquitectura de los siglos XVII y XVIII*, Madrid, 1957

Kubler, George, 'Francesco Paciotto, Architect,' in *Essays in Memory of Karl Lehmann*, ed. Lucy F. Sandler, New York, 1964, 176–89

Kubler, George, *Portuguese Plain Architecture: Between Spices and Dimaonds (1521–1706)*, Middletown, Conn., 1972

Kubler, George, 'The Claustral "Fons Vitae" in Spain and Portugal,' *Traza y Baza*, II, 1972, 7–14

Kubler, George, 'Galeazzo Alezzi e l'Escuriale,' in *Galeazzo Alessi e l'architettura del Cinquecento*, ed. C. Maltese, Genoa, 1975, 599–603

Kubler, George, *Building the Escorial*, Princeton, N.J., 1982

L'Orme, Philibert de, *Nouvelles Inventions pour bien bastir et à petits fraiz*, Paris, 1561 and *Le Premier tome de l'architecture*, Paris, 1567 reprinted in *Traités d'architecture*, ed. and commentary Jean-Marie Pérouse de Montclos, Paris, 1988

Laird, W. R., 'The Scope of Renaissance Mechanics,' *Osiris*, 2nd series, II, 1986, 46–68

Laird, W. R., 'Giuseppe Moletti's "Dialogue on Mechanics (1576)",' *Renaissance Quarterly*, XL, 1987, 209–23

Laird, W. R., 'Archimedes among the Humanists,' *Isis*, LXXXII, 1991, 629–38

Laird, W. R., 'Patronage of Mechanics and Theories of Impact in Sixteenth-Century Italy,' *Patronage and Institutions*, Woodbridge, 1991, 51–66

Lampérez y Romea, Vicente, *La Arquitectura civil española desde el siglo I hasta el siglo XVIII*, 2 vols., Madrid, 1922–3

Larquié, Claude, 'Barrios y parroquias urbanas: el exemplo de Madrid en el siglo XVII,' *Anales del Instituto de Estudios Madrileños*, XII, 1976, 33–63

Lavaña, Juan Bautista, *Regimento Navtico*, Lisbon, 1606

Lavaña, Juan Bautista, *Breue compendio delas cosas de España*, Monasterio de San Lorenzo El Real de El Escorial, ms. 1616

Lavaña, Juan Bautista, *Viagem de Catholica Real Magestad del Rey D. Felipe N. S. ao Reyno de*

Portugal, Madrid, 1622

Lazzaro Claudia, *The Italian Renaissance Garden: from the conventions of planting, design and ornament to the grand gardens of sixteenth-century Central Italy*, New Haven and London, 1990

Lemerle-Pauwels, Frédérique, *Architecture et Humanisme au mileu du XVIe siècle: les annotations de Guillaume Philandrier, introduction, traduction et commentaire, Livres I–V*, 3 vols., PhD dissertation, Université François Rabelais, Tours, 1990

Lhermitte, Jehan, *Le Passetemps*, ed. Charles Ruelens, 2 vols., Antwerp, 1890

Licht, Marjorie, *L'edificio a pianta centrale. Lo sviluppo del disegno architettonico nel Rinascimento*, Florence, Gabinetto Disegni e Stampe degli Uffizi, LXI, 1984

Llaguno Amirola, Eugenio and Agustín Céan-Bermúdez, *Noticias de los arquitectos y arquitectura de España desde su restauración*, reprint, 4 vols., Madrid, 1977

Lleó Cañal, Vicente, *Nueva Roma: mitología y humanismo en el renacimiento sevillano*, Seville, 1979

Llewellyn, Nigel, 'Two Notes on Diego da Sagredo. I: The Cornice and the Face,' and 'II: The Baluster and the Pomegranate,' *Journal of the Warburg and Courtauld Institutes*, XXXVII, 1977, 292–300

López Piñero, José María, *Ciencia y técnica en la sociedad española de los siglos XVI y XVII*, Barcelona, 1979

López Serrano, Matilde, *Catálago de Dibujos I, Trazas de Juan de Herrera y sus seguidores para el monasterio del Escorial*, Patrimonio Nacional, Biblioteca de Palacio, Madrid, 1944

López Serrano, Matilde, 'Bibliografía Escurialense. Complemento (1963–1966),' *Revista de Archivos, Bibliotecas y museos*, LXXI, 1963, 485–95

Los Santos, P. Francisco de, *Descripción breve del Monasterio de S. Lorenzo el Real del Escorial. Vnica maravilla del mvndo*, Madrid, 1657, facsimile, Madrid, 1984

Lotz, Wolfgang, 'Das Raumbild in der Architekturzeichnung der italiennschen Renaissance,' *Mitteilungen des Kunsthistorischen Instituts in Florenz*, VII, 1956, 193–226; reprinted as 'The Rendering of the Interior of Architectural Drawings of the Renaissance,' in W. Lotz, *Studies in Italian Renaissance Architecture*, Cambridge, Mass., and London, 1977, 1–65

Lotz, Wolfgang, 'The Piazza Ducale in Vigevano: A princely Forum of the Late Fifteenth Century,' in W. Lotz, *Studies in Italian Renaissance Architecture*, Cambridge, Mass., and London, 1977, 117–39

Lotz, Wolfgang, 'Sixteenth-century Italian Squares,' in W. Lotz, *Studies in Italian Renaissance Architecture*, Cambridge, Mass., and London, 1977, 74–92

Lowry, Bates, 'Notes on the Speculum Romanae Magnificentiae and Related Publications,' *Art Bulletin*, XXXIV, 1952, 46–50

Lull, Ramon, *El Libro de la 'Nova Geometria' de Ramón Lull*, ed. J. M. Millás Vallicrosa, Barcelona, 1953

MacDougall, Elizabeth, 'Ars Hortulorum: Sixteenth Century Garden Iconography and Literary Theory in Italy,' *The Italian Garden*, ed. David Coffin, Washington, D.C., 1972

Madrid, Biblioteca Nacional, *Dibujos de arquitectura y ornamentación de la Biblioteca Nacional: siglos XVI y XVII*, ed. Elena Santiago Páez, Madrid, 1991

Madrid, Biblioteca Nacional, *El Escorial en la Biblioteca Nacional, IV Centenario del Monasterio de El Escorial*, ed. Elena Santiago Páez, Madrid, 1986

Madrid, Museo Muncipal, *Juan Gómez de Mora (1586–1648), arquitecto y trazador del Rey, maestro mayor de la villa de Madrid*, with essay and catalogue by

Virginia Tovar Martín, Madrid, 1986

Maggiorotti, Leone Andrea, *Architetti e architetture militari*, 3 vols., Rome, 1933–9, vol. 3: *Gli Architettii militari nella Spagna, nel Portogallo e nelle loro colonie*, Rome, 1939

Maio, Romeo di, *Michelangelo e la Contrariforma*, Rome and Bari, 1978

Manetti, Antonio, *The Life of Brunelleschi*, introduction and notes by Howard Saalman, trans. Catherine Engass, University Park, Penn., and London, 1970

March, José M., *Niñez y juventud de Felipe II*, Madrid, 1941

Marchi, Francesco de', *Della Architettura militare*, Brescia, 1599

Marconi, P. and Pier Nicola Pagliara, 'Un Progetto di città militare,' *Controspazio*, I, 1969

Marías, Fernando, 'Juan de Herrera y la obra urbana de Zocodover en Toledo,' *Boletín del Seminario de Estudios de Arte y Arqueología de la Universidad de Valladolid*, XLIII, 1977, 173ff

Marías, Fernando, 'El Problema del arquitecto en la España del siglo XVI,' *Academia, Boletín de la Real Academia de Bellas Artes de San Fernando*, 48, 1979 173–216

Marías, Fernando, 'El monasterio de la Immaculada Concepción de Chinchón y Nicolás de Vergara el Mozo. El castillo de Villaviciosa de Odón y los arquitectos reales,' *Anales del Instituto de Estudios Madrileños*, XVII, 1980, 253–75

Marías, Fernando, 'Juan Bautista de Monegro, su biblioteca y De Divina proportione,' *Academia, Boletín de la Real Academia de Bellas Artes de San Fernando*, 53, 1981, 91–117

Marías, Fernando, *La Arquitectura del Renacimiento en Toledo (1541–1631)*, 4 vols., Toledo, 1983–6

Marías, Fernando, 'Orden y modo en la arquitectura española,' introduction to E. Forssman, *Dórico, jónico, corintio en la arquitectura del Renacimiento*, Madrid, 1983, 7–47

Marías, Fernando, 'Un tratado inédito de arquitectura de hacia 1550,' *Boletín del Museo e Instituto 'Camon Aznar'*, XIII, 1983, 41–57

Marías, Fernando, 'La Escalera imperial en España,' *L'Escalier dans l'architecture de la renaissance*, ed. André Chastel and Jean Guillaume, Paris, 1985, 165–70

Marias, Fernando, 'Proporciones y órdenes: Juan de Herrera y la arquitectura clasicista en Toledo,' in Valladolid, Palacio de Santa Cruz, *Herrera y el Clasicismo*, Valladolid, 1986, 126–37

Marías, Fernando, 'Sobre un Dibujo de Juan de Herrera: de El Escorial a Toledo,' in *Real Monasterio-Palacio de El Escorial: Estudios inéditos en conmemoración del IV Centenario de la terminación de las obras*, ed. E. Bermejo, Madrid, 1987, 167–77

Marías, Fernando, 'De Iglesia a templo: notas sobre la arquitectura religiosa del siglo XVI,' *Seminario sobre arquitectura imperial*, ed. Ignacio Henares Cuéllar, Granada, 1988, 113–36

Marías, Fernando, *El Largo siglo XVI, conceptos fundamentales en la historía del arte español*, Madrid, 1989

Marías, Fernando, 'El Escorial de Felipe II y la sabiduría divina,' *Annali di architettura, Revista del Centro Internazionale di Studi di Architettura 'Andrea Palladio' di Vicenza*, I, 1989, 63–76

Marías, Fernando, 'City Planning in Sixteenth-century Spain,' in *Spanish Cities of the Golden Age*, ed. Richard Kagan, Berkeley, 1990, 84–105

Marías, Fernando, 'Sobre el castillo de la Calahorra y el Codex Escurialensis,' *Anuario del Departamento de Historia y Teoría del Arte (Universidad Autó-*

Bibliography

noma, Madrid), II, 1990, 117–30

Martín González, Juan José, 'El Palacio de Carlos V en Yuste,' *Archivo Español de Arte*, XXIII, 1950, 27–51 and 235–51; XXIV, 1951, 125–40

Martín González, Juan José, 'El Antiguo Ayuntamiento de Valladolid,' *Boletín del Seminario de Estudios de Arte y Arqueología de la Universidad de Valladolid*, XVIII, 1951, 115–27

Martín González, Juan José, 'Dibujos de monumentos antiguos vallisoletanos,' *Boletín del Seminario de Estudios de Arte y Arqueología, de la Universidad de Valladolid*, XIX, 1953, 23–49

Martín González, Juan José, 'La colegiata de Villagarcía de Campos y la arquitectura Herreriana,' *Boletín del Seminario de Estudios de Arte y Arqueología de la Universidad de Valladolid*, XXIII, 1957, 19–40

Martín González, Juan José, 'Notas Vallisoletanas: anotaciones sobre la plaza mayor de Valladolid,' *Boletín del Seminario de Arte y Arqueología de la Universidad de Valladolid*, XXV, 1959, 161–8

Martín González, Juan José, 'Nuevos Datos sobre la construcción del Alcázar de Toledo,' *Revista de Archivos, Bibliotecas y Museos*, LXVIII, 1960, 271–86

Martín González, Juan José, 'El Alcázar de Madrid en el siglo XVI,' *Archivo Español de Arte*, XXXV, 1962, 1–19

Martín González, Juan José, 'El Palacio de Aranjuez en el siglo XVI,' *Archivo Español de Arte*, XXXV, 1962, 23–52

Martín González, Juan José, 'Tipología e iconografía del retablo español del Renacimiento,' *Boletín del Seminario de Estudios de Arte y Arqueología, University of Valladolid*, XXX, 1964, 5–66

Martín González, Juan José, 'Yuste y El Escorial,' *Monasterio de San Lorenzo el Real El Escorial en el cuarto centenario de su fundacion 1563–1963*, *Biblioteca Ciudad de Dios*, vol. 10, Real Monasterio de El Escorial, 1964, 99–123

Martín González, Juan José, 'El Palacio de "El Pardo" en el siglo XVI,' *Boletín del Seminario de Estudios de Arte y Arqueología de la Universidad de Valladolid*, XXXVI, 1970, 5–41

Martín González, Juan José, 'Urbanismo y arquitectura de Valladolid durante el Renacimiento,' in *Corazon del mundo hispanico, siglo XVI, Historia de Valladolid*, vol. 3, Valladolid, 1981

Martín González, Juan José, 'Estructura y tipologia del Retablo Mayor del Monasterio de El Escorial,' *Real Monasterio-Palacio de El Escorial: Estudios inéditos en conmemoración del IV Centenario de la terminación de las obras*, ed. E. Bermejo, Madrid, 1987, 203–20

McGinniss, Lawrence R., *Catalogue of the Earl of Crawford's Speculum Romanae Magnificentiae*, New York, 1976

McGrath, Elizabeth, 'Le Déclin d'Anvers et les Décorations de Rubens pour l'entrée du Prince Ferdinand en 1635,' in *Les Fêtes de la Renaissance*, ed. Jean Jacquot and Elie Konigson, vol. 3, Paris, 1972, 173–86

Méndez Zubiría, C., 'La Casa Lonja de Sevilla,' *Aparejadores*, Seville, 1981, 11–15

Mendoza, Bernardino de, *Theorica y práctica de guerra*, Madrid, 1595

Mezzatesta, Michael, 'Charles V and the Tradition of Habsburg devotion to the Eucharist,' in press

Mezzatesta, Michael, 'The Leoni and Habsburg Iconography 1550–1600: Charles V, Augustus and the Eucharist,' in press

Millon, Henry A. and Craig Hugh Smyth, 'Michelangelo and St. Peter's: I: Notes on a Plan of the Attic as Originally Built on the South Hemicycle,' *The Burlington Magazine*, CXI, 1969, 484–501

Millon, Henry A. and Craig Hugh Smyth, 'Observations on the Interior of the Apses, a Model of the Apse Vault, and Related Drawings,' *Römisches Jahrbuch für Kunstgeschichte*, XVI, 1976, 137–206

Modino de Lucas, Miguel, 'Constituciones del Colegio de S. Lorenzo el Real,' in *Documentos para la historia del Monasterio de S. Lorenzo el Real de El Escorial*, ed. Gregorio de Andrés, vol. 5, 1962, 129–225

Moleón Gavilanes, Pedro, 'Las cases de oficios del Escorial en seis planos inéditos de su arquitecto: Juan de Herrera,' *Revista del Consejo Superior de los Colegios de Arquitectura de España*, LXIV, 1983, 12–27

Moleón Gavilanes, Pedro, *La Arquitectura de Juan de Villanueva: el proceso del proyecto*, Madrid, 1988

Molina Campuzano, Miguel, *Planos de Madrid de los siglos XVII y XVIII*, Madrid, 1960

Montero Vallejo, M., '"Laguna" a la Plaza Mayor, la Plaza del Arrabal,' *Anales del Instituto de Estudios Madrileños*, XXIV, 1987, 203–15

Montreal, Musée des beaux-arts de Montréal, *Léonard de Vinci, ingénieur et architecte*, ed. J. Guillaume, Montreal, 1987

Morán Turina, J. Miguel and Fernando Checa Cremades, *Las Casas del rey: casas de campo, cazaderos y jardines, siglos XVI y XVII*, Madrid, 1986

Morales, A. J., 'Juan de Herrera, Juan de Minjares y el Antecabildo de la Catedral de Sevilla,' in *Real Monasterio-palacio de El Escorial, Estudios inéditos en commemoración del IV centenario de la terminación de las obras*, ed. E. Bermejo, Madrid, 1987, 179–84

Moreira, Rafael, 'O Torreao do Paço da Ribeira,' *Mundo da Arte*, XIV, 1983, 43–8

Moreira, Rafael, 'A Aula de arquitectura do Paço da Ribeira e a academia de matemáticas de Madrid,' in *As Relações artísticas entre Portugal e Espanha na época dos descobrimentos, II Simpósio Luso-espanhol de História de Arte*, Coimbra, 1987, 65–78

Morel Fatio, A., 'Memorial de Pedro Tamayo de la guarda a pie de Su Majestad,' *Revista da la Biblioteca, Archivo, y Museo del Ayuntamiento de Madrid*, I, 1924, 286–325

Mosser, Monique and Georges Teyssot, eds., *Histoire des jardins de la renaissance à nos jours*, Paris, 1990; trans. as *The Architecture of Western Gardens: A Design History from the Renaissance to the Present Day*, Cambridge, Mass., 1991

Navascués Palacio, Pedro, 'Puentes de acceso a el Escorial,' *Archivo Español de Arte*, LVIII, 1985, 97–107

Navascués Palacio, Pedro, 'El Patio y templete de los Evangelistas de El Escorial,' in *Real monasterio-palacio de El Escorial. Estudios inéditos en el IV Centenario de la terminación de las obras*, ed. E. Bermejo, Madrid, 1987, 61–74

Navascués Palacio, Pedro, *El Libro de Arquitectura de Hernan Ruiz el Joven*, Madrid, 1974

Navascués Palacio, Pedro, 'La Obra como espectáculo: el dibujo Hatfield,' in *Las Casas Reales: El Palacio, IV Centenario del Monasterio de El Escorial*, Madrid, 1986, 55–67

Nesselrath, Arnold, 'Raphael's Archaeological Method,' in *Raffaello a Roma, il Convegno del 1983*, Rome, 1986, 357–71

Nieto, Victor, Alfredo J. Morales and Fernando Checa, *Arquitectura del renacimiento en España, 1488–1599*, Madrid, 1989

Nuttall, Zelia, 'Royal Ordinances Concerning the Laying Out of New Towns,' *Hispanic American Historical Review*, IV, 1921, 743–53

Ondériz, Pedro, *La Perpectiva y especularia de Euclides*, Madrid, 1585

Onians, John, *Bearers of Meaning: the Classical Orders in Antiquity, the Middle Ages and the Renaissance*, Princeton, N.J., 1988

Onians, John, 'Filarete and the "qualità": Architectural and Social,' *Arte Lombarda*, XXXVIII–IX, 1973, 116–28

Orgel, Stephen, *The Illusion of Power*, Berkeley, 1978

Orso, Steven N., *Philip IV and the Decoration of the Alcázar of Madrid*, Princeton, N.J., 1986

Osten Sacken, Cornelia von der, *Studien zur Baugeschichte und Ikonologie* (1979); as *El Escorial Estudio iconológico*, trans. María Dolores Abalos with an introduction by Alfonso Rodriguez G. de Ceballos, Madrid, 1984

Pagliara, Pier Nicola, 'Studi e pratica vitruviana di Antonio de Sangallo il Giovane e di suo fratello Battista,' in *Les Traités d'architecture de la Renaissance*, ed. André Chastel and Jean Guillaume, Paris, 1988, 179–206

Palacio de Santa Cruz, Valladolid, *Herrera y el clasicismo, ensayos, catálogo y dibujos en torno a la arquitectura en clave clasicista*, catalogue ed. Javier Rivera with essays by others, Valladolid, 1986

Palladio, Andrea, *I Quattro Libri dell'Architettura*, Venice, 1570, trans. Issac Ware, *The Four Books of Andrea Palladio's Architecture*, London, 1738, reprint with introduction by Adolf Placzek, New York, 1965

Palm, Erwin Walter, 'Los orígenes del urbanismo imperial en America,' *Instituto Panamericana de Geografía e Historia*, 1951

Panofsky, Erwin, 'The First Page of Vasari's "Libro," A study on the Gothic Style in the Judgment of the Italian Renaissance With an Excursus on Two Façade Designs by Domenico Beccafumi,' *Meaning in the Visual Arts*, New York, 1955, 169–253

Parker, Geoffrey, *Philip II*, Boston and Toronto, 1978

Parro, Sixto Ramón, *Toledo en la mano*, 2 vols., Toledo, 1857, reprint Toledo, 1978

Pauwels, Yves, *Théorie et pratique des ordres au mileu du XVIeme siècle: de L'Orme, Goujon, Lescot, Bullant*, 3 vols., dissertation, Université François Rabelais, Tours, 1991

Pérez Arroyo, S., 'La Casa de la Panadería. Apuntes para una reconstrución de su evolución typológia,' *Villa Madrid*, XXIII, 1985/6, 44–52

Pérez de Herrera, Cristóbal, *Discurso a la católica y real magestad del rey don Felipe nuestro señor, en que se le suplica, que considerando las muchas calidades y grandezas de la villa de Madrid, se sirva de ver si convendria honrarla, y adornarla de muralla, y otras cosas que se proponen, con que mereciesse ser corte perpetua, y assistencia de su gran monarchia*, Madrid, 1597

Pérez de Herrera, Cristóbal, *A la católica real magestad del rey don Felipe III, nuestro senor: cerca de la forma y traza, como parece podrían remediarse algunos pedcados, excessos, y desórdenes, en que los tratos, bastimentos, y otras cosas, de que esta villa de Madrid al presente tiene falta, y de que suerte se podrían restaurar y reparar las necessidades de Castilla la vieja*, Madrid, 1600

Pérez de Herrera, Christóbal, *Elogio a las esclarecidas virtudes de la C. R. M. del Rey N. S. Don Felipe II, que está en el cielo . . .*, Valladolid, 1604; reprinted in Luis Cabrera de Córdoba, *Felipe Segundo Rey de España*, segunda parte, vol. 4, Madrid, 1877, 335–402

Pérez de Herrera, Cristóbal, *Discursos del amparo de los legítimos pobres, y reducción de los fingidos:*

y de la fundación y principio de los albergues destos reynos, y amparo de la milicia dellos, ed. Michel Cavillac, Madrid, 1975

Pérouse de Montclos, Jean-Marie, Architecture à la française, Paris, 1982

Pérouse de Montclos, Jean-Marie, Histoire de l'architecture française de la Renaissance à la Revolution, Paris, 1989

Philandrier, Guillaume, M. Vitruvij Polionis De Architectura Libri X, Lyon, 1552

Picatoste y Rodriguez, F., Apuntes para una biblioteca científica española del siglo XVI, Madrid, 1891

Pleguezuelo Hernández, Alonso, 'La Lonja de mercaderes de Sevilla: de los proyectos a la ejecución,' Archivo Español de Arte, LXIII, 1990, 15–42

Ponz, Antonio, Viaje de España en que se da noticia de las cosas mas apreciables, y dignas de saberse, que hay en ella, 13 vols., Madrid, 1776–83

Porreño, Baltasar, Dichos y hechos del señor Rey den Felipe Segundo el Prudente, Potentissimo y glorioso monaka de las Españas y de las Indias, Seville, 1639

Portables Pichel, Amancio, Los Verdaderos Artífices de El Escorial y el estilo indebidamente llamado herreriano, Madrid, 1945

Portables Pichel, Amancio, Maestros Mayores, arquitectos y aparejadores de El Escorial, Madrid, 1952

Prado, Jerónimo and Juan Bautista Villalpando, In Ezechielem Explanationes et Apparatus Urbis ac Templi Hierosolytani, 3 vols., Rome, 1596 (vol. 1) and 1604 (see also Villalpando J.B.)

Prager, Frank D. and Gustina Scaglia, Mariano Taccola and His Book De Ingeneiis, Cambridge, Mass., 1972

Prager, Frank D. and Gustina Scalia, Brunelleschi, Studies of His Technology and Inventions, Cambridge, Mass., 1970

Proclus, A Commentary on the First Book of Euclid's Elements, trans. with an introduction by G. R. Morrow, Princeton, N.J., 1970

Promis, Carlo, 'La Vita di Francesco Paciotto da Urbino, architetto civile militare del secolo XVI,' in Miscelanea di storia italiana, vol. 4, Turin, 1863, 361–442

Pseudo Juanelo Turriano: see Garcia Diego, J. A.

Quintana, Jerónimo, A la muy, antigua noble y coronada villa de Madrid, Historia de su antigüedad, nobleza y grandeza, Madrid, 1629, reprint, ed. E. Varela Hervías, Madrid, 1954

Real Monasterio-palacio de El Escorial, Estudios inéditos en conmemoración del IV centenario de la terminación de las obras, ed. E. Bermejo, Madrid, 1987

Rebollo Matías, Alejandro, La Plaza y mercado mayor de Valladolid, 1561–95, Valiadolid, 1989

Recht, R., '"Théorie" et "traités pratiques" d'un architecture au Moyen Age,' in Les Traités d'architecture de la Renaissance, ed. André Chastel and Jean Guillaume, Paris, 1988, 19–30

Richard, Robert, 'La Plaza Mayor en Espagne et en Amerique espagnole, Notes pour une étude,' Annales, XIX, 1947, 433–8

Rivera Blanco, Javier, Juan Bautista de Toledo y Felipe II, La Implantation del Clasicismo en España, Valladolid, 1984

Rivera Blanco, Javier, 'De Juan Bta de Toledo a Juan de Herrera,' in Valladolid, Palacio de Santa Cruz, Herrera y el Classicismo, Ensayos, catálogo y dibujos en torno a la arquitectura en clave clasicista, Valladolid, 1986, 69–83

Rodríguez G. de Ceballos, Alfonso, Bartolomé de Bustamante (1501–1570) y los orígenes de la arquitectura jesuítica en España, Rome, 1963

Rodríguez G. de Ceballos, Alfonso, 'El P. Bustamante, inciador de la arquitectura jesuítica en España,'

Archivum Historicum Societatis Iesu, XXXII, 1963, 3–102

Rodríguez G. de Ceballos, Alfonso, 'Juan de Herrera y los jesuitas, Villalpando, Valeriani, Ruiz, Tolosa,' Archivum Historicum Societatis Iesu, XXXV, 1966, 1–37

Rodríguez G. de Ceballos, Alfonso, 'Planos para la colegiata de Villagarcía de Campos,' Boletín del Seminario de Estudios de Arte y Arqueología de la Universidad de Valldolid, XXXVI, 1970, 493–5

Rodríguez G. de Ceballos, Alfonso, 'La Librería del arquitecto Juan del Riberto Rada,' Academia, Boletín de la Real Academia de Bellas Artes de San Fernando, 62, 1986, 123–54

Rodríguez G. de Ceballos, Alfonso, 'En Torno a Felipe II y la arquitectura,' in Real Monasterio-Palacio de El Escorial: Estudios en el IV centenario de la terminación de las obras, ed. E. Bermejo, Madrid, 1987, 107–25

Rodríguez G. De Ceballos, Alfonso, La Iglesia y el convento de San Esteban de Salamanca, estudio documentatdo de su construcctión, Salamanca, 1987

Rodríguez G. De Ceballos, Alfonso, 'La Planta elíptica: de El Escorial al clasicismo español,' Anuario del Departamento de Historia y Teoría del Arte (Facultad de Filosofía y Letras, Universidad Autonoma, Madrid, II, 1990, 151–72

Rodríguez G. de Ceballos, Alfonso and A. Casaseca, 'Juan del Ribero Rada y la introducción del clasicismo en Salamanca y Zamora,' in Valladolid, Palacio de Santa Cruz, Herrera y el Classicismo, Ensayos, catálogo y dibujos en torno a la arquitectura en clave clasicista, Valladolid, 1986, 95–109

Rodríguez G. de Ceballos, Alfonso, 'Liturgía y configuración del espacio en la arquitectura española y portuguesa a raíz del Concillo de Trento,' Anuario del Departamento de Historia y Teoría del Arte (Facultad de Filosofía y Letras, Universidad Autonoma, Madrid, III, 1991, 43–52

Rojas, Chistóbal de, Sumario de la milicia antigua y moderna y un tratado de Artilleria (1607) Madrid, Biblioteca Nacional, ms. 9286

Rojas, Christóbal de, Compendio y breve resolucion de fortificacion conforme a los tiempos presentes, con algunas demandas curiosas provandolas con demonstracioness Mathematicas, y algunas cosas militares; por el capitán Cristoval de Rojas, ingeniero militar de su Magestad, Madrid, 1613

Rose, Paul Lawrence, The Italian Renaissance of Mathematics: Studies on Humanists and Mathematicians from Petrarch to Galileo, Geneva, 1976

Rosenfeld, Myra Nan, 'From Drawn to Printed Model Book: Jacques Androuet Du Cerceau and the Transmission of Ideas from Designer to Patron, Master Mason and Architect in the Renaissance,' Revue d'art canadienne/Canadian Art Review, XVI, 1989, 131–46

Rosenthal, Earl, 'The Image of Roman Architecture in Renaissance Spain,' Gazette des Beaux Arts, LII, 1958, 329–46

Rosenthal, Earl, The Cathedral of Granada, Princeton, N.J., 1962

Rosenthal, Earl, The Palace of Charles V in Granada, Princeton, N.J., 1985

Rosenthal, Earl, 'El Programa iconográfico-arquitectónico del Palacio de Carlos V en Granada,' in Seminario sobre arquitectura imperial, ed. Ignacio Henares Cuéllar, Granada, 1988, 159–77

Rossi, Paolo, I Filosophie e le macchine, Milan, 1962; trans. as Science, Technology and the Arts in the Early Modern Era by S. Attenasio and ed. B. Nelson, New York, Evanston, and London, 1970

Rowe, Colin, 'Grid/Frame/Lattice/Web: Giulio Romano's Palazzo Maccarani and the Sixteenth

Century,' The Cornell Journal of Architecture, Fall 1990, 6–21

Rubio, Luciano, 'Cronología y topografía de la fundación y Construcción del Monasterio de San Lorenzo el Real,' in Monasterio de San Lorenzo el Real el Escorial. En el cuarto centenario de su fundación, 1563–1963, Biblioteca La Ciudad de Dios, Libros, vol. 10, El Escorial, 1964, 11–70

Rubio, Luciano, 'El Monasterio de San Lorenzo el Real. I: Ideales que presidieron la fundación. II: Su Estilo,' in Real Monasterio de El Escorial: Estudios en el IV Centenario de la terminación del Monasterio de San Lorenzo el Real de El Escorial, San Lorenzo El Escorial, 1984, 223–93

Ruiz de Arcaute, Agustin, Juan de Herrera, arquitecto de Felipe II, Madrid, 1936

Rykwert, Joseph, 'On the Oral Transmission of Architectural Theory,' Les Traités d'architecture de la Renaissance, ed. André Chastel and Jean Guillaume, Paris, 1988, 31–48

Sagredo, Diego de, Medidas del romano, Toledo, 1526, facsimile ed. Valencia, 1976; reprint ed. with commentary by Agustín Bustmante and Fernando Marías, Madrid, 1986

Saliba, George, 'The Function of Mechanical Devices in Medieval Islamic Society,' Annals of the New York Academy of Sciences, CCCXLI, 1989, 141–51

San Gerónimo, Juan de, Memorias de Fray Juan de San Gerónimo, monge que fue, primero de Guisando, y despues del Escorial sobre varios sucesos del reinado de Felipe II in Colección de Documentos inéditos para la historia de España, vol. 3, ed. M. Salvá and P. Sainz de Baranda, Madrid, 1845, reprint Madrid, 1985

San Nicolás, Fray Lorencio de, Arte y vso de architectvra, Madrid, 1639 and Segunda parte del arte y vso de architectvra, Madrid, 1663; reprinted in 2 vols., with introduction by Juan José Martín González, Madrid, 1989

Sanabria, Sergio L., 'The Mechanization of Design in the Sixteenth Century: The Structural Formulae of Rodrigo Gil de Hontañón,' Journal of the Society of Architectural Historians, XLI, 1982, 281–93

Sánchez Cantón, F. J., 'La Librería de Velázquez,' Homenaje a Menéndez Pidal, Madrid, 1925, vol. 3, 379–406

Sánchez Cantón, F. J., La Libreria de Juan de Herrera, Madrid, 1941

Sánchez de León Pacheco, Vicente, ed., El Escorial, La Arquitectura del Monasterio, Colegio Oficial de Arquitectos de Madrid, Madrid, 1986

Sánchez Rivero, A. and A. M. Sánchez Rivero, ed., Viaje de Cosme III por España y Portugal, Madrid, 1933

Santiago Páez, Elena, 'El Escorial, historia de una imagen,' in Madrid, Biblioteca Nacional, El Escorial en la Biblioteca Nacional, IV Centenario del Monasterio de El Escorial, ed. Elena Santiago Páez, Madrid, 1986, 221–366

Scamozzi, Vicenzo, Idea della architettura universale, Venice, 1615

Schubert, Otto, Geschichte des Barock in Spanien, Eslingen, 1908; trans. as Historia del barroco en España, Madrid, 1924

Schulz, Juergen, 'Jacopo Barberi's View of Venice: Map Making, City Views, and Moralized Geography before the year 1500,' Art Bulletin, LX, 1978, 425–74

Schulz, Juergen, 'Maps as Metaphors: Mural Cycles of the Renaissance,' in Art and Cartography, ed. David Woodward, Chicago, 1987, 97–122

Scotti, Aurora, 'Il Trattato sull'architettura de Pellegrino Tibaldi,' in Les Traités d'architecture de la

Bibliography

renaissance, ed. André Chastel and Jean Guillaume, Paris, 1988, 263–8

Scotti, Aurora, 'Pellegrino Tibaldi ed il suo discorso d'architettura,' *Fra rinascimiento, manierismo e realtà, scritti di storia dell'arte in memoria di Anna Maria Brizio*, Florence, 1984

Sebastián Lopez, Santiago, 'El Escorial como Palacio emblematico,' in *Real Monasterio-Palacio de El Escorial: Estudios inéditos en conmemoración del IV Centenario de la terminación de las obras*, ed. E. Bermejo, Madrid, 1987, 95–106

Segurado, Jorge, 'Juan de Herrera em Portugal,' *As Relações artísticas entre Portugal e Espanha na época dos descobrimentos*, Coimbra, 1987, 99–112

Segurado, Jorge, *Da Obra Filipina de São Vicente de Fora*, Lisbon, 1976

Sendín Calabuig, M., *El Colegio del Arzobispo Fonseca en Salamanca*, Salamanca, 1977

Serlio, Sebastiano, *Libro III, Le Antiquità di Roma*, Venice, 1540

Serlio, Sebastiano, *Libro VI, Gli Habitationi di tutti li gradi degli homini*, Columia University Avery Library ms., ed. Myra Nan Rosenfeld, *Sebastiano Serlio on Domestic Architecture*, New York, 1978

Serlio, Sebastiano, *Libro VI, Habitationi di tutti li gradi degli homini*, ed. Marco Rosci, 2 vols., Milan, 1966

Serlio, Sebastiano, *Settimo Libro d'architettura nel qual se tratta di molti accidenti*, Frankfort, 1575

Serlio, Sebastiano, *Tercero y quarto libro de architectura*, trans. Francisco Villalpando, Toledo, 1552; reprint Valencia, 1977, with introduction by George Kubler

Serlio, Sebastiano, *Tutte le opere d'architettura*, Vicenza, 1619

Seta, Cesare de', *Cartografia della città di Napoli, lineamenti dell'evoluzione urbana*, 3 vols., Naples, 1969; revised edn., Naples, Rome, Bari, 1973

Shearman, John, 'Raphael, Rome and the Codex Escurialensis,' *Master Drawings*, XV, 1977, 107–46

Shelby, Lon B., 'The geometrical Knowledge of Medieval Master Masons,' *Speculum*, XL, 1972, 395–421

Shelby, Lon B., 'Mariano Taccola and his Books on Engines and Machines,' *Technology and Culture*, 1975, XVI, 466–75

Shelby, Lon B., 'The Secret of Medieval Masons,' in *On Pre-Modern Technology and Science: A Volume of Studies in Honor of Lynn White Jr.*, ed. B. S. Hall, and D. C. West, *Humana Civilitas: Sources and Studies Relating to the Middle Ages and the Renaissance*, I, 1976, 201–19

Shelby, Lon B., *Gothic Design Techniques*, Carbondale and Edwardsville, Ill., 1977

Sieber, Claudia, *The Invention of a Capital: Philip II and the First Reform of Madrid*, PhD dissertation, The Johns Hopkins University, 1986; University Microfilms International, Ann Arbor, Michigan, 1990

Sigüenza, José de, *La Fundación del Monasterio de El Escorial*, Madrid, 1605; reprint Madrid, 1986

Sigüenza, José de, *Historia de la Orden de San Gerónimo*, Madrid, 1605, reprint ed. J. Catalina García in *Nueva Biblioteca de autores españoles*, XII, 2 vols., Madrid, 1909

Simons, E. y R. Godoy, *Discurso del Sr. Juan de Herrera aposentador mayor de S.M. sobre la Figura cúbica*, Madrid, 1976

Sitoni, Giovanni (Juan Fran. Siton), *Mémoires au Roi Catolique sur les fiances de l'Espagne*, Paris, Bibliothèque Mazarine, ms. 1907

Sitoni, Giovanni, *Delle Virtù et proprietà delle acque, del trouarle, eleggerle, liuellarle, et condule et di alcuni altri circonstanze. Opera et inuentione di Gio.*

Francesco Sitoni, Ingegnero del Catolico Don Felippo d'Austria, di questo nome secondo, Re di Spagna, et Duca di Milano, Milan 1599, ms. in the collection of the Burndy Library, Norwalk, Conn. (see José García-Diego and Alexander Keller, *Giovanni Francesco Sitoni*, for Spanish trans.)

Spanochi, Tribulcio, *Sobre reparar las inundaciones que en Sevilla causa el Gaudalquivir; Descripcion de las marinas de todo el reyno de Sicilia* (Madlid, Biblioteca Nacional, ms. 788) and *Discurso sobre la conquista de Inglaterra* (Madrid, Biblioteca Nacional, ms. 1750)

Stevin, Simon, *De Sterctenbouwing*, Leyden, 1594; reprinted with English translation in *The Principal Works of Simon Stevin*, vol. 4: *The Art of War*, ed. W. H. Schukking, Amsterdam, 1964

Strong, Roy, *Henry Prince of Wales and England's Lost Renaissance*, New York, 1986

Summers, David, *Michelangleo and the Language of Art*, Princeton, N. J., 1981

Summerson, John, *The Classical Language of Architecture*, Cambridge, Mass., 1983

Tartaglia, Niccolo, *Euclide Megarense philosopho solo introduttore delle scientie mathematice*, Venice, 1543

Tartaglia, Niccolo, *Nova Scientia*, Venice, 1537

Taylor, J., *The Didascalion of Hugh of St Victor*, New York, 1969

Taylor, René, 'El padre Villalpando (1552–1608) y sus ideas esteticas,' *Academia, Boletín de la Real Academia de Bellas Artes de San Fernando*, 1952, 410–73

Taylor, René, 'Architecture and Magic: Considerations on the Idea of the Escorial,' *Essys in the History of Architecture Presented to Rudolf Wittkower*, ed. Howard Hibbard, New York, 1967, 81–109

Taylor, René, 'Hermeticism and mystical architecture in the Society of Jesus,' in *Baroque Art: The Jesuit Contribution*, ed. Rudolf Wittkower and B. B. Jaffe, New York, 1972, 63ff

Taylor, René, 'Juan Bautista Crescencio y la arquitectura cortesana española (1617–1635),' *Academia, Boletín de la Real Academia de Bellas Artes de San Fernando*, 1979, 63–126

Thoenes, Christof, 'La Regola delli cinque ordini del Vignola,' in *Les Traités d'architecture de la Renaissance*, ed. André Chastel and Jean Guillaume, Paris, 1988, 269–79

Thompson, David, *Jacques Androuet du Cerceau*, unpublished PhD dissertation, London, 1976

Thompson, David, *Renaissance Paris: Architecture and Growth 1475–1600*, London, 1984

Torija, Juan de, *Bovedas asi regulares como irregulares*, Madrid, 1660; reprinted with introduction by G. Barbé-Coquelin de Lisle, Valencia, 1981

Torija, Juan de, *Breve tratado de todo género de bovedas asi regulares como irregulares*, Madrid, 1660; reprinted with introduction by G. Barbé-Coquelin de Lisle, Valencia, 1981

Torija, Juan de, *Tratado breve sobre las ordenanzas de la villa de Madrid y polizia della*, Madrid, 1661

Torres Balbás, Leopoldo, *Arquitectura gótica, Ars Hispaniae*, vol. 7, Madrid, 1952

Tovar Martín, Virginia, *Arquitectos madrileños de la segunda mitad del siglo XVII*, Madrid, 1975

Tovar Martín, Virginia, *Arquitectura Madrileña del siglo XVII. Datos para su estudio*, Madrid, 1983

Tratado anonimo de arquitectura dedicado al Principe don Felipe III [sic], Madrid, Biblioteca Nacional, ms. 9681

Tresadmirable, tressmagnificque, & triumphante entree, La, du treshault & trespuissant Prince Philipes, Prince d'Espaignes, filz de lempereur Charles Ve., ensemble la vraye description des Spectacles, theatres,

archz triumphaulx. &c. lesquelz ont este faictz & bastis a sa tresdesiree reception en la tresnommee florisante ville dAnuers. Anno 1549, Antwerp, 1549

Trevor-Roper, Hugh, *Princes and Artists: Patronage and Ideology at Four Habsburg Courts 1517–1633*, New York, Hagerstown, San Francisco, and London, 1976

Ubaldo, Guido, *Mechanicorum Liber*, Pesaro, 1577

Urgorri Casado, Fernando, 'El Ensanche de Madrid en tiempos de Enrique IV y Juan II. La urbanizacion de las cavas,' *Revista de la Biblioteca, Archivo y Museo del Ayuntamiento de Madrid*, XXIII, 1954, 3–63

Vagnetti, L., ed., *2000 Anni di Vitruvio, Documenti di Architettura*, VIII, 1978

Valladoldid, Palacio de Santa Cruz *Herrera y el Clasicismo: ensayos, catálogo y dibujos en torno a la arquitectura en clave clasicista*, ed. Javier Rivera Blanco, Valladolid, 1986

Vandelvira, Alonso de, *Tratado de arquitectura de Alonso de Vandelvira*, 2 vols., ed. G. Barbé-Coquelin de Lisle, Albacete, 1977

Vasari, Giorgio, *Le Vite de più eccellenti pitttori, scultori et architetti, scritte et di nuovo ampliate da Giorgio Vasari pittore Aretino*, Florence, 1568; 9 vols., ed. Gaetano Milanesi, Florence, 1878–85

Vasari, Giorgio, *La Vita di Michelangelo nelle relazione del 1550 e del 1568*, 5 vols., ed. P. Barocchi, Milan, 1962

Vayssière, Bruno and Jean Paul Le Flem, 'La Plaza Mayor dans l'urbanisme hispanique: essai de typologie' in *Forum et Plaza Mayor dans le Monde Hispanique, Publications de la Casa de Velázquez, série 'recherches en sciences sociales,'* fasc. IV, Paris, 1978, 43–78

Velásquez Salamantino, Isidro, *La Entrada que en el reino de Portugal hizo a S. C. R. M. de done Philippe Invictissimo Rey de las Españas, segundo deste nombre, primero de Portugal, assi con su Real presencia como con el exercito de su felice campo*, Lisbon, 1583

Sánchez Rivero, A. and A. M. Sánchez Rivero, ed., *Viaje de Cosme III por España y Portugal*, Madrid, 1933

Victor, Stephen K., *Practical Geometry in the High Middle Ages*, Philadelphia, 1979

Vicuña, Carlos, 'Juan Bautista de Toledo, principal arquitecto del Monasterio de El Escorial,' *El Escorial 1563–1963, IV Centenario de la fundación del monasterio de San Lorenzo el Real*, 2 vols., Madrid, 1964, vol. 2, 71–97

Vignola, Jacopo Barozzi da, *Regola delli cinque ordini*, Rome, 1562

Villacastín, Fray Antonio de, *Memorias de Fray Antonio de Vallacastín, Documentos para la Historia del Monasterio de San Lorenzo el Real de El Escorial*, ed. P. Julian Zarco Cuevas, vol. 1, 2nd edn., Madrid, 1985

Villalpando, Francisco de, *Tercero y quarto libro de architectura de Sebastian Serlio Boloñes, en los quales se trata de las maneras de como se pueden adornar los hedificios con los exemplos delas antiguedades. Agora nueuamente traduzido de Toscano en Romance Castellano por Francisco de Villalpando Architecto*, Toledo, 1552; reprint with introduction by George Kubler, Valencia, 1977

Villalpando, Juan Bautista and Jerónimo Pardo, *In Ezechielem Explanationes et Apparatus Urbis ac Templi Hierosolymitani*, 3 vols., Rome, 1596–1604

Villalpando, Juan Bautista, *De postrema Ezechielis Prophetae Visione…Tomi Secundi Explanationvm pars secvnda*, Rome, 1604

Villalpando, Juan Bautista, *El Tratado de la arquitectura perfecta en la ultima visión del profeta*

Ezequiel, trans. of portions of Latin text and commentary by Luciano Rubio, Madrid, 1990

Viñas Mey, C. and R. Paz, *Relaciones histórico-geográfico-estadísticas de los pueblos de España hechas por intención de Felipe II* (vol. 1: *Provincia de Madrid*, and vol. 2: *Reinos de Toledo*), Madrid, 1949–51

Vincent de Beauvais, *Speculum doctrinale*, Douai, 1624; reprint Graz, 1965

Vitruvius, *The Ten Books on Architecture*, trans. Morris Hicky Morgan, Dover edition, New York, 1960

Warnke, Martin, *Hofkünstler. Zur Vorgeschichte des modernen Künstlers*, Cologne, 1985; trans. Sabine Bollack as *L'Artiste et la cour: aux origines de l'artiste moderne*, Paris, 1989

Weise, Georg, 'Die Hallenkirchen der Spätgotikk und Renaissance in Spanien,' *Zeitschrift für Kunstgeschichte*, IV, 1935, 214–27

Weise, Georg, 'Die spätgotischen Wandpfeilerkirchen mit zentralisirender Ostpartie als Vorläufeer der barocken Kirchenanlagen vom Typus des Gesù,' in *Studien zur spanischen Architektur der Spätgotik*, Reutlingen, 1933, 311ff

Wiebenson, Dora, ed., *Architectural Theory and Practice from Alberti to Ledoux*, Chicago, 1983

Wiebenson, Dora, 'Guillaume Philandrier's Annotations to Vitruvius,' *Les Traités d'architecture de la Renaissance*, ed. André Chastel and Jean Guillaume, Paris, 1988, 67–72

Wilkinson, Catherine, *The Hospital of Cardinal Tavera in Toledo*, PhD dissertation, Yale University, 1968

Wilkinson, Catherine, 'Juan de Mijares and the Reform of Spanish Architecture,' *Journal of the Society of Architectural Historians*, XXXIII, 1974, 122–32

Wilkinson, Catherine, 'The Escorial and the Invention of the Imperial Staircase,' *Art Bulletin*, LVII, 1975, 65–90

Wilkinson, Catherine, 'Observations on Herrera's View of Architecture,' *Studies in the History of Art (National Gallery, Washington, D.C.)*, XIII, 1984, 181–7

Wilkinson, Catherine, 'La Calahorra and the Spanish Renaissance Staircase,' *L'Escalier dans l'architecture de la Renaissance*, ed. André Chastel and Jean Guillaume, Paris, 1985, 153–60

Wilkinson, Catherine, 'Planning a Style for the Escorial: an Architectural Treatise for Philip II of Spain,' *Journal of the Society of Architectural Historians*, XLIV, 1985, 37–47

Wilkinson, Catherine, 'Proportion in Practice: Juan de Herrera's Design for the Façade of the Basilica of the Escorial,' *Art Bulletin*, LXVII, 1985, 229–42

Wilkinson, Catherine, 'Renaissance Treatises on Military Architecture and the Science of Mechanics,' *Les Traités d'Architecture de la Renaissance, De Architectura*, ed. A. Chastel and J. Guillaume, Paris, 1988, 467–76

Wilkinson, Catherine, 'Building from Drawings at the Escorial,' *Les Chantiers à la Renaissance*, ed. Jean Guillaume, Paris, 1991, 263–78

Wilkinson, Catherine, 'Madrid in 1590/91,' *Kritische berichte, Zeitschrift für Kunst-und Kulturwissenschaften*, I, 1992, 93–105

Winner, Matthias, 'Neues zu Dupérac in Rome,' *Kunst-chronik*, XIX, 1966, 308–9

Wittkower, Rudolf, 'Brunelleschi and Proportion in Architecture,' *Journal of the Warburg and Courtauld Institutes*, XVI, 1953, 275–

Wittkower, Rudolf, *Art and Architecture in Italy 1600–1750*, Baltimore and Harmondsworth, 1956; revised edn., Baltimore, 1974

Wittkower, Rudolf, *Architectural Principles in the Age of Humanism*, New York, 1962

Wittkower, Rudolf, *Gothic vs Classic: Architectural Projects in Seventeenth-century Italy*, New York, 1974

Yates, Frances, 'The Art of Ramón Lull: An Approach to it through Lull's Theory of the Elements,' *Journal of the Warburg and Courtauld Institutes*, XVII, 1964, 115–73

Yates, Frances, 'Ramon Lull and John Scotus Erigena,' *Journal of the Warburg and Courtauld Institutes*, XXIII, 1960, 1–44

Yates, Frances, *Giordano Bruno and the Hermetic Tradition*, London, 1964; reprint Chicago, 1969

Yates, Frances, *The Art of Memory*, Chicago, 1966

Yates, Frances, *Theatre of the World*, London, 1969

Yates, Frances, *The Occult Philosophy in the Elizabethan Age*, London, 1979

Zarco Cuevas, Julián: see *Documentos para La historia del Monasterio de San Lorenzo el Real el El Escorial*, vols. 1–VI and Villacastín, Fray Antonio de

Zerner, Henri, 'Du Mot à l'image,' *Les Traités d'architecture de la Renaissance*, ed. André Chastel and Jean Guillaume, Paris, 1988, 281–94

Zuazo Ugalde, Secundino, *Los Orígenes arquitectónicos del Real Monasterio de San Lorenzo del Escorial*, Madrid, 1948

Zuazo Ugalde, Secundino, 'Antecedentes arquitectónicos del Monasterio de El Escorial,' *El Escorial 1563–1963, IVo Centenario*, 2 vols., Madrid, 1964, vol. 2, 105–54

Zubov, Victor, 'Vitruve et ses commentateurs du XVIe siècle,' *La Science au XVIe Siècle, Colloque de Royaumont*, Paris, 1956, 69–90

Index

Index

Index